Bombay Cinema's Islamicate Histories

Bombay Cinema's Islamicate Histories

EDITED BY

Ira Bhaskar and Richard Allen

Bristol, UK / Chicago, USA

First published in the UK in 2022 by
Intellect, The Mill, Parnall Road, Fishponds, Bristol, BS16 3JG, UK

First published in the USA in 2022 by
Intellect, The University of Chicago Press, 1427 E. 60th Street, Chicago, IL 60637, USA

Copyright © 2022 Intellect Ltd

All rights reserved. No part of this publication may be reproduced, stored in a retrieval system, or transmitted, in any form or by any means, electronic, mechanical, photocopying, recording, or otherwise, without written permission.

A catalogue record for this book is available from the British Library.

Copy editor: Newgen
Cover and frontispiece designer: Aleksandra Szumlas
Production manager: Sophia Munyengeterwa
Typesetting: Newgen

Print ISBN 978-1-78938-397-3
ePDF ISBN 978-1-78938-398-0
ePub ISBN 978-1-78938-399-7

Printed and bound by CPI.

To find out about all our publications, please visit
www.intellectbooks.com
There you can subscribe to our e-newsletter, browse or download our current catalogue, and buy any titles that are in print.

This is a peer-reviewed publication.

Contents

List of Illustrations	vii
Acknowledgements	xi
A Note on Transliteration	xv
Introduction: Bombay Cinema's Islamicate Histories	1
Richard Allen and Ira Bhaskar	

PART 1: ISLAMICATE HISTORIES 35

1. Passionate Refrains: The Theatricality of Urdu on the Parsi Stage	37
Kathryn Hansen	
2. The Persian *Maṣnavī* Tradition and Bombay Cinema	64
Sunil Sharma	
3. Reflections from Padminī's Palace: Women's Voices of Longing and Lament in the Sufi Romance and Shi'i Elegy	83
Peter Knapczyk	
4. Situating the *Ṭawā'if* as a Poet: Nostalgia, Urdu Literary Cultures and Vernacular Modernity	106
Shweta Sachdeva Jha	
5. Mughal Chronicles: Words, Images and the Gaps between Them	132
Kavita Singh	
6. Justice, Love and the Creative Imagination in Mughal India	155
Najaf Haider	
7. The 'Muslim Presence' in *Padmaavat*	182
Hilal Ahmed	

PART 2: CINEMATIC FORMS — 201

8. Alibaba's Open Sesame: Unravelling the Islamicate in Oriental Fantasy Films — 203
 Rosie Thomas

9. The Textual, Musical and Sonic Journey of the *Ghazal* in Bombay Cinema — 229
 Shikha Jhingan

10. The Sufi Sacred, the *Qawwālī* and the Songs of Bombay Cinema — 259
 Ira Bhaskar

11. Avoiding Urdu and the *Ṭawā'if*: Regendering Kathak Dance in *Jhanak Jhanak Payal Baaje* — 295
 Philip Lutgendorf

12. The Poetics of *Pardā* — 320
 Richard Allen

13. Transfigurations of the Star Body: Salman Khan and the Spectral Muslim — 347
 Shohini Ghosh

14. Terrorism, Conspiracy and Surveillance in Bombay's Urban Cinema — 370
 Ranjani Mazumdar

Notes on Contributors — 399
Index — 403

Illustrations

All film illustrations are frame grabs unless otherwise stated.

1.1	Victoria Theatre, 1870.	46
1.2	Cowasjee Patel and son, posing against a painted backdrop.	49
1.3	*Romeo and Juliet*, Act I, Scene 2, Bombay.	50
1.4	Āghā Ḥashr Kāshmīrī, Urdu playwright.	56
1.5	Nawab and Rattan Bai in *Yahudi ki Ladki* (1933). Production still.	58
4.1	Frontispiece of Malkā Jān's *dīwān*.	121
5.1	*The Death of Kh̲ān Jahān Lodhī*, by 'Ābid.	136
5.2	Shāh Jahān receives his three eldest sons and Asaf Kh̲ān during his accession ceremonies, by Bichitr.	139
5.3	Jahāngīr receives the imprisoned Mirzā Husain of Badakshan, attributed to Govardhan.	143
5.4	Akbar fights with Raja Mān Singh, by Daulat.	148
6.1	Emperor Jahāngīr at the *jharoka* window, ascribed to Abū'l Ḥasan.	159
6.2	Illustration of Shāh Jahān's first *darbār*, by Bichitr.	161
6.3	Folio from *Pseudo-Jahāngīrnāma* praising I'timādu'd Daula's family and Nūr Jahān.	167
6.4	Gold *muhr* minted in the name of Nūr Jahān at Surat.	169
6.5	Jean Baptiste Tavernier's account of Nūr Jahān's zodiac coins.	172
7.1	The Bhārat Mātā image in *Padmaavat*.	191
7.2	Alāuddīn's soldiers offering *namāz* in *Padmaavat*.	193
8.1	Marjana's dagger dance with Abdullah – production still of the 1937 *Alibaba*.	211
9.1	Record cover of HMV-ECLP 2640.	235
9.2	Begum Akhtar.	238
9.3	Dilip Kumar performs '*Ai dil mujhe aisī jagāh le ćal*' in *Arzoo* while lip syncing to Talat Mahmood's expressive voice.	242
9.4	Record cover of HMV-ECLP 2265.	243

9.5 Meena Kumari as Naaz Ara performs '*Nagmā-o-shĕ'r kī saugāt kise pesh karūṅ*' at a *Zanānā Mahfil* in *Gazal*. — 246

9.6 Sunil Dutt as Ejaz sings '*Ishq kī garmī-ĕ-jazbāt kise pesh karūṅ*' at a *mushā'ara* in *Gazal*. — 247

9.7 Naaz Ara slowly gets drawn to Ejaz's passionate performance as a listener in *Gazal*. — 247

10.1 The sacred landscape of faith – *Dharmputra*. — 265

10.2 The sacred landscape of faith (2) – *Dharmputra*. — 265

10.3 The *qawwāl* and the *pandit* – *Dharmputra*. — 266

10.4 Shīrīn praying at the *dargāh* – *Shirin Farhad*. — 268

10.5 Farhād entering the *dargāh* singing – *Shirin Farhad*. — 269

10.6 Farhād at the steps of the sanctum – *Shirin Farhad*. — 269

10.7 Farhād's glimpse of Shīrīn – *Shirin Farhad*. — 269

10.8 Farhād gazing at Shīrīn – *Shirin Farhad*. — 270

10.9 Shīrīn overwhelmed by her vision – *Shirin Farhad*. — 270

10.10 Farhād and Shīrīn – *Shirin Farhad*. — 270

10.11 Shama and Shabab seem to be losing the *qawwālī* competition – *Barsaat ki Raat*. — 273

10.12 Daulat Khan's paen to '*ishq* – *Barsaat ki Raat*. — 273

10.13 Amaan joins the *qawwāl*s – *Barsaat ki Raat*. — 273

10.14 Shabnam arrives at the *dargāh* – *Barsaat ki Raat*. — 274

10.15 Shabnam as Radha, Sita and Mira – *Barsaat ki Raat*. — 275

10.16 The Haji Ali *dargāh* – *Fiza*. — 276

10.17 The Haji Ali *qawwālī* – *Fiza*. — 277

10.18 Nishat Bi imagining Amaan is with her – *Fiza*. — 277

10.19 The *qawwāl*s – *Veer Zaara*. — 279

10.20 Veer and Zaara in *Veer Zaara*. — 280

10.21 The *fanā* image – *Dil Se*. — 285

11.1 The film's title credit (*Jhanak Jhanak Payal Baaje*, Rajkamal Kalamandir Ltd.). — 299

11.2 Mangal Maharaj confronts Rupkala's poster in *Jhanak Jhanak Payal Baaje (JJPB)*. — 300

11.3 Neela's mansion in *JJPB*. — 301

11.4, 11.5 Neela performs, as Mangal Maharaj and Giridhar watch from outside in *JJPB*. — 302

11.6, 11.7 Mangal Maharaj accepts Neela as a dance pupil and she assumes a male costume for her initiation in *JJPB*. — 303

11.8 Neela in exile, as a female ascetic in *JJPB*. — 304

11.9, 11.10 After nearly dying in the forest, Neela is married by Mangal Maharaj to his son, Giridhar in *JJPB*. — 312

ILLUSTRATIONS

11.11	Neela's opening performance in *JJPB*.	313
11.12, 11.13	Mangal Maharaj's quarters in *JJPB*.	313
11.14, 11.15	The tower and interior of the fictional *Naṭeśvar* Temple in *JJPB*.	314
11.16, 11.17	Giridhar astonishes Neela with his athletic leaps in *JJPB*.	315
11.18, 11.19	The final ensemble number in *JJPB*.	316
12.1	Jameela lifts her veil – *Chaudhvin ka Chand*.	323
12.2	Pyare steals a glance at Jameela – *Chaudhvin ka Chand*.	323
12.3	Pyare, concealed, spies on Jameela at the party – *Chaudhvin ka Chand*.	324
12.4	Jameela framed by fireworks – *Chaudhvin ka Chand*.	324
12.5	Pyare spies on the female qawwāls – *Chaudhvin ka Chand*.	325
12.6	Jameela returns an admonishing glance at Pyare – *Chaudhvin ka Chand*.	325
12.7	Shaida in his old mendicant disguise at the *mujrā* – *Chaudhvin ka Chand*.	326
12.8	Tameezan performs for Shaida – *Chaudhvin ka Chand*.	326
12.9	Love at first sight – *Mere Mehboob*.	327
12.10	Husna and Naseem confide – *Mere Mehboob*.	328
12.11	Imran encounters Asiya covered by a *burqa'* – *Naqab*.	330
12.12	While Aslam veils Jameela, Pyare is seen arriving in the mirror behind them – *Chaudhvin ka Chand*.	332
12.13	Pyare sees Aslam with Jameela – *Chaudhvin ka Chand*.	333
12.14	Pyare reacts to what he sees – *Chaudhvin ka Chand*.	333
12.15	Anwar courts Husna behind a *pardā* screen – *Mere Mehboob*.	334
12.16	Anwar hears Husna singing 'Mere Mehoob' – *Mere Mehboob*.	335
12.17	Anwar sees Naseemara at the window believing that she is Husna – *Mere Mehboob*.	335
12.18	Firdaus and Akhtar at the jewellery store – *Deedar-e-Yaar*.	337
12.19	Akhtar and Javed with Firdaus disguised by her veil – *Deedar-e-Yaar*.	337
12.20	Firdaus unveiled by Javed – *Deedar-e-Yaar*.	338
12.21	Javed reacts in horrified recognition – *Deedar-e-Yaar*.	338
12.22	Shaida steals a photograph – *Chaudhvin ka Chand*.	340
12.23	Imran pursues Haya with a camera strapped over his shoulder – *Naqab*.	341
12.24	The mysterious Haya pursued by Imran – *Naqab*.	341
12.25	Akhtar appears out of focus between Javed and Firdaus – *Deedar-e-Yaar*.	343

12.26	Akhtar comes into focus as Javed declares that he is now a reality – *Deedar-e-Yaar*.	343
13.1	The ripped, muscular body of Salman Khan – *Sultan*.	349
13.2	Salman Khan as an Olympic wrestler – *Sultan*.	361
13.3	The return of Salman Khan – *Sultan*.	363
14.1	Hindu militants atop the Babri Mosque just before its destruction.	373
14.2	A closer view of the Babri Mosque showing militants waving saffron flags.	373
14.3	Poster of *Black Friday*.	377
14.4	An anguished Badshah Khan in custody – *Black Friday*.	379
14.5	The protagonist in *Aamir* trapped by the cell phone.	383
14.6	Poster of *Aamir* highlighting the sequence with the red suitcase.	385
14.7	A stylized poster of *A Wednesday* showing the policeman and the Common Man as opponents in the city of Mumbai.	387
14.8	Rooftop view of the Common Man (Naseeruddin Shah) sitting with all his gadgets – *A Wednesday*.	389
14.9	Prakash Rathod (Anupam Kher) at the police station's high-tech informational space – *A Wednesday*.	393

Acknowledgements

This book developed out of a workshop entitled 'Islamicate Cultures of Bombay Cinema', which we organized at New York University Abu Dhabi on 20–21 March 2009. This workshop was funded by the New York University Institute, Abu Dhabi, and we wish to specially thank the then Institute Director Philip Kennedy and the then Provost Mariët Westermann for hosting the event. We would also like to thank the then Indian Ambassador to the UAE, Mr Talmiz Ahmad for his generous support and for ensuring that the Indian participants had the required visas to be present at the workshop. Participants on that occasion included Shyam Benegal, Kaushik Bhaumik, Najaf Haider, Kathryn Hansen, Mukul Kesavan, Philip Lutgendorf, Saeed Mirza, Yatindra Mishra, Kavita Singh, Rosie Thomas and Ravi Vasudevan, and we are grateful to them all for making it such a stimulating event. Some of the chapters in this volume hearken back to presentations made at that event, but many of them are newly commissioned as, over the years, the book changed its nature and scope.

The publication of *Bombay Cinema's Islamicate Histories* was made possible by a grant given to Richard Allen when he was visiting professor at NYU Abu Dhabi in spring 2015, and he wishes to thank the then deputy vice chancellor of NYU Abu Dhabi, the late Hilary Ballon, for her support. He is also grateful to Provost Alex Jen at City University, Hong Kong, for sabbatical leave in 2019 which aided in the completion of this work. Ira Bhaskar would like to thank Jawaharlal Nehru University (JNU) for sabbatical leave in 2016 that enabled her to pick up this book project once again, initiating and working with writers of new chapters for the volume. She would also like to thank JNU for a grant from the UGC's UPE II project that enabled her research at the National Film Archive (NFAI) in February 2019; and Prakash Magdum, director of NFAI, Arti Karkhanis of the Documentation Section, NFAI, and Veena Kshirsagar at the NFAI Library for their help during her research there.

We are very grateful to our publishers, Tim Mitchell and James Campbell at Intellect and Vidya Rao at Orient BlackSwan, for sticking with us through the years of delay and for encouraging us to complete the volume. We would also like to

thank Sophia Munyengeterwa at Intellect and Veenu Luthria and Roopa Sharma at Orient BlackSwan for working with us patiently on the production of the book.

Two of the chapters in this volume have been published before, and we thank the publishers for enabling us to republish them here. Kathryn Hansen's chapter 'Passionate refrains: The theatricality of Urdu on the Parsi stage' was first published in *South Asian History and Culture* (7:3 [2016]), and we thank Taylor and Francis for the right to include it here. Ranjani Mazumdar's chapter 'Terrorism, conspiracy and surveillance in Bombay's urban cinema' was earlier published in *Social Research* (78:1 [Spring 2011]), and we thank the journal for allowing us to republish it. Shohini Ghosh's chapter in the volume is a substantially revised and expanded version of a paper that recently appeared as 'The Irresistible Badness of Salman Khan', in *Indian Film Stars: New Critical Perspectives*, edited by Michael Lawrence (London: Bloomsbury, 2020, pp. 193–203).

For Kavita Singh's chapter, we would like to thank the Royal Collection Trust /© Her Majesty Queen Elizabeth II 2019 for permission to reproduce an image of *The Death of Khān Jahān Lodī* by 'Ābid (from the *Pādshāhnāma*, Royal Library, Windsor Castle, Acc. No. RCIN 1005025.q) and an image of Shāh Jahān receiving his three eldest sons and Asaf Khān during his accession ceremonies by Bichitr (from the *Padshāhnāma*, Royal Library, Windsor Castle, Acc. No. RCIN 1005025.k). We would also like to thank the trustees of the Chester Beatty Library, Dublin, for permission to reproduce an image of Jahāngīr receiving the imprisoned Mirza Husain of Badakshan, which was intended for the *Jahāngīrnāma* (Acc. No. CBL In 34.5), and the double folio image of Akbar fighting with Rajā Mān Singh by Daulat (Acc. Nos CBL In 03.168v and CBL In 03.169r).

For Najaf Haider's chapter, we would like to thank the Royal Collection Trust /© Her Majesty Queen Elizabeth II 2019 for permission to reproduce an image by Bichitr of Shāh Jahān's first *darbār* which shows the persistence of the memory of Jahāngīrī justice in the representation of his son's kingship (from the *Pādshāhnāma*, Royal Library, Windsor Castle, Acc. No. RCIN 1005025.k). We would also like to thank the Aga Khan Museum for permission to publish an image of Emperor Jahāngīr at the *jharoka* window (1620), ascribed to Abū'l Ḥasan, with the inscription *Amal kamtarīn Nādiru'z Zamān* ('Work of the humble "Wonder of the Age"') (© The Aga Khan Museum, AKM136). Thanks are also due to the Raza Library, Rampur, for permission to publish a folio from the *Pseudo-Jahāngīrnāma* praising I'timādu'd Daula's family and Nūr Jahān (MS. Tārīkh Fārsī 174, f. 28a.). The Classical Numismatic Group, LLC gave permission to publish an image of a gold *muhr* minted in the name of Nūr Jahān at Surat in 1624 AD, and the Bibliothèque Nationale de France enabled us to publish an image of Tavernier's account of Nūr Jahān's zodiac coins – we thank them both.

ACKNOWLEDGEMENTS

A big thank you to all the contributors for their chapters and for stimulating conversations and discussions at different stages of work on this volume. Many thanks to Spandan Bhattacharya, Isabelle Frank, Kathryn Hansen, Philip Lutgendorf, Carla Petievich, Nasreen Rehman, Yousuf Saeed and colleagues at JNU; and to Kaushik Bhaumik, Najaf Haider, Veena Hariharan, Shikha Jhingan, Ranjani Mazumdar and Kavita Singh for their support, help and advice as we worked on the volume. We would also like to thank Aseema Karandikar for her work on diacritics, Sandeep Singhal for his help with images for several of the chapters and the late Gulam Rasul, the then librarian at the School of Arts & Aesthetics Library, JNU, for his help with books and articles required by some of the contributors. Ira Bhaskar is very grateful to Uday, Swara, Ishan and Bhoomika for accompanying her on the long journey of this book, for the wonderful discussions on the issues that this book addresses and for sharing their passion for the *qawwālī* with her. She would also like to thank Sureshwar Sinha, her father, for his support of her work even when he was recently hospitalized, and her siblings Vanita Shastri, Nikhil Sinha and Rajita Sinha for giving her time during the difficult period of their father's medical emergency to enable her to complete her work at the last stages of the editing. And finally, she would like to remember and thank her late mother, Rama Sinha, for her consistent support and acknowledge that she would have been very delighted at the completion of this book project.

A Note on Transliteration

Given the many different languages that this volume draws upon, we have used two different systems for transliteration. For Hindi and Hindustani/Urdu words, we have followed John T. Platts's *A Dictionary of Urdu, Classical Hindi and English*. For Persian words, we have followed Francis J. Steingass's *A Comprehensive Persian-English Dictionary*. In order to maintain a correspondence with the words that are familiar in the present, we have not used diacritics for the names of languages, place names, modern names in the twentieth century and after, film titles and common words such as *Bhakti*, *ghazal*, Sultan (except when used as a proper noun), Sufi and Parsi, and the names of gods such as Krishna and Sita. We have used diacritics for historical names, like those of rulers and writers of historical and literary texts, for works of literature and historical texts, for the lyrics of songs and their titles and for dialogues from films.

Introduction:
Bombay Cinema's Islamicate Histories

Richard Allen and Ira Bhaskar

Bombay Cinema's Islamicate Histories gathers together a group of leading and emerging scholars of Indian history, literature, cinema and the arts, to explore traditions of Islamicate culture in the subcontinent and the ways in which they permeate and inform the Hindi-Urdu language cinema of Bombay, which has recently come to be known as Bollywood. We use this title to indicate the subject of the book which is the historical forms of Islamicate culture that influenced Bombay cinema and the Islamicate imaginaries and histories of Bombay cinema itself. We will reserve use of the term 'Bollywood' to refer specifically to contemporary Bombay cinema from when the character of the industry changed after the economic liberalization of 1991.[1] We use the term 'Islamicate' here, following Marshall Hodgson, to refer not to the Islamic religion per se but to the aesthetic and cultural forms 'historically associated with Islam and the Muslims, both among Muslims themselves and even when found among non-Muslims' (1958: 59). As Bruce B. Lawrence (2008) has argued, 'Islam in civilizational discourse must be viewed as a cultural variable, linked to but exceeding religious connotations', and it evokes 'a larger geo-cultural grid than would be defined solely by loyalty to Islam as creed, liturgy and law' (n.pag.). Islamicate culture, he continues, should not be viewed 'as part of some inherent or deterministic world system', and furthermore, it 'cannot be understood apart from the other civilizations with which it interacted, both shaping and being shaped by them, in its long historical trajectory' (n.pag.). Thus this volume investigates Islamicate cultural and aesthetic forms not in isolation but as they permeate Indian culture and cinema while in dialogue with and sometimes fused with elements that have their origins in different religious and cultural frameworks, including that of Hinduism. The book is designed as a 'reader' in the field that will be of value above all to the student of cinema who wishes to understand not only the way in which Islamicate idioms inform Bombay

cinema but also something of the background and origins of those idioms. In this introduction we will provide a brief exposition of the history of Islam in India, defend the use of the term 'Islamicate' in the Indian context, in spite of the pitfalls and blind spots it gives rise to, summarize the Islamicate idioms discussed in this volume and how they are partly constitutive of Bombay cinema and finally provide the reader a guide to the contents of this volume.

Islam in India

Islam has a thousand-year history in India, and even before the first Muslim kingdoms were established in the twelfth century, an Arab invasion of Sind had taken place in the eighth century which led to a productive encounter with Indian astronomy and to India's contribution of the numerical and the decimal systems to mathematics. However, it is with the Ghaznī invasions from the end of the tenth and the early eleventh centuries that India became a destination for different Central Asian Turks – Muslim adventurers and invaders – which led to the establishment of the first Muslim kingdom in India in the early thirteenth century with the foundation laid by Muhammad of Ghor in 1192 (Embree 1991: 384–85). Five dynasties – the Mamluks, the Tughlaks, the Khaljīs, the Sayyīds and the Lodīs – formed the subsequent rule of the Delhi Sultanates for over three hundred years until the defeat and death of Ibrāhīm Lodī by Bābur at the Battle of Panipat in 1526 and the establishment of the Mughal Empire. During this period, under the different sultans, the Delhi Sultanate ruled over much of India, though over time parts of the empire broke away and independent Sultanates were established in these regions. While this history is politically volatile and violent, the different Sultanate kingdoms were extremely significant for the development of social and cultural life in India. Not only was Islam established in the region but Muslim scholars who found refuge in India also codified religious and legal principles, and the Sharia became the basis of jurisprudence that impacted all aspects of social, economic and personal relations (Embree 1991: 386). Persian was the official language of these kingdoms, and Arabic was significant for all Islamic religious and ritual practices.

At the same time as the top-down establishment of political and religious authority by the Sultanate courts, the arrival of Sufi mystics initiated a contact with ordinary people that enabled the wider acceptance and spread of Islam (Embree 1991; Qureshi 1986) and yielded a complex conversation between cultures (Flood 2009). Sufi thought and practices resonated with the ideas, customs, festivals and languages of the local population, which in turn influenced the philosophical discourses and the poetic compositions produced by the Sufis and their disciples, as

the work of Amīr K̲h̲usrau in the thirteenth and fourteenth century attests (Sharma 2006). This process of mutual influence that brought different cultural and aesthetic forms together is evident also in the emergence during this time of what is known as Indo-Islamic architecture. The monumental buildings of this period – the mosques, forts and Rajput palaces – demonstrate the coming together of different architectural styles – the Central Asian and the local Indian – engendering the syncretic form that became the basis of the architecture that was to follow during the Mughal age (Michell 1986; Asher 1992; Merklinger 2005). Also during the Sultanate period, a distinctive style of miniature painting emerged as manuscript illustrations of Awadhi epics like the *Ćāndāyan* and the *Mirigāvatī* drew on indigenous traditions that were both folk and courtly (Chaitanya 1982). The language and literature of the time also significantly reveal the interaction of different linguistic forms and traditions. It is during this period that Amīr K̲h̲usrau used Persian, Hindavi and Braj, spoken in and around Agra and Mathura, for his poetic compositions (Sharma 2006). This practice of linguistic syncretism continued with the emergence of Rekhta and Urdu, which brought together Persian, Arabic and the different Hindi and other vernaculars of various regions. This led to poetic compositions in these languages that were both devotional and erotic in nature (Sharma 2006; Bangha 2010; Petievich 2010).

The productive symbiosis of cultural forms and practices continued and was heightened during the Mughal period. Bābur's victory in 1526 laid the foundations of the Mughal Empire which, after successive military campaigns, had grown by the end of Aurangzeb's rule in 1707 to become a vast imperial power that held sway from Kabul in the west and Bengal in the East to the Deccan plains in the South. The period of the great Mughals – Akbar (1556–1605), Jahāngīr (1605–27) and Shāh Jahān (1628–58) – was marked by exceptional achievements in the fields of the arts, literature, architecture and the performing arts, and the Timūrid Empire was unusually ecumenical and open to cultural influences from the regions it ruled. Akbar and Jahāngīr married Rajput princesses, and all the Mughal rulers appointed Rajput commanders and nobles to the court, accepted Hindu religious practices and had a vibrant interaction with Hindu saints and Muslim Sufis and mystics, as well as with artists from different parts of the world. An efflorescence of vernacular literatures was a significant feature of the Mughal period, when the encounter between Sufism and *Bhakti* (devotional) movements (see Chapter 10 by Bhaskar in this volume) led to intensely emotional and charged devotional and philosophical articulations, as Sufi writers absorbed local influences and found points of connection with the Vaishnavite Krishna-worshipping cultures of the Braj and Bengal regions.[2] A whole range of *Bhakti* literature in the different vernaculars of North India was produced during this period (Schelling 2011). Storytelling traditions also evolved through cultural cross-pollination as the Persianate *mas̲navī*

was transformed into the Punjabi *qiṣṣa* (see Chapter 2 by Sharma in this volume). At the same time, vibrant Sanskrit textual production continued under the Mughals and Sanskrit was incorporated into the Persianate world (Truschke 2016).

There was also a renaissance of Indian painting, architecture and performing arts under the Mughals which drew upon a wide range of Indic practices. The different regions of India had rich visual cultures evident in the sculpture and painting traditions that came down from the ancient period onwards. There were robust indigenous histories of cave and mural paintings from Jain, Buddhist and Hindu traditions, and visualizations of *Bhakti* imaginaries, especially from the Vaishnav Krishna traditions from the medieval period, were extremely popular. Beginning in the Sultanate and intensifying in the Mughal period, these traditions interacted with the Persian traditions of miniature painting and illustrated manuscripts which had been taken up in the Indian courts. Courtly painting practices were further modified in response to European Renaissance prints that the Jesuits brought to the Mughal courts, especially those of Akbar and Jahāngīr (Singh 2017). The hundred-year reign of these three great Mughal emperors also witnessed the building of extraordinary monuments like the Humāyūn's Tomb, the Agra Fort, Akbar's city in Fatehpur Sikri, I'timādu'd Daula's tomb in Agra, the Red Fort in Delhi and of course the crowning jewel of Mughal architecture, the Taj Mahal. These are some of the well-known examples of Mughal architecture, but there are scores of others, all of which were built by artisans and craftsmen of Indian origin – both Hindu and Muslim – as well as those who travelled to India from different parts of the Persianate and Arab world. Cultural historians of the Mughal period have looked at literary, historical and visual sources to demonstrate 'the gradual Indianization of Persianate musical culture' (Wade 1999: xlix) which in interaction with vibrant indigenous musical traditions created a cultural synthesis of different forms. Katherine Butler Brown has demonstrated that even Aurangzeb, the allegedly repressive emperor who is supposed to have prohibited music, was actually a patron, evidenced by the 'number of dhrupads composed in [his] Aurangzeb's honour still preserved in oral and written forms' and by the fact that there was a virtual 'renaissance of musical life' during his reign (2007: 86, 104). Similarly, the dance form of Kathak, which arguably drew on earlier traditions, became, in the Mughal courts and their satellites, highly refined and was performed by courtesans as *mujrā*s (dances) in courts and in their salons. It subsequently became redefined in the post-independence period as a 'classical' dance of India (see Chapter 11 by Lutgendorf in this volume). The history of Islam in India is thus marked by a profound cultural syncretism that is also evident in the development of Urdu.

Urdu emerged through the interaction between Hindavi, Persian, Arabic and Khari Boli and was also known as Rekhta in the eighteenth and nineteenth

centuries. It came to be written in the *Nasta'līq* script which it drew from Persian and its vocabulary is derived from the above languages. Hindavi was also significant for the development of Dakhani, which had already developed as a poetic language in the south in the fifteenth and sixteenth centuries. Dakhani had similar origins and character to Urdu but also drew on the local vernaculars of the Deccan region – Marathi, Kannada and Telugu (Rahman 2011). It was the influence of literary Dakhani that led to Urdu's development as a literary language in the Delhi courts with the arrival, in 1700, of Walī Dakhanī (1665–1707) from Aurangabad in the south (Faruqi 2010). In the compositions of Urdu poets of the late eighteenth and nineteenth centuries like Mīr, Ghālib, Dāgh, Momin and Zauq, who also wrote in Persian, literary Urdu reached its height of sophistication.

In the meantime, Hindustani had evolved out of Khari Boli and Urdu as the spoken language of the ordinary people of North India. In the political struggles and the language wars of the early twentieth century, the emergence of Hindi as a language that claimed descent from Sanskrit denied the shared heritage of Urdu/Hindustani as the language spoken by both Muslims and Hindus. In its spoken forms both Urdu and Hindi were essentially the same language as Hindustani though written in different scripts with Urdu using the *Nasta'līq* and Hindi the Devanagari script (King 1994; Orsini 2002; Rahman 2011). Within the recitational tradition of poetry, aesthetically refined Urdu and the song forms that grew out of it were also part of a shared cultural heritage between Muslims and Hindus (see Chapter 9 by Jhingan and Chapter 10 by Bhaskar in this volume).

After Aurangzeb's death, the Mughal Empire began to break up under a series of weak emperors and assaults from several directions: Delhi was sacked by the military conqueror Nāder Shāh, the shah of Iran, in 1739, while in the west and south, the Maratha Confederacy had grown in power, and in the eastern region of Bengal, the East India Company had established a foothold. By the time of the last Mughal emperor, Bahādur Shāh Zafar (1837–57), the Mughal kingdom was limited to the old city of Delhi and its surrounding areas. In 1857, after the brutal suppression of the Great Rebellion against British rule, Bahādur Shāh was exiled to Burma and the British Crown took over complete control. With the weakening and break-up of the Mughal Empire, regional centres began to grow in power and influence. One such centre was Awadh in central north India, which had gained autonomy from Delhi in the early eighteenth century and, with Faizabad and later Lucknow as its capital, had become a rich and vigorous cultural nucleus of poets, litterateurs and painters who produced a distinctive Islamicate culture in this region. While Awadh fell under the indirect control of the British after their victories over the Mughal armies at Plassey (1757) and Buxar (1764) (Keay 2000), it continued to flourish as a centre of Urdu and Islamicate courtly culture until its annexation in 1856. After the failure of the Great Rebellion of 1857

and the sacking of Lucknow by the British, Lakhnawī culture subsequently came to denote all that was lost in the cultivation and taste of courtly life, in which the figure of the *ṭawā'if* or the Islamicate courtesan had played a central role (Oldenburg 1990). However, in spite of the destruction of the *ṭawā'if* culture, the idioms of poetry and performance it had cultivated, though dispersed, lived on and evolved through the popular medium of Urdu poetry collections, the growing professionalization of *ṭawā'if* performance (see Chapter 4 by Jha in this volume), Parsi theatre (see Chapter 1 by Hansen in this volume) and the emerging mass media of radio and recording, finally leading to cinema itself (see Chapter 9 by Jhingan in this volume).

With power passing from the East India Company directly to the English queen after the Indian Rebellion of 1857, India became part of the British Empire and imperial control over India was consolidated. The earlier convergence of cultures began to break apart. Although tensions had periodically erupted between different religious constituencies under Islamic rule, these differences hardened into communal allegiances only within colonial modernity. The reasons for this were complex. In part, this was due to the oft-cited British strategy of 'divide and rule' that was most evident in the partitioning of Bengal by Lord Curzon in 1905, but it was also due to the pressures of negotiating an abrupt and peremptory modernity that required staking a claim in the newly emerging public sphere. Muslim and Hindu elites were at once anglicized and increasingly self-conscious about their respective religious traditions, both of which underwent 'reform' and revival. In 1828, the Hindu *bhadrolok* (gentry) of Bengal established the Brahmo Sabhā (forerunner of the Brāhmo Samāj), a Hindu reform movement founded by Raja Ram Mohan Roy and Debendranath Tagore. The Muslim aristocracy, led by Sayyid Ahmad Khan, founded Aligarh Muslim University in 1875, which combined Muslim religious studies with a western curriculum and was the seedbed for the formation of the All India Muslim League in 1906. By the turn of the century, in spite of the prevalence of Urdu in Punjab, Delhi and Awadh, a new Hindi public sphere emerged that sought to purify Sanskritized Hindi from a Persianized Urdu (Orsini 2002). Hindi was championed as the 'mother tongue' of an imagined common Hindu culture from which the debased and decadent language of Urdu was to be excised. Muslims responded in defence of the Urdu language and with purification campaigns of their own (see Chapter 3 by Knapczyk and Chapter 11 by Lutgendorf in this volume).

By the end of the nineteenth century, Indian elites had begun to demand reform and rights from the British. This led to the formation of the Indian National Congress in 1885 with co-founders W. C. Banerjee and A. O. Hume as the president and secretary respectively. The initial demands of the Congress in the first decade were civil rights, the appointment of Indians to administrative positions and elected

Indian representatives on legislative councils, and the right to suggest economic measures. However, in the second decade of its existence, the Congress began to demand a greater role in the governance of India, and with the arrival of M. K. Gandhi from South Africa in 1915, it launched a fully fledged anti-colonial agenda for self-governance. The Congress had members from all religions, including the Muslims, and as a multireligious and multicultural country, it was very important for Indians to be united against the British. In this context, inspired by Gandhi, a distinctively Indian conception of secularism evolved that embraced religious plurality and equality and respect for all religions in the nation without state interference. This was enshrined in the Constitution of India under Ambedkar's leadership in January 1950. What secularism meant in practice was fluid, and the Congress accommodated a wide range of political positions which were not always so accepting of this constitutional ideal (Gould 2004); nonetheless, it remains the case that throughout the independence movement from 1915 onwards, the Congress remained officially committed to Indian secularism.

The Muslim leader Muhammad Ali Jinnah, who had trained as a barrister in England, joined the Congress Party in 1906 but left it in 1920 in protest against Congress support for Gandhi's campaign of *satyagraha* (non-violent protest) in the same year. He became a member of the All India Muslim League in 1913 and initially worked for Hindu-Muslim unity. He fought for self-governance with the Home Rule League and initially accepted that the rights of Muslims could be protected in a united India. While Jinnah was himself non-religious and an atheist, he did believe in the distinctive cultural identity of Muslims, and by the end of the 1930s he had come to support Muhammad Iqbal's proposal, first drafted in 1930, for a separate state for Muslims in the Indian subcontinent in order to ensure that Muslims in a democratic India were not exploited under Hindu majoritarian rule. The new separatist aspirations of the League initially had support only in the northern states where Muslims were in a minority but lacked support in the Muslim majority states in the west where Muslim political elites already held sway. Ironically, it was the democratic reforms of the India Act (1935) that granted greater autonomy to Indian provinces, as well as direct elections, which brought the interests of these two opposed constituencies together in a common cause, and at the Lahore Conference of the Muslim League (22–24 March 1940), the demand for Pakistan, a separate nation for Muslims, was made (Nasr 2010). The period between 1940 and 1947 witnessed terrible communal conflicts between Hindus and Muslims, and finally the Congress and the Muslim League accepted Lord Mountbatten's hasty Partition Plan of 3 June 1947, and two new nations of India and Pakistan came into being on 14–15 August 1947. Independence was accompanied by the traumatic division of the subcontinent that led to large-scale killings (1 million), the rape and abduction of women (75,000) and mass migration

(16 million) (Nandy 2001: 110; Butalia 1998: 3). Hindus and Sikhs moved across the border from the new state of Pakistan into India and Muslims from India moved to Pakistan. Approximately 35 million Muslims forming roughly 10 per cent of the population according to the 1951 census, mostly relatively poor and uneducated, were left behind in India.

Within the new post-independence, post-Partition India, Muslims were now placed in an unenviable position. While the new Indian nation was cast as secular and embraced religious pluralism, it was a country which Hindus could implicitly or explicitly claim as their rightful inheritance. Muslims, on the other hand, were not only marked as a minority but the Hindu right wing from the very beginning questioned their loyalty to India (Pandey 1999). This had profound implications for the representation of Islamicate culture in post-independence India. In the cinema of the pre-independence period, the Mughal rulers, with the exception of Aurangzeb, were seen as the embodiments of justice and the ideals of love, and as patrons of the arts. This celebration of the Mughals was directed against a compromised colonial legacy and offered a justification for self-rule (see Chapter 6 by Haider in this volume). During the Nehruvian period, a celebratory portrayal of the Mughals was directed against the Hindu right wing's hostile responses to the presence of Muslims in India. However, with the recent political ascendancy of the Hindu right, their ideology and their definition of India as a Hindu nation whose mythical foundations are cast in a pre-Islamic past has come to be widely accepted. Consequently, the thousand-year history of Islam in India is conveniently erased and perceived as antithetical to the core spiritual and cultural identity of the nation. In this context, while the idealization of Muslim-Hindu amity may itself serve as a welcome antidote to the erasure of common history, it may also appear naïve in relationship to the reality of Muslim experience in the present. Most distressing, however, is the emergence in the recent past of stridently Islamophobic historical films like *Padmaavat* (2019) in which a Muslim sultan, Alāuddīn Khaljī, is crudely represented as a rapacious marauder, hell bent on destroying the noble Hindu heartland of Rajputana (see Chapter 3 by Knapcyzk and Chapter 7 by Ahmed in this volume). However, before we address the nature of Islamicate idioms in Bombay cinema that have continued into Bollywood, we need to understand more clearly the history and use of the term 'Islamicate'.

Debating 'Islamicate'

As already mentioned, the term 'Islamicate' was first coined by Marshall Hodgson, the western scholar of Islamic history, in his seminal three-volume work, *The Venture of Islam*, in contradistinction to the term 'Islamic' and alongside another term

'Islamdom'. 'Islam', like 'Christianity', refers to a religion. 'Islamdom', by analogy with 'Christendom', is 'the society in which the Muslims and their faith are recognized as prevalent and socially dominant, in one sense or another' (Hodgson 1958: 58). It does not refer to a geographical region as such but to a complex set of social relationships that are found in Muslim societies even as they vary from region to region. The purpose of the term 'Islamicate' is to signify 'of or pertaining to' the society and culture of Islamdom. It might immediately be objected that we do not use the term 'Christianate' to describe Christian culture; however, we do use the word 'Occidental', and in a vaguer sense 'western', to describe the society and culture of Christendom. There is no cognate term to describe the society and culture of Islamdom. For this reason, the term 'Islamicate' is a useful addition to our vocabulary.

Some take the distinction marked by Hodgson to be essential and obvious. Kevin Reinhart writes that failure to observe it constitutes 'a kind of intellectual sloth that requires justification by those who would choose not to take pains to speak precisely' (2003: 24). Kathryn Babayan and Afsaneh Najmabadi point out that the use of the term 'Islamicate' offers a corrective to the universalizing and reductive tendency of western scholarship prior to Hodgson of distinguishing world cultures on the basis of religion alone (2008: ix). The advantage of the term is that it isolates and characterizes the aesthetic and cultural forms of 'Islamdom'. It is an umbrella term that encompasses the wide variety of different cultural traditions that issue from the Islamic world, such as the culturally specific Persianate tradition or a widely distributed aesthetic form like 'arabesque' design. Furthermore, as David Gilmartin and Bruce B. Lawrence write, it opens up 'the space between reductive religious orientations and mobile collective identities' (2000: 3) and it allows a way of characterizing cross-cultural interactions not only within the Islamic world but beyond it. This is especially important for understanding the influence of Islamic culture within a society like India, in which Islam is not the dominant religious formation, and where Islamicate forms circulate independently of their religious context and enter into complex mutual influence with other cultural forms. Nonetheless, several objections can and have been raised against the idea.

One objection is precisely that it hives off considerations of culture from considerations of religion, whereas the term 'Islamic' encompasses both. For example, *pardā*, or the seclusion and veiling of women, is a social practice that historians believe pre-existed the emergence of Islam in West Asia (Keddie 1991: 2–3), and in Northern India, after the arrival of Muslims, the practice extended beyond Muslims to upper-class Hindu households. At the same time, *pardā* is clearly a religious practice that is sanctioned in the Qur'an (Khalidi 2008: 24, 31). However, the term 'Islamicate' is not intended to exclude religion but to emphasize the way that social and cultural practices within Islamdom are not simply (or only)

religious in nature and may have a role that is not reducible to religious explanation. As Hodgson argues, this is essential for understanding Islamic culture in contexts where Islam is not the dominant religion and where Islamicate idioms are shared and embraced by non-Muslims. In a persuasive article on the courtly culture of the medieval South Indian state of Vijayanagarā, art historian Philip Wagoner (1996) substantiates Hodgson's view by demonstrating how courtly dress and deportment were profoundly influenced by Islamicate cultural norms, though not by Islam as a religion.[3]

A second objection pertains to origins. While defending the term, Babayan and Najmabadi note that it does tend to 'reproduce a tradition of equating the Islamic world with its initial Arabo-Persian Center' (2008: ix). In this centre-periphery conception of history, the Islamicate tradition in India might be seen as merely derived from or a copy of some more authentic original and its distinctive cultural contribution diminished. Furthermore, in the Indian context, it supports the view of the Hindu right that Muslims are outsiders, whether on religious or cultural grounds (see Chapter 7 by Ahmed in this volume). Islamicate society and culture spread with Islam from its base in Arabia and Persia, east across the steppes of Asia, west into the Magreb and south-east into the Indian subcontinent. Maḥmūd of Ghaznī's raids on the northwest of India in the eleventh century, the expansion of the Ghurid Dynasty across the Northern Plains of India in the twelfth century and Khaljī's subsequent conquest of the Deccan in the thirteenth century brought a Persian-flavoured Islamicate high culture to India. However, the spread of Islamicate society does not exclude the emergence of regionally distinct cultures or render them mere copies of an original. Later iterations of Islamicate cultures may echo ancient forms; equally, they may be both regionally distinct and indigenous, like the Urdu literary and musical Islamicate cultures of India (see Chapter 4 by Jha; Chapter 9 by Jhingan; and Chapter 10 by Bhaskar, all in this volume) or Kathak dance (see Chapter 11 by Lutgendorf in this volume). Most significantly, it is in the interaction with local literary, performative and cultural practices like the different *Bhakti* traditions and rituals and festivals like Basant and Holi that Indian Islamicate cultures acquired a distinct and unique identity.[4] Indian Sufism is an example. Thus, distinguishing these idioms as Islamicate certainly does not mark them as foreign; the imputation of foreignness to both Islam and Islamicate culture in India is simply a denial of the Indianization of Islam in its millennial history in this region.

A third objection to the usage of the term to describe Islamicate cultural forms is that it potentially occludes what precedes it. Thus the use of the term 'Islamicate' to describe Arab-Persian culture after the coming of Islam might appear to subsume the Arab and Sasanian cultures which existed prior to Islam and to some extent continued under it into an Islamicate mould. There is some merit to this

objection, but it pertains to all classification and reference by historical epochs. We must simply acknowledge the extent to which the culture we might call 'Islamicate' may have absorbed aspects of pre-Islamicate culture, just as the Persian culture that became the centre of Islamicate civilization after the collapse of the Caliphate in Baghdad absorbed elements of Arabic high culture into the Persian idiom. Arabic love poetry and classic Persian stories in the oral tradition, like that of Shīrīn-Farhād, pre-exist their absorption into Islamicate culture and Sufi idioms (see Chapter 2 by Sharma and Chapter 10 by Bhaskar in this volume), and we should acknowledge the Arabic and Persian origins of certain stories within Bombay cinema (Roy 2015), while recognizing their overall contribution to Indo-Islamicate culture.

This worry is closely related to a fourth objection: namely that the term 'Islamicate' homogenizes patterns of cultural variation and difference; it assumes similarity where there is diversity and variation. Presumably to combat such homogenization, the recent reopening of the galleries that used to house Islamic art at the Metropolitan Museum in New York are labelled not as Islamic or Islamicate art but according to the countries or regions in which the art was made. This bracing revisionism has its value, but so, too, does a category that allows us to recognize the commonality across diversity. For example, it can scarcely be denied that what Hodgson labels the 'arabesque', a non-representational idiom of elaborately patterned, geometric lattices and surfaces, which is often also informed by elaborate Arabic calligraphy, is a cultural idiom found across the Islamicate world from the Alhambra in Seville, to Humāyūn's Tomb in Delhi, to the mosques and Sufi shrines of Africa and Southeast Asia. At the same time, as we have already suggested, within Islamicate culture we can also recognize the distinctive contribution of the Persianate tradition to the development of the Urdu *ghazal*, for instance, even as we see the constitution of the Urdu language from different linguistic sources in India.

A fifth objection, less explicitly stated but salient to the themes of this book, concerns the nature and character of Islamicate culture. Hodgson identifies Islamicate forms with high culture, particularly the social conventions of politeness and etiquette which he calls '*ādāb*', and with the literary and poetic traditions distilled by Persian culture out of the Arab tradition in the eleventh to the twelfth centuries. There is good reason to identify the Islamicate tradition with high culture because it was through the courts and courtly language, particularly what Sheldon Pollock (2003: 11) refers to as the 'cosmopolitan' languages of Arabic and Persian, that commonalities of custom and cultural expression were spread among diverse peoples and geographic regions in a way that justifies speaking of Islamicate traditions. At the same time, to think of Islamicate culture as a uniquely high cultural tradition is insufficient, as Hodgson himself is dimly aware in his

brief references to the *Tales of Arabian Nights*. These stories of adventure, mystery, love, sex, magic, intrigue, deception and narrative invention form an irreverent counterweight to the elevated social and spiritual aspirations of the poetic tradition, and although not especially popular in Arabic-speaking countries, they gained tremendous currency elsewhere, particularly in South Asia. If we are to take Islamicate traditions seriously, we must understand the influence and mediations of both high and low cultures. High-brow and low-brow were mixed together in the literary print cultures of Indian modernity (Roy 2015; see Chapter 4 by Jha in this volume), and this was especially true of the mass medium of cinema in which the 'Oriental' genre influenced by bodies of Islamicate narratives such as the *Tales* was of central importance (Roy 2015; see Chapter 8 by Thomas in this volume).

The putatively high-brow associations of Islamicate culture in the North Indian context are troublesome in a different way. There is a tendency to associate the Muslim cultures of India with the legacy of the Sultanate and Mughal Empires and the cultural aristocracies that precipitated from them, including and most notably, late-eighteenth and early-nineteenth-century Awadh. One difficulty here is that these cultures may present a fetishized, idealized view of Islamdom as an exotic other that has little to do with the lives of ordinary Indian Muslims (see Chapter 7 by Ahmed in this volume). Furthermore, glamorized representations of particular aspects of this culture, for example, courtly courtesan cultures, are mistakenly taken by some as evidence of the essential corruption, decadence and 'otherness' of Islam in general (see Chapter 11 by Lutgendorf in this volume). All films, of course, carry ideological baggage, and these representations are especially charged, given the position of Muslims in India. It is a question of who is speaking, what is being said and the context in which these idioms are being used. However, we do not see these challenges of representation as grounds for abandoning 'Islamicate' as an analytical category; rather, it forces us to diagnose the complexity of its manifestations.

The seventh and final objection is that any attempt to isolate or identify Islamicate culture in a region where Islam is not the dominant religion is bound to raise questions about differentiation and delineation. The risk here is of being reductive, and the challenge is not simply to differentiate putative Islamicate idioms and motifs but to recognize and understand the complex cultural dialogue and syncretism between different cultures. From the earliest arrivals in India of Muslims from different parts of the Islamic world, Islamicate cultures evolved to create distinctive Indo-Islamicate forms, such as the Sufi romances of the fourteenth to sixteenth centuries, for example, Maulānā Dā'ūd's *Ćāndāyan* (1379), Shaikh Quṭban Suhravardī's *Mirigāvatī* (1503), Malik Muḥammad Jāyasī's *Padmāvat* (1540) and Shaikh Mīr Sayyid Mañjhan Shaṭṭārī Rājgīrī's *Madhumālatī* (1545), written within the Sultanate courts in the Indian vernacular languages of Hindavi, including Awadhi. These famous romances combine Sufi ideas about human perfectibility

through the absorption in Divine Love, with Indian *rasa* aesthetics, in which the spiritually attuned emotional response of *rasa* elicited through poetry invokes both the relation of the lover to the beloved and of the believer to God (Manjhan 2000; Behl 2012; see Chapter 10 by Bhaskar in this volume).

As we have emphasized, the identification of Islamicate motifs and idioms in cinema and elsewhere thus cannot take place apart from an understanding of the broader context in which Islamicate idioms were renewed and transformed in interaction with other Indic traditions which along with the Sufic included *Bhakti* traditions of Hinduism, Jainism and Buddhism as well as a whole range of classical literary and folk performative, cultural and ritual forms. Hence, we see the term 'Islamicate' as not in any way an exclusionary or a ghettoizing one but rather one that enables the recognition and valuation of forms that have non-Hindu histories, as well as an acceptance of the circuits and flows of ideas and emotions that are indicative of a generous and open interaction of cultures and influences that were mutually enriching and generated multiple constellations of cultural meaning and senses of self-identity. It is these circuits of cultural exchange and interaction that are constitutive of the Indian traditions of literature, poetry, the visual arts, architecture, the performance arts and, in the twentieth century, cinema.

Islamicate idioms of Bombay cinema

It was Mukul Kesavan (1994) who, in a pioneering essay 'Urdu, Awadh and the tawaif: The Islamicate roots of Hindi cinema', first identified Bombay cinema as a critical repository of Islamicate culture. He identified three Islamicate features that permeate it: the Urdu language, including especially but not exclusively poetry; the culture of *nawābī* Awadh, centred on Lucknow as 'the last bastion of a beleaguered Islamicate culture' (1994: 251); and the figure of the *ṭawā'if* (courtesan) and the iconic role of her *mujrā* dance and song performance. In our book *Islamicate Cultures of Bombay Cinema* (Bhaskar and Allen 2009), we sought to expand Kesavan's triple lexicon to include song forms like the *ghazal* and the *qawwālī*, architectural idioms like cusped or multifoil arches and what are sometimes called the 'arabesque' motifs of Islamicate architectural decoration, and the storytelling forms that are derived from the Persian-Arabic tradition, like the *maṣnavī*, which was instrumental in shaping the portrayal of romance in Bombay cinema. Similarly Anjali Gera Roy (2015) has argued for 'Perso-Arabic genealogies of the Hindi Masala Film', which she asserts are essential for understanding the storytelling forms, character types and notions of romance in this cinema and which forms an 'alternative aesthetic' tradition within Hindi popular cinema. In addition to these varied idioms, Bombay cinema also developed distinctive Islamicate genres and

subgenres that were both contemporary and historical in their emphasis (Dwyer 2006; Bhaskar and Allen 2009).

The Muslim Social, the 'marked form' of the social genre, consolidated in the 1940s by Mehboob Khan in films like *Najma* (1943) and *Elaan* (1947), focused on the problem of how to maintain and renew traditional values in the face of modernity and the need to reconcile desire with duty. The lineaments of the genre developed in the 1940s with recognizable character types of the decadent *nawab*, the long-suffering *begam*, the educated young professional hero and the courtesan with a heart of gold. The genre was then transformed in the 1960s under the impact of the modernizing forces of Nehruvian India in films such as *Mere Mehboob* (1963) and *Bahu Begum* (1967). In addition to the Muslim Social we should also note the importance of what Yousuf Saeed (2009) and Rachel Dwyer (2010) have identified as the 'Muslim devotional film', such as *Mere Gharib Nawaz* (1973), *Dayar-e-Madina* (1975), *Madine ki Galian* (1981) and others. These films are often set in Bombay rather than the old centres of Muslim culture, and their focus is upon how to maintain religious practices in a context where traditional values are threatened by modern life.

The Islamicate courtesan film and the Muslim-themed historical represent historically focused subgenres. Islamicate courtesan films like *Pakeezah* ('The pure one', 1971) and *Umrao Jaan* (1981, 2006) are centred on the figure of the courtesan who, while subject to the lustful gaze of men, is at once a source of value in her essential purity and integrity and a repository of culture in her mastery of the performing arts. In the Islamicate courtesan film, the resources of the cinema are used to imaginatively recreate the ambience of Lakhnawī courtesan culture and, in particular, the *mujrā* performance of the courtesan within the *maḥfil* (salon entertainment), where patrons gather to watch her perform.

The traditions of Muslim-themed historical films such as *Pukar* (1939), *Humāyūn* (1945), *Shahjahan* (1946), *Taj Mahal* (1963), *Mughal-e-Azam* (1960) and *Noor Jehan* (1967) celebrated the legacy of the Mughal imperium (Bhaskar and Allen 2009). They emphasized an indigenous tradition of justice, iconically embodied in the figures of Akbar and Jahāngīr; portrayed amicable relations and a powerful political alliance between Mughal rulers and the Rajputs; celebrated the atmosphere of religious respect and tolerance for other religions bequeathed by Akbar's court; and depicted Mughal rulers, especially Akbar, Jahāngīr and Shāh Jahān, as patrons of the arts and culture. Equally, Muslim Historicals celebrated love across religious and class boundaries as a symbol of a unified nation that is ideally enshrined in Akbar's love for Jodhaa and in the myth of Prince Salīm's love for the slave girl, Anārkalī. As we have already suggested, the genre performed a crucial ideological function in the period of the 1940s to the 1960s: first, by supporting the anti-colonial struggle with its powerful representation of indigenous

systems of politics and justice; and second, by articulating the central role of Muslims and Islamicate culture in the formation of the nation under Nehruvianism. In this period a certain critique of authority and centralization was also present that is evident in the authoritarian and rigid portrayal of the aging patriarch, Akbar, in *Mughal-e-Azam*.

A final genre which is distinct from all of these is the Oriental genre. This genre of films was very popular in the silent period, in part, no doubt, because it afforded not only fairy-tale romance in exotic locales but also, through special effects, the imagined embodiment of these fairy-tale worlds on the silver screen. As Rosie Thomas points out in Chapter 8 of this volume, the Oriental film drew on two main sources. The first was the *Tales of the Arabian Nights* with its canonical stories such as 'Alibaba and the Forty Thieves', which was retold numerous times in silent and sound cinema. The second was the oral storytelling tradition of the *dāstān* from the eleventh century onwards, perhaps the most influential of which were the stories of Amīr Hamzā that Akbar commissioned as an illustrated manuscript, the *Hamzānāma*, in 1562. These stories were published in 46 volumes in the late nineteenth century as the *Dastān-e-Amīr Hamzā*. Another well-known *dāstān* was Mīr Ḥasan's eighteenth-century love story of Benazīr and Badr-e-Munīr (Suvorova 2000), which featured fairies and flying carpets and was popular both in Urdu theatre and silent cinema.

In *Islamicate Cultures of Bombay Cinema* (2009), we explored the rich and varied Islamicate idioms of Bombay cinema through the lens of the Muslim Social, the Historical, the Courtesan Film and what we termed the New Wave Muslim Social since we took what we consider to be the reasonable view that these genres or subgenres tended to showcase Islamicate idioms in the most sustained and elaborate way. However, for our critics (Saeed 2009; Taneja 2010), this decision seemed to confound the motivation of Kesavan's intervention, which was to demonstrate that Islamicate culture has determined the 'very nature' of Bombay cinema and not just some 'marked' Muslim components of it (1994: 49). While we believe that these criticisms of our genre-based perspective in *Islamicate Cultures of Bombay Cinema* are misguided (Bhaskar and Allen 2010), in this complementary volume we maintain a focus on the idioms, contexts and histories of Islamicate forms that were ubiquitous in Bombay cinema and are present in Bollywood cinema as well. The idioms are diffuse and occur in both Muslim and non-Muslim contexts and not just in Muslim-themed films: the Urdu language, for instance, and its usage particularly in the songs of these films. Furthermore, the musical forms of the *ghazal* and the *qawwālī* were present widely in Bombay cinema, as were also the poetic idioms of these forms that drew from a larger social and cultural repertoire of different vernacular language traditions of North India. In the current political context it is especially important to indicate the culturally defining significance of

Islamicate traditions for India as a whole and their constitutive role in the history of Bombay cinema, as well as their presence in the films of Bollywood.

Islamicate cultural forms have been absorbed into the warp and woof of these cinemas in such a way that their influence is no longer readily apparent. The reason for this lies both in the thousand-year presence of Islam in India and the cultural convergence that issued from it, and in the heterogeneous and syncretic nature of popular culture itself. One broad and pervasive example of this is the way that the Sufi 'love-in-separation' story, which leads to the perfection of self in an ecstatic union with the other, combines with the Hindu idea of perfect love as being the realization of a timelessly reincarnated union. This fusion occurs early in Hindavi romances, like the *Madhumālatī*, where, uncommonly, ecstatic union is achieved without the intervention of death (*fanā*) (Suvorova 2000). More commonly, however, the star-crossed couple perishes in order to realize their love. In post-independence cinema, this fusion of tradition occurs in what may be termed the 'reincarnation romance', beginning with *Madhumati* (1958) and leading us through countless subsequent exemplars to the present (Allen 2022). Here the star-crossed lovers are separated through the intervention of a feudal (often colonial) patriarch and perish. In the *masnavi* tradition, *fanā* is associated with the river, sea or the whirlpool of love in which the two lovers die and are united, and films like *Madhumati* and *Milan* (1967) explicitly invoke this Sufi idiom. At the same time, the lovers also find their true love validated in rebirth as a timeless love according to Hindu belief systems. In this cycle of films, so fundamental to and exemplary of Bombay cinema, the Islamicate tradition clearly helps to inform and define the larger whole.

The question remains, however, about what role 'marked' genres like the Muslim Social, or 'marked' elements like the de rigueur Muslim cap for men, play in representing Muslim social life. The realist project of New Wave Muslim Social films, which we discussed in our earlier volume, embedded Islamicate idioms within a Muslim social context. Similarly there are several Bollywood films which feature Muslim characters, where the social world of these characters is similarly realized, for example, in *Maqbool* (2003), *Khakee* (2004), *Chak De! India* (2007), *My Name Is Khan* (2010) and others. At the same time, the issue of stereotyping Muslim characters and culture through the use of Islamicate idioms remains. It goes without saying that the design features of popular cinema as a mass art involve simplification of the phenomena they depict in order to seduce, entertain and appeal to large numbers of people in ways that may distort and misrepresent. This is true even of popular songs idioms like the *ghazal* and the *qawwālī* which have been streamlined and 'simplified' for the purposes of mass entertainment (see Chapter 9 by Jhingan and Chapter 10 by Bhaskar in this volume). Popular cinema that 'marks' Muslim cultures in certain ways may

typecast Muslims in certain roles, freeze the depiction of Muslim cultures in a timeless nostalgia for *nawabī* regimes and otherwise stereotype Islamicate culture through its most spectacular emblems, such as the Taj Mahal or the *maḥfil*, at the expense of the representation of the everyday lives of Muslim peoples. Furthermore, some of the conventions that emerge within a genre like the Muslim Social, such as the drama of mistaken identity, have little to do with Muslim culture and everything to do with the conventions of Bombay cinema as a whole (see Chapter 12 by Allen in this volume).

And yet, a certain level of typification allows for the identification, representation and self-recognition of social groups. Muslim Socials and Muslim Devotionals arguably played an important role in representing their own experience for Muslim audiences (Bhaskar and Allen 2009; Dwyer 2010). Furthermore, the reduction of type to stereotype may be unavoidable in a popular cinema like the one produced in Bombay, where storytelling trades in simplified formulas, and the audience, until the recent past, has been largely illiterate.[5] The lesson is that Islamicate idioms cannot be taken simply at face value. They must be understood symptomatically in terms of what they occlude or misrepresent, as well as what they enable with respect to the articulation of Islamicate cultures more broadly and the place of Islam within Indian society as a whole. Stereotypes invariably diminish, distort and caricature their subject. At the same time, as Richard Dyer (2009) notes, even stereotypes may have a value depending on how they are used. Khalid Mohammed's film *Fiza* (2000) features Hrithik Roshan as a terrorist, but the film examines seriously the reasons for a young Muslim's turn towards terrorism.

Popular cinema in India, as elsewhere, is a highly syncretic and heterogeneous medium. It both borrows from a multiplicity of narrative and aesthetic traditions and makes overt appeals to cultures and contexts of everyday life. The Islamicate forms and idioms that infuse popular cinema necessarily mimic the heterogeneity of popular cinema as a whole; they are in many ways as different from each other as they are from other aspects of the cinematic tradition of which they form a part. They may directly inscribe tradition (the 'arabesque' motifs of architecture), they may be invented forms (the 'Muslim Social') or they may transform the tradition they borrow from (the 'cine-*qawwālī*'). They may be pervasive and diffused throughout popular cinema like the Sufi ideal of love or very specific and defined such as the Taj Mahal as a synecdoche for the Mughal imperium. They may be primarily fantastical, like the idioms of the 'Oriental' genre, or primarily concerned with representing forms of Islamic religious life, as in the Muslim Devotional. They may share motifs with other cultures, like the *Tales of the Arabian Nights*, or they may be culturally specific like the dance form of Kathak. They may be 'marked' forms like the 'Muslim Social' or they may be 'unmarked' forms like the *qawwālī*. We must recognize that to explore Islamicate idioms and cultures in

Bombay cinema is not to explore one thing but an irreducible multiplicity that is reflected in the contributions to this volume.

Given the complex relationship between representations, the societies they represent and the ideological refractions and distortions that enter into Islamicate imaginaries, it is important to acknowledge that those imaginaries do not encompass everything there is to say about the representation of Muslims in cinema. Three of the most notable male stars of Bollywood cinema are Muslim: Salman Khan, Aamir Khan and Shah Rukh Khan. The fact that they are Muslim has implications for how their star personae are deployed and understood in cinematic storytelling (see Chapter 13 by Ghosh in this volume). There are narrative idioms that develop around Muslim characters such as the mistaken identity plot in the Muslim Social (see Chapter 12 by Allen in this volume) or the conspiracy plot in recent films about Islamic terrorism (see Chapter 14 by Mazumdar in this volume), which are in no measure specific to Muslim culture but are important to understanding the representations of Muslims on screen. In contemporary Bollywood cinema, the portrayal of Muslims as mafia dons and terrorists has increased exponentially, and under the impact of an ascendant Hindutva ideology such representations are indicative of Islamophobia or at least of states of anxiety and fear caused by the figure of the Muslim (see Chapter 14 by Mazumdar in this volume). Cinema responds to stereotyping and scapegoating within the culture at large, and here we need to be both aware and critical of the deployment of cinematic idioms that contribute further to the stereotyping and othering of Muslims.

Inevitably, the question arises as to whether Islamicate cultures and idioms have run their course in contemporary Bollywood cinema in the sense that they have become conventions which have lost their life, like dead metaphors. On this question, the picture is mixed. Genres like the 'Oriental' and the 'Muslim Social' now seem old-fashioned and form the subject of parody and pastiche. Beginning as early as *Amar Akbar Anthony* (1977), and more recently in films like *Dedh Ishqiya* ('One and a half parts passion', 2014) and *Gulabo Sitabo* (2020), the courtship conventions and the world of manners that defined the Muslim Social have been parodically subverted (see Chapter 12 by Allen in this volume). The 'Oriental' has been the subject of pastiche. For example, in *Love Story 2050* (2008), Zeisha (Priyanka Chopra), a heroine of the future, has her music studio decked out as a self-designated gold and blue 'Alibaba Room' complete with an oriental flying carpet and columnar arabesque motifs, at the centre of which is situated a gigantic chaise longue in front of an immense moon-like window with lights evoking stars, which recalls in a hyperbolic pastiche the *mise en scène* of *Chaudhvin ka Chand* ('Full moon', 1960).

Muslim-themed historicals have continued to be made with interfaith romance integral to the imagination of the Indian nation as in films like *Jodhaa Akbar*

(2008) and *Bajirao Mastani* (2015). At the same time, it is also true that in the contemporary moment, the mere suggestion of interfaith passion, albeit one-sided, generates hysterical Muslim hatred, as in a film like *Padmaavat* (2018). Clearly, a genre that once celebrated Muslim culture is marked today by Islamophobia, which is undoubtedly a sign of the times. At the same time, a small number of other Bollywood films depict interfaith romance in contexts which invariably are coded with Islamicate conventions like the *ghazal*-spouting poet-lover in *Teri Meri Kahani* ('The story of you and me', 2012) or the hyperbolic arches and arabesque motifs associated with the home base of the Muslim heroine Sakina (Sonam Kapoor) in Sanjay Leela Bhansali's lushly romantic confection *Saawariya* ('My love', 2007). Quite how much the Islamicate milieu has become merely a feature of art design is evident when the faithful who have heeded Eid-time call to prayers in an implausibly large and 'nearby' mosque enter into the Hindu hero's song performance as back dancers. Narrative forms, like the *maṣnavī* in the reincarnation romance, remain salient in popular cinema, in part no doubt because they articulate Sufi ideals of love and offer rich possibilities for narrative and stylistic invention. It is equally clear that musical idioms, like the *qawwālī*, are firmly implanted in popular music and hence in popular cinema and continue to provide some of the finest examples of the song form (see Chapter 10 by Bhaskar in this volume).

The thriller, a popular genre that has responded to urgent contemporary issues of today like the impact of terrorism on India, is another idiom of Bollywood cinema in which Islamicate imaginaries and idioms are understandably integral, as in films like *Kurbaan* ('Sacrificed', 2009), *D-Day* (2013) and *Phantom* (2015). *Qawwālī*s like '*Shukrān Allāh*' ('Thanks to the Lord', *Kurbaan*), '*Murshid Khele Holī*' ('My Lord plays Holi', *D-Day*), the *qawwālī*-inspired '*Nachdā ve Merā Auliyā*' ('My Lord dances in joy', *Phantom*) and Sufi-inspired songs such as '*Alvidā*' ('Farewell', *D-Day*), '*Sāware*' ('My beloved', *Phantom*) as well as several songs in *My Name Is Khan* (2010) – '*Sajdā*' ('Worship'), '*Tere Nainā*' ('Your eyes') and '*Noor-e-Khudā*' ('The light of the Lord') – are just a few examples that indicate how widely Islamicate imaginaries, particularly of a heightened conception of love, where the human meets the Divine, are integral to Bollywood cinema. Of course, these forms are not related just to Muslim-themed films but also to non-Muslim romances like *Rab Ne Bana Di Jodi* (2008), *Rockstar* (2011) and *Jab Tak Hai Jaan* (2012) whose conceptions of love are similarly inspired by Sufi ideals which are evident in their songs.

We have noted earlier the distinctive engagement with Muslim themes and milieu by new wave filmmakers where Bombay cinema engaged with Muslim social life in a manner that was shorn of the stereotypes that govern popular cinema. In contemporary Bollywood cinema a group of films exist with stories and *mise en scènes* which are reminiscent of these works. Some are small-budget 'indie' films

and others are more mainstream, but in contrast to the terrorist thriller, these films dramatize social lives of ordinary Muslims who face physical and psychological violence on a day-to-day basis. Three recent films, *Shahid* (2013), *Mulk* ('Country', 2018) and *Nakkash* ('The craftsman', 2019) are powerful explorations of the serious ontological crisis of the idea of India and its polity today where the politics of hatred and fear have been normalized.

Thus, like other popular cultural forms, Islamicate idioms are part of the social context to which they are also a response. Heterogeneous and widely ramified, they are subject to historical change and transformation both as conventions that become worn out or transformed, renewed or parodied, but also as potent vehicles of a wider Islamicate culture and social life whose histories they make reference to and whose contemporary manifestations they evoke, sometimes only obliquely, sometimes only in a grotesquely distorted fashion but sometimes, also, in ways that are profoundly affecting. Whether they seem worth only parody, or whether they are deemed to be highly expressive, Islamicate forms and idioms are not only constitutive of Bombay cinema's past but continue to resonate in the mainstream Bollywood and independent cinemas of today.

Content and chapters

This is a volume that focuses on the Islamicate cultures and idioms that were historically crucial for the development of the cinemas produced in Bombay. The first section of the book, 'Islamicate Histories', explores aspects of the historical contexts, and the poetic, performative, art historical, cultural and political-ideological forms that led to the development of different Islamicate idioms that, in various ways, contributed to the textures of Bombay cinema and the continuities of these idioms that are evident in contemporary, Bollywood film. Here the focus is not mainly on cinema but on the Islamicate forms that impacted the cinema. The second section, 'Cinematic Forms', focuses on cinema itself and discusses the genres, imaginaries, aesthetic forms and ideologies of Bombay cinema in which Islamicate cultures have had a constitutive role. The volume cannot claim to be comprehensive; however, we do hope to have conveyed the range and depth of the Islamicate traditions in Bombay cinema and also the continuing significance of Islamicate idioms in Bollywood cinema today.

The first section of the volume comprises seven chapters which explore different histories, traditions, idioms and imaginaries of Islamicate culture in India which subsequently influenced and informed Bombay cinema from a wide variety of critical and historical perspectives. These chapters discuss the role of the Urdu language in Parsi theatre that has been a foundational basis for the idioms

of Bombay cinema; Persian romance tales and Urdu poetic traditions that have been crucial for the romance imagination of this cinema; the significance and the history of the courtesan figure; Mughal painting and the fantasies of history; the concept of Mughal justice and its significance for films of the historical genre; and the political implications of the memory of Muslim invasion that has currently been circulating in popular culture.

The Parsi theatre, a secular form that thrived between 1860 and 1930, is known to have had a profound influence on Bombay cinema. It supplied capital, producers, scriptwriters and actors and also furnished some of the major genres and idioms of the emergent Bombay film industry. In her vital contribution to the volume, 'Passionate refrains: The theatricality of Urdu on the Parsi stage', Kathryn Hansen shows how the aesthetic sensibility of the Urdu language, cultivated by Parsi theatre playwrights and performers, shaped the Islamicate forms of Bombay cinema. Hansen describes how Urdu storytelling traditions entered Parsi theatre through the popularity of the Lakhnawī Urdu drama *Indar Sabhā* ('Indra's court'), where the poetic and musical traditions of the Indo-Muslim romance offered an attractive alternative to the then dominant folk traditions of Gujarati theatre; how the rhythmic cadences and rhymed prose of Urdu poetry were integrated into the emerging rhetorical style of delivery influenced by proscenium theatre and European melodrama; and how the Parsi theatre 'became a repository of the Urdu poetic tradition' with its conventions of love ('*ishq* and *muḥabbat*) and the vocabulary of separation and despair that accompanied them. Hansen concludes with a discussion of the works of the prolific Urdu playwright Āghā Ḥashr Kāshmīrī, whose plays recast Shakespeare into an Indo-Islamicate milieu and who translated the idioms of Urdu theatre into the cinema. She discusses in detail his allegorical play *Yahūdī kī Laṛkī* ('The Jew's daughter'), a tale of love between a Roman and a Jew in the context of religious persecution, which was adapted in 1955 into a film starring Sohrab Modi, Meena Kumari and Dilip Kumar.

Sunil Sharma's chapter, 'The Persian *masnavī* tradition and Bombay cinema', points out that the Persianate tradition remained a distinctive one within Islamicate culture, even as Urdu replaced Persian as the language in which these stories were told. Sharma describes how stories drawn from the *Shāhnāma* and the Persian romances, such as those of Lailā-Majnūn and Shīrīn-Farhād, were a staple of Parsi theatre and shows how the latter were widely adapted in Bombay cinema. He explores the relationships between the different adaptations of the romances, the degree to which the Persian elements of the tales were emphasized or attenuated in favour of a more diffused oriental or Islamicate idiom and the way in which the Persianate idiom of star-crossed lovers fused with the indigenous *virahiṇī* tradition (see Chapter 3 by Knapczyk in this volume). Sharma also discusses a series of films indirectly inspired by the *Shāhnāma*, often involving the famous Parsi actor and

21

director Sohrab Modi, as well as the widely adapted story of the folk hero Rustam who tragically kills his son Sohrāb in battle where, unknown to him, he is fighting for the opposing side. Since these films focus on the courtly environment of ancient Persia, they attempt typically to evoke an imagined Persianate world. The chapter concludes by comparing the popularity of these stories in India and Iran and speculating on the causes of the decline of the Persianate tradition in the recent past.

Peter Knapczyk begins his chapter, 'Reflections from Padminī's Palace: Women's voices of longing and lament in the Sufi romance and Shi'i elegy', by considering the irony of the controversy over *Padmaavat* (see also Chapter 7 by Ahmed in this volume). While Islamophobic Hindu critics railed against a love scene between a Hindu princess and a Muslim sultan that they imagined to be in the film, the film itself is actually deeply Islamophobic in its portrayal of the rapacious Muslim sultan. Yet what both the film and its critics alike have forgotten is the way in which the original story, by the Sufi poet Jāyasī, grew out of a syncretic Hindavi cultural tradition that often deployed the trope of the woman (*virahiṇī*) who, in separation (*viraha*), longs for her loved one. Seeking to recover this shared tradition, Knapczyk analyses in detail two genres of Islamicate literature. The first is the *premākhyān* or Sufi romance to which *Padmāvat* belongs, wherein male poets writing in women's voices developed elaborate emotional topographies of love-in-separation that may be understood allegorically in terms of separation from the Divine. The second is the *marsiya*, or Shi'i elegy, a narrative poem memorializing the martyrdom of Husain, grandson of the Prophet Muḥammad, which features the lamentations of womenfolk, separated from the beloved men of their family who are in battle, and employs the trope of *viraha* in the mode of elegy. Knapczyk demonstrates the way in which zealous reformers, both of Urdu and Hindi, who had internalized the colonial critique of oriental decadence, sought to purge what they perceived as an effeminate and decadent literature of longing and lamentation. He concludes by observing that while this shared tradition survives in the films of classical Bombay cinema, it is, nonetheless, threatened with erasure in the doctrinaire environment of the present.

Similar to the aforementioned chapters, the next one also elaborates on an important literary genre – Urdu poetry produced by *ṭawā'if*s. Although the eponymous heroine of Ruswa's novella *Umrao Jaan* (1899) is celebrated as a poet, the extent of actual *ṭawā'if* poetry is not widely appreciated. In her chapter, 'Situating the *ṭawā'if* as a poet: Nostalgia, Urdu literary cultures and vernacular modernity', Shweta Sachdeva Jha sets the stage for understanding courtesan poetry by describing the popular Urdu literary culture of what she terms 'vernacular modernity', including the dissemination of cheaply reproduced *taẕkirā*s or poem collections that moulded public taste. After discovering the works of Māh Laqā Bāi 'Chandā's, Jha uncovered the existence of *taẕkirā*s that were solely devoted

to women's poetry and where more than half the contributions were by *ṭawā'if*s. These works were compiled by men who forged their own literary careers through the celebration of women's poetry. Jha reconstructs the lives of two of these poet-courtesans, Zohrā and Mushtarī from Lucknow, as well as the story of Adeline Hemmings or Malkā Jān from Benares, who became *ṭawā'if*s in order to achieve upward mobility. All these courtesan performers became renowned as poets who fashioned their own distinctive styles of writing the Urdu *ghazal*. Jha suggests that even as earnest reformers sought to excise their contributions to tradition in the latter half of the nineteenth century, their works continued to circulate among appreciative audiences. It is this poetic tradition that created the alluring imaginary in popular Bombay cinema of the beautiful tragic figure of the *ṭawā'if* or the courtesan, skilled in the literary and performative arts as well as in the art of seduction but unlucky in love and condemned usually to a life of loneliness. Not only was the *ṭawā'if* central to the courtesan genre of films like *Pakeezah* and *Umrao Jaan*, but also, as a staple figure of popular cinema, she has enabled sharp critiques of patriarchy and gender inequities as well as embodied ideas of romance – both devotional and erotic – that are so central to Sufi-*Bhakti* imaginaries.

Moving from the literary to the visual arts, the next contribution to this volume, 'Mughal chronicles: Words, images and the gaps between them' by Kavita Singh, explores the relationship between texts and images in Mughal paintings. Akbar had established a tradition of commissioning paintings alongside texts to illustrate courtly life, but in the case of illustrated manuscripts we discover intriguing examples where the interpretation offered by the painting is at variance with the history told in the text which it is supposed to illustrate. How are we to understand this discrepancy between word and image? Singh explores in detail three different examples, one each from the times of Akbar, Jahāngīr and Shāh Jahān. In the painting *The Death of Khān Jahān Lodī*, whose story is told in the *Padshāhnāma*, the al fresco battle and execution scene of the rebel governor, Lodī, is arranged to reflect the structure of the *darbār* (court) with the absent Emperor Shāh Jahān symbolically presiding over it as the *chinār* tree. The figures are realistically rendered with Lodī's face drained of blood, his head half severed from his body and his eyes reflecting the horror of his own execution. In a painting from *Jahāngīrnāma*, a witness is included in the picture who was not actually there because, although a suspected rebel at the time, he was subsequently rehabilitated. Finally, a painting from the *Akbarnāma* illustrates Akbar in a demeaning posture, venting his fury upon his loyal courtier Mān Singh who has just prevented him from madly falling on his own sword. The picture frankly depicts Akbar's erratic behaviour, while the text wraps the image in the myth of his divine inscrutability. Singh concludes that the discrepancy between text and image in these works demonstrates that

they were not intended simply as documents but as invitations to the reader to interpret and understand them.

There are two further points that we can draw out from the chapter as being relevant for the concerns of our volume. At the beginning, Singh clearly indicates how the naturalism of Mughal paintings and the minute details of everything rendered in the paintings were clues to the forms of life during the Mughal period and have formed our imagination of the period. It is not surprising that the Mughal miniatures that circulated among the elite of the time, which have subsequently been collected in museums and in private collections and are valued legacies of the Mughal period, would be significant sources for the *mise en scènes* of the historical films of Bombay and Bollywood cinema. Ashutosh Gowariker researched the *Akbarnāma* paintings for his film *Jodhaa Akbar* just as others before him had also used Mughal miniatures for their films. But there is another significant point about the representation of history itself that is relevant here and that we can extrapolate from Singh's chapter on paintings for cinema. Mughal paintings and historical films are not 'realistic' records of the past; they are interpretations of the past. Historical films, like Mughal paintings, intervene in the ideological force field of the time they are made in by refracting contemporary events through the political complexities of the past, which they dramatize in accordance with present concerns (Bhaskar and Allen 2009: 24–43).

The next two chapters of this volume also take up issues of historical memory and the significance of the circulation of these memories in the present. Najaf Haider's chapter, 'Justice, love and the creative imagination in Mughal India', describes how the ideals of justice and love were represented through texts and pictures in the Mughal imperium under Emperor Jahāngīr and how these two ideals came into conflict in the story of Jahāngīr's love for Nūr Jahān. He begins by exploring how, during the reign of Jahāngīr, the ideal of justice as an overarching value served to legitimize and delimit kingship and was expressed through his fabled 'chain of justice'. Designed to overcome the bureaucratic hurdles faced by ordinary people who were seeking redress, the legendary chain became invested with miraculous powers that reflected the quasi-divinity of the emperor himself. Subsequently, Haider charts how the myth of Jahāngīr's great love for Nūr Jahān, one of his many wives, arose as a way to resolve factionalism within his court and how, in the later chronicles of Muḥmmad Shāh, this love story became entwined with the legend of Jahāngīr's justice. The story goes that when Nūr Jahān killed a stranger who had the temerity to look at her, Jahāngīr handed her over to the plaintiffs for punishment, thereby demonstrating his willingness to sacrifice even his most beloved in order to uphold the principle of equality before the law. Haider concludes with a discussion of how this legend of Jahāngīr's justice was

the occasion for a critique of British colonial rule in India, first in the poetry of Shiblī No'manī and then in Sohrab Modi's film *Pukar* (1939).

From the memorialization in popular culture of the memory of Jahāngīrī justice, the pernicious circulation and implications of an ideologically constructed and hostile memory of the Muslim invasion of India is the focus of the next chapter in the volume. In 2016, as we have already noted, an extraordinary controversy erupted, led by a little-known Hindutva or Hindu fundamentalist party known as the Shree Rajput Karni Sena (SRKS), over an alleged love scene between a Rajput princess and a Muslim sultan in Sanjay Leela Bhansali's film *Padmaavat*. In his chapter titled 'The "Muslim presence" in *Padmaavat*', Hilal Ahmed develops the concept of 'Muslim presence' in order to diagnose the ideological construction of Muslim identity that informed the SRKS's assault on the film. According to Ahmed, the concept of 'Muslim presence' involves three crucial components: the belief that the Muslims of India belong to a single pan-Islamic community; the inference that Muslims, unlike others, are defined by their religiosity; and the assumption that Muslim culture is the remnant of a royal Islamic past. For the SRKS, the Padmāvatī legend demonstrates that Muslims are outsiders, defined by an alien religion that licenses the brutal invasion of the Hindu heartland and the rape of women who enshrine its values. The only recourse that Hindu women have in the face of this dire threat is committing *jauhar* (righteous mass suicide) as an act of patriotic resistance. In spite of the SRKS's opposition to *Padmaavat*, this ideology turns out to be exactly the message conveyed by the film. However, such a sacrifice is also a mark of historical defeat, one that is still to be rectified and overcome in the here and now; hence, Ahmed argues, the paradoxical need to affirm, through protest and political agitation, the fact of 'Muslim presence' again and again.

The second section of the book, which is also comprised of seven chapters, is entitled 'Cinematic Forms'. Here, the writers focus specifically on the permeation of Islamicate forms of cultural expression within Bombay cinema of the past and in Bollywood cinema of the present and the distinctive cinematic conventions that have arisen from them. The first of the chapters in this section is a detailed exploration of three Alibaba films and their constitution of an imaginary of the Orient so popular in early Bombay cinema. The next three chapters focus on musical and dance forms: the first of these analyses the history and journey of the *ghazal* in cinema, the second examines the relationship of Sufi mysticism to the Bombay film song through the idioms of the *qawwālī* and the third critically examines how a popular film by V. Shantaram, *Jhanak Jhanak Payal Baaje* ('The ankle bells ring', 1955), reimagines the figure of the *ṭawā'if* and Kathak dance. The cluster of three chapters that follows these examines the poetics of *pardā* in the Muslim Social film, the implications of the deployment of a Muslim star in contemporary

Bollywood and the transformed imagination of the figure of the Muslim from the earlier social films to recent Bollywood cinema.

Rosie Thomas's contribution, 'Alibaba's Open Sesame: Unravelling the Islamicate in Oriental fantasy films', anatomizes the elements of the so-called Oriental genre through a close examination of the three earliest tales of Alibaba to have survived on film: Modhu Bose's 1937 Bengali version, Mehboob Khan's 1940 Hindi and Punjabi version and Homi Wadia's 1954 Hindi version. She argues that set in a Persian or Arabian never-never land somewhere west of India and combining international orientalism with Indo-Islamicate language and motifs, the oriental film could be at once cosmopolitan and modern, and national and traditional. Thomas tracks how the Alibaba story made its way onto the sound screen via British Victorian pantomime, Parsi theatre, the Bengali stage and a series of silent movie versions, and she describes in detail the different kinds of cultural syncretisms that inform each of the sound versions. Bose's film combines the highbrow cosmopolitan oriental exoticism of the Ballet Russe and Diaghlev with Islamicate architectural idioms and middle-class Bengali theatre. Khan's film draws on the lowbrow orientalist tropes of European and Hollywood cinema, including Walter Ford's regressive 1934 British film *Chiu Chin Chow*, with an Islamicate touch and turns the story into a melodrama of good and evil. Wadia's film, in contrast, situates lowbrow European and American influences within the idioms of an Urdu Islamicate romance, cementing the shift of the Oriental genre from a mishmash of styles to what Thomas terms the Islamicate Oriental.

The *ghazal* is a genre of Persian and Urdu poetry formed from couplets in which love, in particular, love-in-separation or *viraha*, plays a central role. Shikha Jhingan, in 'The textual, musical and sonic journey of the *ghazal* in Bombay cinema' notes how, within the performative context of *mujrā*s and *maḥfil*s, the musical genre of the *ghazal* was consolidated, and she traces its refinement and dissemination through gramophone recordings, broadcasting and cinema to become a truly 'intermedial' genre. She describes in detail the historical significance of three contrasting *ghazal* performers. K. L. Saigal was a successful actor-singer who developed an influential mellifluous baritone voicing of the *ghazal* in the streamlined 3 minute 20 second format of gramophone recording. Begum Akhtar, from Faizabad, worked closely with poets and lyricists of the time and, as an experienced performer, disseminated a more improvisational style in her broadcasts for All India Radio in Lucknow. Talat Mahmood inhabited the soft, soulful style of Saigal in the era of the playback singer and transitioned seamlessly from the broadcasting and recording studios of Lucknow to the vocalizing of *ghazal*s in film, especially for the star actor Dilip Kumar. In the final part of her chapter, Jhingan explores in detail the forms and functions of the *ghazal* in film, contrasting the *maḥfil*-style *ghazal*, in which the performance of the song is staged for an audience within the

film, with the melancholy *ghazal*, in which an isolated performer laments his or her anguished condition of love-in-separation for the audience of the film.

Similar to the *ghazal*, the *qawwālī* too is a significant aural form of Bombay cinema that has been very important in expressing its devotional and romantic imagination. In her chapter 'The Sufi sacred, the *qawwālī* and the songs of Bombay cinema', Ira Bhaskar demonstrates that Sufi ideas and traditions of poetry, music and performance have been important for this cinema from the very beginning of the sound period. She characterizes in detail the devotional imagination of the cine *qawwālī* and sees it as an articulation of Sufi philosophical ideas that are fundamental to the imagination of both love and faith in this cinema. Critics have suggested that unlike the *qawwālī*s performed in *dargāh*s (shrines), the film *qawwālī* was, through 70 years of its history, an entertainment form oriented towards romance and that the *dargāh qawwālī* has been dominantly present in Bollywood cinema only after 2000. Bhaskar claims that, on the contrary, the *dargāh qawwālī* arrived in cinema with the coming of sound and demonstrates through film examples the presence, function and significance of devotional *dargāh qawwālī*s in the history of Bombay cinema. Furthermore, she argues that the devotional imagination is present not only in the *dargāh qawwālī* but also in the romance *qawwālī* since the central Sufi idea of single-minded devotion to the loved one simultaneously references both the human and the Divine Beloved. This idea has formed the core of many iconic songs of Bombay cinema in the past as well as of Bollywood songs in recent times. The expressive reservoirs of Sufi thought have thus been inspirational for a new kind of 'Sufiana' feel to recent Bollywood film songs that circulate widely, even independently of the films. In that sense, the celebration of love, human and divine, that we witness in the inspirational impact of Sufism on Bollywood film music, has a significance for our understanding of Islamicate culture that merits scrutiny.

In his chapter 'Avoiding Urdu and the *ṭawā'if*: Regendering Kathak dance in *Jhanak Jhanak Payal Baaje*', Philip Lutgendorf analyses the narrative and representational strategies of V. Shantaram's influential film from 1955 as a symptom of the profound ambivalence in post-independence India towards Islamicate culture, particularly towards its musical legacy. He describes how, at the opening of the film, the heroine's sensual dance performance in an Islamicate setting is lambasted by a 'classical' Kathak dance teacher and his son, who seek to tutor her in the correct ways of performance, in preparation for a dance at the Shaivite temple of *Naṭeśvar* ('The Lord of dance [Shiva]'). The father then suspects her of trying to seduce his son, and she flees into exile as a female ascetic, only to finally return, anguished and ill, to perform with him a Shiva-Parvati dance duet. Lutgendorf argues that *Jhanak Jhanak Payal Baaje* performs the ideological work of at once glamorizing the Muslim roots of Kathak, in the exotic sensuous dance of the Islamicate *mujrā*,

while at the same seeking to show that it is a debased version of an authentic, purified, 'classical' (read Hindu) dance form that has, perforce, existed from time immemorial. The work of the film is thus to discipline the supposedly debased, feminine, sensuous excesses of the Islamicate idiom with the robust, masculine and spiritually pure performance style of a Hindu classical idiom.

The final chapters focus on the Social film both in Bombay cinema and in the contemporary period. Within the genre of the 'Muslim Social', *parda*, the practice of veiling and seclusion within the family, plays a central role in maintaining the values of traditional patriarchal culture, which are dependent on preserving the purity of women from the intrusive gaze of male strangers. In his chapter 'The poetics of *parda*', Richard Allen explores a group of films, beginning with M. Sadiq's and Guru Dutt's *Chaudhvin ka Chand*, in which the risks of public unveiling are dramatized through Bombay cinema's trope of mistaken identity leading to incipiently tragic results. He argues that by the 1960s, the institution of *parda* had become a site of ambivalence. On the one hand, the values it upholds were considered sacrosanct; on the other, the veiled woman is dramatized as a source of allure and enticement. He explores how the moment of unveiling and love at first sight is staged; the dramatization, through poetry and song, of love-in-separation that *parda* affords; the convoluted plots of mistaken identity that issue from love at first sight once the woman's face is again covered by the veil; and how the medium of film itself both maintains and transgresses *parda* in a manner that is, in part, thematized in the role played by photography as a modern technology that, like cinema itself, publically represents and disseminates the female image.

Shohini Ghosh's contribution analyses the cultural significance of a single individual, the Muslim Bollywood box-office superstar Salman Khan, widely condemned by the liberal press for his off-screen infractions and lampooned for his on-screen, larger-than-life, muscle-bound persona, yet beloved by the subaltern masses. In 'Transfigurations of the star body: Salman Khan and the spectral Muslim', Ghosh argues that by always falling short of the law off-screen, and by inhabiting, in his heroic roles, the liminal, disenchanted underworlds of Bombay, Khan holds particular appeal for the underprivileged Muslim community, and his films are carefully calibrated for an Eid release. As Ghosh points out, with the emergence of blockbuster films like *Dabangg* ('Fearless', 2010) and *Ek Tha Tiger* ('There was a Tiger', 2013), Khan also captured the imagination of a broader middle-class audience without losing his core constituency. In the body of her chapter, she undertakes a close analysis of Khan's persona and roles in four films from two different periods: *Tumko Na Bhool Payenge* ('I will not be able to forget you', 2002), *Garv: Pride and Honour* ('Pride', 2004), *Bajrangi Bhaijaan* ('Brother Bajrangi', 2015) and *Sultan* (2016). She demonstrates that in a period that is communally polarized and 'haunted by the spectre of the "dangerous" Muslim', Khan's

films are far from the simplistic action films they are sometimes assumed to be and instead offer a complex and evolving meditation on the 'visibility' of the Muslim and on being Muslim in a Hindu majoritarian society.

Some of these concerns continue in the last chapter of this volume. In 'Terrorism, conspiracy and surveillance in Bombay's urban cinema', Ranjani Mazumdar argues that the omnipresent threat of Islamic terror in the urban landscape, cultivated by the mass media in the wake of the demolition of the Babri Mosque in 1992, yielded a new idiom for Bombay cinema that represented the everyday urban landscape as a space of incipient paranoia and conspiracy, which the investigatory camera, framed in a narrative of suspense, seeks to map and ultimately contain and control. Mazumdar explores three films that deploy this conspiracy motif in detail, beginning with Anurag Kashyap's *Black Friday* (2007), an unmasking of the conspiracy that resulted in the Bombay bomb blasts of 1993. She argues that the film deploys the aesthetic of an 'X-ray' vision that penetrates the dense and multiple layers of the cityscape in order to reveal the identity of the perpetrators and in this way aligns itself with the point of view of the police. In Rajkumar Gupta's *Aamir* (2008), the protagonist is a Muslim who must himself plant a bomb in order to secure the release of his family from Islamic terrorists. Here Mazumdar points out that it is the terrorists, not the state, who surveil the city through their control of cellular technology. Finally, in Neeraj Pandey's *A Wednesday* (2008), a vigilante film, the hero is a common man who masterminds a series of blasts in order to have the police deliver Muslim terrorists to him for summary execution. Here the street-level view gives way to the bird's-eye panorama of rooftop surveillance. Thus all three films, in different ways, construct the city as a site of conspiracy and seek to evoke, through the apparatus of cinema, the deployment of technology as a means of social control in the face of Islamic terror.

We hope that this collection of chapters will demonstrate the deeply constitutive nature of Islamicate traditions for Indian culture as a whole, which have evolved in dialogue with other cultural forms and are certainly as important for Indian identities as non-Muslim social and cultural practices. This is not surprising since Islam has been in the subcontinent for a thousand years and has, in this period, become an Indian religion with which Indians are deeply familiar. The aesthetic forms of Islamicate cultures, as articulated in literary narratives, poetry, music, architecture and cinema, have not only made Indian culture what it is but are forms that are inseparable from Indian identities. Today, when these identities are facing the threat of violently being cast in one mould, that of Hinduness, it is extremely urgent that we acknowledge the constitutive cultural and affective traditions that form identities in India and celebrate both the multiplicity and syncretism that make India what it is. We hope that, taken together, the diversity of chapters in this volume constitutes such an acknowledgement.

NOTES

1. In Indian film studies, 'Bollywood' is used to describe the globalization of Bombay film that happened after the liberalization of the Indian economy in 1991. While first used in the 1970s, the term 'Bollywood' did not enter wide usage until the 1990s (Rajadhyaksha 2008; Vasudevan 2010; Ganti 2013). Thus it is appropriate to use the term only to describe Bombay cinema of the recent past.

2. *Vaishnavism* refers to cults around the worship of Vishnu and his incarnations. Ram and Krishna are both considered to be incarnations of the Hindu god Vishnu, and Krishna cults were very important during the *Bhakti* movement. See also note 2 in Chapter 10 of this volume for a brief discussion of *Bhakti* movements.

3. Thanks to Philip Lutgendorf for this reference and for his comments on an earlier draft of the introduction.

4. Basant, also known as Basant Panchami, is an extremely popular festival of North India. It is celebrated on the fifth day of the month of Magh in the lunar calendar and occurs either in late January or in early February. It marks the arrival of spring and is celebrated by flying kites, eating sweets and wearing yellow-coloured garments. In the Punjab region – both in Indian and Pakistani Punjab – this is an extremely important festival which is not religious in nature. As a festival celebrating spring, joy and new life, it has been commemorated in poetry and performances from the thirteenth century onwards as evidenced in the work of the poet Amīr Khusrau. Khusrau has also memorialized the other festival of spring, Holi, the festival of colours and the festival of love, which too figures in his well-known compositions. Holi is celebrated on the full moon day of the month of Phagun or Phalguna in the Hindu calendar and usually falls in March. This festival is observed all over North India and people smear colour on each other – both dry colour and with water – accompanied by lots of singing and dancing. There are different myths associated with this festival, especially about Krishna and Radha playing Holi, and this is a very popular theme in Rajput miniature paintings as well as in the different classical dance forms of India. Bombay cinema and Bollywood films often feature Holi sequences.

5. According to the Census of India website (n.d.), Indian adult literacy was 9.5 per cent in 1931, 16.1 per cent in 1941, 18.3 per cent in 1951, 28.3 per cent in 1961, 35.5 per cent in 1971, 43.6 per cent in 1981, 52.2 per cent in 1991, 64.8 per cent in 2001 and 74 per cent in 2011.

REFERENCES

Allen, Richard (2022), 'The poetics of karma: Reincarnation and romance in Bombay cinema', in M. Hjort and T. Nannicelli (eds), *Companion to Motion Pictures and Public Value*, Hoboken, NJ: Wiley-Blackwell, n.pag.

Asher, Catherine B. (1992), *Architecture of Mughal India: The New Cambridge History of India, Volume 1, Part 4*, Cambridge: Cambridge University Press.

INTRODUCTION

Babayan, Kathryn and Najmabadi, Afsaneh (eds) (2008), *Islamicate Sexualities: Translations across Temporal Geographies of Desire*, Cambridge, MA: Harvard University Press.

Bangha, Imre (2010), 'Rekhta: Poetry in mixed language: The emergence of khari boli literature in north India', in F. Orsini (ed.), *Before the Divide: Hindi and Urdu Literary Culture*, New Delhi: Orient BlackSwan, pp. 21–83.

Behl, Aditya (2012), *Love's Subtle Magic: An Indian Islamic Literary Tradition, 1379–1545*, Oxford: Oxford University Press.

Bhaskar, Ira and Allen, Richard (2009), *Islamicate Cultures of Bombay Cinema*, Delhi: Tulika Press.

Bhaskar, Ira and Allen, Richard (2010), 'Islamicate projections: A reply', *Economic and Political Weekly*, 45:10, pp. 79–80.

Brown, Katherine Butler (2007), 'Did Aurangzeb ban music? Questions from the historiography of his reign', *Modern Asian Studies*, 41:1, pp. 77–120.

Butalia, Urvashi (1998), *The Other Side of Silence: Voices from the Partition of India*, New Delhi: Penguin Books India.

Census of India (n.d.), *State of Literacy*, https://censusindia.gov.in/2011-prov-results/data_files/india/Final_PPT_2011_chapter6.pdf. Accessed 6 January 2020.

Chaitanya, Krishna (1982), *A History of Indian Painting: Rajasthani Traditions*, New Delhi: Abhinav Publications.

Dwyer, Rachel (2006), *Filming the Gods: Religion and Indian Cinema*, London: Routledge.

Dwyer, Rachel (2010), 'I am crazy about the lord: The Muslim devotional genre in Hindi film', *Third Text*, 24:1, pp. 123–34.

Dyer, Richard (2009), 'The role of stereotypes', in P. Morris and S. Thornham (eds), *Media Studies: A Reader*, 3rd ed., New York: New York University Press, pp. 206–12.

Embree, Ainslee T. (ed.) (1991), *Sources of Indian Tradition, Vol One: From the Beginning to 1800*, 2nd ed., New Delhi: Viking by Penguin Books India (P) Ltd.

Faruqi, Shamsur Rahman (2010), 'Urdu literature', in R. Irwin (ed.), *Islamic Cultures and Societies to the End of the Eighteenth Century: The New Cambridge History of Islam 4*, Cambridge: Cambridge University Press, pp. 434–43.

Flood, Finbarr B. (2009), *Objects of Translation: Material Culture and Medieval 'Hindu-Muslim' Encounter*, Princeton and Oxford: Princeton University Press.

Ganti, Teja (2013), *Bollywood: A Guidebook to Popular Hindi Cinema*, New York: Routledge.

Gilmartin, David, and Lawrence, Bruce B. (2000), *Beyond Turk and Hindu: Rethinking Religious Identities in Islamicate South Asia*, Gainesville: University Press of Florida.

Gould, William (2004), *Hindu Nationalism and the Language of Politics in Late Colonial India*, New York: Cambridge University Press.

Hodgson, Marshall G. S. (1958), *The Venture of Islam, Vol. 1*, Chicago: University of Chicago Press.

Keay, John (2000), *India: A History*, New York: Atlantic Monthly Press.

Keddie, Nikki R. (1991), 'Introduction: Deciphering Middle Eastern women's history', in N. Keddie and B. Baron (eds), *Women in Middle Eastern History: Shifting Boundaries of Sex and Gender*, New Haven: Yale University Press, pp. 1–22.

Kesavan, Mukul (1994), 'Urdu, Awadh and the tawaif: The Islamicate roots of Hindi cinema', in Z. Hasan (ed.), *Forging Identities: Gender, Communities and the State*, New Delhi: Kali for Women, pp. 244–57.

Khalidi, Tarif (2008), *The Qur'an*, London: Penguin Books.

King, Christopher (1994), *One Language, Two Scripts: The Hindi Movement in Nineteenth Century North India*, Bombay: Oxford University Press.

Lawrence, Bruce B. (2008), 'Islam in Eurasia-Islamicate as a bridge civilization', *APSA 2008 Annual Meeting*, Hynes Convention Center, Boston, Ma, 28–31 August.

Manjhan, Mir Sayyid (2000), *Madhumalati* (trans. A. Behl and S. Weightman), New York: Oxford University Press.

Merklinger, Elizabeth Schotten (2005), *Sultanate Architecture of Pre-Mughal India*, New Delhi: Munshiram Manoharlal Publishers Pvt Ltd.

Michell, George (ed.) (1986), *Islamic Heritage of the Deccan*, Bombay: Marg Publications.

Nandy, Ashis (2001), 'The invisible Holocaust and the journey as an exodus: The poisoned village and the stranger city', in A. Nandy (ed.), *An Ambiguous Journey to the City: The Village and Other Odd Ruins of the Self in the Indian Imagination*, New Delhi: Oxford University Press, pp. 98–139.

Nasr, Vali (2010), 'South Asia from 1919', in F. Robinson (ed.), *The Islamic World in the Age of Western Dominance: The New Cambridge History of Islam Vol. 5*, Cambridge: Cambridge University Press, pp. 558–90.

Oldenburg, Veena Talwar (1990), 'Lifestyle as resistance: The case of the courtesans of Lucknow, India', *Feminist Studies*, 16:2, pp. 259–87.

Orsini, Francesca (2002), *The Hindi Public Sphere 1920–1940: Language and Literature in the Age of Nationalism*, New Delhi: Oxford University Press.

Pandey, Gyanendra (1999), 'Can a Muslim be an Indian?', *Comparative Studies in Society and History*, 41:4, pp. 608–29.

Petievich, Carla (2010), 'Gender politics and the Urdu *ghazal*: Exploratory observations on *Rekhta* versus *Rekhti*', in M. Bhargava (ed.), *Exploring Medieval India II Sixteenth to Eighteenth Centuries: Culture, Gender, Regional Patterns*, New Delhi: Orient BlackSwan, pp. 186–217.

Pollock, Sheldon (2003), *Literary Cultures in History: Reconstructions from South Asia*, Berkeley: University of California Press.

Qureshi, Regula Burckhardt (1986), *Sufi Music of India and Pakistan: Sound, Context and Meaning in Qawwali*, Cambridge: Cambridge University Press.

Rahman, Tariq (2011), *From Hindi to Urdu: A Social and Political History*, Karachi and Delhi: Oxford University Press and Orient BlackSwan.

Rajadhyaksha, Ashish (2008), 'The "Bollywoodization" of the Indian cinema: Cultural nationalism in a global arena', in A. Punathambekar and A. R. Kavoori (eds), *Global Bollywood*, New Delhi: Oxford University Press, pp. 17–40.

Reinhart, Kevin A. (2003), 'On the "introduction to Islam" ', in B. M. Wheeler (ed.), *Teaching Islam*, New York: Oxford University Press, pp. 22–45.

Roy, Anjali Gera (2015), *Cinema of Enchantment: Perso-Arabic Genealogies of the Hindi Masala Film*, New Delhi: Orient BlackSwan.

Saeed, Yousuf (2009), 'Muslim exotica of Hindi filmdom' [a review of Ira Bhaskar and Richard Allen's *Islamicate Cultures of Bombay Cinema*], *The Book Review*, South Asia Special – XIV, August–September, pp. 23–24.

Schelling, Andrew (ed.) (2011), *The Oxford Anthology of Bhakti Literature*, New Delhi: Oxford University Press.

Sharma, Sunil (2006), *Amir Khusraw: The Poet of Sufis and Sultans*, Oxford: Oneworld Publications.

Singh, Kavita (2017), *Real Birds in Imagined Gardens: Mughal Painting between Persia and Europe*, Los Angeles: The Getty Research Institute.

Suvorova, Anna A. (2000), *Masnavi: A Study of Urdu Romance* (trans. M. O. Faruqi), Oxford: Oxford University Press.

Taneja, Anand Vivek (2010), 'Stereotyping the Muslim in Bombay cinema', *Economic and Political Weekly*, 45:4, pp. 30–32.

Truschke, Audrey (2016), *Culture of Encounters: Sanskrit at the Mughal Court*, New Delhi: Allen Lane in India by Penguin Books India.

Vasudevan, Ravi (2010), 'The contemporary film industry – I: The meanings of "Bollywood"', in R. Vasudevan, *The Melodramatic Public*, New Delhi: Permanent Black, pp. 334–61.

Wade, Bonnie C. (1999), *Imaging Sound: An Ethnomusicological Study of Music, Art, and Culture in Mughal India*, New Delhi: Oxford University Press.

Wagoner, Phillip B. (1996), '"Sultan among Hindu kings": Dress, titles, and the Islamicization of Hindu culture at Vijayanagara', *The Journal of Asian Studies*, 55:4 (November), pp. 851–80.

PART 1

ISLAMICATE HISTORIES

1

Passionate Refrains:
The Theatricality of Urdu on the Parsi Stage

Kathryn Hansen

India in the late nineteenth century witnessed epochal changes in urban lifestyles and entertainment. Each night capacity crowds filled European-style playhouses, drawn by the magic of the Parsi theatre. Dramatic fare organized by Parsi entrepreneurs brought an entirely new level of sophistication to the world of popular performance. Capitalizing on the technologies introduced from the West, the Parsi theatre paraded showy styles of acting, singing and storytelling. Embracing innovation, it outfitted and popularized the proscenium stage as the appropriate venue for theatrical representation. This cosmopolitan entertainment spread from the colonial port cities to all corners of the subcontinent as roving theatre companies toured the provinces. The allure was so great that by the end of the century the Parsi theatre had become a ubiquitous part of India's public culture. It reached audience members from one end of the class spectrum to the other and knew no religious, linguistic or ethnic bounds.

The era of the Parsi theatre's sway stretched from the 1860s through the 1930s. Even as the momentum began to wane with the coming of sound films, the Parsi theatre left behind a rich legacy that contributed to the formation of popular Indian cinema in a variety of ways. The sprawling repertoire of story and theme provided a ready cache of narrative material available to early filmmakers. With its orientation towards middle-brow taste, the Parsi stage established conventions of melodrama and comedy that would prove influential and enduring. Moreover, it bequeathed certain genres distinctive to the Indian environment. The mythological, the historical and the social film were all indebted to their antecedents from the world of theatre. As an industry also, the Parsi theatrical enterprise had

a major impact. It supplied experienced actors, writers and directors, technical and managerial expertise and capital vital to the venture into cinematic production. Many a playhouse was converted to cinema hall, the most notable example being the old Gaiety Theatre which became the Capitol Cinema near Victoria Terminus in Bombay.

Some of these continuities will be explored in later sections of this chapter. The central focus herein, however, is on another aspect of the Parsi theatre's connection to Bombay cinema: the stylized structures of language, thought and feeling associated with the Urdu language. The adoption of Urdu as the principal medium of the stage was a strategy that enabled the Parsi theatre to extend its audience far beyond Bombay. But Urdu was much more than a lingua franca. The universe of Urdu culture conveyed realms of romance, sweet speech and lofty thought. It celebrated a distinctive sensibility by means of poetic utterance, particularly in the form of the lyric *ghazal*. Supplemented by the elegant rhythms and melodies of Hindustani music, Urdu expression gave the musical stage a tremendous aesthetic and commercial advantage. The Parsi theatre, in turn, exploited the sonorities of Urdu and enhanced Urdu's inherent theatricality. The aesthetic sensibility associated with Urdu created a foundation that still figures prominently and counts as a cornerstone of the Islamicate idiom in Bombay cinema.

In the first section of this chapter, I introduce the Parsi theatre of the later nineteenth century and describe the process by which Urdu became its most popular language. Even before the Parsi theatre, the *Indar Sabhā* ('The assembly of King Indra') marked the starting point of the transmission of Urdu lyric and narrative poetry to the popular stage. Soon thereafter, professional theatre companies managed by Parsis were hiring Urdu playwrights or *munshī*s in force. Together with their illustrious counterparts, the famed actor-managers of the day, they co-created the Parsi-Urdu theatrical style. In the second section, I review the urban topography of Bombay and the changing location of theatrical entertainment within it. European playhouse design and the new conventions of melodrama called for a forceful, rhythmic style of delivery, for which those tutored in Urdu were well-suited. The third section provides some examples of the kinds of Urdu found on the Parsi stage, with a discussion of how Urdu poetry's rhythmic cadences and rhyming refrains enhanced the audience's experience. The chapter concludes with a case study of Urdu playwright Āghā Ḥashr Kāshmīrī, focusing on his historical allegory, *Yahūdī kī Laṛkī* ('The Jew's daughter', 1913). This stirring melodrama treated the religious repression of the Jews in ancient Rome, with a cross-community love affair at its centre. The 1955 film version of the play, starring the Parsi actor Sohrab Modi, exemplifies the rich inheritance bestowed by the Parsi-Urdu theatre on the Bombay cinema.

Parsi pioneers and Urdu *munshī*s

The Parsi theatre was named for its pioneers who were members of a distinct community in India. Zoroastrians by faith, the Parsis migrated from Iran to the coast of Gujarat in western India over a thousand years ago. A section of the community shifted to Bombay in the eighteenth century and due to a variety of economic and cultural advantages became agents and brokers for the British. By the nineteenth century many Parsis were leaders in the city's financial, educational and social circles.

Social interaction between Parsis and their colonial counterparts led to the Parsis being exposed to English-language theatre and drama in the early nineteenth century. Theatricals, as they were called, were one of the principal diversions of European society. Evenings of drama, music and dance were presented both by resident amateurs and by professional artists on tour, under the patronage of military and civil dignitaries. These shows caught the fancy of elite Indian spectators who accompanied their colonial colleagues on occasion. As students too, Parsis were introduced to English dramatic literature and avidly took part in school and college productions. The new passion for dramatics, conjoined with financial resources and entrepreneurial skills, inclined certain Parsis to organize the first modern theatrical companies in South Asia.

The audience for Parsi-initiated theatrical performances was heterogeneous from the beginning, with non-Parsis outnumbering Parsis. The Parsi theatre never projected Parsi religious beliefs; it was entirely secular. Over decades, the management of the large companies remained under the firm control of Parsi businessmen, but as time went on, the majority of performers and stage crew were drawn from other communities. Thus the label 'Parsi theatre' is something of a misnomer. Some scholars would replace it with 'Company Nāṭak', to facilitate comparison with other professional theatres that developed in this period, especially in South India. Because of its origins in Bombay and its custodianship by a particular group, 'Parsi theatre' nevertheless remains the most appropriate and widely employed rubric.

During centuries of residence in Gujarat the language of the Parsis had become Gujarati, and this language was retained by the community after their move to Bombay. Gujarati was also the mother tongue of other trading groups in the metropolis, including the sizeable Muslim communities of Bohras, Memons and Khojas, as well as Hindu and Jain Banias. Collectively, the business class of Bombay had a markedly Gujarati character, and Gujarati was the common tongue for trade in the city. Although English education made some inroads among the elite, in the middle of the nineteenth century most Parsi school children were first educated in Gujarati.

It is no surprise, then, that when the first Parsi theatre troupe mounted a production in 1853, the centrepiece drama, a version of the classic tale of Rustom and

Sohrāb, was performed in Gujarati. Over the next two decades, plays performed in the Parsi theatre frequently dealt with themes like this one from the epic history of pre-Islamic Iran. These tales were ultimately derived from the *Shāhnāma* ('The book of kings'), written in Persian around 1000 AD by the poet Firdausī/ Ferdowsi. Episodes from the masterwork had previously circulated among the Parsi community in the form of both oral tales and lithographed chapbooks in Persian and Gujarati. Another popular source for plays in the early years of the Parsi theatre was Shakespeare, and both his comedies and tragedies were performed initially in English by student clubs based at Elphinstone College. These soon gave way to adaptations of Shakespeare in Indian languages, especially Gujarati. The earliest printed book of playscripts from the Parsi theatre is *Shakespeare Nāṭak* by Nānābhāī Rustamjī Rānīnā (1865). The third type of play characteristic of the young Parsi theatre was the farce, a short piece presented after the main drama, typically in Hindustani (Hansen 2003: 386–88).

Given that Gujarati was the Parsi community's principal language, and that it was the primary tongue used in the early days of the Parsi theatre, how did Urdu rise to prominence? For whom and by whom was it utilized, and how was it perceived? The story of Urdu and its association with the stage actually begins outside of Bombay, in the court of the last Nawab of Lucknow, Wājid 'Alī Shāh. Here, in the middle of the nineteenth century, Urdu drama (or at least a rudimentary form of it) originated in the musical pageant titled the *Indar Sabhā* ('The assembly of King Indra'). First penned by Āghā Ḥasan Amānat, a poet attached to the court, the *Indar Sabhā* marked the moment at which the Urdu *ghazal*, with its declarations of passion (*'ishq*) in recurring refrains (*radīf*s), entered the theatrical space in South Asia. The wildly popular *Indar Sabhā* had a slim plot focused on a heavenly monarch identified with the Hindu deity Indra. He was attended upon by four beautiful *parī*s or fairies, until the arrival of a prince named Gulfam who becomes smitten – almost fatally – with one of them. The story borrowed elements from several earlier *maṣnavī*s, most notably the *Siḥr ul-Bayān* ('The enchanting story') of Mīr Ḥasan and *Gulzār-i Nasīm* ('Zephyr's rose garden') by Dayā Shankar Nasīm. In addition to the *Indar Sabhā*'s countless Urdu *ghazal*s, it featured *ṭhumrī*s in Braj Bhasha, folk songs in Awadhi and accompanying dances. Although the work debuted in Lucknow, it soon escaped aristocratic circles and was carried outside the city by travelling troupes. When it reached Bombay, it entered the repertoire of the Parsi theatre companies and eventually gained even wider circulation, being carried to South India, Ceylon and Malaysia with the movements of the troupes. In the process it was reprinted countless times, transliterated into scripts as diverse and distant as Gurmukhi, Sinhala and even Hebrew and translated into German, Malay and assorted Indian languages; it also spawned many imitations (Hansen 2001: 97–99).

Meanwhile, in Parsi theatre circles in Bombay, experiments were underway to familiarize audiences and performers with the possibilities of Urdu as an alternative to Gujarati for serious drama. The first Urdu play written for the Parsi stage was *Sone ke Mol kī Khurshed* ('Khurshed for the price of gold), a translation by the journalist Behrām Fardun Marzbān, based on a Gujarati drama by Edaljī Khorī. This play was commissioned for the Victoria Theatrical Company by its then director, Dadi Patel, in 1871. Dadabhai Sohrabji Patel, or 'Dadi Patel M.A.', as he was known, was perhaps the most highly educated Parsi attached to the early theatre. Along with introducing Urdu, he is credited with popularizing 'opera' or musical drama as a prestigious form, championing 'scientific' stagecraft and professionalizing the relations between actors and theatrical companies.

Urdu or Hindustani, it must be recalled, was not the mother tongue of many Bombay residents. Parsis were acquainted with it only as a third language, and the Muslims of Bombay mainly spoke Gujarati. Even the translator, Marzbān, acknowledged in his preface to *Sone ke Mol*, 'Hindustani is not the language of your humble servant, nor has he studied its grammar and rules'. Marzbān's translation was published in the Gujarati script rather than the *nasta'līq* script commonly used (then and now) for Urdu. This curious, hybrid printing practice set the standard for scores of Urdu plays written for the Parsi theatre in the next twenty years (Hansen 2003: 395).

Nasarvānjī Mehrvānjī 'Ārām' was another Parsi and non-native speaker of Urdu who translated the plays of Khorī into Urdu in the early 1870s. In one of his prefaces he noted, 'Neither Urdu nor Braj are my own languages, so there is no doubt that many errors must have been unknowingly introduced' (Tāj 1969: 2, 365). Newspaper reviews of these early plays commented on the audience's surprise at hearing Parsi actors enunciate the words of the Urdu language. Urdu poetry was alien and exotic to both spectators and performers, and Dadi Patel was deemed brilliant for successfully rehearsing his cast in a language that was not their own. As a result, the use of Urdu caught on as the latest fad. A series of Indo-Islamic romances cast in Urdu soon filled the playhouses of Bombay. In 1873, the Elphinstone Company mounted a lavish production of the *Indar Sabhā*, and this gala event was countered by a Victoria Company production of the same play in 1874; both companies repeated these shows throughout the year.

The adoption of Urdu may well have been motivated by the desire to reach beyond the Gujarati-speaking audience and appeal to other classes of spectators. No doubt the desire for profit induced company owners to introduce this and other audience-pleasing novelties. The turn towards Urdu had an aesthetic purpose as well. It was part of a process of expansion in the musical, poetic and visual economies of the stage. Urdu connected the theatre to rich narrative and lyric traditions, increasing its stature and pleasurability. More specifically, the

Indo-Muslim cultural heritage offered an aristocratic alternative to the folk styles of performance that Gujarati speakers had previously patronized. An early task for the Parsi theatre was to decouple the notion of secular entertainment from groups of roaming street performers, such as the Khayālīs and Bhavaiyās mentioned in the play prefaces, who were considered low-class and disreputable. That the actors in this period were educated middle-class youth from upstanding families certainly helped. The concern with upgrading the image of the Parsi stage similarly led to advocates equating their efforts with the principle of 'rational amusement' borrowed from English theatrical discourse (Hansen 2003: 392–93).

From the 1870s onwards, Urdu poets penned not dozens but hundreds of dramas for the Parsi-run companies. Many of these plays were extremely successful and were performed to packed houses. They formed the staple of popular entertainment, providing the *masālā* of song, dance, poetry, melodrama and spectacle in the era before cinema. The earliest Urdu playwrights were actually Parsis whose Urdu was imperfect. Following the efforts of Marzbān and 'Ārām' to create a rough-and-ready Hindustani for the stage, Muslim playwrights with deeper moorings in Urdu and sometimes Persian entered the scene. The next Urdu playwright of record was Mahmūd Miyāṅ 'Raunaq', a prolific writer for the Victoria Company in the 1870s and 1880s. Raunaq may have been a Gujarati Muslim, despite the label 'Banārasī' sometimes attached to his name. In his sole preface, he says he was a purifier of the Urdu language, evincing a measure of self-consciousness in the use of Urdu that suggests formal study (Hansen 2003: 397–98).

The subsequent generation of Urdu dramatists, who wrote and published plays for the Parsi theatre in the 1880s, hailed from northern India. They were Muslims trained in the classical languages to which Urdu was heir. Karīmuddīn 'Murād' was born in Bareli and was educated in Arabic and Persian. He was known as 'Maulvī Sāheb' even after joining the Parsi theatre around 1883 (Tāj 1972: 7, 3–4). Amānullāh Khāṅ 'Habāb' came from Fatehpur, where he was a court poet in the service of the Nawabs of Rampur and Rewan in the 1870s. He began writing plays for the Parsi theatre in 1881 (Tāj 1970: 8, alif-ye). Ḥāfiẓ Muḥammad 'Abdullāh, like Habāb, was from Fatehpur and was the son of a *zamīndār*. 'Abdullāh was educated in Arabic and Persian and was a *ḥāfiẓ-i qur'ān* ('protector of the Quran', one who has the entire book by heart). His plays date from approximately 1880 (Tāj 1971: 10, 1–3).

How did these men of the north make contact with the Bombay Parsi theatre? Murād is said to have been recruited by one Pestanjī, who was sent to look for *munshī*s (professional writers) for Dadabhai Ratan Thunthi's theatrical company. Pestanjī tested Murād's talents by having him compose new lyrics to a pre-existing melody, then negotiated his salary and returned to Bombay with him (Tāj 1972: 7, 3–4). Habāb moved to Jabalpur in 1881 and was attracted to the performances of

the Original Victoria Theatrical Company. He offered his services as a poet and writer, and the company owners commissioned his play *Sharar 'Ishq* ('Spark of love') and performed it. It is not clear whether he ever actually went to Bombay (Tāj 1970: 8, alif-ye). 'Abdullāh first became a dramatist and actor with the Light of India Theatrical Company. In 1882 he founded the Indian Imperial Theatrical Company and became its managing director (Tāj 1971: 10, 3). The patron of this company was the Maharaja of Dholpur, and its plays were published in Agra. 'Abdullāh also appears to have been a *munshī* for the Alfred Theatrical Company of Bombay under the ownership of N. R. Rānīnā, and some of his plays were published by that company in Bombay.

The Gujarati script was still used for the Bombay publications of these Urdu playwrights. Habāb's *Sharar 'Ishq* was published in 1881 in Gujarati script. 'Abdullāh's plays commissioned by the Alfred Company were also printed in Gujarati script. However, 'Abdullāh's plays written for his U.P. based Indian Imperial Company were published in *nasta'līq*, the script ordinarily used for Urdu lithography, and three of them contain Urdu prefaces. When the seasonal tours of the Bombay companies reached northern India, innumerable spin-off companies sprang up in the cities and towns. Local publishers ventured into bringing out Urdu plays, often aided directly by these theatrical companies. By 1890, Parsi theatre plays in Urdu were being printed in *nasta'līq* from Agra, Meerut, Kanpur, Delhi and Fatehpur.

A contemporary account captures the fervour with which Parsi-Urdu dramatic entertainment was awaited in the provincial towns of north India. The author is Rādheshyām Kathāvāchak, a well-known playwright later associated with the New Alfred Theatrical Company. He writes of Bareli, his hometown, in 1900:

> The next year a company came from Agra to perform Munshi Nazir's drama, *Shakuntala*. I pleaded with father to go see it, but he wouldn't take me. The New Alfred returned next with *Dil Farosh*, but we were out reciting on tour and missed it. Then Aulad Ali's company arrived with *Gulru Zarina*, and Bareli went wild. Unable to hold me back, father bought two tickets in the four-anna class and we went one night. Those actors were powerful singers who belted it out in a way seldom heard later. The company's style favored plenty of songs without much scenery or stagecraft and lots of encores or 'once-mores.' Sometimes a song was repeated four or five times. The show lasted till four in the morning.
>
> Muslims were greater fans of drama than Hindus in those days, and the company management, actors, and writers were mostly Muslims too. Plays were written in pure Urdu, with sentiments of romance and beauty dominating. Even the dialogues featured refrains with end-rhymes like *amma jan*, *mehrban*, *qadr-dan*. The chief playwrights or *munshis* were Murad, Ahsan, and Nazir.

<div align="right">(Hansen 2011: 113)</div>

Rādheshyām attests to the powerful appeal of touring theatre troupes that swept through the town, one after the other. He and his father, poor Brahmins who made their living by performing religious songs and tales, were part of the heterogeneous crowd of enthusiasts. Recalling the 'pure Urdu' of those days, Rādheshyām mentions the reigning trio of Urdu playwrights. Naẓīr Beg Naẓīr, a disciple of Ḥāfiz 'Abdullāh, was active as an actor, director and playwright between 1888 and 1913; he composed *Shakuntalā* and *Gulrū Zarīnā* ('Pretty Zarina'). Mehdī Ḥasan Aḥsan, descendant of a lineage of poets from Lucknow, was known for his Shakespearean adaptations like *Dil Farosh* ('Merchant of hearts'), based on *The Merchant of Venice*. Murād 'Alī Murād, an Urdu playwright from Bareli, was the leading dramatist of the Alfred Theatrical Company under Kavasji Khatau and later the New Alfred of Sohrabji Ogra; he wrote *Alāūddīn*, *Harishchandra* and *Chandrāvalī*.

By the turn of the century, the structure of the Bombay-based Parsi theatre companies reflected the unique partnership that had evolved over the preceding 50 years. Wealthy Parsis who were skilled in finance and had money to invest were the impresarios – the producers, promoters, organizers. Illustrious actors like K. M. Baliwala and Kavas P. Khatau came from the less privileged class of Parsis; they rose to prominence as successful managers and directors. The Urdu playwrights or *munshī*s comprised the creative staff. They conceived the new plots or adapted old ones, wrote the new songs and brought their imagination and talent to the stage through their scripts. Often too they rehearsed the actors and worked with the musicians and dancers to develop the musical and choreographic components that ensured a production's success. Despite the stress of nightly shows and the rigors of travel, the companies operated amicably across lines of class, ethnicity and religion. Collaboration in the theatre continued in the face of the fault lines that were beginning, under the impact of colonial modernity and nationalism, to strain intercommunal relationships in the surrounding society.

Sight and sound in the urban playhouse

The urban playhouses utilized by Parsi theatre companies in the nineteenth century offered unprecedented scope for theatrical production and reception. In contrast with the makeshift platforms in markets and temple courtyards where folk theatre was staged, or the large-scale outdoor topography deployed for religious pageants like the Rām Līlā, the purpose-built theatre houses of colonial India allowed for a certain elegance and decorum. As enclosed physical spaces, these buildings by their nature restricted access. Their design incorporated principles of order and compartmentalization meant to maintain boundaries between various groups.

The proscenium arch rose high above the stage, positioning the players within an expansive picture frame and separating them from the spectators. The spectators themselves were divided by their assigned seating, arranged by class and row and priced according to the location. In a newspaper advertisement for a performance of *Rustam and Sohrab* in 1870, tickets for box seats were offered at Rs. 5, stalls at Rs. 3, gallery at Rs. 2 and pit at Re. 1.

The display of distinctions of class and status ensured that a secondary spectacle operated within the playhouse. Playgoers went to the theatre not only to see the play, but also to see others in society and to be seen. On special occasions, British dignitaries attended as chief guests and patrons, increasing the level of pomp on view and recreating the atmosphere of the *darbār*. The interior spatial set-up in the playhouse had the effect of creating new social categories and modes of negotiating social distance. Newspaper ads and reviews acknowledged the composite character of the audience. In the Gujarati press, the public for theatrical entertainment was described through phrases such as *khāṣ-o-'ām* ('the elite and the ordinary').

The enclosure provided by the playhouse permitted theatre as an art to assume an enlarged social value in comparison with previously available forms of entertainment. The structure and location of early playhouses affirmed the importance of theatre to civic life. When the Bombay Amateur Theatre first opened in 1776, it was prominently situated in the British colony. Near to the Government House and the church, it was built on the Green, now known as Horniman Circle, at the intersection of the main streets leading from the three city gates. In 1840, the construction of a new playhouse was mooted, and a group of leading citizens submitted a petition to the Governor of Bombay, pressing for theatre as an enhancement of civil society (Hansen 2013: 359). This time the building came up at the growing edge of the so-called Native Town far from the European quarter. The shift of theatrical entertainment to the northern part of the city suited the growing Indian public, and Grant Road was shortly populated by a number of other theatre houses including the Victoria Theatre, established in 1870 (Figure 1.1). The area rapidly developed into a thriving commercial district, but the Grant Road vicinity remained distinctly down-market.

Claims to elite status and access to elite patrons were reaffirmed when Parsi company owners opened two new theatres near the Victoria Terminus (now Chhatrapati Shivaji Terminus, or popularly Bombay VT). As Bombay acquired its metropolitan skyline in the 1880s and became linked to the hinterland through the railways, these theatres assumed renewed significance as urbane venues for leisure and sociability. The Gaiety Theatre was built by C. S. Nazir, a leading Parsi actor-manager, in 1879. Designed by an architect named Campbell, its stage dimensions were 70 by 40 feet with a curtain height of 22 feet. In anticipation of its opening, the newspaper *Rāst Goftār* provided construction details:

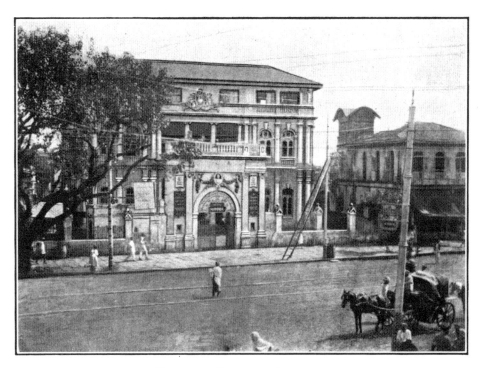

VICTORIA THEATRE, BOMBAY

FIGURE 1.1: Victoria Theatre, 1870.
Source: Charles Jasper Sisson, *Shakespeare in India: Popular Adaptations on the Bombay Stage*, 1926.

> In this theatre on the first floor there are private boxes with four seats each. The amount of the season tickets for these is Rs. 3400, but Mr. Nazir has promised that this money would be kept in a bank to pay the actors coming from abroad. This tells us that the large sum of Rs. 20,000 will be spent to pay the actors for just one season. The cost of the reconstruction of the theatre would come to Rs. 40,000. At the top a small dome will be built above the theatre. In the lower portion will be the stalls and the third class. In total there would be a seating arrangement for about 800 people. The boxes have been constructed in such a way that all spectators will be able to see from all sides. With the same intention, the height of the stage has been increased. The height of the roof being nearly 30 feet, the whole set of the play can be accommodated very easily.
>
> (Anon. 1879a: 771)

The Novelty Theatre, constructed by the Victoria Company's owners Baliwala and Moghul in 1887, was even larger, with a stage size of 90 feet by 65 feet. It

seated 1,400 people. Following a benefit performance by the Victoria Theatrical Company in aid of the Indian Medical Women's Fund, the *Times of India* praised its appearance:

> There can be no doubt that the best expectations of Lord and Lady Reay [the presiding dignitaries] were realised, inasmuch as the whole house was filled to its utmost capacity by an audience of an influential character, consisting of all castes and creeds. The grounds in and about the theatre were most tastefully decorated and brilliantly illuminated with myriads of *buttee* lamps and coloured lanterns. The passage on the north side of the house, through which H.E. the Governor's carriage was to pass, was lined on both sides with Venetian masts, and there was besides a large display of flags, buntings and festoons of banners in front and on the sides of the building. The interior of the house was also prettily decorated.
>
> (Anon. 1888: 3)

The late nineteenth century was of course the Victorian age in England, and colonial administrators, educationists and missionaries disseminated the discourses of morality, utility and reform to the populace in India. Influenced by the dominant ideology, the early Indian thespians viewed theatre as a rational amusement and promoted its educational potential. They particularly sought to distinguish it from the morally ambiguous entertainments associated with the courtesan's salon or *kothā*, the locus of refined leisure and sociality for the post-Mughal aristocracy. In actuality, the Parsi theatre retained ties with forms of music and dance that flourished in the north Indian *kothā*. Composers made use of Hindustani ragas and talas for their song genres, and orchestras featured ṭabla, sāraṅgī, harmonium and other musical instruments. The theatre also recirculated the verbal art of the *kothā* by adopting Urdu and the stylized expression of the *ghazal* as its métier. Continuities in formal vocabularies and structures of feeling persisted as the Parsi theatrical idiom entered the cinema in the twentieth century. Nonetheless, as if buttressing the moral distinction between the theatre and the *kothā*, the grand proscenium stage and its technological possibilities broadcast the Parsi theatre's superiority and advancement.

Here the players strutted on a vast platform framed by a soaring arch. A massive painted curtain provided the background upon which densely detailed scenic representations were projected. In front, the 'drop curtain', also elaborately painted, was raised and lowered to demarcate the start and finish of the several acts of the drama. Transformation sets were employed that shifted between scenes. Flying machines enabled the descent of heavenly figures, just as trapdoors below the platform allowed creatures from the netherworld to suddenly appear on-stage. Lavish costumes and precious jewellery created a sumptuous atmosphere. Even amenities

such as refreshment rooms and intervals added a sense of civilized decorum to the proceedings.

The size of the stage and technical innovations increased opportunities for melodramatic spectacle, then in vogue in Europe. Conventions of Western melodrama reached India via travelling actors stopping on their way to and from China. Notices in Bombay newspapers in the 1820s mention Gothic melodramas by Moncrieff and Monk Lewis being performed locally. Later, military, equestrian and nautical melodramas were also imported. These were joined by sentimental melodramas like Bulwer-Lytton's *The Lady of Lyons*, which was adapted into Gujarati and performed by a Parsi theatre club in 1868. Crime melodramas also proliferated on the model of English melodramas, beginning with Raunaq's play *Khūn-i 'Āshiq* ('Lover's blood').

European melodrama in its theory and practice was closely affiliated with painting, especially the realistic depiction of scenes from everyday life known as genre painting. Diderot emphasized that a painting should represent an instant, capturing a moment in time's passage. He introduced the notion of the tableau, the signature of European melodrama, 'where the actors strike an expressive stance in a legible symbolic configuration that crystallizes a stage of the narrative' (Meisel 1983: 45). In the Parsi theatre, arrested pictures were used to punctuate the ends of acts just before the 'drop' fell. With this new pictorialism came the use of perspective, often combined with architectural motifs such as receding arches or vaulted ceilings that feature in late-nineteenth-century photographs from India (Figure 1.2).

The frontal arrangement of performers on stage was in part a legacy of the pictorial mode of composition, but it was also imposed by the technical limitations of the lighting scheme. Footlights fuelled by piped-in gas were placed at the edge of the stage, in close proximity to the actors who stood almost directly above them with the curtain only a few feet behind. This strategy was necessary to illuminate the actors' faces and the painted scene, but it had the effect of casting eerie and exaggerated shadows that reinforced the players' heightened emotions. In the photograph of a Parsi theatre production of *Romeo and Juliet*, the foreshortened distance between the foot lights, the actors' feet and the painted backdrop is apparent (Figure 1.3). The tableau here illustrates the so-called pointed style, the freezing of bodily movement in elongated or angular poses that suggest the conclusion of a dance-like sweep of movement.

Given the large dimensions of the playhouse and the remote position of the viewer, the actor needed to project his presence to fill the space. Outstretched arms, pointed fingers and bent knees were intrinsic elements of the exaggerated acting technique favoured in this period. They were accompanied at the level of sound by declamatory speech-making, projected at high volume to reach the farthest corners of the playhouse. Newspaper reviewers sometimes commented

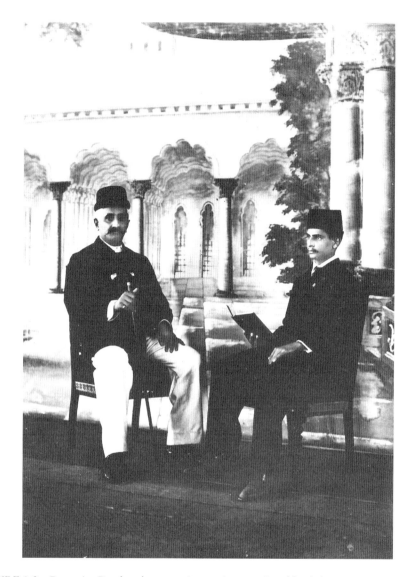

FIGURE 1.2: Cowasjee Patel and son, posing against a painted backdrop.
Source: The IGNCA Collection.

unfavourably on the loud din created by the shouting and bellowing of Parsi theatre actors. The tendency was attributed to the immature histrionic art of the natives, who had not yet come up to the European standard (Anon. 1879b). Other reports in the press noted the excessive noise and rowdy behaviour that occasionally erupted among the spectators during dramatic performances. Outbreaks of fighting among performers on-stage were also not unknown. The aura of discipline

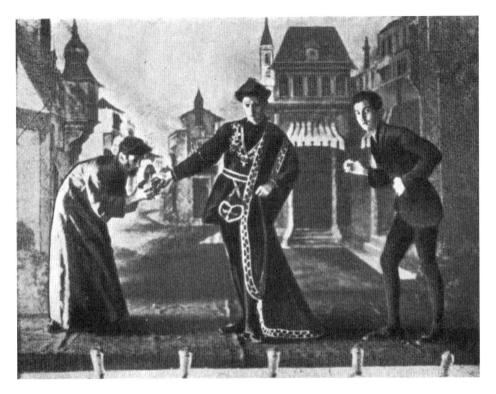

FIGURE 1.3: *Romeo and Juliet*, Act I, Scene 2, Bombay.
Source: Charles Jasper Sisson, *Shakespeare in India: Popular Adaptations on the Bombay Stage*, 1926.

and progress signalled in the architectural design of the playhouse, it appears, could not suppress the boisterous energies of live theatre.

Meanwhile, the enormous gulf between the stage and the boxes demanded that actors make ample use of their lungs and vocal cords. The challenge of being heard and understood became a significant problem for actors in the Parsi theatre. Whereas stage lights could illuminate the actor's figure, there were no mechanical means for amplifying sound. The matter was not left entirely to the actor's vocal technique, however. The use of formulaic language, composed in recognizable cadences with rhyme as a regular feature, assisted the audience in following along. Poet-playwrights composing in Urdu adopted the practice of putting dialogue into rhyming prose and couplets. Both prose and verse exploited the characteristic feminine rhyme pattern of Urdu prosody, whereby line-ends are punctuated by a highly audible and predictable set of syllables known as *qāfiya* and *radīf*. The *radīf* is the syllable or syllables which terminate the line and remain constant throughout. The *qāfiya* is the single syllable leading into the *radīf*, which

is joined with other syllables to make a *qāfiya* word. It is the anticipation of the *radīf*, signalled by enunciation of the *qāfiya*, that prompts the audience to supply the anticipated syllable or syllables and thereby complete the line.

The ubiquity of devices of sound in the Urdu dramas of the Parsi theatre facilitated a high degree of audience participation. Members of the crowd would guess the rhyming words at the end of each line and shout them out vociferously. Verbal response from the spectators during a show was expected and was taken as a sign that the performance was going well. *Dād denā*, the oral display of audience approval, took other forms as well. Appreciation and praise of poetic speech, songs, dances and even fight scenes would be shouted out using typical Urdu turns of phrase. In the Parsi theatre, moreover, a particular practice of expressing praise emerged, the famed 'once more'. When this English phrase was interjected loudly by spectators, the sequence just completed – be it a *ghazal*, a dance or a fight unto death – was always repeated, sometimes multiple times if so demanded. The constant interaction between players and spectators heightened the excitement as the performance advanced, bridging the physical distances in the playhouse and drawing the audience together into a community of listeners.

Registers of Urdu

The character of the Urdu used in these dramas varied from simple Hindustani to speeches full of Persianate constructions. The register could move back and forth within a dialogue, as witnessed in an exchange between Azra and his daughter Rahil in Āghā Ḥashr's *Yahūdī kī Laṛkī*:

EZRA: *Batā, tū duniyā aur dīn, donoṅ meṅ se kis chīz ko pasand kartī hai?*
RAHIL: *Abbā jān! Dukh bīmārī aur dīgar takālīf se bharī huī duniyā ke liye haqīqī masarrat aur jāvedānī surūr se āṅkheṅ band karūṅ? Lāl ko ṭhokar mār kar patthar ko pasand karūṅ?*

<div align="right">(Kāshmīrī 2001: 89)</div>

('EZRA: Tell me, of the two, which do you like better, the world or the faith?
RAHIL: Father, dear! How could I shut my eyes to eternal happiness and everlasting joy for this world full of pain, suffering, and other troubles? How could I trample on the ruby and prefer the stone?')

The Persianate phrases *haqīqī masarrat* and *jāvedānī surūr*, both referring to the rewards of religious belief, elevate the tenor of Rahil's speech, whereas the Hindustani phrasing used to contrast the ruby and the stone make the point in a down-to-earth way.

In the tradition of the *Indar Sabhā*, songs and invocations were often written in dialects of Hindi, such as Braj Bhasha and Awadhi. In *Yahūdī kī Laṛkī*, a number of scenes begin with romantic songs sung by a chorus of girls, such as:

> *Sakhī joban ke māte haiṅ*
> *Kaise tīkhe pyāre najariyā ke bān.*
> *Jin nainan ke saṅg chheṛ kare*
> *Vāre apnī jān.*

<div align="right">(Kāshmīrī 2001: 12)</div>

> ('Girlfriends, he's mad with the pride of youth.
> How sharp are my darling's arrow-like glances.
> Whoever collides with his piercing gaze,
> May their lives be spared!')

Language was often used to mark differences between characters. A common structural device of these plays was to match a dramatic main plot with a comic sub-plot. Serious scenes featuring high-status characters tended to alternate with buffoonery featuring servants or other lowly figures. Partly this was to allow for the change of sets and scenery in the background, and partly to maintain audience interest. In the sub-plot, farce, slapstick and obscenity reigned, while in the main plot, the tone was more exalted. In an inversion of colonial hierarchy, the English language was ridiculed by its comic voicing among low-status characters, such as the barber-turned-postmaster Ghasita, in *Yahūdī kī Laṛkī*:

> *Nāī se* tie *lagākar banā maiṅ kaisā* gentleman,
> *Chhoṛī hai desī* line, *mujh se ḍarte haiṅ ab* postman.
> *Vāh-vā, jisko ho ik māh meṅ* three thousand income,
> *Usī malkā ko banāūṅ maiṅ apnī* madam.

<div align="right">(Kāshmīrī 2004: 2, 189)</div>

> ('Putting on a tie, I went from barber to gentleman.
> I left the traditional line, now am feared by the postman.
> Wonderful! Whoever gets three thousand in monthly income,
> I'll marry that queen and make her my madam.')

One peculiar aspect of Urdu's theatricality was the prevalence of rhymed prose. This stylized practice, whose technical name is *naṣr-i muqaffā*, was borrowed from *dāstān*s, long narrative works. Rhymed prose had the effect of raising ordinary speech to the level of oratory and declamation. Its use was appropriate given

the size of the playhouse, lack of amplification and ever-present noise. Actors would shout their lines at volume, often using a high pitch register to enhance the effect. Rhymed prose made dialogues somewhat artificial, but by accentuating the rhythmic cadences of Urdu, it created a special kind of collective enjoyment.

Here is an example from the climactic scene in Āghā Ḥashr's *Silver King*. The profligate husband, Afzal, has just returned to his wife, the good Parvin, only to anticipate his own arrest. Note three lines of rhyming prose, followed by a *she'r* or couplet in verse:

> *Afsos ke sivā aur kuchh nahīṅ, thoṛi der meṅ subah hogī.*
> Police *hathkaṛī aur* warrant *le kar mere liye ātī hogī,*
> *thoṛī der ke bād* police *merā nām le kar darvāzā khaṭkhaṭātī hogī.*
>> *Kiran sūraj kī, lekar maut kā paighām ātī hai,*
>> *Sahar ātī nahīṅ, ye zindagī kī shām ātī hai.*

<div align="right">(Kāshmīrī 2004: 2, 56)</div>

> ('Except for sorrow, nothing is left. Soon it will be morning.
> The police will come for me with handcuffs and a warrant.
> After a little while, the police will knock and call out my name.
>> Taking a ray from the sun, the messenger of death arrives.
>> This is not morning: it is the twilight of life.')

Parsi-Urdu plays incorporated the *ghazal*s of the classical *ustād*s. The dramatists freely acknowledged in their prefaces that they cribbed from earlier poets and lifted their verses. Familiar refrains and metrical templates (*zamīn*s) were adjusted to fit the new placement. Following the passage just cited, Ḥashr appended a *ghazal* based on a famous *ghazal* of Bahādur Shāh Ẓafar:

> *Jo khazāṅ huī vo bahār hūṅ, jo utar gayā vo khumār hūṅ,*
> **Jo bigaṛ gayā vo nasīb hūṅ, jo ujaṛ gayā vo siṅghār hūṅ.**
> *Maiṅ kahāṅ basūṅ maiṅ kahāṅ rahūṅ, na ye mujh se khush na vo mujh se khush,*
> *Maiṅ zamīn kī piṭh kā bojh hūṅ, maiṅ falak ke dil kā ghubār hūṅ.*

<div align="right">(Kāshmīrī 2004: 2, 57)</div>

> ('I am the aftermath of autumn's desolation, I am the gloom after intoxication.
> To what has spoiled, I am the heir. Of what is ruined, I am the relic.
> Where shall I settle, where can I stay? No one cares for me, neither this man nor that.
> I am the load that burdens earth's back; I am the dust at the heart of the sky.')

Compare the famous opening couplet and parallel verses of the original (with identical phrases marked in bold):

Na kisī kī āṅkh kā nūr hūṅ, na kisī ke dil kā qarār hūṅ;
Jo kisī ke kām na ā sake, maiṅ vo ek musht-i g̲h̲ubār hūṅ.

Merā raṅg rūp bigaṛ gayā, merā yār mujh se bichhuṛ gayā,
Jo chaman k̲h̲azāṅ se ujaṛ gayā, maiṅ usī kī fasl-e bahār hūṅ.

Na to maiṅ kisī kā habīb hūṅ, na to maiṅ kisī kā raqīb hūṅ,
Jo bigaṛ gayā vo naṣib hūṅ, jo ujaṛ gayā *vo diyār hūṅ.*

(Matthews and Shackle 1972: 135)

('I am the light of no one's eye, I am the solace of no one's heart.
A thing of use to no one, I am a mere handful of dust.

My health and form are gone to ruin; my loving friend is shorn from me.
I am the spring harvest of the garden wrecked by autumn.

I am no one's favourite, I am no one's rival.
I am the heir to what has spoiled, I am the land that lies in waste.')

The poem is especially renowned because it is associated with the British takeover of the Red Fort in Delhi in 1857 and the humiliating exile of Ẓafar, the last of the great line of Mughal emperors, to Burma. It has been sung by many vocalists, notably Mohammed Rafi in the film *Lal Quila* (1960) and Iqbal Bano (both versions are available on YouTube).

The Parsi theatre thus became a repository of the Urdu poetic tradition, of conventions of love, *'ishq* and *muḥabbat*, along with the despair and self-effacement that accompanied them. Through the Parsi theatre, *shā'irī* circulated among a broader audience in terms of both class position and geographical location. The public sphere for Urdu was thus enlarged through the institution of theatre, as was aesthetic appreciation of Urdu poetry's Islamicate cultural moorings. The extended performative reach of Urdu poetry was to have enduring effects on the development of Indian cinema, especially on the figuration of love and desire.

By the same token, the discriminating taste fostered within the ranks of esteemed poets and the cognoscenti was no longer maintained. One of the chief complaints against the Parsi-Urdu theatre was that it dissolved the boundary between high and low art. Its dramas were meant for enjoyment by the public at large, and as a result the playwrights were easy-going in their use of language.

The literati may have decried the weakening of critical judgment, but this democratizing effect arguably endowed Urdu with the flexibility and utility it needed as a language of cinema.

Āghā Ḥashr and *Yahūdī kī Laṛkī*

Āghā Ḥashr Kāshmīrī, the most prolific playwright of the Parsi-Urdu theatre, was one of the most important figures connecting the Islamicate culture of the stage to its successor form, the Bombay cinema (Figure 1.4). Ḥashr's achievement rested firmly on the foundation of popular playwriting in Urdu that had already been established. He pushed the theatrical potential of the medium even further by developing the core structures and style of melodrama in relation to different generic conventions. His contribution to the early cinema is particularly significant in view of the numerous screenplays and song lyrics he composed and his close personal relationships with leading figures of the stage and early cinema (Gupt 2005: 84–86; Rajadhyaksha and Willemen 1999: 123).

Ḥashr was born in Banaras in 1879, a descendant of shawl merchants from Kashmir. He wrote professionally for numerous Parsi theatrical companies, including the Alfred, the New Alfred and the Corinthian in Calcutta. He established and ran several companies himself, such as the Indian Shakespeare Theatrical Company, but these did not endure long. Over his lifetime, Ḥashr composed in a number of different genres: romantic, historical, social and mythological.

He began with imaginary tales, focusing on idealized beauties and their tortured admirers. These plays were highly lyrical but largely derivative and unrelated to social reality. In his next phase, Ḥashr produced a number of adaptations from Shakespeare. His strategy involved relocating a given story within a pseudo Indo-Islamic milieu, renaming the characters and adjusting the plot to bring out elements of melodrama and miraculous spectacle. These plays were set in imaginary time and space, but unlike his youthful romances, they projected individual dilemmas and solutions. Ḥashr's interaction with changes in the surrounding society developed in his middle years. Beginning with *Khūbṣūrat Balā* ('Beautiful affliction', 1909), he made dynamic use of the Shakespearean style but integrated it within the format of contemporary social drama. The melodramatic structure of his 'socials' followed the familiar formula. It provided the satisfaction of clearly delineating good and evil and heightening moments of dramatic climax through the device of the tableau, while evoking social themes and familial relationships.

Yahūdī kī Laṛkī began a larger project of critique of the colonial state, albeit set in a historical framework. The strategy of temporally displacing the narrative

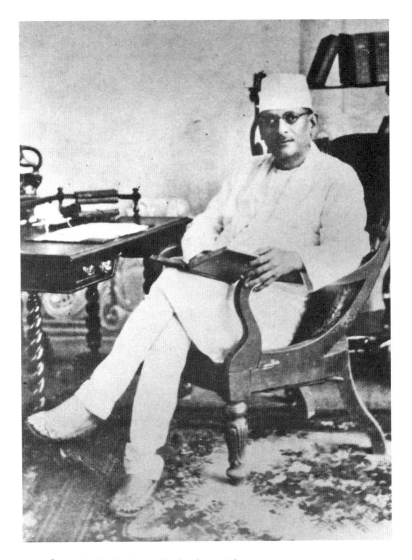

FIGURE 1.4: Āghā Ḥashr Kāshmīrī, Urdu playwright.
Courtesy: Natya Shodh Sansthan, Kolkata.

was a necessary one imposed by strict codes of censorship. In an implicit allegory with British rule, Ḥashr set up a conflict between the oppressive Romans of ancient times and the victimized Jews who were compelled under threat of death to worship idols and engage in pagan revelry. Other dramas that expressed patriotic leanings include *Hindustān Qadīm o Jadīd* ('Hindustan old and new'), *G͟harīb kī Duniyā* ('The world of the poor') and *Bhārat kī Pukār* ('India's cry').

From 1915 onwards, Ḥashr wrote a number of mythologicals, plays retelling episodes from Hindu epics and legends. Plays such as *Bilvā Maṅgal* or *Bhakt Sūrdās* ('Sūrdās'), *Sītā Banvās* ('Sita's exile') from the *Rāmāyaṇa* and *Bhīshma Pratigyā* ('Bhishma's vow') from the *Mahābhārata*, show the inclusive scope of his craft. Writing primarily for the Madan Theatres in Calcutta, Ḥashr in these plays turned increasingly to Hindi expressions over Urdu ones. Late in his career, Ḥashr similarly extended his range to the traditional narrative corpus of the Parsi community. In *Rustam o Sohrāb* ('Rustom and Sohrab'), a play that is still performed, he celebrated the primordial struggle between two warriors who were father and son.

Ḥashr also figured importantly in the construction of the early Bombay cinema, adapting his plays for the screen and writing memorable songs to accompany them. Most of Ḥashr's screenplays were based on his early set of dramas. During the silent film era, his socials and mythologicals, such as *Ankh ka Nasha* ('Eye's delight') and *Dhruva Charitra* ('The tale of Dhruva'), contributed to the development of early Indian cinema. Unfortunately, none of the films survive. With the coming of sound, Ḥashr's genius as script-cum-song writer could be most fully realized. His dialogues and lyrics for *Shirin Farhad* ('Shirin and Farhad') were famously enacted by the singing duo Kajjan and Nisar. Several of his plays came to life on screen with the famous actor Sohrab Modi in title roles.

His most influential play, *Yahūdī kī Laṛkī*, was remade several times as a film. In 1933, New Theatres released a version starring Kundan Lal Saigal as Marcus, the Roman prince, Rattan Bai as his Jewish beloved Hannah and Nawab as Prince Ezra, her father (Figure 1.5). Ḥashr wrote the screenplay, and the plot followed the drama closely. Several songs from the film including a rendition of G̲h̲ālib's well-known *ghazal*, *Nuktachīṅ hai g̲h̲am-e dil*, are available on YouTube. In the late 1950s, the film reappeared in multiple forms: as *Yahudi ki Beti* directed by Nanubhai Vakil, as *Yahudi ki Larki* directed by S. D. Narang, and most memorably as *Yahudi* directed by Bimal Roy in 1958. The latter was co-written by Ḥashr and Nabendu Ghosh, and starred Meena Kumari, Dilip Kumar and Sohrab Modi. The music was by Shanker Jaikishan, and Helen and Cuckoo danced.

A closer examination of Ḥashr's original drama alongside the 1958 film (available on DVD) reveals how conventions of melodrama reinforced by the sonorities of Urdu enabled new modes of imagining Indian history, myth and nationhood. *Yahūdī kī Laṛkī* is a cross-cultural romance between a Roman and a Jew set in pre-Christian times. When written, it was most likely intended to encode a critique of British colonial rule. Recently the play has been staged to counter Hindutva through the equation of the Jews with present-day Muslims. It has been revived for drama festivals in Delhi and Chandigarh, earning renewed acclaim as a representation

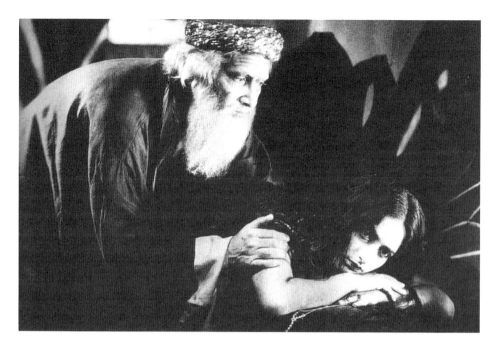

FIGURE 1.5: Nawab and Rattan Bai in *Yahudi ki Ladki* (1933). Production still.
Courtesy: B. D. Garga Collection.

of India's composite culture (Hansen 2009:162). The plot may well have been adapted from *The Jewess*, a historical drama by William Thomas Moncrieff (Singh 2000: 51). Moncrieff's play in turn was an adaptation of *La Juive*, a French opera composed by Halévy with libretto by Scribe. The opera presented a parable of religious intolerance, focusing on Rachel, the putative Jewess who fell in love with a Christian in medieval Switzerland and was eventually martyred (Valman 2007: 2).

In both *La Juive* and *Yahūdī kī Laṛkī*, events unfold in a historical epoch when the state is engaged in oppressing religious minorities. Ḥashr's play transports us to the ancient world and the dominion of the Romans, who insist on imposing their religion. Against them stands the Jewish patriarch Ezra, played by Sohrab Modi in the film. He views the Romans as oppressors and declares himself a rebel. Arguing for justice and freedom of religion, he refuses to bow down.

Sivā khudā ke kisī ke āge na dil jhukā hai na sar jhukegā.

(Kāshmīrī 2001: 22)

('Except before God, I have never bowed my heart, nor will I bow my head.')

Manshiya the hero (Marcus in the film) is a Roman who has disguised himself as a Jew in order to woo Ezra's daughter Rahil (Hannah in the film). He espouses religious tolerance, insisting that the Romans treat everyone the same:

Yahūdī ho yā īsāī, pūrab kā bāshindā ho yā eshiyāī, bad ho yā nek,
Magar khudā ke rahm-o-karam kī nazar sab par hai ek.

(Kāshmīrī 2001: 29)

('Whether the man be Jew or Christian, Easterner or West Asian, evil or good,
God casts his gaze upon each one with the same mercy and kindness.')

After Manshiya reveals his true identity and Rahil rejects him, he invokes the universal spirit within man and places love above all else.

Yahūdī hūṅ ki roman hūṅ, maiṅ nūrī hūṅ ki nārī hūṅ
Koī hūṅ kuchh bhī hūṅ, par terī sūrat kā pujārī hūṅ.

(Kāshmīrī 2001: 39)

('I may be a Jew or a Roman, born of light or from the fire,
But whatever I am, however I am, I worship your countenance.')

The Romans thus represent the politically repressive state that attempts to impose its religious orientation on all subjects. The Jews appear as a largely defenceless minority who refuse to bow to persecution. Understood as a historical drama, Ḥashr's play recalls a period in which conflict raged between these two peoples. But there is also an obvious allegory that operates together with the historical mode of telling – not displacing it but supplementing it – whereby the Romans represent the West and the Jews the East. (Somewhat oddly, in the verse the Christians are termed 'Asian', *eshiyāī*.) By extension the conflict is between the European colonial regimes and the peoples of the Orient, or more specifically the British Raj and India. This elision of identities is apparent in the 1958 film, wherein the costuming, hairstyles and dance moves of the Romans often gesture towards the European manner. The wedding ceremony in the film, which provides the setting for the climactic confrontation between Hannah and the Roman king, looks quite Christian.

To the extent that the drama proposes a resolution to communal conflict, it is through a common discourse of justice (*insāf*) that knows no distinctions of class, community or religion. The twist is that this justice is to be found in Roman law (*roman qānūn*). A major turning point occurs when Rahil/Hannah makes an impassioned complaint (*faryād*) before the Roman king to prevent Manshiya/

Marcus from marrying his intended, Desiya/Octavia. Accusing her lover of infidelity, she demands capital punishment – an extraordinary sentence for the 'crime' of jilting her. Put on the spot, the Roman king declares his commitment to justice. He announces his impartiality to the status of the petitioner, agreeing to hear out Rahil/Hannah even though she is a Jewish commoner.

In the 1958 film *Yahudi*, this scene forms the dramatic climax that showcases the histrionic talents of Meena Kumari and Sohrab Modi. Importantly, it is here that the Roman state appears in a very different light. The possibility of a moral order beyond religion and community is suggested as Meena Kumari goes beyond her father's hostility to the Romans and appeals to the king. In the course of her long, impassioned speech, spectators may be reminded of Meena Kumari's own Islamicate heritage and her career in several classic Muslim Socials. She was born Mahjabin to the Parsi theatre actor Ali Bux and his wife Prabhavati, who as a dancer had taken the name Iqbal Begam. She inherited the composite culture of the Bombay entertainment industry of the 1940s and 1950s, and she herself projected Urdu's elegant sophistication.

The great actor, Sohrab Modi, veteran of Parsi theatre, also appears at the height of his powers, declaiming in rhymed couplets in true Parsi theatre style. Accusing the king of a double standard, he ironically intones:

> *Tumhārā ghōm hai ghōm, mufālis kā sadmā ik kahānī hai.*
> *Tumhārā 'aish hai 'aish aur hamārā 'aish fānī hai.*
> *Yahāṅ bachpan buṛhāpā vahāṅ buṛhāpā bhī javānī hai.*
> *Tumhārā khūn hai khūn aur hamārā khūn pānī hai.*

<div align="right">(Kāshmīrī 2001: 66)</div>

('Your sorrow is true sorrow, the misfortune of the poor but a story.
Your enjoyment is a way of life, and ours merely transitory.
We go from childhood to old age, but for you even old age is youthful.
Your blood runs pure, and ours is but water.')

The grand theatricality of the mise-en-scène, the broad physical gestures and the frontal address of the actors before the camera emphasize the connections between the film and its dramatic roots.

In the end, Roman *qānūn* proves adequate to the demands for justice – the rhetoric of *insāf* – that rings throughout the play. The impartiality of Roman law, put to the test through the freighted act of a father sentencing a son, offers an overarching order in which religious communities may coexist. The melodrama's resolution draws religious rivals together under the banner of equality and

mutual dependence: they have, after all, fostered each other's children. The clever interweaving of family loyalties and romantic alliances with themes of political oppression and religious persecution distinguish this play as a mature example of melodrama in the Parsi theatre. Such high-pitched, overwrought narratives continue to engage theatrical and cinematic audiences today. Their emotional appeal remains a powerful tool for gathering audiences together in moments of mutual recognition and cohesion across lines of difference.

To conclude, the legacy of the Parsi theatre is evident in the Bombay cinema's preference for Urdu and its Islamicate poetic tradition. Poetic utterance in Urdu as passed down from the canon of the nineteenth century entailed an exalted tone, abundant metaphor, rhyme, rhythm and ornate speech. In the twentieth century, litterateurs and critics attempted to diverge from classical *ghazal* style in order to make Urdu literature modern. Yet, theatre audiences and their successors, the spectators in the cinema halls, relished the grandiloquent gestures of the old *ustād*s. To some extent, their preference evinced nostalgic yearning for feudal certainties and for the pleasures associated with the precolonial courts. Considering the deep sense of loss and powerlessness that colonialism induced, it is obvious why an alternative zone of cultural affirmation appealed so strongly.

Urdu expressivity might also be considered as harbouring an element of the timeless. The stylized language of Urdu poetry infused the Parsi theatre and Bombay cinema with beauty and grace. It had the power to arouse passionate and sentimental responses in those who sought entertainment on stage or screen. Audiences revelled in the sense of elevation, exaggeration and excess. In this regard, the predilection for Urdu poetry reveals an attraction to a heightened state of aesthetic enjoyment, anticipated much earlier in the theory of *rasa* presented in Sanskrit treatises. As a scheme to explain the transformative effect of dramatic poetry, the concept of *rasa* stresses the distillation of emotion into a 'juice', taste or essence. Although genealogically alien to the Urdu poetic tradition, Sanskrit aesthetics also elaborates the notion of the connoisseur, the *rasika* or *sahridaya*, 'one with heart', identifying a superior capacity to respond to intense feeling. This understanding has guided the concept of the ideal audience member in India across regions and eras. The Bombay cinema continues to work within this framework, valorizing the production of feeling within the boundaries constructed by particular forms. The patterned structures of Urdu poetry allied with its colourful emotional palate provided one of the avenues for this continuity to develop. Through Urdu, the Parsi theatre and its heir, the Bombay cinema, gained a distinctive sensibility that is still widely enjoyed and appreciated.

ACKNOWLEDGEMENTS

This chapter developed from a presentation for the workshop 'Islamicate Cultures of Bombay Cinema', organized by the New York University Institute Abu Dhabi, 20 March 2009. I owe abundant thanks to Richard Allen and Ira Bhaskar for hosting a stimulating weekend, and to Rosie Thomas, Ravi Vasudevan, Mukul Kesavan and Kaushik Bhaumik for their thought-provoking responses. For assistance with the translation from Gujarati of the newspaper items from *Rāst Goftār*, I wish to thank Sucharita Apte. All other translations are my own.

This chapter was previously published in *South Asian History and Culture* 7:3 (2016).

REFERENCES

Anon. (1879a), 'The approaching "Gaiety"', *Rāst Goftār*, 16 November, p. 771.

Anon. (1879b), 'Histrionic art among natives', *Rāst Goftār*, 20 April, p. 263.

Anon. (1888), 'The Indian Medical Women's Fund', *Times of India*, 1 March, p. 3.

Gupt, Somnath (2005), *The Parsi Theatre: Its Origins and Development* (trans. and ed. K. Hansen), Calcutta: Seagull Books.

Hansen, Kathryn (2001), 'The *Indar Sabha* phenomenon: Public theatre and consumption in Greater India (1853–1956)', in R. Dwyer and C. Pinney (eds), *Pleasure and the Nation: The History, Politics and Consumption of Public Culture in India*, Delhi: Oxford University Press, pp. 76–114.

Hansen, Kathryn (2003), 'Languages on stage: Linguistic pluralism and community formation in the nineteenth-century Parsi theatre', *Modern Asian Studies*, 37:2, pp. 381–405.

Hansen, Kathryn (2009), 'Staging composite culture: *Nautanki* and Parsi theatre in recent revivals', *South Asia Research*, 29:2, pp. 151–68.

Hansen, Kathryn (2011), *Stages of Life: Indian Theatre Autobiographies*, New Delhi: Permanent Black.

Hansen, Kathryn (2013), 'A place of public amusement: Locations, spectators, and patrons of the Parsi theatre in 19th-century Bombay', in V. Lal (ed.), *The Oxford Anthology of the Modern Indian City*, Delhi: Oxford University Press, vol. 2, pp. 359–72.

Kashmīrī, Āg̱ẖā Ḥashr (2001), *Yahūdī kī Laṛkī* (ed. Abdul Bismillāh), Delhi: Rājkamal Paperbacks.

Kashmīrī, Āg̱ẖā Ḥashr (2004), *Āg̱ẖā Ḥashr Kāshmīrī ke Chuniṅdā Ḍrāme* (ed. A. Āzmī), vol. 2, Delhi: Rāṣḥtrīya Nāṭya Vidyālaya.

Matthews, David John and Shackle, Christopher (1972), *An Anthology of Classical Urdu Love Lyrics*, London: Oxford University Press.

Meisel, Martin (1983), *Realizations: Narrative, Pictorial, and Theatrical Arts in Nineteenth-Century England*, Princeton: Princeton University Press.

Rajadhyaksha, Ashish and Willemen, Paul (1999), *Encyclopaedia of Indian Cinema*, rev. ed., New Delhi: Oxford University Press.

Singh, Anurāg (2000), 'Kahāṅ se lī ūrjā āgā hashr ne apnī nāṭya-rachnāoṅ ke liye', *Chhāyānaṭ*, 90 (April–June), pp. 50–52.

Tāj, Imtiāz 'Alī (ed.) (1969), *Ārām ke Ḍrāme, Ḥiṣṣa Avval: Urdū kā Klāsikī Adab [Ḍrāme]*, vol. 2, Lahore: Majlis-i Taraqqī-i Adab.

Tāj, Imtiāz 'Alī (ed.) (1970), *Habāb ke Ḍrāme: Urdū kā Klāsikī Adab [Ḍrāme]*, vol. 8, Lahore: Majlis-i Taraqqī-i Adab.

Tāj, Imtiāz 'Alī (ed.) (1971), *Ḥāfiẓ 'Abdullāh ke Ḍrāme: Urdū kā Klāsikī Adab [Ḍrāme]*, vol. 10, Lahore: Majlis-i Taraqqī-i Adab.

Tāj, Imtiāz 'Alī (ed.) (1972), *Karīmuddīn Murād ke Ḍrāme: Urdū kā Klāsikī Adab [Ḍrāme]*, vol. 7, Lahore: Majlis-i Taraqqī-i Adab.

Valman, Nadia (2007), *The Jewess in Nineteenth-Century British Literary Culture*, Cambridge: Cambridge University Press.

2

The Persian *Maṣnavī* Tradition and Bombay Cinema

Sunil Sharma

In the early history of Bombay cinema many continuities and connections with the world of Persian literature and Iran are discernable.[1] Classical Persian literature was read and appreciated in India to some extent until the middle of the twentieth century. Even if actual knowledge and use of the Persian language in India had been in decline since the nineteenth century, through the medium of Urdu and the influence on other languages and literatures, Persianate culture was widespread in South Asia, especially through an interest in lyrical (*ghazal*) and narrative (*maṣnavī*) poetry along with allusions to a cluster of iconic characters in these texts.[2] Many of these narrative tales entered the popular realm by way of retellings in various Indian languages, as well as through the medium of Parsi theatre and then the silver screen. What I call Bombay's Persianate films ultimately derive from the *maṣnavī* tradition in Persian and through that medium from Urdu literature in two broad literary genres, epic and romance. Mythological and historical films on Persian themes relate to the tenth- to eleventh-century epic by the poet Firdausī, the *Shāhnāma* ('Book of kings'), and include heroic tales about champions such as Rustam and Sohrāb. Films from Persian romances were based on tales of star-crossed lovers such as Vāmiq-Azrā, Shīrīn-Farhād and Lailā-Majnūn that were first versified by various classical Persian poets such as Nizāmī, Amīr Khusrau and Hātifī.[3] These films enjoyed immense popularity from the earliest days of Indian cinema until the mid 1970s, and although references to heroic or romantic characters such as Lailā-Majnūn and Shīrīn-Farhād crop up in songs and even in the plots of films, this cinematic subgenre seems to have died out. After offering a survey of the history of these films, I explore the possible sources from which their plots derived and speculate on their demise as popular entertainment.

The Persianate component of Bombay cinema overlaps with the broader category of Islamicate and Orientalist films to some degree. In terms of setting, as Rosie Thomas explains:

Key to India's 'oriental' fantasy film was its setting within an imaginary world outside India. Although sometimes coded as quasi-Arabian and/or ancient Iranian, this was in fact a hybrid never-never land.

(2013: 32)

Persianate films were inspired directly or indirectly by Persian literature and the culture of Iran from pre-Islamic times.[4] These films had a literary history of several centuries behind them in the form of original poetic texts, adaptations, abridgements and translations. Studying them in isolation may seem to be an arbitrary approach since the term is not a historical category; nonetheless it is useful because it allows us to focus on one particular aspect of Bombay films and their relationship to other genres discussed in this volume, as well as to understand the reception of classical Persian literature in the cinematic form. I would argue that for some viewers there was indeed a consciousness of the Persianate as a distinct category with links to Iran and the pre-modern Persian literary tradition. The stories of the Persianate films discussed here almost never adhere to the original classical Persian *maṣnavī*, although their textual genealogy goes back a long way even as the plots were modified, sometimes in predictable ways, into a recognizable genre of Hindustani films. Once theatre went into decline, representation on the screen was the only way that classical tales would be palatable for large audiences who were not schooled in the fine points of Persianate culture.

By the nineteenth century Persian learning among Indians, both Muslims and non-Muslims, was not what it once was in the high Mughal period, and Urdu had replaced it as the lingua franca of the region. Persian classics such as Sa'dī's *Gulistān* ('Rose garden') and the romances of Nizāmī were rendered into popular versions in Urdu, and consequently stories from the latter and from the *Shāhnāma* were also performed in Gujarati and Hindustani in the heyday of Parsi theatre. Therefore, Persianate literary culture was largely fostered in two environments, one by the Parsis, who had a strong connection to Iran because of their Zoroastrian religion, and the other among Muslims and non-Muslims who had knowledge of Urdu literature and its Persian literary background. Along with the ever popular Urdu *ghazal* whose subject is worldly and mystical love, narrative poetry also had an immense appeal for readers of books and viewers of plays and films. As Kaushik Bhaumik has discussed, the narrative poem in *maṣnavī* form, originally from the Persian literary tradition and popularized by

Urdu poets, 'fused spirituality with images of romantic heroic action in the quest for love and wealth' (2001: 131).

The first obvious link between classical Persian stories and Bombay cinema is the medium of Parsi theatre in Gujarati and Hindustani (i.e. Urdu and Hindi). That there was a direct connection between the two artistic realms is not in doubt. According to Kathryn Hansen, 'Parsi theatre is widely credited with contributing to popular Indian cinema its genres, aesthetic, and economic base' (2003: 381). In fact, the first motion picture with sound, *Alam-ara* (1931), was a screen rendering of an Urdu drama, *Khūn-e nāhaq*. Somnath Gupt's work on the origins of Parsi theatre sheds light on this topic. He says that being of Iranian extraction and largely settled in Bombay and south Gujarat,

> [i]n the early stages of the theatre, Parsis were drawn to their history and religion. Kaikhushro Kabraji recognized this craving and in consequence created the plays *Bejan and Manijeh* [Bīzhan and Manīzha], *Jamshed and Faredun*.
>
> (2005: 175)

Parsi theatre flourished from the mid-nineteenth century until the advent of cinema and even later; thus, for a variety of reasons, it was natural for those who were involved in the older drama industry to turn wholesale to the new medium of cinema. There was an economic impetus to this too:

> Parsee mercantile capital underpinned India's entertainment industry until the 1930s and substantially founded the early film distribution infrastructure [...] together with at least three major silent and sound studios: Imperial Film, Minerva Movietone and Wadia Movietone.
>
> (Rajadhyaksha and Willemen 2004: 171)

Themes from the *Shāhnāma* that were a regular part of the dramatic repertoire at this time included the romance of Bīzhan and Manīzha, stories of kings Jamshed and Faredūn (also staged as Faredūn Zohak) and plays with titles such as *Rustam ane Sohrāb*, *Rustam ane Barjor* (Barzū or Borzū), *Kaikāus ane Sudāba*, *Shahzāda Shyābakhsh* (Siyāvash) and *Behrāmgor ane Bānū Hoshang*.[5] Most of these tales, with the exception of Rustam and Sohrāb, were not rendered into film, perhaps because there was too much of an Iranian historical context to them that would not transfer to the large screen or be of interest to any but a specialized audience.

Among the non-*Shāhnāma* tales enacted on the Parsi stage were the romances of Khusrau-Shīrīn, Shīrīn-Farhād and Lailā-Majnūn. A striking scene from a Parsi stage version of the romance of Shīrīn and Khusrau described by Somnath Gupt highlights the romantic appeal of the tale:

The Persian plot and costumes were like sweet-smelling gold. Two or three things in the play enchanted the audience. While travelling through a deserted forest towards the city of Madayan, Shirin loosens her hair and submerges herself in a fountain to wash the dust from it. This scene was very captivating and worth viewing.

(2005: 107)

Unfortunately, the film versions of this story were not as daring and this scene is not to be found in them.

Besides sharing features with the Orientalist or Islamicate film, especially in the case of the romance of Lailā-Majnūn, it is also necessary to place Persianate films in the larger category of Indian romantic tales that at one time enjoyed immense popularity. From the titles of Parsi dramas and early films, it is clear that epic and romantic tales of Indic origin, rather than Iranian, were equally, if not more, popular. We find that the Hindu epics *Mahābhārata* and *Rāmāyaṇa* were a source for many a cinematic plot. Romantic tales such as the story of *Shakuntalā*, and especially Punjabi legends about star-crossed lovers such as Hīr-Rāṇjhā and Sohnī-Mahīwāl, were frequently the preferred subjects of films (Bhaumik 2001: 117). At the same time, it would be incorrect to assume that the various types of films catered to different communal groups and could be neatly divided into Hindu and Muslim. There was no such differentiation in the production of these films, and in the end they adhered to the prevailing aesthetics and catered to a pan-Indian, cross-communal audience. The situation may have been slightly more complex when a film about a historical or religious theme was made by someone from a community connected to it, as Hansen explains in the context of Parsi theatre: 'The religious and ethnic boundaries defining the Parsi community were in this way reinscribed with this theatrical reinvention of the past' (2003: 391). Thus, the makers of Persianate films would have banked on audiences from Parsi or Muslim backgrounds, but they were made in such a way as to appeal to everyone. Not surprisingly, non-Persianate epic and historical romance films also lost their appeal after the 1970s, and the broader implications of the shift away from these genres will be taken up in the conclusion of this chapter.

Appendix 1 provides a list of films that fall within the purview of this chapter. This list has been compiled by going through various websites and reference works and, except for those that date from the 1930s, many of them are available online today (Rajadhyaksha and Willemen 2004).[6] Not meant to be a comprehensive catalogue by any means, it is a starting point to show the range of Persian themes and characters that were once, and some still are, popular in Indian cinematic culture. Although it is impossible to judge the extent of the use of scripts of Parsi plays in the early Persianate films because of their unavailability, at least the films from the 1950s seemed to have been independent of Parsi theatre. Thus,

although thematically Persianate films were a continuation of an older dramatic tradition, in terms of the texts of the scripts they may be unrelated. The situation, however, may have been different with the very first films since several prominent figures in Bombay cinema took an interest in actively promoting Persianate films in the 1920s and the 1930s. For instance, the studio Arya Subodh Natya Mandali was established in Poona, and among its managers was the Parsi Rustam Modi, the elder brother of the renowned director and producer Sohrab Modi. Sohrab Modi himself began as a Shakespeare actor on the stage and then founded the Minerva Movietone under which as a director he 'launched the "romanticised quasi-historical melodramatized" genre, with big budgets and spectacular effects' (Thoraval 2000: 95). Another example is Homi Master (d. 1949) who began in the Parsi theatre company Baliwala and went on to make films in Gujarati, some in the oriental genre (Rajadhyaksha and Willemen 2004: 145).

Most certainly the tragic tale of Lailā and Majnūn was the most popular of the Persian romances, there being at least nine productions of it in Bombay cinema: 1922, 1927, 1931, 1935, 1945, 1953, 1954, 1974 and 1976.[7] With its origins and setting in pre-Islamic Arab Bedouin society, the tale is one that straddles both the Arabian and Persian worlds since it was first versified and transformed into a Persian romantic *maṣnavī* by the twelfth-century poet Nizāmī. In the next century the Indo-Persian poet Amīr Khusrau composed his own version of the story and made certain modifications to the plot in order, perhaps, to suit his own cultural environment and the tastes of his Indian readers. After Amīr Khusrau, over the centuries, numerous Persian, Turkish, Hindi and Urdu poets rewrote this story in the form of verse romances.[8] The simple story begins with two Bedouin children who fall in love as schoolchildren but are separated by their parents because Qais (the given name of Majnūn) is unable to control his passion for his beloved, besmirching Lailā's reputation in the process. As Majnūn grows up, his obsession with Lailā drives him to shun society and wander the Arabian desert as a madman, hence his new name. In Nizāmī's original tale, Lailā pines away secretly for her lover even as she is married off to another man and dies a virgin, followed shortly by her lover giving up his soul over her grave. The three available films based on this romance retain only the bare plot and are all free renderings of the original storyline in which Arabian costumes and settings combine with Persianate *ghazal*s to provide an exotic Middle Eastern ambience.[9]

The earliest one that I have seen, the 1953 film starring Shammi Kapoor and Nutan, with Begum Para playing Lailā's strong-willed mother, is actually not well known anymore but is closest to the spirit of Nizāmī and with the least implausible interventions in the plot. In contrast, the 1974 version, *Dastan-e Laila Majnu*, directed and produced by R. L. Desai, was a low-budget obscure production that followed the plot of the 1953 version with some modifications. Despite the Arabian

extravaganza it also manages to stay on course and maintain the subtlety of the earlier film, which the next version, although the most popular one, did not. The 1976 *Laila Majnu* starring Rishi Kapoor, the nephew of Shammi Kapoor, and Ranjeeta was a blockbuster hit. According to Rokus de Groot who has analysed the film in detail, it is 'a confluence of widely different currents – Muslim, Sufi, Hindu, Christian, Pre-islamic Udhri, as well as Indian film conventions, and European literary traditions' (2006: 132). The most poignant scenes in all the films, and this is where some of the essence of the original tale is preserved, involve the crazed Majnūn traversing the sand dunes in his tattered cloak. The scene where the madman is stoned by the townspeople has also become emblematic. The 1976 film plot has strange complications that reflect that decade's cinematic obsession with villains, smugglers and evil social elements. All three films have the requisite *qawwālī*s that must appear in films on Muslim themes, rendering an Arab Bedouin story into a typical Indian Muslim feature, blending Persianate elements in terms of language and lyrics with Arabian settings and costumes. Lailā always appears as a *virahiṇī*, the heroine pining for her absent lover who is a stock figure in traditional Indian literary traditions, her characterization lacking the complexity and strength endowed on her centuries ago by Nizāmī. The Persian Lailā throughout remains the model of modesty and chastity until the end, not dreaming to venture out of the harem to defend her lover from a public stoning, as the filmic heroine does.

The tale of Lailā and Majnūn transcended cultural boundaries and attained popularity in various literary and entertainment forms, especially in Muslim societies, and because of this universal appeal and its Arabic origins, unlike the other stories discussed later, its connection to the Persian original is tenuous. Although the last film version of this tale was made over three decades ago, its star-crossed lovers have remained in the memory of audiences all over South Asia. A spectacular and not quite successful example of this, in my view, was the film *Aja Nachle* ('Come, let's dance', 2007) whose plot revolves around the stage production of the Lailā-Majnūn romance in a provincial town. The second half of the film is entirely taken up by the enactment of the story, and there is a feeling of watching a film within a film. Directed by Anil Mehta and produced and written by Aditya Chopra, this film was meant to mark the return of Madhuri Dixit, the star of the 1990s, who had gone into retirement after her marriage. In all likelihood the 1976 hit film seems to have been the source for the plot of the dance-drama performance in the 2007 film. The film marked the return of both the actress and the story of Lailā and Majnūn to the screen in a most dramatic rendering. With the audience in the film watching the performance, another layer of separation is added between us and the original story, thus making it even more remotely part of the past. Yet, there is a degree of intertextuality and continuity that is often seen in Bombay films, as in the song from the 2007 film *Koi patthar*

se nā māre mere divāne ko ('Let no one throw a stone at my madman') that was taken from the 1976 film, which in turn is a phrase from the 1953 film uttered by Lailā in an attempt to save her lover from public censure. In fact, the genealogy of the phrase may extend back to older films or textual versions of the romance, but I have not been able to trace it. In 2018, a new film named *Laila Majnu* was made under the direction of Sajid Ali, with the story set in the present-day Kashmir valley, which is the site of political strife and violence. Using a modern setting for an old story is a technique that has been employed successfully in other Indian films, chiefly the plays of Shakespeare and the novel *Devdās* by Saratchandra Chatopadhyay, but despite its Persianate elements the story's connection to its literary antecedents is tenuous.

Another story to enjoy a similar popularity, mostly during the decades before independence, is that of Shīrīn and Farhād (in the Parsi dramas, the title Shīrīn and Khusrau is often found), with films from 1926, 1929, 1931, 1945 and 1956.[10] The 1931 version was actually 'a bigger hit than *Alam Ara*', India's first film with sound that was released earlier in the same year (Rajadhyaksha and Willemen 2004: 254). As is the case with the Lailā-Majnūn tale, Nizāmī was the first poet to compose a romantic *maṣnavī* in Persian on this topic, followed by Amīr Khusrau a century later. The original story is based on an incident in Firdausī's *Shāhnāma* about the love of the seventh-century Iranian king Khusrau Parvez II for a slave girl Shīrīn, but Nizāmī transformed the tale and represents the heroine as a positive character who is the princess, then queen, of Armenia. In his poem it was the figure of the sculptor Farhād, absent in Firdausī's epic, which captured the hearts of readers and later audiences. A further transformation of the tale took place when the Indian poet Amīr Khusrau portrayed Farhād in a sympathetic light, fusing his character with that of Majnūn and fashioning the perfect lover in Indian literature. Over time, Farhād and Majnūn were invoked as idealized lovers, and the distinction between their separate stories was lost. The Majnūn-Farhād suffering figure came to be hugely emblematic in numerous *ghazal*s in Persian and Urdu, and the 1956 film version, called *Shirin Farhad*, follows this representation as well. The scene where Farhād is stoned by the townsmen for his crazed behaviour is reminiscent of the same scene with Majnūn. Similarly, in the film version Shīrīn and Farhād meet and fall in love as children, just as Lailā and Majnūn did. Nizāmī's original tale described the development of King Khusrau into an able ruler through the lessons he learns in love, and the title of his work was *Khusrau and Shīrīn* after all, with Khusrau being the protagonist of the story. Although later versions of the story focused on Farhād, in this film Khusrau is an unattractive and evil character who becomes obsessed with Shīrīn and hatches a sinister plot to get rid of his rival Farhād.

As in the case of the Lailā-Majnūn films, there are twists and turns in the plot and additional characters appear who are not present in the Persian texts, such as

the slave girl, Shama, who loves King <u>Kh</u>usrau and is used by him to bring about the death of Farhād. <u>Kh</u>usrau's friend Shāpur who first tells him about the beautiful princess of Armenia is transformed into a court buffoon, and Shīrīn is the princess of Istanbul. The end of the story is also dramatically different where Shīrīn and Farhād are joined together in the grave, much to the consternation of the king. An interesting addition to the dramatic end, also in the 1970 Iranian version of the film mentioned later, is the presence of an old hag (who is Shama) who deceives Farhād into believing that Shīrīn is dead before he kills himself. Fate in classical Persian literature was personified as an old woman, and this folk feature seems to have been transferred to the screen although it is missing in the verse romances. Overall, the film does not have much of a Persian feel as did those made by Sohrab Modi, the only successful attempts being the décor of <u>Kh</u>usrau's palace and references to the Iranian new year (*nauroz*), but the requisite *qawwālī* and oriental elements make it an Islamicate film without reference to an 'authentic' cultural context of the story.

By the time *Shirin Farhad* was made, Pradeep Kumar and Madhubala were famous stars, with the former having established himself as an actor in historical films such as *Anarkali* (1953) and *Adl-e-Jahangir* (1955) among others. Pradeep Kumar went on to appear in numerous films on Mughal themes that overshadowed the memory of his Farhād role, while Madhubala is also best remembered for her role in the Mughal romance *Mughal-e-Azam* (1960). The story of Lailā and Majnūn seems to have survived, as in the film *Aja Nachle*, because of the universal appeal it enjoyed even before the advent of cinema, but the characters Shīrīn, Farhād and <u>Kh</u>usrau, whose background is grounded in ancient Iranian history, have gradually receded to the obscure pages of the forgotten past. This is even more the case with another romance from the Persian tradition, that of Vāmiq and Azrā.

The romance of Vāmiq and Azrā is not a story that was as popular as the previous two, and few in South Asia would even recognize these names today. This tale of star-crossed lovers goes back to the ancient Greek romance of Metiochus and Parthenope. It made its way into Persian and was versified in the eleventh century by the poet Unsurī at the court of the legendary Sultan Maḥmūd, just around the same time as the composition of the *Shāhnāma*. In South Asia the tale was better known before 1947, again due to the enduring legacy of Persianate culture, and two films were made on this story in 1935 and 1946.[11] I have not been able to locate copies of either of these films and therefore am unable to say how faithful these versions were to the original story. As in the other instances it is certain that the plots must have been modified to suit a twentieth-century Indian cinema audience. The 1946 film was directed, produced by and starred Nazir along with his wife Swarnalata, who after 1947 appeared together in many films produced in Lahore. The songs from the second Indian film version are still available and presumably survived independently of the films.

A group of films that were made in the early decades of Bombay cinema indirectly took their inspiration from Firdausī's *Shāhnāma*, such as *Shah-e-Iran*, *Shah Behram*, *Sikandar* and *Nausherwan-e-Adil*, all about renowned kings of Iran. Although I have not been able to find anything about the first two, the latter two deserve some discussion because of the involvement of the legendary Parsi director Sohrab Modi in their making. It has been mentioned that Sohrab Modi came from a family that was involved in Parsi theatre; he was himself an actor, and given that he was a Zoroastrian, he would have been interested in pre-Islamic Persian history as well. He founded Minerva Movietone in 1936 and went on to make a series of films on historical topics, one of the most famous being on a Mughal historical theme, *Pukar* (1939). His next film, *Sikandar* (1941), a remake of a silent film released in 1923, dealt with the Indian conquest of Alexander the Great. Although there is a long tradition of the Alexander romance in classical Persian literature, this dramatic film is a fictionalized account of the encounter between Alexander, memorably played by Prithviraj Kapoor, and the Indian king Porus, played by Sohrab Modi himself, with the peace-making Iranian consort of Alexander, Rukhsana, played by Vanmala, who makes Porus her *rākhī* brother. The *Shāhnāma* included many descriptions of the various adventures of Alexander, including some episodes about his time in India, but the story as told in the film is not found there. Phiroze Vasunia explains that this film was 'the product of several overlapping histories, quite apart from any cinematic and theatrical traditions from which it was borrowing' (2010: 324). This powerful film with its theme of foreign occupation and war enjoyed great success during the war years and the movement leading to India's independence. *Sikandar* was also dubbed into Persian, perhaps in an effort to popularize it beyond India (Rajadhyaksha and Willemen 2004: 292). There was a remake of this film by Kedar Kapoor in 1965 as *Sikandar-e-Azam*, but it was not as monumental or memorable, with the older Prithviraj Kapoor playing the role of Porus and Dara Singh, who was enjoying popularity in a series of Rustam films, as Alexander.

Similarly, the story of the ancient Persian king Nūshīrvān the Just, who was known for his justice, filmed as *Nausherwan-e-Adil* (1957), vaguely derives from the *Shāhnāma* as well. Sohrab Modi himself plays the eponymous just king, and Naseem Bano his Christian wife, while Raj Kumar is his son Nūshzād who secretly follows his mother's religion and falls in love with a girl, Marziā (Mala Sinha), who is also Christian. Here too, '[t]he plot rehearses many of Modi's favourite motifs (cf. *Pukar*, 1939) as the patriarch victimised by his own law' (Rajadhyaksha and Willemen 2004: 351). Just as in *Pukar*, the idea of justice and the making of a just ruler, the underlying themes of the entire *Shāhnāma*, are predominant themes in this film too. All films by Sohrab Modi continue to display his theatrical background in the formalist staging of scenes and dialogues in high Urdu. But he

comes closest to all the directors in conveying the grandeur of ancient Iran with the iconography, historical references and even use of Persian phrases throughout his films. On the one hand, his films reach out to the Parsi community who would have had an interest in all things Iranian and Zoroastrian, while their larger themes rendered them of pan-Indian interest.

The stories of ancient Iranian kings may have held the interest of an earlier generation of urban audiences, but it was the folk hero Rustam who would appeal to a larger public and become an iconic figure in the later decades of cinema. *Rustam Sohrab* (1963) was a black and white film directed by Vishram Bedekar, written by the acclaimed author Pandit Sudarshan,[12] starring Prithviraj Kapoor, Prem Nath, Suraiya and Mumtaz, all big stars at one time or another in their careers. Bedekar was a Marathi writer and directed a few Hindi films. Prithviraj Kapoor was already a veteran actor when this film was made, and given his roles in pseudo-historic films such as *Sikandar* and *Mughal-e-Azam*, he was the perfect choice for the role of Rustam. His son Sohrāb was played by Prem Nath. Suraiya, playing the role of the sexually independent Tahmina, had also performed historic roles in the films *Taj Mahal* (1941) and *Mirza Ghalib* (1954), as well as in *Umar Khayyam* (1946). This was to be Suraiya's last film, a fitting swan song for a brilliant actress.

As we have seen with other films that are loosely based on Persian stories, the story in this film also underwent numerous modifications and a process of Indianization. The basic plot of Firdausī's story is that Rustam, the champion of ancient Iran and protector of its kings, fathers a son by the princess Tahmina of Samangan and after a single night leaves her. Sohrāb grows up without knowing the identity of his father, and when he finally finds out his father's name he goes off in search of him. As fate would have it, Sohrāb joins the forces of Iran's enemy with the idea that this would surely bring him into contact with Rustam. Father and son meet on the battleground as champions, one a veteran hero of many battles, the other an inexperienced but maverick champion. In the ensuing encounter Rustam kills his son, only to realize too late, to his horror, what he has done.

Rustam Sohrab is a magnificent period piece, although the ancient Persian characters appear more Roman in their martial gear and, at times, Rustam's costumes are reminiscent of Beowulf or Othello. Although the core of the original story is intact, this is no longer Firdausī's tale. The meeting of Rustam and Tahmina is a formulaic Bombay film scene, with a romantic twist added to their prolonged encounter that is absent in Firdausī's work. Instead of spending one night with her, the two get married and enjoy a blissful domestic life of singing and love-making until the real world of politics and battles claims Rustam's attention. When Rustam is summoned to rescue the king of Iran from the ruler of Mazandaran, a northern province now part of Iran, who has imprisoned him, the strong female character

Tahmina of Firdausī who seduces the great hero and freely lets him go is transformed into a *virahiṇī* who henceforth pines quietly for her faraway husband. Sohrāb is more mature in years than one would expect, and his involvement with Shāhrū (played by Mumtaz), a young woman he meets in the countryside, seems gratuitous but perhaps requisite for a formulaic romantic film where every hero must have a love interest.[13] Despite bits of comic relief at the beginning, the film maintains a grand epic tone with fine acting by Prithviraj Kapoor and impressive combat scenes. In order to make a successfully commercial film it would have been impossible for the script to remain faithful to Firdausī's epic narrative that is psychologically subtle in its simplicity but not complex enough in terms of plot. Thus, subplots from other parts of the *Shāhnāma* are brought in to enhance the plot, such as the episode with the king of Iran being taken prisoner in Mazandaran, Rustam's violent encounter with the White Demon (*safed dev*) and Arzhang *dev*, with a *kālābhūt* (black ghost) thrown in for good measure. Afrāsiyāb, the king of Turan, and sworn enemy of Iran, has a larger role in the film than he should have, and he makes a nasty villain.

Despite the free interpretation of the Rustam story and introduction of new elements, the film successfully conveys a sense of the world of the *Shāhnāma*. The music and use of songs are very effective, strikingly different from other films in order to convey an exotic Persian tone, and fortunately free of elements such as a distinct type of music and setting usually reserved for anything Middle Eastern or even Muslim in some Indian films. The song sung by Tahmina on the harp, with the playback also by Suraiya who plays the princess, *Ye kaisī 'ajab dāstān ho gai hai* ('What a wondrous tale this has become'), has a charming melody and remained popular for a long time. Perhaps it should not surprise us that no attempt was made to make another version of this story into a film. Befitting the epic tone of the film, the dialogues and song lyrics are in chaste Urdu, one of the languages of the Parsi stage and also for Muslim Historical films in general. The use of phrases such as *inshallāh* and *khudā hāfiz* is somewhat culturally anachronistic since the story is set in pre-Islamic Iran, but few people other than academics would have been bothered by this. Kathryn Hansen explains the historical development of this phenomenon:

> The commercial expansion of the theatre certainly favoured the use of a lingua franca, and Urdu as the cosmopolitan version of Hindustani provided the most obvious choice in mid-nineteenth century. But more importantly, Urdu and the larger Indo-Muslim cultural heritage in which it was embedded were capable of bestowing on the Parsi theatre rich legacies of poetry, music, and narrative.
>
> (2003: 402)

It has been a convention from the earliest days that just as films about the non-Muslim Indian past use Sanskritic Hindi, anything about the Persians and Arabs must be in Urdu.

The popularity of the story of Rustam inspired a series of B-grade films that are related to the original story only tangentially. Most of these films star the Punjabi wrestler Dara Singh who actually held the title 'Rustam-e-Hind' ('Rustam of India'). All these films seem to relocate the Persian hero to a new locale: *Rustom-e-Baghdad* (1963), *Rustom-e-Rome* (1964), *Rustom-e-Hind* (1965), *Rustam Kaun?* (1966), which starred Dara Singh's brother Randhawa, and his own production *Rustom: The Champion* (1982), are all stories about wrestlers with absolutely no overt reference to the original Rustam.[14] The plot of *Rustom-e-Hind* involves a young champion whose mission to locate his father, as with the original Rustam – his mother dies without revealing the identity of his father – results in a series of adventures involving a young princess of a small kingdom. What these films did was to preserve the memory of the hero Rustam as a stock character, while the particulars of the Persian tale lost its appeal for audiences.

We would have expected that many more films and remakes would have been undertaken in Persian-speaking countries, but this is not the case. Going by sheer numbers, there are more Indian films on Persianate topics.[15] Since the earliest Iranian films were actually made in India, Appendix 2 includes a corresponding list of films from Iran. A pioneering name in the history of Iranian cinema is Abdol-Hossein Sepanta (1907–1969), who made the first talkie, *Dukhtar-e-Lor* (*The Lor Girl*, 1932), in seven months in Bombay. Sepanta was encouraged by the success of this film to produce other films in India under the banner of the Imperial Film Company of Bombay, such as *Firdausi* (1935), based on the life of the epic poet who composed the *Shāhnāma* discussed earlier, and the romance *Shirin va Farhad* (1935). Another early historical film was *Chashmha-ye-Siyah* (*Black Eyes*, 1935), the story of Nadir Shah's 1739 invasion of India and its consequences on the relationship of two lovers, and finally the romance *Laili and Majnun* (1936). After making these films Sepanta went back to Iran where he remained inactive due to the political situation there, and after a decade-long hiatus the Iranian film industry began again in 1947 in earnest. As in the list of Indian films, this one does not claim to be comprehensive and is based on research on various websites. Interestingly, in the post-1947 period in Iran two versions of Lailī-Majnūn (Lailā is Lailī in Iran) and Yūsuf-Zulaikhā and one of Shīrīn-Farhād and Rustam-Sohrāb were produced. To the best of my knowledge, there has been no Indian version of the Koranic story of Yūsuf (Joseph) and Zulaikhā, although it existed in a popular Persian *maṣnavī* composed by the fifteenth-century poet Jami. This may be due to the religious and Sufi overtones of the story along with the prophet status of

Yūsuf, details that may not have signified in the same way in predominantly Shia Iranian society.

Why did the films on Persianate themes die out in the 1970s? In discussing Kimyagarov's Tajik films on *Shāhnāma* themes, Darius Kadivar (2008) states that

> in most epics however history is just a pretext to create a canvas for a more intimate story that reflects the movie director's own thematic concerns or visual obsessions. What clearly defines Kimyagarov's filmography is the awakening of the Tajik's national self-consciousness and the '*Epic genre*' was certainly what allowed him best to translate his cinematic vision and sensitivities.

According to him, by the 1970s, the genre of epic films was 'an obsolete form of cinema entertainment both in Europe and Hollywood'. The link between nation and cinema has been explored in various writings, albeit more in the context of mainstream Hindi films, and is somewhat relevant to the topic under discussion here, although it does not fully answer the question I have posed. In the Indian case at least, with the virtual disappearance from public memory of the legacy of its Persianate connections, stories such as those of Shīrīn-Farhād, Vāmiq-Azrā and Rustam-Sohrāb that are set in pre-Islamic Iran do not resonate with the larger public anymore. As we have seen, the tale of Lailā-Majnūn is alive despite many modifications to the original story, partly because of all the Persianate stories it has a more universal appeal and has often been read as a Sufi allegory. Over the centuries the story has had a huge transnational impact through the many retellings in Persian and Persianate societies in numerous languages. In the realm of cinema too, it would seem that generally the broader Islamicate film category has subsumed the Persianate, although there are Persianate elements that exist mainly in the form of allusions and references in *ghazal*s. Historical epic and romantic films have appeared in recent times too, but they have a specific national agenda, such as *Jodhaa Akbar* (2008), directed by Ashutosh Gowariker, which took the Mughal historical film genre and offered a different perspective by foregrounding the Mughal ruler Akbar's Rajput queen. In this category fall other recent films such as *Bajirao Mastani* (2015) and *Padmaavat* (2018). On the other hand, the medium of television has been a boon for historical and oriental tales since serials are not constrained by a time limit and can stretch the drama and pathos of epics and romances over a longer period of time. Thus, *Ramayana* (1987–88) and the orientalist *Alif Laila* (1993–96), made by Ramanand Sagar, and *Mahabharata* (1988–90), produced by B. R. Chopra, were lengthy and overwhelmingly popular productions, and even Kālidāsa's Sanskrit play *Shakuntalā* was televised by Sagar

Pictures (2009), but nothing from the Persianate repertoire has made it to the television screen.

How do we compare Persianate films that were produced in India to those from Iran? In India such films were not all made by members of the Parsi or Muslim communities but represent a deliberate popularization of them on a larger multicultural national canvas. In the Iranian case, there have been fewer film or television versions of the stories discussed in this chapter, and when they are made, they have a more overtly political or nationalist message. When the renowned Iranian director Bahram Bayzai wrote a play that was later made into an art film on the death of the last pre-Islamic king Yazdegird, again based on a section of Firdausī's *Shāhnāma*, there was a political message embedded there. The reality is that Iran has not lost interest in its pre-Islamic past, and knowledge and pride in the *Shāhnāma* is very much alive there. Most students in school and college read selections from the extensive works of Firdausī and Niẓāmī, but this does not translate into frequent adaptations for the screen. In South Asia, the kind of pleasure audiences derived from watching film versions of these stories was only possible up to a certain generation when people from different religious and linguistic backgrounds felt connected to the Persianate past, and this was more so in pre-independence India. As has been suggested earlier, the ability to discern Persian from Arabic, non-Muslim Iranian from Muslim, was never a concern with these films or audiences. However, this is not to say that the Persianate element has disappeared from Indian films. Although there are no longer any productions of Persian literary romances in Bombay cinema, we have seen that creative efforts are made to find new ways to make these stories available to an even more general audience. In Bombay cinema today, the innovative retellings of the Lailā-Majnūn story and the allusions to Persian lovers such as Lailā-Majnūn and Shīrīn-Farhād in songs have fused with localized folktales such as Hīr-Rānjhā and Sohnī-Mahīwāl and are a testimony to the persistence of the Persianate. But the heyday of films on Persianate themes in India went out along with more general mythological and historical films. Rather than focusing on the 'original' versions of the plots of the films discussed in the chapter, as I was initially tempted to do because of the disappointing changes introduced in them, it would be well to keep in mind that Firdausī, Niẓāmī and Amīr Khusrau, the three authors behind most of these stories, had themselves freely modified and transformed older stories for their own purposes. Stories, thus, live on in many forms, and it is more interesting to study the transformations, rather than bemoan the loss of authenticity over the centuries and across different forms of representation.

Appendix 1: Indian films

1922 *Laila Majnu*
Director: J. J. Madan
Cast: H. B. Waring, Jeanetta Sherwing, Patience Cooper, Ms Dot Foy

1926 *Shirin Farhad*
Director: Homi Master; Production: Kohinoor
Cast: Gohar, Khalil, Daji

1927 *Laila Majnu*
Director: Manilal Joshi; Production: Excelsior
Cast: Zubeida, Shahzadi, Vakil

1929 *Shirin Khusrau*
Director: R. S. Choudhry; Production: Imperial for Seth Vazir Haji
Cast: Gauhar, Vakil, Mehboob

1931 *Laila Majnu*
Director: K. Rathod; Production: Krishnatone
Cast: Rampyari, Gaznavi, Haider Shah

1931 *Shirin Farhad*
Director: J. J. Madan; Production: Madan Theatres (Calcutta); Lyrics: Āghā
Ḥashr Kāshmīrī
Cast: Master Nissar, Jahanara Kajjan, Mohammed Hussain

1934 *Shah-e-Iran* (*Shapur the Great/Sher-e Shahpur*)
Production: Central Movietone

1935 *Majnu*
Director: Roop K. Shorey; Music director: Ghulam Haider; Pro-
ducer: Kamla M.
Cast: Mukhtar, Shyama, Mattu, Sultan Beg, Hukum Singh, Majnu, Kamla

1935 *Shah Behram*
Director: Jagatrai Pesumal Advani
Cast: Nisar, Sardar Akhtar

1935 *Wamaq* [*Vāmiq*] *Azra* (*Sachchi muhabbat*)
Director: Tarit Bose; Production: Radha Film
Cast: Trilok Kapur, Indiradevi, A. Kabuli

1941 *Sikandar*
Director: Sohrab Modi; Production: Minerva Movietone; Music: Mir
Saheb, Rafiq Ghaznavi; Script/lyrics: Sudarshan
Cast: Sohrab Modi, Prithviraj Kapoor, Vanamala

1945 *Laila Majnu*
Direction: Nayyar and Nazir; Production: Hind Pictures; Music: Rafiq Ghaznavi and Gobindram
Cast: Swarnalata, Nazir, Esmail

1945 *Shirin Farhad*
Director: Prahlad Dutta; Production: Pancholi Pictures; Music: Amarnath and Rashid Atra
Cast: Ragini, Jayant, Mohammed

1946 *Wamiq Azra*
Director, producer: Nazir
Cast: Nazir, Swarnalata

1953 *Laila Majnu*
Director: K. Amarnath; Producer: All India Picture; Story: Munshi Dil; Lyrics: Shakeel Badayuni; Music: Ghulam Mohammed and Sardar Mullick
Cast: Shammi Kapoor, Nutan, Begum Para, Ratan Kumar, Ulhas

1954 *Laila*
Director: Naseem Siddiqui; Production: Shah Pictures; Music: A. R. Qureshi
Cast: Daljeet, Shakila, Hiralal, Noorjahan, Kammo, Durga Khote, W. M. Khan

1955 *Shah Behram*
Director: N. Vakil; Producer: Baharistan Prod.; Music: Hansraj Behl
Cast: Mahipal, Asha Mathur

1956 *Shirin Farhad*
Director and producer: Aspi Irani; Production: Basant Studios; Story, scenario and dialogue: Hakim Riaz Latta; Songs: Tanvir Naqvi; Music: S. Mohinder
Cast: Pradeep, Madhubala

1957 *Nausherwan-e-Adil*
Director: Sohrab Modi; Production: Minerva Movietone; Story, screenplay and dialogue: Shams Lucknowi; Music: C. Ramchandra
Cast: Sohrab Modi, Naseem Banu, Mala Sinha, Raaj Kumar

1963 *Rustom Sohrab*
Director: Visham Bedekar; Production: Ramsay; Story: Kumar Ramsay; Co-dial/lyrics: Qamar Jalalabadi; Co-lyrics: Jan Nissar Akhtar; Cinematography: Nariman Irani; Music: Sayed Hussain
Cast: Prithviraj Kapoor, Suraiya, Premnath, Mumtaz

1965 *Sikandar-e-Azam*
Director: Kedar Kapoor; Written by: Qamar Jalalabadi
Cast: Prithviraj Kapoor, Dara Singh, Mumtaz

1974　*Dastan-e-Laila Majnu*
Director: R. L. Desai; Production: R. L. Desai; Story embellished by: Fauq Jami; Music: Iqbal Qureshi
Cast: Kanwaljeet, Anamika, K. N. Singh

1976　*Laila Majnu*
Screenplay and direction: H. S. Rawail; Production: Seeroo Daryani and Ram B. C.; Dialogues: Abrar Alvi; Music: Madan Mohan, Jaidev
Cast: Rishi Kapoor, Ranjeeta, Danny

Appendix 2: Iranian films

1934　*Firdausi*
Director and producer: A. H. Sepanta; Studio: Imperial Film Studio (Bombay)

1934　*Shirin va Farhad*
Director and producer: A. H. Sepanta; Studio: Imperial Film Studio (Bombay)

1936　*Laili va Majnun*
Director: A. H. Sepanta; Producer: B. L. Khemka; Studio: East India Film Co. (Calcutta)

1956　*Laili va Majnun*
Director and producer: Ali Mohamad Nurbakhsh; Studio: Zohreh Film

1956　*Yusuf va Zulaikha*
Director and producer: Syamak Yasami; Studio: Pars Film Studio

1957　*Rustam va Suhrab*
Director and producer: Shahrokh Rafiee; Studio: Diana Film

1968　*Yusuf va Zulaikha*
Director: Raiees Firuz; Studio: Rudaki Film

1970　*Laila va Majnun*
Director and producer: Syamak Yasami; Studio: Purya Film

1970　*Shirin va Farhad*
Director and producer: Esmail Kushan; Studio: Pars Film Studio

NOTES

1.　I would like to thank the editors, Ira and Richard, as well as the anonymous reviewer, for their valuable comments, which helped in giving final shape to this chapter.

2.　The term 'Persianate' was coined by the late scholar Marshall Hodgson. It is used so widely in academic circles that a brief definition here should suffice. Persianate denotes the influence

THE PERSIAN *MAṢNAVĪ* TRADITION

and use of Persian literary and artistic forms and practices in new non-Persian contexts, such as Ottoman Turkish and classical Urdu literatures or Mughal painting.

3. Firdausī (d. 1020), Nizāmī (d. *c.*1209), Amīr <u>Kh</u>usrau (d. 1325) and Hātifī (d. 1521) were all canonical classical Persian poets who composed epic and romantic narratives in the *maṣnavī* form. They have had a huge influence on Persianate traditions, inspiring spinoffs and imitations of their works in different languages.

4. I use the term 'Islamicate film' as defined by Bhaskar and Allen (2009: ix). The Islamicate category encompasses a larger subgenre of films, such as Muslim Historical, Muslim Courtesan and the Muslim Social, and also includes the category of Orientalist films as discussed by them (2009: 4–5). The Arabian Nights genre is a related one (Irwin 2004).

5. The printed copies of 80 plays are to be found in the British Library (Hansen 2003: 385, 403).

6. Also see http://www.ultraindia.com/movies/filmogaphy/filmography.php. Accessed 4 May 2021.

7. I do not include K. Asif's *Love and God* that was released in an incomplete form in 1986, fifteen years after the death of the director. In all, there are around sixteen versions of this film in various Indian languages, including Pashto, Punjabi, Telugu, Tamil, Malayalam and Hindi-Urdu (de Groot 2006: 130–31). Incidentally, the first Malaysian film made in 1933 by B. S. Rajhans of the Motilal Chemical Company of Bombay (Singapore) was *Leilā Majnūn* (van der Heide 2002: 126). Two Pakistani versions were made in 1957: *Ishq-e-Lailā* (http://pakmag.net/film/db/details.php?pid=112. Accessed 4 May 2021) and *Lailā-Majnū* (http://pakmag.net/film/db/details.php?pid=113. Accessed 4 May 2021).

8. Michal Hasson's (2018) recent dissertation cited in the reference list is a detailed study of the reception and transformation of this story in pre-modern Indian literary traditions.

9. I have checked the 1887 work, Mirzā Hādī Rusvā's *Muraqqa Lailā Majnūn*, to see if it had been an inspiration for any of the later films, but the author's verse narrative seems closer to Nizāmī's original version and has no bearing on the films.

10. *Shirin Farhad* was also a Pakistani film made in 1975: http://pakmag.net/film/db/details.php?pid=1475. Accessed 4 May 2021. The 2012 Bombay film *Shirin Farhad ki to Nikal Padi*, directed by Bela Bansali Sehgal, a comedy about a Parsi couple in love, ostensibly references the legendary Persian romantic pair and is an example of pastiche. The attempt at pastiche can also be mocked: the film *Zindagi Na Milegi Dobara* (2011) has three young male friends travelling in Spain, and when a beautiful woman of Indian origin introduces herself as Laila, one of them responds that he is often called Majnu; his two friends are disgusted with his pathetic allusion to the legendary lovers.

11. A Pakistani version of this film was made in 1962 with the title *Azra*: http://pakmag.net/film/db/details.php?pid=286. Accessed 4 May 2021.

12. A look at Āghā Ḥashr Kāshmīrī's play *Rustam Suhrāb* revealed that the film script is not based on it. As suggested earlier, the earliest films may have taken their scripts from Parsi plays, but this was not the case later, perhaps after the 1940s. Incidentally, the Parsi Theatre Company continued to stage *Shīrīn Farhād* and *Lailā Majnūn* between 1967 and 1973.

13. Sohrāb dies young in Firdausī's *Shāhnāma* and has no love interest. His wife Shāhrū appears in a pre-modern spin-off tale in which Sohrāb and Shāhrū have a son Borzū who himself becomes a great hero.

14. Others that I have not been able to see are *Samson* (1964), *Khakan* (1965) and *Sher-e-vatan* (1971).

15. It is also worth mentioning the Tajik film director Benision Kimyagarov, who made a trilogy based on famous epic tales from the *Shāhnāma*. These were: *The Banner of the Blacksmith* (1961) on the hero Kava, *The Legend of Rostam* (or *The Timeless Story of Rostam and Sohrāb*, 1971) and *The Legend of Siavash* (1977). Tajik is a form of Persian, and Tajik speakers in Central Asia, as well as Dari speakers of Afghanistan, also view the classical Persian literary heritage as their own.

REFERENCES

Bhaskar, Ira and Allen, Richard (2009), *Islamicate Cultures of Bombay Cinema*, New Delhi: Tulika Books.

Bhaumik, Kaushik (2001), *The Emergence of the Bombay Film Industry, 1913–1936*, Ph.D. dissertation, Oxford: University of Oxford.

De Groot, Rokus (2006), 'The Arabic-Persian story of Laila and Majnun and its reception in Indian arts', *Journal of the Indian Musicological Society*, 36–37, pp. 120–48.

Gupt, Somnath (2005), *The Parsi Theatre: Its Origins and Development* (ed. and trans. K. Hansen), Calcutta: Seagull Books.

Hansen, Kathryn (2003), 'Languages on stage: Linguistic pluralism and community formation in the nineteenth-century Parsi theatre', *Modern Asian Studies*, 37:2, pp. 381–405.

Hasson, Michal (2018), 'Layla's lotus eyes: The story of Layla and Majnun in early modern South Asia', Ph.D. dissertation, Cambridge, MA: Harvard University.

Irwin, Robert (2004), '*A Thousand and One Nights* at the movies', *Middle Eastern Literatures*, 7:2, pp. 223–33.

Kadivar, Darius (2008), 'The timeless legend of Rostam and Sohrab', *Payvand*, 18 September, http://www.payvand.com/news/08/sep/1212.html. Accessed 15 November 2019.

Rajadhyaksha, Ashish and Willemen, Paul (eds) (2004), *Encyclopaedia of Indian Cinema*, new rev. ed., New Delhi: Oxford University Press.

Thomas, Rosie (2013), *Bombay before Bollywood: Film City Fantasies*, Hyderabad: Orient BlackSwan.

Thoraval, Yves (2000), *The Cinemas of India*, New Delhi: Macmillan.

van der Heide, William (2002), *Malaysian Cinema, Asian Film: Border Crossings and National Identities*, Amsterdam: Amsterdam University Press.

Vasunia, Phiroze (2010), 'Alexander Sikandar', in S. A. Stephens and P. Vassunia (eds), *Classics and National Cultures*, Oxford: Oxford University Press, pp. 302–24.

3

Reflections from Padminī's Palace: Women's Voices of Longing and Lament in the Sufi Romance and Shiʿi Elegy

Peter Knapczyk

In January 2017, a group of protestors stormed the set of the film *Padmaavat* in the midst of production, vandalizing the movie's sets and assaulting the film's director, Sanjay Leela Bhansali. The following twelve months would witness a series of high-profile protests throughout India marked by mob violence and the destruction of property, death threats against the film's director and lead actress and a heightening of the country's communal tensions and identity politics. Although the film was based on a fictional tale from medieval times (the best-known version was the Sufi romance by the poet Malik Muhammad Jāyasī [d. 1542] written in 1540), protestors declared that the film was an affront to their Hindu Rajput cultural heritage, citing rumours of an amorous scene between the Hindu queen Padmāvatī and the Muslim sultan ʿAlāuddīn <u>Kh</u>aljī. In fact, no such scene existed.

After months of delays and a battle in the courts, *Padmaavat* opened at last in early 2018. Given the year-long frenzy over scenes that existed only in rumours, it is striking how most audiences overlooked the actual film's offensive portrayal of its Muslim characters as lechers and brutes. The film indulges shamelessly in the clichés of Islamophobia, framing the narrative around a Muslim sultan driven mad with lust and his pursuit of the elegant and dignified Padmāvatī. It is ironic that Hindu nationalist groups rallied against the film, because the picture of medieval India that the film presents seems drawn directly from their communal propaganda which blames Muslim invaders for the corruption of Hindu civilization.

In their obsession with the themes of Hindu-Muslim conflict, both the protestors and the creators of *Padmaavat* demonstrated an utter disregard for the film's source material. In early modern India, the story of Padmāvatī was told in many ways – it was a fantasy, a quest, a romance, a love triangle, a tragedy,

a mystical allegory and an evening's entertainment. Each of these tellings was a complex narrative woven together from motifs and tropes that were shared across early modern literary traditions. Yet the filmmakers ignored this legacy and chose to recast the tale as a one-dimensional communal conflict.

This decision also required silencing Padmāvatī and other women who were central to Jāyasī's *Padmāvat*, especially in their expressions of longing and lament. These voices are noticeably absent from both the film and the debates over its depictions of women whose so-called honour was so fiercely defended. The controversy over the film *Padmaavat* exemplifies the process of revisionist history through which the heritage of cultural exchange from India's past is being rewritten to suit modern-day identity politics. At the centre of these protests was a wilful cultural amnesia and a misunderstanding of the role of women's desire in India's early modern literary traditions. Simply put, the story of Padmāvatī became a pawn in India's modern-day culture wars, its appropriation made possible by an ignorance of the literary traditions in which it once thrived.

Taking both the film and the story of Padmāvatī as a point of departure, this chapter examines the trope of women's longing and lament in early modern North India and the literary cultures that became precursors to modern Hindi and Urdu. At the centre of this trope is the *virahiṇī*, a woman suffering in a state of *viraha* or separation from her lover. This trope became a centrepiece of several genres in the literary cultures of Awadhi, Braj-Bhasha and Hindavi and is a prime example of the cultural exchanges that connected these traditions in a complex intertextual web. Yet due to the discourse of communal history and cultural purification, this shared literary heritage has been overlooked, if not intentionally ignored. In order to recover the literary and cultural exchanges facilitated by the *virahiṇī*, I will focus on the use of this trope in two genres associated with South Asian Islamicate literature: the *premākhyān* or Sufi romance (to which Jāyasī's *Padmāvat* belongs) and the *marṣiya* or Shiʿi elegy. These genres will serve as touchstones to explore such questions as: Why was the *virahiṇī* such a popular trope in early modern literature? How was it used to create meaning as it moved across genres, languages and religious orientations? And why did it remain a common trope in classic Hindi-Urdu cinema, invoked, for example, in the lyrics of countless Bollywood film songs?

The *virahiṇī* became the focus of a prominent setpiece in the *premākhyān*, one of the first genres of narrative poetry written in the literary dialect of Awadh, beginning with Maulānā Dāʾūd's *Cāndāyan* (1379).[1] Perhaps the best-known poet of this genre is Jāyasī, who completed his masterwork, *Padmāvat*, in 1540. Jāyasī named his poem after its main character, Padmāvatī, the mythical queen of Singhaldīp.[2] Although Jāyasī's poem is characterized as a romance, Padmāvatī's story is seldom a happy one. Born into a kingdom of wealth and splendour, Padmāvatī's troubles began soon after she married a Rajput named Ratansen.

Ratansen, prince of Chittor, became entranced with Padmāvatī upon hearing descriptions of her exquisite beauty recited in minute, head-to-toe detail. These descriptions were recited to Ratansen by a parrot who had been kidnapped from Singhal-dīp and brought to Chittor by a band of fowlers. With this parrot as guide, Ratansen set out to find Padmāvatī, a quest that led him across the subcontinent, tracing the footsteps of Rām and Lakshman. Soon after Ratansen's arrival in Singhal-dīp, he and Padmāvatī married, but their nuptial bliss turned sour when Padmāvatī learned that Ratansen had left behind a first wife in Chittor.

The story is likewise an unhappy one for Ratansen's first wife, Nāgmatī, who finds herself abandoned for months on end while Ratansen is away on his quest. Nāgmatī pines for her husband, her mind and body wasting away through the seasons as if ravaged by disease.

> In the lover's absence, her heart had gone mad.
>> Like a *papīhā* bird, she began repeating, '*piyā, piyā*' ['my love,
>> my love'].
> She was scorched by the intensity of desire.
>> Her very life was snatched away with the name of her lover.
> The arrow of separation pierced her; she could not move.
>> The blouse of her body was soaked through with blood.
> Her friends saw that the jewelry of love had become a burden,
>> She trembled and seemed on the verge of death.
> One moment breath entered her chest,
>> The next moment she expired and everyone gave up hope.
> Her friends fanned her and cooled her with water.
>> At last she came to and said,
> 'Life is leaving. Who can stop it?
>> Who can reunite me with the *papīhā*'s song?'
> A sigh of *viraha* left her mouth and flames leapt up all around.
>> The feathers of the swan that lived within her body were singed.
>>>>> (Agravāl 1956: 342, author's translation)

In composing Nāgmatī's stylized lament, Jāyasī employs many of the elements associated with the *virahiṇī* trope. She curses her fate, complaining that she is afflicted by a grave illness; it is as if she has been consumed by fire, so intense is her fever. The natural world seems to mock her: birds call out her lover's name and storm clouds gather, blocking the sunlight and threatening rain. The only recourse, the *virahiṇī* maintains, is the return of her lover.

Two centuries after Jāyasī, North Indian literature once again saw the rise of a narrative poetic form that had as its core women and their voices of longing and

lament. In the eighteenth century, the genre of *marṣiya* or elegy became a popular vehicle for commemorating the heroism and sacrifice of Imām Husain and his followers who were killed in the Battle of Karbala. The women who survived are given voice in the *marṣiya*, and these poetic expressions of mourning have remained models for generations of devotees.

The *premākhyān* and *marṣiya* are just two of the many genres of early modern literature that feature women's voices of longing and lament. I will argue that this trope became a favoured device because it was able to evoke a shifting set of moods and meanings when placed in different interpretive frames, from the mundane to the mystical, and from the erotic to the elegiac. I will explore some of the interpretive frames that shaped the meaning of the *virahiṇī* trope in Awadhi and Braj, focusing on the *premākhyān*. I will then turn to the Hindavi *marṣiya* tradition in Delhi and Awadh, which is the focus of my current research on the development of this genre and its contribution to the rise of Urdu literary culture.[3] In the *marṣiya*, the mode of the *virahiṇī* shifted from longing for an absent lover to mourning a deceased family member. I will argue that the wide appeal and intertextual resonances of the *virahiṇī* trope in such genres helped facilitate literary exchanges that shaped the aesthetics and genre conventions of early Hindi and Urdu literary cultures.

Finally, I will discuss how this trope was later rejected at the turn of the twentieth century during the age of literary reform when it came to be seen as a symbol of decadence, blamed for corrupting society and impeding the development of 'modern' literature in Hindi and Urdu. During this period, these two languages served as proxies for the culture wars that led to the Partition. This discourse is reflected in scholarship from this era, with literary histories dividing up the legacy of early Hindi and Urdu literature and constructing discrete narratives of traditions separated by language, geography and religion. I argue that the campaign to censor literary devices like the *virahiṇī* has helped to obscure the shared legacy of Hindi-Urdu before the divide and enabled the cultural amnesia that drives today's communal politics.

Efforts to obscure literature and history were central to the high-profile controversy over the film *Padmaavat*, which is a work of historical fantasy like the earlier blockbusters *Jodhaa Akbar* (2008) and *Bajirao Mastani* (2015), and this mix of epic spectacle and A-list stars has proven to be a lucrative formula. With a budget of $31 million, *Padmaavat* was one of the most expensive productions in Bollywood history, an investment which raised the stakes for all involved: the controversy was covered regularly in the international press, and protesters took full advantage of the spotlight.

Padmaavat was in some ways an unlikely target for such virulent protests, given that the film is based on a fictional tale that was much loved in early modern

India. Today, scholars of literature are most familiar with Jāyasī's *Padmāvat*, but tales of Padmāvatī were part of an oral tradition that circulated long before the sixteenth century, and dozens of versions were composed after Jāyasī between the sixteenth and nineteenth centuries in Hindi, Bengali and Urdu.[4]

Jāyasī's version follows the conventions of the *premākhyān*, a romance genre that was associated with Sufism and at times read allegorically as a mystical quest for the Divine. Although the *premākhyān* genre was never understood as a historical record, at some point the legends of Padmāvatī became entwined with traditions recounting the siege of Chittor in 1303 by ʿAlāuddīn Khaljī, the sultan of Delhi. These narratives also converge in Jāyasī's *Padmāvat*: after the couple's return from Singhal-dīp, rumours of Padmāvatī's beauty spread to Ratansen's rivals, including Khaljī, who moved to lay siege to Chittor desiring Padmāvatī for his own. In the end, Ratansen was betrayed and murdered by a rival Rajput prince. Padmāvatī and Nāgmatī, fearing that Khaljī's army would break through Chittor's defenses, immolated themselves on Ratansen's pyre in an act of *jauhar*.[5] In Jāyasī's final scene, Khaljī throws open the palace doors, eager to witness Padmāvatī's beauty, only to find the smouldering pyre. The curtain falls on a wistful Khaljī and his musings:

> He picked up a handful of ashes
> And threw it in the air, declaring
> 'Earth is vanity! Until ashes fall upon it,
> Desire for the world cannot be extinguished!'

<div align="right">(Behl 2012a: 215)</div>

With its talking parrots and other supernatural elements, it should go without saying that the tale of *Padmāvat* was woven together from the threads of fantasy and legend. Despite Khaljī's pursuit of the mythical queen, most scholars agree that there are few useful historical details in Jāyasī's *Padmāvat*.

And yet history and religious identity were central to the controversy over the film *Padmaavat*. Ignoring the story's fantastical premise, protestors raised objections to the film in the form of historical critique, targeting the audacity of Khaljī's desire for Padmāvatī. For example, in Jāyasī's telling, Khaljī first sees Padmāvatī when he visits Chittor's mirror palace and catches a glimpse of her reflection. This episode has long captured the imagination of tourists, and mirrors were installed in Chittor's Padminī Palace decades ago for dramatic effect. At the height of the protests over the film, vandals broke into the palace and shattered these mirrors, enraged by this symbol of Khaljī's transgressive glance (Wadhawan 2017). In another incident, before the film's release, protesters were livid over a rumoured dream sequence in which Khaljī envisions himself in an intimate embrace with Padmāvatī. Officials who viewed pre-release screenings denied the existence of the

scene (Siddique 2017). Yet once again the outrage of the protestors demonstrated that Khaljī's desire for a Hindu queen is beyond the pale, even when this desire is found in a genre of fantasy and still further removed from reality by being presented as a vision in a dream.

In their policing of fantasy and history, the film's protesters defended a narrow reading of history, one that ignores a documented heritage of diversity in favour of an imagined cultural purity. Regarding the controversy, Sreenivasan and Gururaja (2017) have written: '[T]he remembrance of legendary figures in the collective memory requires as much deliberate and sustained effort as the remembrance of historical figures and events' (n.pag.). In other words, both history and legend are sustained by intentional acts of remembering and forgetting. What has been forgotten, I propose, are the ways in which legend and literature once flourished across the boundaries of these later-day political and communal divisions.

The *virahiṇī* in early modern Awadhi and Braj literature

The *premākhyān* genre thrived upon such literary exchanges, reaching the peak of its popularity in the mid-sixteenth century. In their prologues to these works, the writers of *premākhyān*s reveal a strong Sufi orientation; Jāyasī, for his part, stresses his affiliation with the Chishtī brotherhood. But the main narratives of the *premākhyān* reflect the greater complexity of Sultanate Awadh's multireligious environment. The plot of a typical *premākhyān* involves a Hindu prince who disguises himself as a Nāth Yogī and sets out on an elaborate quest to find a princess possessed of great power and beauty.[6] The consummation of their love is described through the symbolism of mystical union. But this moment of union is fleeting, and the narrative themes that endure are desire deferred and longing in separation.

The *virahiṇī* is an ancient trope that was common in Sanskrit and Prakrit long before it became a signature element of the *premākhyān* genre. This trope circulated freely among literary communities in early modern India as a multivalent device whose meaning shifted and resonated dialogically as it was incorporated into genre after genre. The meaning of the *virahiṇī* trope was generated by its interpretative frame, a flexibility evident in the earliest examples of Hindi-Urdu literature. For example, scholars of both Hindi and Urdu have pointed to the riddles of Amīr Khusrau (1253–1325) as among the first compositions in their respective literary histories.[7]

> Without him I feel no relief;
> He cools my thirst in an instant;
> He is full of good qualities.

Is it your lover, my friend?
No, it's water!

(Sandīlvī 1986: 112, author's translation)

Khusrau's riddles position the reader as an eavesdropper listening in as two female friends discuss an absent lover. In their suggestive double entendre and risqué humour, we find an example of the fascination with women's desire, believed to be all-consuming, that often accompanies the *virahiṇī* trope.

In other traditions of early modern literature, the meaning of this trope is reimagined by framing erotic desire as a metaphor for religious devotion. With this move, the *virahiṇī* trope became central to *bhakti* or devotional poetry, most notably in poetry describing the longing of the *gopīs* (milkmaids) of Braj for an absent Krishna. The desire of the *gopīs* is understood as the reflexive response of artless villagers, and the intensity of their attraction to Krishna is an indication of the purity of their love. In this way, the authenticity of women's longing and passion surpasses the cultivated devotion of the scholar. The *virahiṇī* trope was a frequent theme for Sūrdās, the sixteenth-century poet who composed in the dialect of Braj.

It all seems something else these days –
Now that our enchanting Cowherd has gone,
 everything in Braj has changed.
Our homes have turned to caverns, lion's lairs,
 and the beast is panting for its prey.
You know how they say, friend, that moonbeams are cool
 and soothing, but we've been scalded instead,
And no matter how much we women shower each other
 with water mixed with *kumkum* and sandalwood powder
And musk from the deer, it all comes to naught
 in face of the fever of being apart.
We've heard that love is a life-giving vine,
 but now, without Sur's Lord, it bears a poison fruit.
And deprived of the light from Hari's lunar face
 the lotus of our hearts declines to bloom.

(Hawley 2009: 113)

In such poems, devotion itself is gendered feminine, with women seen as natural devotees drawn uncontrollably towards Krishna; without him they remain inconsolable and incomplete.

Given this fascination with women's desire and the view of women as natural devotees, it is notable that most examples of this trope in early modern Awadhi and Braj were composed by men who adopted the voices of women. Still, tradition tacitly acknowledges the pretence of men's attempts to inhabit a woman's voice, as it holds up Mirabai – one of the few women poets from this period – as the *virahiṇī*'s most authentic expression.

> He's bound my heart with the powers he owns, Mother –
> > he with the lotus eyes.
> Arrows like spears: this body is pierced,
> > and Mother, he's gone far away.
> When did it happen, Mother? I don't know
> > but now it's too much to bear.
> Talismans, spells, medicines –
> > I've tried, but the pain won't go.
> Is there someone who can bring relief?
> > Mother, the hurt is cruel.
> Here I am, near, and you're not far:
> > Hurry to me, to meet.
> Mira's Mountain-Lifter Lord, have mercy,
> > cool this body's fire!
> Lotus-Eyes, with the powers you own, Mother,
> > with those powers you've bound.
>
> > (Hawley 2005: 168)

In the mode of *bhakti*, the *virahiṇī* trope not merely sanctions Mira's abandonment of social propriety but sanctifies her transgressions against the patriarchy of her time.[8]

The *virahiṇī* trope continued to evolve and elicit new meanings, becoming fashionable among Mughal-era *rīti* poets. These court poets sought to flatter their patrons by casting them as the absent lover for whom the *virahiṇī* longs, as in Sundar Kavirāi's verse in praise of Shāh Jāhān (Busch 2011: 145).[9] *Rīti* poets developed elaborate typologies of the *virahiṇī* and her various emotional states during separation. Take Keshavdās's illustration of the *virahiṇī* who is 'openly anxious':

> Did he just forget?
> Or has somebody cast a spell on him?
> Has he lost his way?
> Is he afraid of someone?
> Perhaps he's met another woman more beautiful than I.

He may have left already.
Or it could be that he's just arriving now,
or will arrive at any moment.
My friend, comfort me –
Nanda's son is delayed, and I don't know the reason.

(Busch 2011: 81)

Amid the many interpretive frames that shaped the meaning of the *virahiṇī* trope is the genre of the *bārah-māsā* – twelve-month poems that describe the sufferings of a *virahiṇī*, each stanza dedicated to a particular month and the host of afflictions that it brings (Vaudeville 1986; Orsini 2010). The *bārah-māsā* was often incorporated within larger compositions, becoming, for example, a standard feature of the *premākhyān* genre of Jāyasī's *Padmāvat*. In some of his most imaginative passages, Jāyasī incorporates *bārah-māsā* set pieces to describe the physical and mental decline of Padmāvatī and Nāgmatī. Here Nāgmatī describes her longing for Ratansen in the month of Sāvan, the peak of the rainy season when separated lovers traditionally unite.

Much rain falls from the clouds in *Sāvan*.
 The floods have come, but still I am withering in *viraha*.
It's the time of *punarvasu*, but there is no sign of my lover.
 I'm going mad wondering where he is.
Tears of blood fall to the earth,
 Scattering about like red insects.
My friends and their lovers have hung up a swing.
 Green all around, they decorate their blouses with flowers.
My heart is like that swing rocking back and forth.
 Separation gives it a push and it is forever in motion.
The road is inscrutable, immeasurable, mysterious.
 My heart has gone mad, fluttering about like a dragonfly.
I look out at the world drowning in water,
 My boat is grounded with no one at the helm.
Between us are mountains, deep oceans, and dense forests.
 How can I reach you, when I have neither feet nor wings?

(Agravāl 1956: 345, author's translation)

Aditya Behl's (2012a) work on the *premākhyān* highlights the genre's allegorical nature, how the hero's quest can be read as a search for divine union characteristic of Sufism. As in *bhakti* poetry, there is constant play in the *premākhyān* between the mundane and the mystical, with the character's deferred desire equated

with sublimation and spiritual purification (Behl 2012b: 29–30). Read as allegory, Jāyasī's Ratansen is the ideal devotee who achieves his spiritual aim only after progressing through the stages of ascetic refinement and integrating the demands of both the mundane and the mystical, symbolized by his ability to mediate the rivalry between his co-wives Nāgmatī and Padmāvatī.

There is no doubt that the narrative outline of *Padmāvat* accommodates an allegorical interpretation, but such readings tend to fall short of illuminating finer details, the rich intertextual links that point beyond a narrow Sufi reading. In fact, we know that this was only one interpretive frame in which *Padmāvat* and other works of the *premākhyān* genre were enjoyed; for example, a Jain merchant, Banārsīdās, in his autobiography written in 1641, describes evening gatherings where he recited *premākhyān*s for his friends (Behl 2012a: 323–24). Perhaps the secret to *Padmāvat*'s appeal to both Sufis seeking spiritual refinement and merchants seeking evening amusement is to be found in its intertextual links, such as the trope of the *virahiṇī*, that were immediately familiar to a diverse audience.

Inter-canonical connections and the Hindavi *marṣiya*

Such intertextual links continued to permeate the literary traditions of North India into the eighteenth century as the Mughal capital, Delhi, became the centre of literary production in the local vernacular, referred to by some as Hindavi. One can trace the journey of the *marṣiya* genre in North India from its beginnings in Delhi, to its growing prominence in the ritual life of Awadh, and finally to its emergence in the mid-nineteenth century as one of the signature forms of the classical Urdu tradition. The trope of women's longing and lament was prominent throughout, making the *marṣiya* genre a useful touchstone for understanding how this trope inspired literary exchanges that crossed cultural, regional and sectarian lines.

Marṣiya is a long narrative poem that commemorates the martyrdom of Husain – grandson of the Prophet Muḥammad and the third Shi'i Imām – and his companions in the Battle of Karbala in 680 CE. Due to its associations with mourning, *marṣiya* is usually translated as 'elegy'. The word comes from Arabic (*marthiya*), where it signifies an elegy written to lament and commemorate the death of any honoured person. But in Urdu, *marṣiya* is usually used in a narrower sense to denote a genre of Shi'i devotional poetry whose recitation has long been a centrepiece of the annual gatherings held to commemorate the martyrs of Karbala.

The Battle of Karbala was the culmination of a decades-long struggle for the leadership of the early Muslim community, a struggle that began after the Prophet Muḥammad's death in 632 CE. Some argued that a caliph should be chosen by consensus to lead the community, while others asserted that the Prophet, prior to

his death, had designated his son-in-law, ʿAlī ibn Abī Tālib, to succeed him as the community's leader. Those who supported ʿAlī's claim to leadership became known as *ShīʿatuʿAlī* or the partisans of ʿAlī. (This is the origin of the familiar English word 'Shiʿa', signifying those who trace their spiritual lineage to ʿAlī's early supporters.)

This struggle over the leadership of the early Muslim community continued even after ʿAlī's assassination in 661 as the following generation remained deeply divided over a line of controversial caliphs from the Umayyad family. When the second Umayyad caliph, Yazīd, succeeded his father in 680, many considered it a travesty, and he is still condemned widely as a ruthless tyrant whose rule threatened to undermine the success of Islam and the teachings of the Prophet. Yazīd's rule was actively opposed by ʿAlī's younger son, Husain, who began organizing a rebellion. Husain set out from Medina with a small caravan of his family and companions, planning to join supporters in the city of Kufah. But a contingent from Yazīd's army rode out to intercept the caravan at Karbala, leaving Husain and his companions blockaded in the desert and surrounded by a vast army. Despite the proximity of the Euphrates, Yazīd's army denied Husain's camp – women and children included– access to food and water. Days passed in the relentless heat of the desert. Finally, Yazīd's general received orders to attack Husain's camp on the tenth day of the Islamic month of Muharram. In the ensuing battle, Husain and most of his companions were martyred. The events of this day, also known as ʿAshurah, are narrated and commemorated most prominently in the Urdu *marsiya*.

<center>* * *</center>

The month of Muharram marks the annual commemoration for the martyrs of Karbala. Neighbourhoods with large Shiʿi communities, such as those in Lucknow and Hyderabad, are transformed overnight into spaces for mourning, with black canopies and banners draped over and alongside major thoroughfares. The incessant din of the city's marketplaces is reduced to a murmur beneath recordings of plaintive *nauha*s (dirges) broadcast over loudspeakers and reverberating down alleyways. Devotees, dressed solemnly in black, fill the streets, making their way to one of the local *imāmbāra*s (lit. house of the imāms).These are the traditional sites of the *majlis*, a gathering of devotees who assemble to commemorate the martyrs of Karbala by listening to prose sermons and recitations of *marsiya*s.

A typical *marsiya* comprises some one hundred stanzas and recounts an episode from the Karbala narrative in dramatic detail. A full recitation of a *marsiya* may last well over an hour, tracing an emotional arc whose emphasis gradually turns from heroism and valour to tragedy and sorrow. This arc guides listeners in the performance of religious ritual and the expression of communal grief and mourning. The *marsiya* genre presents the Battle of Karbala in stark terms: this is

not a dispassionate litigation of two families' opposing claims to the caliphate but rather a basic struggle between good and evil, whose repercussions are measured on a cosmic scale. Those gathered in the *majlis* understand that this is a demonstration of Imām Husain and his followers' resolve to resist evil at any cost and renew the faith of the Muslim community with their impending martyrdom. Moved by the sacrifice of the martyrs detailed in the *marsiya*, devotees shed tears and mourn in solidarity, rising from the *majlis* with their faith reaffirmed.

As eyewitnesses to the Battle of Karbala and the only survivors left to mourn the martyrs, the women of Imām Husain's family are given a prominent voice in the *marsiya*, and these poetic expressions of mourning have remained models for generations of devotees in the *majlis*. These voices of longing and lament incorporate elements of the *virahiṇī* trope, although the interpretive frame has shifted from the erotic and mystical union of lovers to the mourning of family.

> *Dukh kī badlī ghar āvat hai jharne nīr lagāvat hai*
> > *ānsū pal pal umḍāvat hai bochārā menh barsāvat hai*
> *kālī rain ḍarāvat hai jīvrā morā ghabrāvat hai*
> > *āhẽ hirdā kī jāvat hai ġam kī bijlī camkāvat hai*
> *yār abb maĩ hū bāvarī bhejat hū pardes*
> > *jõ koiliyā kūk tī kālā karke bhes.*

<div align="right">(Sikandar c.1800: n.pag.)</div>

('Clouds of sorrow surround me; tears begin to fall.
> Tears pour forth constantly; a dark cloud rains down.
The dark night is scary; I'm anxious for my life.
> The breath of life is departing; the lightning of grief flashes.
Oh God, I have gone mad; I am sent to this strange land
> Wearing black clothes and crying like a cuckoo.')[10]

In such passages, the *virahiṇī* trope that I have traced through earlier traditions emerges once again, demonstrating its ability to adapt and generate meaning, now in the devotional context of the *majlis*.

Many *marsiya*s open with descriptions of the dawn of ʿAshurah and proceed to narrate any one of several episodes from that day, often focusing on a single member of Husain's camp as he prepares for battle, bids farewell to his family and finally seeks permission from the Imām to enter the battlefield. The emotional intensity of the *majlis* begins to climb when the *marsiya* turns to a poignant moment in the Karbala narrative, such as an allusion that foreshadows the death of one of Imām Husain's companions or the reaction to his martyrdom by the wives, sisters and daughters of the family. Nearly all the males of Imām Husain's

immediate family and kin were killed at Karbala, with the exception of his son, Zain ul-ʿĀbidīn, who was bedridden with an illness and too weak to fight. (He became the fourth Imām after Husain.) It is the martyrdom of these men that serves as the emotional peak of the recitation.

At the battle's end, Husain stands as the only able-bodied man left in his camp. He rides out to battle on his horse, Zuʾljanāh, armed with his father's sword, Zuʾlfiqār. *Marsiya* poets here describe the magnificence of the horse and sword in battle as well as the majesty of Husain himself. Though weakened by days of starvation and dehydration imposed by Yazīd's army, as well as the intense desert heat, Husain is infused with a seemingly invincible strength born from his piety and the righteousness of his cause. One by one, Husain overpowers the succession of opponents who approach him in battle, until, in desperation, they resort to deception, attacking Husain as a group. Yet it is only when, in the midst of battle, Husain is reminded by a divine voice of his destiny to join the martyrs of Karbala that he becomes vulnerable to the attack and falls, mortally wounded.

At such moments, voices scattered throughout the *majlis* assembly join in lament, inconsolable with grief. As the *marsiya*'s focus turns to scenes of mourning and the women of Imām Husain's camp, more and more in the assembly are moved to tears, including the reciter, whose voice rises and cracks, straining to recite the final stanzas. After the closing verses of the *marsiya*, a final prayer is spoken to honour the martyrs of Karbala, marking the end of the recitation. Devotees stand affirmed in their support of Imām Husain and the martyrs of Karbala, who battled evil and injustice and through this sacrifice renewed their community's faith.

Today the *marsiya* is best known in its classical iteration, with its six-line-per-stanza structure (*musaddas*) that has been its primary form since the early nineteenth century. The word 'classical' implies that posterity has come to revere a certain stage in a tradition's past as its consummation. In this sense, most scholars and aficionados of Urdu literature would recognize the classical Urdu *marsiya* to be synonymous with the poets Mīr Anīs (1803–74) and Mirzā Dabīr (1803–75). Anīs and Dabīr are widely credited with the refinement of the Urdu *marsiya* and were among the first *marsiya* poets to earn respect outside the devotional context of the *majlis* based upon their literary merits and poetic ingenuity.[11]

Prior to Anīs and Dabīr and the acceptance of the *marsiya* genre among the wider Urdu literary community, the Hindavi *marsiya* assumed an array of literary forms and was known primarily for its ritual function. The earliest extant *marsiya*s composed in Hindavi date to the turn of the eighteenth century. For much of that century, the *marsiya* genre and its poets remained on the margins of the Persianate literary culture in Delhi, sometimes called *Rekhta*.[12]

Rekhta was also based upon Delhi's local vernacular but was modelled closely on the time-honoured form and conventions of the *ghazal* and other Persian genres.

Although *Rekhta* poets enjoyed the prestige of following the Persian masters, their fidelity to Persian also ensured that freedom to experiment with the conventions of these genres remained relatively circumscribed.

By contrast, *marsiya* poets who adopted Hindavi found few formal models for their genre in Persian, leaving them without links to a prestigious literary tradition like *Rekhta*, which no doubt contributed to the low estimation of the *marsiya* genre early on. Yet the *marsiya*'s marginal status in the eighteenth century allowed these poets freedom to experiment with the very fundamentals of the genre, incorporating linguistic, formal, poetic and narrative elements from both Persianate and Indic sources, such as the *virahiṇī* trope of the longing and lament that had long circulated in the *premakhyān* and other genres discussed earlier. This trope was especially prevalent in Hindavi *marsiya*s in which the voices of the women of Karbala are the primary focus. In contrast to the *marsiya*s of later poets like Anīs and Dabīr who dwelled on scenes of battle and valour, earlier *marsiya* poets took up the narrative after Imām Husain's martyrdom to follow the female survivors of the camp, including his daughters Sakīnāh and Fāṭimāh Sughrā, his wife Bāno and his sister Zainab, mother of ʿAun and Muḥammad. Even in the *marsiya*s that narrate episodes from the Battle of Karbala, these female characters are outspoken and eloquent; their voices are prominent as each warrior prepares to enter the battlefield and later as they mourn the warrior's martyrdom at the *marsiya*'s close.

These female characters are also central in *marsiya*s that focus on the events following the battle, when they and Zain ul-ʿĀbidīn are captured and imprisoned in Yazīd's palace in Damascus. The confusion and sufferings of Husain's young daughter Sakīnah are particularly poignant as she struggles to comprehend the deaths of her beloved father, uncle and brothers and eventually succumbs to death herself. But the most outstanding character of such *marsiya*s is Zainab. She leads the women survivors in the first ceremonies to commemorate the martyrs of Karbala and composes *marsiya*s in their honour. Zainab denounces Yazīd and his supporters fearlessly when she is brought before them at the Umayyad royal court. Hers is an unwavering voice empowered by moral authority, speaking against corruption and tyranny (Hyder 2005).

To evoke these women's voices, *marsiya* poets incorporated allusions to common tropes, including the *virahiṇī*. What distinguishes the use of this trope in the *marsiya* was its interpretive frame, rather than its content; unlike the *bhakti* and the *premakhyān*, the *marsiya* tradition portrays this trope in the mode of elegy. Take this example from Sikandar.

> *zainab rove bāno rove rove kumbah sārā*
> *dekh sakīnah bālī kahtī hai hai bābā pyārā*
> *pyāri beṭi choṛ akelī ban mē kīdhar sidhārā*

gale lagā kulsum ne usko ro ro yahī pukārā
hai koī aisā jāe ke ḍhunṛhe ran ke bīc
joṛī betī bāp kī bichaṛī ban ke bīc.

(Sikandar *c*.1800: n.pag.)

('Zainab weeps, Bāno weeps, the entire family weeps.
Little Sakīnah sees this and says, "Oh, my dear father.
You have abandoned your dear daughter in this wasteland. Where have
 you gone?"
Kulsum embraces her, and says as she weeps:
"Is there anyone who can search this battlefield
and reunite this daughter and father who are separated in this waste-
 land?"')[13]

Those familiar with the ritual and theological importance of the *marṣiya* in the modern period are aware that the women it portrays – strong and defiant women who confront injustice and tyranny head on – have become symbols of resistance adopted for a range of social movements – from the Iranian revolution to feminist poetry. And yet scholars disagree about the significance of gender in the Hindavi *marṣiya*. Shantanu Phukan (2001) and Christina Oesterheld (2010) have investigated the connection between mourning, femininity and language. Like the *gopī*s of *bhakti* poetry, both have proposed that this Hindavi register evokes a rustic, domestic and, above all, feminine form of speech that was well suited to the expression of sorrow and mourning. As Phukan puts it: 'The emotions it exploits are often quite unambiguously women's emotions. [...] this specifically gendered set of emotions are best expressed in an un-Persianised, and [...] unpolished, speech' (2001: 447–48). Phukan contrasts this with Persianized speech, which he sees as its masculine counterpart. The audience for both of these registers, he argues, was composed of male elites for whom the feminine voice bore emotional and aesthetic resonance, not unlike the *virahiṇī* of *rīti* poetry.

Oesterheld agrees with Phukan that the un-Persianized style of such *marṣiya*s was a distinctly feminine voice, but she envisions a very different audience. Whereas Phukan pictures Mughal elites eavesdropping on a feminine lament and relishing in aesthetic delight, Oesterheld suggests that this style is meant for an audience with little education, requiring direct, functional language.

My own study of unpublished manuscripts from this era reveals that as the language of the *marṣiya* developed, poets extended the boundaries of the genre to include allusions to both Indic and Persian literary traditions. This is seen in a remarkable macaronic *marṣiya* by Dargāh Qulī <u>Kh</u>ān from the mid-eighteenth century in which he alludes to the famous opening of Rūmī's Persian *maṣnavī*:

Ba shanū az nai cūn hikāyat mī-kunad
Az judāī-hā shikāyat mī-kunad.

(*c*.1700s: n.pag.)

('Listen to the reed-flute as it tells its tale,
lamenting the separations.')

Consider the first stanza of <u>Kh</u>ān's *marṣiya* that alludes to Rūmī's verse:

Fāṭimāh kahtī suno yeh dukh <u>kh</u>udā ke vāste
 Aur rasūlu'llāh hazrat mustafā ke vāste
Kyā jigar-goshō ko pālī thī balā ke vāste
 zulm-o be-dard-o musībat aur jafā ke vāste

Ba shanū az mādar hikāyat mī-kunad jān mī-dahad
 vaz judāī-hā shikāyat mī-kunad jān mī-dahad.

(*c*.1700s: n.pag.)

('Fāṭimāh says, "Listen to this sorrow, for the sake of God,
 and for the sake of the Messenger of God, Mustafā,
Did I raise these dear ones for the sake of this misfortune,
 and for the sake of this tyranny, heartlessness, pain, and injustice?"

Listen to the mother as she tells her tale, as she sacrifices her life.
 Lamenting the separations, as she sacrifices her life.')[14]

Reaching across languages and genres, Fāṭimāh emulates Rūmī's reed-flute as she laments her separation from her loved ones. Given the heavy demands that such *marṣiya*s make upon their listeners, they hardly seem intended for an uneducated audience. If anything, these *marṣiya*s seem intended for a super-reader able to negotiate wide-ranging linguistic and literary allusions. Or perhaps the intertextuality of these texts ensured that they could reach across to each member of a diverse audience. The widespread use of multivalent tropes like the *virahiṇī* was a hallmark of the literary, linguistic and cultural exchanges that permeated the heritage of Hindi-Urdu literature.

The *virahiṇī* in the age of literary reform

The appeal of such tropes during the early modern period, along with their role in fostering literary innovation and exchange, seems to have been lost on reformers at the turn of the twentieth century who sought to usher in a new era of literature

for Hindi and Urdu. They were inspired to meet the challenges of modernity and imperialism and were troubled by their respective communities' waning political power. They believed that the success of British imperialism was due to the moral decay of their communities. And they adopted western literary forms like the novel, arguing that the traditional poetic genres of Hindi and Urdu had grown, as Ḥālī would put it, 'more foul than a cesspool' (Shackle and Majeed 1997: 193).

Woven through this reform movement was a gendered critique which claimed that in recent generations India's social elites had grown increasingly effeminate, making them susceptible to foreign rule. Ironically, this discourse was an internalization of the propaganda that the British had long deployed to undermine the sovereignty of India's rulers. Historians have highlighted the use of shame regarding gender as a tactic in Awadh; for example, rumours circulated questioning the fertility and sexual orientation of rulers, the subtext being that they were insufficiently manly to govern (Fisher 1998: 512).

Such ideas were later invoked by reformers in their attack on traditional literature. We see this play out in Nazīr Ahmad's 1874 novel *Taubatu'n Nasūh*. When the novel's patriarch, Nasūh, strives to reform his household, he comes into conflict with his eldest son, Kalīm, an aspiring poet. This conflict comes to a head when Nasūh gathers up his son's library of classical poetry and commits it to the flames of a bonfire, signalling a renunciation of Urdu's literary heritage (Ahmad 2004: 59–60).

Urdu's most influential literary reformer during these years was Alṭāf Ḥusain Ḥālī (1837–1914). In 1879, Ḥālī completed a lengthy poem detailing the condition of the Muslim community titled *Musaddas Madd-o jazr-e Islām* ('The ebb and flow of Islam'). Just as the fictional patriarch Nasūh had blamed traditional poetry for his son's corruption, Ḥālī reserves some of his harshest criticism for classical poets:

> *Burā shi'r kahne kī gar kuch sazā hai*
> *'abas jhūṭ baknā agar nā-ravā hai*
> *to vuh mahkmah jiskā qāzī <u>kh</u>udā hai*
> *muqarrar jahān ek-o bad kī jazā hai*
> > *gunahgār vā chūṭ jāeñge sāre*
> > *jahannam ko bhar deñge shā'ir hamāre.*

> ('If there is a punishment for writing bad verse,
> and if it is impermissible to give tongue to vain lies,
> Then in that court of which God is the judge,
> where penalties for the good and the bad are determined,
> > All sinners will be acquitted,
> > while our poets fill up hell.')

> (Shackle and Majeed 1997: 192–93)

Ḥālī later presented his plans for modernizing poetry in a treatise titled *Muqaddamah-e shi'r-o shā'irī* ('Introduction to poetry and poetics'). He sifted through the works of past masters for fragments that he could repurpose to create what he called *ikhlāqī shā'irī* or moralistic poetry to address modern concerns (Ḥālī 2001: 150–56). In his evaluation of the *marsiya*, Ḥālī claimed that the genre's emphasis on mourning and lamentation did not allow the *marsiya* to accommodate the variety of themes that modern literature demands.

As detailed earlier, in the *majlis* where *marsiya*s are traditionally recited, expressions of mourning have long been valued as pious demonstrations of solidarity with the martyrs of Karbala. And yet the *marsiya*'s association with tears and lamentations also came under criticism for being effeminate. Critics, falling prey to the discourse of 'gender shame', faulted the *marsiya* for portraying its characters in a manner unmanly and undignified. As literary critic Muhammad Sadiq writes:

> [T]he impression one carries of the *marsiyas* is that they are much too tearful. [...] Are we not all agreed that excessive indulgence in grief or an unusual display of sensibility is deleterious and should, therefore, be deprecated and condemned? On the other hand, do we not value manliness, fortitude, and endurance? If so, the *marsiyas* do not live up to the highest human ideals.
>
> (1984: 212)

In addition to a host of troublesome preconceptions about gender, emotion and aesthetics, Sadiq's argument rests precariously upon the misguided assumption that tears and mourning represent concession and defeat. Given the *marsiya*'s association with Shi'i Islam, one suspects a thinly veiled sectarianism as well by critics who failed to acknowledge the genre's ritual and theological value.

While Ḥālī and other Urdu literary reformists were busy singling out the so-called feminine aspects of genres that they deemed incompatible with their vision for modern literature, a parallel movement of reform was playing out in the newly founded Hindi literary journal *Saraswatī* edited by Mahāvīr Prasād Dwīvedī (1864–1938). Dwīvedī's influence on the course of Hindi at the turn of the twentieth century was so profound that these decades are often referred to by scholars of Hindi literature as the Dwīvedī era. Like his contemporaries writing in Urdu, Dwīvedī and his followers blamed traditional poetry in Hindi for the decline of morals and manliness, and they often attributed the decadence of early modern poetry to the impact of Muslim rule, reflecting the communal 'two nations' rhetoric of the era.

As in the gendered criticism of *marsiya* by Urdu reformists, the *virahiṇī* trope was dismissed by Hindi reformists as immoral and frivolous, targeting it for the cultural amnesia that would enable the division of Hindi-Urdu literary history.

Dwīvedī himself denounced the female *nāyikā* and the trope of the *virahiṇī* in early modern Hindi poetry. Here he writes:

[N]owhere does the nayika dominate as much as in Hindi [...]. Let us see what is written in these books: [...] Sinful conduct of unmarried girls! Meaningless babble of shameless and lewd women, who corrupt the minds of men! [...] Somewhere some nayika is running in the dark on the banks of Yamuna, somewhere she is waiting in the moonlight for her beloved [...] Can there be any greater power to destroy the moral conduct of our people? [...] I plead for an immediate stop to the composition of such works and the proscription of those already existing.

(Gupta 2000: 100)

Dwīvedī's call to censor early modern Hindi literature ran parallel to that of Ḥālī and other Urdu reformers – both rejecting genres and tropes, both equating femininity and especially longing and lament with decadence and immorality. These literary elements were to be purged and forgotten to allow their respective communities to regain their former glory.

In light of the rejection of such tropes by reformers and critics at the turn of the twentieth century, it must be affirmed that the heritage of cultural diversity and exchange in Hindi-Urdu literature continued to thrive in the world of film and song. From the earliest days of Bombay cinema allusions to the *virahiṇī* are encountered in the anguish of a heroine who finds herself separated from her lover, creating yet another interpretive frame in which women's voices of longing and lament continued to generate meaning. The intertextuality of this trope also persisted, with song lyrics that cast the heroine's lament in the persona of a *gopī* calling out to Krishna, drawing upon elements that have evoked the *virahiṇī* for centuries. Take this example from the film *Pyaasa* (1957), '*Āj sajan mohe ang lagā lo*', written by Sahir Ludhianvi:

> Today, my love, take me in your arms,
> May my life bear fruit.
> My heart's pain, my body's fire,
> May they all be cooled.
>
> For ages my wretched eyes have kept watch,
> Without you, my heart finds no solace.
> I see no joy ahead, sorrow chases me from behind
> Without you, the world is empty.
> Make the nectar of love rain down, my love,
> Make it rain down so the world becomes full.

Make me yours, make me yours,
Take me by the arm, birth after birth I have served you.
Quench my thirst, Mountain-holder, quench my thirst,
This thirst has touched my core.
Make the nectar of love rain down, my love,
Make it rain down so the world becomes full.[15]

In this scene, Gulabo, a prostitute, overhears this devotional hymn for Krishna (the Mountain-holder) sung in the persona of a *gopī* and is moved deeply as she discovers it gives voice to her own longing for the poet Vijay. Similar examples from this era include '*Mohe bhūl gae savariyā*' ('My beloved has forgotten me') from the film *Baiju Bawra* (1952) and '*Mohe panghaṭ pe nandlal*' ('Nand's son teased me on the water-path') from *Mughal-e-Azam* (1960), both written by Shakeel Badayuni. During this classic era of Indian cinema, countless film songs based on the *virahiṇī* trope were written, acted, produced and directed by Muslim artists for an audience who celebrated the subtle allusions and intertextual links they contained.

In the literary cultures of early modern North India that were the precursors to modern Hindi and Urdu literature, the trope of women's desire and longing created dialogic resonances across regions, languages and interpretive frames. These voices were likewise valued by multiple religious communities as models for devotion that transcended sectarian identities, as seen in examples from the *premākhyān*, *marṣiya* and other genres. Rather than a weapon of cultural transgression, this trope circulated widely during the early modern period as a shared literary device and a productive tool for innovation and cultural exchange.

Today, nonetheless, it is the echoes of the reformists' criticisms that reverberate most clearly through the protests over the film *Padmaavat* and the efforts to advance a revisionist history driven by the politics of division. By and large, it seems, the campaign of the reformers to shape subsequent generations' reception of this literary heritage was a successful one. Desire and longing are still targets for censors and protests, and we are still asked to forget the cultural diversity of the past in order to maintain contemporary constructions of an imagined cultural purity. The project of purging and censoring this literary heritage is enabled by a willingness to forget the links and exchanges that for centuries nourished innovation, from the *premākhyān* and the *marṣiya* to classic cinema. Recovering these intertextual connections will help us set aside the persistent paradigm of modern linguistic nationalisms and create a more accurate picture of the literary and cultural heritage of Hindi-Urdu in all its complex detail before the divide.

NOTES

1. During the early modern period the language of Awadhi was one of many regional literary dialects. Extant manuscripts from the *premākhyān* genre are typically in the Perso-Arabic script, although the Nagari and Kaithi scripts were used as well. In addition to the *premākhyān* genre, Awadhi is also the language of the *Rāmcharitmānas* of Tulsīdās.

2. *Singhal-dīp* is the Awadhi term for a mythical kingdom sometimes equated with modern-day Sri Lanka.

3. It is generally accepted that the term 'Urdu' did not signify a language or literary culture before the last decades of the eighteenth century, circa 1780 (Faruqi 2001: 23). Prior to this, poets writing in Delhi's local vernacular used various names to describe the language of their poetry. Here I use 'Hindavi' to describe the language of poets – like the *marṣiya* poets mentioned in this chapter – whose language was a precursor to modern Hindi-Urdu linguistically but who remained outside the literary circles of *Rekhta* poets due to social or aesthetic reasons. For more on this distinction, see Knapczyk (2014: 88–100).

4. Sreenivasan (2007) has studied the 'many Padmāvats' phenomenon at length, documenting how the tale was reframed as an example of Hindu-Muslim communal conflict during the colonial era when the two-nation paradigm began to gain traction.

5. *Jauhar* was a form of ritual mass-suicide performed by the women relatives of a defeated army to avoid being captured and mistreated by the enemy. As in the ritual of *satī*, this was an act of self-immolation.

6. Members of the Nāth *sampradāya* (spiritual lineage) trace their tradition to saints such as Matsyendranāth and Gorakhnāth. The Nāths are associated with a form of mystical symbolism revolving around Shaivism and the practice of Hatha yoga. The trope of the prince who disguises himself as a Nāth Yogī in order to search for his beloved incognito also highlights the peripatetic and socially liminal status of this group.

7. The riddles traditionally attributed to Khusrau have a rather shallow textual history, raising suspicion about their authenticity. Nonetheless, the circulation of these riddles in oral traditions illustrates the popularity of the *virahiṇī* trope.

8. According to tradition, Mirabai rejected her marriage to a Rajput prince and devoted herself to Krishna whom she saw as her true husband.

9. The *rīti* style of Braj poetry, which became popular in regional courts during the Mughal period, was characterized by the incorporation of poetics and other literary elements from Sanskrit. For more on this tradition, see Busch (2011).

10. My translation from Sikandar, *Marāsī-e Sikandar*, unpublished manuscript, Aligarh University, University collection Urdu, MS 549.

11. For a translation of a *marṣiya* by Mīr Anīs and an introduction to his life and art, see Matthews (1994). For a classic introduction to the Urdu *marṣiya*, see Naim (2004).

12. My discussion of the term *Rekhta* references its specific usage in the mid-eighteenth century to describe a poetic form modelled on Persian genres but written in the language of Delhi. For more on *Rekhta* and an overview of the term's many usages, see Bangha (2010).

13. My translation from Sikandar, *Marāsī-e Sikandar*, unpublished manuscript, Aligarh University, University collection Urdu, MS 549.
14. My translation from Dargāh Qulī K̲h̲ān, unpublished manuscript, Salarjung Library collection, MS 137.
15. My translation.

REFERENCES

Agravāl, Vāsudev Sharaṇ (ed.) (1956), *Padmāvat*, Jhānsī: Sāhitya Sadan.

Ahmad, Nazir (2004), *The Repentance of Nussooh* (trans. M. Kempson), Delhi: Permanent Black.

Bangha, Imre (2010), 'Rekhta: Poetry in mixed language', in F. Orsini (ed.), *Before the Divide: Hindi and Urdu Literary Culture*, New Delhi: Orient BlackSwan, pp. 21–83.

Barnett, Richard B. (1998), 'Embattled begams: Women as power brokers in early modern India', in G. R. G. Hambly (ed.), *Women in the Medieval Islamic World: Power, Patronage, and Piety*, New York: St. Martin's Press, pp. 521–36.

Behl, Aditya (2012a), *Love's Subtle Magic: An Indian Islamic Literary Tradition, 1379–1545*, New York: Oxford University Press.

Behl, Aditya (2012b), *The Magic Doe*, New York: Oxford University Press.

Busch, Allison (2011), *Poetry of Kings: The Classical Hindi Literature of Mughal India*, New York: Oxford University Press.

De Bruijn, Thomas (2012), *Ruby in the Dust*, Leiden: Leiden University Press.

Faruqi, Shamsur Rahman (2001), *Early Urdu Literary Culture and History*, New Delhi: Oxford University Press.

Fisher, Michael H. (1998), 'Women and the feminine in the court and high culture of Awadh, 1722–1856', in G. R. G. Hambly (ed.), *Women in the Medieval Islamic World: Power, Patronage, and Piety*, New York: St. Martin's Press, pp. 489–519.

Gupta, Charu (2000), '"Dirty" Hindi literature: Contests about obscenity in late colonial North India', *South Asia Research*, 20:2, pp. 89–118.

Ḥālī, Altāf Husain (2001), *Muqaddamah-e shiʿr-o shāʿirī*, Lahore: K̲h̲azīnah-e ʿilm-o adab.

Hawley, John Stratton (2005), *Three Bhakti Voices: Mirabai, Surdas, and Kabir in Their Time and Ours*, Oxford: Oxford University Press.

Hawley, John Stratton (2009), *The Memory of Love: Sūrdās Sings to Krishna*, Oxford: Oxford University Press.

Husain, Sālihah ʿĀbid (1973), *K̲h̲avātīn-e Karbalā kalām-e Anīs ke āine mẽ*, New Delhi: Makta bah Jāmiʿah.

Hyder, Syed Akbar (2005), 'Sayyedeh Zaynab: The conqueror of Damascus and beyond', in K. S. Aghaie (ed.), *The Women of Karbala*, Austin: University of Texas Press, pp. 161–81.

Hyder, Syed Akbar (2006), *Reliving Karbala: Martyrdom in South Asian Memory*, New York: Oxford University Press.

Khān, Dargāh Qulī (*c*.1700s), *Bayāz-e Marāsī*, unpublished manuscript, Salarjung Library collection, MS 137, Hyderabad: Salarjung Library.

Knapczyk, Peter (2014), 'Crafting the cosmopolitan elegy in North India: Poets, patrons, and the Urdu *Marsiya*, 1707–1857', Ph.D. dissertation, Austin: University of Texas.

Masīhuʾz Zamā (2002), *Urdū marsiye ka irtiqā: Ibtidā se Anīs tak*, rpt., New Delhi: Qaumī Kaunsil barā-e farogh-e Urdū zabān.

Matthews, David (trans.) (1994), *The Battle of Karbala: A Marsiya of Anis*, New Delhi: Rupa.

Naim, C. M. (2004), 'The art of the Urdu marsiya', in *Urdu Texts and Contexts: The Selected Essays of C. M. Naim*, New Delhi: Permanent Black, pp. 1–18.

Oesterheld, Christina (2010), 'Looking beyond Gul-o-bulbul: Observations on marsiyas by Fazli and Sauda', in F. Orsini (ed.), *Before the Divide: Hindi and Urdu Literary Culture*, New Delhi: Orient BlackSwan, pp. 205–21.

Orsini, Francesca (2010), 'Barahmasas in Hindi and Urdu', in F. Orsini (ed.), *Before the Divide: Hindi and Urdu Literary Culture*, New Delhi: Orient BlackSwan, pp. 142–77.

Petievich, Carla (2002), 'Making manly poetry: The construction of Urdu's "golden age"', in R. B. Barnett (ed.), *Rethinking Modern India*, New Delhi: Manohar, pp. 231–56.

Phukan, Shantanu (2001), 'Through throats where many rivers meet: The ecology of Hindi in the world of Persian', *Indian Economic and Social History Review*, 38:1, pp. 33–58.

Pyaasa (1957), Guru Dutt (dir.), S. D. Burman (music), Sahir Ludhiavni (lyrics), India: Guru Dutt Films Pvt. Ltd.

Sadiq, Mohammed (1984), *A History of Urdu Literature*, 2nd ed., Delhi: Oxford University Press.

Sandīlvī, ShujāatʿAlī (1986), *Amīr Khusro aur unkī Hindī kavitā*, Chicago: Ameer Khusro Society of America.

Shackle, Christopher and Majeed, Javed (1997), *Hali's Musaddas: The Flow and Ebb of Islam*, Delhi: Oxford University Press.

Siddique, Salma (2017), 'The futility of dreaming of the Padmavati-Khilji dream sequence', *The Wire*, https://thewire.in/communalism/futility-dreaming-padmavati-khiljis-dream-sequence.

Sikandar, Khalīfah Muhammad ʿAlī (*c*.1800), *Marāsī-e Sikandar*, unpublished manuscript, MS 549, University collection, Aligarh: Aligarh Muslim University.

Sreenivasan, Ramya (2007), *The Many Lives of a Rajput Queen: Heroic Pasts in India, c. 1500 1900*, Seattle: University of Washington Press.

Sreenivasan, Ramya and Gururaja, Samana (2017), 'To continue seeking Padmini is to miss the point once again', *The Wire*, 12 December, https://thewire.in/communalism/padmavati-rajput-protests-gujarat-rajastha. Accessed 11 June 2021.

Vaudeville, Charlotte (1986), *Bārahmāsā in Indian Literatures: Songs of the Twelve Months in Indo-Aryan Literatures*, New Delhi: Motilal Banarsidass.

Wadhawan, Dev Ankur (2017), 'Vandals damage mirror work at Padmini Palace in Chittorgarh Fort', *India Today*, 5 March, https://www.indiatoday.in/india/story/padmini-palace-chittorgarh-fort-vandals-mirror-work-964065-2017-03-05. Accessed 11 June 2021.

4

Situating the *Ṭawā'if* as a Poet: Nostalgia, Urdu Literary Cultures and Vernacular Modernity

Shweta Sachdeva Jha

The figure of the *ṭawā'if* has been central to the vocabulary of history and modernity in Bombay cinema (Bhaskar and Allen 2009; Vanita 2017). Whether it is Kamal Amrohi's *Pakeezah* (1972), Muzaffar Ali's *Umrao Jaan* (1981) or J. P. Dutta's *Umrao Jaan* (2006), the character of the *ṭawā'if* has been both complex and ubiquitous in popular imagination (Jha 2009a: 268–87). For each generation of filmmakers, the *ṭawā'if* has become a palimpsest to reinscribe the story of female sexuality, marriage and the ambiguous status of music and dance in Islamicate culture. In this chapter, I probe the provenance of the cinematic representations of *ṭawā'if*s through their literary counterparts and the colonial past. Comparing literary representations of the *ṭawā'if* to the texts authored by them in late-nineteenth-century colonial India, I will reveal the complex, variegated and many layered world of commercial Urdu print culture. I will argue that the figure of the *ṭawā'if* simultaneously became a symbol of nostalgia for a lost *nawābī* culture and *tahẓīb* (cultural etiquette) as well as a subject of moral criticism and social reform due to a complex process of idealization and critique. I study the forgotten story of the *ṭawā'if*'s poetry and how her history in Islamicate cultures is rewritten, retold, romanticized and at times erased in popular print culture after the Rebellion of 1857, which forms the historical past of the *ṭawā'if* in Bombay cinema.

The Urdu word '*ṭawā'if*' has been variously translated as courtesan, prostitute or nautch girl in English. The origins of the term lie in the Arabic word '*ṭawāf*', which means 'moving round the Mecca' (Platts 1884: 754). Katherine Butler Schofield (2012: 152) argues that it was only by 1800 that the term '*ṭawā'if*' came to be used for a 'unitary meta-community' of elite female performing artists in North India. In the late eighteenth century, the Persian term '*ṭawā'if*' could refer to

'tribes' of female performers or be used as a generic term for both male and female performers; however, by the late nineteenth century in casual usage, *nāchnewale tā'ifa* meant a group of singers and dancers and the *tawā'if* had come to represent a courtesan in Urdu literary representation while for the colonial officers she was a mere prostitute (Sachdeva 2008; Jha 2015). In 1990, Veena Oldenburg published a landmark paper on the history of the *tawā'if* and the discrimination and marginalization they faced after the uprising of 1857. She argued that the Anti-Contagious Diseases Act implemented by the British colonial authorities targeted the *tawā'if* and bracketed them with low-ranking prostitutes whom they saw as a major threat to security and governance (Oldenburg 1990). The *tawā'if*s were skilful in the arts of poetry, dance, music and love. They had sexual relationships with their patrons but were distinct from prostitutes who mainly offered sexual services to men and were lowly paid. More recently scholars such as Saleem Kidwai (2004, 2008), Amlan Das Gupta (2005, 2007) and Anna Morcom (2016) have elaborated upon this process of marginalization to show that both colonial legislation and the anti-nautch movement along with social reformers pushed these talented women into a state of ignominy while erasing their erstwhile status as women of culture, artistic skill and *tahzīb* or etiquette. Lata Singh (2010) has documented the role played by the *tawā'if* in the 1857 revolt, while Pallabi Chakravorty (2008 and Margaret E. Walker (2014) in dance studies and scholars of music such as Regula Burckhardt Qureshi (2006) and Amelia Macziewski (2006), Vidya Rao (1996) and Jennifer Post (1987) have been instrumental in retrieving the immense contribution of these talented performers to the making of Hindustani music. They have charted their changing conditions after the Rebellion of 1857, especially the loss of courtly patronage in princely states, and the migration of performers, singers and *tawā'if*s towards towns and the cities of Calcutta and Bombay. The arrival of gramophone companies in the early decades of the twentieth century offered some *tawā'if*s opportunities to refashion their identity as gramophone singers (Jha 2009a).

Although scholars have retrieved the history of *tawā'if*s as singers and *gānewālī*s, their history as poets and as muse for male writers remains forgotten. One of the main reasons behind this erasure is that Urdu poetry went through a drastic literary and cultural restructuring after the Rebellion of 1857 which was accompanied by the sanitization and reform of Urdu poetic practices. Attempts to create a taste and readership for a modern style of Urdu poetry were marked by the rise of two intellectuals, 'Āzād' and Ḥālī, and the slow erasure of *tawā'if* poets from the annals of Urdu poetry.

Pritchett (2003) studies the role played by Moḥammad Ḥusain 'Āzād' (1830–1910) and Alṭāf Ḥusain 'Ḥālī'(1837–1914) in reshaping and 'reforming' the Urdu literary world. Āzād ('free') and Ḥālī ('modern'), as their pseudonyms suggest,

were men who wanted to promote new standards of poetic taste. Both of them had suffered personal tragedies during the Rebellion and were soon to emerge as significant literary scholars. Their works are now part of the Urdu canon, and their legacy still carries on. Their reaction to the British criticism of the 'emotional effeteness' of Indo-Muslim cultures represented by the lifestyles of *nawāb*s like Wājid 'Alī Shāh was to cleanse the history of Urdu poetry and refashion poetic standards and styles of composition. At the forefront of a new school of poetry, they tried to make Urdu poetry conform to a new model of aesthetics and ideals different from earlier ones. Āzād and Ḥālī also wrote the first 'modern' histories of Urdu poetry and established a poetic canon of talented writers. Āzād's *Āb-i-Hayāt* (1880) and Ḥālī's *Muqaddamā-i-She'r-o-Shā'irī* (1883) were texts in this direction. They perceived a need for educational and moral poetry, and with them, Mirzā Asadullāh Baig Khān Ghālib' (1797?–1869) and Mīr Taqī Mīr (1723–1810) soon became 'canonical' poets in Urdu scholarship. Instead of love, wine and women, poets were encouraged to 'elevate' the literary standards of Urdu poetry and think of poetic gatherings as educational gatherings to critique and engage with literary creativity rather than leisure or entertainment (Naim 2001).

In this reshaping of Urdu poetic tradition, there was no space for the *tawā'if* or their compositions. In his attempt to reignite Muslim pride, Āzād had hardly included any Hindu poets of Urdu although there were several who were famous at that time. Āzād's *tazkira* was an attempt to rewrite a new history of Urdu poetry for Muslims which was 'clean' of all references to sensuality and pleasure such as that of *rēkhtī* poetry. While doing my doctoral research, I came across the famous anthology on writing by Indian women compiled by Tharu and Lalita (1991), and they had featured Urdu women poets. This included a famous *tawā'if* Māh Laqā Bāi 'Chandā' (*c.*1768–*c.*1824) of Hyderabad, and soon I began to look for more. This chapter is a search for these forgotten *tawā'if* poets as well as an attempt to understand their history both as literary representations and as women who were poets and writers in the emerging milieu of Urdu print culture. To begin with, a brief context of the changing urban scape of Urdu print culture can help us locate her in Urdu literary history.

Urdu print culture and vernacular modernity

Print technology affected the practices and discourses of everyday life in ways peculiar and specific to the colonies; it is this domain of everyday experience that I refer to as 'vernacular modernity'. As Dipesh Chakrabarty (2011) put it wittingly, the concept of modernity remains a muddle in Indian history. Colonial modernity was not the same as its European counterpart; rather, it was specific to

its colonial origin. For colonies like India, this phase did not mark a clear break from its past even though the advent of printing technology transformed the public sphere to a certain extent. Following Jürgen Habermas's ([1962] 1989) formulation of the public sphere, Benedict Anderson (1983) had argued that increase in literacy, access to information through availability of cheap books and pamphlets along with the practice of reading had altered the sense of community in colonies and produced a new form of public discourse. However, in recent years, scholars of vernacular literature have contested his theory of a clear break from earlier traditions of communication to argue for a more complex relationship between printing technology, print culture, oral and performative traditions and a heterogeneous reading public (Ghosh 2006; Orsini 2009; Stark 2009). Stuart Blackburn and Vasudha Dalmia (2004) posit that vernacular literary cultures did not necessarily replace previous oral traditions and practices; rather they blended earlier traditions with new forms of printed texts and reading pleasure.

Apart from literary fiction, Urdu print culture also includes cheaply available almanacs, songbooks, magazines, detective fiction and other narratives that offer a rich field to explore ideas of entertainment, changing notions of gender and vernacular modernity. As argued by Sanjay Joshi (2001), the discourses of social reform and nationalism in late-nineteenth-century colonial India were never singular. Francesca Orsini (2002: 74) postulates that vernacular print cultures were heterogeneous and vibrant; they included a range of 'high-brow' and 'low-brow' works with standards of authorship and readership constantly changing with the times. In the context of Urdu, which had become the language of official communication for the English East India Company since 1837 and a medium of vernacular education in school and colleges, the establishment of commercial printing presses in the mid-nineteenth century in North India led to a flourishing of Urdu print culture (Lelyveld 1993).

The advent of lithography and the setting up of printing presses like the famous Nawal Kishore Press of Lucknow in 1858 altered the political and literary landscape of Urdu and Hindi. Owners of printing presses began printing official reports, vernacular textbooks and newspapers while also printing songbooks, pamphlets, satires, detective stories and other genres for the reading pleasure of a growing public (Orsini 2009; Stark 2009). Urdu plays and songbooks were cheap to buy and widely read along with some unique forms, which, as Christina Oesterheld points out (2004: 169), have largely been ignored by literary historians of Urdu. The popularity of Urdu songbooks and plays was in tandem with the emergence of new forms of urban leisure such as commercial theatre. By 1871, Parsi theatres in Bombay were staging Urdu plays and tapping into a rich heritage of narratives and lyric traditions. As Kathryn Hansen (1998) analyses in her brilliant study, commercial theatres enhanced their 'literary stature and pleasurability' by staging

Urdu plays and became a source of employment to several Urdu playwrights. In 1873, one of the leading theatre companies, the Elphinstone Company, launched a lavish production of an Urdu play, Amānat's *Indar Sabhā*. Soon, many Parsi theatre companies were travelling with their Urdu productions to cities like Delhi, Lucknow, Lahore and Hyderabad. Several editions of *Indar Sabhā* were printed in the 1870s as theatrical productions had made it popular and the owners of printing presses were keen to cash in on this popularity. Parsi theatre companies used a rich mix of local musical genres such as *thumrī*s, *ghazal*s, *tappā*s and other seasonal genres for plays; thus, the profit in printing Urdu plays soon led the press owners to print songbooks. Three kinds of publication in music became popular: musical treatises written by connoisseurs who frequented schools and libraries and wrote in a style similar to Persian manuscripts, manuals on musical instruments and songbooks (Sachdeva 2008: 195–237; Orsini 2009: 81–105).

Oesterheld (2004) makes a crucial point that in the late nineteenth century, there were no clear boundaries between reformist literature and literature meant for entertainment or between 'high' and 'low' brow literature. She writes that 'the spirit of the times was such that even obviously commercial products show traces of the prominent themes of contemporary reformist discourse' (190). In the context of this literature, circulation and readership patterns are important signifiers. Anindita Ghosh (2006) points out that Bengali texts were bought by working men, petty clerks and *bābū*s who worked in offices, schools, printing presses, municipal councils, courts and railway offices. New consumers of printed plays, songbooks and cheap satires read these on their way to work. Reading for pleasure became a habit for many of these men in cities who lived away from their families in the villages. For example, Dhanpat Rai Srivastava, who later became famous as the writer Munshī Premchand, was one among many who were often transferred from one place to another initially as government school teachers and later as deputy inspectors of schools. Reading became a passion for some like him as much as writing. The transformation of Dhanpat Rai Srivastava into Premchand is also part of the story of the role played by printing presses in publishing journals, books and other forms that offered opportunities for men and women to become authors (Gopal 1965).

Until the early decades of the twentieth century, poetry held a higher status than prose in Urdu. Many owners of printing presses organized *mushā'ara*s on specific themes, and later these poems were published in the form of a *guldasta* or bouquet – a reproduction of all or part of the poetry recited at one particular *mushā'ara*. For example, Karimuddin owned a press in Delhi and sponsored a personal *mushā'ara* series held at his house each month. He then published the verses recited on each occasion in a series of brief pamphlets (Pritchett 1994: 74). The growing relationship between *mushā'ara*s and printed texts was accompanied by

literary discussions in Urdu newspapers such as *Avadh Akhbar*, *Me'yar* and *Avadh Punch* (Stark 2003: 66–94). As pointed out by C. M. Naim (1984), during these years the departments of education and British officers also encouraged the publication of Urdu prose and poetry in an effort to produce textbooks for learning Urdu and to encourage 'good' literature based on 'good morals'.

Frances Pritchett notes that one printed form that made Urdu poetry even more popular was the *tazkira*. Etymologically the Persian term '*tazkira*' has its roots in Arabic and means 'to mention or to remember' (Pritchett 2003: 864). The *tazkira* was similar to *bayāz* or little notebooks kept by connoisseurs to record their favourite verses. There was no set pattern to this collection of verses; they could be organized randomly, belong to living poets or earlier ones and at times be based on specific genres. The *tazkira*s in Urdu were influenced by their Persian counterparts, and till about 1845, most *tazkira*s of Urdu poetry were also written in Persian. Initially these texts circulated in manuscript form but with the emergence of printing presses, they also became available in print. The poet himself compiled whatever was easily known, or he based his record on conversations with his friends and his *shāgird*. Earlier *tazkira* compilers did not cite other texts they consulted, possibly because they were circulated amongst a coterie of poetry-lovers who already knew the basic rules and protocols. Pritchett (1994: 74) compares these texts to modern-day chess books which are meant for players and not beginners.

In printed form, *tazkira*s widened the circle of readership and created new discursive spaces for upcoming poets. The *tazkira*s compiled after 1860s were much longer compared to earlier compilations. Farman Fatehpuri (1972: 69–70) explains that by late nineteenth century, the *tazkira*s' compilers were influenced by literary models from the West (*magrib ke ishārat*) and employed a 'modern' style by putting emphasis on extensive research. Some of these *tazkira*s were exclusively on women poets.

Tazkiras on women poets and *tawā'if* poets

I first came across a *tazkira* that mentioned Māh Laqā Bāi Chandā's poetry in an essay by Carla Petievich (2005) on *rēkhtī* poetry. Māh Laqā Bāi used the pen name 'Chandā' and wrote using both the female and the male voice and excelled in using the tropes and imagery of *rēkhtī* poetry as did most male poets. As a performer, Chandā gave her first performance in the court of Nizām Asaf Jāh II (r. 1761–1803) and became famous in the court of Nizām Sikandar Jāh Asaf Jāh III (r. 1803–29) where she also earned the title *Māh Laqā* or the 'moon-faced one' (Azmi 1998). For Chandā, who performed in six courts during her lifetime, poetry was a means of self-fashioning. In the court of Hyderabad, most ministers and

Nizāms were poets and learning Urdu poetry was crucial for her career. In the following *ghazal*, Chandā showers praise on her patron Aristu Jāh (1732–1804), a minister in the court of Hyderabad:

> Aristu Jāh Oh Fortunate, Beautiful faced and Learned One
> Whose abundant beneficence is known throughout the world
> This is a prayer from Maulā Alī for charity land
> Let Maulā Alī keep you in his love and care always
> Nothing adorns the moon better in this world
> And whatever is visible on Chandā is for you.

<div align="right">(Jha 2015: 153)[1]</div>

Chandā excelled in all forms of the Urdu *ghazal* and could compose both in the *rēkhtā* and *rēkhtī* traditions. Her use of the masculine persona is visible in the *ghazal*s where she seeks land or patronage and/or praises the wealthy patron. In the Urdu *ghazal*, the lover could be a male or female devotee in search of a spiritual communion with his/her beloved, which could also be God in a Sufi context. Chandā's preference for the male persona as a poetic convention marked her as an elite and trained poet at par with other poets in a professional space such as the princely state.

Research on Chandā's *dīwān* soon led me to a few *tazkira*s exclusively on women's poetry.[2] These texts included compositions by *tawā'if*s who formed the largest number of women poets.[3] The *Bahāristān-i-Nāz* ('Garden of grace') was first published from Meerut in 1864. Subsequent editions were published in 1869 and 1882. The author of these texts was Moḥammad Faṣīḥ-al-din 'Ranj' (1836–85), a professional *ḥakīm* (doctor) of *yūnānī* medicine from a family of doctors in Meerut. Ranj thanked the British magistrate in Meerut for his support in printing the text. Durgaprasad 'Nādir' (1833?–) published a *tazkira* on women poets called *Gulshan-i-Nāz* ('Rose garden of grace') from Delhi in 1876. A second part of this *tazkira* was published from Delhi in 1878 and was titled the *Chaman Andāz* ('Garden of grace'). It was also called *Mir'āt-Khayāl* and *Tazkirat al-nisa-i-Nādirī* ('Tazkira on women by Nādir'). These were also printed from Delhi. All these *tazkira*s used variations of the word 'Nāz' in their titles. Petievich (2005: 228) has perceptively suggested that '*Nāz*' could variously mean 'grace, coquetry or blandishment'. Both the writers associated women with qualities of grace, yet they also found them to be coquettish. Both compilers showed off their popularity and proximity to famous women, especially the *tawā'if*s. The women poets included famous princesses and queens such as Razia Sultan (r. 1205–40), Nūr Jahān (1577–1645), Zebunissa Begam (1638–1702) and others who wrote in Persian and Urdu. The 1869 edition of *Bahāristan-i-Nāz* listed 70 women poets,

but by the third edition in 1882, the number had increased to 174; 46 wrote in Persian, 3 composed both in Persian and Urdu and the rest of the 125 women wrote in Urdu. Amongst these 125 Urdu poets, more than half were *ṭawā'if*s. The second edition of *Gulshan-i-Nāz*, also called *Chaman Andāz*, had 144 women poets out of which 87 were *ṭawā'if*s. These texts show that the largest number of women poets in Urdu were *ṭawā'if*s. But till today no anthology on Urdu poetry includes more than one or two *ṭawā'if* poets.

These *tazkira*s had long introductions, references and details on the use of varied sources of information in the form of conversations held with friends and dear ones and references to newspapers, journals, advertisements and earlier *tazkira*s used. Compilers tried to focus on the 'act' and the 'process' of compilation, sharing different stages of their research and the support they received from friends and the British officials in their city. Emphasizing that their *tazkira* was a result of extensive research, they also hoped to contribute towards the discussion on literary style (*adab*). Ranj and Nādir were contemporaries and produced their *tazkira*s almost at the same time when other publications such as dictionaries of women's language were being printed (Lakhnavī 1930). Both participated in the debate on women's education and emphasized the need for books for women further promoting their own texts as an example. They praised the colonial government for building schools and *madrasa*s for women and wanted their texts to encourage a wider readership amongst women. The conflicted position shared by literary intellectuals engaged in social reform after the events of 1857 is visible when we see their gratitude to British officials at educational institutions or local magistrates in their cities as well as their angry response to accusations of illiteracy by the same, and their *tazkira*s are meant to prove how women had access to education and literature in the past and composed poetry (Ranj 1882: 3–6; Durgaprasad 1878: 2).

According to both Ranj and Durgaprasad, women from *sharīf* or honourable households participated in poetic gatherings or *mushā'ara*s held in their households. In the late nineteenth century, '*sharīf*' meant a person of good character, honourable, cultured and respectable rather than noble by birth or status. Ranj iterated that he compiled their verses after attending gatherings of women poets who also allowed him to copy their compositions. He found some verses in old books and in friends' collections. In his descriptions of *sharīf* women, he did not include details on their lives as 'they lived in *pardā* and any attempt to pry into their lives would have been an act of obscenity (*be-hūda-gī*)' (Ranj 1882: 5–7). However, details on their families, poetic lineage and the *mushā'ara*s attended were included.

The texts maintained a distinction between *sharīf* women and *ṭawā'if*s, and personal information on the former was kept to minimum while details on the lovers and scandals of the latter were liberally included. In a few cases, details of

places the *ṭawā'if*s belonged to and the dates of birth were also mentioned. In his *tazkira*, Ranj often pointed out if a particular *ṭawā'if* was alive during the Rebellion of 1857 or had started her career later. Descriptions included their *ustād*s and snippets of personal gossip such as their relationships with other men. More than the poetry of the *ṭawā'if*s, their relationships, sense of humour and ability to entertain their audiences along with wit and coquetry were emphasized. The *ṭawā'if*s made for interesting reading; however, the compilers were biased against them and clearly upheld standards of *sharīf* behaviour and *pardā*. One example of this bias is visible in their treatment of the *ṭawā'if* Māh Laqā Bāi 'Chandā' of Hyderabad. Māh Laqā was an established poet, a wealthy courtesan and a patron of artists, writers and musicians (Jha 2015). Both Ranj and Nadir mentioned her as one of the first woman poets of Urdu but only highlighted her talents in archery and horse riding – both metaphors for coquetry and sexual prowess – rather than including her poetry. Ranj claimed that he did not find more than a verse, but as observed by Petievich (2005: 228) that is highly unlikely considering that her *dīwān* was available. In fact, the stature of Māh Laqā Bāi 'Chandā' as a highly placed courtesan had confused Garcin de Tassy (1870: 488), the French commentator on Urdu literature, enough to call her a queen, but Ranj and Nādir hardly included her poetry. Both men were aware of each other's work and cited them in introductions to subsequent editions. Ranj had generously lent de Tassy (1870: 10) his own compilation to refer to. However, this relationship among the compilers was not always a friendly one. They had fierce arguments and exchanged accusations and letters in print over the number of women poets included in each of their works. They accused each other of copying (Fatehpuri 1972: 457–63, 538–49). Despite similar interests, the printed world of the *tazkira* had clearly become an arena of competition by the late nineteenth century. Each author tried to claim literary status and more research skills which meant whosoever had a longer list of women poets was a better collector and compiler. Although they were keen to emphasize that *sharīf* women were poets, they also wanted to be popular and boasted their proximity to *ṭawā'if*s who were their contemporaries.

Hence by the late nineteenth century, Urdu print culture had become a vibrant arena for competing standards of 'literary' taste. Popular genres like songbooks or *tazkira*s offered men such as Ranj and Nādir the means to forge new identities as authors in a fast changing world. These *tazkira*s were not simply meant to encourage women readers; they also entertained in order to make profit for the printing presses. Authors tried to outsmart each other by adding to the number of *ṭawā'if* poets, which led to more editions. These texts carried blurbs, which claimed that they catered to an audience who wanted to read books on 'amorous thoughts' ('*āshiqānā khayālāt*').[4] Apart from advertisements on their covers, chronograms included in Durgaprasad's *tazkira*s also worked like 'blurbs'. The art of

'*ilm tarīkhgoi*' or composing chronograms in Urdu was based on rules whereby each letter of the Arabic alphabet was assigned a numerical value and the letters were grouped to form words which could be part of a phrase. The words were composed to give the exact year of the composition of the phrase. Chronograms were used in manuscripts before the use of print, but in late-nineteenth-century printed texts, these verses date the production of the book (*qitāb at tārikh*). The art of the chronogram was unique in its blend of poetic praise and historicity of the event and the subject's life. Printed as part of the *tazkira* these verses played with words to give the dates of composition of the *tazkira* and included the name of the composer of the verse. In earlier times, the victories, exploits during wars, any royal births or deaths were all recorded by royal chronogrammers (Qadiri 1988: 134–35). An invaluable source to understand the reception of these *tazkira*s, the following chronogram makes it evident that these compilations were read for pleasure and entertainment:

> This is a *tazkira* of beauties
> In this there are accounts of grace (coquetry)
> Nādir the Pure One wrote it
> It is an account of secrets
> It is fun to read women's secrets
> These are accounts of passion and beauty
> Manners (grace) are not discussed here
> Neither are these accounts of discrimination.
>
> (Nādir 1878: 4)[5]

The *tazkira*s offered a glimpse into women's lives, their 'passions' and 'secrets', and readers waited for them eagerly as suggested by this fellow writer:

> This *tazkira* is a blessing
> We were all hungry for this, each one of us
> And that isn't all, it's a manual
> Which will be famous for ever
> See the affect of sweet compositions
> Each creation is a sweet mango.
>
> (1878: 5)[6]

The chronograms in praise of Nādir's *tazkira*s were written by his friends and colleagues which seems like an interesting means to increase sales. In *Chaman Andāz*, there are many chronograms mostly written by *munshī*s from a wide range of cities such as Tonk, Lahore, Kanpur and Meerut. Some of these *munshī*s were employed

at schools. So clearly, like in Bengal, the *munshī*s in North India made up a large section of the readership for these popular texts.

As I have argued elsewhere, in the late eighteenth and early nineteenth centuries, landed elites, princely rulers, *nabob*s and *nawāb*s had been the main patrons of the *ṭawā'if*s. Some European soldiers who were part of the East India Companies also became their patrons. Low-class prostitutes variously called *ramjanī*, *kanjarī* and *kasbī* catered to the lower ranking soldiers; however, the senior officials were invited to performances by famous nautch girls or *ṭawā'if*s (Sachdeva 2008). Although many *ṭawā'if*s lost patronage and were discriminated against after the Rebellion of 1857, these *tazkira*s show that some *ṭawā'if*s continued to be active in poetic circles in smaller towns and cities. A majority of *ṭawā'if* poets listed in the *tazkira*s belonged to towns such as Tonk, Lahore, Delhi, Kanpur, Meerut, Hyderabad, Lucknow, Calcutta and Murshidabad. On many occasions, their *ustād*s, who belonged to Meerut, Kanpur, Tonk, Lucknow and Delhi, are also mentioned. Clearly the *ṭawā'if*s had found mentors and audiences in men other than the landed elite and many had migrated to Calcutta. Wājid 'Alī Shāh (r. 1847–56), the erstwhile Nawāb of Awadh, had shifted to the Mutiyaburj region near Calcutta during his exile in the year 1856. The landholders there hosted *maḥfil*s or musical soirées as much as the Nawāb himself. Musical genres of *ṭhumrī* and *dādrā* were performed by women known as *bā'ījī*s. Unlike prostitutes who found a few opportunities to transform into actors on the Bengali stage, *bā'ījī*s were professional singers and did not perform on stage (Bhattacharya 1998, 2003). The term '*bā'ījī*' was used in Bengal by performers to distinguish themselves from the prostitutes on stage. As noted by Richard Williams (2017), the Nawāb's senior wife, Khās Mahal, was a talented poet who had published a *dīwān* and *ṭhumrī* collections. Many courtesans had migrated to Mutiyaburj in search of patronage, and composing poetry provided these *ṭawā'if*s with the means to forge new identities as poets; *Umrāo Jān Ádā* famously tells the story of this transformation through a fictional narrative.

The Urdu *ghazal* and the forgotten *ṭawā'if* poets

The most popular genre of Urdu poetic composition and performance in the nineteenth century was the *ghazal*, a genre that had great potential to be read and sung in the courtly culture of performance. Its significance as a form of political diplomacy is clear through the nautch performances organized by rulers as a means of entertainment for other elites.[7] *Ṭawā'if* Māh Laqā Bāi Chandā chose to gift her *dīwān* as a *naẓar* or offering to John Malcolm, an English East India

Company official, during a dance performance. She used it as a strategic tool to seek patronage and engage in political diplomacy in the year 1799 (Dalrymple 2002).[8]

Composers of Urdu poetry often used a *takhallus* or pen name, and *tawā'if*s and *sharīf* women used similar pen names such as Zohrā (Venus), Ḥijāb (veil), Shīrīn (sweet) or Ḥayā (shame). The same holds true for their compositions. *Ghazal*s composed by *tawā'if*s, *sharīf* women and male poets are not glaring in terms of difference or peculiarities in styles of poetic composition and language. Scott Kugle convincingly argues that these pen names and *ghazal*s cannot be read as practices of self-portraiture in search of some coherent, unique subjectivity which may be seen as feminine or masculine (2010: 368). Composing *ghazal*s was a common pastime for women of all backgrounds, both professional *tawā'if*s and *sharīf* women (Jha 2015). However, the *tawā'if*s were aware of using this poetic skill to their advantage as it offered them a means of self-fashioning. The relationship between *ustād* and *tawā'if*s was crucial in this transformation.

Two famous *tawā'if* sisters of Lucknow, Zohrā and Mushtarī, who were contemporaries of Ranj and Nādir, become case studies in this context. Although popular *tawā'if*s at that time, tracing their biographies is extremely difficult in the light of scanty information and the difficulty of separating gossip and scandal from factual detail. Any history of retrieval is riddled with hurdles; however, an attempt is essential. Daughters of Imām Bandī *Tawā'if* alias Chhotī Bī (d. 1868), 'Zohrā' and 'Mushtarī' of Lucknow were sisters (Sitapuri 1962: 166–86).[9] They were born in Khairabad and came to Lucknow with their mother and their aunt at a very young age. We do not know the date of birth of the elder one, who was called Bī Chuttan, but the younger sister, called Manjhū, was born in 1842. On moving to Lucknow, both sisters began to learn Persian and Urdu from a poet, Mirzā Āghā Alī 'Shams'. As a poet, Shams had initially been supported by the patronage of Nawāb Moḥammad 'Alī Shāh of Awadh (r. 1837–42) and was on the payroll of the court. He was honoured by the title of 'Khān Bahādur' (Sitapuri 1962: 173). However, during the later phase of his life, Shams began to face dire financial conditions. Since he was in love with *tawā'if* Imām Bandī, he began to stay at her house. At this time, he also became the *ustād* to her two daughters, Bī Chhutan and Manjhū. Shams often got into quarrels with other poets who teased him about staying at the house of the *tawā'if* (Asi 1929: 150; Nadir 1878: 80–81). As the sisters grew older, they took up different names as professional performers: Bī Chuttan became Umrāo Jān and Manjhū began to call herself Qāmrān Jān. Upon learning to compose poetry, they took upon the following *takhallus* or pennames: Zohrā and 'Mushtarī (Jupiter), respectively. Both sisters then received musical training under Haidar Alī *Qawwāl* and learnt dance from Ustād Ghaisat

Khān. Born to a *ṭawā'if*, they had achieved fame in the elite *maḥfil*s of Lucknow during the reign of Wājid 'Alī Shāh. Zohrā and Mushtarī survived the Rebellion of 1857 and continued to be famous in Lucknow.

In his biography of the famous Urdu poet Ghālib, Nadim Sitapuri recalls that these women had established themselves as poetic rivals (*ḥarīf*) to his style of poetry and their compositions were published in newspapers like *Urdu Akhbār* as a response to Ghālib's verses (1962: 174). In late-nineteenth-century Lucknow, there were few followers of Ghālib. Poets Khwāja Haidar Alī 'Ātish' (1778–1846) and Imām Baksh 'Nāsikh' (1787–1838) were more famous at that time. Discussions and criticism of poetry was common in Urdu newspapers, and the sisters were trying to put forth a distinct style of their own. Another biographer of Ghālib, Malik Ram, wrote about a poetic quarrel that took place between the poet and the *ṭawā'if* sisters:

> It is known that Lucknow's two famous prostitutes [*raṇḍī*] Qamran Jān 'Mushtarī' [also known as Manjhu] and Umrāo Jān 'Zohrā' [also known as Bi Chuttan] also participated in that quarrel. These women are talented and educated students of Aga Alī 'Shams' however many people think that Aga Alī Khān wrote these criticisms of Ghālib's style and published them in the name of Zohrā, Mushtarī.
>
> <div align="right">(cited in Sitapuri 1962: 171)</div>

Ram wrote of the two sisters as talented and educated students of Shams but was quick to assert that most probably it was the *ustād* who printed his criticism in the name of the *ṭawā'if* sisters. It seems strange that Shams would choose to do so at a time when he was being criticized for staying at the house of a *ṭawā'if*. It might be that the *ṭawā'if* poets asserted their own style or upheld their *ustād*'s teachings as better over Ghālib's. Ram was of course biased in his opinion as he referred to Zohrā and Mushtarī as *raṇḍī*, a term which had become clearly derogatory and meant a low-class prostitute by the time he wrote his *tazkira* in 1867. The literary quarrel between Ghālib and the sisters shows that *ṭawā'if*s were participants in debates over poetic taste printed in Urdu newspapers. They also had readers who admired them such as Pandit Kishan Lal 'Dehalvī' from Delhi, who wrote this verse in their praise:

> Students of Shams are Zohrā and Mushtarī
> The elder one is great the younger one is pure gold.
>
> <div align="right">(Sitapuri 1962: 169)</div>

Of the few women listed in *tazkiras* who could compose poetry both in Persian and Urdu, *ṭawā'if* Mushtarī had compiled two texts which included Persian

*ghazal*s and were respectively titled *Tarāna-i-Khayāl* and *Khana-i-Khayāl*, which were printed in Lucknow.[10] The titles suggest that they were probably collections of songs. These songbooks went into print again and the second edition of *Khana-i-Khayāl* had a note in its praise by one *munshī*, Javahar Singh 'Jauhar'. The other, *Tarāna-i-Khayāl*, was also famously known as *Dīwān-i-Mushtarī* ('Diwan of Mushtarī') and had more than 100 *ghazal*s (Sitapuri 1962: 181). In the later years of their lives, both the sisters got married and stopped participating in musical or poetic gatherings. Mushtarī married Saiyyid Aijāz Ḥusain 'Aijāz' and died in the year 1892. Unfortunately, I could find nothing more about Zohrā.[11]

These life histories of Zohrā and Mushtarī show us the trajectory of two girls who were born to a *deredar tawā'if* and became famous but retired from their professional careers after marriage. Trained in poetry by an *ustād* who might have also been their mother's lover, the sisters were active participants in debates on poetic taste and continued to be famous performers even after the Rebellion. In the following years, writers and *munshī*s often recalled their compositions and wrote about their skills at poetry. Their own collections of songs were printed by Urdu presses, and their compositions added to the sales of *tazkira*s in the late nineteenth century. Men like Ranj and Nādir were all aspiring writers based in cities like Meerut, Delhi and Hyderabad who became popular by writing about *tawā'if*s. Meanwhile, unlike Zohrā and Mushtarī who belonged to *tawā'if* backgrounds, some women like Adeline chose to enter this profession as a means of upward mobility and sustenance. Adeline Victoria Hemmings soon became the now famous Malkā Jān 'Banāraswāli' or Memsahib *Tawā'if* 'Banārasī' (1857?–1906).

Vikram Sampath notes that Adeline Victoria Hemmings was born to an English father, Hardy Hemmings, and his Indian *bībī*, Rukmanī. Rukmanī converted to Christianity and was baptized as Mrs Elijah Hemmings while they lived in Azamgarh. After Hardy's death, Rukmanī had to struggle for a living. She soon began to work in a dry ice factory. She had to bring up her daughters, Adeline or Bikī and the younger Belā. When the beautiful Bikī was just 15 years old, she found a suitor in the 20-year-old supervisor Robert William Yeoward, a young man of Armenian descent. Adeline and Robert were married on 10 September 1872 at the Holy Trinity Church of Allahabad (Sampath 2012). Robert soon got a lucrative offer to work at an indigo plantation far away from Azamgarh. Adeline and Robert had a daughter who was born on 26 June 1873 whom they named Angelina. During the time Robert spent at the plantation, Adeline began to frequent her neighbour Jogeshwar Bharati who was a man of letters and interested in music. Apparently, Robert became suspicious of their relationship which soon led to a divorce. The couple legally separated in the year 1879. Adeline found some support in Khurshīd, a local Muslim man who was interested in her and music. After the divorce, Khurshīd and Adeline moved to Banaras with her mother Rukmanī

and her daughter Angelina. In Banaras, Adeline chose to convert to Islam and adopted the name Malkā Jān while Angelina became Gauhar Jān (1873–1930) and would later grow up to be one of the most famous gramophone recording artists in India. Following the tradition of apprenticeship to a male *ustād* in Urdu poetry, Malkā had Husain Aḥmad Aṣgar as her *ustād* in Urdu, while Qadar Husain taught her Persian. Hakīm Banno Ṣāhib 'Hilāl' also taught her Urdu poetry. She learnt dance from Kālū Ustād and Alī Bakhsh of Lucknow. After spending eight years in learning music, dance and poetry, Malkā became a *ṭawā'if* and was known as Malkā Jān 'Banāraswāli' or Memsahib *Ṭawā'if* 'Banārasī' (Sampath 2012). The name of the city that she trained in was crucial as it distinguished her from the other *ṭawā'if*s who also chose Malkā Jān as a professional name.

By the late nineteenth century, names of cities and towns became important for performers and gave them a distinct identity (Neuman 1980). Like *gharānā*s or musical households, the regional location became significant because patrons were no longer restricted to princely courts; rather upwardly mobile groups of *bābū*s and landowners in smaller towns and cities also offered performers opportunities to perform. The name of the town or city allowed the *ṭawā'if* to fashion an identity based on the 'tradition' of a local musical *gharānā* with a specific style of poetry and singing. Travelling to distant cities and towns had always been part of a performer's itinerary, but by the late nineteenth century when many women from performing and non-performing backgrounds were competing to be famous *ṭawā'if* singers, and most of them took up common professional names such as 'Malkā', it was necessary to appear different from each other and yet to appeal to 'tradition' and a hoary past. During the time of Malkā Jān 'Banārasī', other performers included Malkā Jān of Agra, Malkā Jān of Mulk Pukharaj and Malkā Jān of Chulbuli. Adeline became 'Badi Malkā' (Sampath 2012).

In the year 1883, Malkā Jān moved to Calcutta and settled down in the area of Bow Bazār with her daughter. Badi Malkā was employed as a performer by Wājid 'Alī Shāh and soon her wealth and popularity helped her to buy a house on Chitpore Road for 40,000 rupees (Sampath 2012; Nevile 1996). One of the oldest streets in Calcutta, Chitpore Road was known for its many shops and cosmopolitan inhabitants ranging from rich merchants and shopkeepers to prostitutes. In 1886, Malkā Jān's collection of songs called *Dīwān-i-Malkā Jān* was printed from Calcutta by Ripon Press. It was unique in its frontispiece and iconographic use of a crown and angels which showed Malkā Jān as a *malikā* ('queen') (figure 4.1). The frontispiece image was ingenious in its sketch of a hall of fame or palace with angels holding a crown resting firmly on a sketch of Malkā Jān of Banaras, followed by the words, 'Bibi Malka Jan of Benares Now at Calcutta'. An illustrated frontispiece, together with the iconographic use of the crown and the sketch and

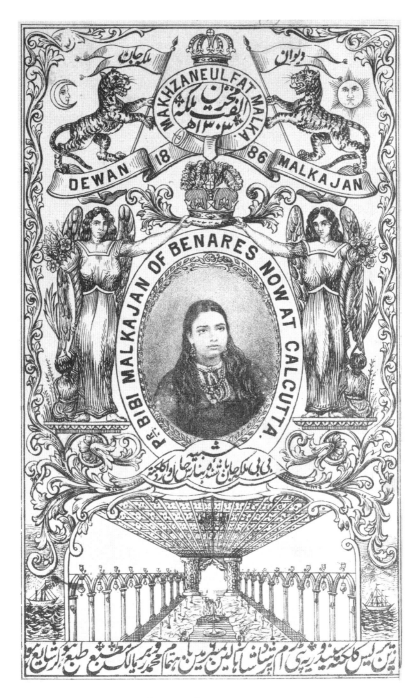

FIGURE 4.1: Frontispiece of Malkā Jān's *dīwān*.
Source: Malkā Jān, *Dewan-i-Malkā Jān* (Calcutta: Ripon Press, 1886). © The British Library Board (14114.b.43.1).

these words, clearly exhibited the status of Malkā Jān as a celebrity. The *dīwān* also had a Persian title, *Makẖzān-e-Ulfat Malkā* ('Treasury of desire by Malka').

The extent of Malkā's fame can be judged from the fact that *dīwān*s printed in the late nineteenth century usually had flowers, calligraphy and animal figures such as lions, but hers had a complex illustration of a woman with a crown. This illustration was also called a *shabīh* or portrait. Anyone who bought this *dīwān* could not only read her songs but also carry an image of her. *Dīwān-i-Malkā Jān* had 108 pages, of which the first 86 were devoted to Malkā's compositions, including *ghazal*s, 14 *thumrī*s, *holī*s and other popular musical genres. An exhibition of the considerable range of her repertoire, the *dīwān* also showed her skill at composing *ghazal*s like the following:

> *Josh men phir lab nāshād āyā*
> *Phir mujhe āj waṭan yād āyā*
> *Faṣl gul bhī nahīn āne pāyī*
> *Pahle hī bāgh men sayyād āyā*
> *Ḥukm hote hī ga'ī jān meri*
> *Bād mardon mere jallād āyā*
> *Dekh kar ẓa'īf ko woh bhī royā*
> *Beṛiyān le ke jo ḥaddād āyā*
> *Shīrīn kī yād se taskīn hu'ī*
> *Josh men jab dil farhād āyā*
> *Ġair maujūd nahīn tha ye dil*
> *Khāna-e-yār se to shād āyā*
> *Āp hī āp jo yūn rotī ho*
> *Malkā sach kaho kya yād āyā.*

<div align="center">(Jan 1886: 7)</div>

('Once again, gloom has overwhelmed passion
For, once again, I remember my beloved homeland
The flowers were yet to bloom
But the destroyers were already in the garden
At his command, my life was already lost
The executioner arrived after my death
He also wept at my feebleness
Old age had got its own shackles
Thinking of Shirin brought some comfort
When my heart became like Farhad
My heart was still here, beating
When happiness arrived from my beloved's home

What made you cry so?

Malka, Tell the truth, what is it that you remembered?')[12]

Written in simple colloquial Urdu, Malkā's *ghazal*s were clearly meant to be sung. Her command over seasonal genres like *holī* and *thumrī* is also visible through her compositions. One poet who expressed his appreciation for Malkā's compositions was Moḥammad Ibrāhīm Shāh Ṣāḥib Bahādur 'Rasa' from the royal family of Mysore. Shāh wrote a *taqrīz* or laudatory foreword for her in the *dīwān*. A disciple of Ḥazrat Shokhī, his note of appreciation was written in ornate Urdu that carried a strong Persian flavour in contrast to the simple Urdu of the *ghazal*. Lamenting the loss of the 'great days of golden age and great poets whose *dīwān*s were their only memories left', Shāh recalled:

> Since Ripon Press was printing the *dīwān* of Malkā Jān, I thought I might also become famous by writing something on this subject and seek recognition [...] the fame of Malkā Jān may achieve even higher heights and her compositions need not just be limited to lovers of her charms but also become a collection for posterity.
>
> (1886: 86–90)

In his appreciation, Shāh further reiterated that although Malkā was a woman, 'her talents were commendable' and her poetry was 'wonderful' and 'sweet'. His preface was full of praises for her charms, her beauty and her songs. Ram Babu Saksena (1927), the first Indian compiler of a history of Urdu literature in English, who also compiled Urdu poetry written by European poets, also lavished praise on Malkā Jān. He called her a 'professional dancer and singer of great repute throughout India' who participated in *mushā'ara*s where she recited her own compositions (Saksena 1941: 292–96). Malkā Jān 'also used to convene [...] *mushā'ara*s in her house' and appreciating the poetic quality of her *ghazal*s, Saksena recalled:

> [They] are remarkable for the flow of the language and correctness of the idiom. Most of them are suited for singing and can easily be adapted to vivacious tunes. There is not much of literary merit but they are free from solecism of idioms or rules of prosody. There are no flights of fancy or literary beauties or subtleties of feeling. A purist can point to flaws, but such as they are they prove conclusively that the authorship belongs to Malika. On the whole they show considerable skill and Malika does not eschew difficult metres and stiff *qāfiya*s and *radīf*s. The *ghazal*s are a proof of her poetical powers and skill. In the composition of songs Malika has acquitted herself with great credit and they bear testimony to her great knowledge of music, and her proficiency of Hindi language.
>
> (1941: 295)

Even before Ram Babu Saksena included Malkā Jān in his anthology, she had her own contemporaries praising her. Her *dīwān* ran 18 pages of chronograms in praise of her work. Most of these were written by men who were employees with the colonial government such as the East Indian Railways and *munshī*s from cities like Delhi, Punjab, Dhaka, Bhagalpur and Patna, magistrates, court poets from Azimabad, a *rājā* from Bhagalpur, a *nawāb* from Hyderabad and owners of printing presses like Moḥammad Vazīr of Ripon Press, who had printed Malkā's *dīwān*. The most interesting aspect of these chronograms is that they reveal the readership of these songbooks was not limited to men only but also extended to women; most of them were *ṭawā'if*s like Bībī Manjhū Ṣāḥibā *Ṭawā'if* Mushtarī of Lucknow, Bībī Chhattā Jān *Ṭawā'if* of Bareli, Bībī Naṣīran Jān alias Payyan *Ṭawā'if*, Bībī Majho Ṣāḥibā Yahūdan Parī from Calcutta, Bībī Khurshīd Jān alias *Ṭawā'if* Ḥasīn Dehalvī from Calcutta and Bībī Gunnāh Jān *Ṭawā'if* alias 'Bā Ḥusn' from Darbhanga and others. There were as many as eleven *ṭawā'if* singers who had congratulated Malkā on the printing of her songbook. The *ṭawā'if*s were part of a community who kept in touch with each other and read each other's work. This case study of Adeline Victoria Hemmings shows a girl who may not have been born into a *ṭawā'if* family but who chose to become a *ṭawā'if*. Opportunities to become singers and celebrity entertainers in cities in North India meant that the *ṭawā'if* poets had an audience amongst landlords, *munshī*s, railway employees, court poets and others. *Ṭawā'if*s such as Zohrā, Mushtarī and Malkā Jān became celebrity entertainers whose songbooks made them famous and added to their glamour and status as 'stars' in a changing urban milieu of consumption and pleasure.

In the year 1799, when two manuscripts of Māh Laqā Bāi Chandā's *dīwān* were compiled, the texts were only meant to be read by a coterie of elite patrons. In the pre-print milieu, getting a *dīwān* scripted and bound was a rare occurrence and being an owner held great symbolic value. Its circulation was limited to two copies, both of which were most probably made in Chandā's *Kutub khāna* or library. But by the late nineteenth century, printed songbooks of Zohrā's and Mushtarī's *tazkiras* were affordable to a wider set of readers. These texts often went into several editions because of the popularity of the *ṭawā'if* which therefore extended beyond specific cities and elite patrons. Interest in the lives of the *ṭawā'if*s earned the press owners revenue and let the *tazkira* writers make their own careers as writers. For some women, the profession of being a performer and the possibility of printing a songbook meant wealth, fame and an escape from an unhappy marriage. Ranj, Nādir and *ṭawā'if*s like Malkā Jān 'Banaraswali', Zohrā, Mushtarī and Umrāo were all part of a group of new professionals based in the cities who had successfully fashioned new identities for themselves as writers, performers, poets and celebrities respectively in the urban cityscape.

The histories of Urdu print culture and that of *ṭawā'if*s are intertwined when we focus on scholars like Abdul Halīm Sharār who made them a part of the historiography of Lakhnawī culture. One of the most commonly used historical sources today, the *Guzishta Lakhnau* was written by Abdul Halīm 'Sharār' (1860–1926) in the first few decades of the twentieth century. The young Abdul had spent about ten years of his life with his father who was an employee in the retinue of the exiled ruler Wājid 'Alī Shāh in Mutiya Burj. On his return to Lucknow in the 1880s, Abdul began to write under the penname of 'Sharār' or the Spark. He became a writer of Urdu stories and novels and started a monthly Urdu magazine in Lucknow called *Dil Gudāz* ('Quickner of the heart') in the year 1887. Sharār was a prolific writer who went on to write about 102 books, including histories. He edited and published about 9 literary journals at different moments in his lifetime. For a short while, he also worked in the court of Hyderabad which took him to England in the Nizām's retinue. Sharār eventually chose to become an independent writer and editor. From the year 1913, he started writing a series of essays on the erstwhile *tahzīb* and *nawābī* culture of Lucknow. These essays portrayed his nostalgia for Lucknow's past and his attempt to write a rich history of Indo-Muslim culture. They were later collected into a book called *Hindustān meṅ Mashrīq Tamāddun ka Ākhrī Namunā*, which literally meant the 'Last Phase of Oriental Culture in India' (Sharār 1975).

Sharār's chronicle on Lucknow described the *ṭawā'if*s in great detail while attributing to them a significant role in shaping Lakhnawī *tahzīb* or etiquette. He wrote that elite families sent their young sons to learn the nuances of etiquette and culture from the *ṭawā'if*s. He described the costumes, poetry, music and dance forms of late-nineteenth-century Lucknow which included the lifestyle of its famous courtesans. Sharār had belonged to an aristocratic background associated with the royal court of Awadh. Although a supporter of the Aligarh school and Muslim revivalism, he held a unique position when it came to the question of Indo-Muslim 'pasts' (Husain and Harcourt 1989: 20). For Sharār, pride in the Indo-Muslim past was important, and he tried to see in it a rich and flourishing cultural heritage. His descriptions of the *ṭawā'if*s and their music and dance were linked to his vision of a beautiful and rich past. However, to others like Āzād, Ḥālī and Nādir the need of the hour was social reform and education. Sharār's history of Lucknow made the *ṭawā'if* an indelible part of a nostalgic history of courtly culture, but as I have argued earlier, the *ṭawā'if*s were also modern-day celebrity entertainers whose written compositions were part of a bourgeoning popular culture whose consumers were no longer the elite *nawāb*s but men and women from a wider range of backgrounds.

Conclusion

Writers of songbooks, subjects for *tazkira*s and Urdu novelists, the *tawā'if*s and their lives as performers were intimately linked to changing cityscapes and the world of Urdu print culture. Since the 1860s, cheaper printing technology had led to a proliferation of all types of literature: poetry, songbooks, novels and chronicles. These books were part of a world of cheap literature that was read for pleasure and entertainment. After the Rebellion of 1857, in cities such as Lucknow, Banaras and Calcutta, some women from performing and non-performing backgrounds continued to find opportunities to be famous as *tawā'if* singers and celebrity entertainers. They travelled across cities and towns to perform in musical gatherings and participated in *mushā'ara*s. Their songs circulated in songbooks, and their lives were written about by *tazkira* writers. This also meant the creation of new groups of male patrons who could not afford to attend their performances but were avid readers of literatures that revolved around the lives of these glamorous women. In this competitive, vibrant and wider urban world of performance and entertainment, many *tawā'if*s began to assert their distinct identity using the name of towns and cities they trained in. Their salons continued to attract landlords, merchants and aspiring poets and writers. For writers like Abdul Halīm Sharār, the *tawā'if*s were an important part of the history of courtly culture. To other petty clerks and working men who could not afford to attend the performances of these *tawā'if*s, the *tazkira*s were a handy source of gossip about their life and the *dīwān*s offered the possibility of owning a collection of their songs. The history of the *tawā'if* is thus a part of the emerging world of vernacular modernity in the late nineteenth century. As Bhaskar and Allen articulate in their earlier volume: 'The Islamicate cultures of Bombay cinema are imagined forms of the past, and therefore a contested site of histories and identities' (2009: 22). This chapter has attempted to trace the contours of the contested figure of the *tawā'if* who continues to inspire filmmakers and academics to decode her life as a writer, entertainer, performer and woman. Her history is not confined to being a mere symbol of courtly culture or moral decadence; rather it is a story of struggle and survival.

NOTES

1. My translation of the *ghazal* beginning '*Rahe hai Nauroz ishrat āfrin*'.
2. Petievich has analysed one *tazkira*, *Bahāristān-i-Nāz*, in great detail. I am grateful to Leena Mitford, who was working as Urdu curator at the British Library in 2006–2008, for introducing me to these texts and helping me at every stage.
3. I focus on those that were printed between the 1860s and 1880s; there was one *tazkira* on women poets printed in 1929. Compiled by Maulawī Abdul Bari 'Asi' (1893–1946), it was called the *Tazkirat-al-Khawātīn* ('Tazkira on women').

SITUATING THE ṬAWĀ'IF AS A POET

4. Such as *Bahāristan-i-Nāz* published in 1882.

5. The verses are my translation of the following chronogram:

> *Tazkira shě'r-go ḥasīnoṅ kā*
> *Jismeṅ haiṅ ḥusn nāz kī bāteṅ*
> *Nādir Pakbaz ne likhā*
> *Jiskī bāteṅ haiṅ rāz kī bāteṅ*
> *Hai mazā'aurātoṅ kī bātoṅ meṅ*
> *Hai jo soz-o-gulzār kī bāteṅ*
> *Nāz-o-andāz kā nahīṅ yahāṅ zikr*
> *Aur nā hai imtiyāz kī bāteṅ.*

6. Similarly, the following verse has also been translated by me:

> *Goyān ně'mat hai ye goyā tazkira*
> *Jis meṅ bhūke baiṭheṅ haiṅ sab khās-o-ām*
> *Yahī nahīṅ bātoṅ kā guṭkā banā hai*
> *Jis kī taa-hashr rahegī dhūm dhām*
> *Dekhnā shīrīn kalamī kā asar*
> *Uskā har fiṭra hai goyā mīṭhā ām.*

7. Nautch was a distortion of the word '*nach*' or dance performance which involved musicians and women dancers. Since the English did not know the difference between trained dancers and prostitutes, their condemnation of this practice soon led to the anti-nautch movement.

8. The performance was hosted on 18 October 1799 by Mīr Alam Bahādur who later became a powerful minister in the court of Hyderabad.

9. I am grateful to the late Usman Ḥusain of Khairabad for sharing Nadim Sitapuri's biography of Ghālib with me during my doctoral research. In this text, Sitapuri specifically mentioned the role played by the people of Khairabad in the transformation and emergence of Ghālib as a famous poet. This biography of the two sisters is based on my translation of the Urdu text.

10. The late Usman Ḥusain recalled that his grandfather was a patron of Mushtarī and both had often exchanged letters with each other. Unfortunately, the letters are now lost, but Sitapuri mentions one letter written by Mushtarī in Persian, and many others might be in personal collections. Personal communication, 10 September 2005, Lucknow.

11. Mushtarī's birth and death dates often vary. Either she was born in 1842 and died at the age of 50 years in 1892 or she was born in 1835 and died at the age of 57 in 1892.

12. For a digital copy of an undated modern reprint of the *dīwān*, see *Deewan-e-Bibi Malka Jan* at https://rekhta.org/ebooks/deewan-e-bibi-Malika-jaan-ebooks. Accessed 11 June 2021. The translation from Urdu to English is mine.

REFERENCES

Anderson, Benedict (1983), *Imagined Communities: Reflections on the Origin and Spread of Nationalism*, London and New York: Verso.

'Asi', Maulwi Abul Bari (1929), *Taẕkirat-al-Khavātin*, Lucknow: Naval Kishore Press.

Azmi, Rahat (1998), *Mah Laqa: Halat-i-Zindagi Mah-i-Diwan*, Hyderabad: Urdu Academy Andhra Pradesh.

Bhaskar, Ira and Allen, Richard (2009), *Islamicate Cultures of Bombay Cinema*, Delhi: Tulika Books.

Bhattacharya, Rimli (1998), *Binodini Dasi's 'My Story and My Life as an Actress'*, New Delhi: Kali for Women.

Bhattacharya, Rimli (2003), 'The nautee in "the second city of the Empire"', *The Indian Economic and Social History Review*, 40:2, pp. 192–235.

Blackburn, Stuart and Dalmia, Vasudha (eds) (2004), *India's Literary History: Essays on the Nineteenth Century*, Delhi: Permanent Black.

Chakrabarty, Dipesh (2011), 'The muddle of modernity', *The American Historical Review*, 116:3, pp. 663–75.

Chakravorty, Pallabi (2008), *Bells of Change: Kathak Dance, Women, and Modernity in India*, Chicago: University of Chicago Press.

Dalrymple, William (2002), *White Mughals: Love and Betrayal in Eighteenth Century India*, London: Harper Collins.

Das Gupta, Amlan (2005), 'Women and music: The case of North India', in B. Ray (ed.), *Women of India: Colonial and Post-Colonial Periods*, London: Sage Publications Ltd, pp. 454–84.

Das Gupta, Amlan (ed.) (2007), *Music and Modernity: North Indian Classical Music in an Age of Mechanical Reproduction*, Kolkata: Thema.

De Tassy, Garcin (1870), *Histoire de la Littererature Hindouie et Hindoustanie*, vol. 3, Paris: n.p.

Fatehpuri, Farman (1972), *Urdu Shu'ara ke Tazkire aur Tazkīrā Nigārī*, Lahore: Majlis Taraqqi-e-Adab.

Gopal, Madan (1965), *Munshi Premchand: A Literary Biography*, New York: Asia Publishing House.

Ghosh, Anindita (2006), *Power in Print: Popular Publishing and the Politics of Language and Culture in a Colonial Society*, Delhi: Oxford University Press.

Habermas, Jürgen ([1962] 1989), *The Structural Transformation of the Public Sphere: An Inquiry into a Category of Bourgeois Society*, Polity Press: Cambridge.

Hansen, Kathryn (1998), 'The migration of a text: The *Indar Sabha* in print and performance', *Sangeet Natak Akademi Journal*, 127–28, pp. 3–28.

Husain, Fakhir and Harcourt, E. S. (1989), 'Note on Abdul Halim Sharar', in E. S. Harcourt and F. Husain (eds), *The Last Phase of an Oriental Culture*, Oxford: Oxford University Press, p.20.

Jan, Malka (1886), *Dīwān-i-Malkā Jān*, Calcutta: Ripon Press [Digital undated reprint of a modern edition, *Deewan-e-Bibi Malka Jan*, https://rekhta.org/ebooks/deewan-e-bibi-Malika-jaan-ebooks. Accessed 10 March 2019.].

Jha, Shweta Sachdeva (2009a), 'Eurasian women as *tawa'if* singers and recording artists: Entertainment and identity-making in colonial India', *African and Asian Studies*, 8:3, pp. 268–87.

Jha, Shweta Sachdeva (2009b), 'Frames of cinematic history: The *tawa'if* in *Umrao Jan* and *Pakeezah*', in M. Jain (ed.), *Narratives of Indian Cinema*, Delhi: Primus Books, pp. 167–92.

Jha, Shweta Sachdeva (2015), '*Tawa'if* as poet and patron: Rethinking women's self representation', in A. Malhotra and S. Lambert-Hurley (eds), *Speaking of the Self: Gender, Performance and Autobiography in South Asia*, Durham: Duke University Press, pp. 141–64.

Joshi, Sanjay (2001), *Fractured Modernity: The Making of a Middle Class in Colonial India*, Delhi: Oxford University Press.

Kidwai, Saleem (2004), 'The singing ladies find a voice', *Indian* Seminar, https://www.india-seminar.com/2004/540/540%20saleem%20kidwai.htm. Accessed 9 September 2019.

Kidwai, Saleem (2008), 'Of begums and *tawa'ifs*: The women of Awadh', in M. E. John (ed.), *Women's Studies in India: A Reader*, New Delhi: Penguin Books, pp. 118–24.

Kidwai, Saleem and Vanita, Ruth (eds) (2001), *Same-Sex Love in India: Readings from Literature and History*, United States: Palgrave Macmillan.

Kugle, Scott (2010), 'Mah Laqa Bai and gender: The language, poetry and performance of a courtesan in Hyderabad', *Comparative Studies of South Asia, Africa and the Middle East*, 30:3, pp. 365–85.

Lakhnavī, Muḥammad Munīr (1930), *Muhāvarāt-e-Niswān-o-Khās Begamāt kī Zubān*, Kanpur: Majidiya Press.

Lelyveld, David (1993), 'Colonial knowledge and the fate of Hindustani', *Comparative Studies in Society and History*, 35:4, pp. 665–82.

Macziewski, Amelia (2006), '*Tawa'if*, tourism and tales: The problematics of twenty-first century musical patronage for North India's courtesans', in M. Feldman and B. Gordon (eds), *Courtesan's Arts: Cross-Cultural Perspectives*, Oxford: Oxford University Press, pp. 332–68.

Morcom, Anna (2016), *Courtesans, Bar Girls & Dancing Boys: The Illicit Worlds of Indian Dance*, Gurugram: Hachette India.

Nādir, Durgaprasad (1876), *Gulshan-i-Nāz* ('Rose garden of grace'), Delhi: n.p.

Nādir, Durgaprasad (1878), *Taẕkirat-al nisā Nādirī* ('The Tazkira of women poets by Nadir'), Delhi: n.p.

Naim, C. M. (1984), 'A study of five Urdu books written in response to the Allahabad government gazette notification', in B. D. Metcalf (ed.), *Moral Conduct and Authority: The Place of Adab in South Asian Islam*, Berkeley: University of California Press, pp. 290–314.

Naim, C. M. (2001), 'Transvestic words? The Rekhti in Urdu', *The Annual of Urdu Studies*, 16, pp. 3–26.

Neuman, Daniel M. (1980), *The Life of Music in North India: The Organization of an Artistic Tradition*, New Delhi: Manohar.

Nevile, Pran (1996), *Nautch Girls of India: Dancers, Singers, Playmates*, Delhi: Ravi Kumar Publishers.

Oesterheld, Christina (2004), 'Entertainment and reform: Urdu narrative genres in the nineteenth century', in S. Blackburn and V. Dalmia (eds), *India's Literary History: Essays on the Nineteenth Century*, Delhi: Permanent Black, pp. 167–212.

Oldenburg, Veena Talwar (1990), 'Lifestyle as resistance: The case of the courtesans of Lucknow, India', *Feminist Studies*, 16:2, pp. 259–87.

Orsini, Francesca (2002), *The Hindi Public Sphere, 1920–1940: Language and Literature in the Age of Nationalism*, Oxford: Oxford University Press.

Orsini, Francesca (2009), *Print and Pleasure: Popular Literature and Entertaining Fictions in Colonial North India*, New Delhi: Permanent Black.

Petievich, Carla (2002), 'Making "manly" poetry: The construction of Urdu's "golden age"', in R. B. Barnett (ed.), *Rethinking Early Modern India*, New Delhi: Manohar, pp. 231–56.

Petievich, Carla (2005), 'Feminine authorship and Urdu poetic tradition: *Baharistan-i-Naz* vs *Tazkira-i-Rekhti*', in K. Hansen and D. Lelyveld (eds), *A Wilderness of Possibilities: Urdu Studies in Transnational Perspective*, New Delhi: Oxford University Press, pp. 223–50.

Platts, John T. (1884), *A Dictionary of Urdu, Classical Hindi, and English*, W. H. Allen & Co., https://dsal.uchicago.edu/dictionaries/platts/. Accessed 2 January 2019.

Post, Jennifer (1987), 'Professional women in Indian music: The death of the courtesan tradition', in E. Koskoff (ed.), *Women and Music in Cross-Cultural Perspective*, Westport, CT: Greenwood Press, pp. 97–109.

Pritchett, Frances W. (1994), *Nets of Awareness: Urdu Poetry and Its Critics*, London: University of California Press.

Pritchett, Frances W. (2003), 'A long history of Urdu literary culture, Part 2', in S. Pollock (ed.), *Literary Cultures in History: Reconstructions from South Asia*, Berkeley: University of California Press, pp. 864–911.

Qadiri, Khalid Hasan (1988), *Janab Maulana Hamid Hasan Qadiri and the Art of the Chronogram*, Karachi: Anjuman Press.

Qureshi, Regula Burckhardt (2006), 'Female agency and patrilineal constraints: Situating courtesans in twentieth-century India', in M. Feldman and B. Gordon (eds), *The Courtesan's Arts: Cross Cultural Perspectives*, New York: Oxford University Press, pp. 312–32.

Ranj, Moḥammad Fasīḥ-al-Dīn (1864), *Bahāristān-i-Nāz* ('Garden of grace'), Meerut: n.p.

Ranj, Moḥammad Fasīḥ-al-Dīn (1882), *Bahāristān-i-Nāz* ('Garden of grace'), Meerut: n.p.

Rao, Vidya (1996), 'Thumri and Thumri singers: Changes in style and life-style', in I. Banga and Jaidev (eds), *Cultural Reorientation in Modern India*, Shimla: Indian Institute of Advanced Studies, pp. 278–315.

Sachdeva, Shweta (2008), 'In search of the *tawa'if* in history: Courtesans, *nautch* girls and celebrity entertainers in India (1720s–1920s)', Ph.D. thesis, London: University of London.

Saksena, Ram Babu (1927), *A History of Urdu Literature*, Allahabad: Ram Lal Narain Press.

Saksena, Ram Babu (1941), *European and Indo-European Poets of Urdu and Persian*, Lucknow: Naval Kishore Press.

Sampath, Vikram (2012), *'My Name Is Gauhar Jaan!': The Life and Times of a Musician*, New Delhi: Rupa Books.

Schofield, Katherine Butler (2012), 'The courtesan tale: Female musicians and dancers in Mughal historical chronicles, c. 1556–1748', *Gender and History*, 24:1, pp. 150–57.

Shāh, Moḥammad Ibrāhīm (1886), 'Taqrīz', in Malka Jan, *Dīwān-i-Malkā Jān*, Calcutta: Ripon Press.

Sharār, Abdul Halīm (1975), *The Last Phase of an Oriental Culture* (ed. E. S. Harcourt and F. Hussain), Boulder, CO: Westview.

Singh, Lata (2010), 'Courtesans and the 1857 Rebellion: The role of Azeezun in Kanpur?', in B. Pati (ed.), *The Great Rebellion 1857 in India: Exploring Transgressions, Contests and Diversities*, London: Routledge, pp. 95–110.

Sitapuri, Nadim (1962), *Ghālib Nām Avram*, Lucknow: Idarah-farogh-i-Urdu.

Stark, Ulrike (2003), 'Politics, public issues and the promotion of Urdu literature: *Avadh Akhbar*, the first Urdu daily in Northern India', *The Annual of Urdu Studies*, 18:1, pp. 66–94.

Stark, Ulrike (2009), *An Empire of Books: The Naval Kishore Press and the Diffusion of the Printed Word in Colonial India*, New Delhi: Orient BlackSwan.

Tharu, Susie and Lalita, K. (1991), *Women Writing in India: 600 B.C. to the Present*, vol 2. New York: The Feminist Press.

Vanita, Ruth (2017), *Dancing with the Nation: Courtesans in Bombay Cinema*, Delhi: Speaking Tiger.

Walker, Margaret E. (2014), *India's Kathak Dance in Historical Perspective*, London: Routledge.

Williams, Richard (2017), 'Songs between cities: Listening to courtesans in colonial north India', *Journal of the Royal Asiatic Society*, 27:4, pp. 591–610.

5

Mughal Chronicles:
Words, Images and the Gaps between Them

Kavita Singh

Ashutosh Gowariker's *Jodhaa Akbar* (2008) introduces the central characters of the film – the Mughal emperor Akbar and the Amber princess that he married, here called Jodhaa – through a montage of miniature paintings. As the camera presents details of illustrations from the *Akbarnāma* – an imperial manuscript completed for Akbar *c*.1595 – the voice-over describes the assumption of power in India by the first Mughal ruler Bābur, his son Humāyūn and then his grandson, Akbar; we see a painting of an elderly man and then we see the portrait of a very young Akbar on the throne, which dissolves to a view of a mature emperor, whose face now bears its characteristic moustache. Not only do the painted portraits of Akbar and his courtiers stand in for the historical characters in this introductory montage, but, the director avers, many such paintings provided visual models for the scenography of the film (IANS 2007). The grooming and costumes of the actor who played Akbar in the film were modelled on the appearance of the emperor as recorded in the *Akbarnāma* and in countless other Mughal paintings, made both in Akbar's lifetime as well as after his demise. Mughal paintings also provided information on the way a *darbār* should look or the manner in which a scene showing the taming of elephants should unfold.

It is hardly surprising that Mughal paintings, with their meticulous finish and rich detail, should offer themselves as an unparalleled resource for the visual appearances of people and things in an era before photography. These paintings have proven to be a valuable source of documentary information and historians, artists, conservators, film producers and fashion designers, among others, have depended on them in their research into the past. Several scholars have used the evidence of paintings to reconstruct what Mughal buildings and interiors might have been like when they were in use (Andrews 1999) or to guide the restoration of buildings and gardens today (Wescoat and Wolschke-Bulmahn 1986). Others

have used the information contained in paintings to interpret norms and rites of courtly behaviour (Parodi 2010: 51–76; 2012: 87–110) or even to decode the interplay of personal relations and political factions at court (Leach 1995: 354; Koch 1997: 141). A fine example of the extent to which miniature paintings can be used as a historical resource is Bonnie Wade's (1998) magisterial study of Mughal music via paintings: as she demonstrates, the images record a wealth of information that is not available in any textual source. From the evidence provided by the paintings, Wade is able to reconstruct the range of musical instruments that were once used at court, and she makes inferences about the occasions and sites of musical performance such as court ceremonials, formal concerts and rites of passage celebrated in the public and private portions of the palace. Making even more precise use of the visual evidence provided by miniature paintings is Stephen Markel's (2003) study of jewellery, arms and armour and decorative objects that have been depicted in a number of Mughal portraits. The dagger tucked in a Mughal emperor's waistband is so scrupulously rendered that Markel is able to correlate it with an actual surviving dagger in a museum collection, demonstrating how very accurately Mughal artists could and did depict the world that surrounded them.

And yet, it would be a mistake to think of these paintings as dependable visual records of the way things really were or as snapshots of times past. For all their detailed renderings of people and things, these paintings are not always reliable records of history. Even the material culture that the miniature paintings depict in elaborate and exquisite detail includes items which are not known to have existed and which are sometimes so fantastical that they could never have existed beyond the artist's fertile imagination. An excellent example of this would be the 'Dream Painting' that shows Jahāngīr seated on a throne in the shape of a giant hourglass.[1] The portly emperor could not have actually perched on such a fragile and unlikely object: as the sands of time slip away beneath him, it is clear that the artist has invented this outlandish throne as an allegory of the emperor's mortality. But the artist has painted this impossible piece of royal furniture with such dazzling acuity – attending to the light bouncing off the glass, showing the thin stream of sand falling from the upper to the lower chamber of the hourglass, recording the orderly sequence of gems encrusting the throne's golden rim – that it entirely deceives the mind; the perceptual realism of this unreal object tugs the mind between belief and disbelief. More plebeian, but no less puzzling, is the appearance in many *Hamzānāma* paintings of a large, elaborate metalwork object, so carefully and consistently depicted in a number of images that it might well have been a common artefact; but no historical objects of this type survive and what it was, and what purpose it might have served, remains unknown.[2]

If, for all their meticulous rendering of physical objects, one cannot be sure that the Mughal artist was in fact depicting actual things, then we are on even more

shaky ground when we depend upon these paintings to give us insights into the events, lives, relationships and politics of the Mughal court. After all, these paintings are not *records* of courtly life as much as they are *representations* of it. And like all representations, these paintings reflect the ideological positions of their makers – who in this case would have been collectively the painters, the senior artists and literati who may have supervised them, as well as the patrons whose preferences might have been explicitly stated to, or implicitly intuited by, the artists.

The painted representations of historic events often involved conscious manipulations – sometimes subtle and sometimes gross – of 'what really happened'. Benjamin would have called these paintings chronicles rather than histories. As he points out: 'The historian is bound to explain in one way or another the happenings with which he deals' while chroniclers deal in 'interpretation, which is not concerned with an accurate concatenation of definite events, but with the way these are embedded in the great inscrutable course of the world'. What we dismiss as an earlier era's propaganda was its eschatology: events were worth recording because they illustrated a Higher Plan, 'their historical tales (based) on a divine plan of salvation' (Benjamin 2011: 95). Mughal histories were all chronicles in this sense, and both visual and verbal records were intended to demonstrate the inevitability and justness of a divine plan in which the emperor played a leading role.

Mughal illustrated manuscripts offer interpretations of events in both image and text. Curiously, there are often significant differences between the way the same event is rendered in painting and described in words. In some cases, the version of events offered by an image in one manuscript or album is contradicted by the account provided in another manuscript. Here, the difference between the two versions arises from a quite understandable difference in the authors' respective perspectives and their intended audiences. But in other and more puzzling instances, *the image is at variance with the very text that it illustrates*. In these cases, the reader is presented with two different versions of the same event within the covers of the same book and indeed on facing pages. This is a situation that raises a number of interesting questions.

Before we articulate these questions, it would be well to recall the nature of the books under consideration here. These were imperial manuscripts that were official and authorized products of the imperial workshops. As prestigious projects, every aspect of their contents, from the text to the calligraphy and from the painting to the border decoration, would have been closely supervised. When text and image are at variance with each other in such manuscripts, their divergence from each other cannot be accidental; the divergence must have been conscious and indeed it must be programmatic. How should we account for the discrepancy between the visual and the textual narrative within the same book? Does this discrepancy arise simply from the different authorial voices of the painter and the historian?

Or was there a structural difference between the position of the textual chronicler and the position of the artist at court? Were images expected to serve a function different from the text? How did the reader absorb the text, the image and, most significantly, the gap between the two? And was this gap itself visible to the reader, and if so, was it seen as meaningful, producing a semantics of its own? It may not be possible to answer all of these questions, but by studying a few Mughal paintings this chapter hopes at the very least to mark this rhetorical, ontological and epistemological gap between words and images as an area that is worthy of study.

Let us begin with a celebrated painting that shows *The Death of Khān Jahān Lodhī* (Figure 5.1). Khān Jahān Lodhī had once been a prominent courtier in Shāh Jahān's service, but he betrayed his master by entering into a pact with the rival Sultanate of Ahmednagar. Since Khān Jahān had a large following of his own, his rebellion offered a serious challenge to Shāh Jahān's authority, and the emperor spared no effort to put him down. Despite this, Khān Jahān managed to evade the imperial forces for two years before he was finally defeated, and his head was cut off and displayed at the gate of the imperial fort.

The scene of Khān Jahān Lodhī's death was depicted by the artist 'Ābid in a masterly painting that was included in the imperial copy of the *Pādshāhnāma*, Abdul Hamid Lahori's official chronicle of the reign of Shāh Jahān. With 44 sumptuous illustrations, this seventeenth-century manuscript is considered the finest one produced in Shāh Jahān's time; indeed, the *Pādshāhnāma* paintings are now acknowledged as some of the most exquisite Mughal paintings ever created.[3] The majority of the *Pādshāhnāma*'s illustrations show *darbār* scenes in which the enthroned Shāh Jahān presides over a court thickly populated with courtiers, guards and attendants, most of whom are portrayed with great accuracy and consistency. Shāh Jahān's own image is not just recognizable in every instance but is depicted at an age appropriate to the event; from his days as crown prince to his reign as emperor, his facial features and body thicken with age, and his beard turns from jet-black to being flecked with white. The detailed depiction of the architectural setting, textiles and objects that surround the characters reinforces the sense of verism in these paintings.

Like other *Pādshāhnāma* paintings, *The Death of Khān Jahān Lodhī* shows a carefully rendered assembly of generals and officials from Shāh Jahān's court. Unlike the majority of the manuscript's illustrations, however, the emperor is absent and the scene is set outdoors in a stylized mountain-scape reminiscent of early Persian painting. A row of soldiers peeps over the horizon to gaze at the event that is taking place in the foreground. Here, two men bend over a difficult task: they are sawing through the bones and sinews of the rebel governor's neck in order to behead him. Although he is still alive, blood has drained out of Khān Jahān's body, and his face is taking on the pallor of death. On the ground nearby

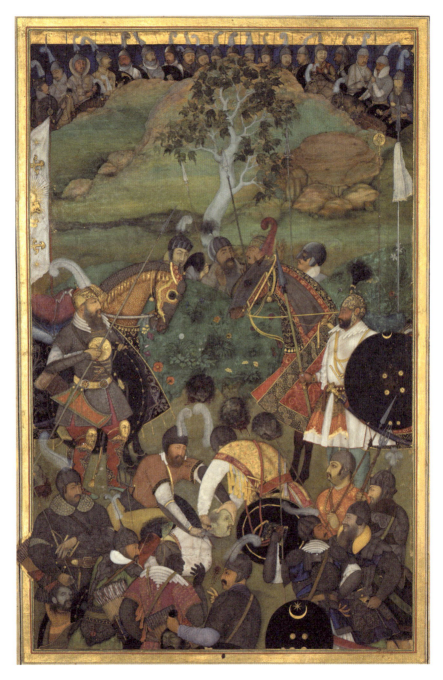

FIGURE 5.1: *The Death of K͟hān Jahān Lodhī*, by 'Ābid. Event of 3 February 1631; painted c.1633. From the *Pādshāhnāma*, Royal Library, Windsor Castle, Acc. No. RCIN 1005025.q. *Courtesy*: By kind courtesy of the Royal Collection Trust/© Her Majesty Queen Elizabeth II 2019.

are the heads of three others who have already been executed. The text tells us that two of these were Khān Jahān's sons, and a third might represent another son who was killed the previous day, or it might be any of the hundred followers of Khān Jahān whose heads were also cut off. These decapitated heads are grey, nearly black, entirely lacking in life-blood and in a bravura gesture the artist paints infinitesimally small flies hovering over them that are flecked with the tiniest dots of red, their blood.

Even in the absence of other corroborating portraits of Khān Jahān Lodhī, we sense that 'Ābid's image of the dying man accurately captures his appearance, for he has painted an individualized face with heavy jowls, an aquiline nose and a balding head. Thus, when we look at this painting, we know that we are seeing a particular man at a particular moment of a particular, horrific event. And yet, for all its attention to detail, and its morbidly fascinating rendering of death and decaying flesh, the painting cannot be taken as an accurate eyewitness account for it offers a narrative of Khān Jahān's death that veers well away from Lahori's text.

We know, for instance, that Khān Jahān's head was cut off and sent to Shāh Jahān as a trophy; but it was cut off from a body that was already dead, pierced by the lance of Mādho Singh of Bundi, a Rajput prince in Shāh Jahān's service. According to Lahori's text, Mādho Singh was in the party that launched the final assault on Khān Jahān Lodhī, where he killed the former governor as well as two of his sons (Elliot 1875: 24). Mādho Singh is present in 'Ābid's painting. He is the figure at the lower right corner, clad in orange and standing among other soldiers, prominently holding the lance that he had wielded with such success. But while the figure of the Rajput prince is prominent, it is also passive: he is shown to be witnessing the execution, rather than performing it.

The middle register of the painting is dominated by the figures of two symmetrically arranged warriors who stand beside their horses. These are the two leaders of the force that pursued Khān Jahān Lodhī; on the left, clad in armour, is Abdullāh Khān, and on the right, wearing a white *jāma*, is Syed Muzaffar Khān Bārhā. Historical records tell us that Abdullāh Khān had personally cut the head off the dead Khān Jahān's body and dispatched it to Shāh Jahān. Several Mughal albums preserve portraits of Abdullāh Khān which show him holding Khān Jahān's severed head, suggesting that he was remembered chiefly for this triumph, for which he was richly rewarded by Shāh Jahān.[4] And yet, like Mādho Singh, Abdullāh Khān is shown simply attending Khān Jahān's decapitation rather than performing it.

If agency is taken away from the two main actors in the historical drama, to whom is it given in their stead? Who are the two figures that are shown cutting Khān Jahān's head? Of the two men who decapitate Khān Jahān, we can see the face of one man who holds the knife and saws through the rebel governor's neck. The other figure turns his back to the viewer, and we can only see his richly

brocaded coat. However, there are inscriptions on the clothing of both of these figures that identify them. Two words are written in black ink on the shoulder of the man who faces us; in its format it resembles inscriptions that often identify individual figures in crowded court scenes. However, rather than a personal name, this inscription reads 'Shāh Jahānī' or 'of/belonging to Shāh Jahān'. The other figure bears a subtler inscription, for woven into the edge of his coat is a benediction wishing the emperor long life. From these inscriptions it becomes clear that 'Ābid does not intend these executioners to be individuals who were involved in the capture of Khān Jahān. Rather, they are abstract figures that emblematize service to Shāh Jahān.

If the two men who actually killed and beheaded Khān Jahān Lodhī seem merely to attend on the scene, then – in a most disturbing twist – Khān Jahān Lodhī is also made to attend the scene of his own beheading. Instead of showing him as being already dead when his head was cut off, 'Ābid paints Khān Jahān Lodhī as a living and conscious figure with wide-open eyes. As the blade saws through the sinews and the bones of the fallen man's throat, he seems to be aware of just what is being done to him, and why. In the hands of the artist 'Ābid, Khān Jahān's last moments are filled with a painful realization: it is as though he understands what he has done to deserve his fate.

Khān Jahān's open eyes are the crux of the painting, whose central theme is the witnessing of a wrathful justice being done. The act of seeing is reinforced multiple times in this painting, as the execution is witnessed by so many actors in the scene: the theatrical 'chorus' of soldiers, arranged behind the horizon line in the background, the knot of soldiers in the foreground, the solemn commanders who stand by their horses. In contrast to all those who look upon the event, the decapitated heads that lie on the ground all have eyes that are shut, as though they do not deserve to look upon the majesty of the scene.

But whose majesty is it that these traitors are not allowed to see? As we study the painting's composition, hidden meanings begin to reveal themselves. We see that the scene is arranged in three distinct registers: the lowest occupied by the soldiers who cluster around the decapitation of Khān Jahān; the middle register dominated by the two commanders and their horses; the uppermost a landscape, empty apart from a single chinar tree and the chorus-line of soldiers who peep over the horizon. Now, if we compare this painting with the *darbār* scenes of the *Pādshāhnāma* (Figure 5.2), we see that these too are arranged in three registers that reproduce the hierarchical space of the Shāh Jahānī audience hall. There, the lowest register generally shows attendants and servants who stand outside the hall. Occupying the central register of the painting are those of higher rank, who stand within the hall's golden or silver railings. The highest register is reserved for the emperor himself who occupies his magnificently decorated and elevated throne.

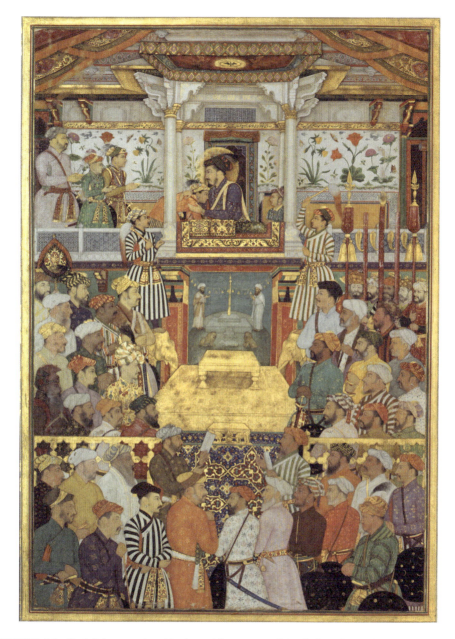

FIGURE 5.2: Shāh Jahān receives his three eldest sons and Asaf K͟hān during his accession ceremonies, by Bichitr. Event of 8 March 1628; painted 1656–57. From the *Pādshāhnāma*, Royal Library, Windsor Castle, Acc. No. RCIN 1005025.k.
Courtesy: By kind courtesy of the Royal Collection Trust/© Her Majesty Queen Elizabeth II 2019.

By juxtaposing the *Pādshāhnāma darbār* scenes with 'Ābid's *Death of Khān Jahān Lodhī*, we can now see how the alfresco scene reproduces the format of the formal audience at court. Those who actually perform the execution are mere servants of the court. By placing the two commanders above the scrum of soldiers and executioners, 'Ābid lifts them to the level of high-ranking courtiers who stand close to their ruler in *darbār*. They stand flanking a chinar tree: a tree beloved of Mughal rulers that had been dubbed 'the king of trees'. Could the king of trees stand in for the king of men? As we look more closely at the painting, we see how the ground beneath the chinar is sprinkled with flowers. Although these seem to be part of the landscape, the flowers are concentrated only at the foot of the tree, as though forming a decorative carpet for it. Naturalistic though these flowers appear, they repeat pervasive motifs in the decorative arts of Shāh Jahān's time, which are seen not just in miniatures but in murals, textiles and architecture, such as the famous *pietra dura* of the Taj Mahal. In the *darbār* scenes depicted in the *Pādshāhnāma*, these flowers appear in carpets, hangings, wall paintings or inlay panels that are clustered around Shāh Jahān's throne, as though concentrating beauty around his presence. Their location in this painting, at the base of the chinar, confirms that the tree is a metaphor for Shāh Jahān's own self.

When Shāh Jahān sent his forces to hunt down Khān Jahān Lodhī, he remained in the capital, far from the battlefield. Yet, by imposing the structure of the *darbār* upon the battlefield, and by letting the symbolic representation of the emperor preside over the scene, 'Ābid finds ways to make Shāh Jahān present despite his absence. The victory won in a distant battlefield becomes a tribute presented to the emperor at court; the brave and shrewd warriors who won the victory become courtiers, pinned to subservient positions in the emperor's court. And now, the shifting of agency from the actors begins to make sense. 'Ābid does not deny the role of Mādho Singh or Abdullāh Khān; he gives both of them a prominent place in his composition. But he takes their actions away from them and transfers them to other fictitious and anonymous characters who simply stand for service and devotion to Shāh Jahān. By doing this, 'Ābid is suggesting that Mādho Singh or Abdullāh Khān were merely instruments of the emperor's will: what they did was not of *their* doing. It was Shāh Jahān's might that animated them.

Those who held the *Pāshāhnāma* in their hands and turned its pages would have seen 'Ābid's painting alongside the text that describes the campaign against Khān Jahān Lodhī in great detail. There, the skirmishes between the imperial and rebel forces are recounted over several pages, and there is no obfuscation of the role of Mādho Singh or Abdullāh Khān. Seen alongside the text, 'Ābid's manipulation of the scene would have been clearly visible to the reader; the gap between the text's account and the paintings would have been an important part of the painting's rhetorical flourish and would have prompted the reader to search for its

implications. By turning the battlefield into an alfresco *darbār*, by suggesting the omnipresence of the faraway ruler, by making the warriors witnesses rather than actors, by rendering Kh̲ān Jahan Lodhī as alive so that he could witness his own beheading and by doing all this next to a text that gives a painstaking, plodding account of the incident, ʿĀbid shows how a painting can offer a layered and symbolic account of the same event: one that functions as an *interpretation* rather than a *representation*. The painting does not deviate from the text so much as it transcends it, and it does so by using purely visual elements. Altering and rearranging pictorial space, motifs, composition, portraiture, gesture and expression, ʿĀbid makes a claim on behalf of the art of painting, arguing that it can have a status higher than prose: combining beauty with compression, allusion with metonymy, a painting can function in a manner akin to poetry.

A less sympathetic viewer might see ʿĀbid's reinterpretation of the event simply as propagandist flattery. But such a verdict is perhaps more properly deserved by the next painting we will consider: an illustration that had been prepared for the *Jahāngīrnāma*, the memoirs of Shāh Jahān's father Jahāngīr.

Unlike the *Pādshāhnāma*, or the *Akbarnāma* (the history of Akbar's reign) which were chronicles written by officially appointed litterateurs, the *Jahāngīrnāma* (or more properly, the *Tuzuk-i-Jahāngīrī*) was a diaristic account of Jahāngīr's reign written by the emperor himself. Sometimes dull and sometimes surprisingly intimate, the *Jahāngīrnāma* is composed of impressionistic and informal entries written by the emperor from the time of his accession to the throne in 1605.[5] Illustrating the *Jahāngīrnāma* became a major project for the imperial painting workshop under Jahāngīr, and the finest painters laboured over pages that depicted signal events of his reign. Unlike the *Akbarnāma* or the *Pādshāhnāma*, however, no imperial manuscript of the *Jahāngīrnāma* was ever collated, and the beautiful illustrations intended for it were eventually scattered far and wide.[6]

It is ironic that the illustrated book of Jahāngīr's life should never have been completed for Jahāngīr prided himself as a great connoisseur of art and took a personal interest in the work of his artists (Jahāngīr 1999: 267–68). In his reign, Mughal painting attained a refinement unknown in earlier times. While he was a still a prince, the Mughal atelier had been exposed to European Renaissance art and artists had begun to experiment with perspective and naturalism, bringing to Mughal painting an unprecedented verisimilitude. This reached its apogee during Jahāngīr's reign. Even as the patron and his atelier valued European art's capacity for illusion, however, they continued to cherish Persian painting's ability to make allusions through the deployment of symbolic devices and meaningful compositions. One of the triumphs of Jahāngīrī painting lay in the way it laminated these two impulses, cladding Persianate symbolism in a Europeanizing cloak of naturalism (Singh 2017).

In its naturalism, Jahāngīrī painting seems simply to mirror the world; yet, this very naturalism is often used by his artists as a screen to hide an inconvenient reality. The verisimilitude of these paintings is frequently used to persuade us that a certain version of events is the truth. The painting we consider now demonstrates this well (Figure 5.3). Undoubtedly intended for the *Jahāngīrnāma*, this painting is now preserved in a Mughal album in the Chester Beatty Collection. It records an event connected with the rebellion of Jahāngīr's eldest son, Khusrau. Khusrau had long been the favourite of his grandfather Akbar. When Jahāngīr fell out of Akbar's favour for a while, Khusrau expected to succeed his grandfather. After the crown passed to Jahāngīr, Khusrau appeared at first to accept the turn of events. But in 1606, a few weeks after his father's accession, he led a band of followers in an ill-considered revolt. Jahāngīr pursued Khusrau and captured him; although his life was spared, he was blinded and lived out the rest of his days in chains.

Several episodes relating to Khusrau's rebellion are depicted in the *Jahāngīrnāma* illustrations, but in the painting we consider here it is not Khusrau but Mirzā Husain, an ally of his, who has been captured. We see the slight figure of this unfortunate man at the lower left: his hands are bound, and he is being pushed down by his jailor who is forcing him to bow before Jahāngīr. The emperor's figure, mounted on a horse, towers over the prisoner and dominates the painting. It occupies the centre of the page and is surrounded by an envelope of space; the gold-coloured ground seems to create a halo around the entire body and not just the head of the emperor. In contrast, all the other figures, which include many high officials of state, are crowded together and are drawn on a slightly smaller scale.

With its closely observed portraits and beautifully rendered outdoor setting, the painting seems like a carefully researched representation of a historical event. The portraits are accurate and even the depiction of the locale is carefully done. The event occurred in Sikandra, close to Akbar's tomb, and we see this building in the background at the upper left. But the painting has a number of inaccuracies that have been deliberately introduced. At the bottom right, we see an elderly man in white clothes who is prominently placed in Jahāngīr's retinue. This is a portrait of Mirzā ʿAzīz Kōka, an important courtier and governor of Gujarat whose daughter was married to the rebel Khusrau. In his text, Jahangır mentions speaking to ʿAzīz Kōka during this incident, thus recording his presence. In the painting, ʿAzīz Kōka is shown participating in the capture as though motivated by an unshakeable loyalty to his sovereign. But Jahāngīr suspected that ʿAzīz Kōka had sided with his son-in-law, and just a few pages later he called him a turncoat and stripped the elderly governor of his titles and had him thrown into prison. Nine years passed before ʿAzīz Kōka was forgiven and reinstated (Faruqui 2012: 227).

Asok Das (1978) has shown how Jahāngīrī painting often air-brushed unwanted characters from the scene. Sons who fell out of favour were expunged from family

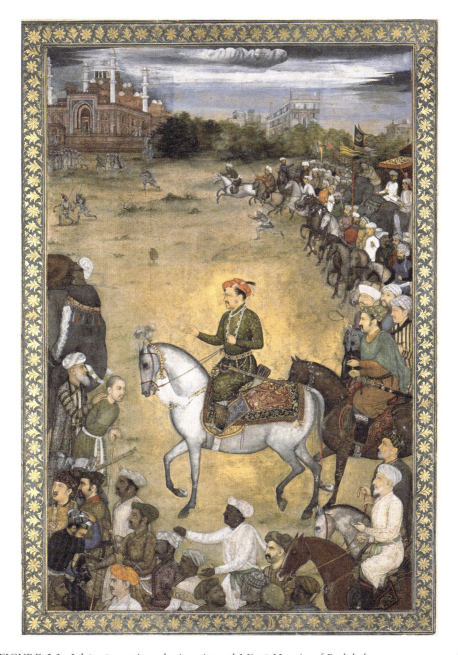

FIGURE 5.3: Jahāngīr receives the imprisoned Mirzā Husain of Badakshan, a supporter of Khusrau. Intended for the *Jahāngīrnāma*; attributed to Govardhan. Event of 1606; painted c.1618–20. Chester Beatty Library, Dublin, Acc. No. CBL In 34.5.
Source: © The Trustees of the Chester Beatty Library, Dublin.

portraits and *darbār*. Here, the opposite seems to have occurred: a character who is unlikely to have been present is included in both text and image. One doubts that ʿAzīz Kōka participated in the campaigns against K̲h̲usrau or his supporters, not just because K̲h̲usrau was his son-in-law but because Jahāngīr punished him for siding with the rebellious prince, which he may not have done if ʿAzīz Kōka had so ostentatiously acted against K̲h̲usrau.[7] Is ʿAzīz Kōka's presence in the scene a kind of wishful thinking, with the artist painting a picture where Jahāngīr's courtiers are always loyal, even under extreme circumstances? Or does the painting reflect the circumstances that obtained when the painting was made (*c.*1620) several years after K̲h̲usrau's rebellion, when Mirzā ʿAzīz Kōka had been forgiven and rehabilitated within Jahāngīr's echelons at court? In that case, the painting would retrospectively depict Mirzā Kōka doing what he *should* have done, rather than what he did do.

A piece of dissimulation that certainly *is* in this painting relates to the building that we see in the background. This is the tomb of Akbar at Sikandra near Agra. Its presence in the painting is appropriate because Mirzā Husain was captured nearby, but the tomb – and Akbar's spirit which was resident there – also played a role in Jahāngīr's telling of the event. Jahāngīr writes that as he embarked on the campaign against K̲h̲usrau, he went to his father's tomb and 'sought assistance from his spirit'. Soon after, this ally of K̲h̲usrau was captured, and Jahāngīr took it as 'the first good omen to appear from the blessed assistance of His Majesty' (Jahāngīr 1999: 50). The tomb thus is not just a marker of place but the source of Akbar's benediction and is a sign of his approval of Jahāngīr's campaign against his son. It was important for Jahāngīr to claim his father's blessings in this context, for when he was a prince he had rebelled against his father and set up a rival court for several years. At that time, Akbar had been inclined to appoint his grandson K̲h̲usrau as successor, but he and Jahāngīr were eventually reconciled. By crediting his success against K̲h̲usrau to the blessings of Akbar, Jahāngīr is making a claim for the legitimacy of his succession, which Akbar had granted to him during his lifetime and continued to support in the afterlife as well. Simultaneously, it nullifies any claim that K̲h̲usrau might have had to his grandfather's favour. Of course, in his memoirs Jahāngīr draws a discreet veil over his own rebellion, denying that it ever occurred. 'Short-sighted men […] tried hard to persuade me to rebel against my father', he says in his memoir, but 'I was not led astray' (Jahāngīr 1999: 55–56).

If the *Jahāngīrnāma* tells us that Akbar's spirit supported Jahāngīr, then the painting shows us that Jahāngīr too was a loyal son to his father. Akbar's mausoleum is believed to have been commissioned by Akbar in his own lifetime, but when Jahāngīr inspected it after his father's death, he found that the tomb was not to his taste and he had much of it torn down and rebuilt according to his designs. The renovated tomb was completed in about 1613, but in this painting, it stands

already completed as a witness to events of 1606 (Leach 1995: 358). The artist shows the tomb as renovated and improved by Jahāngīr, to testify to Jahāngīr's piety and filial devotion towards his father as opposed to the disloyal behaviour of his own son.

As we have seen, Mughal artists who worked in the ateliers of Jahāngīr and Shāh Jahān were masters of naturalism. But they used their skills to create persuasive images for their versions of history that were often very far from the truth. It is ironic that this should be so because the Mughal impulse to make history paintings derived from that era's obsession with the accurate documentation of the here and now. Visual chronicles – paintings that depict contemporary events and persons – are such a pervasive theme within Mughal painting (travelling thence to other Indian courts) that we take it for granted that this should have been the painting atelier's major concern. We realize how special Mughal painting was in its desire to document current events and rulers only when we see the *absence* of this drive in the art traditions that inspired the Mughals. For while the writing of chronicles was de rigueur in Islamicate kingdoms, the *illustration* of these chronicles was very uncommon – so uncommon that one might even imagine it was taboo. We see no such paintings in Safavid painting from Iran, for instance. The manuscripts that were made under the greatest patron of Persian painting, Shāh Ṭahmāsp, celebrate the legendary kings of the past as in the magnificent *Shāhnāma* he patronized, but we know of scarcely any contemporary portraits of Shāh Ṭahmāsp himself and no paintings dedicated to events from his biography.[8] When historical kings are memorialized in pre-Mughal Islamicate painting, as, for instance, in the famous *Zafarnāma* relating the deeds of Timūr, these paintings are made at least 80 years after the sovereign's death and are commissioned by his admiring descendants.[9] So, while keeping a textual record of the reigning monarch's deeds was routine for Islamic kings, to paint what the emperor did yesterday, or whom he is likely to meet tomorrow, was unheard of until the time of the third Mughal emperor, Akbar.[10]

Akbar clearly wanted vivid visual records of his own family members and himself. He commissioned illustrated manuscripts of the *Bāburnāma*, the memoirs kept by his grandfather, and then he commissioned similarly illustrated histories of his own life. Two *Akbarnāma* manuscripts that are substantially preserved in libraries have literally hundreds of images of the dynamic young prince hunting or engaged in battle or attending a *darbār* or supervising the construction of his new capital.[11] This dense visual record parallels the equally fastidious textual record that was kept of his acts and deeds. In the nineteenth year of his reign, Akbar established a Record Office which was directed to preserve copies of all of his letters and edicts. Fourteen clerks were appointed to document everything that Akbar did, two for each day of the week (Brand and Lowry 1986: 72). Their documentation formed

the basis for the authorized biography that was later written by Abū'l Faẓl. Akbar's biographer proudly claimed that for events for which he had no documentary evidence he took the testimony of at least twenty witnesses; if they contradicted each other, he submitted their testimonies to Akbar who decided upon the truth (Mukhia 1976: 71). Clearly, accuracy and authenticity were important to Abū'l Faẓl (and presumably to Akbar too) who wanted to claim that his text was not propaganda but truth.[12] In this, Abū'l Faẓl seems to be echoing Sharafuddīn Alī Yazdī, author of the *Zafarnāma*, about the life of Timūr, cherished ancestor of the Mughals. Yazdī had claimed that his book (written two decades after Timūr's death) was distinguished by its 'garb of truth and veracity' and that he had used accounts kept by Timūr's officials who 'continually verified every deed and word that issued from His Majesty'. These documents were reliable for '[i]t was ordered that every event be recorded exactly as it happened, without any interpolation, addition or subtraction […] in what concerned His Majesty's bravery and daring' (Thackston 1989: 64).[13] Both Yazdī and Abū'l Faẓl assure readers that they have produced accurate accounts based on thorough documentation that are free of hyperbole.

A particularly magnificent manuscript of Yazdī's text adorned with illustrations by the revered artist Bihzād was in the collection of the Mughals from the time of Humāyūn onwards, and it must have been a powerful inspiration for the *Akbarnāma*'s text and images. The Mughals were proud of their Timūrid ancestry, but Timūr himself had been a low-born warrior whose military successes had carried him to dazzling heights. With little to boast of in his past, it was the present that Timūr had forged that was worth recording. Similarly, the Mughals derived from a junior branch of the Timūrids, who had been ousted even from their insignificant valley in Central Asia and who had shallow roots in India. When Akbar wanted to proclaim the glories of his dynasty, the achievements of the present were much more impressive than those of the past. For this reason, in Akbar's life as much as in Timūr's, the documentation of their history-in-the-making, and its retelling, assumed such importance.

The question arises: why illustrate these accounts? We know from many sources that Akbar enjoyed looking at paintings and even learned to paint himself. But for him painting was also a practical tool and an aid to statecraft. Abū'l Faẓl tells us that Akbar had an enormous album of portraits made so that he could study the face and form of the governors, generals and allies as well as enemies. In accordance with the theories of physiognomy current at the time, it was believed that a man's face revealed his character: Akbar would 'read' the faces of his courtiers to decide whether they were trustworthy or not. He even instructed the law courts to follow the rules of physiognomy when making judgements about guilt or innocence in cases that were difficult to prove (Rice 2011; Di Francesca 1994). We can imagine how seriously this was taken, and for how long, when we hear

that Akbar's son, Jahāngīr, sent his most talented portraitist Bishandās as a secret member of an embassy to Iran, so that he could bring back a likeness of Shāh Abbās – the image being a clue to his personality and likely military strategies in the future. Since the portraits served almost a diagnostic function, it was important that they be accurate and true-to-life.

A second reason has been given for why Akbar was so irresistibly drawn to paintings. We know that Akbar loved books and amassed an enormous library; inheriting 4,000 books from his bibliophilic father Humāyūn, Akbarī left behind a collection of 24,000 volumes. And yet this lover of books remained unlettered all his life, and he had to ask attendants to read to him daily. A modern reader immediately understands that Akbar was dyslexic. In that case, it would have been natural for him to want books which he could 'read' without engaging with the written words. This may explain why Akbar's manuscripts are not just illustrated but are *profusely* illustrated: the *Bāburnāma* had more than 180 paintings in its 528 folios; in a 268-page volume of the *Akbarnāma*, 110 pages bear miniatures. In contrast, the famous Timūrid *Zafarnāma* was a manuscript of 539 pages that only had 6 double-page illustrations. Akbari manuscripts were truly extraordinary for the sheer profusion of their illustrations.

What was the relationship between word and image in the manuscripts made for Akbar? Having considered the connection between text and image in the *Pādshāhnāma* and the *Jahāngīrnāma*, let us end this chapter with a similar exploration of the *Akbarnāma* by taking up a particularly piquant example. The illustration we will discuss now occurs in volume II of the 'second' *Akbarnāma*, a presentation copy made some ten years after the first illustrated manuscript. It takes up a theme not attempted in the earlier imperial copy (Figure 5.4).

One evening, Abū'l Fażl tells us:

> Discourse fell upon the bravery of the heroes of Hindustan, and it was stated that they paid no regard to their lives. For instance, some Rajputs would hold a double-headed spear, and two men, who were equally-matched, would run from opposite sides against the points, so the latter would transfix them and come out at their backs.
>
> (Ibn Mubārak and Beveridge 2002: 43)

On hearing of this Akbar suddenly decided to equal this feat. 'He fastened his special sword to a wall, and placing the point near his sacred breast declared that if Rajputs were wont to sell their valour in their way, he would rush against this sword' (2002: 43–44). The party watched in horror. Only Mān Singh of Amber, Akbar's brother-in-law and close friend, had the courage to act and struck the sword down. As the sword fell, it cut Akbar's hand, and an infuriated Akbar seized

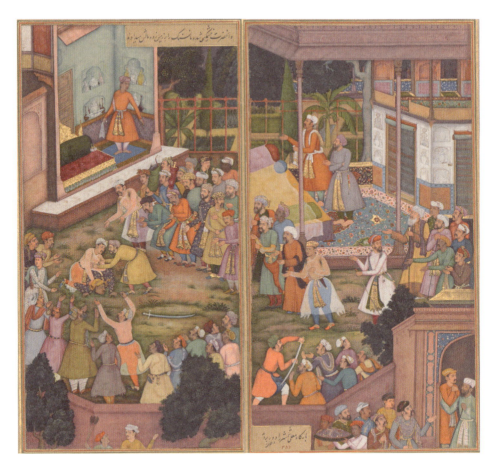

FIGURE 5.4: Akbar fights with Raja Mān Singh, by Daulat. Event of 1578; painted March 1600. Chester Beatty Library, Dublin, Acc. Nos CBL In 03.168v and CBL In 03.169r.
Source: © The Trustees of the Chester Beatty Library, Dublin.

Mān Singh and threw him to the ground. To save Mān Singh another man named Sayyid Muzaffar intervened; he seized Akbar's injured hand 'and by twisting his wounded finger released Mān Singh' (2002: 44).

This extraordinary event is given a double-page illustration by the artist Daulat in the Chester Beatty Library's volume of the *Akbarnāma* (Figure 5.4). The scene is set in an enclosed garden whose pavilions have been decked out with carpets, cushions and a low throne for the evening's gathering. Here, surrounded by a ring of astonished courtiers, Akbar pins Mān Singh to the ground. The amber raja's turban is unravelling, his face is contorted and his mouth open as though gasping for breath, his arms trying futilely to lift his body off the ground. Akbar too is in an

undignified position, kneeling on the ground beside Mān Singh and pressing down on his neck with one hand and digging his other arm's elbow into his back. His face, a serene mask in other portraits, here has a furrowed brow and a scowl; this must be a grimace of pain, for the painting also shows Sayyid Muzaffar restraining Akbar and twisting his injured hand.

There is nothing in the painting that dignifies Akbar. He is not shown at a heroic moment – for instance, when he pointed the sword at himself – but rather at a moment when he is treating a close ally, who has just saved his life, in a shameful manner. As the painting shows Sayyid Muzaffar twisting Akbar's hand, it also underlines Akbar's vulnerability arising from a trifling injury to his thumb. If the narrative moment chosen by Daulat does not dignify Akbar, his painting's composition too refuses to give the emperor a place of honour. It places him in the lower half of the painting instead of letting him occupy the apex. Akbar is not drawn here (as he often is) on a larger scale than the others. Even more damningly, Akbar is placed on the *left* half of the double page. In a literary culture whose script reads from right to left, paintings too tend to follow the textual reading order by putting the dominant or more active figures on the right and the passive or subordinate figures on the left. Accordingly, most other paintings in this *Akbarnāma* place Akbar on the right. Thus, if Akbar is shown bestowing a gift on a courtier who has come to his court, for instance, and the emperor is shown at right, this gives him a position analogous to the subject of a transitive verb: 'Akbar gave a gift to the courtier'. On the other hand, if Akbar were placed on the left, the painting would 'read', 'The courtier received a gift from Akbar'. In this painting that shows Akbar venting his fury on Mān Singh, the reversal of the expected compositional order occurs twice over. Not only is Akbar shown in the left half of the double-page painting, but he is placed at the left of the little knot of figures of which he is a part. It is Sayyid Muzaffar who is the active one in this group, standing at the right and seizing and twisting Akbar's hand. To a knowing eye, the painting 'says': 'Sayyid Muzaffar rescued Mān Singh from Akbar'.

The painting seems shockingly frank, showing Akbar as vulnerable and wrong-headed. In this it is, predictably, at variance with Abū'l Fazl's text, which is full of circumlocutions and prevarications. At the start of his magnum opus, Abū'l Fazl had made it clear that he did not regard Akbar as an ordinary man but as the *insān-ĕ-kāmil*, the 'perfect man', a '"descent" of the One, ineffable God' on earth. For Abū'l Fazl, Akbar's being had a cosmological quality (Hardy 1985). As a result, the *Akbarnāma* was framed less as an account of a man's life and more as a moral exemplum, and every act or utterance of Akbar was presented as proof of his greatness. Things that were difficult to understand or condone were explained as evidence that Akbar's greatness was beyond human comprehension. So it was with this event, whose description Abū'l Fazl began thus:

> [T]he sitter on the throne of the Caliphate is always shrouding himself under a special screen, while the stewards of fate are ever removing this screen and displaying the spiritual and physical glories of him who has been magnified by God. One night there was a select drinking party. Discourse fell upon the bravery of the heroes of Hindustan.
>
> (Ibn Mubārak and Beveridge 2002: 44)

From this small hint we realize that Akbar may have done what he did under the influence of alcohol. But Abū'l Faẓl tells us that Akbar was fully conscious of what he was doing and in control of himself. He acted 'for the sake of screening his glory, or for testing men': his erratic behaviour thus was calculated to make the emperor appear as a fallible human, and it was intended to test the loyalty of his companions who did succeed in saving him from himself. Sadly, in the *Akbarnāma* poor Sayyid Muzaffar gets no credit at all, for the text accusingly says that 'he foolishly tried to free (Mān Singh) from the grasp of that tiger of God and by twisting his wounded finger released Mān Singh' (2002: 44). The final outcome offered proof of God's favour upon Akbar, for although his hand suffered a cut, 'by the Divine protection it soon healed' (2002: 43–44). As we can see, in Abū'l Faẓl's adoring vision, Akbar's erratic behaviour was proof of his inscrutability and ordinary bodily processes of healing and self-repair were proof of divine blessings.

As with the *Jahāngīrnāma* and the *Pādshāhnāma*, there is a gap between the word and image in the *Akbarnāma*, but the gap is of a different sort. In the *Akbarnāma* it is the text, written by a courtier and professional litterateur, that is hyperbolic. The image carries none of this rhetorical weight and shows Akbar in a frank and unflattering manner. Although we have focused on an *Akbarnāma* painting that is an extreme instance of this tendency, in general *Akbarnāma* paintings are not as flattering or highly wrought as the text; in images Akbar appears as a man: extraordinary and dynamic, but still a man. In the text he is divinized and wrapped in layer upon layer of purple prose. What shall we make of this gap? Might we imagine Akbar hearing the flattering words in the honeyed tongue of his courtier but taking the book of his life in his own hands and smiling at the memories stirred by the images that he sees?

It has not been my intention in this chapter to demonstrate that Mughal paintings are unreliable as records of history. Indeed they are, but that is hardly a point that needs to be laboured. Nor is it my intention to privilege text over image as a source of historical 'truth'. As we have seen in the few examples discussed here, texts too prevaricate, embroider and obfuscate 'what really happened'. Rather, my focus has been the relationship of text and image within a manuscript. I hope it has become clear that text and image were not designed to map directly onto one another; images were not intended as illustrations of the text. Instead, image

and text had a degree of autonomy from each other, and they expressed their own construal of events. Beholders of the manuscript would see the text and image in conjunction with each other, and as they did so, their differences would become etched in sharp relief. As a reader's eye moved from image to text, the gap between them would create awareness of the work of interpretation that had informed them both. And this work, already done by the writer and the artist, was now laid at the reader's door for her to do her share.

Today when we use these images simply as a historical resource to suggest details of setting and costume or physiognomy and behaviour in our reconstructions of the past – or worse, when we use them as straightforward records of a past era – we do them a disservice. Just as we understand that historical films that are made today are reflections on the present as much as the past, and are embedded in the contemporary politics of memory and memorialization, we owe it to miniature paintings to recognize their delicate dance between image and imagination and the rhetorical capacities they once had, to complicate histories and disturb the settled certainties of their time.

NOTES

1. This celebrated painting is at the Freer Gallery of Art, Smithsonian Institution, and can be seen at https://asia.si.edu/object/F1942.15a/. Accessed 20 June 2021.
2. I am referring here to the enormous multi-tiered golden vessels seen in Seyller and Thackston (2002: cat. nos 59 and 64).
3. The paintings of the Pādshāhnāma have been fully published in Beach et al. (1997).
4. Two of these portraits are in the Minto Album in the Victoria and Albert Museum (V&A 16-1925) and in the Shāh Jahān Album (also called the Kevorkian Album) in the Metropolitan Museum of Art (MMA 55.121.10.25 r). Both are nineteenth-century copies of an earlier, unknown original which was possibly made by Abū'l Ḥasan, the celebrated artist who was the brother of 'Ābid, as the Minto Album version has an inscription bearing his name. The Kevorkian Album painting is also from the nineteenth century but is a finer version of the same theme and is signed by the otherwise unknown artist Muhammad Alam. In both portraits, Abdullāh K̲h̲ān is dressed as in the *Padshahnāma* painting.
5. Jahāngīr kept his memoir till 1622, when, enfeebled by age and the consumption of too much opium and wine, he asked his secretary Mu'tamad K̲h̲ān to write entries on his behalf, which the emperor would read and correct. The memoir continued thus for another two years but ends abruptly with events from 1624, three years before Jahāngīr's death.
6. Scholars have assumed that the many paintings illustrating events from Jahāngīr's reign, all of a roughly similar format, were intended for the grand manuscript that was never compiled. The paintings that have come down to us have been preserved in various albums. We do not know how many of the illustrations made for the *Jahāngīrnāma* have been lost.

Most of the known illustrations are reproduced in Wheeler Thackston's translation of the *Tuzuk-i-Jahāngīrī*.

7. It is not uncommon for Jahāngīr to be inconsistent or to misremember events or misidentify people in his memoirs. Indeed, in the scattered references he makes in the text to this young ally of Khusrau's – Mirzā Husain, son of Mirzā Shāhrukh of Badakshan – he reports entirely different fates for him. On page 50 of the edition we are using of the *Jahāngīrnāma*, Jahāngīr describes his capture; on page 82 he says Mirzā Husain had fled Burhanpur (where presumably he was imprisoned) and gone to Badakshan, where he was still at large; but on page 220 he makes him the diwan of Gujarat and on page 276 mentions that he had been the diwan of Bengal (Jahāngīr 1999).

8. It has been conjectured that an unnamed figure in one page of the Shāh Ṭahmāsp *Shahnāma* might be the shah himself. If so, it does doubtful honour to the patron of the manuscript, since he is shown as a marginal figure, akin to an attendant, who stands and watches an assembly of poets, including Firdausī, the author of the text (Welch 1972: 82).

9. The text of the *Zafarnāma* of Sharafuddīn Alī Yazdī was commissioned by Timūr's grandson Sultan Ibrāhīm in 1425. The most famous illustrated manuscript of this text is the 'Garrett' *Zafarnāma* (completed *c.*1485), commissioned by Sultan Ḥusayn Bayqārā, great-great-grandson of Timūr. This manuscript was in the possession of the Mughals, as I discuss later.

10. One exception to this rule comes to mind – the *Ni'matnāma*, that curious illustrated cookbook that was made in the sixteenth century for a pleasure-loving Sultan of Mandu, and whose illustrations show the sultan supervising kitchen operations (see Titley 2005).

11. Several manuscripts of the *Akbarnāma* are known, both without and with illustrations. Two of these are accepted as 'presentation' manuscripts that were probably made for the emperor. The 'first' *Akbarnāma* was completed *c.*1595; most of volume I, which originally had 81 illustrations, is in the Gulshan Library in Tehran and most of volume II, with 116 illustrations, is in the Victoria and Albert Museum. A 'second' *Akbarnāma* was completed in *c.*1604. Volume I of this version, with 40 illustrations, is in the British Library and volume II, with 61 illustrations, is in the Chester Beatty Library in Dublin. None of these manuscripts has survived intact, and several illustrations have been excised from each volume, so the manuscripts in their original form would have had even more images.

12. It is another matter that Abū'l Faẓl wraps all this documentary evidence in a blanket of mysticism and predestination and uses every incident and utterance to prove that Akbar is the 'perfect man' and the culmination of history. This is ably analysed by Harbans Mukhia.

13. There are obvious parallels between the *Zafarnāma* and the *Akbarnāma*, in text and illustration, which are worthy of separate study.

REFERENCES

Andrews, Peter Alford (1999), *Felt Tents and Pavilions: The Nomadic Tradition and Its Interaction with Princely Tentage*, London: Melisende.

Beach, Milo Cleveland, Koch, Ebba and Thackston, W. M. (eds) (1997), *King of the World: The Padshahnama: An Imperial Mughal Manuscript from the Royal Library, Windsor Castle*, London: Azimuth Editions.

Benjamin, Walter (2011), 'The storyteller', in *Illuminations*, New York: Random House, pp. 83–107.

Brand, Michael and Lowry, Glenn D. (1986), *Akbar's India Art from the Mughal City of Victory*, New York: Asia Society Galleries.

Das, Asok Kumar (1978), *Mughal Painting during Jahangir's Time*, Calcutta: Asiatic Society.

Di Francesca, John (1994), 'Knowledge, pictorial documentation and inductive reasoning in Akbari theological politics and ideology', MA thesis, New York City: Columbia University.

Elliot, Henry Miers (1875), *Shāh Jahān*, Lahore: Hafiz Press, https://archive.org/stream/cu31924006140374#page/n29/mode/2up/search/Sahenda. Accessed 19 December 2019.

Faruqui, Munis Daniyal (2012), *Princes of the Mughal Empire, 1504–1719*, Cambridge and New York: Cambridge University Press.

Hardy, Peter (1985), 'Abul Faẓ'l's portrait of the perfect Padshah: A political philosophy for Mughal India – or a personal puff for a pal?', in C. W. Troll (ed.), *Islam in India: Studies and Commentaries*, New Delhi: Vikas Publications, pp. 2:114–37.

IANS (2007), '*Jodhaa-Akbar* is 80 percent my imagination: Gowariker', *India Forums*, 12 October, http://www.india-forums.com/bollywood/starry-takes/1041-jodhaa-akbar-is-80-percent-my-imagination-gowariker.htm. Accessed 19 December 2019.

Ibn Mubārak, Abū ăl-Faḍl and Beveridge, Henry (2002), *The Akbar Nāma of Abu-L-Fazl*, Delhi: Low Price Publications.

Jahāngīr (1999), *The Jahangīrnāma: Memoirs of Jahangīr, Emperor of India* (trans. W. M. Thackston), New York: Freer Gallery of Art, Arthur M. Sackler Gallery in association with Oxford University Press.

Koch, Ebba (1997), 'The hierarchical principles of Shah-Jahani-painting', in M. C. Beach, E. Koch and W. M. Thackston (eds), *King of the World: The Padshahnama: An Imperial Mughal Manuscript from the Royal Library, Windsor Castle*, London: Azimuth Editions, pp. 130–43.

Leach, Linda York (1995), *Mughal and Other Indian Paintings from the Chester Beatty Library*, London: Scorpion Cavendish.

Markel, Stephen (2003), 'Correlating paintings of Indian decorative objects with extant examples: Correspondences and issues', 24 February, https://www.asianart.com/articles/markel/index.html. Accessed 24 March 2021.

Mukhia, Harbans (1976), *Historians and Historiography during the Reign of Akbar*, New Delhi: Vikas Publishing House.

Parodi, Laura (2010), 'From tooy to darbār: Materials for a history of Mughal audiences and their depictions', in J. K. Bautze and R. M. Cimino (eds), *Ratnāmala: A Garland of Gems*, Ravenna: Edizioni del Girasole and Fondazione Flaminia, pp. 51–76.

Parodi, Laura (2012), 'darbārs in transition: The many facets of the Mughal imperial image after Shah Jahan as seen in the ex-Binney collection at the San Diego Museum of Art', in A. Patel and K. B. Leonard (eds), *Indo-Muslim Cultures in Transition*, Leiden and Boston: Brill, pp. 87–110.

Rice, Yael (2011), 'The emperor's eye and the painter's brush: The rise of the Mughal court artist c. 1546–1627', Ph.D. dissertation, Philadelphia: University of Pennsylvania.

Seyller, John William and Thackston, Wheeler M. (2002), *The Adventures of Hamza: Painting and Storytelling in Mughal India*, Washington, DC: Freer Gallery of Art, Arthur M. Sackler Gallery and Smithsonian Institution in association with Azimuth Editions, London.

Singh, Kavita (2017), *Real Birds in Imagined Gardens: Mughal Painting between Persia and Europe*, Los Angeles: Getty Research Institute.

Thackston, Wheeler M. (1989), 'Sharafuddin Ali Yazdi: Zafarnāma', in W. M. Thackston (ed.), *A Century of Princes: Sources on Timurid History and Art*, Cambridge, MA: The Aga Kẖān Program for Islamic Architecture, pp. 63–100.

Titley, Norah M. (2005), *The Ni'matnāma Manuscript of the Sultans of Mandu: The Sultan's Book of Delights*, London and New York: Routledge Curzon.

Wade, Bonnie C. (1998), *Imaging Sound: An Ethnomusicological Study of Music, Art and Culture in Mughal India*, Chicago: University of Chicago Press.

Welch, Stuart Cary (1972), *A King's Book of Kings: The Shah-Nameh of Shah Tahmasp*, New York: Metropolitan Museum of Art.

Wescoat, James L. and Wolschke-Bulmann, Joachim (1986), 'Sources, place, representations and prospects: A perspective of Mughal gardens', in J. Wescoat and J. Wolschke-Buhlman (eds), *Mughal Gardens: Sources, Places, Representations*, Washington, DC: Dumbarton Oaks, pp. 5–30.

6

Justice, Love and the Creative Imagination in Mughal India

Najaf Haider

This chapter is about the representation of Mughal justice and love in literary texts and visual material for over three centuries.[1] Moreover, it is about the antagonism between justice and love. The chapter is as much concerned with the accuracy of historical events as the ways in which they are presented in our sources. Justice figured prominently in religious, political and folk traditions as a high ideal denoting righteousness. In medieval Islamic political thought, justice (*'adl*) legitimized kingship, an essentially non-Islamic institution (Haider 2008: 75–92). In the Mughal Empire (1526–1757), justice epitomised God's will to govern the universe through His vicegerent, the emperor. The Mughal emperor was a manifestation of divinity like a ray of light from the world-illuminating sun (*āftāb-i 'ālam afrōz*) (Abū'l Faẓl 1872: 2). Justice and love for subjects were expressed in the official doctrine of the Mughal state called *ṣulḥ-i kul* ('absolute peace'), a spin-off from the mystical *muḥabbat-i kul* ('absolute love'). Love in Sufism was a deeply personal emotion experienced by human beings for union with God, the ultimate Beloved. Politically, love for the Divine and His creation dissolved worldly differences and created harmony. Expressions and signs of love permeated Sufi poetry in which Divine Love (*'ishq-i ḥaqīqī*) was communicated through worldly love (*'ishq-i majāzī*) (Rizvi 1975; Lumbard 2007: 345–85; Zargar 2011; Yarshater 1960: 43–53).

Powerful ideas produced popular images. The power and grandeur of the Mughal monarch became the stuff of legend. Akbar (1556–1605), the real founder of the Mughal Empire, was depicted in folk stories and bardic narratives as a wise and brave ruler (*mahābalī*) who loved his Rajput wife, Jodh Bai (terribly difficult to verify), and administered the vast Mughal Empire with the help of a council of nine talented ministers (*navratana*), one of whom, Bīrbal, had a reputation for wit (Khan 2014: 173–80; Naim 1995: 1456–64). The romance between Akbar's son and successor, Salīm (later Jahāngīr), and a courtesan, Anārkalī, was read into a

155

verse engraved on an anonymous grave in Lahore's Anarkali Bazar. The verse that follows, embodying deep nostalgia of the lover, was signed by Salīm as Majnūn, a legendary figure from the Islamicate world known for his love for Laila (Moosvi 2014: 63–68; Koch 2010: 277–311):

> tā qiyāmat shukr goyam kirdigār-i khwesh rā
> āh gar man bāz bīnam rūy-i yār-i khwesh rā.

> ('I would remain eternally grateful to my Lord
> If I could see the face of my beloved once again.')[2]

Justice in Jahāngīr's memoir and paintings

The Mughal Emperor Jahāngīr (r. 1605–27) exceeded his brilliant father Akbar in one kingly virtue, namely justice, and acquired a legendary reputation for it. Like all legends this one too grew from a lore, which was rooted in a widely held perception that the subjects of the Mughal Empire lived under an emperor who did not discriminate between strong and weak when it came to delivering justice. The historical core of Jahāngīr's justice is contained in his memoir, *Jahāngīrnāma*, and paintings commissioned by him.

Soon after he became emperor, Jahāngīr began to write a memoir that doubled up as the chronicle of his regime. The *Jahāngīrnāma* was meant to document the Mughal political and cultural world with the emperor at the centre. One of Jahāngīr's earliest achievements listed in the *Jahāngīrnāma* is the chain of justice:

After my accession, the first order I gave was for the fastening up of the chain of justice (*zanjīr-i 'adl*), so that if the officers of the judiciary (*dāru'l adālat*) are negligent or procrastinate in delivering justice to those who have suffered, the oppressed could themselves come near the chain, shake it and announce their presence with its sound (*ṣadā*). The chain was made of pure gold, thirty *gaz* [101 feet] in length and containing sixty bells (*shaṣt zang*). Its weight was four Indian *maunds* [120.5 kg], equal to thirty-two Iraqi [i.e. Iranian] *maunds*. One end of it was attached to the battlements of the Shah Burj of the fort at Agra and the other one to a stone column fixed on the bank of the river [Yamuna].

(Jahāngīr 2006: 3–4; 1989: I.7)

Through the chain of justice, Jahāngīr was reinforcing the Mughal notion of ideal kingship and consolidating his claim to the throne. The memory of Jahāngīr's failed rebellion against his father was fresh. Although the royal pardon paved

JUSTICE, LOVE AND THE CREATIVE IMAGINATION

the way for his accession, Jahāngīr had to deal with his own son Khusrau as a rival claimant to the throne backed by a powerful clique (Prasad 1962: 128–43; Faruqui 2012: 30–35). Jahāngīr's legitimacy to rule was strengthened with justice as a major prop. Soon people started talking and writing about the chain of justice within and outside the courtly circle. The Jesuit Father Jerome Xavier, who was present in the Mughal capital during the tumultuous days of Jahāngīr's accession, sent the following report to the Provincial of Goa:

> Having put an end to these disorders, the king occupied himself with the government of his kingdom. He displayed so great a love for justice that, calling to mind what one of the ancient kings of Persia had done, he gave orders that a silver bell with a chain twenty cubits long should be suspended close to his apartments, so that all who felt that they had grievances and were unable to obtain redress at the hands of the law or the officers of the state, might pull this chain, when the king would immediately come forth and deliver justice verbally.
>
> <div align="right">(1997: 13)</div>

Far away from the capital, the chain was visualized as an embodiment of Jahāngīr's justice in a colourful tale of love, *Chitrāvalī*:

> The Emperor has ornamented a rope with a thousand bells of gold (*sahas ghāt kanchan ke sāje*) and stretched it to his court. The bells ring (*jhaṅkārā*) when touched by a victim of injustice (*dukhiyā*), and officials shiver. The Emperor comes out and gives not only audience (*darsan*) but also justice (*dād*). We have heard about Naushīrwān, but we have seen this king with our own eyes (*sukhan sunā nausērwān, sāh jo dēkhā nain*).
>
> <div align="right">(Usmān 1912: 8)</div>

The three versions of the chain and imperial justice intersect and diverge. If sixty gold bells contract into one silver bell in Xavier's missive, they proliferate in Usman's epic poem. Crucially, the emperor came for justice to the same oriel window where he presented himself to the public in a royal ritual (*jharoka darshan*) designed to popularize Mughal kingship. The priest and the poet compared Jahāngīr to the famously just Sasanian Emperor Khusrau Anushīrwān (Naushīrwān), who had fastened a chain (*silsila*) with bells (Tūsī 1965: 44). In the courtly circle, the rhetoric to flatter the vanity of imperial ambition was of a different order. A courtier held Naushīrwān to be the sweeper of Jahāngīr's floor of justice ('Abdus Sattār 2006: 199). Later, a laudatory poem commencing the court history of Jahāngīr's son and successor, Shāh Jahān (r. 1628–58), made the chain laugh at Naushīrwān's justice with its many mouths (Qazwīnī 2015: 40; Koch

2012: 208). The Naushīrwān of Perso-Islamic imagination was merely easing the petitioner's access to the imperial court. The three versions here are in unison that Jahāngīr was actively pitched against his own judiciary.

True to his proclamation, Jahāngīr dispensed justice as a corrupt judiciary continued to provide him with opportunities such as the one during the visit to the distant province of Gujarat:

> As the people of this city [Ahmadabad] are exceedingly weak-hearted and helpless (*za'if dil wa 'ājiz*), in order to guard against any of the men from the imperial camp entering their houses with a view to oppress them, or interfering with the affairs of the poor and miserable, and lest the judge (*qāzī*) and the judicial advisor (*mīr 'adl*) should show partiality and not stop such oppression, I, from the date on which I entered the city, notwithstanding the heat of the air, every day, after completing the midday prayer, went and sat in the *jharoka* [oriel window]. It was towards the river, and had no impediment in the shape of gate, or wall, or watch men (*yasāwal*), or stick-bearers (*chūbdārs*).
>
> (Jahāngīr 2006: 232; 1989: II.13–14)

The passage shows Jahāngīr's justice in a different setting. Still, except for the chain, everything in Ahmadabad appears to be the same as Agra. The emperor sat in the *jharoka* and met people with an awareness of possible oppression and the frailty of judicial administration.

The imperial sense of justice towering over all others is the subject also of Mughal paintings. It has been well argued that the inspiration for symbolic representation of sovereignty in visual art came from European works (Koch 2010: 277–311; Franke 2014: 123–27; Skelton 1988: 177–87). There was yet another interesting reason that had to do with writing. Jahāngīr did not have a court historian of the calibre of Abū'l Fazl who wrote a magnificent history of Akbar's reign. The purpose of the *Akbarnāma* was to provide an officially accurate version of events adorned with a genuine praise of the emperor (Abū'l Fazl 1873–87; 1989–98). Since Jahāngīr was writing about himself, Persian literary conventions imposed on him a code of modesty (Moin 2012: 179–81). No such protocol needed to be followed in the paintings prepared in his workshop (*taṣwīrkhāna*). In a unique painting by Jahāngīr's favourite artist Abū'l Ḥasan, the emperor is shown in the *jharoka* of the imperial palace at Agra looking at the chain of justice that stretches from the ramparts of the palace to the riverbank not shown in the scene (Figure 6.1). The painting shows stick-bearing men (*chūbdārs*) preventing people from reaching the royal threshold, a theme Jahāngīr touched upon twice in his memoir. The depiction of the chain of justice along with the stick bearers is a curious illustration of the

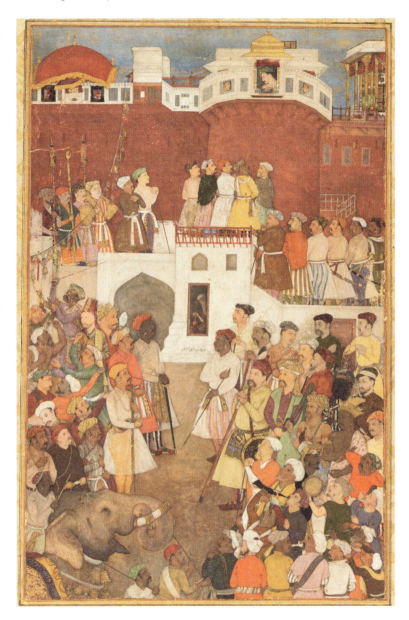

FIGURE 6.1: Emperor Jahāngīr at the *jharoka* window, ascribed to Abū'l Ḥasan, Northern India, c.1620. Opaque water colour, ink and gold on paper. 56 x 32.5 cm. The painting shows the purpose of the chain of justice amidst obstruction of justice. The chain was meant to overcome bureaucratic hurdles for those seeking justice. The elephant in this painting connects with an episode about Jahāngīr's justice in which an aggrieved woman likened its bell with the bells of the chain. The inscription reads: *Amal kamtarīn Nādiru'z Zamān* ('Work of the humble "wonder of the age"').
Source: © The Aga Khan Museum, AKM136.

challenges of delivering justice described in the memoir. Modern scholars of Mughal art have missed the contrasting dichotomy of imperial and sub-imperial justice depicted in a single frame. The painting is discussed by Welch and Welch (1982: 208–12) and Skelton (1988: 182), who consider it to be an example of travesty of justice! The presence of a figure resembling the Byzantine emperor is equally symbolic. Jahāngīr had wished his memory to last longer than the Byzantine emperor whose image he saw on a coin ('Abdus Sattār 2006: 242; another image of the Byzantine emperor in Jahāngīr's painting is discussed by Ettinghausen [1961: 112]). Clearly, in literary and visual portrayal of his kingship, the Mughal emperor was reacting to the glory and grandeur associated with the Byzantine and Sasanian emperors (*qaiṣar* and *kisrá*). Mughal imperial paintings tell us mostly about taste and self-perception. Yet, they seem to be in tune with the public image of the sovereign. A European account of the Mughal Empire based on popular memory mentioned that Jahāngīr was loved by the people and feared by his officials on account of his strict adherence to the canon of justice (Manucci 1996: 168).

A purely allegorical painting by Abū'l Ḥasan is of Jahāngīr piercing arrows through a frail figure enveloped in a cloud of darkness in contrast to the radiant nimbus of the emperor symbolizing divine effulgence. One end of the chain of justice is attached to a carved pillar on earth while a cherub in the sky holds the other. A later hand interprets the theme as 'the auspicious portrait of His Exalted Majesty who, by the arrow of generosity, eradicated poverty personified in human form (Hindi *daliddar*, Persian *shakhṣ-i iflās*), and laid the foundation of a new world with his justice ('*adl*)' (Koka n.d., LACMA M.75.4.28; Okada 1992: 48). The peaceful pairing of animals, an old Indian concept (Dāūd 1996: 49; Usmān 1912: 8), is an allegory of justice in this and other paintings of Jahāngīr and Shāh Jahān (Figure 6.2).

Legends of Jahāngīr's justice

Jahāngīr acquired a reputation for justice in his lifetime. A recently discovered record of the emperor's nightly sessions (*majālis-i shabāna*) with scholars, poets and nobles has a fantastic tale of his fame as a just king. A Mughal officer of Multan was conducting an investigation into the wealth of a deceased person called Imāmuddīn Joyā. A maidservant was suspected of hiding the cash and valuables of her master, but she denied any knowledge. The officer signalled a *mast* elephant to trample her. Protesting her innocence, the old woman stood in front of the charging elephant and cried for justice in the name of Jahāngīr the just king (*pādshāh-i'ādil*). The elephant heard the woman's cry and stopped. No matter how much

JUSTICE, LOVE AND THE CREATIVE IMAGINATION

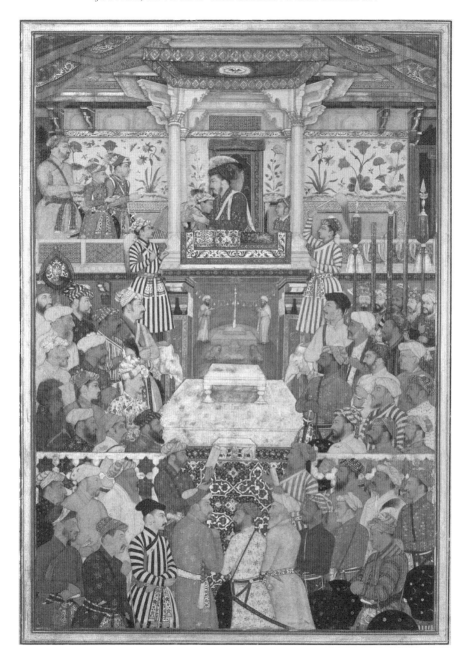

FIGURE 6.2: Illustration of Shāh Jahān's first *darbār* shows the persistence of Jahāngīr's chain of justice in the representation of his son's kingship. Below the throne alcove is an allegory of justice and peace (a goat flanked by lions) painted specially by Bichitr to illustrate Shāh Jahān's official history, *Pādshāhnāma*.
Source: Royal Collection Trust/© Her Majesty Queen Elizabeth II 2019.

the mahout goaded the elephant, the beast would not budge. The crowd stood spellbound. The incident was narrated to Jahāngīr and verified by the woman, but he was not convinced. The courtiers were asked to explain, and the author of the nightly sessions submitted that the incident would not seem all that incredible (*bisyār'ajīb*) if considered in the light of Jahāngīr's exalted sense of justice ('Abdus Sattār 2006: 93–94). The fantasy of imperial justice was at odds with Jahāngīr's rational objectivity, but a majestic elephant with a prominent bell resembling the bells of the overhanging chain of justice in the painting shown in Figure 6.1 seems to connect with the anecdote.

To the extent that they could reach them, Jahāngīr's memoir and paintings left impressions on the minds of the people. The memoir's wider reach was spurred by Jahāngīr's personal interest in its pre-circulation (Jahāngīr 2006: 239; 1989: II.26–27). Copies of allegorical paintings too were made for limited viewing, and in one of them a later hand equated justice with prosperity. A highly creative and inauthentic version of Jahāngīr's memoir circulated with an exaggerated account of imperial justice not to be found in the original (Pseudo-Jahāngīr n.d., MS Tarī<u>kh</u> Fārsī 174: 51a). The most interesting turn in the narrative of imperial justice came when the author of a chronicle of the Mughal Empire, written in Dutch (1627–29 AD) but modelled on Indo-Persian histories, blamed Nūr Jahān for ruining the emperor's impeccable reputation of 'Adil Padshah or Just King' (Anon. 1957: 91). The chronicle is attributed to the Dutch East India Company (VOC) merchant Farncisco Pelsaert and his superior Pieter van den Broecke.

Popular interest in imperial justice revived in the eighteenth century when Muḥammad Shāh (r. 1719–48), the last effective Mughal emperor, installed a chain with bells (*jara*s) from the tower of the imperial palace at Shāhjahānābād (Delhi) to the bank of the river Yamuna. Muḥammad Shāh made a proclamation for those oppressed people who could not come to court, to shake the chain and seek justice (Tabāṭabāi' 1897: 453). Memories of Jahāngīr's justice resurfaced and, what is more interesting, intertwined with stories of his love for his queen, Nūr Jahān, in a most creative manner.

Jahāngīr's union with Nūr Jahān

The Mughal Empress Nūr Jahān was born on the borders of India and Iran to a noble family of the Safavid Empire which had fallen in bad times. Nūr Jahān's (then Mihru'n Nisā') father, I'timādu'd Daula (then <u>Gh</u>iyās Beg Tehrānī), joined the administration of the Mughal Emperor Akbar. Her husband, Sher Afgan, was a Turkish officer of the Mughal Empire (and an ex-official of the Safavid Empire) who served in Bengal. After the death of Sher Afgan in a fight in 1607 AD, Nūr

Jahān was attached to the establishment of Ruqaiya Sulṭān Begam, Jahāngīr's stepmother. She was not sent to the house of her father, an officer in Jahāngīr's administration, because of the disgraceful conduct of her deceased husband. For about four years, Nūr Jahān lived quietly in the quarters of the begam. During the celebration of the festival of *naurōz* in the imperial capital of Agra, Jahāngīr saw her and decided to bring her into his harem (Khān 1865: 55–56; Bhakkarī 1970: 47; 2003: 14).

Jahāngīr's marriage with Nūr Jahān in 1611 AD is a known fact in modern biographies (Findly 1993: 37–38; Shujauddin and Shujauddin 1967: 26; Lal 2018: 101). The sources, however, present a complex picture of the union. Official histories of the Mughal Empire rarely commented upon the circumstances of royal marriage or concubinage. The authors were either not privy to matters pertaining to the ladies of the harem or, following a literary protocol, maintained a dignified silence. In contemporary works, the names of the women of the imperial and noble families were removed from the final draft although they could be read in early versions of the manuscript. Only the title of Jahāngīr's mother is known (Maryamu'z Zamānī or 'Mary of the age'), not her name or social background. It is extremely rare to find in the sources the name of Nūr Jahān's daughter with Sher Afgan, Bahu Begam (Shīrāzī 2003: 197–99). Sometimes the authors found solace in subtle allusions. With the passage of time, and distance from the court, the narratives became bolder. Events were retold to give the authors a sense of fulfilment. In the narratives of the union of Jahāngīr and Nūr Jahān all these elements are present: silences, allusions and bold assertions.

Jahāngīr composed his memoir practically every day based on personal observations, court proceedings and news reports from different parts of the empire. In the memoir there is no mention that he married Nūr Jahān. The omission was so glaring for a copyist of the memoir that he appended a marginal note in first person adding the precise date of the wedding (Jahāngīr n.d.: MS Or. 3276: 132a). The memoir also omitted a big feast Nūr Jahān attended soon after the union to celebrate the elevation of the prince Shāh Jahān to a higher official rank (Khān n.d., MS Bankipore 565: 6b). Once the reign of Jahāngīr had passed, historians were obliged to write about the event and fill the lacuna. The first biography of Jahāngīr was written in the court of his son and successor, Shāh Jahān. The author of this work, Mu'tamad Khān, was a news writer and a trusted officer of Jahāngīr ('he understood well my words and thoughts'). Jahāngīr had invited Mu'tamad Khān to scribe the last part of the imperial memoir with access to the material (Jahāngīr 2006: 352). Mu'tamad Khān was in a better position to chronicle the reign of the late emperor, but writing about Nūr Jahān in a court hostile to her was challenging. Mu'tamad Khān's account of the union comes to us in two versions. In the short version, possibly an early draft of the book, Nūr Jahān's misfortune ended

when on *naurōz* she became the object of the emperor's alchemical eye (*manẓūr-i naẓar-i kīmiyā aṣar*) and one of the consorts of the harem (*parastārān-i ḥarām sarā*) (Khān 1870: 529). The long version mixed fate with feelings:

> When the time came for her stars to rise and shine, good fortune woke up from a deep sleep and welcomed her, happiness showed its face, felicity ornamented the bride's chamber and the world became her bride-dresser (*mashshāṭa*), lust became manifest, hope felt proud, desire flew from all sides, a key arrived to open the closed doors and a remedy was found for the broken heart (*dil hāi khasta ra dawā shud*).
>
> (Khān 1865: 56)

The sensuous delicacy of the passage left enough room for the reader to speculate about the nature of the union. Marriage was not mentioned in either of the two versions.

It seems Jahāngīr's union with Nūr Jahān was circumscribed by the religious rule of Muslim marriage (*nikāḥ*). Till the time of Akbar, the Mughal emperors followed the Timūrid tradition of marrying as many women, freeborn or slave, as they wished even though Islam restricted the number of wives to four at a time. Akbar was anxious to find a solution to his polygamy, which had exceeded the legal limit (Badāūnī 1865: 207–08; 1973: 211; Bano 1999: 354–57). A solution was found in the stratagem to split marriages into two. Muslim women were married through *nikāḥ*, and non-Muslim women by following wedding customs of the bride. If the emperor wanted yet another woman, she had to wait in the harem to be among the four 'legally' wedded wives. The visiting Jesuit priest, Father Monserrate, offers the best description of the duality prevailing in the harem:

> [Akbar] also invented and introduced amongst the Musalmans two forms of marriage, first that with regular consorts, who may number four: and second that with those who are merely called wives, and who may be as numerous as a man's resources allow. Musulman kings employ this sanction and license of the foulest immorality in order to ratify peace and to create friendly relationships with their vassal princes or neighbouring monarchs. For they marry the daughter and sister of such rulers. Hence Zeladinus [Jalāluddīn Akbar] has more than 300 hundred wives, dwelling in separate suite of rooms in a large palace.
>
> (2003: 202)

Jahāngīr most likely followed the footsteps of his father. An Englishman present in Agra in 1611 AD, the year the union took place, mentioned that the emperor 'has three hundred wives, where of foure be chiefe as queenes, to say, the first named, Padasha Banu, daughter to Kaime Chan; the second is called Noore Mahal, the

daughter of Gais Beyge' (Hawkins 1999: 101). With rare access to palace information, Hawkins is our earliest source for Nūr Jahān. It is obvious from his statement that in the circle that he moved she was already a prominent member of the harem, next only to Sālihа Bānū, entitled Pādshāh Maḥal ('wife of the king') and daughter of a leading noble of Akbar, Qā'im <u>Kh</u>ān.

Jahāngīr chose not to include Nūr Jahān's entry into the harem in the events he recorded in his memoir. In a private conversation, also recorded but never meant to be made public, he gave air to his feelings. Theologians and judges were invited to a special nightly assembly where the emperor posed the following question:

> If a woman upon becoming a widow takes another husband, which husband she would live with on the Day of Judgment, first or second? Qāzī Shukr said she would be with her second husband. His Majesty asked the reason for that. The *qāzī* replied that if this did not happen, the wives of the Prophet who were widows [when they married him] would be with other men on the Resurrection (*qiyāmat*). His Majesty argued that probably these women would be with the Prophet on the Resurrection because of his exceptional nobility and dignity [and not because he was their second husband]. Then His Majesty said, 'I want an answer based on reason (*dalīl-i 'aqlī*) whereas your replies are based on dogma'. The scholars then said that on the Resurrection she would be with the second husband because the first died before her and therefore went out of her possession. His Majesty asked what would happen if the second husband also died before her? They all said then she would be with her first husband.
>
> <div align="right">('Abdus Sattār 2006: 265–66)</div>

The person at the centre of the theological hair-splitting was undoubtedly Nūr Jahān. Jahāngīr was imagining Nūr Jahān not only as his legally wedded wife (or wife to be) but also contemplating spending his life with her till eternity! From the last response, it seems that the learned scholars present there were not sure about the identity of the woman or the objective behind the discussion.

In the numerous fictive elements surrounding the legends of Jahāngīr and Nūr Jahān, the one about the Islamic wedding is striking. It is present in the already mentioned marginal note in the manuscript of the imperial memoir where 'Jahāngīr' was retrospectively claiming to have married Nūr Jahān in a *nikāḥ* ceremony. The following passage from Jahāngīr's forged memoir that circulated as genuine till the nineteenth century extolled Nūr Jahān's virtues and asserted the Islamic character of the wedding:

> Nūr Jahān *begam* who is the chief among the 400 [women] of my *haram*, holds the rank (*manṣab*) of 30,000. There is hardly any city in which she has not built

a splendid garden and a beautiful building. Her influence in everyday affairs is supreme. Until she came into my house, I had no understanding of domestic affairs and the real meaning of conjugality. During the time of my father, she was betrothed in Lahore to Shēr Afgan; but when he was killed I sent for the *qāzī*, and married her (*'aqd*). A sum of 80 lakh *ashrafīs* of 5 *misqāls* was fixed as her bride money (*mahr*). She demanded the amount from me to purchase jewels and I gave it to her at once. I presented her with a pearl rosary of forty beads, each bead costing 40,000 rupees. At present, my entire household, with gold and jewels, is in her hands. My opium doses too are under her control. I have reposed my full trust in her. The kingdom and its administration are in the hands of this family: the father being my chief *dīwān* [in charge of finances], the son my *wakīl* [first minister], and the daughter my confidant and close companion (*hamrāz o musāhib*).

(Pseudo-Jahāngīr n.d., MS Tārīkh Fārsī 174: 28a; Figure 6.3)

When Pseudo-Jahāngīr was composing this passage, Nūr Jahān's fame as a powerful and accomplished royal woman was well established, and the *nikāh* and the bride money reflected the preoccupations of a later period. It was difficult not to believe that she was married in the most proper way. The passage mixed the authentic, such as Nūr Jahān's passion for building, with invented facts. From 1616 AD, if not before, Nūr Jahān was the leading lady in a large harem (400 is an order of magnitude) of women who were not all wives or concubines, and the highest recipient of cash and gifts among the begams (Khān 1865: 105). She did indeed command resources exceeding those of a Mughal grandee (see later), but *mansab*s (numerical ranks) were given only to men in Jahāngīr's reign. The award of the highest rank to Nūr Jahān was meant to enhance her prestige and the effect of the narrative. Pseudo-Jahāngīr generally followed this strategy as in keeping the amount of the bride money at an astonishing eight million gold coins, fifteen times the cost of the Taj Mahal complex. The language of affection in the passage was not Jahāngīr's but the sentiments were. Nūr Jahān's earliest biographer (*c.*1650 AD), someone close to the family of I'timādu'd Daula, remarked that Jahāngīr's love for her relegated Majnūn to the realm of fantasy (*afsāna*) (Bhakkarī 1970: 49).

Nūr Jahān's rise to power

The union of Jahāngīr and Nūr Jahān was a personal and political success. A strong bond developed between the two, and the family of Nūr Jahān rose in status and power. I'timādu'd Daula and Āsaf Khān, Nūr Jahān's father and

JUSTICE, LOVE AND THE CREATIVE IMAGINATION

FIGURE 6.3: Folio from *Pseudo-Jahāngīrnāma* praising I'timādu'd Daula's family and Nūr Jahān. The pseudo-memoir circulated widely, and many writers used it as source material in the eighteenth century. An English translation in 1829 AD by Major David Price triggered a debate over its identity. The publication of the Persian text of Jahāngīr's memoir by Saiyid Ahmad in 1864 clinched the debate. MS Tārī<u>kh</u> Fārsī 174, f. 28a.
Courtesy: Raza Library, Rampur.

brother, held ministerial positions and served the regime with loyalty. Nūr Jahān's maternal uncle, Ibrahīm Khān Fateḥ Jang, became the governor of Bengal and died fighting for her cause (Khan 1865: 56; Bhakkarī 1970: 230–38; Habib 1969: 74–95). Jahāngīr made a rare entry in the memoir of his intimate feelings for Nūr Jahān. In 1616 AD, five years after the union, she was given the title of Nūr Jahān, although her first title Nūr Mahal remained popular (Jahāngīr 1989: I.266, 318–19; Broecke 1963: 270, 380; Lāhorī 1878: 476). The name Nūr Jahān or 'moonlight of the world' resonated with Jahāngīr's first name, Nūruddīn, in which *nūr* meant the light of the sun. Nūr Jahān's prestige and resources increased considerably when the emperor gave her the estates of her deceased father. The extraordinary endowment included revenue yielding territory (*jāgīr*), the personal establishment of the late noble, a contingent of soldiers (*ḥashm*) and a pair of kettledrums (*naqqāra wa naubat*) (Jahāngīr 1989: II.228; 2006: 342; Khān 1865: 190–91). Drumbeats heralded her arrival even in the presence of the emperor. Towards the end of 1623 AD, Jahāngīr's illness prevented him from focusing fully on administration ('my heart and head did not work in accord with each other'), and Nūr Jahān's influence extended to the affairs of the state (Jahāngīr 1989: II.353). The gold and silver coins ordered by the emperor to be issued in the name of Nūr Jahān from 1624 AD were a sign of shared sovereignty, an extraordinarily novel aspect of Mughal kingship (Figure 6.4). Nūr Jahān's seal, stamped on official documents, conveyed the idea of the sun and the moon ruling the Mughal universe: 'By the sun [or love, since *mihr* means both] of the Emperor Jahāngīr, the seal (*nagīn*) of Nūr Jahān, the first lady, has become resplendent like the moon' (Hodivala 1929: 59–68).

Nūr Jahān would sit in the *jharoka* of her palace behind a specially designed latticed screen and hold court attended by nobles who performed salutation and noted her decrees (*farmān*). To this phase belongs the famous statement attributed to Jahāngīr: 'I have conferred the government on Nūr Jahān Begam. What do I want except one *ser* of wine (*yak ser sharāb*) and half a *ser* of meat (*nīm ser gōsht*)!' (Khān 1865: 56–57; Ḥusainī 1978: 144). Although Nūr Jahān was tactful and resourceful, she lost out to Shāh Jahān (r. 1627–58) in the succession struggle following Jahāngīr's death and was pensioned off. People believed she lived in a state of perpetual mourning. According to Muḥammad Ṣādiq Khān, she wore white and never laughed (Khān n.d., MS Or. 174: 115a). Nūr Jahān died in 1645 and was buried in Lahore near the tomb of Jahāngīr where she had built her own (Lāhorī 1878: 475–76).

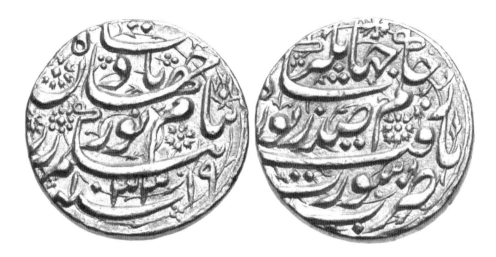

FIGURE 6.4: Gold *muhr* minted in the name of Nūr Jahān at Surat in 1624 AD. By order of the King Jahāngīr, gold (*zar*) obtained a hundred splendours (*ṣad zewar*) when it received the impression of the name of Nūr Jahān, the first lady (*padshāh begam*).
Courtesy: Classical Numismatic Group, LLC. https://www.cngcoins.com/Coin.aspx?CoinID=193477. Accessed 1 June 2021.

Legend of romantic love

The narrative of Jahāngīr's prior romantic interest in Nūr Jahān originated in a tradition (oral and written combination of connected reports) hostile to her and the house of I'timādu'd Daula. The composite Mughal nobility masked tensions based on cultural identity and hegemony. The rise of the Iranians in the nobility of Jahāngīr was resented most notably by the Central Asian (Tūrānī) faction which was powerful until then (Koka n.d., MS Add. 16859, f. 19a). The provenance of the tradition may have been the province of Gujarat under the governorship of the prince Shāh Jahān. The tradition of romantic love, preserved in European accounts, hinged on the disgrace of I'timādu'd Daula and the dramatic reversal of his fortune with Nūr Jahān as the causal link. According to the tradition, I'timādu'd Daula committed the crime of embezzlement that was compounded by the murder of the governor of Bengal by his son-in-law, Sher Afgan. The complicity of his son, Muḥammad Sharīf, in a plot to assassinate the emperor and put the prince Khusrau on the throne was the nadir of I'timādu'd Daula's career in a bureaucracy where family mattered. I'timādu'd Daula was sentenced to death but released on payment of a hefty fine at the intercession of Diyānat Khān. Jahāngīr had nourished the desire to marry Nūr Jahān from his princely days and found

the moment right to proclaim his love for her once again during his regular visits to I'timādu'd Daula's house across the river. He was emperor during the day and 'Cupid's slave' in the night. The family, facing the ignominy of sedition, accepted Jahāngīr's proposal for marriage and a judge (*qāẓī*) solemnized the wedding. Grand celebrations were held and the nobility gave expensive gifts to the emperor (Anon. 1957: 41–42; Herbert 1638: 74–75).

The tradition reconfigured elements from real life, adapted material passed on as authentic and addressed ambiguities. I'timādu'd Daula was notorious for taking bribes, but he was never charged with embezzlement. There was a contentious issue involving Diyānat Khān, not a friend of the family in real life but a saviour in the story, which sources did not reveal. When I'timādu'd Daula's son, Muḥammad Sharīf, was convicted for high treason, there was intense speculation about the identity of the co-conspirators since the incriminating document was destroyed by the emperor to avoid unrest (Khān 1865: 29, 55; Ḥusainī 1978: 106). The tradition made I'timādu'd Daula a member of the secret group that planned the coup. The sources also suggest that the charge against Sher Afgan was more of disobedience than disloyalty. The tradition conflated the crimes and held the head of the family culpable.

Roles were reversed in a variant version of the tradition in Jean Baptiste Tavernier's short biography of Nūr Jahān. The marriage here was a quid pro quo for the pardon received by I'timādu'd Daula, an ungrateful wretch convicted for treason. Sedition, seduction and mercy were the critical components of this version rather than love and romance:

> This daughter of Persian General, who was unique, was only fourteen years old, and she was an accomplished beauty with no match in the whole kingdom. She had been very well brought up, and could speak and write Arabic, Persian, and Indian [languages]. The mother and the daughter went to Court every day to find out what the fate of the General would be, and having learned from the Sultana that the King had decided to put him to death, or to send him into exile, they came to the harem and threw themselves at the feet of his Majesty, and to ask him for forgiveness, one for her husband, the other for her father, which they had the good fortune to obtain, the King having been struck by the extraordinary beauty of this girl to whom he afterwards gave all his affections (*le Roy ayant esté frapé d'abord de l'extraordinaire beauté de cette fille à qui il donna ensuite toutes ses affections*).
>
> (Tavernier 1676: 36)

The tradition was designed to propagate the view that the rise of an undeserving Iranian family was entirely due to the personal predilection of the emperor and

the force of passion. The tradition thus added a new element of love leading to murder. Polyandry was not permissible in the Mughal palace, and Nūr Jahān was determined not to look at any other man as long as her husband was alive. Jahāngīr hatched a conspiracy to murder Sher Afgan, which was crowned with success. The reasons for Sher Afgan's defiance of imperial authority were not known, and the murder motif was meant to fill the gap in the historical record. The murder charge came on the back of an exaggerated account of Nūr Jahān's beauty (*jamāl-i bemisāl*) and of Jahāngīr falling head over heels for her (Bhandārī 1918: 446; Manucci 1996: 157). By the end of the seventeenth century, the key motifs of the Jahāngīr-Nūr Jahān saga, namely beauty, romance, passion, murder, wedding and appropriation of power, had come together. The stage was set for a well-rounded romance narrative to emerge.

In the early eighteenth century, an Indo-Persian history entitled *Muntakhabu'l Lubāb*, or *Selections from Essences of Histories*, was written by a retired news writer Khāfī Khān from the date of establishment of the Mughal Empire (1526 AD) to the fourth regnal year of Muḥammad Shāh (1723 AD). Khāfī Khān used old histories, state papers, oral testimonies and reminiscences for writing the book. For the life of Nūr Jahān, Khāfī Khān claimed to possess two unique sources that replaced the 'tendentious' narrative of Jahāngīr and Nūr Jahān (i.e. in which there was no romance) with a 'true and authentic' one (i.e. in which there was). The first source was a text entitled *Minhāju's Ṣadiqīn* that Khāfī Khān inserted into the final draft of his work. The other crucial source, one that bridged the narrative distance, was an 'alert and truthful' Iranian *darwesh*, who travelled in I'timādu'd Daula's caravan as a boy and spoke to Khāfī Khān at the ripe age of 128 years (Khān n.d. MS Add. 6573: 104a; Khān 1874: 247).

According to Khāfī Khān, Mihru'n Nisā', the future Nūr Jahān, was abandoned as a newborn by her parents and raised by the leader, Malik Masūd, of the caravan in which the family was travelling from Iran. Iranian caravans, unlike Indian ones, had fewer women and Malik Masūd could find no woman other than Mihru'n Nisā's mother herself to breastfeed the child. From Qandahār to Lahore, the real mother travelled in the caravan as foster mother. She was well fed to feed the child well.

The wife of Malik Masūd regularly visited the imperial palace with Mihru'n Nisā' and her real mother and received gifts on *nauroz*, the beginning of the Iranian New Year on the vernal equinox. When Mihru'n Nisā' reached puberty her beauty (*ḥusn*) attracted Salīm, and he fell for her. One day Salīm found her alone in a corner of the palace and unable to resist embraced her. Mihru'n Nisā' pulled herself away, ran off to the ladies of the palace and complained. The women spies of the palace (*munhiyān-i maḥal*) reported the incident to Akbar. Salīm was reprimanded and Mihru'n Nisā' was married to Sher Afgan.

The French original, reproduced as an image, reads:

> 32.
>
> # MONNOYES
> ### QUI REPRESENTENT LES DOUZE SIGNES;
> *Et qui ont esté batuës durant les vingt-quatre heures que Gehan-guir Roy des Indes permit à la Reine Nour-mahal son épouse de regner en sa place.*
>
> SULTAN Selim appellé autrement *Gehanguir Patcha*, IX. Roy des Indes pere de Cha-gehan aimoit fort les femmes; mais il avoit une tendresse toute particuliere pour l'une d'entre celles qu'il avoit dans son Serrail, laquelle il avoit épousée, & qui avoit aussi un merite tout particulier Elle avoit beaucoup d'esprit & étoit fort liberale, & elle sçavoit si bien ménager l'esprit du Roy & si bien le divertir qu'il ne pouvoit vivre sans elle, & qu'elle estoit en possession de tout obtenir de luy. Elle avoit deux noms; l'un estoit *Nour gehan-begum*, qui signifie *la lumiere du Monde*, & c'est le nom qui estoit dans son cachet; car comme je l'ay remarqué dans mes relations on ne signe rien, au lieu de quoy on applique son cachet. L'autre nom dont on l'appelloit à la Cour estoit *Nour-Mahal*, qui signifie *la lumiere du Serrail* Elle fut toûjours grande ennemie des deux fils du Roy, & particulierement du second appellé alors *Sultan Kourom*, & qui depuis estant sur le thrône se fit nommer Cha-gehan. Il s'opposoit à tous les desseins de cette Princesse, laquelle de son costé gouvernoit si bien l'esprit du Roy qu'elle le portoit à se tenir la plus grande partie de l'année à la campagne, soûlevant sous main contre luy quelques Rajas des frontieres, pour l'obliger d'aller à la guerre & l'éloigner de ses fils. Cette Reine estant tout-à-fait ambitieuse, ne s'étudioit qu'à complaire au Roy pour venir plus aisément à bout de ses desseins, & ayant une grande passion d'éterniser sa memoire, elle crut n'y pouvoir mieux reüssir qu'en faisant fabriquer en son nom quantité de monnoye, & de differente marque de celles que les Roys des Indes ont accoûtumé de faire batre. Car il faut remarquer que toutes les monnoyes de

FIGURE 6.5: Jean Baptiste Tavernier's account of Nūr Jahān's zodiac coins. The French jeweller visited India several times since the early 1640s and heard stories. This one is about Nūr Jahān's design to perpetuate her memory by minting coins with twelve zodiac signs during her 24-hour rule (*régner souverainement l'espace seulement de vingt-quatre heures*). Nūr Jahān's regular coins were rare and her zodiac coins extremely rare, having been restruck, as Tavernier rightly mentions, by Shāh Jahān. Tavernier's illustrations on the facing page are therefore those of Jahāngīr's zodiac coins. The Nūr Jahān story here got cross-fertilized with the episode of a water carrier (*saqqa*) who was allowed to mint coins during his 24-hour reign by the Mughal Emperor Humāyūn in 1539 AD (Tavernier 1676: 31–36).

Courtesy: Bibliothèque nationale de France.

When Jahāngīr became emperor, the romantic interest was revived. Secret instructions were given to the governor of Bengal, Qutbuddīn <u>Kh</u>ān Kokaltāsh. Sher Afgan got wind of Jahāngīr's intentions ('the scent of love and musk, *'ishq wa mushk*, can never be concealed') by the letters of his trusted men, renounced his official position and discarded the weapon-gear (*yarāq*). The meeting between Sher Afgan and the governor turned into a bloody conflict, and they both got killed. Before his death Sher Afgan attempted to kill Nūr Jahān, but her quick-witted mother saved her.

Jahāngīr was devastated by the death of Qutbuddīn <u>Kh</u>ān who was the scion of a saintly family. Mihru'n Nisā' was brought to Agra and Jahāngīr sent the marriage proposal. She refused and showed grief and anger. Jahāngīr was outraged and sent her to join the group of condemned slave girls in the establishment of his stepmother, Sultan Salīma Begam (sc. Ruqaiya Sul<u>t</u>ān Begam). After some time, when the bitterness of the event diminished, Jahāngīr saw her and the 'flame of love was rekindled'. At last, due to the special attention she received from the emperor she gave in, and the two got married in accordance with the religious law (*sharī'a*). A royal celebration was organized, and she was given the title of Nūr Ma<u>h</u>al. Subsequently, she was given the title of Nūr Jahān Pādshāh Begam and the highest status in the harem. Gradually, she became so influential that the emperor gave the reins of government in her hands. Except for matters relating to *sharī'a* and justice (*'adālat*), Jahāngīr would consult Nūr Jahān on everything. He would never stay away from her and even carry her in the litter while riding an elephant (<u>Kh</u>ān 1874: 263–71).

<u>Kh</u>āfī <u>Kh</u>ān mixed known historical facts, reports and information in his possession to build a coherent narrative. A new incident of the abandoned child was added to the life of Nūr Jahān on the strength of the *darwesh*'s account. The romance story was amplified with details. <u>Kh</u>āfī <u>Kh</u>ān was conscious that his book would be the first Persian language account of Nūr Jahān's life with the romance narrative, though it is possible that he masqueraded as *Minhāju's Ṣādiqīn*, an anonymous literary-historical text that he found and used. Till then, readers had access to the romance only if they could read the Dutch chronicle, which seems to have drawn on a textual tradition in Persian not known to people at the time. This can be inferred from a statement about I'timādu'd Daula's arrest and release in a Persian dictionary of nobles that appeared also in the Dutch chronicle (<u>Kh</u>ān 1888: 129). The two narratives of romantic love are similar but not identical. <u>Kh</u>āfī <u>Kh</u>ān's narrative is neutral to the figure of I'timādu'd Daula, and he does not consider Nūr Jahān's influence inimical to Jahāngīr's justice. The domains of justice and love kept separate by <u>Kh</u>āfī <u>Kh</u>ān collided once again.

Love and lex talionis

Muḥammad Shāh's chain of justice breathed a new life into Jahāngīr's legend. In 1748 AD, an Iranian scholar settled in Shāhjahānabād (Delhi) composed a biographical dictionary (*tazkira*) of Persian poets entitled *Riaẓu'sh Shu'arā* (*Garden of Poets*). Jahāngīr's reputation as a poet and literary critic earned him an entry in the book. The tradition of the *tazkira* was to combine specimens of poetry with anecdotes. One anecdote is an amazing story of Jahāngīr's justice and his love for Nūr Jahān.

In the *Riaẓu'sh Shu'arā*, Jahāngīr was a pleasure-seeking emperor with a strict sense of justice and Nūr Jahān his sweetheart and the most beloved queen (*mā'shuqa-i shīrīn tar az jān-i shahryār*). One day she came to the roof of the palace and a passer-by caught a glimpse of her beautiful face. Nūr Jahān despised the gaze and shot him with a musket (*tufang*). The murder caused uproar, and the family of the victim shook the chain of justice. An internal investigation revealed that it was Nūr Jahān who had done it:

> Even though the love of the king for the wonder of the age was such that morning and evening he kissed her feet and smeared his august face with the dust of her path, and had ordered coins to be struck in her name throughout the realm of Hindustan, and all the grandees (*umarā'*) and chieftains (*rāja*) of the empire rubbed their forehead on her door, the wrath of the second Naūshīrwān (*kisrá-i ṣānī*) was awakened.
>
> (Dāghistānī 2001: 169–70)

Jahāngīr enquired about the motive for the heinous crime, and Nūr Jahān replied that even a passing glimpse of an outsider called for a severe action. The emperor retorted that all this would never have happened had she not gone on the roof for amusement and made a spectacle of her beauty (*tamāshā-i ḥusn*). The defence was flimsy and the judgement swift and severe. Nūr Jahān was given over to the plaintiffs with the instruction that they could punish her as they liked. After prolonged negotiations with Nūr Jahān's well-wishers, the victim's family agreed for a pardon in exchange for cash and village revenues. When the matter was over, Jahāngīr went into the harem, fell at Nūr Jahān's feet and said: 'Had they executed you, what would have I done (*agar tura mī kushtand man chi mī kardam*)!' (2001: 169–70).

The apocryphal anecdote brings out the essence of Jahāngīr's putative justice that everyone is equal before the law. In most accounts, Jahāngīr had been upholding the ideal of justice by punishing members of the high nobility (Findly 1993: 68–72; Lefevre 2007: 470). For the first time in the story of Jahāngīr's justice he was not the only star. Had Nūr Jahān not been the object of Jahāngīr's

passionate love, the act of justice would have lost its greatest effect – the sacrifice of the beloved. Nūr Jahān's saviours were the victim's family and the provision of compensation in Islamic law of retribution (*lex talionis*). Dāghistanī did not explicitly mention blood money perhaps because the practice was well known in the Mughal Empire (Anon. 1678–80: 24b; Anon. *c.*1650: 10a).

At the turn of the twentieth century, the legend of Jahāngīr's justice appeared as a critique of the British administration in India. The first poetic expression of the critique was in the writings of the historian, Persian literary critic and Urdu poet Shiblī No'mānī (1857–1914). Shiblī obtained *madrasa* education in both the traditional and rational sciences and was appointed assistant professor of Arabic at the Mohammedan Anglo-Oriental College, Aligarh (1883–98). Here, Shiblī developed a special interest in Islamic history under the influence of T. W. Arnold and argued that experiences of the past were relevant for the modern needs of the Muslim community. Towards this end, Shiblī wrote poetry with religious and moral themes drawn from the history of Islam and India. The poem (*nazm*) entitled '*Adl i Jahāngīrī* belongs to a set of poems composed to demonstrate the just and non-sectarian character of political rule in the central Islamic lands and Mughal India. The first poem is about the second caliph 'Umar (634–645 AD), celebrated for justice in Islam along with Naūshīrwān. The second poem (of which the first and last couplets are given in this chapter) is based on the *Riazu'sh Shu'arā* and narrates the entire story of the murder, trial and conviction. Shiblī praises Jahāngīr for not discriminating between the parties at suit. At the time of passing the verdict against his most beloved queen, Jahāngīr was unmoved by considerations of status, love, virtue or greatness (No'mānī n.d.: 48–49). Shiblī did mention the offer of blood money (*khun bahā*), even though it was applicable in Islam only to accidental death (Lange 2014: 169).

> *Qasr-i shāhī main ke mumkin nahin ghairon ka guzar*
> *ek din Nūr Jahān bām pe thī jalwa figan*

('One day Nur Jahan was standing on the roof of the imperial palace
Which was a forbidden place for outsiders')

[...]

> *dafa'tan paon pe begam ke gira aur ye kaha*
> *'tū agar kushta shudī āh chi mī kardam man'.*

('Suddenly he fell at her feet and said
"Had you been executed, oh, what would have I done!"')

Justice versus mercy: Sohrab Modi's *Pukar*

Shiblī's poem circulated widely in the twentieth century and entered Urdu text-books. My mother remembered reading it as a young student. The poem was recited in literary gatherings and gladdened the hearts of those nationalists who found the claims of British justice hollow. A big moment in the poem's popularity came when Kamal Amrohi and Vishnupant Aundhkar used it for the script of the Urdu film *Pukar* ('Cry for justice') made by Sohrab Modi in 1939 AD (Bhaskar and Allen 2009: 33, 36, 111–22). *Pukar* is essentially about Jahāngīr's justice, but touches upon chivalry, loyalty, duty, love and, ultimately, mercy. Set at the court of Jahāngīr (Chandra Mohan), the film tells entangled love stories. The first story is of the love between Mangal Singh (Ali) and Kanwar (Sheela) amid the violent feud raging between their rival Rajput families, both in the Mughal bureaucracy. When Kanwar's brother hears that his sister is in love with Mangal Singh, he challenges the latter to a duel. Mangal kills the brother and fatally wounds Uday Singh, Kanwar's father. Uday Singh appeals to Jahāngīr by pulling the chain of justice and demands retribution as he dies before the emperor. Mangal's father Sangrām Singh (Sohrab Modi), a Mughal *manṣabdār* of 6000 *zāt* (personal rank), captures his son and brings him to the imperial court. Jahāngīr tries the case and passes the death sentence based on the law of retaliation. He is untouched by the plea of mercy brought before him by Sangrām Singh, who reminds the emperor eloquently of the Rajput contribution to Mughal rule. Nobility, loyalty and service have no dissolving influence on Jahāngīr's justice.

The second story is of Jahāngīr and Nūr Jahān (Naseem Banu). Jahāngīr's claim that the law knows no class distinction is put to test when a washerwoman, Rānī (Sardār Akhtar), accuses Nūr Jahān of having killed her husband with an arrow shot from the palace. The scriptwriters made changes to Shiblī's poem. They kept the roof as the site of the shooting, but gave the victim, the anonymous passer-by, a proper identity and name. The act of murder was rendered acci-dental and the arrow replaced the gun. The accident mitigated a brazen crime and deflected sympathy away from the victim's family. The image of a musket-wielding Nūr Jahān, although historically more accurate, may have been found to be less popular with the viewers. In a well-known hunting expedition in Malwa, Nūr Jahān shot four lions from an elephant top with six musket shots and earned praise, pearl and gold from the emperor (Jahāngīr 2006: 185–86). The term used for bullet (musket ball) and arrow in Persian is the same (*tīr*), and this may have helped the switch.

In the grand trial presided over by the emperor, Nūr Jahān is convicted. Once again the scriptwriters intervened in the story to place an ingenious interpretation on *talionic* punishment. Jahāngīr argues that justice would be served only if the

life of the convict's husband was taken to compensate for the life of the plaintiff's husband. Monarchs are never brought to court, and the effect of the legislative reasoning is stunning. The apocalyptic thought of regicide provokes a powerful appeal for mercy from Sangrām Singh, and the washerwoman accepts it along with the blood money, thus resolving a critical problem for the empire.

In the film, Jahāngīr's justice is interrogated and exposed. Twisting the tale, Amrohī and Aundhkar draw Jahāngīr out of the parochial conception of justice to reveal its ultimate objective. A meaningful conversation between Jahāngīr and Nūr Jahān on the relative merits of justice and mercy (*raḥm*) impacts deeply and leads to the denouement.

The film was a success with positive reviews. The famous Urdu writer Sa'ādat Ḥasan Manto watched the premier show and recorded his reaction:

> I was invited to the premiere of *Pukar*. It was a fictionalised account of Jahāngīr's justice presented in deeply sentimental and theatrical way. Two things about the film were outstanding: dialogues and costumes. The dialogues were artificial and theatrical, but they were powerful and majestic (*zōrdār wa pur shukōh*) and had a tremendous impact on the viewers. Since this was the first film of its kind it was a big hit on the box-office and revolutionized the film industry. Nasīm was unimpressive as an actor but this was more than compensated by her beauty and Nūr Jahān's costume.
>
> (Amrohavi 2007: 42–43)

Conclusion

Creative imagination is a way of going beyond human experience. In their experience, people in the Mughal Empire remembered two exceptional things about the Emperor Jahāngīr: his justice and love for Nūr Jahān. The legends surrounding the lives of Jahāngīr and Nūr Jahān were not accurate records of what happened in history, but they were not far removed from it either. Nothing was created out of thin air. The legend of Jahāngīr's justice developed against the backdrop of an inept judicial system and the efforts of the emperor to override it. In popular perception, Jahāngīr's justice was the hallmark of his kingship just as warfare and wisdom were the attributes of Akbar's.

The romance legend had its origin in courtly factionalism, mystery surrounding the union and misogyny. As Nūr Jahān stood at the pinnacle of power, it was tempting to locate the source of it in the special relationship with the emperor. The bond between them became more and more explicable as the romance was projected back in time. Although there was a grudging acceptance of her virtues in

sources less than sympathetic, Nūr Jahān's striking historical contour was diminished.

The two legends developed separately but came together due to the discordance between the most formidable quality of justice, namely impartiality, and love. Jahāngīr was expected to be impartial to the contending parties, but the ultimate test of impartiality was to convict and sentence the beloved. The *tazkira* anecdote fused the two elements effectively. Its appearance (reappearance!) soon after the installation of the second chain of justice does not seem to be a coincidence. The Mughal Empire was declining, and there was a longing for the glorious past. The trial of Nūr Jahān would have lain buried in the corpus of Persian literature had it not been retrieved as a popular poem. The film widened the circulation of the legend and added yet another layer to it.

NOTES

1. This chapter was presented at a symposium on 'Muslim Cultures of Bombay Cinema' in Abu Dhabi. I am grateful to Ira Bhaskar and Richard Allen for inviting me to make the presentation and encouraging me to write it out. Parts of the chapter were presented at a conference on *Contextualizing History Writing in Ottoman and Indian Worlds*, Istanbul Bilgi University, June 2017; at the University of Bonn as visiting professor, Sonderforschungsbereich, December 2017; and at the Centre of Advanced Study in History, Aligarh Muslim University, November 2018. Thanks are due to members of the audience and especially to Suraiya Faroqhi, Eva Orthmann, Anna Kollatz, Shireen Moosvi, Ali Nadeem Rezavi, Chander Shekhar, Ziaul Haq, Sumit Bhardwaj, Shahid Jamal, Ram Shankar, Savita and Awadhesh Jha for their help and suggestions. All mistakes are mine.

2. All translations are those of the author unless otherwise stated.

REFERENCES

'Abdus Sattār (2006), *Majālis-i Jahāngīrī* (eds 'Ārif Naushāhī and Mo'een Nizāmī), Tehran: Mīrās-i Maktūb.

Abū'l Fazl (1872), *Ā'in ı Akbarı*, vol. 1 (ed. H. Blochmann), Calcutta: Bibliotheca Indica.

Abū'l Fazl (1873–87), *Akbarnāma*, 3 vols (eds Āgha Aḥmad Alī and 'Abdur Raḥīm), Calcutta: Bibliotheca Indica.

Abū'l Fazl (1989–98), *Akbarnāma*, 3 vols (trans. H. Beveridge), Delhi: Low Price Publications.

Amrohavi, Anees (2007), *Woh Bhi Ek Zamāna Thā*, Delhi: Takhleeqkar Publishers.

Anon. (*c.*1650), *Surat Documents*, MS Supplement Persan 482, Paris: Bibliotheque Nationale de France.

Anon. (1678–80), *Waqā'i'-Ajmer wa Ranthanbōr*, MS Tārīkh 2242, Hyderabad: Hyderabad Asafia Library and Telangana State Central Library.

Anon. (1957), *A Contemporary Dutch Chronicle of Mughal India* (trans. B. Narain), Calcutta: Susil Gupta India Ltd.

Badāūnī, ʿAbdul Qādir (1865), *Muntakhabu't Tawārīkh*, vol. 2 (eds A. Alī and W. N. Lees), Calcutta: Bibliotheca Indica.

Badāūnī, ʿAbdul Qādir (1973), *Muntakhabu't Tawārīkh*, vol. 2 (trans. W. H. Lowe), Patna: Academica Asiatica.

Bano, Shadab (1999), 'Marriage and concubinage in the Mughal imperial family', in *Proceedings of the Indian History Congress*, vol. 60, Delhi: Indian History Congress, pp. 353–62.

Bhakkarī, Shaikh Farīd (1970), *Zakhīratu'l Khawānīn*, vol. 2 (ed. S. M. Haq), Karachi: Pakistan Historical Society.

Bhakkarī, Shaikh Farīd (2003), *Zakhīratu'l Khawānīn* (trans. Z. A. Desai), Delhi: Sandeep Prakashan.

Bhandārī, Sujān Rā'i (1918), *Khulāṣatu't Tawārīkh* (ed. Z. Hasan), Delhi: J & Sons Press.

Bhaskar, Ira and Allen, Richard (2009), *Islamicate Cultures of Bombay Cinema*, Delhi: Tulika Books.

Broecke, Pieter van den (1963), *Pieter van Den Broecke in Azie*, vol. 2 (ed. W. Ph. Coolhaas), Gravenhage: Martinus Nijhoff.

Dāghistānī, ʿAlī Qulī Khān Wālih (2001), *Riāẓu'sh Shu'ara*, vol. 1 (ed. S. H. Qasmi), Rampur: Rampur Raza Library.

Dāūd (1996), *Chāndāyan* (ed. M. Ansarullah), Patna: Idara Tahqiat e Urdu.

Ettinghausen, Richard (1961), 'The emperor's choice', in M. Meiss (ed.), *De Artibus Opuscula 40: Essays in Honor of Erwin Panofsky*, New York: New York University Press, pp. 98–120.

Faruqui, Munis D. (2012), *The Princes of the Mughal Empire, 1504–1719*, Cambridge: Cambridge University Press.

Findly, Ellison Banks (1993), *Nur Jahan: Empress of Mughal India*, New York: Oxford University Press.

Franke, Heike (2014), 'Emperors of Surat and Mani: Jahangir and Shah Jahan as temporal and spiritual rulers', in G. Necipoglu (ed.), *Muqarnas*, 31, Leiden: Brill, pp. 123–49.

Habib, Irfan (1969), 'The family of Nur Jahan during Jahangir's reign: A political study', in *Medieval India: A Miscellany*, vol. 1, Bombay: Asia Publishing House, pp. 74–95.

Haider, Najaf (2008), 'Justice and political authority in medieval Indian Islam', in R. Bhargava, M. Dusche and H. Reifeld (eds), *Justice: Political, Social, Juridical*, New Delhi: Sage Publications, pp. 75–93.

Hawkins, William (1999), *Early Travels in India, 1583–1619* (ed. W. Foster), Delhi: Low Price Publications.

Herbert, Thomas (1638), *Some Yeares Travels into Divers Parts of Asia and Afrique*, London: Jacob Blome and Richard Bishop.

Hodivala, Shahpurshah Hormasji (1929), 'The coins bearing the name of Nur Jahan', *Journal of the Asiatic Society of Bengal, Numismatic Supplement*, 92:1, pp. 59–68.

Ḥusainī, Kāmgār (1978), *Ma'āsir-i Jahāngīrī* (ed. A. Alavi), Bombay: Asia Publishing House.

Jahāngīr, Nuruddīn Muḥammad (1989), *Tuzuk-i Jahāngīrī or Memoirs of Jahāngīr*, vol. 2 (ed. H. Beveridge, trans. A. Rogers), Delhi: Low Price Publications.

Jahāngīr, Nuruddīn Muḥammad (2006), *Tuzuk-i Jahāngīrī* (ed. S. Ahmad), Aligarh: Sir Syed Academy.

Jahāngīr, Nuruddīn Muḥammad (n.d.), *Jahāngīrnāma*, MS. Or. 3276, London: British Library.

Khan, Iqtidar Alam (2014), 'The legend of Akbar: Images from a fading tradition', *Studies in People's History*, 1, pp. 173–80.

Khān, Khāfī (1874), *Muntakhabu'l Lubāb*, vol. 1 (ed. K. Ahmad), Calcutta: Bibliotheca Indica.

Khān, Khāfī (n.d.), *Muntakhabu'l Lubāb*, MS Add. 6573, London: British Library.

Khān, Mu'tamad (1865), *Iqbālnāmā-i Jahāngīrī* (ed. Abdul Hai and A. Ali), Calcutta: Bibliotheca Indica.

Khān, Mu'tamad (1870), *Iqbālnāmā-i Jahāngīrī*, vol. 3, Lucknow: Nawal Kishore.

Khān, Mu'tamad (n.d.), *Aḥwāl-i Shahzādgi-i Shāhjahān Padshāh*, MS Bankipore 565, Patna: Khuda Bakhsh Oriental Public Library.

Khān, Sadiq (n.d.), *Shāhjahānāma*, MS Or. 174, London: British Library.

Khan, Shahnawāz (1888), *Ma'āsiru'l Umarā'*, vol. 1 (ed. 'Abdur Rahim), Calcutta: Bibliotheca Indica.

Koch, Ebba (2010), 'The Mughal emperor as Solomon, Majnun, and Orpheus or album as a think tank for allegory', *Muqarnas*, 27, pp. 277–311.

Koch, Ebba (2012), 'How the Mughal *padshahs* referenced Iran in their visual construction of universal rule', in P. F. Bang and D. Kolodziejczyk (eds), *Universal Empire: A Comparative Approach to Imperial Culture and Representation in Eurasian History*, Cambridge: Cambridge University Press, pp. 194–209.

Koka, Mirzā 'Azīz (n.d.), 'Letter to Jahāngīr', MS Add. 16859, London: British Library, ff. 17a–19b.

Lāhorī, 'Abdul Ḥamīd (1878), *Bādshāhnāma* (ed. 'Abdur Rahīm and K. Ahmad), vol. 2, Calcutta: Bibliotheca Indica.

Lal, Ruby (2018), *Empress: The Astonishing Reign of Nur Jahan*, Gurgaon: Penguin Random House India.

Lange, Christian R. (2014), 'Public order', in R. Peters and P. Bearman (eds), *The Ashgate Research Companion to Islamic Law*, Surrey: Ashgate Publishing Limited, pp. 163–78.

Lefevre, Corinne (2007), 'Recovering a missing voice from Mughal India: The imperial discourse of Jahangir (r. 1605–1627) in his memoirs', *Journal of the Economic and Social History of the Orient*, 50, pp. 452–89.

Los Angeles County Museum of Art (LACMA) (n.d.), M.75.4.28, https://collections.lacma.org/node/240917. Accessed 4 May 2021.

Lumbard, Joseph B. (2007), 'From *Hubb* to *Ishq*: The development of love in early Sufism', *Journal of Islamic Studies*, 18, pp. 345–85.

Manucci, Niccolao (1996), *Mogul India or Storia do Mogor*, vol. 1 (trans. W. Irvine), Delhi: Low Price Publications.

Moin, A. Azfar (2012), *The Millennial Sovereign: Sacred Kingship and Sainthood in Islam*, New York: Columbia University Press.

Monserrate, Father (2003), *The Commentary of Father Monserrate on His Journey to the Court of Akbar 1580–82* (trans. J. S. Hoyland), New Delhi: Asian Educational Services.

Moosvi, Shireen (2014), 'The invention and persistence of a legend: The Anarkali story', *Studies in People's History*, 1, pp. 63–68.

Naim, C. M. (1995), 'Popular jokes and political history: The case of Akbar, Birbal and Mulla Do-Piyaza', *Economic and Political Weekly*, 30, pp. 1456–64.

No'mānī, Shiblī (n.d.), *Kulliyāt-i Shiblī*, Azamgarh: Maarif Press.

Okada, Amina (1992), *Indian Miniatures of the Mughal Court*, New York: Harry N. Abrams.

Prasad, Beni (1962), *History of Jahangir*, Allahabad: Indian Press.

Pseudo-Jahāngīr (n.d.), *Jahāngīrnāma*, Tarīkh Fārsī 174, Rampur: MS Raza Library.

Qazwīnī, Muḥammad Amīn (2015), *Padshāhnāma*, vol. 1 (ed. M. Z. Minhāj), Aligarh: Aligarh Muslim University.

Rizvi, Saiyid Athar Abbas (1975), *Religious and Intellectual History of the Muslims in Akbar's Reign*, New Delhi: Munshi Ram Manohar Lal.

Shīrāzī, Kāmī (2003), *Waqā'u'z Zamān* (ed. W. H. Siddiqi), Rampur: Raza Library.

Shujauddin, Mohammad and Shujauddin, Razia (1967), *The Life and Times of Noor Jahan*, Lahore: The Caravan Book House.

Skelton, Robert (1988), 'Imperial symbolism in Mughal painting', in P. Soucek (ed.), *Content and Contexts of Visual Arts in the Islamic World*, Pennsylvania: Pennsylvania State University Press, pp. 177–91.

Tabāṭabāī', Ghulām Ḥusāin (1897), *Siyāru'l Mutakhirīn*, vol. 2, Lucknow: Nawal Kishore.

Tavernier, Jean Baptiste (1676), *Les Six Voyages de Jean Baptiste Tavernier, en Turquie, en Perse, et Aux Indes*, vol. 2, Paris: Gervais Clouzier et Claude Barbin.

Tūsī, Niẓamu'l Mulk (1965), *Siyāstanāma* (ed. M. Qazwini), Tehran: Intisharat Kitabfuroshi Zawwar.

Usmān (1912), *Chitrāvalī* (ed. J. Verma), Kashi: Nagari Pracharani Sabha.

Welch, Anthony and Welch, Stuart Cary (1982), *Arts of the Islamic Book: The Collection of Prince Sadruddin Aga Khan*, Ithaca, NY: Cornell University Press.

Xavier, Jerome (1997), *Jahangir and the Jesuits* (trans. C. H. Payne), New Delhi: Munshi Ram Manohar Lal.

Yarshater, E. (1960), 'The theme of wine-drinking and the concept of the beloved in early Persian poetry', *Studia Islamica*, 13, pp. 43–53.

Zargar, Cyrus Ali (2011), *Sufi Aesthetics: Beauty, Love, and the Human Form in the Writings of Ibn Arabi and Iraqi*, Columbia: The University of South Carolina Press.

7

The 'Muslim Presence' in *Padmaavat*

Hilal Ahmed

This chapter discusses the controversial, yet successful, Hindi film *Padmaavat* (dir. Sanjay Leela Bhansali, 2018) as a reference point to understand the cultural portrayals of Muslims in the media-driven public discourse in contemporary India. Focusing upon the notion of 'Muslim presence' – a dominant mode of thinking about India's Muslims – this chapter looks at the formation of two corresponding narratives of nation and nationalism: Shree Rajput Karni Sena's (SRKS) account of a glorious Rajput Hindu past and the cinematic reconstruction of it in the film *Padmaavat*.

The *Padmaavat* controversy, it is worth noting, revolved around two prominent issues: the alleged distortion of revered Rajput history and the freedom of expression of an artist. The SRKS, a rather unknown Rajasthan-based Hindu upper-caste group, which led a nationwide protest against the film *Padmaavat* in 2016, opposed the making of this film on two grounds: such a film might distort the history of Rānī Padmāvatī – a respected and revered Rajput queen; and the cinematic representation of this distorted history would affect the religious-cultural sensibilities of the Rajput community. The SRKS claimed that the sacred historical figures of the past are deeply associated with the collective psyche of the community; hence, any fictional presentation of such figures is morally impermissible. To register these grievances, an aggressive campaign was launched in Jaipur – one of the key locations for the shooting of the film. The SRKS activists assaulted the director of the film, Sanjay Leela Bhansali, and vandalized the sets. The organization also filed a petition in the court to stop the release of the film. Eventually, it forced the producer to change the name of the film from *Padmaavati* to *Padmaavat*!

This negative and violent protest against *Padmaavat* was severely criticized. Film personalities, celebrities, political commentators and a section of the media came out in defence of the project. They condemned the SRKS's protests and expressed solidarity with Bhansali for asserting his freedom of expression. For the opponents of the SRKS, any restriction on the artistic sensibilities and the

imagination of the filmmaker goes against the freedom of expression, which is also a fundamental right in India. After a series of negotiations, the film was finally released in 2018.

Interestingly, there was no direct reference to Muslims in this debate. Yet, the Muslim presence eventually survives as one of the crucial constitutive features of this controversy. The SRKS envisages the struggles of the Rajput/Hindu community against Muslim rulers of medieval India as sacred history. Similarly, the film *Padmaavat*, which claims to be inspired by Malik Muḥammad Jāyasī's epic poem, also embraces the Hindu/Rajput assertion against Muslim dominance as an explanatory framework to represent the sacrifice of Queen Padmāvatī. In fact, it gives a cinematic/artistic expression to this Hindu subjugation thesis. This uncritical acceptance of Hindu struggles versus Muslim rule makes *Padmaavat* an appropriate example to unpack the dominant imaginations of Muslim presence in contemporary India.

It is important to clarify that the *Padmaavat* controversy was not at all about the rewriting of Indian history from an overtly Hindu perspective. Instead, it contemporizes the story of Padmāvatī in the existing Hindu versus Muslim schema.[1] The SRKS's adherence to a sacred Rajput past represents a popular historical reconstruction, which does not entirely depend on historically verifiable facts and sources. This accessible ready-to-use history employs myths, memories, folklore, legends and everyday stories to offer a new political life to the Khaljī-Rajput conflict. It amalgamates neatly with certain prevalent anxieties and stereotypes about religious communities to reconstitute the glorious Rajput/Hindu past as a culturally sacred entity. Precisely for this reason, I examine the SRKS's version of the Padmāvatī legend – especially in the backdrop of the film *Padmaavat* – as a political object that has nothing to do with a factual, source-based history of Mewar.

The chapter is divided into four parts. The first section seeks to conceptualize the idea of 'Muslim presence' to provide a thematic background to the *Padmaavat* debate. The second examines the nature of Karni Sena's protest to understand the recent transformation of the figure of Padmāvatī into a Hindutva icon. The third unpacks the storyline of the film *Padmaavat* to extract those cinematic elements that define the complex interconnections between Muslim identity and Rajput patriotism. The final section summaries the discussion to make a broad comment on the emerging symbols of patriotism.

What is Muslim presence?

The idea of Muslim presence underlines various interpretative strategies that are used to accommodate Muslims in different ideological configurations by producing

certain popular images and acceptable icons. The negative or positive portrayal of Muslims in public life is actually an outcome of these intellectual strategies (Pande 2009). The secular Akbar of *Mughal-e-Azam*, the pious figure of Khan Sahab – the pukka Musalman of *Zanjeer*, the barbaric ʿAlāuddīn Khaljī of *Padmaavat* and the nationalist A. P. J. Abdul Kalam (a veena player, a Baghavad Gita reader, a Sanskrit lover and yet a Muslim scientist!), in this sense, are not isolated, independent images; rather these are the concrete illustrations, which represent various context-specific interpretations of Muslim presence in postcolonial India.

There are at least three powerful metaphorical imaginaries that constitute this Muslim presence: *Muslim homogeneity* – the belief that Muslims of India belong to a homogeneous pan-Islamic community, which is arguably represented by every single Muslim; *Muslim religiosity* – the inference that Muslims are more religious than others and hence it is legitimate to recognize the *burqaʿ* and *ṭopī* as markers of Muslimness; and *Muslim historicity* – the assumption that Muslim cultures are exotic remains of a royal Islamic past, which is lived and practiced by common Muslims.

These constitutive features of Muslim presence find concrete cultural political meanings only when Muslim identity is defined in a broad postcolonial Indian framework. For instance, Muslims as a homogeneous community become an inseparable fragment of Indian identity to celebrate 'unity in diversity' as a constitutional value. However, the same idea of Muslim homogeneity turns out to be a problematic entity when it is contrasted with Hindu religious diversity. Islamic adherence to monotheism, according to this interpretation, transforms Muslims into a homogeneous group and does not allow them to become fully Indian. Precisely for this reason, Muslims are often asked to prove their loyalty to the Indian nation.[2]

The Hindutva interpretation of Muslim presence seems to dominate contemporary public discourse (Palshikar 2015; Sardesai and Gupta 2019; Ahmed 2019). The pro-Hindutva media discourse has created an impression that Muslim presence is an irresolvable political phenomenon for the country. We are told that the birth of a Muslim child is a threat to the Hindu population; the *madrasa* education of a Muslim child is a symbol of separatism; the eating habits of Muslims are anti-Hindu (since Muslims eat beef); the married life of a Muslim couple is a social evil (since Muslims practice triple *ṭalāq* – the right of Muslim men to divorce their wives at will by uttering the word '*ṭalāq*' [divorce] three times). Even the death of a Muslim is an anti-national act (because Muslims occupy valuable land for graveyards!).

These stereotypical perceptions, quite interestingly, have been translated into political issues post 2014. For instance, the debate on Muslim population growth took on an overtly communal overtone in the electoral politics of Assam and West

Bengal. The triple *ṭalāq* and the *Waqf* status of Muslim graveyards emerged as an important electoral issue in the Uttar Pradesh assembly elections in 2016. The popular, media-driven discussions on the National Register of Citizens (NRC) and the earlier proposed Citizenship Amendment Bill normalized Hindutva's critique of secular citizenship which the recently enacted Citizenship Amendment Act has only confirmed.[3] These political trajectories indicate that the Bhartiya Janata Party (BJP) had already transformed the collective Muslim presence into an electoral agenda even before the 2019 election for an effective Hindu polarization.[4] In such a volatile political environment, a new set of popular Muslim images have emerged, which have not been given adequate intellectual attention.

Karni Sena's *Padmaavati*

The SRKS is not a well-organized social or political outfit. In fact, there are at least three groups that claim to represent the 'real Karni Sena'. These groups are led by a few politically connected individuals who operate independently among the upper-caste Rajput communities of Rajasthan. This fragile organizational structure helps them to function as a network of individuals, who come together from time to time for specific collective activities such as occasional premeditated protests or social media activism.[5] These Karni Senas do not subscribe to any stated ideology, though they always evoke the protection of Rajput interest and pride as a political objective. This ideological openness gives them an advantage to define Rajput pride in contextually appropriate and politically acceptable terms – either as a struggle for social justice or as a manifestation of Hindu awakening.

The first Karni Sena was formed in 2005 under the patronage of Lokendra Singh Kalvi in Jaipur. The inclusion of the Rajput community in the other backward classes (OBC) list for the purposes of reservation in jobs and educational institutions was one of the main objectives of this organization (Ahmad 2018). In a way, the formation of SRKS was an extension of the Social Justice Front, which Lokendra Kalvi had established in 2003 to demand reservations for economically backward upper castes, especially the Brahmins and the Rajputs. However, the SRKS was not entirely concerned about the reservation-based politics of social justice. It also followed a radical sectarian agenda to save Rajput pride. One of the stated goals of the organization is to put 'an end to the sidelining of Rajput figures in textbooks' and in popular culture (Ahmad 2018). This radicalism contributed significantly to the success of SRKS, especially when it organized protests against the films *Jodhaa Akbar* and *Veer* (Saini 2019).

The *Padmaavati* controversy began in 2016. An online web portal reported that Sanjay Leela Bhansali was planning to include a romantic dream sequence between Ranveer Singh (as ʿAlāuddīn K̲h̲aljī) and Deepika Padukone (as Padmāvatī) in the film

(Zoom 2016). The SRKS objected to it and threatened that they would not tolerate the insult to Queen Padmāvatī. Although Bhansali ruled out any possibility of this dream sequence, SRKS activists did not take notice of his statement. They staged a protest at the Jaigarh Fort (Jaipur) on 27 January 2017 where Bhansali was shooting for the film (Talukdar 2017). Bhansali was physically assaulted and protesters vandalized the sets (Indian Express Online 2017). This was the beginning of a series of violent protests by SRKS in Rajasthan and Maharashtra in the next few months.

The SRKS demanded a complete ban on the film and approached the Supreme Court in November 2017. The court rejected this petition and declined to intervene in this matter. It observed that the Central Board of Film Certification (CBFC) was the competent body to take a final decision on the film and 'when the grant of certificate is pending before the CBFC, any kind of comment or adjudication by [...] (the) Court would be pre-judging the matter' (Misra 2017). Meanwhile, many BJP leaders extended support to SRKS. BJP-ruled states such as Rajasthan, Haryana and Gujarat announced that this film would not be released in their territories. This official support to SRKS encouraged the organization to expand the scope of its politics outside Rajasthan. It organized protests and agitations in Gujarat, Uttar Pradesh, Bihar and Karnataka.

In December 2017, the Censor Board constituted a panel to review the film for public screening. The royal family of Mewar and two veteran historians from Jaipur, Professors B. L. Gupta and R. S. Khangarot, were part of this panel. This special committee recommended five changes/modifications in the film (IANS 2017). It was also suggested that the title of the film should be changed. The film *Padmaavati* eventually became *Padmaavat* – the title of the epic poem Malik Muḥammed Jāyasī wrote almost two hundred years after the reign of ʿAlāuddīn K͟halji!

The SRKS filed another criminal petition against the film. The Supreme Court was requested to order the police to file an FIR against Bhansali. Rejecting the petition, the court made a very critical observation about the SRKS's treatment of law:

> Rambling of irrelevant facts only indicates uncontrolled and imprecise thinking and exposes the inability of the counsel. On certain occasions, it reflects a maladroit design to state certain things which are meant to sensationalize the matter which has [the] roots in [a] keen appetite for publicity. When these aspects are portrayed in a nonchalant manner in a petition, it is the duty of the Court to take strong exception to the same and deal with it with iron hands.
>
> (Misra 2017)[6]

The film finally released in January 2018. By that time, SRKS had succeeded in gaining much support and media attention for its cause. However, the controversy worked in favour of the film which went on to become a blockbuster hit.

The Karni Sena's imagination of Padmāvatī is highly unclear. Although the Sena leaders forcefully argued that the film distorted historical facts, no attempt was made to present the factual *history* of Padmāvatī from the point of view of Rajput pride. The story was invoked as a *faith-based history* to transform the figure of Padmāvatī into a sacred Hindu icon. In fact, the Karni Sena tried to take advantage of the Babri Masjid-Ram temple controversy to provide a wider legitimacy to its politics of Rajput/Hindu assertion.[7] The Karni Sena chief, who described himself as a descendant of Ratan Sen and Padmāvatī, also claimed that his family had a direct connection with Luv, the elder son of Lord Rāma (Wadhawan 2019)!

This sacred history of Padmāvatī, nevertheless, is employed to make three broad claims about Muslim presence. First, the contest between the Rajput king Ratan Sen and the Muslim ruler ʿAlāuddīn Khaljī is seen as a clash of values. The Rajputs/Hindus, the Sena leaders seem to argue, always practice a politics of principle based on Hindu religion and traditions. The Muslims/Khaljī, on the other hand, adhere to a very different world-view based on Islam – an alien religion. This conflict between the Islamic values of destruction and the Hindu values of peaceful coexistence is seen as natural, inevitable and permanent by Karni Sena's leaders (HariBhakt n.d.).

The act of *jauhar* is the second important aspect of the Padmavatī legend, which is invoked very powerfully to define the nature of Hindu/Rajput assertion. It appears that the Sena celebrates *jauhar* as a symbol of great sacrifice for protecting the nation (Meena 2017). However, at the same time, they find it deeply problematic. Sacrifice as bravery actually goes against the core idea of Rajput pride. The Karni Sena strongly propagates (and practices!) a radical politics of attack and destruction. It would have been politically difficult (if not impossible) for them to appreciate sacrifice as an accepted technique. This dilemma, it seems, had forced the Karni Sena activists to redefine the idea of sacrifice itself.

The historical conflict between Islam and Hinduism is reconfigured as a fight between Muslim men and Hindu women. The Hindu men appear gentle, caring and brave, while Muslim men seem to be brutal womanizers and misogynists. The sacrifice of Padmāvatī is juxtaposed with Khaljī, a Muslim man, in this framework to symbolize the 'love-jehad' mentality.[8] This tussle between Hindu women and Muslim men also helps the Karni Sena to make a powerful claim: Hindu men must be mobilized to protect the honour of their women in the present circumstances (Dhara 2019).

Finally, the construction of inside/outside geographies, people and communities contributes to the political position of the Karni Sena on India's Muslims. The depiction of Khaljī as an outsider is invoked to legitimize India as a well-defined territory and Rajput/Hindus as the indigenous community. Followers of Islam, including the present-day Muslims, are not considered as part of this historically

constituted territory and/or national community. Every aspect of public life is neatly divided into Hindu and Muslim, including those religious sites that are respected and recognized as holy places by both communities.[9]

Now the question arises: does the film *Padmaavat* go against this imagination of Muslim presence?

Padmaavat's Muslims

Let us look at the cinematic representation of the Padmāvatī story in the film. We do not have sufficient information about the original plot of the film *Padmaavati/Padmaavat*. Bhansali's various interviews and statements confirm that he was keen to make a different kind of love story against the backdrop of a seemingly dominant narrative of historical nationalism, bravery and sacrifice. Bhansali had already introduced this new genre of cinema in his successful film *Bajirao Mastani* (2015). However, unlike *Bajirao Mastani*, which depicts the romantic relationship between a Peshwa Hindu ruler, Bajirao, and a half-Muslim princess, Mastani, *Padmaavat* was a difficult plot. The two main protagonists of Jāyasī's epic poem – a possessive anti-hero ('Alāuddīn Khaljī) and a committed queen (Padmāvatī) – were in direct conflict with each other. There was no undeviating love angle in this story. The possibility of a dream sequence between Khaljī and Padmāvatī, which led to the main controversy, hence cannot be ruled out completely. It might have given a dramatic shift to the main narrative. However, the film avoided all controversial experiments and eventually followed a linear narrative of bravery and sacrifice.

Padmaavat begins with a strong disclaimer. It is claimed that this film is inspired by the epic poem of Jāyasī, which is believed to be a work of fiction. This disclaimer also clarifies that the film does not encourage or support *satī* or such other practices. The film takes us to thirteenth-century Ghaznī, Afghanistan, where Jalāluddīn Khaljī, a lazy nobleman of the Delhi Sultanate, is consolidating his military power. His purpose is to organize a workable armed force to capture the throne of Delhi. We do not know the exact status of the fort where he lives; yet this place appears to be the typical headquarters of a Hindi film villain – blackish background where raw meat is prepared in the courtyard! Jalāluddīn eats roasted meat like an uncivilized, barbaric man, while his followers drink wine. Against this backdrop, we are introduced to Jalāluddīn's nephew Alāuddīn – an ambitious Khaljī, who marries Jalāluddīn's daughter and becomes his son-in-law. Alāuddīn is brave, rustic, violent and, above all, a habitual womanizer. He is an unprincipled, immoral, dishonest man. This introductory sequence conveys a simple and direct message: an unprincipled enemy is preparing to attack the country called Hind.

We now meet Padmāvatī, the princess of Singhal country. In a pleasingly romantic atmosphere, the beautiful Padmāvatī chases a deer. While this is a hunting expedition by the young princess, the picturesque background convinces the audience that hunting must be appreciated as non-violent leisure activity, in contrast to the barbaric meat-eating culture of Afghanistan. Padmāvatī misses the target, and Rawal Ratan Singh, the king of Mewar (who follows her in the jungle), gets injured. The romantic encounter that follows is presented as Divine Love or what is called love at first sight. We later come to know that Ratan Singh is already married and the main purpose of his visit to Singhal country is to obtain precious pearls for his wife. Padmāvatī, a practicing Buddhist, takes care of Ratan Singh's injuries, and their closeness develops into feelings of affection and love. Ratan Singh proposes to Padmāvatī, and she accepts unconditionally. They get married with the permission of Padmāvatī's father. Padmāvatī, the new queen of Mewar, is introduced to the royal priest of the kingdom, Raghav Chetan, who is captivated by her beauty and intelligence. He intrudes upon the royal couple in their privacy. Realizing Chetan's evil intentions, Ratan Singh expels him from Mewar.

Jalāluddīn Khaljī is the new sultan of Delhi/Hind, who relies on the military abilities of his nephew and son-in-law, Alāuddīn, for expanding his empire. The ambitious Alāuddīn, however, is keen to eliminate his uncle to become the ruler himself. He eventually kills Jalāluddīn and captures the Delhi Sultanate. In the meantime, Raghav Chetan, the expelled priest of Mewar, visits Delhi and meets Alāuddīn. He informs the new sultan about Padmāvatī's beauty and provokes him to attack Mewar. Alāuddīn decides to wage a war primarily to win Padmāvatī. He proposes a treaty with Ratan Singh and invites him to Delhi with his family. However, this invitation is rejected. Ratan Singh asserts his independence and refuses to accept any help from the Sultanate.

The furious Alāuddīn lays siege to Mewar's capital, Chittor, for the next six months. Failing to subdue the Rajputs, Alāuddīn changes his plans. He sends a peace proposal and wishes to have an interview with Ratan Singh as a friend. This offer is accepted and finally Alāuddīn meets Ratan Singh in his palace. Alāuddīn insists on seeing Padmāvatī. This unusual request from Alāuddīn provokes the Rajputs. However, after some deliberations, they agree to this request. The image of Padmāvatī appears in a mirror carrying an incense burner. The smoke from the incense hides her face.

Now Alāuddīn invites Ratan Singh for a feast in his tent outside the fort. Ratan Singh agrees to pay a visit to the sultan as a guest. Unlike the principled hospitality of the Rajputs, Khaljī does not keep his promise. He detains Ratan Singh and takes him to Delhi as a prisoner. It is communicated to the Mewar kingdom that Ratan Singh can be freed only if Padmāvatī comes to Delhi. Padmāvatī accepts

this proposal. She also makes a few conditions for her visit, including death penalty for Rāghav Chetan, and all her demands are accepted. Padmāvatī travels to Delhi with 800 soldiers (disguised as slave girls) and two commanders of Mewar. Meher-un-nisa, Alāuddīn's wife, takes Padmāvatī to Ratan Singh. She also helps the couple to escape from the fort. Alāuddīn, who gets injured in an attack, fails to stop Ratan Singh and Padmāvatī.

This humiliating defeat forces Alāuddīn to wage a full-fledged war against the kingdom of Mewar. In a dramatic climax, Alāuddīn and Ratan Singh engage in individual combat with each other. Alāuddīn is almost defeated, but Malik Kāfūr, a Khaljī slave, shoots an arrow from behind Ratan Singh and kills him. Alāuddīn enters the Mewar fort with his army, and at this point, Padmāvatī and the other women of Mewar commit *jauhar*.

The storyline of the film revolves around a few core elements: the sacred geography of a country called Hind, a clash of civilizations that leads to a religious war or what is called *dharmyudh* and finally a contest between a principled king and an unprincipled invader. These elements not only provide a sequential continuity to the narratives but also offer certain set identity markers. For instance, there are three geographical entities in the film – Hind, Afghanistan and Singhal. Hind and Singhal share remarkable similarities in terms of culture, religion and customs. Hind is a Hindu nation, where Hindu gods and goddesses are worshiped, while Singhal is a Buddhist country, where one finds *vihāra*s and *stūpa*s with huge statutes of Gautam Buddha. The relationship between Hind and Singhal are cordial and intrinsic. A Hindu Rajput king can certainly marry a Buddhist princess because Hinduism and Buddhism are friendly religions, which treat this geo-cultural region as sacred space. The rulers of both the countries eat vegetarian food, celebrate nature and are deeply committed to religious/cultural values. They also treat women with respect and dignity. Even Ratan Singh's second marriage does not create any problem for the royal household of Mewar, though his first wife certainly feels slighted and neglected.

Afghanistan, on the other hand, is an alien land, ruled by uncivilized, uncultured and unsophisticated men, who follow Islam as a religion. These Afghans do not share the cultural values of Hind. They are non-vegetarians and are not even aware of the etiquettes of dining. Both Alāuddīn and Jalāluddīn are shown eating meat like beasts. Afghans treat women as sex slaves. Even the royal women are kept to satisfy the lust of the male rulers of the Khaljī clan. Afghans are expansionists and want to win over the entire Hindu-ruled Hind. Alāuddīn is shown as an ambitious ruler who appears to have captured many territories of Hind. This expansionist policy is not merely about the annexation of new kingdoms. As an invader, Alāuddīn is seen as being keen to destroy everything associated with Hindu culture. He kills rulers, plunders cities and abducts women.

The Devgiri expedition of Alāuddīn is a good example to elaborate this point. Alāuddīn captures the kingdom of Devgiri without the permission of his uncle and father-in-law Jalāluddīn, the sultan of Delhi. In order to assert his control and supremacy, Jalāluddīn visits Devgiri, where Alāuddīn eventually kills him. This episode comes primarily as a passing reference in the story to provide a logical conclusion to the ongoing tussle between the sultan and his ambitious nephew Alāuddīn. However, the background against which this sequence of events is presented in the film is not entirely about internal power struggles. Here we meet the abducted princess of Devgiri in a typically Bhārat Mātā ('Mother India') image (Figure 7.1).[10] She is in chains and has two burning torches in her hands. Alāuddīn makes fun of her and tells her that she is going to be accommodated in his harem. The princess, however, remains committed to her nationalist resolve. The conversation between the princess and Alāuddīn appears disconnected and isolated from the assassination/murder of Jalāluddīn, which is the core element of this sequence. Yet, it conveys to us a direct message: Alāuddīn/Muslims are responsible for the humiliation of Bhārat Mātā!

Afghanistan and Hind also represent an enduring *clash of civilizations*. This is exactly what Padmāvatī says in her last speech:

> In every age there has been a religious war between truth and untruth: the war between Lord Ram and Ravana, between Pandavas and Kauravas and now between Rajputs and K͟haljīs. The truth always prevails. Thousands of Rajputs have gone to make their sacrifice for our self-respect. [...] When a Rajput fights for his soil and honour, his sword resonates for centuries. [...] Whenever there was darkness in the world, Rajput warriors sacrificed their lives by burning like a flame but did not let religion be extinguished.[11]

FIGURE 7.1: The Bhārat Mātā image in *Padmaavat*.

Although there is no reference to Islam or Hinduism in this comment, the invocation of the *Rāmāyaṇa* and *Mahābhārata* reminds us of Hindu religious idioms. Khaljī is compared with Ravana and Kauravas, while Rajputs are depicted as the people of faith and righteousness.

Rajput identity is further elaborated by Ratan Singh when he says: 'One who braves any situation, is Rajput [...] One who accepts all challenges and emerges victorious, is a Rajput [...] The one who never gives up and fights the enemy till his very last breath, is a Rajput'.[12] And further: 'We cannot attack a visitor, even if he is a devil [...] history may change itself but the Rajput principles are everlasting'.[13] This does not mean that the Islam of the Khaljī warriors is not at all invoked. The film uses a few subtle codes to demonstrate that the Rajput Hindus are actually fighting a war of civilization with the Muslims. Alāuddīn does not have any Hindu commander or even a soldier. His armed men are Afghan Muslims, who strictly practice Islamic rituals. They have beards without moustaches – a typical twenty-first-century image of devout Muslims – wear long Islamic clothes and offer *namāz* five times in a mosque. The Delhi Sultanate is also an Islamic kingdom where one hears the typical sound of *aẕān* (Islamic call for prayer) coming from the principal mosque of the city. Although we do not find any Islamic motifs in Alāuddīn's court, his bedroom has a characteristically Islamic *ṭugrā* (a calligraphic monogram) with one of the prominent names of Allah – *ya Karīm* ('The Generous One'). Malik Kaffur, the eunuch slave of Khaljī, also recites the *Kalima* for Alāuddīn's protection before his visit to the Mewar fort.

This 'clash of civilizations' is not merely about the differences between cultural-religious practices and customs. It also underlines a tussle between a principled king and an unprincipled invader. Ratan Singh adheres to a few basic Hindu/Rajput principles: pride with dignity, respect for women, sacrifice for the nation, righteous war and self-determination. These principles stem from his Hindu religious world-view. This vision of life and death is explained by Padmāvatī. She says:

> There will be another battle that has never been seen or heard. We will fight this war. And that will be the defeat of Alāuddīn. Our enemy will also see how the Rajput heroines turn their pain into heroism. This body will turn into ashes but Rajput pride, our principles, our self-respect will survive forever.[14]

On the other hand, the film is virtually silent about Islamic principles and values. In fact, Islam is merely reduced to certain self-explanatory practices. Alāuddīn's wife – the only Muslim character with positive intentions – is not inspired by Islamic values. She helps Ratan Singh and Padmāvatī primarily because she wants

FIGURE 7.2: Alāuddīn's soldiers offering *namāz* in *Padmaavat*.

to protect her sultan from committing a sin. She even says: 'Do not waste time as soldiers are in *namāz*. Once it's over, they may come and arrest you'. This simply means that *namāz* is an emotionless ritual which does not compel any Muslim to take righteous, principled positions (Figure 7.2).

The following conversation between Alāuddīn and Ratan Singh is very relevant to elaborate this point:

KHALJĪ: My dear all is fair in love and war.
SINGH: History will write this war in black letters as without any principle.
KHALJĪ: We will burn such a history.
SINGH: History is not just written on paper that you may burn.
KHALJĪ: How good are you; how good your principles are.
SINGH: Alāuddīn, you should also learn some principles, you may become a human at least.[15]

Ratan Singh makes a powerful critique of Alāuddīn's argument that all is fair in love and war. He invokes the significance of history to suggest that war without principles is meaningless in history. Although Alāuddīn appreciates Ratan Singh's commitment to his principles, he strongly believes that irrelevant aspects of history may easily be removed to construct a favourable picture of the past. Alāuddīn, nevertheless, is not the only Muslim character of the film who believes in this imagination of historical reality. Amīr Khusrau, the legendary poet, who called himself *Hindavi* (a poet of Hind), is shown as Alāuddīn's intellectual advisor. Khusrau justifies the killing of Jalāluddīn Khaljī and calls it '*waqt kā taqāẓā*'

('the compulsion of time'); he also helps Alāuddīn to improvise and write poetry. Khusrau even goes on to recite his famous couplet – *Khusro daryā prem kā* ('Khusrau love is a river') – to explain Alāuddīn's quest for Padmāvatī. This negative portrayal of Amir Khusrau substantiates the contemporary anti-Muslim Hindutva discourse, which remains highly uncomfortable even with Sufi Islam.

Conclusion

One thus finds a remarkable similarity between Karni Sena's imaginations of Muslim presence and its cinematic representation in the film. The three elements of Muslim presence – Muslim homogeneity, Muslim religiosity and Muslim historicity – are deliberately invoked by Bhansali. The film depicts Muslims as one homogeneous community, which strongly adheres to a ritualistic, unprincipled religion called Islam and which still poses a historical challenge to the identity of Indians/Rajputs/Hindus.

It may be argued that the Karni Sena's pressure eventually forced Bhansali to subscribe to their version of the Padmāvatī legend. After all, the film was actually censored and approved by a set of experts who did not want to deviate from the sacred history of Padmāvatī. This justification is not very convincing. There is a new genre of historical films, which employ a profound anti-Muslim narrative to reclaim the nation in unequivocally Hindu terms. Films like *Bajirao Mastani*, *Kesari* and *Panipat* contribute directly to this form of nationalism. The rhetoric of Rajput/Hindu pride, in this sense, had already become a powerful reference point for Hindi cinema. The main plot of *Padmaavat* is actually inspired by this commercially successful cinematic trend. Precisely for this reason, the impact of the Karni Sena's agitation on the main storyline of the film cannot be overstated.

On the contrary, Hindutva-driven nationalism appears to be the unifying factor in this case. The Karni Sena invoked the dominant discourse of Hindutva for gaining wider acceptability, while the film *Padmaavat* uses Hindutva as an intellectual resource to provide a sequential consistency to the Rajput pride argument. This uncritical adherence to Hindutva, however, poses a very different kind of conceptual challenge: how to make a persuasive equilibrium between Hindu supremacy and Hindu victimhood. It is certainly possible to celebrate Hindu/Rajput pride, bravery, commitment and religious-cultural pre-eminence over other *alien* religious traditions, especially Islam. It is also possible to observe Hindu resistance as a symbol of national wakening. However, this Hindu supremacy does

not correspond to the idea of Hindu victimhood: the belief that Muslims were able to defeat Hindus despite their nationalist resistance.

This conflict between Hindu pride and Hindu defeat is always solved by invoking 'Muslim presence' as a permanent threat. The homogeneity of Muslims is interpreted as a symbol of Muslim unity against Hindus, the Muslim adherence to Islamic rituals is recognized as a motivational force to demolish Hinduism and Muslim culture is seen as salient vestiges of a royal Islamic past that memorializes Hindu defeat. This intentional unpacking of Muslim presence helps the Hindutva discourse to construct a complex Hindu identity. Hindu community, in this framework, appears as a prideful victim: Hindus have superior cultural religious values but unlike Muslims they do not have unity, devotion to a cause and a positive historical imagination. To defeat Muslims, therefore, Hindus must have a sacred history of Hindu honour and a fully worked out strategy to rectify a few historical mistakes.[16]

This is precisely what we observe in the Karni Sena's reconstruction of the Padmāvatī legend. They adore the sacrifice of Padmāvatī as a moral virtue to celebrate the Hindu/Rajput ethical supremacy over Muslims. But this sacred past is not presented to us purely in a historical sense. The Karni Sena leaders call upon the Rajputs/Hindus to recognize the political significance of this story to work out practical strategies to tackle the contemporary form of Muslim presence. The film *Padmaavat* also subscribes to this position, though in a slightly modified manner. It redefines the act of *jauhar* as a symbol of moral patriotic assertion against immoral Muslim invasion. At the same time, it also underlines the limits of this Rajput/Hindu morality. The film reminds the audience that the Rajput/Hindu idea of principled war has always worked in favour of the enemy.

NOTES

1. Giorgio Agamben's notion of the *contemporary* is very relevant here. He writes:

> [T]he entry point to the present necessarily takes the form of an archeology; an archeology that does not, however, regress to a historical past, but returns to that part within the present that we are absolutely incapable of living [...] The present is nothing other than this unlived element in everything that is lived [...]. The attention to this 'unlived' is the life of the contemporary. And to be contemporary means, in this sense, to return to a present where we have never been.
>
> (Agamben 2009: 51–52)

The *Padmaavat* controversy actually invokes this 'unlived present' to establish a direct relationship between the historical trauma of Hindus and Muslim presence in present-day India.

2. Mohan Bhagwat, the Sarsanghchalak of the Rashtriya Swayamsevak Sangh (RSS), delivered a series of lectures on the ideas and ideology of the RSS in September 2018. In an attempt to offer an acceptable and inclusive meaning of the term 'Hindutva', Bhagwat argued: '[A]ccording to us, Hindutva has three basics: patriotism, glory of our forebears, and culture […] If ever it is claimed that Hindutva does not desire Muslims in its ambit, that day it will die down as Hindutva itself'. However, this seemingly inclusive definition of Hindutva was later clarified. Responding to a question about RSS's position on minorities, Bhagwat categorically argued that majority-minority framework had always been problematic, and hence, one must adhere to three principles of Hindutva – patriotism, glory of our forebears and Indian culture – to be recognized as patriot. This clarification makes it clear that Bhagwat's so-called inclusive Hindutva, which has also been seen as a revisionist version of RSS, does not deviate from the old language of *you* Muslims and *we* Hindus! He seems to employ the three core beliefs of his version of Hindutva to remind Muslims that they have to come forward and prove their nationalism (see Ahmed 2019: chapter IV).

3. For a systematic analysis of Muslims and Indian citizenship, see Shani (2010). One finds a reincarnation of the post-partition debate on the citizenship status of Indian Muslims in recent years. BJP leaders often argue that the party wants to implement the NRC throughout the country as if the purpose of NRC is to evaluate the citizenship status of Muslims.

4. Hindu polarization is different from a Hindu vote bank. The BJP has successfully appropriated the growing religiosity among Hindus to rearticulate the religious-doctrinal distinctiveness of Hinduism into an electoral project. This social *polarization* certainly has given an advantage to the BJP to emerge as a legitimate stakeholder of Hindu interests. However, this has not yet emerged as the most decisive factor for Hindus to vote as a community of voters. The success of Naveen Patnaik in Odisha despite Modi's popularity as a national leader is a relevant example to underline the political distinctiveness of Hindu polarization in the present context (Ahmed and Swain 2019). For a discussion on changing Hindu religiosity and its political manifestations, see Kumar (2019).

5. I am thankful to Mohammad Yaqoob (TDT, Rajasthan Partner) for clarifying this to me.

6. All translations are by the author unless otherwise stated.

7. The Hindu nationalists led by the Bhartiya Janata Party (BJP) launched a nationwide movement in 1986 to build a grand temple dedicated to Lord Rama at the site of a sixteenth-century mosque – Babri Masjid – built by Mughal ruler Bābur. It was argued that this was the birthplace of Lord Rama and Bābur destroyed an old Rama temple to construct this mosque. The mosque was finally demolished by a mob of Kar Sewaks led by Hindu nationalist organizations in 1992. The Supreme Court of India finally gave its verdict in this case in 2019. The court acknowledged the demolition of Babri Masjid as a criminal act. However, on certain legal-technical grounds, the land was given to the Hindus for

constructing a temple, while the government has been asked to provide five acres of land in the city of Ayodhya for reconstructing the Babri Masjid. See Ahmed (2014).

8. The term 'love-jehad' refers to the alleged attempts by Muslim men in targeting non-Muslim women for converting them by false expressions of love. The Hindutva organizations use this expression to mobilize Hindus for the protection of their women (Gupta 2009). The Karni Sena seems to redefine the Padmaavati legend as a success story of Hindu women's courage and self-determination.

9. Shri Rashtriya Rajput Karni Sena's chief Sukhdev Singh Gogamedi's statement about the devotees going to the shrine of Khawaja Moinuddin Chishti in Ajmer is very relevant here. In a statement he said that if Hindu devotees of Amarnath yatra in Kashmir were targeted, those going to the Ajmer Sharif Dargah should not feel safe. See https://www.youtube.com/watch?v=M6zs_OHC5ck (accessed 26 December 2019), and *Business Standard* (2019).

10. In recent years the chanting of '*Bhārat Mātā kī Jai*' ('long live Mother India') has emerged as a contentious issue. It began in March 2016 when the RSS chief Mohan Bhagwat said that young generation must chant this slogan to express love for the motherland. See *Business Standard* (2016).

11. *Har yug meṅ ek dharmyuddh hua hai. Jaise Bhagwān Rām aur Rāvaṇ ke bīć; Pāṇḍavoṅ ke bīć aur āj Rājpūt aur* <u>Kh</u>*aljīyoṅ ke bīć. Aur har yug meṅ jīt kewal satya kī hui hai. Āj hazāroṅ Rājpūt kesariyā bānnā pehankar hamāre ātmasammān ke liye balidān dene gaye haiṅ [...] jab Rājpūt apnī miṭṭī aur sammān ke liye laṛtā hai to uskī talwār kī gūṅj sadiyoṅ tak rehtī hai [...] jab bhī duniyā meṅ andhkār badhā hai Rājpūt yoddhaoṅ ne jwālā kī tarah jal kar apnā balidān diyā par dharm ko bujhne nahīṅ diyā.*

12. *Ćintā ko talwār ki nok pe rakhe woh Rājput [...] Ret ki nāv lekar samandar se shart lagāye woh Rājput [...] Aur jiskā sir kaṭe phir bhī dhaṛ dushman se laṛtā rahe, woh Rājput.*

13. *Gaḍh par āaye nihatte mêhmān par hum wār nahīṅ kar sakte [...] ćāhe wo shaiṭān hi kyoṅ na ho [...] Itihās apne panne badal saktā hai par Rājpūt apne uṣūl nahīṅ badalte.*

14. *Ek aur laṛā'ī hogī jo na kisī ne dekhī na sunī. Ye laṛā'ī hum kshatrāṅiyāṅ laṛengī. Aur woh hogī 'Alāuddīn kī hār. Humārā shatrū bhī dekhegā kī Rājpūt vīrāngnāyeṅ vednā ko vīrtā meṅ kaise badaltiṅ haiṅ. Ye sharīr rākh ho jayegā par amar rahegī rājpūtī shān humāre usūl humārā swābhimān.*

15. <u>Kh</u>aljī: *Mere azīz 'ishq aur jung meṅ koi usūl nahīṅ hotā.*
 Singh: *Binā usūl ke is jung ko itihās kāle aksharoṅ meṅ likhegā.*
 <u>Kh</u>aljī: *Jalādeṅge hum aise itihās ko.*
 Singh: *Itihās sirf kāgaẓpar nahī likhā jātā jo tū use jalā de.*
 <u>Kh</u>aljī: *Kitne aćhe ho tum aur kitne aćhe haiṅ tumhāre usūl.*
 Singh: *Kuch usūl tū bhī sīkh le 'Alāuddīn, Insān ban jayegā.*

16. V. D. Savarkar, who actually coined the term 'Hindutva' and defined it as a political ideology, also underlines this dilemma in his book, *Six Glorious Epochs of Indian History.*

He finds a few historical mistakes in the glorious Hindu resistance. The respect for non-Hindu women is one such issue. Savarkar argues that if the Hindus had decided to pay 'the Muslim fair sex [...] then [...] they [Muslims] would have desisted from their evil designs against any Hindu lady' (Savarkar 1971: 97). He further establishes a direct link between historical mistakes committed by Hindus and the present-day Muslims. He writes:

> Our woman-world would not have suffered such a tremendous numerical loss, which means their future progeny would not have been lost permanently to Hinduism and the Muslim population could not have thrived so audaciously. Without any increase in their womenfolk the Muslim population would have dwindled into a negligible minority.
>
> (1971: 97)

REFERENCES

Agamben, Giorgio (2009), *What Is Apparatus and Other Essays*, Stanford: Stanford University Press.

Ahmad, Salik (2018), 'Rajput pride, moustachioed men and legacy: What drives the Karni Sena protests against *Padmaavat*', *Hindustan Times*, 25 January, https://www. Hindustantimes.com/jaipur/in-many-faces-of-karni-sena-lokendra-kalvi-the-pivot/story-tUwFTXtyxczOAkhizitV1H.html. Accessed 26 December 2019.

Ahmed, Hilal (2014), *Muslim Political Discourse in Postcolonial India: Monuments, Memory, Contestation*, London and New York: Routledge.

Ahmed, Hilal (2019), *Siyasi Muslims: A Story of Political Islams in India*, Delhi: Penguin-Random House.

Ahmed, Hilal and Swain, Gyanranjan (2019), 'Post-poll survey: Naveen's track record helps to overcome BJP blitz in Odisha', *The Hindu*, 28 May, https://www.theHindu.com/elections/lok-sabha-2019/naveens-track-record-helps-to-overcome-bjp-blitz/article27267792.ece. Accessed 3 July 2019.

Business Standard (2016), 'Bharat mata ki jai: The controversy around the slogan', 2 April, https://www.business-standard.com/article/current-affairs/bharat-mata-ki-jai-the-controversy-around-the-slogan-116040200319_1.html. Accessed 26 December 2019.

Business Standard (2019), 'Fringe group leader in Rajasthan booked for inciting religious sentiments', 2 April, https://www.business-standard.com/article/pti-stories/fringe-group-leader-in-rajasthan-booked-for-inciting-religious-sentiments-119070101057_1.html). Accessed 26 December 2019.

Dhara, Tushar (2019), 'In Rajasthan, a case of "love jihad" cuts stereotypes of class and party allegiances', *The Caravan*, 26 July, https://caravanmagazine.in/politics/love-jihad-rajasthan-bhadarna. Accessed 26 December 2019.

Dinesh (2019), 'Who is Shri Rajput Karni Sena to protest Jodhaa Akbar and Padmaavat', *Patrika*, 24 January, https://www.patrika.com/jaipur-news/who-is-shri-rajput-karni-sena-protest-jodha-akbar-and-padmaavat-1-2272586/. Accessed 26 December 2019.

Gupta, Charu (2009), 'Hindu women, Muslim men: Love jihad and conversions', *Economic and Political Weekly*, 44:5, 19–25 December, pp. 13–15.

HariBhakt (n.d.), 'Rani Padmini (Padmavati): The epitome of bravery and the pride of Indian womanhood', https://haribhakt.com/rani-padmini-padmavati-the-epitome-of-bravery-and-pride-of-indian-womanhood. Accessed 26 December 2019.

IANS (2017), 'Censor board invites Jaipur historians to view "Padmavati"', *The Statesman*, 31 December, https://www.thestatesman.com/entertainment/censor-board-invites-jaipur-historians-view-Padmaavati-1502552947.html. Accessed 26 December 2019.

Indian Express Online (2017), 'Sanjay Leela Bhansali slapped by protesters on *Padmavati* sets in Jaipur', YouTube, 27 January, https://www.youtube.com/watch?v=wnERzg42b2M. Accessed 26 December 2019.

Kumar, Satendra (2019), *Badalte Gaon, Badalta Dehat: Nayi Samajikta ka Uday*, Delhi: Oxford University Press.

Meena, Mukesh (2017), 'Film "Padmavati" under Rajput fire: Bandh paralyzed Chittorgarh', Hindu Existence, 4 November, https://Hinduexistence.org/2017/11/04/bhansalis-film-padmavati-under-rajput-fire-bandh-in-chittorgarh. Accessed 26 December 2019.

Misra, Dipak (2017), 'Manohar Lal Sharma vs. Sanjay Leela Bhansali', Writ petition (criminal) No. 191, Supreme Court of India, https://indiankanoon.org/doc/122203851. Accessed 26 December 2019.

Palshikar, Suhas (2015), 'The making of a neo-Hindu democracy', *Seminar* #665, January, http://www.india-seminar.com/2015/665/665_suhas_palshikar.htm. Accessed 3 July 2019.

Pande, Mrinal (2009), 'Indian press: The vernacular and the mainstream babel', in A. Farouqui (ed.), *Muslims and Media Images: News versus View*, Delhi: Oxford University Press, pp. 46–57.

Sardesai, Shreyas and Gupta, Pranav (2019), 'The religious fault line in the 2014 elections', in A. Kumar and Y. S. Singh (eds), *How India Votes: A State-by-State Look*, Delhi: Orient BlackSwan, pp. 58–74.

Savarkar, V. D. (1971), *Six Glorious Epochs of Indian History* (trans. and ed. S. T. Godbole), Bombay: Bal Savarkar, http://ebooks.savarkarsmarak.com/category/english-books/. Accessed 30 December 2019.

Shani, Ornit (2010), 'Conceptions of citizenship in India and the "Muslim question"', *Modern Asian Studies*, 44:1, pp. 145–73.

Talukdar (2017), 'Padmavati attack on Bhansali', *The Telegraph*, 28 January, https://www.telegraphindia.com/india/Padmaavati-attack-on-bhansali/cid/1497097. Accessed 26 December 2019.

Wadhawan, Dev Ankur (2019), 'Lord Rama lineage: After Kush's descendants, now Karni Sena chief says he came from Luv', *India Today*, 13 August, https://www.indiatoday.in/india/story/karni-sena-chief-lokendra-singh-kalvi-descendant-of-lord-rama-1580221-2019-08-13. Accessed 26 December 2019.

Zoom (2016), 'Finally Ranveer gets a few minutes opposite Deepika in *Padmavati*', 7 November, https://www.youtube.com/watch?v=fKSObP0f0dU. Accessed 26 December 2016.

PART 2

CINEMATIC FORMS

8

Alibaba's Open Sesame: Unravelling the Islamicate in Oriental Fantasy Films

Rosie Thomas

Mehboob Khan used to enjoy narrating the story of his film industry debut as one of the 40 thieves in B. P. Mishra's *Alibaba Chalis Chor* (*Alibaba and Forty Thieves*, 1927), joking that almost no traces remained on screen as he spent most of his time in a jar. The film itself, however, left many traces, not only on Mehboob, who directed his own version of the tale in 1940, but also on audiences of the day and on Indian cinema history more broadly. The Indian Cinematograph Committee evidence and report of 1928 confirms that Mishra's Arabian Nights fantasy films were major hits throughout the country and, as exhibitors noted happily, such films 'played anywhere', attracting audiences across the regional and religious spectrum (1928: 24, 172, 288). The Alibaba story has been a perennial of Indian cinema, spawning at least two dozen versions since Hiralal Sen's pioneering production of 1903, which I suggest may have been India's first full-length feature film. Moreover, many Alibaba films were classic hits of their day – notably those of 1927, 1937, 1940, 1954, 1956, 1966 and 1980 – all with somewhat varying versions of the story and how it was visualized.

In their ground-breaking work on the Islamicate in Indian cinema, Bhaskar and Allen (2009: xiii) noted their omission, for the time being, of the Oriental genre, a film industry term for a body of fantasy films that were particularly popular in India's silent and early sound eras, as trade press advertisements of the day for films such as *Gulshan-i-Arab* (1929) or *Ghulami Zanjeer* (1931) indicate.[1] These set their stories in an imaginary world outside India, broadly alluding to all lands to its west. Persia and Iraq – and their Muslim cultures – were key references within this fantasy never-never land as it appeared on screen, alongside generically 'Arab' lands. The narrative and visual conventions of these filmic worlds drew not only

on orientalist tropes inspired by the *Arabian Nights* in Euro-American theatre, cinema, literature, music and the arts but also on more traditional Indian sources, including a body of stories loosely associated with the *Nights* that derived from the Indo-Persian *qiṣṣa-dāstān* storytelling tradition.[2]

Bhaskar and Allen's challenge provided one of the key starting points for my own research on India's B-movie fantasy film and the influence of the *Arabian Nights* on Indian cinema. In an earlier essay, I explored the history of the *Nights* in India and argued that the *Nights* became, somewhat paradoxically, a signifier of cosmopolitan modernity in 1920s and 1930s India and that what filmmakers referred to as 'the *Arabian Nights* fantasy film' drew eclectically on both transcultural orientalist trends and local traditions, thereby putting the notion of the Islamicate under particular strain (Thomas 2013: 31–65).[3]

In the current chapter, I wish to flesh out and extend these arguments on the Oriental genre aka Islamicate fantasy film and use as my focus a comparison between the three earliest Indian films of the Alibaba story to have survived: Modhu Bose's 1937 Bengali version from Calcutta, Mehboob Khan's 1940 Bombay version (in Hindi and Punjabi) and Homi Wadia's 1954 Hindi version, also from Bombay but reworked (by others) for a Tamil version in 1956 and for a Telugu version in 1970. I will also briefly set these in the context of other Indian Alibaba films that preceded and followed them. In fact, 'Alibaba' is but one strand within the so-called Oriental genre, and a proper understanding of the genre would also include films based on the Persian *qiṣṣa-dāstān* tradition as well as hybrids of these.[4] However, given that the Alibaba films – several of them major hits by significant directors – have been largely ignored to date, my priority here is to explore these in some detail. I will be arguing that across these three films we see significant changes in how Alibaba is portrayed, in the filmic genre used and in the place of fantasy and magic, and that, insofar as they can be disentangled, the Oriental and the Islamicate are differently inflected in each.

The place of the Alibaba tale within the body of the *Arabian Nights* is controversial. Often referred to as an 'orphan tale', along with 'Aladdin' and 'Sinbad', no version of this story has been found in any Arabic source that predates Galland's French translations of 1704–17. Galland claimed to have heard the story from a Syrian Maronite monk, Hanna Diab, leading many to conclude that 'Alibaba' was primarily invented by the Frenchman himself or, at the least, was his improvisation around the bare bones of Diab's oral tale as recorded in six scant pages of Galland's diary.[5] But as Chraïbi points out (2007: 3–15), while Galland's storytelling skills produced the tale as we now know it, including the name Ali Baba (Galland's notebook suggests Diab called him Hogai Baba), the presence of motifs from several earlier Syrian folktales indicates that it was a composite firmly rooted in Arab sources.[6] And as Marzolph has argued (2006: vii), the *Arabian Nights*, despite its undisputed oriental origins, should now be seen as a transcultural creative

work 'shaped into its presently visible form by European demand and influence'. 'Alibaba' is now firmly part of the canon and, like 'Aladdin' and 'Sinbad', has become one of the best known of the *Arabian Nights* tales worldwide.

Given this history, Galland's 'The Story of Ali Baba and the Forty Thieves Killed by a Slave Girl' can be confidently claimed as an original text. In Galland's tale, set explicitly in Persia, Alibaba is a poor but generous woodcutter and his brother, Qasim, a rich and greedy merchant. The ruthless Abu Hasan leads a band of 40 thieves who rob the unwary and hide their loot in a cave that magically opens to the words 'Open Sesame'. Out in the forest, Alibaba overhears the secret formula, enters the cave once the thieves have left and brings sacks of gold home on his donkeys. His jealous brother Qasim uncovers Alibaba's secret and hastens to the cave to fill his own coffers but, befuddled by greed once inside this treasure trove, forgets the words by which to leave. Abu Hasan's men discover Qasim in the cave, kill and quarter him, hanging the body parts up as a warning to others. The next day, Alibaba rescues Qasim's corpse from the cave, moves into Qasim's house and asks his widow to become his second wife, deputing his 'shrewd and clever' slave-girl Marjana to cover up the nature of this death. Marjana bribes a cobbler to sew together Qasim's body, blindfolds him to ensure the family's identity and address remain a secret and then protects the secret by foiling the thieves' subsequent attempts to mark the door of the house with chalk crosses. Eventually Abu Hasan locates Alibaba's house, disguises himself as an oil merchant and hides his band of (by now) 37 men in nineteen leather oil jars. Taking advantage of Alibaba's hospitality, he begs a bed for the night and brings his jars into Alibaba's home. Marjana uncovers the plot and kills the thieves with boiling oil while her master sleeps. Abu Hasan escapes but returns some weeks later, this time disguised as a cloth merchant, having befriended Alibaba's unwitting son at his market-stall. Alibaba and his son unsuspectingly invite him to dinner. Marjana sees through this disguise too and, on the pretext of dancing to entertain the guest, gets close enough to kill Abu Hasan with her dagger. Alibaba rewards her by freeing her from slavery and marrying her to his son. They and their descendants continue to visit the cave whenever the need arises and live in splendour ever after. 'They had profited from their good fortune but used it with restraint' (Lyons and Lyons 2008: 960).[7]

Eighteenth- and nineteenth-century English-language print versions of 'Alibaba', including children's versions in the Opie collection, remained close to Galland's text, introducing only minor variations.[8] However, by the early 1800s, European theatre was enthusiastically improvising on the tale. A version called *The Forty Thieves: A Grand Romantic Drama* by R. B. Sheridan and George Colman, which opened in London at the Theatre Royal, Drury Lane, in 1806 and travelled widely, including to New York and Philadelphia, begins in a fairy grotto and includes the wicked magician Orcobrand, the good fairy Ardinelle and

an Abdullah as the robber chief (Orr 2008: 128). 'Alibaba' soon became a pantomime favourite, giving full license to companies to improvise, adapt and innovate.[9] The prevalence of the tale in eighteenth- and nineteenth-century British culture undoubtedly influenced its wider take up within India, notably through the Urdu-Parsi theatre, which was key to popularizing the story across India's cities. Urdu-Parsi playwrights reworked 'Alibaba' on their own terms: the Empress Victoria Theatrical Company was touring an Urdu *Ali Baba aur Chalis Chor* across North India in the 1870s, playing it in Chinese costumes and Chinese-style sets as part of its repertory over a five-month stay in Lahore in 1878 (Gupt [1981] 2005: 124–26).

The story also took the Bengali theatre world by storm. *Alibaba or The Forty Robbers*, Kshirode Prasad Vidyavinode's Bengali adaptation, was the biggest hit of the Calcutta stage at the turn of the century. According to Mukherjee (1985: 99), from its first performance in November 1897, 'Alibaba, which scored a sensational triumph [...] placed Classic [Theatre] on a sound financial footing' for at least a decade. Newspaper adverts for the 'Grand Fashionable' opening night of this 'magnificent Comic Opera' and 'genuine Fountain of Mirth and Merriment' trumpeted the 'Charming Songs', 'Soul-captivating Dances' and 'Grand Cave Scene [that] is worth seeing' (*The Statesman*, 20 November 1897, in Mukherjee 1985: 797). Alongside its innovative lighting and special effects (Mukherjee 1985: 106–07), *Alibaba*'s songs were especially popular: when India's first gramophone recordings were made in 1902, Soshī Mukhī and Fāno Bālā, two nautch girls of the Classic Theatre, 'sang extracts from popular theatre shows of the time [including] *Alibaba*' (Farrell 1993: 34). Most significantly for this chapter, this stage-play also provided the raw material for Hiralal Sen's early filmmaking experiments. Sen initially filmed dance scenes from this and other Classic Theatre productions, screening them alongside the plays in 1901. Two years later, an astonishing rumour has it, Sen directed a 'full length' two-hour film version of *Alibaba*, including close-ups, pans and tilts, which was screened in 1904. If true, this would make *Alibaba* India's first feature film. Sadly, only anecdotal evidence remains of Sen's ground-breaking feat.[10]

A number of films based on 'Alibaba' or 'Forty Thieves' were made in India's silent and early sound era. By all accounts, the 1927 Bombay silent version, so fondly remembered by Mehboob, was particularly well regarded. Not only did it launch the career of Sulochana, Bombay's first female mega-star in the 1920s and 1930s, but B. P. Mishra also became recognized as an accomplished director who privileged visuals over plot (Rajadhyaksha and Willemen 1999: 148). A *Times of India* review, albeit patronizing, was unusually complimentary:

A film [...] produced in Bombay for India, but which is worth an international market, is 'Alibaba and the Forty Thieves' now showing at the Imperial Cinema,

Bombay. The producer Mr B.D. Misra (*sic*) has not made the mistake of following American film ideas too rigidly: there are not 'dissolves' and changes of scene and time every few seconds, so that the film possesses a unity of time and place which necessarily makes it much more intelligible to the Indian audience. As may be imagined, the story is brimful of action, well blended with romance and comic relief, while the scenes are the work of a real artist [...] [J]udging by its reception the first day [it] should have a good run in the Indian cinemas while Europeans will find it interesting as indicative of the progress the Indian film industry is making.

(29 November 1927: 8)

Although none of the silent Alibaba films have survived, two early Alibaba talkies – Modhu Bose's of 1937 and Mehboob Khan's of 1940 – may help to throw light on these as Bose based his film directly on Vidyavinode's play (the material on which Hiralal Sen's film was made), while Mehboob had first-hand experience of Mishra's film. How do these two films compare? How do they adapt the Alibaba story? How are their Oriental worlds constructed?

Alibaba (1937): Sadhona and Modhu Bose

Sadhona Bose and her husband, Modhu Bose, the creative forces behind the 1937 Bengali *Alibaba*, were members of Calcutta's cultural and intellectual aristocracy of the 1920s and at the heart of a wealthy cosmopolitan set that was as at home in London or Berlin as in India. This golden couple's cultural credentials were exemplary. Modhu learnt film direction through assisting on the sets of, amongst others, J. J. Madan (in Calcutta), Himansu Rai (on *Light of Asia*), Alfred Hitchcock (at Gainsborough in London) and Fritz Lang (at UFA in Berlin). Sadhona was a classically trained musician and dancer, learning both Kathak and Manipuri dance from the top practitioners of the day and music from the legendary Timir Baran, the pioneer of Indian orchestral music. Both she and Modhu worked on 'ballets' with Rabindranath Tagore and, when Modhu set up the Calcutta Amateur Players theatre group in 1927, she began performing with him.[11] Both were fully committed to the elite nationalist project of developing an authentic but modern Indian classical dance form that would play proudly in the international arena. Their reputation was such that when Anna Pavlova visited Calcutta in the late 1920s, a visit to Calcutta Amateur Players – and time with Sadhona – was firmly on her itinerary. Modhu Bose recalls Pavlova attending rehearsals for their first charity stage production, *Alibaba*, in late 1927 (1967: 125–26).[12]

When the company turned professional in the mid-1930s (and changed its name to Calcutta Art Players), their choice of Vidyavinode's *Alibaba* as their opening

stage production – and subsequently their first major film together – was a canny one. Whilst the play was applauded for its literary and musical merit, it was also an evergreen money-spinner, as Mukherjee had noted. Song, dance and spectacle set in an orientalist never-never land was, the Boses recognized, an irresistible offer.

The film opens with the 40 thieves galloping towards their cave of riches, which unlocks to the magic words: *chi ching phaak* ('Open Sesame'). Shot in the idiom of a Hollywood western, the thieves coded more as Bengali dacoits or Bihari tribals than as Arab marauders (despite the odd Sheikh-style bandana), the scene is accompanied by Timir Baran's rhythmic, light orchestral marching music. The film's first substantial scene moves indoors to Alibaba's wealthy brother's home and sets up the film's themes and its two central characters, the slaves of the household, Marjana and Abdullah, played by Sadhona and Modhu Bose, respectively. The camera pans up from Marjana's ankle-belled feet to introduce her sweeping her master's stairs with her peacock-feather dusters. As she dances, she sings a jaunty song – about the dirtiness of this household – in the idiom of jatra-style Bengali stage music fused with European light opera. Her quasi-Afghan/Kashmiri costume – embroidered waistcoat, long kurta, pantaloons, flowing headscarf, hoop earrings and long swinging plait – gestures westwards towards a hybrid but loosely Islamicate West Asian world. She calls to her fellow slave, Abdullah, who appears at the top of the staircase dressed in white pyjamas and black embroidered waistcoat, brandishing a long broom, before sliding capriciously down the banisters. Under a tall, white fez with swinging tassel, Abdullah's ebony-painted face and exaggeratedly large white lips place him as an African eunuch slave, played here within the blackface conventions of American vaudeville or English music-hall. Hereby announced in no uncertain terms as a star couple, Marjana and Abdullah indulge in amusing banter about Marjana's aspirations to become a *begam*, before singing and dancing together.

The Boses' film is a distinctively Indian adaptation of 'Alibaba'. Whilst closely following Galland's tale in most important respects, such as key characters and plot points, the film's startling innovation is to tell the story from below, from the perspective of the two slaves. Almost all the action unfolds as seen and commented on by Marjana, the clever servant-girl, and Abdullah, Alibaba's family manservant, who form the moral centre of the film.[13] Whilst not a romantic pairing, Marjana and Abdullah dominate the screenplay with their many scenes of comic repartee and songs and dances together, as well as being instrumental in its narrative resolution by saving Alibaba's life and destroying all the villains. Of the film's fourteen songs and dances, ten are performed by either Marjana or Marjana and Abdullah, who are recognizably stars of the show.[14] Even in scenes ostensibly about the master's family, these two lurk nearby: cutaways show them peering through curtains or a crack in a door or watching from balconies as the masters' stupidity

and Qasim's pomposity and greed are revealed. Marjana is the go-between for Alibaba's extended family, sorting out relations between the brothers, between husbands and wives and, later, between the family and the outside world. Only she and Abdullah have the intelligence and cunning to deal astutely with the world. Alibaba himself is a comparatively minor and distinctly non-romantic character and, as in Galland, his son, Marjana's romantic interest, is foolish and ineffectual, with romantic scenes mostly played as comedy. In all this, the film seems to have followed Vidyavinode's 1897 stage play relatively faithfully: contemporary sources and publicity images indicate that the play also told its story from the slaves' perspective and presented Abdullah in blackface.[15]

It cannot be far-fetched to assume that the film (and play) would have been read in colonial Bengal as a nationalist allegory about clever slaves and their greedy colonial masters who live a luxurious lifestyle funded by found and stolen wealth. In adopting the viewpoint of the intelligent slaves, much of the pleasure of the film lies in watching them use the stupidity and avarice of their masters to their own advantage and negotiate their way to freedom, although, as the first scene sets out, they each approach this in a different way. Marjana dreams of becoming a *begam* – a wish fulfilled in the final scene when Alibaba marries her to his son (thereby effecting narrative closure) – while Abdullah remains a wry commentator to the end, retaining his freedom of spirit by living simply and asking for little, although his final words reveal dreams of freedom. And while Abdullah subverts the system from within (by privately refusing its terms of reference), the Marjana figure is more complex. On the one hand, her dance persona is emblematic of the imagined new India – the perfect blend of 'tradition' and 'modernity': through the power of this 'Indian' dance, she can kill off the villains who threaten her homeland and win her own freedom. On the other hand, she chooses to accommodate herself to a benign patriarchal order, which visibly troubles Abdullah.

The contradictions of this positioning are even more apparent around the question of race: *Alibaba*'s nationalist subtext coexists with its flipside – a disdainful othering of India's own less powerful. In drawing directly on a Victorian Calcutta theatre hit based on a European *Arabian Nights* tale, the film could hardly escape the orientalism and racism of its source material and era, most blatantly apparent in Abdullah's blackface, a trope that, by all accounts, was not a feature of traditional Indian – or even Parsi – theatre.[16] To this, the global orientalism of the 1920s, especially as popularized by Hollywood, contributes clichés of an exotic Arab Muslim world that is as hazy and essentializing as any European orientalist fantasy. *Alibaba*'s musical and dance modes are wildly eclectic. The new Bengali urban art song and Indian classical music sit alongside syncopated jazz, western orchestral film music and Gilbert and Sullivan–style light opera; the choreography veers between Kathak and Manipuri dance and Busby Berkeley-inspired

dance formations. It also incorporates an orientalist, modernist dance that was undoubtedly influenced by the Ballets Russes via the route of Uday Shankar and Anna Pavlova, thereby placing it firmly within India's high-culture variant of this 'doubly phantasmagoric' mirage of the Orient (Thomas 2013: 52) (Figure 8.1).[17]

Marjana's final murderous dagger dance exemplifies this eclecticism: it is as much Diaghilev's *Scheherazade* as Indian traditional or folk dance. On a palatial interior set boasting Islamicate scalloped arches, fountains, elaborately tiled floors and grand chandeliers, two large gongs summon a dozen or so female dancers, demurely clad in full-skirts, waistcoats and headscarves – attire quite unlike the gauzy veils and midriff-revealing confections of most European 'oriental dancers'. These chorus girls attempt to distract the robber chief, Abu Hasan, who reclines, disguised as an Arab merchant, drinking with Alibaba, by now resplendent in the pomp, satin and pearls of a fantastical oriental royalty. To a lilting, rhythmic melody, the women dance – or rather sway – in symmetrical formation, the geometric black and white shapes of the tiled floor echoing those of their twirling skirts. Overhead shots highlight the abstract patterns. Intercut with this scene we watch Abdullah and Marjana organizing the demise of the 40 thieves as dozens of giant oil jars are rolled into the cellar, where the thieves will be scalded to death with boiling oil.

Finally, Alibaba summons Marjana to perform as a special treat for his guest (Abu Hasan in disguise), who had shown little interest in the amateurish chorus girls. Marjana runs down the staircase, emerging onto the dance floor in harem pants and a dramatic, long-sleeved, black kurta with bold geometric shapes appliquéd around the waist and wing-like appendages on shoulders and cuffs, her head crowned by an enormous, ornate headdress reminiscent of a Southeast Asian folk theatre deity, perhaps Javanese, Ceylonese or Cambodian. It is far from the Islamicate tropes of mainstream Bombay cinema and, whilst loosely echoing other Western orientalist costumes – such as Ida Rubinstein's in Diaghilev's *Scheherazade* or the *Chu Chin Chow* fashions on display in *The Tatler* in 1917 (Thomas 2013: 49–59) – Marjana's costume offers no hint of indecent sexual display. Like the chorus girls, she is modestly covered and fully clothed. Marjana's dance solo begins slowly, with controlled, Indian folk-dance steps, the music slinky and sensuous but with the unmistakable minor cadences of western orientalist orchestration, alongside the percussive beat of ankle bells. Gradually, as the music builds an ominous momentum, the dance morphs into a dizzying whirl of modernist free expression: brandishing her dagger, Marjana twirls like a crazed dervish, eventually spinning breathlessly round in Abdullah's arms until, suddenly, she lunges over onto Abu Hasan and plunges her dagger into his heart.

Her costume may be modest and her dance steps may include authentic Kathak, but Marjana's final dance also references the familiar orientalist trope of the

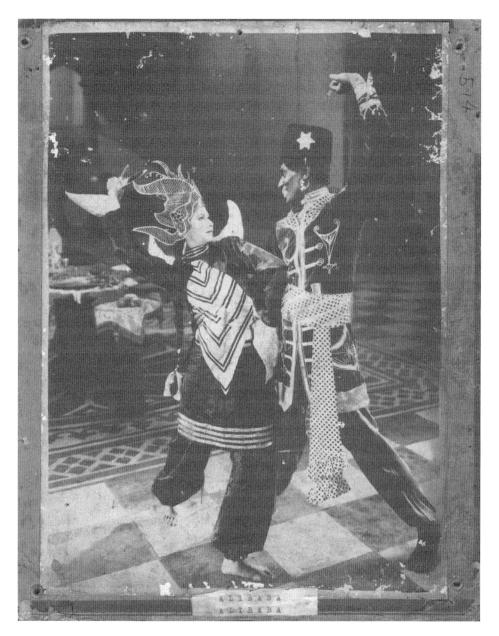

FIGURE 8.1: Marjana's dagger dance with Abdullah begins in *Alibaba* (Modhu Bose, 1937). Production still.

treacherous dancing girl, as seen within the Orient of internationally fashionable modernity. As I have discussed elsewhere, this Orient was a mishmash that was as Hindu as it was Islamic, and Bose's eclectic orientalism is especially apparent in the dance sequences. While the film constructs the ambience of an imagined Islamic world through its *mise en scène* – scalloped arches, filigree walls and Arabic inscriptions – it combines these with domestic scenes played in a Hinduized Bengali theatrical idiom not unlike the socials of New Theatres, old Calcutta's most respectable film studio. In most scenes set in Alibaba's family home, characters speak a literary Bengali, with more Sanskritized than Urduized forms of expression, while body language, costume and gesture (e.g. ways of pulling the sari *pallū*) are recognizably Hindu middle-class – those of the Bengali theatre elite.[18] Apart from peppering Bengali dialogues with a sprinkling of Urdu words, there is little attempt to mimic the codes of the Islamicate as seen in Bombay cinema of the day. Moreover, Bose's songs are essentially in the idiom of the new Bengali art song. Thus, despite a token attempt to Islamicize costumes and set, and the use of more Urduized language at key points, notably when Marjana speaks to the cobbler (a lower-class side character who can be comfortably Othered as Islamic), the film, in its ragbag of cultural reference points, is ultimately closer to international orientalism than to the Indian Islamicate. It thereby signals its impeccable credentials within highbrow cosmopolitan modernity, marking an emphatic distinction from Bombay's Islamicate fantasy films such as *Lal-e-Yaman* (dir. J. B. H. Wadia, 1934), which were considered to be more authentically Islamic – and hence lowbrow – and consequently critically disparaged: a reviewer in *Varieties Weekly* (a mouthpiece of New Theatres) claimed films such as *Lal-e-Yaman* were for 'the Muslim class' and whilst 'welcome entertainment', they 'should not become the order of the day' (Thomas 2013: 58).[19] I will return to the Wadias' oeuvre later. Meanwhile, how does Bose's film compare with the Bombay *Alibaba* that followed?

Alibaba (1940): Mehboob Khan

Where the Boses were among the cultural and artistic elite of Calcutta, Mehboob Khan hailed from a more modest, rural, Muslim background but, by the late 1930s, was making his mark within Bombay's mainstream film industry. He had already notched up major successes with *Al-Hilaal* (1935), *Deccan Queen* (1936), *Hum Tum Aur Woh* (1938) and *Ek Hi Rasta* (1939) and had emerged as Sagar Movietone's star director. Although records suggest that the *Arabian Nights* fantasy genre was on the wane in Bombay by the end of the 1930s – certainly fewer were being produced than before – it is intriguing that Mehboob turned to 'Alibaba' for his final film with Sagar in 1939 (released March 1940).

We have no record of why he chose this *Arabian Nights* tale – assuming he had a choice – although his biographer suggests his 'sentimental' feelings about B. P. Mishra's 1927 *Alibaba* were a significant factor (Reuben 1999: 62). Nor do we know whether his remake followed Mishra's film in any way. However, Mehboob did take the *muhurat* shot at Imperial Studios, where Mishra's film had been made. Proprietor Ardeshir Irani welcomed his protégé back fondly and insisted he shoot the whole film there. As a devout Muslim, Mehboob was fasting for Ramadan, so the film was made throughout the nights of November 1939 but, by the time it released, Sagar had closed and Mehboob had joined a new partnership, National Studios, where he immediately started work on the more realist social *Aurat* (1940). He set up his own Mehboob Productions in 1942.

Only one print of Mehboob's 1940 *Alibaba* has survived, and its dialogue track is so poor that I have been unable even to establish its language.[20] Nevertheless, the film's importance to our understanding of Mehboob's oeuvre, as well as to the story of the Oriental genre in Indian cinema, makes it impossible to ignore. Much can be deduced from the visuals, which show that Mehboob was already a confident talent, with a firm grasp of the language of world cinema: we see inventive use of high- and low-angle shots, close-ups of faces and eyes, well-paced editing and exquisite camerawork by Faredoon Irani. The film boasts dramatic expressionist lighting throughout and spectacular sets and costumes. *The Times of India*'s opening review enthused that *Alibaba* was 'outstanding in many respects' (29 March 1940: 8) and Reuben (1999: 63) tells us the film went on to become a 'superhit'.

From the very first minutes, it is apparent that Mehboob's exotic Orient draws directly, and more explicitly than Bose's, on the orientalist tropes of European and Hollywood cinema. The film opens with graphic stills of silhouetted camels, palm trees, minarets, onion domes and a fantastical Arab cityscape, over which westernised oriental music plays, a genre Bombay film composers knowingly referred to as 'Arab spice' or 'Hollywood Arab not real Arab' (Booth 2007: 318, 324).[21] The action begins in the opulent house of the merchant Qasim, his wealth signified by servants bearing rolls of luxurious carpet, a plump wife being pampered by a bevy of handmaids, and glimpses of scantily clad harem dancers and African male slaves. The house itself boasts a grand staircase, scalloped arches, carved divans, giant urns, filigree lamps and latticework screens, ornate balconies and verandahs – all motifs of Hollywood's exotic East (albeit frequently borrowed or adapted by Indian Islamicate genres). We are soon introduced to the romance between Jaffer (Alibaba's son) and Marjana (Qasim's slave), played by two singing stars of the day: Surendra Nath, Sagar's answer to K. L. Saigal (Ahmed 2008: 29), and Wahidan Bai, the renowned 'songstress of Agra'.[22] Their eight love songs (four duets and two solos each) were undoubtedly major attractions of the film

213

and are especially haunting, picturized within conventional Bombay Islamicate romantic imagery: full moons, gardens with fountains and cypress trees, swaying palm fronds, flitting doves and decorative swings.

However, the storytelling marks some significant differences from the Boses' Bengali *Alibaba* and from Galland's tale. Firstly, both the Alibaba character and his son Jaffer are played by the same actor, Surendra, in a double role. As Alibaba, he is a naïve, bearded, benign but buffoonish man, with a big paunch and weakness for wine, much of the time played in a comic mode. As Jaffer, he is a handsome, clean-shaven, quick-thinking hero, who serenades his love Marjana with romantic songs, finally marrying her when his father frees her from slavery. On the other hand, the clever slave-girl role is split between *two* female slaves in Qasim's household: Marjana is the good, dutiful heroine and the film's romantic interest, whilst Zabba is the temptress who finally kills the robber chief, Abu Hasan, but dies herself in the process. Zabba was clearly conceived as the leading role. Played by Sardar Akhtar, then a 'struggling dancer-artiste' (Reuben 1999: 67) from Lahore with whom Mehboob was romantically involved, Zabba has top billing, both on the film itself and on the song-booklet cover, where her face dominates those of the two male leads, Surendra as Alibaba/Jaffer and Ghulam Mohammed as Abu Hasan. These storytelling innovations change the narrative logic of *Alibaba* into that of a melodrama built around the dynamic of hero/heroine versus villain/vamp. Marjana is heroine; Zabba is vamp. The composite Alibaba and son Jaffer is the hero; Abu Hasan is the villain. Abdullah's role is negligible.

Mehboob's Marjana does not dance or kill – key features of Galland's, Bose's and other early versions of the tale – although, as in Galland, she is astute enough to protect the family in other ways, spying on Zabba and Abu Hasan's love tryst, engaging the cobbler to sew up Qasim's body, confusing the robbers by adding chalk crosses to neighbouring houses and then alerting Jaffer, her love, to Abu Hasan's machinations, as well as helping Jaffer and other servants to kill the robbers with boiling oil. Zabba, on the other hand, is the archetypal oriental siren, a sensual dancing-girl, albeit a victim of circumstances that have forced her to become Abu Hasan's lover and his spy in Qasim's household: she alerts Hasan through carrier pigeon when wealthy guests are expected so that he might intercept and rob them, and plots with him to secure her freedom from Qasim. Sporting bangs – the then risqué hairstyle of the 'modern girl', with its nod to Cecil B. DeMille's *Cleopatra* (1934) – and with the 'languid histrionics and gravelly voice' of the Urdu stage actress (Rajadhyaksha and Willemen 1999: 40), Akhtar plays the role as an outright seductress. Although her costumes are never excessively revealing, they are decidedly vampish for the era – and markedly different from Sadhona Bose's – and include V-necklines, bare shoulders and full legs visible under gossamer-thin skirts or harem pants.

While the choreography has nothing of the originality and style of Sadhona Bose's, Mehboob's sets and dances are nonetheless accomplished and visually engaging spectacle, once again referencing the Busby Berkeley idiom of abstracted geometric forms and overhead shots. However, the dances that Zabba and other harem-girls perform are mostly in the 'Oriental dance' tradition of Indian variety entertainment, marked predominantly by hips swaying sensuously under diaphanous full skirts and bikini tops.[23] The final dance sequence, in which both Zabba and Abu Hasan die, begins with a chorus of five dancers performing their harem routine for Alibaba and his guests, amongst whom Abu Hasan hides disguised as a camel trader. Eventually, Zabba appears and steps slowly but dramatically down the staircase onto the dance floor, a thin veil covering her face so that Alibaba will not recognize her. She flits around in a semblance of a dance, but soon becomes visibly distracted as the robbers fail to arrive on cue from their jars. Abu Hasan looks equally concerned. Intercut with this are shots of boiling oil and jars being rolled into the well. As tension builds, Zabba and Abu Hasan exchange confused looks, then, both simultaneously assuming the other has betrayed them, aim their knives at each other. As Abu Hasan falls, Zabba realizes their mistake and crawls towards her lover, dying on his slumped body. The film ends with Jaffar and Marjana singing and romancing in a moonlit garden, while a dozen or more beautiful women surround an inebriated Alibaba.

Compared with earlier versions of the tale, Abu Hasan is played as a particularly exaggerated, melodrama villain who does not even trust his moll, Zabba. When he first suspects her of having revealed the magic words '*Khul Ja Sim Sim*' to her owners, he locks her in the cave's dungeon, an expressionist-lit, shadowy circle of hell, where she joins a chain gang of abject men tied to a giant horizontal wheel which, like animals, they are doomed to pull and turn. Here, intercut with the thieves killing the hapless, greedy Qasim (as seen via a dramatic overhead shot of a circle of thrusting spears), Zabba is sadistically whipped and tortured – as are her fellow prisoners – at Abu Hasan's command. Sounds of the groaning wheel, clanking chains and cracking whip populate the soundtrack. In a surprise revelation we discover that it is this wheel – and the labour of the chain gang – that opens and closes the cave whenever the 'magic' words are heard.

In explaining the opening and closing of the cave through the chain gang, rather than the power of magic words, the story is bizarrely altered. 'Alibaba' was already one of the least magical of the *Arabian Nights* tales, even though some of its Syrian source stories had included djinn and ogres in the cave, and early European theatre versions of *The Forty Thieves* opened with scenes in a fairy grotto. Why might Mehboob have decided to diminish its magical elements even further?

We can speculate that at a time when fantasy films were already going out of favour – and Mehboob was clearly moving towards more realist socials such as

Aurat – a rationalist explanation of the Open Sesame magic might have appealed. Indeed, the *Times of India* reviewer had specified that Mehboob managed to 'reconstruct the story […] in a realistic manner' (29 March 1940: 8). Moreover, with the nationalist movement intensifying at that time, representations of cruel masters treating prisoners as animals would have had deep emotional resonance. Stories of the Kala Pani jail on the Andaman Islands were fanning the flames of the nationalist movement, alongside numerous tales of brutal British masters. However, there is also a more prosaic – and perhaps disappointing – reason.

In November 1934, a British film *Chu Chin Chow* (dir. Walter Forde, 1934) was released in Bombay, six months after its London premiere. Produced by Gainsborough studios, this version of the Alibaba story was based on Oscar Ashe's orientalist musical comedy stage hit, a sensation that had broken all London theatre box-office records between 1916 and 1921 and toured North America and beyond in the 1920s. I have written elsewhere about the racist stereotypes and mishmash of 'oriental' cultures it contained (Thomas 2013: 49–50). Impresario Maurice Bandmann's touring opera company brought the stage show to India in 1918, although local reviews of the day were muted (see *Times of India*, 13 June 1918). Gainsborough's film version was almost as successful as the original stage play internationally – and almost as racist and misogynist – but it adapted the play's plot to include, amongst other innovations, a slave-wheel torture chamber that operates the cave's 'magical' opening and closing.

Without a doubt Mehboob saw this film, which screened on and off in Bombay between 1934 and 1939. Not only do his set-ups – and even shots – in many scenes directly echo it, but *Chu Chin Chow* (hereafter *Chu*) also splits the clever slave-girl character. *Chu*'s Marjana is the romantic interest for Alibaba's son (in *Chu* a minor character played by a different actor than the one playing Alibaba), while Zahrat Al-Kulub is a scheming, seductive, slave-girl dancer who colludes with Abu Hasan to win freedom for herself and for a lover imprisoned in Hasan's cave. Played by Asian American Hollywood star Anna May Wong, Zahrat was, like Mehboob's Zabba, the film's leading role.[24]

Mehboob not only drew directly on *Chu* for scenes and story elements but also for the overall look of his film, which was equally a feast of expressionist lighting and orientalist *mise en scène*.[25] Nevertheless, he adapted and made the story his own. He brought back elements of Galland's tale that had slipped from *Chu*, for example, Marjana's chalk crosses on neighbouring houses; he invented his own plot twists, for example, unlike Zabba, *Chu*'s Zahrat does not die in the end; and he expunged all traces of Chinese characters (including Abu Hasan's disguise as a Chinese merchant) from the plot. Moreover, much of Mehboob's staging and cinematography is considerably more accomplished and spectacular than Walter Forde's.

How does Mehboob's *Alibaba* compare with its predecessors? Firstly, by accentuating the dynamic of hero/heroine versus villain/vamp, Mehboob has pushed the story away from *Chu*'s or Bose's musical comedy mode towards the melodramatic form (albeit with comic interludes) that was then emerging as India's dominant genre and would be well understood by Indian audiences. Secondly, he has followed *Chu*'s stock western orientalist emphasis on slavery – not only is there the chain-gang torture wheel but also a scene in a slave market, where blonde, semi-naked women and blackface men are displayed for sale – and, in so doing, he intensifies the cruelty of both Qasim and Abu Hasan towards their slaves: for example, there were no gratuitous whipping scenes in *Chu* or in Bose's film.[26] Thirdly, while we might assume that Mehboob's portrayal of a Muslim lifestyle might be more authentic than *Chu*'s or Bose's, given his own pride in his Muslim background (and without dialogue it is hard to assess this),[27] the visual and narrative contours of the Euro-American mirage of an Arab world are scarcely different from *Chu*'s and Hollywood's: cruel despot, dangerously sensual dancing girl, oppressed slaves, 'othered' Arab, European and African bodies, camels and onion domes. However, Mehboob's songs and romantic scenes draw on Islamicate tropes and sensibilities that had been introduced into earlier 1930s Bombay costume and fantasy films, such as J. B. H. Wadia's *Lal-e-Yaman*, with their debt to Urdu-Parsi theatre (Thomas 2013: 53–91).[28] Mehboob's film has it both ways: while dominated by the imagery and thematics of Euro-American orientalism, and hence signalling 'modernity', it nevertheless weaves in Islamicate motifs to construct an Indian hybrid, low-culture Orient. The film laid the groundwork for a string of successful post-independence *Alibaba*s.

Alibaba (1954): Homi Wadia

While the popularity of Islamicate magical fantasy films dwindled in the 1940s and early post-independence years, Basant Pictures' fantasy genre successes, directed by Homi Wadia and co-produced with brother Jamshed, encouraged the genre's revival on the B- and C-circuits in the 1950s (Thomas 2013: 10–14). Wadia's swashbuckling comedy *Alibaba Aur 40 Chor* was one of the top four superhits of 1954 and spawned several remakes. The first Tamil colour film, *Alibabavum 40 Thirudargalum* (dir. T. R. Sundaram, 1956), starring M. G. Ramachandran, followed Wadia's *Alibaba* closely – in plot, visual motifs and even its songs – and was a huge blockbuster. This was itself reworked as *Alibaba 40 Dongalu*, a 1970 Telugu hit starring N. T. Rama Rao. According to Vijay Mishra (2019: 325–26), Homi Wadia's 1954 *Alibaba* has dominated the tale's circulation in the modern Indian cultural imaginary ever since.[29] However, its debt to Mehboob's *Alibaba*, and hence

Chu, is unmistakable. In all three of the aforementioned post-independence versions, we find the tell-tale slave-wheel as the mechanism that opens and closes the cave rather than magic. And while all Indian Alibaba films since Wadia's have made Alibaba himself a romantic hero, with fighting skills and a Robin Hood ethos, this arguably simply pushes Mehboob's innovation of the double-role of Alibaba-Jaffer to its logical conclusion. Moreover, following Wadia, from 1954 onwards Alibaba, not a slave-girl, always kills the robber chief, a significant reworking of the key premise of Galland's tale (and its title). Furthermore, the son figure disappears – as does Alibaba's wife – and, instead, Alibaba becomes a good-hearted young man who hangs out with a male friend (second hero), lives with a mother or sister and woos and marries Marjana.

In Homi Wadia's *Alibaba*, made in black and white, with selected songs handcoloured in the original prints, the hero lives with his sister, Salma, and romances – and fights on behalf of – the dancer Marjana. His friend Abboo is a comic buffoon enamoured of Salma's maidservant Sitara. There is no vampish female but instead three male villains: Qasim, Sher Khan (Qasim's henchman) and Abu Hasan. The latter two not only threaten Marjana's chastity (for which Alibaba must kill them) but also inflict heartless violence on other men, while Wadia's Qasim is more unremittingly cruel than his predecessors. Portrayed here as an emir/king (not a merchant), Qasim is greed personified, cheating his brother of his inheritance and his people of their taxes and even sentencing his innocent brother to death. The film demonstrates an even greater emphasis on whipping and violence – albeit much of this comedic or balletic – than Mehboob's film, including a scene in which Abu Hasan sadistically tortures and eventually kills the tailor (in post-independence India, no longer a cobbler). Marjana is a proud dancer on hard times since Abu Hasan murdered her parents. No longer conceived as a slave-girl, she nevertheless remains Galland's clever heroine: she organizes the tailor, foils the robbers with chalk crosses, uncovers their oil barrel ruse and ensures Sitara and Abboo roll the barrels (with robbers inside) over the waterfall beneath the palace, while she dances to distract Alibaba's guests. Wadia intercuts shots of the robbers' destruction with those of the alluring dance performance, just as Mehboob, Bose and *Chu* had done. Wadia's female characters are all more astute than the males, who are either naïvely trusting or crassly villainous, although the film's point of view is Alibaba's and he and Marjana form its moral centre. The African slave Abdullah has disappeared completely.

There is also a generic shift. Wadia's *Alibaba* focuses more on Douglas Fairbanks–style sword fighting, stunt action and slapstick comedy than Mehboob's or Bose's did, and its romantic scenes are more peripheral. Before Marjana wins his love, this Alibaba 'hates women',[30] and the only romantic song between the leading couple is a jaunty, up-beat, westernised orchestral number in mainstream

1950s Bombay cinema style – rather different from the Islamicate romantic tropes of Marjana's love scenes in Mehboob's film. Misogyny is a subtext that threads through the film: Alibaba's hatred of women results from Qasim's wife's machinations to disinherit him, while the jokey romance between Abboo and Sitara, which merits its own song and more screen-time than Alibaba's and Marjana's courtship, derives much of its humour from Sitara's indulgent impatience with her besotted but foolish paramour, with much tomfoolery as he pretends to be a donkey that she chases and beats with a bundle of twigs, the scenario which immediately precedes the film's brief coda. As often occurs in the Wadias' films, the comedy subplot undercuts and comments on the themes of the central narrative action (Thomas 2007: 299). And while, in the opening scene, Sher Khan's whip threatens Marjana, she subsequently takes the whip to him in a recognizable nod to the Wadia brothers' Fearless Nadia, the remarkable *Hunterwali* (woman with the whip) of 1930s and 1940s Indian popular culture. While Wadia's *Alibaba* appears to celebrate strong women, its strong female characters are, unlike in Galland's tale or Bose's and Mehboob's films, ultimately portrayed as a threat to masculinity requiring narrative containment.

Wadia's film, like its predecessors, references the nationalist movement, here primarily through its dialogues, which are imbued with populist, post-independence rhetoric in which J. B. H. Wadia's voice is unmistakable.[31] For example, Wadia's Marjana is not only no longer conceived as a slave-girl, but she is also outraged that anyone might want to buy her. When Qasim's villainous henchman, Sher Khan, having lassoed Marjana with his whip, insists he take her to dance for Qasim, she refuses, retorting: 'Marjana is not a slave of rich men's desires […] because […] the rich don't have respect for the poor person's *ismat* (honour/modesty/chasity)'.[32] The scene ends in custard-pie knockabout and a sword fight as Alibaba intercedes to save her. When Marjana later (metaphorically) offers to become Alibaba's slave, to thank him for saving her from Sher Khan, he answers, 'I hate slavery, I want *āzādī* (freedom) for all. You are free – now go'.[33] Filmmakers referred to such lines as 'clapworthy', written expressly to provoke cheering, whistling and clapping in cinemas.

The theme of the evil rich and worthy poor dominates the film. When Alibaba first becomes wealthy, his three priorities are those of a dutiful Muslim man: to donate to charity, find a husband for Salma and build a palace for Marjana. A series of tableaux follow of the townspeople praising Alibaba as a model rich man and compassionate ruler. Later Alibaba, as emir, tells Marjana that 'a big man isn't one living in a big palace but one who can build his home in someone's heart'.[34] Thus the story is less an anti-colonial allegory (as in Bose) and more overtly about good and bad governance, a topical theme at that time. Crucially, the new ruler Alibaba is commended for being god-fearing and accepting of his

fate: this fantasy never-never land – outside geography and history yet gesturing to Indian ideas of a larger Islamic world – is a utopia in which the good ruler is a humble but fair, god-fearing patriarch in service to his people. At this point, a key question arises. Is this an Islamicate fantasy land or an orientalist one? Can they be distinguished?

As Bhaskar and Allen noted, all early Islamicate films drew upon and evoked 'a generalised Orientalist imaginary' familiar from Urdu-Parsi theatre, Euro-American cinema and other popular visual, aural and performative culture (2009: 4). However, one can distinguish two elements within this Islamicate: firstly, its visual codes and, secondly, the broader expressive traditions deriving from the 'Urdu language and its literary and performative cultures' which feed into a cultural ethos (2009: 13). While *Alibaba*'s visual codes and background music more or less overlap with the Euro-American orientalist imaginary (like most Indian Orientalist films), its cultural ethos does not. Thus, Wadia's background music veers between the minor cadences, gapped scales and reed instruments of orientalist 'Arab spice' and the western orchestral strings of stunt genre music, while his *mise en scène* draws unapologetically on international cinema's orientalist tropes: J. B. H. Wadia's (1980) memoirs reveal that he and Homi would spend hours poring over German books of orientalist stage sets when designing their fantasy films. However, Wadia's costumes, like Bose's (but less so Mehboob's), refuse the norms of Hollywood's Orient: crucially, Marjana's outfits and those of her chorus dancers are predominantly demure and, apart from modest midriffs (similar to sari midriffs), their bodies are effectively covered throughout. Most importantly, song lyrics and selected dialogues – as well as some imagery and narrative tropes – are steeped in poetic metaphors and sentiments of a recognizably Urdu world-view.

In 'Musicking the Other', Gregory Booth (2007: 325) suggests that not only does Hindi cinema orientalize its background music more than its diegetic music and song sequences but also songs may use recognizably 'Indian' music to mediate the emotional impact of the Otherness of non-Indian heroes and heroines, thereby allowing audiences to empathize with them. In the case of Wadia's *Alibaba*, I extend Booth's observation to suggest there are (at least) three registers in play, not only across song sequences, but also dialogue, *mise en scène* and dances. I broadly characterize these as 'international orientalist', 'Urdu Islamicate' and 'Bombay mainstream'. These are not discrete – each has multiple and common influences and, as Kesavan originally argued, the Islamicate cultural ethos 'of Urdu, Awadh and the *tawā'if* have been instrumental in shaping Hindi cinema as a whole' (1994: 255). However, I suggest that songs, dances and dialogues are differently coded, with different emphases, at different points in the film, leading to degrees of 'orientalist' or 'Islamicate' sensibilities rather than discrete idioms.

Marjana's persona varies significantly throughout the film. Her opening dance – performed to Arab spice music on stage in the public marketplace in front of an orientalist, painted backdrop of a crescent moon rising above a date palm – moves the viewer gradually from an orientalist to an Urdu Islamicate world, signified by increasingly poetic song lyrics, while her hybrid Kathak dance follows mainstream Bombay cinema norms. By contrast, when she dances to trick Qasim and his wife into releasing Alibaba, she transforms herself into an archetypal oriental temptress performing for a despotic ruler: with slinky, sinuous hip movements, shin-length harem pants, bare upper arms and a substantially exposed midriff, she gestures menacingly with her dagger and gyrates seductively to cod-oriental music, providing not only orientalist spectacle but also dramatic suspense. But when she and Alibaba declare their love – and when audience empathy for this non-Indian couple is most required – the scene begins with elaborate metaphors of Urdu romantic dialogue but switches abruptly to the jaunty, upbeat, orchestral Bombay film-song described earlier, albeit picturized over the couple romancing on the terrace of an orientalist palace.

The minor characters' songs and dances further push these three registers in different directions. Abboo and Sitara's courtship song and dance adopts a mainstream Bombay-cinema, Indian folk-music idiom, while a 'Novelty Dance' by the Famous Sibaris Trio, performed at a celebration in Qasim's house, is pure orientalist spectacle, effectively an extension of the opulent palace setting. One man and two women – one blonde, both clad in full skirts and harem pants – perform acrobatic dance feats of breathtaking dexterity to westernised cod-oriental music, recalling the so-called oriental dance of that era's cosmopolitan, variety entertainment circuit.[35] Elsewhere, Mustafa the tailor, a gaunt character with central Asian features, speaks and sings within an identifiably Urdu Islamicate register, weaving elaborate poetic metaphors into his dialogues and songs. In a melodious, mournful song *'Kismet fatī huī thī tānke lagā rahe haiṅ'*, he sings of stitching/mending the 'torn fate' of his life, situating himself as a god-fearing, spiritual man, aware of the traps of wealth and materialism, yet ruined by his own very human failings. As a flawed but sympathetic character, he is in many ways the poetic heart of the film.

Overall, the Urdu Islamicate register – as developed within song lyrics and dialogues, as well as narrative flow and certain characters – frames the film. While the orientalist register is evidenced primarily through the cultural mishmash of visual signs and background score, *Alibaba*'s Urdu poetic language and metaphors provide a paratext that locates its oriental fantasy world within an Urdu Islamicate world-view: the film gestures to (and derives from) a set of values that would be recognizable to Indian audiences, whether Hindu or Muslim. In the early sound era, with *Lal-e-Yaman* and *Noor-e-Yaman* (1935), the Wadia brothers had begun to inflect the syncretism of Euro-American and Indian Oriental genre films (and

Urdu-Parsi theatre) with a more distinctive Urdu Islamicate ethos: *Lal-e-Yaman* drew less on Euro-American orientalism than Bose's *Alibaba* had done and more on Urdu-Parsi theatre as well as low-brow Urdu-Persian storytelling forms and cultural ethos (Thomas 2013: 53–91). And while the Wadias' 1954 *Alibaba* shows a greater debt to Hollywood than their *Lal-e-Yaman* twenty years earlier (not least on account of *Chu*'s influence), their *Alibaba* more effectively integrates its orientalist tropes within a recognizable North Indian Islamicate world. To some extent this was pure box-office nounce, essential for widespread appeal across communities in the immediate post-independence years. But it also reflected Jamshed's sincerely held political views on 'Hindu-Muslim unity' as well as his more porous and hybrid vision of the nation than the Congress mainstream espoused (Thomas 2013: 106).

In summary, while all three films are played across different registers, Bose's *Alibaba* operates in a predominantly high-culture orientalist (and barely Islamicate) register whereas, insofar as we can tell without dialogue, Mehboob's film integrates Islamicate motifs within a Euro-American low-culture, orientalist register. By contrast, Wadia's *Alibaba* situates Euro-American orientalist tropes within a recognizable Urdu Islamicate world, thereby forging a new form of the Islamicate Oriental genre for the new Indian nation.

Conclusion

Galland's original 'Story of Alibaba and the Forty Thieves Killed by a Slave Girl' is a tale about serendipity (as is Burton's version): it celebrates the rewards of luck (or divine destiny) combined with brains. The male has luck; the female contributes brains. No mention is made of brawn. The early Alibaba films – both Indian and Hollywood – remained relatively faithful to this vision. Gradually, as we have seen, core elements were transformed. Alongside the move from action, romance and comedy (1927) to musical comedy (1937) to romantic melodrama with comedy interludes (1940) to comedy action (1954), gender relations changed. By 1954, Alibaba himself had become a muscular romantic hero, while Marjana the clever slave-girl was reduced to a dancer who, although brainy enough to save him, needed his protection from a multitude of villains. Moreover, while the 1937 (and 1903) version was told from the slaves' point of view, by 1954 slaves had disappeared from the story.

Secondly, the magical element of Galland's original *Alibaba* – the cave that opens to magic words, thin as this is in comparison with most other *Arabian Nights* tales – had disappeared completely in India by 1940, replaced by a chain-gang of oppressed slaves turning a wheel when the words commanded, thereby accentuating male cruelty and violence within an apparently more logical world and

emphasizing the trope of the oriental despot.[36] It was only with the Soviet-Indian co-production *Adventures of Alibaba and the 40 Thieves* (dirs Latif Faiziyev and Umesh Mehra, 1980) that the slave-wheel disappeared and the magic of the cave returned to the story. A female *djinni*, Sim Sim, the source of Abu Hasan's power, inhabits this film's cave, and her translucent ethereal form, alongside the cave's special effects, décor and lighting, contrive to produce a frightening, otherworldly space (despite its fleeting transformation into a 1970s disco). I have nothing to add to Salazkina's (2010) excellent reading of the film, except to note that the context of earlier Alibaba films with their own inflections of the original story, notably in respect of gender relations, should be acknowledged. Following Wadia's innovations, Dharmendra's 1980 Alibaba is a fighting romantic hero and a good-hearted naïf, and there is a double villain (Abu Hasan is a robber king disguised as the vizier). But the double heroine also returned in 1980, with Marjana (Hema Malini) and Fatima (Zeenat Aman) to some extent reprising Mehboob's (and *Chu*'s) Marjana/Zabba split. While Salazkina argues that this doubling responded to the increased sexual threat towards women and their need for revenge (2010: 85–88), an element of this had been key to those earlier Marjanas too: the spunky slave-girl always used sexualized dance as well as her wits to outmanoeuvre violent and potentially rapacious villains. Since 1980, various Indian film versions have continued to ramp up special effects and magic: in *Alibaba* animations in 2002 and 2012,[37] the concept of the cave's 'password' is fully intelligible to a twenty-first-century audience (and perhaps in a different way no longer magic).

Thirdly, across our three *Alibaba* films we see a shift from the syncretic orientalism – or cultural mishmash – of the Euro-American and Indian silent era films, as exemplified by films such as *Gul-e-Bakavali* (1927) or *Thief of Bagdad* (1926), towards an orientalism framed within an Islamicate register that draws on Urdu literary forms and their world-view.

The so-called Oriental genre distinguished itself from other Islamicate genres by locating its narratives in a nebulous fantasy space outside India. By operating between and interweaving three broadly distinguishable registers (international orientalist, Urdu Islamicate and Bombay mainstream), it had the potential to appear not only international and modern but also, simultaneously, nationalist and traditional, allowing shifting points of audience identification. Compared with the more inward-looking Muslim Socials and frequently nostalgic historical and courtesan films, Oriental fantasy films had flexible appeal. Indian audiences – especially Muslim audiences – could enjoy a fantastical but recognizable world that was neither Hindu dominated nor directly related to their own lives in India, with a narrative about the utopia of a god-fearing society in which divine destiny rules, an Urdu poetic idiom of romantic love triumphs, villains (and vamps) are

ultimately vanquished and immense wealth is there for the taking, even for the poor woodcutter, all set within a tale known to be part of the wider modern world.

'Alibaba' is a slippery story, doing different work in every era. Significantly, despite a voracious appetite for certain modes of fantasy today, interest in 'Alibaba' – and more broadly this kind of Islamicate Oriental film – has waned in the twenty-first century. The last Indian 'Alibaba' film release (dir. Sunil Agnihotri, 2004) sank without trace at the box office. An expensive computer-animation version starring John Abraham and Priyanka Chopra was launched in 2010 but quietly shelved since then.[38] It appears that the story can no longer be twisted to speak to the contemporary geopolitical world, where the phantasm of an exotic, fantastical, Middle Eastern/Arab Islamic society is neither relevant nor viable. Instead the Alibaba name has been grabbed to brand the world's largest retailer, a global Chinese online merchandising giant. The company's CEO chose the name because 'Alibaba is a kind, smart business person, and he helped the village. So […] easy to spell, and globally known'.[39] The magic of Alibaba lives on as an ever-bountiful global business and consumer paradise – and tellingly the clever slave-girl and the thieves on whom the wealth depended have now both been quietly erased from the story.

NOTES

1. For consistency, I use upper case 'O' for the proper noun Orient, to refer to a fantastical imaginary space, and, following Bhaskar and Allen, for 'Oriental genre' but the lower case 'o' for all derivatives, including adjectives and nouns that describe a critical position, as in 'orientalist' and 'orientalism'.

2. *Qiṣṣa-dāstān* (two Persian/Urdu words for 'story') refers to a traditional Persian – and subsequently Urdu/Hindi – narrative genre that evolved out of medieval Persian-Arabic folk forms, usually involving adventurous quests, romantic love and magic 'enchantments' across human and fairy/spirit worlds. Famous *qiṣṣa-dāstān*s include *Hatimtai*, *Char Darvesh*, *Gul-e-Bakavali*, *Gul Sanobar* and *Amir Hamza*. For more details, see Thomas (2013: 33–36).

3. In 2013, I used the term 'Islamicate' to refer to 'stereotyped conventions that construct an exotic fantasy of an historical cultural complex associated with Islam. This bears no necessary relationship to "real" Islamic cultures – nor can one disentangle essentially "Muslim", "Hindu" or any other elements within this'.

4. I use quotation marks to refer to the generic tale ('Alibaba'), no quotation marks to refer to the character by name or the story adjectivally (Alibaba) and italics for the titles of specific versions of these tales (*Alibaba*). As spellings of key character names vary across the printed literature, promotional material and on-screen credits (even in relation to the same film), for consistency I have chosen to use the forms Alibaba, Qasim and Marjana throughout.

5. Horta argues, on the basis of Diab's recently recovered journals, that Diab's contribution to authoring the story was more significant than Galland's as it was he who revised the tale to suit European sensibilities while travelling from Aleppo to Paris with the orientalist adventurer Paul Lucas, in whose Paris apartment Galland met Diab in 1709 (2017: 82–86).

6. The mention of a meal in the cave in Galland's diary notes, but left out of his published version, allows researchers to establish whether versions subsequently circulating in the Maghreb and elsewhere in the Arab world drew upon Galland's text or developed independently. Earlier versions include a speaking tree that tells the magic formula to open the cave, which is, in one variant, owned by a group of *djinni* or, in another, by a band of ogres.

7. I base this whole paragraph on the Lyons' translation of Galland (2008: vol. 1:929–60).

8. For example, in some, Alibaba takes Qasim's widow as his second wife, and in others, he just 'comforts' her; in some, Abu Hasan refuses to eat salt in Alibaba's house, thereby arousing Marjana's suspicions.

9. Pantomime versions appeared in colonial India, for example, E. A. P. Hobday's *Ali Baba up to Date, or, the Bandits of Boileaugunge* played in 1896 at the Gaiety Theatre, Simla.

10. For details of this anecdotal evidence, see Jha (1980: 54–55); Mukherjee (1985: 51–53); and Chattopadhyay (1998: 154–68). Although these accounts are compelling, I have been unable to corroborate any of their dates from newspapers of the day or any other public source.

11. In her autobiography, Sadhona Bose referred to her theatre dances as 'neo-classical ballet' and her film performances as 'film ballet' to differentiate her art form from the disreputable nautch. The name Calcutta Amateur Players allowed 'respectable' upper-class women to perform on stage as the troupe was thereby designated non-professional, as Iyer discusses (2014: 84–90).

12. Other sources suggest different dates, but it has been impossible to corroborate any of them.

13. In Galland's tale, Marjana does not appear until halfway through, while Abdullah plays a distinct but minor role.

14. The 1937 film booklet profiles Marjana extensively, with Alibaba a comparatively minor character, as Iyer also discusses (2014: 85).

15. An image of the stage Abdullah in blackface in *c*.1903 appears in Chattopadhyay (1998: 88–89).

16. Kathryn Hansen, personal communication.

17. The argument in these paragraphs is expanded and contextualized in Thomas (2013: 46–56).

18. I thank Ranita Chatterjee for these observations, as well as for her translation of sections of Chattopadhyay and of Modhu Bose's autobiography. I also thank Adrija Dey who offered additional useful insights.

19. *Varieties Weekly*, 23 February 1934, quoted in Bhaumik (2001: 174).

20. Although the records of the National Film Archive of India claim their print is in Farsi – and the song-booklet and other sources tell us Mehboob made the film in Punjabi and

Hindi – native speakers of none of these three languages can decipher it. The problem may result from a mistake in copying optical sound on this duped print (some sound effects and music *are* audible). I thank Indranil Bhattacharya for his help in accessing and making sense of this film.

21. Greg Booth (2007) offers invaluable technical description of the kinds of musical forms, such as the 'gapped scale' and the use of instruments like oboe and coranglais, that are knowingly used, in Bombay and Hollywood, to create such scores.

22. There is some confusion as to where Wahidan Bai came from: Reuben (1999: 62) and Ahmed (2008: 34) say Lahore but are probably wrong. Other sources suggest she was from Kinari Bazaar, Agra: the 1940 *Times of India* review calls her 'Wahidan the noted songstress from Agra'; her daughter, actress Nimmi, was born in Agra.

23. On Oriental dance and variety entertainment, see Thomas (2013: 48).

24. *Chu*'s success may have influenced Mehboob's – and Sagar's – choice of the Alibaba story, given that Sagar was in serious financial trouble. Moreover, Wong's internationally praised performance may have encouraged the ambitious young Sardar Akhtar to take on this role, so daring for 1940s India.

25. Borrowings include such scenes as Marjana spying on Zabba and Abu Hasan's love tryst; Zabba sending pigeons to alert Abu Hasan; the slave-wheel chain-gang turning the wheel and Zabba's escape from this; the overhead shot of the killing of Qasim in the cave; and more broadly the erasure of any form of magic.

26. Unsurprisingly, this element was absent in Bose's film, as the slaves provided that film's point of view.

27. However, somewhat controversially, in 1943, *filmindia* berated Mehboob for not portraying the Muslim community accurately in *Najma* (Bhaskar and Allen 2009: 66).

28. It might also be argued that the split heroine was influenced as much by the Ashgari/Akbari two-sister paradigm of the best-selling, nineteenth-century Urdu novel *Mirāt ul-'Urūs* as by *Chu*, thereby placing this intervention within an Islamicate framework as well.

29. Mishra (2019: 325) also assumes that Wadia worked from Richard Burton's 1885 translation, although he cannot evidence this. Burton's version does include some small differences of emphasis and plot points from Galland's but not the radical changes that Homi made.

30. All in-text translations are by the author. The verbatim Hindi dialogue is: *Mujhe aurat-ẕāt se nafrat hai.*

31. Jamshed Wadia, Homi's older brother, is credited with 'screen story, scenario, additional dialogues'.

32. *Marjana amīrōn ki maḥfil ki mohtāj nahi [...] kyonki garīb ki iṣmat wo āb-e-ḥayāt hai, jise dekh ke amīrōn ki nigāhẽn akṣar behek jāti haiṅ.* (Lit. 'Marjana is not dependant on performing for the rich because honour/chastity is the elixir of life for the poor which the rich do not understand or miss'.)

33. '*Alibaba ko ghulāmi se nafrat hai, woh sab ko āzād dekhnā chahta hai. Tum āzād ho, chali jao.*'

34. '*Maḥal maiṅ rehne wālā badā nahi kehlātā, badā ādmi toh wohī hotā hai jo kisī ke dil maiṅ apnā ghar basā letā hai.*'

35. As Joan Erdman pointed out, 'In India [...] oriental dance meant dance from Europe' (1996: 289).

36. However, magic did not disappear in Wadia's other successful fantasy films of the 1950s such as *Hatimtai* (1956) and *Aladdin* (1952), where special effects were key.

37. The 2002 film, directed by Usha Ganesarajah, was produced by a South Indian computer effects company. The 2012 film, a children's short distributed by Shemaroo on YouTube, gives no credits.

38. Aladdin has had more longevity – in India and the United States. Even Disney has not made an Alibaba since the 1960s.

39. Jack Ma in interview quoted on Wordlab, 15 October 2007: https://www.wordlab.com/blog/2007/10/where-did-alibaba-the-brand-name-come-from/. Accessed 22 August 2019.

REFERENCES

Ahmed, Rauf (2008), *Mehboob Khan: The Romance of History*, New Delhi: Wisdom Tree.

Bhaskar, Ira and Allen, Richard (2009), *Islamicate Cultures of Bombay Cinema*, New Delhi: Tulika.

Bhaumik, Kaushik (2001), *The Emergence of the Bombay Film Industry, 1913–36*, D.Phil. thesis, Oxford: University of Oxford.

Booth, Gregory D. (2007), 'Musicking the Other: Orientalism in the Hindi cinema', in M. Clayton and B. Zon (eds), *Music and Orientalism in the British Empire 1780s–1940s: Portrayal of the East*, Aldershot: Ashgate, pp. 315–38.

Bose, Madhu (1967), *Aamar Jeeban*, Calcutta: Bak Sahitya.

Chattopadhyay, Sajal (1998), *Aar Rekho Na Andhare*, Calcutta: Jogomaya Prakashani.

Chraïbi, Aboubakr (2007), 'Galland's "Ali Baba" and other Arabic versions', in U. Marzolph (ed.), *The Arabian Nights in Transnational Perspective*, Detroit, MI: Wayne State University Press, pp. 3–15.

Erdman, Joan L. (1996), 'Dance discourses: Rethinking the history of the "Oriental Dance"', in G. Morris (ed.), *Moving Words: Rewriting Dance*, London: Routledge, pp. 288–305.

Farrell, Gerry (1993), 'The early days of the gramophone industry in India', *British Journal of Ethnomusicology*, 2, pp. 31–53.

Gupt, Somnath ([1981] 2005), *The Parsi Theatre: Its Origins and Development*, (trans. and ed. K. Hansen), New Delhi: Seagull Books.

Hobday, Edmund A. P. (1896), *Ali Baba up to Date, or, the Bandits of Boileaugunge*, Simla: Simla Times Press.

Horta, Paul Lemos (2017), *Marvellous Thieves: Secret Authors of the Arabian Nights*, Cambridge, MA, and London: Harvard University Press.

Indian Cinematograph Committee (1928), *Indian Cinematograph Committee 1927–8, Evidence,* vol. 1, Calcutta: Government of India Central Publication Branch.

Iyer, Usha (2014), 'Film dance, female stardom, and the production of gender in popular Hindi cinema', Ph.D. thesis, Pittsburgh: University of Pittsburg.

Jha, Bagishwar (1980), 'Profiles of pioneers', *Cinema Vision India,* 1:1, pp. 54–55.

Kesavan, Mukul (1994), 'Urdu, Awadh and the Tawaif: The Islamicate roots of Hindi cinema', in Z. Hasan (ed.), *Forging Identities: Gender, Communities and the State in India,* Delhi: Kali for Women, pp. 244–57.

Lyons, Malcolm C. and Lyons, Ursula (trans.) (2008), *The Arabian Nights: Tales of 1001 Nights,* 3 vols (intro. R. Irwin), London: Penguin.

Marzolph, Ulrich (ed.) (2006), *Arabian Nights Reader,* Detroit, MI: Wayne State University Press.

Mishra, Vijay (2019), 'Fairy tale in the Bollywood film', in A. Teverson (ed.), *The Fairy Tale World,* London and New York: Routledge, pp. 324–34.

Mukherjee, Prabhat (1985), 'Hiralal Sen', in T. M. Ramachandran (ed.), *70 Years of Indian Cinema, 1913–1983,* Bombay: CINEMA India-International, pp. 49–53.

Mukherjee, Sushil Kumar (1982), *The Story of the Calcutta Theatres: 1753–1980,* Calcutta: K.P. Bagchi.

Orr, Bridget (2008), 'Galland, Georgian theatre and the creation of popular orientalism', in S. Makdisi and F. Nussbaum (eds), *The Arabian Nights in Historical Context: Between East and West,* Oxford: Oxford University Press, pp. 103–29.

Rajadhyaksha, Ashish and Willemen, Paul (eds) (1999), *Encyclopaedia of Indian Cinema,* new rev. ed., London: BFI and Oxford University Press.

Reuben, Bunny (1999), *Mehboob, India's De Mille,* New Delhi: Indus.

Salazkina, Masha (2010), 'Soviet-Indian co-productions: Alibaba as political allegory', *Cinema Journal,* 49:4, pp. 71–89.

Thomas, Rosie (2007), '*Miss Frontier Mail*: The film that mistook its star for a train', in M. Narula, S. Sengupta, J. Bagshi and R. Sundaram (eds), *Sarai Reader 07: Frontiers,* Delhi: Centre for the Study of Developing Societies, pp. 294–308.

Thomas, Rosie (2013), *Bombay before Bollywood: Film City Fantasies,* Delhi: Orient BlackSwan.

Times of India (1918), 'Chu Chin Chou [sic]: Arabian Night's tale as play', 13 June, p. 5.

Times of India (1927), 'Current Topics: Indian film industry new Indian film: Ali Baba and the Forty Thieves', 29 November, p. 8.

Times of India (1940), 'Circos "Laxmi" opens at Majestic tomorrow: Premiere of Sagar's "Ali Baba" at Pathe on Saturday', 29 March, p. 8.

Wadia, Jamshed B. H. (1980), 'How *Bagh-e-Misr* came to be produced', unpublished memoirs.

9

The Textual, Musical and Sonic Journey of the *Ghazal* in Bombay Cinema

Shikha Jhingan

This chapter focuses on the *ghazal* as a musical genre of Bombay cinema. The *ghazal* has long been a rich source of romantic material and a vehicle for the expression of heightened emotions (Qureshi 1990). As Peter Manuel points out, the *ghazal* has been a musical as well as a poetic genre in all the regional cultures where it has been found (1988–89: 950), and in the late nineteenth and early twentieth centuries, it became a significant genre of Hindustani music within Indian popular culture. This chapter seeks to outline the emergence of the musical *ghazal* from its origins in the performance spaces of the *mushā'ara* and the *maḥfil*, and its presentation within stage drama, to the modern mass media of the gramophone, radio and cinema, and to explore the forms and functions of the *ghazal* in Bombay cinema.

As a poetic form, the *ghazal* was written by stringing together an 'indeterminate number of couplets', or *shĕ'r*, that follow an AA, BA, CA, DA structure of rhyme, and the *ghazal* demands strict adherence to this schema. Furthermore, each couplet in the *ghazal* is meant to be an independent entity to present a 'self-sufficient discrete thought' (Manuel 1988–89: 94). The norms that govern its prosodic meter, and in particular the emphasis on the end rhyme (*radīf*) and the words preceding the end rhyme (*qāfiya*) lend a certain cadence and musical quality to the *ghazal*. It is accepted by poets that the restrictions imposed on them for writing a *ghazal* are an incentive to foster a richness in the form and an appreciative reading and listening public.

The *ghazal* has been seen as being 'at once lyrical, metaphoric and reflective', in which the same lines of a *ghazal* can 'simultaneously articulate emotional, erotic and philosophical-spiritual themes' (Bhaskar and Allen 2009: 14). Drawing attention to its roots in the Perso-Arabic poetry tradition, Francesca Orsini has suggested that love is a central organizing theme in the *ghazal* (2007: 14). Even though

its status as a literary genre cannot be denied, the *ghazal* essentially flourished as an oral and aural form in *mushā'ara*s, a gathering of poets and literary aficionados that allowed poets to interact with a live audience. According to Ralph Russell, the *ghazal* was 'composed to be recited by the poet and only later to be read' and the poet was expected to win his audience with his talent at oratory and performance (1969: 119–20). Given the emphasis on the oratory and performance skills of poets, one can imagine *mushā'ara*s as sensate, sonorous spaces drawing into their folds editors and publishers, amateur poets and lovers of poetry. These 'literary and social gatherings in the public domain' where the *ghazal* was read were, according to Bhaskar and Allen, predominantly male spaces, 'though women had their own version of the mushaira' (2009: 14). Further, biographical and autobiographical accounts have described the *kothā*s of courtesans in the late nineteenth and early twentieth centuries as important spatial venues for *mahfil*s and *mujrā*s that enabled the circulation of Urdu poetry (Sampath 2010: 39).[1] Equally important sites for the proliferation of the *ghazal* were performative spaces such as the Parsi theatre that included live performances of the genre.

These networks, I would like to suggest, underwent major transformations with the coming of the gramophone with music playing a central role in these affective transactions. In his Ph.D. dissertation focusing on the intermedial relations of 'Hindi' cinema, Ravikant (2016) has insightfully pointed out the 'cross-over' of different entertainment forms between print media, gramophone recordings, live performances, Parsi theatre, cinema and the radio. In the case of the *ghazal*, the flow between oral, auditory and musical performance was harnessed by sound reproduction technologies. As the *ghazal* started circulating as a musical genre through gramophone recordings and the radio, it is inevitable that it also found its way into the cinema of the 1930 and the 1940s. These flows were enabled by the heady combination of the textual, musical, performative and sonorous quality of the *ghazal* that relied significantly on a mutually inclusive relationship between reciting, listening and singing. For instance, in Chaudhary Zia Imam's biography of Naushad Ali, we get an account of Naushad spending his evening hours at a *pān* shop located at Ameenabad Chowk in Lucknow (2008: 58). Owned by a certain Naeem Sahib, who wrote and appreciated Urdu poetry, the *pān* shop attracted several poets, and it is here that Naushad is known to have met Behzad Lakhnavi. These networks moved to other locations, spilling into new geographies. The city of Bombay with a thriving film industry attracted several poets, musicians, singers and writers who not only found work there but also reframed these networks in new contexts. In Bombay, Naushad describes his *mahfil*s with poets like Shakeel Badayuni, Khumar Barabankvi, Nakshab Jaravchi and Z. A. Bhukhari in the decade of the 1940s, while he was still struggling to find a firm foothold in the industry. The presence of a music composer amongst some of the top Urdu

THE TEXTUAL, MUSICAL AND SONIC JOURNEY OF THE *GHAZAL*

lyricists and poets itself points to the idea that music played a crucial role in creating a wider sensibility for the *ghazal*. Similarly, Manto has given an interesting account of Rafiq Ghaznavi, who used to hang out with his bohemian friends in Amritsar to sing *ṭhumrī*, *dādrā* and *ṭappā* and recite poetry.[2] Ghaznavi moved to Bombay and worked as a music director with leading film producers of the industry, including Mehboob Khan in the decade of the 1940s.

I am interested in elaborating on this genealogy and in locating the *ghazal* as a musical genre that was amplified through the sound of the gramophone and the radio before finally achieving a firm footing as a musical genre in cinema. Mobilizing biographical information about three artistes, namely K. L. Saigal, Begum Akhtar and Talat Mahmood, blog discussions and textual analyses of song sequences, I ask what textual, musical and stylistic mediations took place when the *ghazal* was incorporated into cinema as a film song. Drawing on its recitational and aural form, I attend to the sensory registers of the *ghazal* in cinema through the figure of the listener, both within the diegetic and the extra-cinematic context. In the last section, I focus on the presentation of the *ghazal* in cinema through two distinct styles to highlight the way the sonic elements become accentuated through the visual coding of the camera, in particular, the point-of-view shots that amplify the acoustic transfers between the star performer and the on-screen listeners.

The *ghazal* and the gramophone era

With the arrival of recording technology, the *ghazal* as a literary and performative genre found its way to gramophone records amplifying its presence in the aural domain. The first list of recordings in London in 1899, described as the *10000 series*, included recitation of poems by Ḥāfiẓ of Shiraz in Persian and verses by Ghālib and Zaheer Fairabi in both Urdu and Persian (Kinnear 1994). In the first recording expedition undertaken by Gaisberg, the earliest recorded *ghazal* is credited to Hari Moti and Miss Susheela, who also recorded a few *dādrā*s in the same series. In this phase, women artists known as *bā'ījī*s or courtesans entertained their patrons in private *maḥfil*s (concerts) recorded for the gramophone industry. Well-known actors and singers like Angūrbālā, who performed for the theatre, also sang for the gramophone companies. Scholars like Shweta Sachdev (in this volume) have noted that many of these courtesans were well versed in Urdu poetry and known for their skill in poetry writing. In several towns and big cities there was a fluid exchange of resources, talent and repertoire between the *koṭhā*s (the salons of courtesans), urban theatre and the recording industry. Musical dramas have also been acknowledged as another important resource for the recording industry. The mobility of artists, music composers and poets between different performance

231

traditions played an important role in the fashioning of music genres that were made available to listeners through commercial recordings. The new medium of sound cinema drew from this repertoire and pool of resources.

But how did the *ghazal* get a distinct identity as a genre in the recording industry? One has to be a bit cautious here since the *ghazal* in its musical form presented in the early recordings seems to be part of the artistes' larger repertoire that included the North Indian style of classical and light classical music genres like the *ṭhumrī, dādrā, ṭappā, khayāl, tarāna, qawwālī* and *bhajan*.[3] If we look carefully at the disc records of the early period, it becomes evident that the gramophone industry preferred to work with individual singing artistes, encouraging them to present their repertoire in diverse genres. Gauhar Jān, Jānkī Bāi, Zohrā Begum, Kālī Jān, 'Ināyat Khān Paṭhān, Azīz Jān, Asgharī Jān, Kamlā Jhariā, Angūrbālā, Indubālā and Miss Dulārī are some of the singers whose *ghazal*s became popular through gramophone records in the first two decades of recorded music in India. Another notable fact is that most of these discs in early recordings do not mention the name of the poet whose work has been performed. For instance, the list of 12" recordings of Gauhar Jan includes the following *shě'r* by Ghālib but without mentioning his name (Sampath 2010: 247):

Yěh na thi hamārī qismat, ke wiṣāl-ě-yār hotā.

('It was not in my destiny that my love be consummated in this lifetime.')[4]

According to Peter Manuel, the *ghazal*'s metre combined with its 'refined, flowery diction', its 'amatory content' and 'refrain-like end-rhymes' lends itself well to the musical form (1988–89: 95). Music in the recorded *ghazal*, according to Regula Qureshi, was meant to 'serve the poetic text structurally and acoustically in terms of enunciation' (1990: 489). In his vocal introduction to *Ghazal ka Safar*, a ten-cassette series brought out by HMV in the early 1990s, Gulzar emphasizes that it was through *sāz* (music) that the *ghazal* could make its journey from the published world to the recorded format.[5] One of the key differences, as noted by Manuel, between a recorded *ghazal* and one performed in a musical *maḥfil* is the improvisational nature of the latter (1988–89: 106). The development of a less improvised form of the recorded *ghazal* has to be seen in the context of the technological and material limitations of the commercial recording format. Singers who were used to singing a khayāl bandish over several hours were now expected to sing in about 3 minutes. The limitation of time to 3 minutes and 20 seconds in 78 rpm records meant a considerable curtailment of musical improvisations, and a 'battering and levelling' of singing to a uniform level (Chandavarkar 1980: 71). In the case of the *ghazal*, this meant that only selected couplets from a poet's work could be included in the recorded format. It is

through this process of inclusion and exclusion that a popular form of the *ghazal* emerged that could be easily accessible to an expanding listenership.

The decade of the 1930s saw tumultuous changes in cinema with the arrival of sound. At the same time, it is in the 1930s that the *ghazal* emerged as an important musical genre for dispersal through gramophone records, cinema and the radio. The city of Calcutta, which had a thriving recording industry, musical dramas and cinema, attracted artists like K. L. Saigal, Jaddan Bai and Talat Mahmood to perform the *ghazal* at the cusp of these intermedial forms. The talented composers of New Theatres developed a distinct style by moulding light classical music genres like the *ghazal* and the *ṭhumrī* into songs that allowed the lyrics to be clearly enunciated with a lot of emotion. Bhaskar Chandavarkar has identified this as a 'Brahmo-Bengali' trend of music that had also been harnessed by the urban-based theatre companies of Calcutta (1987:11). It is during this period that more naturalized presentations of light classical genres, such as *Rabindra Sangeet*, *ṭhumrī*, *bhajan*, *kirtan* and the *ghazal*, were performed and recorded by artists like K. L. Saigal, K. C. Dey and Pahari Sanyal, under the baton of composers like R. C. Boral, Kamal Das Gupta and Pankaj Mullick.

K. L. Saigal is considered to be a pioneer in bringing forth a form of singing with a unique blend of poetry and music. His recorded voice in the genre of the *ghazal* was available to listeners in private albums of gramophone records, that is, in non-film recordings of artistes solicited by music company managers, and one can speculate that this mediated voice was also accessible on the radio. Later, Saigal sang several *ghazal*s for films. Insights from K. L. Saigal's biography can help us better understand the networks of media technologies that formed a subterranean layer on which new aesthetics emerged. Interestingly, there are several versions, scattered across disparate biographical accounts, which narrate how Saigal got his debut role as a singer-actor in New Theatres of Calcutta in the film *Mohabbat ke Aansoo* ('Tears of love', 1932), directed by Premankur Atorthy. In one version, Saigal was discovered at a Calcutta radio station in 1931 singing a *ghazal* for an audition, while other versions describe him being spotted while humming at a *pān* shop at the Esplanade, or in yet another variation, in front of the Metro Cinema. Another account describes how Saigal impressed the producers of New Theatres while singing at a private *maḥfil* to mark the betrothal ceremony of a film distributor (Dutt 2007; Nevile 2011). Rather than deciding which account is true, my intention is to signpost the networks and spatial topographies that enabled artists, talent scouts and music composers to form affective alliances that helped in the fashioning of new emergent forms through mediated technologies. Each account evokes aural and visual perceptions of an event where technologies and social imaginaries came together to create sonic resonances. Each account evokes the desire to hold on to the voice, to record it lest it slips away. It is important then to note the mediated

context of this auditory charge: an aural awakening set in motion by the prolific presence of media technologies like the gramophone, the radio and the cinema.

In 1933, New Theatres released Atorthy's *Yahudi ki Ladki* ('The Jew's daughter') featuring <u>Gh</u>ālib's '*Nuktā čiṅ hai gham-ĕ-dil*' ('She is so critical that I cannot share my despair') sung by K. L. Saigal, which set the tone for the *ghazal* to emerge as a popular genre in cinema. According to Raghava Menon:

> The technique of singing *ghazal*s the way Saigal first sang them could be said to be his own innovation [...] And if <u>Gh</u>alib had heard him sing, for example, the tightly traversing *ghazal*, *Nuqta chi hai gham-e-dil* he would have exulted to know how deeply and directly without meditation, Saigal was giving form and content to the meaning of his words. The musical content of Saigal's *ghazal* lay low like a flame under the kettle of boiling water. It was the bubbling of the text with the pain and understanding of its composer that made you realize that there was the flame of tune underneath the poignant march of exquisite meters.
>
> (1989: 112–13)

It was this particular style of singing underlining the expressivity of the lyrics that made Saigal a key figure in popularizing the *ghazal*. Even after joining New Theatres, Saigal continued to sing *ghazal*s, many of which were recorded and sold as non-film albums by Hindustan Records.[6] What is important to note is that by choosing to sing *ghazal*s penned by few selected poets like <u>Gh</u>alib and Seemab Akbarabadi, Saigal laid the ground for a unique partnership between a singer and a poet. As Pran Nevile writes:

> Saigalwas the first artist to sing <u>Gh</u>ālib in a way that appealed to the masses, thus contributing towards the poet's fame and popularity even with people who were not well versed with Urdu [...] Saigal's choice of Ghalib's poetry was most striking and it was this selection which was taken up in *Mirza Ghalib*, produced in 1954, by Sohrab Modi.
>
> (2011: 52–53).

The popularity of Saigal's private albums of *ghazal*s created a new force-field of musicality in the aural domain, drawing listeners and amateur singers to adopt Saigal's crooning style. The gramophone industry's insatiable desire for content spurred a new line-up of talent in order to impress connoisseurs who patronized artistes to perform for them in private *maḥfil*s. By inscribing <u>Gh</u>ālib's poetry in a recorded format, in his own imitable style, Saigal played an important role in creating a new community of listeners for the *ghazal* (Figure 9.1). His greater emphasis on the poetic text together with his foregrounding the identity of the poet

THE TEXTUAL, MUSICAL AND SONIC JOURNEY OF THE *GHAZAL*

FIGURE 9.1: Record cover of HMV-ECLP 2640. By singing in his unique expressive style, K. L. Saigal helped build a new community of listeners for the *ghazal*. The image in the centre of this gramophone record is from *Yahudi ki Ladki* (1933) for which Saigal sang Ghālib's '*Nuktā čīṅ hai ghām-ĕ-dil*'.
Courtesy: Author's personal collection.

whose literary works were selected for gramophone records enabled the *ghazal* to be recognized, remembered and repeated. Furthermore, the form of the *ghazal* was carefully streamlined: to bring out a *ghazal* confined to about 3 minutes as a gramophone record involved a considerable amount of selection and exclusion of passages from the published/original version. Perhaps it is due to this disciplining of the *ghazal* song in 3 minutes 20 seconds that K. L. Saigal's voice could reach the listeners of Radio Ceylon at 7 hours and 57 minutes every morning. For films, couplets were handpicked that used simple Urdu but could also match the narrative demands of the film. The text of the *ghazal* thus kept shifting as it circulated through oral, printed and aural forms to claim diverse audiences.

Imbued with romanticism and a richness of expression, Ghālib's *ghazals* found a new outlet in cinema. However, journalists and poetry aficionados complained

that original texts were tweaked to meet the demands of the film song. In an article in *Filmfare*, Chitradoot quibbled that Imperial's *Anarkali* (1935) 'committed an anachronism' by using Ghālib's *ghazal*, which he wrote a few hundred years after *Anarkali* (1969: 42). There were other ways, too, in which Ghālib's poetry was made amenable for film songs. A discussion on a popular blog on social media drew my attention to an interesting instance of a well-known couplet of Ghālib's, cleverly used in a *ghazal* by Waheedan Bai for the film *Thokar* ('The fall', 1939). Though the lyrics of this *ghazal* have been written by P. L. Santoshi, this particular *ghazal* is also credited to Ghālib. The confusion occurs because one of the couplets of the *ghazal* has been borrowed from a well-known *ghazal* by Ghālib:

Unko dekhne se jo ā jāti hai muh par raunaq
Voh samajhte hai ki bīmār ka hāl aćhā hai.

('A mere gaze at her brightens my face
And she thinks that my ailment is over.')

The opening lines of the *ghazal* written by P. L. Santoshi are:

Aćhe īsā ho marīzon ka khayal aćhā hai
Hum mar jāte hai tum kehte ho hāl aćhā hai.

('You call yourself a messiah, concerned for the sick
But I am dying here, and you say I look well.')

Connoisseurs of Urdu poetry on this blog have speculated that Santoshi may have been inspired by Ghālib's *shě'r* since his couplets use a similar rhyme scheme to that of Ghālib's (Atul 2012).[7] But it is equally possible that Santoshi was consciously borrowing a well-known *shě'r* from Ghālib, while carefully striking a balance between words that would be easily accessible and add depth to the song. This involved selecting lines or words that were not only familiar and iterable in the popular imagination but could easily be co-opted as a film song.

Begum Akhtar and the *ghazal*

Equally significant in the 1930s was the emergence of Akhtari Bai from Faizabad, who became one of the most prominent exponents of *ghazal* singing in the second and subsequent phases of recorded music. Her journey from being known as Akhtari to Begum Akhtar carries a history of more than two decades in which

she lent her voice with equal facility to private *maḥfil*s, theatre, gramophone companies, the radio and public concerts (Figure 9.2). Akhtari maintained a distinct identity by retaining the improvisatory form of *ghazal gayakī* (singing style), with its roots in a vigorous training in light classical music. While the *maḥfil*s of Awadh sustained Akhtari's musical passion and practice, it was her move to Calcutta that paved the way for her voice to reach out to a much bigger platform. Akhtari made several recordings under a contract with Megaphone records, including one of her most popular *ghazal*s written by Behzad Lakhnavi:

> *Dīwānā banānā hai toh dīwānā banā de.*

> ('If you want to drive me insane [in pursuit of your love], please do so.')

During this prolific phase, Akhtari was also performing for films, theatre and live *maḥfil*s in Lucknow, Calcutta and other centres. In 1942, Akhtari was given a prominent role as a singer-actor in Mehboob Khan's *Roti* ('Bread'). Anil Biswas who composed the music for *Roti* has written that he could not resist the temptation of lifting the 'haunting' tune of '*Dīwānā banānā hai toh dīwānā banā de*', the popular non-film *ghazal* recorded by Akhtari for this *ghazal* for the film:

> *Rehne lagā hai dil men̐ andherā tere ba-gair.*

> ('Darkness pervades my heart without you.')

Written by Arzoo Lakhnavi, this *ghazal* gave Akhtari Bai the opportunity to perform the same tune, now within the film. This indicates the way that music composers were drawing a specific repertoire of tunes from a milieu, while giving listeners a chance to revisit the experience of listening to Akhtari Bai, who was well known for evoking the mood of the *ghazal* in all its nuances (Mehndi 1975).

Though Akhtari has got her due as a legendary singer of *ghazal*s, *ṭhumrī*, *dādrā* and *ṭappā*, I would like to underline her role as a composer of *ghazal*s, which sets her apart as an artiste. According to G. N. Joshi, Akhtari had the 'uncanny knack of choosing the right kind of ghazal and adorning it with a befitting tune' (1984: 69). Apart from composing *ghazal*s by poets like G̱ẖālib, Mīr, Dāg̱ẖ and Momin, Akhtari shared a creative relationship with some of her contemporaries, talented and popular poets of the time including Firaq Gorakhpuri, Hafiz Jallandhari, Behzad Lakhnavi, Jigar Moradabadi and Shakeel Badayuni.[8] In her memoirs on Begum Akhtar, Shanti Hiranand has described the impromptu sessions with poets and music lovers in her hotel room when she travelled to Delhi for her concerts (2005: 140). I have already discussed the *maḥfil*s described by Naushad in the company of poets in the 1940s in Bombay. Begum Akhtar, one can argue, entered a male social and literary space not just as an artiste but also as someone

237

FIGURE 9.2: Begum Akhtar shared a creative relationship with some of the leading poets of her time and popularized the *ghazal* by singing for the radio and at private concerts.
Image courtesy: Sangeet Natak Akademi.

who could be considered a patron. According to Hiranand, Behzad Lakhnavi was her 'court poet' who wrote most of his couplets with her in mind. It was Lakhnavi's '*Dīwānā banānā hai toh dīwānā banā de*' that brought Akhtar into the limelight before she was hired by Mehboob Khan for a role in *Roti*. Another interesting episode, recounted by Hiranand, is the encounter at the Bombay Central Railway Station where Shakeel Badayuni handed over a chit to Akhtar. It was while travelling back from Bombay to Lucknow that Akhtar composed the tune for '*Ai môḥabbat tere añjām pe ronā āyā*' ('Love and its consequences brought me to tears today'), one of her most popular recorded ghazals written by Badayuni. Within a week, Akhtar had sung the *ghazal* on Lucknow Radio (Hiranand 2005: 135).

While a lot of research has focused on B. V. Keskar's broadcast policies and the canonization of music under All India Radio's (AIR) nationalist project of the 1950s, little work is available on the earlier history of AIR. Just as artists and repertoire (A&R) managers of gramophone companies were looking for fresh talent during the 1920s and the 1930s, AIR broadcasting stations became part of new infrastructural networks that created new aesthetics of address. The presence of a radio station in Lucknow in the 1940s, when the colonial administration was broadcasting from only nine cities, shows how radio performance played an important role in anchoring the cultural life of a city that thrived on oral and musical performance traditions based on Urdu poetry. As David Lelyveld notes, the location of AIR's broadcasting stations 'determined the nature of people who were called to the microphone' (1994: 116). Akhtari Bai was one such artist who was persuaded by the station directors of the Lucknow radio station to record her *ṭhumrī*s, *dādrā*s and *ghazal*s. Perhaps, it was radio that provided both anonymity and finally recognition for Akhtari at a time in her career when she felt constrained about singing openly after her marriage to a lawyer from an elite family of Lucknow. It was through AIR recordings that Akhtar established herself as an artiste of merit. In 1951, she was invited to sing at the Shankar Lal festival in Delhi where she was introduced as Begum Akhtar. In her biography on Begum Akhtar, Rita Ganguly writes:

> And now it became a regular practice that once her husband went to court, Begum Saheba would rush to AIR, record her programme and come back before his return. And her frequent interaction with Madan Mohan, a brilliant composer who played on harmonium always reminded her of Wali. She noticed that during those six years, the world of performing arts had altered completely, and all the musicians, poets, playwrights, they were hovering around AIR. And this interface with composers and musicians made her aware of contemporary music.
>
> (2008: 129)

Ganguly's account of the Lucknow radio station, a site that drew together poets, musicians and playwrights, once again points to the way infrastructures and aesthetics get enmeshed with each other (Larkin 2013). Several artistes who worked for the Lucknow station moved to Bombay to showcase their talent in cinema, including Talat Mahmood and Madan Mohan. It is well known that Madan Mohan, often referred to as the '*ghazal* king' of Bombay cinema, met Begum Akhtar while working as a programme assistant at AIR, Lucknow, and formed a 'lasting friendship' with her (Joshi 1984: 70). Another *ghazal* specialist, Roshan, also worked for the Delhi station of AIR for twelve years where he is likely to have met Begum Akhtar who regularly recorded there. Similarly, Shanti Hiranand has written about a *mahfil*-like recording on AIR in which Akhtar and Kaifi Azmi had an impromptu session of reciting verses that Akhtar then composed.[9]

Though Akhtar hardly sang for Hindi commercial films except for her brief stint as a singer-actor in the 1930s and early 1940s and as a playback singer for a few songs in the 1950s, she played an important role in creating a popular listener base for the *ghazal* as a musical genre that helped in consolidating its presence in cinema.[10] Noting the influence of Begum Akhtar's *ghazal*s on Madan Mohan's 'artistic creativity', G. N. Joshi has suggested that many compositions sung by Begum Akhtar were readapted by him for his film tunes (1984: 70). Moreover, several biographical records note the close relationship she shared with poets and music composers of the Bombay film industry. The list includes names such as Kaifi Azmi, Shakeel Badayuni, Madan Mohan and Khayyam.

The playback era and the *ghazal* in Bombay cinema

With playback singing and the role of the lyric writers firmly established, the ghazal entered a new phase in the forties.

(Biswas 1975: n.pag.)

The 1940s heralded the end of the studio era in Indian cinema while Bombay became the most important centre for the industry. The biggest transformation in the domain of film music was the slow eclipse of the era of singer-actors that made way for the playback system. The beginning of the playback era also meant an emphasis on specialization in each department of film music. It was during this phase of specialization that lyricists like Kidar Sharma and D. N. Madhok started gaining importance in the industry. The 1940s was also marked by the emergence of the Progressive Writer's Movement. Urdu poets like Kaifi Azmi, Majrooh Sultanpuri, Sahir Ludhianvi and Jan Nisar Akhtar were some of the luminaries

THE TEXTUAL, MUSICAL AND SONIC JOURNEY OF THE *GHAZAL*

of this movement who became important song writers and brought the *ghazal* to the film industry by reaching out to the listeners in simple, everyday Hindustani.

With the end of the era of singer-actors in Hindi film music in the late 1940s, the industry started relying on a new crop of talented playback singers like Lata Mangeshkar, Mukesh, Mohammed Rafi, Geeta Dutt, Asha Bhosle, Talat Mahmood and Manna Dey. The playback singer spent considerable amount of time rehearsing a song, working on the diction, the expressions, the breathing and the tonal quality that a song demanded (Jhingan 2009). This helped the on-screen star to emphasize the context and the emotion being expressed by the song and its overall appeal to the audience. Thus, the technology of playback contributed significantly to the popularity of stars.

The slow decline of New Theatres in Calcutta had forced artists like Saigal, Anil Biswas and, later, Talat Mahmood to move to Bombay. Born and brought up in Lucknow, Talat Mahmood had benefitted from the culture of the *maḥfils*. Ambrish Mishra (1990) has noted that 'it was Lucknow's culture of *tahẕib* that prodded Mahmood into the world of Urdu poetry, literature and music'. But more importantly, it was by listening to K. L. Saigal's voice on gramophone records and the radio that Mahmood developed his own introspective and subtle style of singing. Mahmood's trajectory followed a somewhat similar path as Saigal's: from singing in private *maḥfils*, he got a chance to sing *ghazal*s for AIR at Lucknow. Finally, it was through his gramophone recordings of *ghazal*s such as '*Tasvīr terī dil merā behlā na sakegī*' ('Your photograph will not be able to amuse my heart'), written by Fayyaz Hashmi, that Mahmood acquired a fan following. He got his break in Bombay when he got a chance to sing '*Ai dil mujhe aisī jagāh le ćal jahāṅ koi nā ho*' ('Take me away to a place where I find no one') for *Arzoo* ('Desire', 1950). Composed by Anil Biswas and written by Majrooh Sultanpuri, the song is a perfect example of how an expressive playback voice could add to the performance of an actor.

In terms of its *mise en scène* and the mood, this *ghazal* was very similar to a *ghazal* sung by Saigal in *Shahjehan* (1946):

Gham diye mustaqil, itnā nāzuk hai dil
Yeh na jānā, hāy hāy yeh zālim zamāna.

('I have been given an abiding grief, my heart is so fragile
No one knows the fragile state of my heart. Oh this world is so cruel!')

Written by Majrooh Sultanpuri and composed by Naushad, songs like '*Gham diye mustaqil*' brought out Saigal's soft crooning style, ably matched by his expressive voice and a deep understanding of the lyrics. In the film, Saigal played the role of a court poet thus allowing Majrooh Sultanpuri and Khumar Barabankvi to

241

FIGURE 9.3: Dilip Kumar performs 'Ai dil mujhe aisī jagāh le ćal' in *Arzoo* (dir. Shaheed Latif, 1950) while lip syncing to Talat Mahmood's expressive voice.

write songs like '*Ćāh barbād karegī humeṅ mālūm na thā*' ('My desire will destroy me, this I did not know') and '*Jab dil hi tūt gayā, hum jī ke kyā kareṅge*' ('When my heart is broken, what use is this living'). In all the three songs mentioned here, we see Saigal as a lone melancholic figure singing to himself, while the camera remains distant, avoiding going too close to his rather stiff body. In contrast, in the song sequences of *Arzoo*, Dilip Kumar performs while lip-syncing to Talat Mahmood's voice where the slight quiver in Mahmood's voice adds to the vulnerability of the protagonist. In the last *antarā* (stanza) of '*Ai dil mujhe aisī jagāh le ćal*', Dilip Kumar, framed in a mid-shot, looks towards the camera inviting the viewer/listener to experience the pain of his vulnerable self (Figure 9.3).

In her work on the *ghazal* as a musical genre, Regula Qureshi (1990) has argued that musical expression helps the singer make a personal connection with the lyrics. Aided by Talat Mahmood's voice, Dilip Kumar's sensitive performance on screen makes the text his own. By the early 1950s, Dilip Kumar was a top-ranking star recognized for his natural style of performance, spontaneity and an impeccable command over the Urdu language, and he thus helped consolidate the musical genre of the *ghazal* in the popular imagination.[11] But as Meghnad Desai has noted, the reviewers of his films also noticed that Dilip Kumar was repeating himself in the role of a tragic figure (2004: 38–39). I would suggest that the film songs that Talat Mahmood sang for Dilip Kumar during these years played an important role in establishing him as a 'tragic hero'.

THE TEXTUAL, MUSICAL AND SONIC JOURNEY OF THE *GHAZAL*

FIGURE 9.4: Record cover of HMV-ECLP 2265. Talat Mehmood popularized the *ghazal* in Hindi films by singing for Dilip Kumar in the 1950s. The slight quiver in Mehmood's voice helped Dilip Kumar to bring out the vulnerability of the protagonist. This dual star alliance had a great fan following across the subcontinent as acknowledged by Mehdi Hassan.
Courtesy: Author's personal collection.

The dual star alliance of Talat and Dilip Kumar and its magnification through the proliferation of their songs on gramophone records and the radio created a ripple effect not only in India but also in the subcontinent (Figure 9.4). It has been acknowledged that while trying to establish himself as a *ghazal* singer, Mehdi Hassan chose to sing two of Talat Mahmood's *ghazal*s at a concert in Rawalpindi, holding the audience 'spellbound' (*The Hindu*, 1991). Both these *ghazal*s had been performed by Dilip Kumar on screen. As Mehdi Hassan has noted:

> It was through the vocals of Talat Saab, that I discovered the gold mine in my throat. It was some time in 1952, when Dilip Kumar was as much the tragedy king to people in India as to us in Pakistan. And Talat Saab those days was the voice of this great lover. These two, Talat and Dilip left a lasting impression on me in my

salad years with '*Ek maiṅ aur ek merī bekasī kī shām hai*, and *Ḥusn wāloṅ ko na dil do, voh mitā dete haiṅ*'.

(1991)[12]

Let us examine the two *ghazal*s mentioned by Hassan.

The *maḥfil*-style *ghazal*

Sung by Talat Mahmood and performed by Dilip Kumar in *Babul* ('Father', 1950), '*Ḥusn wāloṅ ko na dil do*' ('Don't give your heart to these charming beauties') is composed as a simple melody with a minimum use of musical instruments in order to give prominence to the voice and the poetry. The song opens with a short refrain on the harmonium while the camera is focused on Usha (Munawar Sultana) who is the key auditor in the song. The camera frames Dilip Kumar in the foreground with three women sitting as listeners in the background. Through the framing of the characters, the use of gestures and point-of-view shots between the singer and the key listeners, the entire sequence is presented in the style of a *maḥfil*, where listening becomes as performative as singing. The opening line of each couplet is sung in an improvisatory style without the beat of the *ṭabla*. Further, this line is repeated, thus building up the anticipation for the second line of the couplet and the response it generates. The camera stays on Dilip Kumar in the first line of each *antarā*, but his gestures and eye movements underline the presence of the listeners. In certain moments, Dilip Kumar bends forward and extends his hand inviting attention to the play with words. The concluding line of each couplet is timed to further enhance this anticipation, as the on-screen listeners are already aware of the metre and the rhyme scheme. It is in these moments, while teasing out the words, that the camera focuses on Munawar Sultana whom he is addressing in the song. The point-of-view shots are timed to demonstrate dramatically the way the words, the *radīf* and *qāfiya* (the last two words of the second line of each couplet that are double rhymed), become part of the circulation of knowledge amongst the listeners, enhancing the pleasure of this intimate style of performance. This is where the *ghazal* as a musical form works to bring the oral, aural and the cinematic together to animate each other.

In several historical and social films of the 1950s and 1960s set in Islamicate milieus, *mushā'ara*s and *maḥfil*s as performative spaces become the central site for presenting the *ghazal*, allowing the singer-poet to describe and celebrate the various conditions of love from a position that, as Francis Pritchett has pointed out, is 'not narrowly personal' (quoted in Orsini 2007: 18). In *Taj Mahal* (1963), the *mushā'ara* in the Mughal court of Jāhāngīr becomes a transgressive moment for the heroine when she sings '*Jurm-ĕ-ulfat pe humeṅ log sazā dete haiṅ*' ('We get

punished for committing the crime of being in love'). Written by Sahir Ludhianvi, this song is a wonderful example of the way filmic strategies, lyrics and vocal melody are deployed to create a hierarchy amongst listeners. As Mumtaz Mahal (Bina Rai) starts singing, it becomes clear whose authority is being challenged through the lyrics of the *ghazal*. The camera keeps intercutting between Mumtaz Mahal, the singer, and Noorjehan, the key auditor, whose performative gestures highlight her reaction to the concluding line of each couplet. Other notable *mahfil-*style *ghazal*s are: '*Nagmā-o-shě'r kī saugāt kise pesh karūṅ*' ('To whom do I present this gift of poetry' [*Gazal*, 1964]) and '*Hālě dil yuṅ unhe sunāyā gayā*' ('This is how I revealed the state of my heart' [*Jahan Ara*, 1964]). Most of these *mahfil*-style *ghazal*s use simple tunes, a small ensemble of music and short interlude sections allowing the voice and the poetic text to dominate over other elements. In fact, the music in these *ghazal*s is deployed to amplify textual meaning (Qureshi 1990).

Also predominant amongst the *ghazal*s presented on screen were *ta'rīf* songs (in praise of the beloved) where the key addressee is the object of love, such as '*Yeh hawā yeh rāt yeh ćāṅdnī*' ('This breeze in the moonlit night' [*Sangdil*, 'Cold hearted', 1952]) and '*Ćaudvīṅ ka ćāṅd ho*' ('You are the full moon' [*Chaudvin ka Chand*, 'Full moon', 1960]), or songs in which the poet describes the various emotional states that he is going through, such as:

Tujhe kyā sunāūṅ maiṅ dilrubā
Tere sāmne merā hāl hai

('What do I say to you, my beloved
See for yourself the state I am in')

<div align="right">(Akhri Dao, 'Final trick', 1958)</div>

Ai ḥusn zarā jāg tujhe 'ishq bulāye
('Wake up O beautiful one, respond to the call of love')

<div align="right">(Mere Mehboob, 'My love', 1963)</div>

Dil meṅ ek jāně tamannā ne jagāh pāyi hai
('My beloved, a desire has a place in my heart')

<div align="right">(Benazir, 1964)</div>

Móḥabbat hi na jo samjhe voh ẓālim pyār kyā jāne.

('If they do not understand love, how will they know the depth of my adoration.')

<div align="right">(Parchhain, 'Shadow', 1952)</div>

In all these *ghazal*s, the cinematic strategies of shot/reverse-shot editing between the singer and the listeners are mobilized to enhance the sonorous quality of the *ghazal*. Further, the voice, the tune, the extra-diegetic musical elements and the play with the words, with the singer withholding and then enunciating the crucial second line of the couplet, work to create a deeply affective experience.

These *ghazal*s also serve to highlight the transformation of the *ghazal* from the medium of writing to being sung and heard. This transformation yields affective registers by adding to the sonorous quality of the song. This is evident in films like *Gazal*, where Meena Kumari plays the role of a female poetess. In '*Nagmā-o-shě'r kī saugāt kise pesh karūṅ*', the camera frames Meena Kumari sitting with a group of discerning female listeners, some of them even noting down the words of the text (Figure 9.5). Unknown to her, but revealed to the film audience, is the figure of the hero Ejaz (Sunil Dutt), a revolutionary poet who until then had declared his disdain for the *ghazal* but is now struck by the poetry and the voice of the female singer while walking outside her *havelī*. Mesmerized, Ejaz decides to sing a *ghazal* at a *mushā'ara*, cleverly borrowing the same opening couplet so that he can find out the identity of the woman who had sung '*Nǎgmā-o-shě'r kī saugāt*'. Ejaz sings '*Ishq kī garmī-ĕ-jazbāt kise pesh karūṅ*' ('To whom do I present my impassioned love') (Figure 9.6) and receives accolades from his male listeners, while Naaz Ara and her friends call him an upstart plagiarist. But as he continues to sing, we see her getting drawn to his passionate performance and clever play with words (Figure 9.7).

FIGURE 9.5: Meena Kumari as Naaz Ara performs '*Nagmā-o-shě'r kī saugāt kise pesh karūṅ*' at a *Zanānā Maḥfil* in *Gazal* (dir. Ved-Madan, 1964).

THE TEXTUAL, MUSICAL AND SONIC JOURNEY OF THE *GHAZAL*

FIGURE 9.6: Sunil Dutt as Ejaz sings '*Ishq kī garmī-ĕ-jażbāt kise pesh karūṅ*' at a *mushā'ara*, cleverly borrowing Meena Kumari's opening couplet in *Gazal* (dir. Ved-Madan, 1964).

FIGURE 9.7: Despite calling him a plagiarist, Naaz Ara slowly gets drawn to Ejaz's passionate performance as a listener in *Gazal* (dir. Ved-Madan, 1964).

In *Mirza Ghalib* (1954), we hear a fakir singing G͟hālib's *qalām* ('composition') which tickles the poet's curiosity. The fakir then informs him that it is Moti Begum,

a woman passionate about G̱ẖālib's poetry, who has taught him to sing these *g̱ẖazal*s. Moti Begum, played by Suraiya in *Mirza Ghalib*, represents a figure who not only reads and listens to G̱ẖālib's *qalām*s but also composes, sings and performs his work ensuring its wider circulation in the public sphere. In their insightful analysis of *Mirza Ghalib*, Bhaskar and Allen have argued that by focusing on the intense but fictionalized relationship between G̱ẖālib and Moti Begum, the film brings out the expressive quality of the lyrics to articulate the emotional intensities and variations of feeling of the protagonists (2009: 132). By presenting his poetry through eight *g̱ẖazal*s sung by Suraiya, Rafi and Talat Mahmood, Sohrab Modi's film was evoking G̱ẖālib not only as a 'voice of his time' but also as a 'voice that resonated across South Asia far beyond that time' (2009: 131).

Mirza Ghalib allowed listeners to revisit G̱ẖālib's poetry aligned with a fictionalized account of his own life since many of the *g̱ẖazal*s presented in the film had already been in circulation through non-film gramophone recordings by singers like Saigal and Begum Akhtar. I would like to place this in a wider cultural context to highlight the way radio was mobilized in films as a listening device to bring out the poetic and the sonorous registers of the *g̱ẖazal*. While discussing the importance of radio in the narratives of films like *Barsaat ki Raat* (1960), Ravikant has made an important assertion that the 'narrative play of radio' was grounded in the 'tradition of performed poetry' sung live as *g̱ẖazal* and the *qawwālī* in *sufi ḵẖanqa*s, *maḥfil*s and bazaars (2016: 231). I suggest that historical films in particular used inventive strategies to mimic the aural experience of listening to the radio without actually showing the auditory object. In *Babar* (1960), released the same year as *Barsaat ki Raat*, we are made privy to the fluid transformation of the handwritten *g̱ẖazal* into an aurally charged musical performance.[13] The romance between Humāyūn and Hamīdā Bāno is built by the exchange of scrolled letters as poetic messages that get converted into three *g̱ẖazal*s. '*Salāmĕ ḥasrat qubūl kar lo*' ('Please accept my desire-filled salutations') captures the transference from a written letter to musical sound, when Hamīdā Bāno's friend Hijaab starts singing the *g̱ẖazal* written by Humāyūn, while Hamīdā Bāno, the recipient of this letter, listens with rapt attention. This sequence draws from the popularity of radio programmes that invited listeners to send romantic messages with *farmā'ish* ('request') for film songs. Hamīdā Bāno's cold reply reaches Humāyūn as a scroll and turns into a song. As we see the Mughal prince reading the scroll, Bāno's close-up singing the *g̱ẖazal* gets superimposed on the calligraphic text, in sync with Sudha Malhotra's voice on the soundtrack. This is followed by Humāyūn's reply with another scrolled letter which Hijaab leaves in Bāno's chamber. As soon as Bāno picks up the scroll, we hear the *g̱ẖazal* '*Tum ek bār mŏḥabbat ka imtĕḥān to lo*' ('I urge you to test my love at least once') fading up in Mohammed Rafi's soft, sensuous and pleading voice. This sequence evokes the experience of the radio as the camera captures both Bāno and Hijaab (the latter

248

hiding behind the window unknown to Bāno) respond to the auditory charge of the *ghazal*, captivated by its lyrics, musical interludes and Rafi's acousmatic voice.

Another use of the *mahfil*-style *ghazal* is in the film *Lal Quila* (1960), when we see Bahādur Shāh Ẓafar singing '*Na kisī kī āṅkh kā nūr hūṅ*' ('I am not the light of any one's eyes'). Although recent scholarship has established Muzter Khairabadi as the author of this *ghazal* (Akhtar 2005), to bring poignancy to the text, the film draws on the popular belief that this *ghazal* was written by Bahādur Shāh Ẓafar, the last Mughal emperor who was dethroned by the British. With minimal use of extra-diegetic music and a simple melody, Mohammed Rafi's restrained voice haunts the space of the Mughal *darbār* as the emperor sings, while looking help-lessly towards his family members and courtiers. The use of the tracking camera exploring the stunned faces of all those present in the court adds to the emotional registers, drawing us towards the poetic text.

The melancholic *ghazal*

I would like to return to the other kind of *ghazal* mentioned by Mehdi Hassan in his interview, which contrasts with the *mahfil*-style *ghazal*. This is the melancholic *ghazal* that is common in the films of the 1950s and 1960s:

> *Ek maiṅ aur ek merī bekasī kī shām hai.*
>
> ('It's me and my helplessness beside me this evening.')

<div align="right">(Tarana, 'Song', 1951)</div>

This is representative of this second form of *ghazal* in which the lyrics, the musical elements and the *mise en scène* are imbued with the despair of a lost self. In the picturization of this *ghazal*, Dilip Kumar, a lone figure, is framed with a distant camera, accentuating his despair. The song begins just after a very dramatic and tragic sequence in which Tarana (played by Madhubala), the woman whom Moti (Dilip Kumar) loves but cannot marry, is attacked by her father for bringing dis-honour to the family. Falsely informed that his daughter is going to have a child out of wedlock, the enraged father locks Tarana in their home and burns it down with her inside until, too late, he discovers the lie and rushes in to save her. The extended depiction of the torched house with the cries of the father ultimately ends with his death. We are led to believe that Tarana is dead as well. It is at this stage that the camera cuts to a different location, and the song begins with a *dohā* (couplet) or an opening verse in Talat Mahmood's voice without musical accompaniment:

Jali jo sākh-ĕ-ćaman, sāth bāg-bān bhi jalā
Jalāke mere nisheman, voh āsmān bhi jalā.

('As the branch in the garden burnt, the gardener burnt as well
Having burnt my home, the sky burnt as well.')

(*Tarana* 1951)

The use of the *dohā* is a sudden aural intrusion, a cry or *pukār*, before the melody is introduced. It works to articulate the agony of the present moment, in a direct address to the audience, expressing a deep sense of loss.[14] One can recall here Ravi Vasudevan's formulation of musical sequences built on the exploration of narrative blockages through songs performed at a larger public setting (2010: 43). Most of the *ghazal*s in this melancholic style preceded by a *dohā* were presented on screen by isolated figures unmediated by on-screen listeners. Furthermore, the camera in these *ghazal*s remains distant. Dilip Kumar is framed here as a lonesome figure, completely alienated from the world around him. Talat Mahmood's soft and quivering voice over Dilip Kumar's subtle gestures and facial expressions depicted through high-contrast lighting with deep shadows adds to the appeal of this song about the loss of love and a sense of deep despondency. The recurring issues explored in these narratives are about the pressures of patriarchal norms, class distinctions, social hierarchies and the moral ambiguities they give rise to. But the poetic texts never describe these issues or the events related to them directly. Instead, the lyrics bring out a general sense of loss and despair as a result of these events (Ahmad 1995: xxiv).

The use of the *dohā* as an aural intrusion, a rupture, becomes an important stylistic feature in this *ghazal*. Further, the *dohā* became an important strategy for music directors to mediate between the *ghazal* as a musical genre and the film song. Another *ghazal* sung by Talat Mahmood for Dilip Kumar that opens with a *dohā* is:

Hum dard ke mārŏn kā.

('Those of us afflicted by pain.')

(*Daag*, 'The stain', 1952)

Here again Mahmood's soft crooning style allows the words to dominate. Composed with simple hummable tunes, these *ghazal*s are not meant to showcase the singer's virtuosity or skill with words but to foreground the dark, inner landscape of the protagonist. It is also important to note the western orchestration for these songs. Naushad, Anil Biswas and Shankar Jaikishan used the piano, the piano accordion, guitar, violin and the mandolin to bring out more tonal variations. '*Hum dard ke mārŏn kā*' opens with a *dohā*, an agonizing lament:

THE TEXTUAL, MUSICAL AND SONIC JOURNEY OF THE *GHAZAL*

> *Bujh gaye g͟ham kī hawā se pyār ke jalte ćirāg*
> *Be-wafāī ćāṅd ne kī paḍ gayā usme bhī dāg͟.*

> ('The storm of despair has extinguished the lamps of love
> Now the faithless moon too is blemished.')

As is evident in these lyrics, a recurring trope in these *ghazal*s is the way the loss of love or the denial of love is described through the metaphors of arson, of the burning of homes, bodies and selves. For example,

> *Zindā hūṅ is tarāh ke gamĕ zindagī nahī*

> ('I am alive but this sad life cannot be called living')

sung by Mukesh in *Aag* ('Fire', 1948) has the second line of the couplet which describes the self as burning without any light:

> *Jaltā huā dīyā hūṅ magar raushnī nahī.*

> ('I burn like a lamp which brings no light.')

'*Chaudhvin ka Chand*', a *ghazal* and the title song sung by Mohammed Rafi for the eponymous film (1960), also describes the feeling of love that has been singed:

> *Milī k͟hāk meṅ móḥabbat, jalā dil kā āshiyānā.*

> ('My love has turned to ashes, my heart's home burnt as well.')

In the late 1950s and the 1960s, when Dilip Kumar's partnership with Talat Mahmood came to an end, it was Mohammed Rafi who became the prominent playback voice for the star. Rafi sang *ghazal*s like the following for Dilip Kumar in a more dramatic style of vocal performance:

> *Tūte hue khwāboṅ ne hum ko yeh sikhāyā hai*

> ('My shattered dreams have taught me')

> > > *(Madhumati*, 1958)

and

> *Guzare haiṅ āj 'ishq meṅ hum us maqām se,*
> *Nafrat si ho gayī hai, móḥabbat ke nām se.*

('I have passed through that stage of passion,
that the very name of love evokes hatred in me.')

(*Dil Diya Dard Liya*, 'I gave my heart and took your pain', 1966)

In all these *ghazal*s, the anguish expressed by Dilip Kumar resonates in the desolate landscape.

In a recent work, Ira Bhaskar has drawn attention to Indian cinema's encounter with German expressionism during the 1930s and 1940s that had a particular effect on its visual and aural aesthetics resulting 'in the stylized orchestration of emotion that characterizes the Indian melodramatic form' (2018: 253). For Bhaskar, the song is central to Indian cinema's expressionist aesthetic form that draws from a variety of mythic and poetic traditions. In the melancholic *ghazal*s discussed earlier we see an overriding use of this aesthetic style: the lonesome singer, the use of dramatic lighting creating silhouettes or deep shadows that all point towards the formation of an aesthetic style that complements the repetitive use of words like _khatm_ (end), _mātam_ (mourning), _gham_ (grief), *bekasī* (helplessness), *tanhā'ī* (loneliness), *barbādī* (destruction) that work like signifiers, expressing the despair of a dislocated self.

In her work on *viraha* (a condition and mood of love in separation), Kumkum Sangari has examined the way love has been represented through diverse repertoires and intermedial forms, including the oral, textual, musical, theatrical and the cinematic. Sangari notes the way the early forms of *viraha*, such as in *bhakti* and *sufi* poetry, tales of medieval romances and the repertoires of *ṭhumrī* and *ghazal* entered cinema, giving voice to diverse registers of romance, separation and devotion (2011: 266). Mapping the trajectory of *viraha* in a broader context, Sangari foregrounds its multiple registers that could 'enfold new antinomies and speak to the violent coupling of partition and independence' (2011: 276). The continuous and repetitive evocations of despair and the loss of love, self and home in the *ghazal*s of the 1950s may be evoking personal and public losses on a larger cultural-historical scale. In that sense, Mehdi Hassan's account of having found his voice through Talat Mahmood's ghazals not only acknowledges his attraction for both Talat and Dilip Kumar but also indicates the technologies of the gramophone, the radio and the cinema that enabled both the dispersals of these *ghazal*s and shared histories and the registers of loss and despair. These anecdotes thus work as clues that give us a larger picture of the intersecting histories of loss, longing and an abstract sense of incompleteness.

The music composers of Bombay cinema worked in close partnership with poets and lyricists to create space for the *ghazal* as a musical genre for female protagonists. Prominent amongst these as discussed earlier was Madan Mohan, who composed several *ghazal*s sung by Lata Mangeshkar that were imbued with feelings of longing and despair and were filmed on lone female figures. These include:

Hum pyār meṅ jalne wāloṅ ko

('We who get singed in love')

<div align="right">(Jailor 1958)</div>

Hamāre bād ab maḥfil meṅ afsāne bayāṅ hoṅge

('After we are gone, this very gathering will talk about us')

<div align="right">(Baaghi, 'Rebel', 1953)</div>

Na tum bewafā ho na hum bewafā haiṅ

('Neither you nor I are faithless in love')

<div align="right">(Ek Kali Muskayi, 'The bud has smiled', 1968)</div>

and

Ruke ruke kadam ruk ke bār bār ćale.

('My faltering steps, faltered but moved again.')

<div align="right">(Mausam, 'Season', 1975)</div>

Furthermore, the *maḥfil*-style *ghazal* composed by Madan Mohan in courtesan films became an important site for fashioning a morally acceptable representation of the fallen woman. In these *ghazals*, we can hear the traces of Begum Akhtar's dramatic style of presentation with an emphasis on the lyrics as well as the slow tempo which allowed the singer space for improvisation. This improvisatory style can especially be noticed in

Rasmĕ ulfat ko nibhāyeṅ toh nibhāyeṅ kaise

('How do I follow the rules of love')

<div align="right">(Dil ki Rahen, 'Pledge of love', 1973)</div>

and

Āj soćā toh āṅsū bhar āye,
Muddateṅ ho gayī muskurāye.

('Tears welled up in my eyes today as I thought of you,
It has been ages since I smiled.')

<div align="right">(Hanste Zakhm, 'Smiling wounds', 1973)</div>

At the same time, by choosing to invite Lata Mangeshkar to sing these *ghazals*, Madan Mohan helped in distancing the genre from the influence of the *koṭhā*. As

I have argued elsewhere, by raising the pitch of her voice, Lata Mangeshkar had established herself as an antidote to the 'open-throated' style of singing that was associated with the *koṭhā* (Jhingan 2016: 219). Thus, the moral and class identities of singers in the film industry were evaluated through the acoustical properties of their voice. This particular form of the *ghazal* enabled female protagonists to articulate inner narratives of desire, failed alliances, betrayals and feelings of entrapment. Notably in these sequences, the lyrics and the music come together to draw attention to the key auditors on screen. *Ghazal*s such as:

> *Na haṅso hum pe, zamāne ke hai thukrāye hue*
>
> ('Don't mock at us, we have been cast aside by this world')
>
> <div align="right">(Gateway of India, 1957),</div>
>
> *Voh ćup raheṅ toh mere dil ke dāg jalte hai*
>
> ('Silence of my beloved singes my heart')
>
> <div align="right">(Jahan Ara, 1964)</div>

and others composed by Madan Mohan are all *ghazal*s performed by courtesans to sing and entertain men as patrons.

The *ghazal*s in *Adalat* (1958), in which Nargis plays the role of a middle-class woman who gets trapped in a *koṭhā*, illustrate how, when the melancholy *ghazal* enters the arena of the *maḥfil*, the significance of that performance space is transformed. The elaborate setting includes the presence of Nirmal (played by Nargis), seated in a *baithakī maḥfil* along with the accompanying musicians, prominently placed, playing the *sāraṅgī*, the harmonium and the *ṭabla*. The key element is the presence of the listeners who look at the figure of the courtesan as an object of desire. However, the *maḥfil* form is muted through the denial of the returned look by the heroine, thus arresting the flow of glances. '*Yuṅ hasratoṅ ke dāg, mōḥabbat meṅ dho diye*' ('All the stain of my desires melted away in loving you') is performed by a young Nirmal (in Mangeshkar's voice) who refuses to make eye contact with any of her listeners. This makes Nirmal a forlorn tragic figure, despite the fact that she is singing in a *maḥfil*. The mood of the *ghazal* is heightened by the use of an elaborate high-pitched string section that becomes prominent in the interlude. The lyrics of the *ghazal* work towards the expression of emotions, foregrounding the despair and the sense of entrapment felt by Nirmal that has already been elaborated in the film's narrative. The sequence thus subtly creates a distinction between the off-screen listeners/spectators who have been privy to the tragic life and the on-screen listeners in the *koṭhā* who are not invited to be part of this flow of knowledge.

By mobilizing biographical material on prominent *ghazal* singers along with an analysis of *ghazal* recordings as a musical genre, I have tried to demonstrate

the way textual, oral and aural materialities animated each other to bring to the listeners the robust form of the *ghazal*. Media technologies such as the gramophone and the radio brought poets, musicians and singers in a productive relationship with each other. Sound cinema further expanded these networks to foreground the auditory charge of the *ghazal*. I have discussed two distinct ways in which the musical *ghazal* was presented in the films of the 1950s and 1960s. The first was the *mahfil*-style *ghazal* which attached greater importance to the poetic text and the way it was received by a specific discerning on-screen listener. Deeply invested in the expressive registers of romantic love, the *ghazal* was presented in films through the affective charge of the singing voice, amplified by the exchange of looks between the singer and the listener. The second kind of *ghazal* directly addressed the spectators and articulated deep despair and the vulnerability of lonesome figures, framed against desolate spaces. In the case of the heroine as a courtesan figure, the sonorous space of the *mahfil* is invoked but the heroine's direct gaze at the camera denies the on-screen listener the return look, placing the courtesan in a more expanded auditory community. Sangari's argument about *viraha* speaks poignantly to my own analysis of the cinematic *ghazal* that, through its recurring motifs of loss and anguish, was able to evoke larger emotional and historical registers in the postcolonial era.

NOTES

1. Sampath's biographical account of Gauhar Jaan describes Malka Jaan as a well-known poet who published a collection of her poetry in 1886. He has also noted that Dagh Dehlvi and Akbar Allahabadi were her contemporaries and held her in high esteem.

2. *Thumrī* is a semi-classical genre of Hindustani classical music that is rendered in vocal form. *Dādrā* is a semi-classical form of vocal classical music which is set to a *tāl* of six beats or *dādrātāl*. According to Ashok Ranade, the lilt of the *tāl* or beats gets emphasized in *dādrā*. *Tappā* is another form of semi-classical music, inspired by the camel riders of Punjab area, which employs melodic and rhythmic jumping movements.

3. *Khayāl* is a major genre of Hindustani classical music sung in a definite *rāg* and *tāl* in which the composition is used to elaborate the *rāg*. *Tarānā* is a composition-driven vocal music that uses sound syllables inspired by the sound of musical instruments. *Bhajan* and *kirtan* are genres of Hindu devotional vocal music. The latter is performed as a chorus.

4. All translations are mine. I want to thank Ira Bhaskar and Richard Allen for giving me their useful suggestions that helped me rework some translations. I also found https://rekhta. org/ with its online dictionary a very useful resource for this chapter.

5. In his introduction to *Ghazal ka Safar*, Gulzar said 'after being written, *ghazal* was secured in books and publications but it was after it was sung with music that it got stored in the recorded format. *Khayāl mahfūz thā lekin āwāz pehli dafā mahfūz hui* ['Imagination/ thought were already there but the voice could be inscribed for the first time']. Gulzar's

words are available in this audio link: https://wynk.in/music/song/introduction-by-gulzar-and-jagjit-singh/sa_INH101103014?autoplay=true. Accessed 8 January 2020.

6. According to figures given by Suresh Chandavarkar (n.d.), Saigal recorded 33 *ghazal*s. His records were also released by Jien-O-Phone, HMV and Columbia Records: http://members.tripod.com/oldies_club/klsaigal.htm. Accessed 15 December 2016.

7. See https://atulsongaday.me/2012/09/03/achcha-eesaa-ho-mareezon-ka-khayaal-achcha-hai/. Accessed 15 December 2016.

8. I am aware that many women artists who came from courtesan backgrounds shared a creative relationship with poets. But what I would like to underscore is that in Begum Akhtar's case this creative relationship was much more in the public domain.

9. This recording can be seen on YouTube: https://www.youtube.com/watch?v=FvSi6ZlpL6E (accessed 15 December 2016).

10. Begum Akhtar sang two Madan Mohan composed *ghazal*s in the 1950s: '*Ai 'ishq mujhe kuć aur yād nahī̃*' in *Dana Pani* (1953) and '*Humeiṅ dil meṅ basā bhi lo*' in *Ehsan* ('Favour', 1954). Unfortunately, the record of the latter song is not available.

11. Dilip Kumar's alliance with Talat Mahmood was consolidated in the same year through the popular songs of *Babul* ('Father', 1950), composed by Naushad Ali and written by Shakeel Badayuni.

12. Unlike Talat and Dilip Kumar's other songs, '*Husnwāloṅ ko nā dil do*' is set in a lighter mood in which Dilip Kumar's character engages in a banter with some women.

13. Sahir Ludhianvi and Roshan had teamed up for the lyrics and music in *Barsaat ki Raat*, whose music had become very popular.

14. I would like to thank Ira Bhaskar for pointing this out to me.

REFERENCES

Ahmad, Aijaz (ed.) (1995), 'Introduction', in *Ghazals of Ghalib: Versions from the Urdu*, New Delhi: Oxford India, pp. vii–xxviii.

Akhtar, Javed (2005), *Talking Songs: In Conversation with Nasreen Munni Kabir*, New Delhi: Oxford.

Atul (2012), '*Achche eesaa ho mareezon ka khayaal achcha hai*', Wordpress blog, 3 September, https:// atulsongaday.me/2012/09/03/achcha-eesaa-ho-mareezon-ka-khayaal-achcha- hai/. Accessed 15 December 2016.

Bhaskar, Ira (2018), 'Expressionist aurality: The stylized aesthetic of *bhava* in Indian melodrama', in C. Gledhill and L. Williams (eds), *Melodrama Unbound across History, Media, and National Cultures*, New York: Columbia University Press, pp. 253–72.

Bhaskar, Ira and Allen, Richard (2009), *Islamicate Cultures of Bombay Cinema*, New Delhi: Tulika Books.

Biswas, Anil (1975), 'The ghazal in Indian films', *Sangeet Natak*, 37, pp. 12–15.

THE TEXTUAL, MUSICAL AND SONIC JOURNEY OF THE *GHAZAL*

Biswas, Anil (n.d.), 'My journey into the world of film music', in D. Hathi and P. Sharma (eds), *Tribute to Anil Biswas*, Bangalore: Vintage Hindi Music Lovers Association, pp. 7–10.

Chandavarkar, Bhaskar (1980), 'The great Indian film song controversy', *Cinema Vision India*, 1–4, pp. 66–75.

Chandavarkar, Bhaskar (1987), 'Birth of the film song', *Cinema of India*, April, pp. 7–11.

Chandvankar, Suresh (n.d.), 'Kundan Lal Saigal (1904–1947)', Oldies Club, https://members.tripod.com/oldies_club/klsaigal.htm. Accessed 15 December 2016.

Chitradoot (1969), 'Ghalib in films', *Filmfare*, 25 April, pp. 41–43.

Daag 1952, Amiya Chakravarty (dir.), India: Mars & Movies Productions.

Desai, Meghnad (2004), *Nehru's Hero: Dilip Kumar in the Life of India*, New Delhi: Lotus Collection, Roli Books.

Duggal, Vebhuti (2018), 'Imagining sound through the pharmaish: Radios and request-postcards in North India, c. 1955–75', *Bioscope*, 9:1, pp. 1–23.

Dutt, Sharad (2007), *Kundan Saigal Ka Jeevan Aur Sangeet*, New Delhi: Penguin Books India.

Ganguly, Rita (2008), *Ae Mohabbat: Reminiscing Begum Akhtar*, New Delhi: Stellar.

Gulzar (*c*.1990), 'Introduction', *Ghazal ka Safar*, 10 cassette series, India: HMV.

Hasan, Mehndi (1991) 'The living legend', *The Hindu*, 27 September.

Hiranand, Shanti (2005), *Begum Akhtar: The Story of My Ammi*, New Delhi: Viva Books.

Imam, Chaudhary Zia (2008), *Naushad: Zarra jo Aaftaab Bana*, New Delhi: Penguin Books India.

Jhingan, Shikha (2009), 'The singer, the star and the chorus', *Seminar*, 598, pp. 58–63.

Jhingan, Shikha (2016), 'Sonic ruptures: Music, mobility and the media', in A. Rajagopal and A. Rao (eds), *Media and Utopia: History, Imagination and Technology*, New York: Routledge, pp. 209–34.

Joshi, G. N. (1984), *Down Melody Lane*, Bombay: Sangam Books.

Kinnear, Michael (1994), *The Gramophone Company's First Indian Recordings: 1899–1908*, Bombay: Bombay Popular Prakashan.

Larkin, Brian (2013), 'The politics and poetics of infrastructure', *The Annual Review of Anthropology*, 42, pp. 327–43.

Lelyveld, David (1994), 'Upon the subdominant: Administering music on All-India Radio', *Social Text*, 39, pp. 111–27.

Manto, Sadat Hasan (1998), *Stars from Another Sky: The Bombay Film World of the 1940s*, New Delhi: Penguin Books.

Manuel, Peter (1988–89), 'The historical survey of the Urdu gazal-song in India', *Asian Music*, 20:1, pp. 93–110.

Mehndi, S. M. (1975), 'Development of the Urdu ghazal', *Sangeet Natak*, 37, pp. 5–11.

Menon, Raghava (1989), *K. L. Saigal: The Pilgrim of Swara*, New Delhi: Hind Pocket Books.

Mishra, Ambrish (1992), 'Melody your name', *The Times of India*, 3 May.

Nevile, Pran (2011), *K. L. Saigal: The Definitive Biography*, Delhi: Penguin Books.

Orsini, Francesca (2007), 'Introduction', in F. Orsini (ed.), *Love in South Asia: A Cultural History*, South Asia ed., Delhi: Cambridge University Press, pp. 1–39.

Pritchett, Francis (1994), *Nets of Awareness: Urdu Poetry and Its Critics*, Berkeley: University of California Press.

Qureshi, Regula (1990), 'Musical gesture and extra-musical meaning: Words and meanings in the Urdu ghazal', *Journal of American Musicological Studies*, 43, pp. 457–97.

Ravikant (2016), 'Words in motion pictures: A social history of language of "Hindi" cinema', unpublished doctoral thesis, Delhi: University of Delhi.

Russell, Ralph (1969), 'The pursuit of the ghazal', *The Journal of Asian Studies*, 29:1, pp. 107–24.

Sampath, Vikram (2010), *My Name Is Gauhar Jaan!: The Life and Times of a Musician*, New Delhi: Rupa Publications.

Sangari, Kumkum (2011), 'Viraha: A trajectory in the Nehruvian era', in K. Panjabi (ed.), *Poetics and Politics of Sufism and Bhakti in South Asia: Love, Loss and Liberation*, Hyderabad: Orient BlackSwan, pp. 256–87.

Shahjehan (1946), A. R. Kardar (dir.), India: Kardar Productions.

Tarana (1951), Ram Daryani (dir.), India: Krishin Movietone.

Thokar (1939), Waheedan Bai (dir.), India: Ranjit Movietone.

Vasudevan, Ravi (2010), *The Melodramatic Public: Film Form and Spectatorship in Indian Cinema*, Ranikhet: Permanent Black.

10

The Sufi Sacred, the *Qawwālī* and the Songs of Bombay Cinema

Ira Bhaskar

Sufi ideas and traditions of poetry, music and performance have been important for Bombay cinema from the very beginning of the sound period. Significantly, the Wadia brothers' first sound film, *Lal-e-Yaman*, in 1933, had a Sufi holy man in a central and normative role. Not only does the film use the figure of the spiritual leader to critique the injustices of those in power, but it also introduces through him the centrality of music to Sufi practices and furthermore, interestingly, to the evolving aesthetics of the emerging sound film in India.[1] Drawing on earlier arguments I have made about 'a new aural and visual aesthetic as an expressive language for the articulation of *bhāva* (emotion)' in the Indian cinemas of the 1930s and the 1940s (Bhaskar 2018: 253), and the 'privileging and amplification of emotion' via the song and the integral presence of the sacred in Indian melodrama (2012: 166, 172), in this chapter, I examine the implications of Sufi-inspired ideas for the songs of Bombay cinema. A central form of Sufi devotional music is the *qawwālī* present in Bombay cinema from the first decade of sound cinema as an articulation of devotion and as spiritual longing. Very soon after its introduction, reinventions of the *qawwālī* began to take place. From the precincts of a *dargāh* (shrine of a holy man) where *qawwālī*s were traditionally performed, the cine-*qawwālī* came to be set in homes, palaces and the performance stage, appearing transformed in the process from a devotional musical form to become an entertainment and secular genre of music about romance. Writers on the cine-*qawwālī* have argued that it is this latter form of musical competition between two groups of people, and often a group of men against another of women performing songs of love, often teasingly and sometimes aggressively, that became the dominant form of the *qawwālī* in Bombay cinema (Dwyer 2007; Sarrazin 2014; Zuberi and Sarrazin 2017; Sundar 2017). It has also been argued that the devotional *qawwālī* picturized as performed in the traditional space of the *dargāh* has been

significantly present in Bollywood cinema only after 2000 (Sundar 2017; Kibria 2016). Responding to these arguments, as also to the philosophical ideas, the lyrical poetry of the form and its social and cultural implications (Qureshi 1986; Morcom 2007; Bhaskar and Allen 2009), I argue that the devotional imagination of the *qawwālī* is present not only in the *dargāh* forms but also in several romance *qawwālī*s since the central Sufi idea of single-minded devotion to the loved one simultaneously references both the human and the Divine Beloved. Hence this chapter responds to the question of what the sacred idiom of the *qawwālī* signifies and what yearnings of the soul does the use of the *qawwālī* in films indicate. Through detailed textual work, I discuss here specific examples of the cinematic *qawwālī* as articulations of Sufi ideas and the impact of these ideas both on the love song of Bombay cinema and as expressions of faith in situations of crisis in this cinema.

Sufism: Philosophy, poetic idioms and musical performance

Sufi ideas and poetry have an almost thousand-year history in the subcontinent from the time when Sufis arrived here with other Muslim travellers from the eleventh century onwards (Saeed 2016). As a spiritual and devotional tradition, Sufism is centred philosophically in the brotherhood and humanity of all mankind, in the rejection of power hierarchies, including those of the state and orthodox religion, and in the aspiration for a mystical and spiritual union with the Divine Being. It is not surprising that Sufism's spread in India took place in the context of the *Bhakti* (devotional) movement, and like the other articulations of the *Bhakti* tradition, it provided common people of different faiths an emotionally intense, personal and unmediated communication with the spirit of divinity, becoming in the process a powerful cultural and social form.[2] The dissemination of Sufism in India, like that of other *Bhakti* traditions, led to an efflorescence of poetry in different vernacular languages, which was marked by the use of the language of love for devotional poetry with metaphors and images drawn from ordinary experience (Panjabi 2011). While emerging from the Islamic world, Sufi thought has always been critical of and maintained a distance from Islamic religious dogma, orthodoxy and the rule of religious clerics. Instead, mystical Islam inspired in Sufi poets and mystics a passionately intense love relationship with the Divine Being, often addressed as the Beloved, or when the poets took on a female persona as the Lover. Central to Sufi philosophy is the idea of the phenomenal world as an expressive manifestation of the divine principle, the ultimate Reality, with Divine Love as the central essence of the universe. Furthermore, a reciprocal love for the Divine is felt as the deep aspiration of the human soul, and human experience then is seen as a state that needs to be ultimately transcended, with love as an affective condition that

THE SUFI SACRED, THE *QAWWĀLĪ* AND THE SONGS OF BOMBAY CINEMA

can both embody and lead to an ecstasy of union with the Divine. This is clearly indicated in a central Arabic phrase that, as Christopher Shackle says, is often cited in Sufi thought: *al-majāz qantarat al-ḥaqīqā* (the 'phenomenal is a bridge to the real'). Moreover, as Shackle points out, 'phenomenal love' or *'ishq-ĕ majāzī* and 'real love' or *'ishq-ĕ ḥaqīqī* can be seen as deeply linked, with human love as essentially mirroring the Divine, and offering thus the 'prospect of bringing sexuality into full alignment with spirituality' (2007: 88). It is not surprising then that the vocabulary of human love bespeaks the Divine in Sufi thought with romantic, emotional love and eroticism imbued with the ecstasy of a spiritual union with the Divine. It is this belief in the inherent connection of the sacred and the profane, of the possibility that the human being can be infused with divine essence, which enables the experience of transcendent states of consciousness.

While the realization of 'Real' or Divine Love can be seen as the goal of the aspiration of the mystic, and of human life, Sufi thought also places a central emphasis on the figure of the *murshid*, the guru, the mystic, the spiritual guide, the one who reveals to devotees that the home of divine essence resides within their own souls. Sufism deeply influenced and imbued secular and courtly forms of Persian poetry in their travels all over the Persianate world and especially into the South Asian subcontinent (Qureshi 1986: 83–85; Sharma 2000, 2006). While the different strands of Sufi poetry express the central tenets of Sufi philosophy, Sufism's acceptance among ordinary and even among non-Muslim populations has been made possible by the central role of music and the soul-stirring and uplifting quality of musical and dance performance in Sufi rituals and worship that can create in listeners states of complete enchantment. It is in the music then that the appeal and power of Sufi thought resides, and Sufi poetry is sung in many different forms with the *qawwālī* as one of its traditional forms of musical expression.

The word '*qawwālī*' comes from the word '*qaul*' which means utterance and refers to the sayings of Prophet Muhammad, and the *qawwāl* is the one who sings these utterances in the form of the *qawwālī*. But the *qawwāl*s do not sing only the utterances of the Prophet. They also sing the compositions of Sufi mystics and poets. Hence the mystical-poetic text has a privileged position in the *qawwālī* form. Traditionally, the *qawwālī* was performed for the Sufi *samā*, an assembly of Sufis and devotees ritually gathered to listen, meditate and remember, praise and repeat (*ẕikr*) the names and attributes of Allah, the Prophet or the Saint, and in whom the music brought about a heightened state of spiritual exaltation. As devotional music, the *qawwālī* is performed at different holy shrines by one or two main lead singers who are given vocal and rhythmic support by a group of performers who maintain the rhythmic beat by the clapping of hands that is meant to induce a state of heightened emotion. As a form, the *qawwālī* has an open and fluid structure that privileges the musical performance of poetic texts with the *qawwāl* free

261

to improvise and bring in different poetic compositions, knotting them into the dominant theme that is being sung. These improvisations and movements out of the main song are known as *giraha lagānā* (to tie a knot) and provide an opportunity for lead singers to sing verses by different Sufi poets that over the years has formed the *qawwālī* repertoire (Singh 2008).

This repertoire in North India and Pakistan comprises poetry in classical Persian, Hindavi, Punjabi, Sindhi, Saraiki and Urdu. Amīr Khusrau, the thirteenth- to fourteenth-century poet and disciple of the Sufi saint Niẓāmuddīn Auliyā, who wrote in both Persian and Braj, the vernacular language of the Agra-Mathura region, is credited with having composed a number of *qawwālī*s that are sung even today. *Qawwālī* songs articulate a desire for the mystic's union with the Divine and can vary from celebrations of the saint, of the Divine Being, expressions of abstract mystical thinking or the articulation of an intense yearning for a union with the Beloved (see Qureshi 1986: 1–15). Thus central to this repertoire is the Sufi conception of *'ishq* ('love'), and like other *Bhakti* poetic traditions, the *qawwālī*, too, uses the metaphor of human love to speak of the Divine. It is this metaphoric amplification of human love that resonates with single-minded devotion to the beloved that enables the articulation of both spiritual devotion and romance we see in the cinematic performances of the *qawwālī* in Bombay and later Bollywood cinema.

Sufism and the *qawwālī* in Bombay cinema

Sufi poetry and philosophy are clearly evident in the musical forms of the *ghazal* and the *qawwālī* that developed into privileged expressive forms constituting important strands of the romantic and devotional imagination of Bombay cinema. While the *ghazal* has been discussed by Shikha Jhingan in this volume, I would like to focus on certain imaginal, affective and performative implications of the *qawwālī* in Bombay cinema. Pavitra Sundar has argued that the *qawwālī* became 'a more serious devotional form in the early 2000s' (2017: 139). While it is true that the romantic *qawwālī* performed in non-religious and non-shrine spaces, for example, at homes, in the court and on stage, were prolific and very popular, there are significant examples of the devotional *qawwālī* performed at *dargāh*s (shrines of saints) in the films of the early period as well. Two examples have been pointed out to me: the first is from a 1934 film, Jayant Desai's *Sitamgar* ('The tyrant') written by Pt Narayan Prasad Betab with a *mukhdā* ('refrain') that is '*Idhar dekhtā huṅ udhar dekhtā huṅ, khudā hī khudā hai jidhar dekhtā huṅ*' ('I look in different directions, and it is Lord I see wherever I look'); the second is from a 1938 film, G. R. Sethi's *Shareef Daku* ('Noble dacoit') with a *mukhdā* that is '*Jagdīsh ke ćaraṇoṅ meṅ jo lau haiṅ lagā baithe*' ('At the feet of the Lord I sit with a lit flame of devotion

and desire').[3] Interestingly, the divine being named here is *Jagdīsh* – a word used by Hindus for the Lord. I will discuss the implications of this later in the chapter. I would also like to point out that several romantic *qawwalī*s during this period drew on devotional ideas and the Sufi idea of *'ishq* to express human love, which will be evident in the examples discussed in this chapter.

An oft-quoted early *qawwalī* is from the Muslim Social film, Syed Shaukat Hussain Rizvi's *Zeenat* (1945), which is indicative of the cinematic transformation of the *qawwalī*'s real-life performative location and form. Unlike the *Sitamgar* and *Shareef Daku* examples of the devotional *qawwalī* mentioned earlier, this one is a secular, community performance by an all-female group who tease a blushing bride-to-be about the impact of love upon her. Thus, unlike the *dargāh qawwalī*s performed by all male troupes, this *qawwalī*, performed at home in the *zanānā* (women's quarters) by women, is in itself an innovation of the form for cinema. While the *qawwalī* is sung in the voices of Zohrabai Ambalewali, Kalyani and Noor Jehan and we can identify three singers who are dominant, there are several young women who lip-sync the verses of the *qawwalī* and provide vocal support for the main singers, making the performance truly that of a community. The lyrics by Nakshab Zarachvi articulate the paradoxical pleasure and pain of being in love:

> *Āheiṅ na bharī śikwe na kiye, kuć bhī na zubān se kām liyā…*
> *Is par bhī mŏḥabbat chup na sakī, jab terā kisī ne nām liyā.*
>
> ('I did not sigh or complain, I did not use my voice at all…
> And yet I was unable to hide my love when your name was taken by
> anyone.')

The song picturization has all the accoutrements of a *qawwalī* performance with the clapping of hands and off-screen *dholak*s (two-headed hand drums) marking the rhythmic beat of the song, while two of the singers also provide accompaniment on the harmonium. This genre of the all-female *qawwalī* did become extremely popular, and there are examples in several films through the 1950s and 1960s. A similar example of 'a playful teasing form of the *qawwalī*' with all-female performers is '*Sharmā ke ye kyūṅ pardānashīṅ, āṅcal ko sawārā karte haiṅ*' ('Why do these veiled women shyly readjust their veils') from *Chaudhvin ka Chand*, which we have discussed earlier (Bhaskar and Allen 2009: 19). The romantic cinematic *qawwalī* here draws on the *ghazal* world and its dominant metaphors to articulate romance in its different shades.

Simultaneously with the deployment of the all-female playful *qawwalī*, the devotional *dargāh qawwalī* continued to be used in the films of the 1950s and 1960s. This form was often a site for the expression of devotion to the saint of the shrine as well as a passionate articulation of intense commitment to the beloved.

The Shakeel Badayuni *qawwālī* from Sohrab Modi's *Mirza Ghalib* (1954), '*Sajde meṅ hai sar, tujh par hai naẓar*' ('The head is bowed in obeisance to you, the gaze is fixed upon you for deliverance'), set at the *dargāh* of the Sufi saint of Delhi, Niẓāmuddīn Auliyā, has lyrics of obeisance, faith and submission that invoke the faithful's relationship with the Saint.[4] At the same time, the lyrics also evoke the desperate faith of the two women who seek the Auliyā's intervention to save the man they love, Ghālib, the poet of Delhi, who has been unfairly imprisoned. This chance meeting of Ghālib's wife, Umrao, and his beloved, Chaudhviṅ, at the *dargāh* during the *qawwālī*, brings about the narrative resolution of the film. Chaudhviṅ's realization that Ghālib is a married man evokes from her a desperate plea to the Khwājā (the saint of the shrine) that the wishes of Ghālib's wife may be fulfilled while simultaneously realizing that she must leave. As she withdraws from the *dargāh* towards a reverse-tracking camera, with the music rising to a crescendo, the time for her final act of *ibādat* (worship) and of *fanā* (ultimate surrender and self-annihilation) for her beloved is clear to her and is realized with her departure from Delhi and her death. As Ghālib carries her bier, her voice echoes through the dark night with a ghazal line 'Where will this storm of love go after my death'. The world is impoverished by her death, but her passion and her devotion to her beloved inscribe her yearning for a union beyond the grave that is typical of a Sufi romance in which the deep commitment of lovers to each other transcends death.

The *Mirza Ghalib qawwālī* is an example of a devotional performance in a devotional space, and in several films of this period between the late 1930s and the 1970s, this form of the *dargāh qawwālī* articulated the devotee's faith and surrender to the patron saint of the shrine. The protagonists usually visited or arrived at the shrine as an act of pilgrimage, often turning to the sacred figure in moments of intense personal crisis. While there are numerous examples, I would like to mention just a few here. Yash Chopra's *Dharmputra* (1961) has two *qawwālī*s, one of them a *dargāh qawwālī* which occurs at a critical moment of the narrative. Having realized that he had committed a mistake, out of social considerations, in not allowing his daughter, Husn Bano, to marry her lover, Javed, Nawab Badruddin attempts to atone for his guilt towards his grieving daughter by setting out on a pilgrimage. Their visit to various holy Islamic sites is evoked through a combination of dissolves and circular pans, superimposing medium shots of the Nawab and Bano over the sacred landscape of faith (Figures 10.1 and 10.2). The repeated circular pans evoke the sacred geography of Islamic India, with the images, among others, of sites like the Jama Masjid in Delhi, the tomb of Garib Nawāz in Ajmer, that of Salīm Chishtī in Fatehpur Sikri, that of Bandā Nawāz in Gulbarga and the Niẓāmuddīn *dargāh* in Delhi.[5] However, these images create a spiritual space that is not the preserve of just one community but rather is a space that provides solace to all those with faith who seek divine grace. That there is a

THE SUFI SACRED, THE *QAWWĀLĪ* AND THE SONGS OF BOMBAY CINEMA

FIGURE 10.1: The sacred landscape of faith – *Dharmputra*.

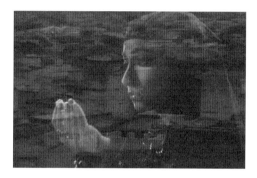

FIGURE 10.2: The sacred landscape of faith (2) – *Dharmputra*.

strong and important cross-faith address here to the nation at large is clear from Sahir Ludhianvi's *qawwālī*, which is the finale of this sequence: '*Kābe meṅ raho ya Kāśī meṅ / Nisbat toh usī kī dās se hai*' ('Whether you live in Mecca or in Varanasi / One's relationship to the Divine is one of faith and service'). While the words of the *qawwālī* are crucial, the image track is equally evocative. The picture of the *qawwāl* and the *pandit*[6] sitting together against a background of a mosque and a temple, singing of the value of faith in whichever God one believes in, 'for every house is his Abode' creates the emotional textures of what it means to live in a multifaith, plural culture that is rooted in respect for different spiritual traditions (Figure 10.3). It is the value of the spiritual experience itself, and not the different names by which we call the Divine Being, that is celebrated in this powerful *qawwālī* that articulates the belief that whether one visits a mosque or a temple, it is the Divine Being one worships, and therefore we may believe in what we will, for ultimately the goal is to touch the heart with faith.[7] It is clear that wishes may be fulfilled in Kaaba (in Mecca) or Kasi (Varanasi), that the gift of love may be

265

FIGURE 10.3: The *qawwāl* and the *pandit* – *Dharmputra*.

found in any place of faith, and miraculously Bano and the Nawab come face to face in this holy space with Javed, and a reconciliation takes place.

The discussion of the *Dharmputra qawwālī* here is also relevant for the word *Jagdīsh* used by Hindus to name God in the *Shareef Daku qawwālī* mentioned earlier, which is indicative of the acceptance of the plurality of spiritual traditions and respect for every religion that was an essential aspect of the nationalist movement. In a diverse country with multiple faiths and communities, it was extremely important for the leaders of the independence movement to imagine the democratic character of the new nation to be founded on an acceptance and respect for India's multicultural and multireligious communities and their belief systems. Several leaders, both Hindu and Muslim, in the 1920s, asserted their faith in an idea of India which 'neither is nor will be exclusively Hindu, Muslim, Sikh or Christian. *It will be each and all*' (Lala Lajpat Rai cited in Pandey 1990: 213). It is based on this idea of India that Indian secularism was conceived. While the various versions of secularism in western countries emphasize, at least in theory, the separation of the dominant religion, Christianity, from the state, there are two ways in which secularism is understood in India. Nehru's vision of secularism as '*dharma nirapekṣatā*' ('neutrality in regard to all religions') meant not only that the state would be neutral to all religions but also that no one religion would be privileged for any claims or policy formations. On the other hand, the Gandhian understanding of secularism as '*sarva dharma sambhāva*' ('equal respect for all religions') meant not only that the state would be neutral to all religions but that respecting the different religions of India implied imparting a value and equality to them all. Furthermore, as Ashis Nandy points out, Indian secularism meant 'not the opposite of "sacred" but of "ethnocentrism", "xenophobia" and "fanaticism"' (2003: 34). The two examples of the devotional *qawwālī* mentioned earlier are

clear articulations then of the value of the sacred for the Gandhian understanding of secularism which popular cinema upheld during the Nehruvian period.

There are several other examples of the devotional *qawwālī* in the cinema of this time, performed in *dargāh*s but also in spaces that are not shrines. They vary from being direct addresses to the patron saint to having a dual register in that while the lyrics articulate devotion and faith in Allah, in the Prophet or in the Saint, the words also express a profound yearning or a psychological crisis that the protagonists are undergoing. At other times, the *qawwālī* may be a devotional *qawwālī* performed outside of the *dargāh*. An interesting example is '*Batā aĕ āsmān wāle tere bande kidhar jāyeṅ*' ('Tell us O Lord, where are your people to go') from the film *Marine Drive* (1955). Shot on the iconic Marine Drive in Mumbai, this *qawwālī* features a group of poor performers who earn their livelihood through their performances on the street. In a post-Partition world, it is not difficult to imagine the reasons for their homelessness and their turning to the Lord in an appeal for help. While not a traditional *dargāh qawwālī* in that it is not shot in a *dargāh*, the lyrics, the emotions evoked and the soundtrack clearly reference the form. In contrast, '*Āṅkhoṅ meṅ tumhāre jalwe haiṅ, hothoṅ pe tumhāre afsāne*' ('My eyes are filled with your brilliant radiance, my lips speak your wonderful stories') from *Shirin Farhad* (1956) and '*Murādeiṅ leke sab āye haiṅ, maiṅ dil leke āyā huṅ*' ('Everyone has come with desires, I have brought my heart to you') from the film *Johar in Kashmir* (1966) are both traditional *dargāh qawwālīs*, with *qawwāl*s performing at a *dargāh* while simultaneously in a choric articulation foregrounding the situation of the protagonists. There are several other examples as well,[8] but I would like to pick up the *Shirin Farhad qawwālī* mentioned earlier in order to focus on an important significance and realization of the miraculous and of a miracle that is associated with the space of the *dargāh*.[9]

This 1956 version of the Shīrīn-Farhād love tale was directed by Aspi with Madhubala and Pradeep Kumar in the lead roles, music by S. Mohinder and lyrics by Janveer Naqvi with the *qawwālī* written by Saba Afghani. While the princess, Shīrīn, and the son of a sculptor, Farhād, are childhood friends who grow up to be intensely in love with each other, her father is against their marriage, and sends Shīrīn to Tehran to be married to King <u>Khusrau</u> Pervez, the Shah of Tehran. Shīrīn continues to refuse the marriage when she is brought to the Tehran palace as <u>Khusrau</u>'s fiancée and wastes away in separation from Farhād, who has been exiled. Wandering through the desert, like the other legendary lover Majnūn,[10] Farhād has only one name on his lips, that of his beloved. On hearing of Shīrīn's arrival in Tehran, Farhād makes his way there and is stoned by the people of the city for daring to take Shīrīn's name, one who is engaged to be married to their king. Shīrīn, too, has no peace, fears the worst and is advised to get relief by

FIGURE 10.4: Shīrīn praying at the *dargāh* – *Shirin Farhad*.

visiting a nine-hundred-year-old *dargāh* where wishes are fulfilled. It is with her visit that the aforementioned *qawwālī* takes place: '*Āṅkhoṅ meṅ tumhāre jalwe haiṅ, hothoṅ pe tumhāre afsāne*'.

The *qawwālī* is a paean to the abilities of the patron saint of this space whose brilliance and power is awe inspiring and at whose abode arrive desperate and suffering lovers.[11] The lyrics go on to assert that this is the home of justice and no one has returned from this door empty handed, and it is here that broken destinies have been remade. All this while, in medium shot alternating with close-ups, Shīrīn sits before the shrine with her hands lifted in prayer and eyes fixed on the sanctum inside (Figure 10.4). The lyrics then seem to be articulating her pain and the injustices of her destiny which she has brought to the saint for redressal. The camera cuts between the singing *qawwāl*s, Shīrīn's still and praying figure and Khusrau-Pervez who is watching her. At this point, a voice is heard off-screen singing that he will not return without hope from this space. The camera remains in a low-angle medium shot on the seated Shīrīn on whose face an immediate recognition of the voice prompts a slow turning of the face towards the entrance. Farhād enters singing that he has come here not only to articulate his grief, his pain, but with the decision that either he realizes the desire of his heart or be reduced to dust (Figure 10.5). This line is taken up by the *qawwāl*s who sing it in chorus. Having moved inside, Farhād has, at this point, fallen on the ground and, as he drags himself to the steps of the sanctum and is about to hit his head on the last step (Figure 10.6), a hand prevents his head from hitting the stone. Dali Daroowala's camera moves up to reveal Shīrīn's quiet presence in medium close-up (Figure 10.7), followed by alternate close-ups of the two lovers (Figures 10.8 and 10.9). As Farhād moves closer to her, Daroowala frames them in a two-shot close-up (Figure 10.10) while Farhād sings his final couplet:

THE SUFI SACRED, THE *QAWWĀLĪ* AND THE SONGS OF BOMBAY CINEMA

FIGURE 10.5: Farhād entering the *dargāh* singing – *Shirin Farhad*.

FIGURE 10.6: Farhād at the steps of the sanctum – *Shirin Farhad*.

FIGURE 10.7: Farhād's glimpse of Shīrīn – *Shirin Farhad*.

FIGURE 10.8: Farhād gazing at Shīrīn – *Shirin Farhad*.

FIGURE 10.9: Shīrīn overwhelmed by her vision – *Shirin Farhad*.

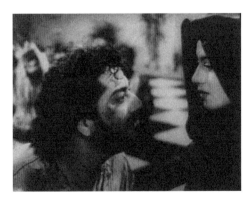

FIGURE 10.10: Farhād and Shīrīn – *Shirin Farhad*.

Aĕ śamā tere jalwoṅ ki kasam
Jal kar hī raheṅge parwāne.

('Vowing faith to the brilliance of your flame
The moth promises to be consumed entirely.')

The *qawwāl*s pick up and sing Farhād's verse while Daroowala now has alternating shots of the two lovers in low-angle extreme close-ups with the revelatory power of the camera articulating not just the miracle of beauty but the miracle of this meeting and the miracle of a love, of an *'ishq* that consumes the lovers burning brightly all the while. Two close-ups of the clapping hands of the *qawwāl*s are intercut with several alternating tight close-ups of the lovers, which, together with the music rising to a crescendo, imbue this human love (*'ishq-ĕ-majāzī*) with the feeling of divinity, for what is this love that is single-mindedly devoted, completely setting aside worldly concerns, but like love for the Divine or *'ishq-ĕ-ḥaqīqī*. The miracle of *'ishq-ĕ-ḥaqīqī* has taken place at the finale of this devotional *qawwālī*. From here onwards, the final miracle of Shīrīn responding to Farhād's voice from the grave and calling upon her death and union with Farhād into whose grave she falls as it opens up to receive her is only to be expected.

Another paean to *'ishq* is the iconic *qawwālī* of this period from P. L. Santoshi's film *Barsaat ki Raat* ('One rainy night', 1960):

Nā toh kārvāṅ kī talāsh hai, nā toh hamsafar kī talāsh hai
Mere sauq-ĕ-khānā kharāb ko, terī rahguzar kī talāsh hai.

('I do not quest a caravan of travellers, nor a fellow traveller
My ruined heart seeks a path that leads to you.')

This *qawwālī* is the climactic denouement of the film that unlike *Shirin Farhad*, which is based on a legendary love tale, is set in contemporary Nehruvian India. While drawing on the poetical and musical aesthetics of the Muslim Social genre, *Barsaat ki Raat* imagines a transformed future of gender relations and community identities. Amaan is a poet who earns his living through his poetic compositions and radio performances. Encountering the beautiful Shabnam on a rainy night, he not only falls in love with her but composes the title song of the film, '*Zindagī bhar nahī bhūlegī woh barsāt kī rāt*' ('All my life I will not forget that monsoon night') which becomes their personal declaration of love for each other. Their relationship soon faces the objections of Shabnam's father, the police commissioner, who has promised Shabnam to someone else of a higher social standing. Amaan and Shabnam elope from Hyderabad, but she is found out and brought back and

then taken to Lucknow in order to be hastily married. She is dead against the marriage and begins to waste away at its prospect. Meanwhile, Amaan has also come to Lucknow where he meets his former landlord Mubarak Ali, a retired musician, and his two daughters, the *qawwālī* singers Shama and Shabab, and Mubarak Ali elicits Amaan's help to compose verses for a *qawwālī* competition that his daughters must win in order for the family to survive. The film has three *qawwālī*s, all of which are in the format of competitions between two rival groups of *qawwāl* performers. While they are all variations on ideas of *'ishq*, '*Na toh kārvāṅ kī talāsh*' is the final and resounding statement on the theme. The *qawwālī*s are performed in three different classic spaces of the cinematic *qawwālī*, with the first a competition on stage, the second in the Baradari in Lucknow, a palace built by the last Nawāb of Awadh, Wājid ʿAlī Shāh, and the last within the precincts of the Ajmer Sharif *dargāh*. While Shama and Shabab lose the first competition to Chand Khan and win the next with Amaan's help with the verses, the finale is a competition between the party of the *qawwāl* Daulat Khan Dhauns, on one side, and Shama, Shabab and finally Amaan on the other. As earlier, the outcome of the competition is essential for the professional survival of Shama, Shabab and Mubarak Ali as performers. Before the *qawwālī* begins, Shama is emotionally distraught having just discovered that Amaan and Shabnam are in love, which destroys any chances of the consummation of her love for Amaan.

Daulat Khan's opening verse establishes the lover's desire to find the path to his beloved, but Shama's opening verse counters Daulat Khan's quest of love with lines that are defeated and distraught, calling for death as the only cure for her unfortunate obsession. In response, Daulat Khan has a few more couplets affirming the value of *'ishq* for the Lover, which the audience is very appreciative of and chant the refrain with him of '*Yeh 'ishq 'ishq hai, 'ishq 'ishq*' ('This is love, this is love, this is love'). Clearly the competition seems to be slipping from Shama and Shabab with the latter's retaliatory verse about the destructive power of *'ishq* weak against Daulat Khan's uplifting celebration (Figures 10.11 and 10.12). It is then that Amaan enters the competition and joins Shabab and Shama (Figure 10.13). Beginning with a long *ālāp* that Shabnam hears and recognizes as Amaan's voice on the radio where the *qawwālī* competition is being broadcast,[12] Amaan picks up on the celebration of *'ishq* that Daulat Khan had begun. *'Ishq* is the force that cannot be controlled by the destructive powers of the heart, the world, the gallows or daggers and spears. It is the voice of Majnūn that Lailā followed and no one could stop her, for it is *'ishq*, *'ishq*, *'ishq*. While listening to these words, convinced that Amaan is at the *dargāh* singing at the competition, Shabnam leaves the house quickly and arrives at the *dargāh* (Figure 10.14). Daulat Khan and his associates return with another verse on *'ishq* and its difficulties, and Amaan responds that '*'ishq āzād hai, Hindu nā Musalmān hai 'ishq*' ('Love is free, it is neither Hindu

THE SUFI SACRED, THE *QAWWĀLĪ* AND THE SONGS OF BOMBAY CINEMA

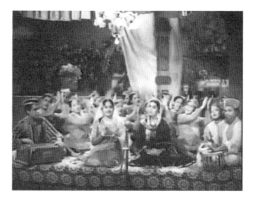

FIGURE 10.11: Shama and Shabab seem to be losing the *qawwālī* competition – *Barsaat ki Raat*.

FIGURE 10.12: Daulat Khan's paen to *'ishq* – *Barsaat ki Raat*.

FIGURE 10.13: Amaan joins the *qawwāl*s – *Barsaat ki Raat*.

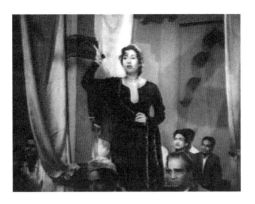

FIGURE 10.14: Shabnam arrives at the *dargāh* – Barsaat ki Raat.

nor Muslim'). It transcends all barriers whether that of class, caste or religion for *'ishq* is a religion by itself: '*Āp hi dharm hai aur āp hi īmān hai 'ishq*'. Here Amaan is citing the Sufi poets Bulleh Shāh and Ghulām Farīd (Singh 2008) and goes on to cite Kabīr and Bulleh Shāh again when he says that this truth, understood neither by the sheikh nor by the brahman, is what it roaringly announces. Amaan's virtuoso performance here inspires Shabab as well, who sings a verse in Punjabi about how *'ishq* does not countenance differences in identities and then picks up the line from Daulat Khan and knots in a verse from another Sufi poet, Amīr Khusrau, when she sings his well-known composition in Braj-Bhasa: '*Bahut kathin hai dagar panghat kī*' ('The path down to the river is very difficult').[13] Sahir Ludhianvi's lyrics while citing Sufi stalwarts like Bulleh Shāh, Ghulām Farīd, Sultan Bhau, Waris Shāh and Kabīr clearly establish him as the *qawwāl* par excellence – one who in his improvisation and tying in of the knots in the composition (*girah*) can mobilize an entire affective and philosophical Sufi and *Bhakti* cosmos. The narrative situation is climactic in a double sense – not only will the *qawwālī* bring to resolution the central triangular love relationship between the poet Amaan, his beloved Shabnam and Shama, it will also bring about a transformation of a traditional world-view in the haloed space of Ajmer Sharif, the most venerated of the Sufi shrines of the Chishtī order.

Using imagery from the Krishna and Sita traditions, as well as the Islamicate Lailā-Majnūn and Sufi traditions,[14] the *qawwālī* announces triumphantly the liberation of love from all constraints in an amazing tour de force of poetry, music and performance that celebrates plural cultural and spiritual traditions. Shabnam, the beloved, is Radha, Sita and Mira together (Figure 10.15), while Amaan also asserts that the teachings of Allāh and the Qu'rān, Buddha and Christ are love and that *'ishq* is everlasting and victorious, that it turns clay into idols and idols

FIGURE 10.15: Shabnam as Radha, Sita and Mira – *Barsaat ki Raat*.

into Gods and finally the pinnacle of Love is that it can turn a human being into a revered and loved God. The assertion of the miraculous power of *'ishq* in these heightened verses can only be followed by the ecstatic refrain of '*Yeh 'ishq 'ishq hai, 'ishq 'ishq, yeh 'ishq 'ishq hai, 'ishq 'ishq*' in which the entire audience joins in marking the culmination of the *qawwālī* and the win for Amaan and his group. The escalation of the situation with the arrival of Shabnam's father bent upon destroying Amaan is quickly defused when Aftab, Shabnam's fiancée, asserts that it is Amaan and not him who is her true love and therefore deserving of Shabnam. The heavens bestow their grace on everyone and as the rains pour down, the film concludes with the strains of '*Zindagī bhar nahī bhūlegī woh barsāt kī rāt*', while the group looks on happily at the now united Amaan and Shabnam.

At an imaginary level, what is at stake in this example is also the value of the world that the *qawwālī* evokes. It is appropriate then that this *qawwālī* celebrates the essence of Sufi doctrine – the value of *'ishq* itself and the assertion of love takes place now envisioned as imbued with Sufi and *Bhakti* imaginaries of immersion and submission of the self to the Beloved. The location (of the Ajmer Sharif *dargāh*) also inspires a plural sense of religion and of love that transcends all barriers. It is thus at the Sufi *dargāh* at Ajmer Sharif, under the sign of that tradition which is truly modern in that it liberates the self from the shackles of religion, caste, class and prejudice, that a modern selfhood is wrought and a new sense of a secular community is envisioned. What is noteworthy at the same time is that with the *qawwālī* (a modernized one no doubt in which women and men *qawwāls* sing together) as the climactic move of the film, we are within the imaginary of the best examples of the Islamicate genre of the Muslim Social and its celebratory drive and articulation (Bhaskar and Allen 2009). Furthermore, in its celebration of the Sufi *qawwālī*, the film also articulates a distinctive vision of Indian modernity

within which plural spiritual traditions are celebrated even as a liberated sense of the self is articulated.

The *dargāh qawwālī* was also used in the New Wave period of the 1970s to the mid-1990s though there the deployment of the *qawwālī* was ironic, even melancholic. An iconic example of this is the *Maulā Salīm Chishtī qawwālī* from M. S. Sathyu's 1973 film *Garm Hava* ('Scorching winds'). Performed by Aziz Ahmed Khan Warsi and party before Salīm Chishtī's tomb, which is located within the monumental architecture of Fatehpur Sikri, the lyrics of this *qawwālī* request beneficence and grace and assert faith in the powers of the Saint. However these lyrics 'evoking hope, abundance, joy, and a plea for honour and dignity are tragically ironic and ring hollow' in the aftermath of the Partition as the Mirza family faces one tragedy after another (Bhaskar and Allen 2009: 290). During the New Wave period, Bombay had emerged as the site for an exploration of the questions of Muslim identity and the problems faced by Muslim communities, and hence in the Islamicate films of the 1980s and 1990s, in the New Wave Muslim Socials, the Haji Ali *dargāh* on the sea front in Bombay (Figure 10.16) was deployed as an iconic site for the evocation of a mystical and devotional Islam that the *dargāh qawwālī* enables. However, the *qawwālī*s, powerful and beautiful as they are, function to critique social realities or evoke with irony the condition of Muslims in contemporary India. '*Piyā Hajī Alī, Piyā Hajī Alī*' ('O my love, Haji Ali') from Khalid Mohamed's *Fiza* (2000) is a *qawwālī* that is performed at the *dargāh* (Figure 10.17) and is used to express the faith that Nishat Bi has in the saint who she hopes will return her son to her (Figure 10.18). However, all her visits there,

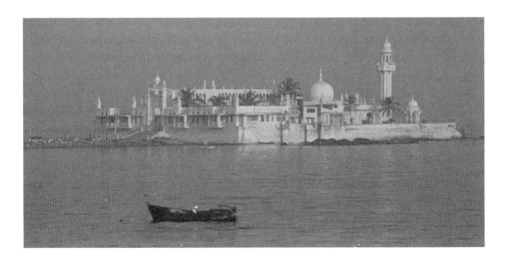

FIGURE 10.16: The Haji Ali *dargāh* – *Fiza*.

THE SUFI SACRED, THE *QAWWĀLĪ* AND THE SONGS OF BOMBAY CINEMA

FIGURE 10.17: The Haji Ali *qawwālī* – *Fiza*.

FIGURE 10.18: Nishat Bi imagining Amaan is with her – *Fiza*.

when she prays for the return of Amaan who had disappeared during the Bombay riots of 1993, come to naught for the reality of Muslims in India is one of marginalization and oppression. In the context of the realist project of the New Wave, the hopes expressed in the Haji Ali *qawwālī* are ironic, as is the case with the soft aural presence of a Haji Ali *qawwālī* in Saeed Mirza's *Salim Langde Pe Mat Ro* ('Do not cry over the lame Salim', 1989) and similarly with the use of the site in Benegal's *Mammo* (1994) (Bhaskar and Allen 2009). In contrast, in Akbar Balam's *Khwaja ki Diwani* ('Besotted by the Lord', 1981), a Muslim devotional film from the same period, the *qawwālī*s that are used, with '*Man Kunto Maulā*' ('To whom I am the

277

Master') being performed at the Haji Ali *dargāh* in Bombay, reaffirm faith in the effectiveness of Muslim devotion and the miraculous powers of saint figures.

More recently, as others have also pointed out, the devotional *qawwālī* has been consistently used more widely in Bollywood cinema (Sarrazin 2014; Zuberi and Sarrazin 2017; Sundar 2017; Kibria 2016). The secular and modern casting of Indian spirituality was evident in the *Barsaat ki Raat qawwālī*, and the *qawwālī* continues to be mobilized in Bollywood cinema for goals that persuasively argue for new imaginaries of selfhood that are constituted not by hardened and divisive ideologies of communal and national constitutions of the self but centrally by a liberated sense of love and devotion that goes beyond the boundaries set by society, religious communities or nationality. The narrative drive of Yash Chopra's *Veer Zaara*'s (2004) fictional world is charged by precisely such a vision and explores the price that individuals must pay for a devotion that challenges social norms. The film is a love story between an Indian Air Force officer, Veer, and a Pakistani woman, Zaara, who meet when she visits India to immerse the ashes of her nanny, according to her wishes, in the Sutlej river at Kiratpur, a holy site for the Sikhs. Though Zaara returns to Pakistan after a couple of days, the time that Veer and she spent together marks them both forever. On her return, she is engaged to marry Raza, the son of a high-ranking politician, a marriage she does not want for herself. At the engagement ceremony and later, she imagines Veer everywhere and feels she is going insane. Shabbo, her companion, realizes her agony and calls Veer to let him know that Zaara does not want to go through with the marriage that has been arranged for her and wonders whether Veer loves her. Veer realizes immediately what he must do. Putting in his letter of resignation, he leaves for Lahore where he is met by Shabbo who informs him that Zaara and her family, along with Raza's family, are visiting a *dargāh* to seek blessings for the impending wedding. Thus, very appropriately, Veer and Zaara's first meeting after their separation is at the sacred space of a Sufi shrine.

When Veer arrives at the *dargāh*, the two families are already there and the *qawwālī*, 'Āyā tere dar par dīwānā' ('The besotted lover has arrived at your door') has begun. In this traditional *dargāh* space with the *qawwāl*s seated and singing on one side (Figure 10.19), the *qawwālī* lyrics deploy well-known and traditional metaphors of devotion for the Saint of the shrine. While the besotted lover of the *qawwālī* references the devotee who has come to pay obeisance to the Saint, and the *qawwālī* articulates devotion to the object of love, it works simultaneously in a double register as an expression of devotion to the Saint, and to the Beloved, and the words announce the arrival of the lover as the devotee, one who will immerse all of himself – his heart, his life in love, will be consumed by it as the moth is by the flame:

THE SUFI SACRED, THE *QAWWĀLĪ* AND THE SONGS OF BOMBAY CINEMA

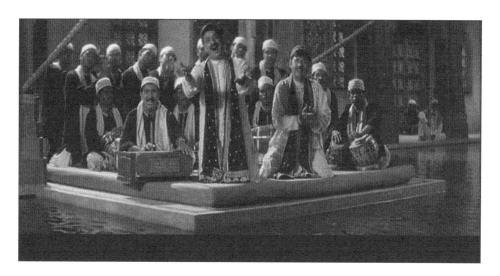

FIGURE 10.19: The *qawwāl*s – Veer Zaara.

Jān-o-dil wār dūṅ maiṅ
Zindagī hār dūṅ maiṅ
Jaise śammā par martā hai parwānā
Āyā tere dar par dīwānā.

('I have given my heart to you
I will give my life for you
As the moth dies for the flame
Your besotted lover has come to your door, O beloved.')

While the moth-flame imagery may be generic and stereotypical, it centrally evokes the affective and imaginal being of a lover-devotee who the beloved recognizes and commits to. Sensing a presence, Zaara turns around from her family almost expecting Veer, though still a little disbelieving, and as if in a trance walks towards him, much to the utter amazement and horror of her family. And while Veer and Zaara stand facing each other (Figure 10.20), the refrain '*Āyā tere dar par dīwānā*', becomes incantatory, repeating in different variations the word '*dīwānā*' ('the besotted lover who loves beyond limits'). At that point, the camera cranes up and fluidly moves down into medium close-up, and then in one movement jibs forward towards the stunned family members, and then lyrically circles in close-ups the lovers clasped in a tight embrace oblivious of their affronting of all norms. Meanwhile, the music rises to a crescendo and the lyrics reiterate the lovers' besottedness, even as their narrative seems to have taken a strange turn ('*Āyā kis mod pe*

FIGURE 10.20: Veer and Zaara – *Veer Zaara*.

afsānā'). What follows this climactic moment of the public declaration of their love by Veer and Zaara is inevitably a retributive punishment; Veer is imprisoned and the lovers are separated for 22 years. However, during this time, the two remain committed to their love and to each other. As a cinematic narrative of spiritual and emotional belongingness despite worldly severance and separation, *Veer Zaara* is thus deeply invested in overcoming geographical and psychological boundaries and uses the spiritual conception of *'ishq* to do so, which is articulated forcefully in the central *qawwālī* of the film.

The Sufi *qawwālī* is clearly an extremely charged articulation that addresses the ideological fissures of the present through its message of love. Thus, in the Islamicate imaginaries of contemporary films, the Sufi *qawwālī* evokes an entire emotional, imaginal, devotional and ideological realm that crucially generates a different set of associations about Islam from those that associate it with militancy or terrorism. Other significant examples are the <u>Kh</u>*wājājī qawwālī* sequence from Gowariker's *Jodhaa Akbar* (2008) that allegorically addresses precisely this associational flow (Bhaskar and Allen 2009: 160–62) as well as the devotional *qawwālī* '*Bhar do jholī*' ('Grant me my heart's desire, O Lord') from *Bajrangi Bhaijaan* (2015) that celebrates the miracles that faith in the Saint can bring about.

Sufi idioms and Bollywood songs

While the *qawwālī* has been a consistent feature of Bombay cinema, Sufi concepts and vocabulary have in the recent years also made an entry into more mainstream

Bollywood film song lyrics that do not have a *qawwālī* format. There are different stages and elements through which the creative influence and inspiration of Sufism can be mapped. With the widespread and international impact of Nusrat Fateh Ali Khan's music in the 1990s (Sundar 2017), as well as that of the Pakistani rock band Junoon, whose '*Bulleyā kī jānā meiṅ kaun*' ('Bullah, I know not who I am') was turned by Rabbi Shergill into a hugely popular fusion song in 2004,[15] it is not surprising that Sufi poems and ideas came to inspire and inform contemporary Bollywood film music. Again the initiative for this trend came from Nusrat Saab himself whose devotional *qawwālī* '*Dum mast Kalandar mast mast*' ('Upon my breath and in my intoxication is the great Qalander') was adapted as the hugely successful,[16] eroticized song '*Tu čīz badi hai mast mast*' ('You are intoxicating, intoxicating) from *Mohra* in 1994. Clearly the popularity of Nusrat Saab's Sufi music had impacted Bollywood, though in a completely transformed form. With him as the music composer for the film *Aur Pyaar Ho Gaya* ('And we fell in love', 1997) which also featured him singing parts of his song '*Koi jāne koi nā jāne / Yeh parwāne hote haiṅ dīwāne*' ('Some may know and others not / That lovers are besotted beings') and '*Zindagī jhūmkar muskurāne ko hai*' ('Life is meant to be danced through and lived with a smile'), Nusrat Saab's music was the new rage in Bombay. His music for Milan Luthria's 1999 film *Kachche Dhaagey* ('Fragile bonds') also featured a *dargāh qawwālī* in his voice:

Is śān-ĕ-karam kā kyā kehnā
Dar pe jo sawālī āte haiṅ.

('Can one praise enough this wonderful generosity
Of the one at whose doorstep come those looking for answers to their questions.')

Another 1999 film in which Nusrat Saab's well-known Sufi composition '*Ishq dā rutbā*' ('The distinction of love') was used in his voice as a background song was the Punjabi film, Manoj Punj's *Shaheed-e-Mohabbat Boota Singh* ('Martyr-in-love Boota Singh'), which was also repeated the same year in the Bollywood film *Kartoos* ('Cartridge').

The lyrics of Nusrat Saab's song '*Ishq dā rutbā, 'Ishq hī jāne*' ('The distinction of love, the essence of love, only the true lover will understand') express certain central ideas of Sufi thought: the idea of *'ishq* as transcending all division, the integrity and honour of *'ishq* that is a value unto itself and the yearning for and the ecstasy of union with the Beloved. These are ideas that also form the core of many iconic songs of Bollywood cinema. This overvaluation of the power of love, of its ability to inspire the strength to go beyond every obstacle, and the completely consuming nature of the quest for union with the beloved is central to the expression of 'phenomenal' human love or *'ishq-ĕ majāzī* that the romance narratives of this cinema encapsulate in their love songs. At the same time, this

dedication to the beloved is conceived in terms of a single-minded devotion to the Divine Being that *'ishq-ĕ-ḥaqīqī* ('real love') signifies. If Nusrat Saab's work was an important element of this strain in Bombay film music, the extremely popular adaptation of Bulleh Shāh's '*Tere 'ishq naćāyā kar ke thaiyā thaiyā*' by Gulzar for Mani Ratnam's *Dil Se* ('From the heart', 1998) set to a brilliant score by A. R. Rahman is another significant example of Bollywood film music's 'Sufiana' feel.

A. R. Rahman has made an important contribution to the musical experience of Sufism in Bollywood cinema. As others have also pointed out (Kibria 2016; Sundar 2017), Rahman has not only used devotional *qawwālī*s in his films, but he has also 'returned film *qawwālī*s to their sacred settings' (Sundar 2017: 144), and thus in films like *Fiza* and *Rockstar* (2011), *qawwālī*s are performed in *dargāh* spaces. And in Ashutosh Gowariker's *Jodhaa Akbar* (2008) the wonderful <u>*Khwājājī*</u> *qawwālī* in its outdoor performance creates a sacred experience of devotion (Bhaskar and Allen 2009: 160–62). But even when the songs are not shot as performed *qawwālī*s, they resonate on the soundtrack as background songs that comment on the narrative or draw out the significance of what is taking place, for example, in the Prasoon Joshi written '*Arziyāṅ*' ('Requests') *qawwālī* from Rakeysh Omprakash Mehra's *Delhi 6* (2009) or Irshad Kamil's '*Piyā mileṅge*' ('You will find your Beloved') from Aanand L. Rai's *Raanjhana* ('Beloved one', 2013).

In the past two decades of this century, the dissemination of this devotional Sufi idiom as an articulation of faith in the Lord and in the nation by Muslims, hurt by constant attacks on them by the majority community, is evident in a number of songs that are usually present as commentative background songs articulating the anguish of the community. There are several examples. Sameer Anjaan's lyrics for '*Mere Maulā karam ho karam*' ('Oh my Lord, please shower me with your blessings') for Rajkumar Santoshi's film *Khakee* ('The uniform', 2004), or Jaideep Sahni's lyrics for the song '*Maulā mere le le merī jān*' ('Oh God, take my life, it is yours') from Shimit Amin's *Chak De! India* ('Go for it! India', 2007). The latter has the following lines that articulate both the anguish of rejection and at the same time a commitment of faith:

> *Tījā terā raṅg thā maiṅ toh*
> *Jiyā tere dhaṅg se maiṅ toh*
> *Tū hī thā maulā tū hī ān.*

> ('I was your third colour
> I lived my life according to you
> You're my God and my pride.')[17]

The music director for the former example is Ram Sampath and for the latter it is Salim Sulaiman. Karan Johar's *My Name Is Khan* (2010) has music by Shankar

Ehsan Loy and the lyrics for the '*Nūr-ĕ-Khudā*' song are written by Niranjan Iyengar. The desperate anguish of the soul searching for the beneficence of the Lord is evident in these lines:

Nūr-ĕ- Khudā, Nūr-ĕ- Khudā…
Tū kahāṅ chhupā hai humeiṅ yeh batā
Nūr-ĕ- Khudā, Nūr-ĕ- Khudā
Yūṅ nā humse nazareiṅ phirā
Nūr-ĕ-Khudā.

('Oh Lord, you who are all light…
Tell us where you're hiding
Oh Lord, you who are all light
Please don't turn away from us
Oh Lord, you who are all light.')

There are several other examples, all of which are clearly indicative of the permeation of the Sufi idiom in the songs of Bollywood cinema both as devotional forms and as central to the articulations of romance.

So apart from the devotional *qawwālī*s either performed on the screen or existing as background songs and the devotional appeals to the Lord for consideration and grace by different music directors and lyricists, Sufi ideas now permeate romance songs of Bollywood as in the example from *Dil Se* mentioned earlier. The Punjabi version of Bulleh Shāh's song '*Tere 'ishq naćāyā kar ke thaiyā thaiyā*' sung by Sukhvinder for the released soundtrack of Mani Ratnam's *Dil Se* retains the following crucial lines:

Ho tere 'ishq naćāyā kar thaiyā thaiyā
Tere 'ishq naćāyā kar thaiyā.

('O Your Love has led me to dance in ecstasy
Your Love has made me dance.')

The international hit number '*Chaiṅyyāṅ Chaiṅyyāṅ*' for the film may not contain Bulleh Shāh's words, but in a general sense, Gulzar's song retains the essence of Shāh's thoughts:

Jinkey sar ho 'ishq ki chāṅv, pāṅv key nīchey jannat hogī…
…Gulposh kabhī itrāye kahīṅ, mehke toh naẓar ā jāye kahīṅ
Tābīz banā ke pehnū use, Āyāt kī tarāh mil jāye kahīṅ

Merā nagmā wahī merā kalmā wahī...
Yār misāley os ćaley, pāoṅ key taley firdaus ćaley...
...Sāri 'ishq ki chāiṅ ćal chaiṅyyān chaiṅyyān...

('He whose head falls under the shade of love, will have paradise below his feet...
...Sometimes my Beloved's coyness is so fragrant that it visibilizes her
I will wear her as my charmed amulet, may I find her as a miracle,
She is my song, my declaration of faith...
She moves like the dew, with the garden of paradise below her feet...
... Walk in the shade of Love, walk in the shadow of Love.')

Dil Se also contains, both narratively and musically, ancient Arabic literature's seven shades of love in the song '*Satraṅgi re*' that in its climactic moment metaphorically suggests and foreshadows the ending of the film with the act of *fanā*, a very important Sufi concept of annihilation of the Self in and for the Beloved, one of the stages a Sufi works towards. The complete submission and dedication to the beloved, in a context that life has no meaning, no passion, no desire other than the ecstasy of union – a union that death alone can realize, is expressed in the lyrics:

Merā jīnā junūṅ merā marnā junūṅ.
Ab iske sivā nahīṅ koi sukūṅ

('My living is an obsession with my love for you, my dying is being possessed by it
Without it I have no peace.')

Junūṅ ('obsession') is one of the seven stages of Love in Arabic Sufi thought as indicated on the DVD cover of the film.[18]

With this couplet, the song and its choreographed picturization reaches a crescendo of ecstasy with Amar, the central character like a dervish dressed in black, on his knees and his upper body whirling in an ecstatic enactment of submission. The circular camera movements, the circling of Meghna, Amar's beloved, around him as he sings passionately repeating the lines quoted earlier and the entire choreography of camera, performers and music reinforce in an evocative and resonant stylization the affect of the dissolving of the self in the Other, of *fanā*, and the core of Amar's unrequited passion for Meghna. This is reiterated in the last section of the song that repeats Ghālib's verse:

'Ishq par zor nahīṅ, hai ye woh ātish Ghālib
Jo lagāye nā lage, aur bujhāye nā bane.

FIGURE 10.21: The *fanā* image – *Dil Se*.

('Love cannot be brought under control, it is an uncontrollable fire, O Ghālib
Which can neither be lit at will nor extinguished with effort.')

Both characters are now in white, and are shot in medium close-ups as they look at each other and then, in a finale, the sequence ends with Amar's body gently laid out in Meghna's spread-out lap in a gesture of final submission of the Self to the Beloved (Figure 10.21) (also see Kabir 2003). Colour, choreographed camera and dance movements, music and the lyrics all set against an elemental landscape of earth, mountains, water and sky combine to create the feeling of some of the central tenets of Sufi thought.

In the past two decades, Bollywood songs have repeatedly drawn inspiration from Sufi poetry that the lyrics of these songs reflect. The idea of the soul wearing the colours of the Beloved, in order to express the merging of two bodies into one soul and the immersion of the Self in the Other, can be seen in several songs of contemporary Bollywood. This idea is particularly inspired by the genre of *Raṅg* ('colour') songs that have come down to the *qawwāl*s of today from the poet Amīr Khusrau that I have discussed elsewhere (Bhaskar 2018: 268–70). An extremely popular *qawwālī* of his that most *qawwāl*s, including Nusrat Fateh Ali Khan, have sung is '*Chāp tilak sab chīnī moh se nainā milāike*' ('I have lost my sense of separate being ever since our eyes have met') which contains the lines:

Apnī sī raṅg dīnī re, moh se nainā milāike…
Aisī raṅg do ke raṅg nāhīṅ chhutey,
Dhobiyā dhoye ćāhe sārī umariyā.

('You have dyed me in your colours, once our eyes met…
Colour me so that the color never fades
Even if the washerman were to wash over a whole lifetime.')

Lyricist Nida Fazli's song from Govind Nihalani's film *Dev* (2004) is clearly inspired by the *Raṅg* genre of Sufi songs:

Raṅg dīnī, raṅg dīnī … Piyā ke raṅg, Raṅg dīnī oḍhnī.

('You have coloured, have coloured … my scarf in the colours of my Beloved.')

There are other Sufi themes that have similarly inspired the songs of Bollywood cinema: the centrality of love as the only experience that gives meaning to life and for living; the desire to give up everything for devotion to love; and the fear not of death but of separation from the beloved as the only major concern of the lover. Prasoon Joshi's song from Kunal Kohli's *Fanaa* (2006):

Mere hāth meiṅ terā hāth ho
Sārī Jannateiṅ mere sāth ho
Tū jo pās ho phir kyā yeh jahāṅ
Tere pyār meiṅ ho jāūṅ fanā

('With your hand in mine,
I have all the heavens with me
When you are with me, what is the world to me
I will extinguish myself in your Love')

and Jaideep Sahni's lyrics for a song from Aditya Chopra's film *Rab Ne Bana Di Jodi* (2008) are illustrative of the point I am making:

Tū hī toh jannat merī, tū hī merā junūṅ
Tū hī mannat merī, tū hī rūh kā sukūṅ.

('You are my Heaven, you my obsession
You my prayer, you the peace of my spirit.')

It is evident, then, that in contemporary Bollywood, several music composers and lyricists are clearly inspired by Sufi ideas. Two songs of Niranjan Iyengar's for Karan Johar's *My Name Is Khan* are good examples: '*Tere nainā*' ('Your eyes') and '*Terā Sajdā*' ('My worship of you'), which has the following lines:

Sajdā ... terā sajdā
Din rain karūṅ
Nā hī ćain karūṅ
Ab jāṅ lūt jāye
Yeh jahāṅ chūt jāye
Sang pyār rahe maiṅ
Rahūṅ na rahūṅ
Beliyā...
'Ishq meiṅ Khudā mil gayā.

('My worship, my worship of you
Will last day and night
Will never rest
Now even if my life is lost
Or I lose this world
But my love will be with you
Whether I live or not
My beloved ...
In Love I have found God.')

Prasoon Joshi's lyrics of Rensil D'Silva's song '*Shukrān Allāh*' ('Praised be the Lord') for the film *Kurbaan* ('Sacrificed', 2009) also celebrates the uplifting, almost divine quality of the love that unites the two lovers, evident in the following lines:

Nazroṅ se nazreiṅ milīṅ toh
jannat sī mehkī fizāyeiṅ...
Aisī apnī mŏḥabbat, aisī rūh-ĕ-ibādat
Hum pe meḥerbāṅ do jahāṅ.

('When our eyes met,
the breeze was fragrant as paradise...
Such is our love, such our soul's worship
That the grace and blessings of the two worlds are on us.')

It is also important to point out that the composers and lyricists of these songs are not all Muslim and that Sufi ideas like those of *Bhakti* traditions are culturally integral and valued ideals in India. The examples given here do not use the lyrics of Sufis like Bulleh Shāh, Bābā Farīd, Shāh Hussain or others; neither are they adaptations of the poems and songs of the Sufi poets like the 2007 Emraan Hashmi starrer *Awaaraapan* ('Vagrancy') directed by Mohit Suri, which features '*Maulā Maulā*' using lyrics from Bābā Farīd's '*Mendā 'ishq vī tū, mendā yār vī tū*' ('You are my Love; you are my Beloved'), or Neeraj Pandey's *A Wednesday* (2009) which on its released soundtrack carried '*O Bulleh Shāh*', adapted by Irshad Kamil from a poem by Bulleh Shāh. The lyrics quoted above reflect a different trend. They demonstrate the deep impact of Sufism and Sufi thought on the imagination and realization of love on the screen. While the narratives of these films may or may not really articulate the mystic Sufi journey of the soul's quest for ultimate union with the Divine,[19] the metaphors of phenomenal human love – passionate, romantic and erotic in nature – that Sufi poets used to express this quest are sacralized in the process and evoke the 'qualitative affect of Real love' or '*ishq-ĕ ḥaqīqī* for the expression of human love. The deepening and intensification of the emotion of love, the intoxicating quality of its passion and the delirious stagings of self-immersion in the spirit of the Beloved that the last line of the '*Satraṅgi re*' song discussed earlier indicates – '*Terī rūh meiṅ jism ḍubone de*' ('Let me immerse myself, my body in your soul') – can be seen to have been directly inspired by Sufi poetry and mysticism.

While the quality of the affect that these songs generate is comparable in feeling, in thought content and a certain uplifting quality which is central to the expression of love in Sufi poetry and music, the techno beats, and rock and fusion forms, together with their picturizations, demonstrate a marked difference from the work of older Sufi musicians. The success of the Pakistani band Junoon, and the work of Rabbi Shergill mentioned earlier, and more recently of Pakistan's Coke Studio renditions of *qawwālī*s and other Sufi-inspired music are closer to the qualitative realization on screen of the Bollywood songs discussed here and may well have inspired a new kind of 'Sufiana' feel to contemporary Bollywood film songs that certainly seem to be responding to the changed rhythmic and lyrical vocabulary of the global music scene.

Natalie Sarrazin has pointed to the emergence of the ethno-techno movement to explain the recent *qawwālī* reincarnations as techno-*qawwālī*s which have substituted 'traditional instrumentation with synthesizers, hyped-up bass and other sampled sounds' such that the techno-*qawwālī*s that we see on screen today have a 'modernizing pulse-like enhancement of the rhythmic line' and '*zikr*-like repetition'

from 'newly exploited globalized trance folk rhythms' (2014: 194). A number of the songs mentioned earlier, including the '*Ishq dā rutbā*' song from *Kartoos* and the '*Chaiṅyyāṅ Chaiṅyyāṅ*' and '*Satraṅgi re*' songs from *Dil Se* are examples of the techno-*qawwālī*s that Sarrazin has explained. Furthermore, they seem to deploy a 'remix aesthetic' (Duggal 2010), bringing together popular musical percussion and melodic forms and rhythms as well as a visual aesthetic and *mise en scène* that combine a highly postmodern fragmented editing pattern and associative flow that has been popular in music videos from the 1990s onward. At the same time, songs like '*Māhi ve, mŏḥabbatāṅ saćiyā ne*' ('O my Beloved, my love is true') from Sanjay Gupta's *Kaante* ('Thorns', 2002) and '*Tū hī dīwāngī, tū hī āwārgī, Rabbā merey tū hī merī zindagī / Taubā taubā, 'ishq maiṅ kariyāṅ*' ('You are my madness, You my wandering, O Lord you are my life / O blasphemy, blasphemy, I do and will love') from Shoham Shah's *Kaal* ('The time of doom', 2005) with their eroticized disco dance movements, visually represent a quality that cannot be associated with Sufism while the lyrics certainly reference Sufi ideas. Evocations of a discotheque experience, clothes inspired by haute couture and a *mise en scène* of the club and the stage are strangely disjunctive from Sufi experience and seem to move in a direction completely the opposite of what the lyrics suggest. The kinetic, visual and aural pleasure that these songs offer is what Sarrazin has characterized as 'hedonistic sexualized fantasy', which paradoxically 'seem to allow the simultaneous consumption of both pleasure *and* devotion' (2014: 195, 197, original emphasis). How much of the original devotional and sacred affect of traditional *qawwālī*s do these Bollywood *qawwālī*-inspired songs retain? And is the consumption of eroticized spectacles of desire the only significance of the music videos and albums of these songs that have a different life from that of the films in which they were first present? While clearly there is a literalization of the erotic resonances of Sufi poetic idioms in these songs, there is another dimension worth paying attention to. The circulation of Sufiana music, thoughts and emotions and their popularity perhaps demonstrate significant aspects of the contemporary moment: the plural nature of the religious traditions of South Asia, and the acceptance and provenance of aural, emotive and the thought content of popular cultural and religious practices like Sufism that are deeply counterposed, in a widespread cultural sense, to the fundamentalist agendas of different communal projects (Manuel 2008). In these disenchanted and violent times, the miraculous connections with the powerful source of Life, and the celebrations of Love, human and divine that Sufi-inspired Bollywood songs articulate enable an enchanting, ecstatic experience, an intensification and uplifting of the spirit that is inspirational and extremely valuable, and accounts for the power and popularity of these forms.

ACKNOWLEDGMENTS

This chapter develops arguments that were first made in *Islamicate Cultures of Bombay Cinema* which I co-authored with Richard Allen. I would like to thank Richard Allen for his comments on an earlier draft of this chapter. I would also like to thank Sudhir Kapur and Swara Bhaskar for conversations about the cine *qawwālī*, and Sandeep Singhal and Ravinder Singh for their help with the images for the chapter. Unless otherwise indicated, translations of the lyrics are mine.

NOTES

1. In a significant essay, Rosie Thomas analyses *Lal-e-Yaman* as J. B. H. Wadia's experimentation with and exploitation of 'the new potential of sound, using it in innovative ways to represent the powers of truth and God'. She explores the film as engaging deeply with 'the power of the voice – and its divinity' (2014: 67) through the miraculous powers of the Sufi figure which metaphorically also indicates the value of sound for cinema.

2. The *Bhakti* tradition refers to the various cults of personal devotion to chosen gods and goddesses. Beginning from the eighth and ninth centuries in South India, the movement coalesced around certain male and female saint figures who were devotees of Hindu gods and goddesses. *Vaishnavism* (cults around the worship of Vishnu and his incarnations), *Shaivism* (the worship and devotion of Shiva) and *Shakti* or different goddess cults were dominant *Bhakti* cults. Devotional poetry, sometimes of an erotic nature, composed by saint figures in the vernacular as opposed to the classical Sanskrit was a defining and popularizing feature of this movement. In the early twentieth century the *Bhakti* saints were used by nationalist leaders for their anti-colonial struggle against the British. In the 1930s a number of films on the lives of these saint figures formed a subgenre known as the Devotionals. See Bhaskar (1998).

3. I am thankful to Sudhir Kapur for these references. *Sitamgar* is a Ranjit Movietone film that was destroyed. However, there is a reference to this *qawwālī* in Hamraaz's *Hindi Film Geetkosh* (vol. I, p. 172) which lists this song as a *qawwālī* and attributes it to the writer Betaab. Similarly, the *Shareef Daku qawwālī* is also listed in this volume of the *Hindi Film Geetkosh* (p. 438) as a *qawwālī*. This film too does not exist. The song listings and other details in the *Geetkosh* volumes are from the song booklets of these films that have been accessed by Hamraaz (1988).

4. *Sajde meṅ hai sar, tujh par hai naẓar ...*
 Āye haiṅ kisī umeed se ham, jab tū hai hamārā phir kyā gham
 Woh bāt bhalā kyā bigdegī, jo bāt yahān tak ā pahuṅchi.

 ('The head is bowed in obeisance to you, the gaze is fixed upon you for deliverance...
 We have come to you in hope, why worry when you are ours
 How will our concern be betrayed when the matter has been placed at your door.')

5. Apart from the Jama Masjid in Delhi, which is a mosque, all the other examples here are of *dargāh*s that are shrines of popular Sufi saints of the Chishtī order. The shrine

of Garīb Nawāz refers to the tomb of Moinuddīn Chishtī who came from Iran in the thirteenth century, travelled all over North India and finally settled in Ajmer, Rajasthan. Muḥammad Niẓāmuddīn Auliyā, known as Haẓrat Niẓāmuddīn, was the spiritual guide of Amīr Khusrau. His *dargāh* in Delhi is a living shrine where performances of *qawwālī*s take place every Thursday even today.

6. Two traditions are being referenced here: the *qawwāl* who sings the *qawwālī* performs in a *dargāh*, a shrine of Muslim saints; and the *pandit* performs rituals in a Hindu temple. Here, they both sing a *qawwālī* together.

7. This is a paraphrase of the words of this *qawwālī*.

8. Sudhir Kapur has pointed out other examples from Hamraaz's (1980, 1988) *Geetkosh* volumes that deserve further exploration. For example: '*Nabī ke chāhne wāle nīralī shān rakhte haiṅ*' ('Those who love the Prophet have a unique glow') from the film *Awaara Shehzaadi* ('The vagrant princess', 1956) (vol. III, p. 274); '*Bājooz tumhāre kahūn kis se ya Gharīb Nawāz*' ('Who else except you, O Gharīb Nawāz should I say this to') from the Muslim Devotional film *Dayaar-e-Habib* ('The abode of the Beloved', 1956) (vol. III, p. 287). Yousuf Saeed (2010) has indicated the proliferation of depictions of Muslim piety in the period that followed the 1960s in the subgenre of the Muslim Devotional films, and the *qawwālī* is integral to these films as can be expected. My own encounter with a Muslim Devotional film *Khwaja ki Diwani* (1981) revealed the use of three well-known devotional *qawwālī*s performed at *dargāh*s that the film uses – the titular '*Khwājā kī dīwanī*', '*Maulā Alī Maulā*' and '*Tajdār-e-haram*' all of them well-known examples of non-filmy *dargāh qawwālī*s reinterpreted and recomposed for the cinema.

9. *Bhakti* and Sufi saints have always been associated with the performance of miracles like the healing of the sick or, as in *Amar, Akbar, Anthony* (1977), with the miraculous return of sight to the blind mother of the eponymous heroes at the *dargāh* of the Shirdi Sai Baba while unbeknownst to her, her youngest son sings praises of the Saint. Here I am discussing the miracle of '*ishq* as realized in cinema with a mobilization of space, the song, camerawork and performance.

10. The love story of Majnūn and Lailā is of Arabic origin and passed from Arabia to Persia, Turkey and South Asia. It was recreated in the different languages of these regions, the most famous renderings being the Persian Niẓāmī version from 1188 and the Amir Khusrau version believed to have been completed in 1299. Qais and Lailā are childhood sweethearts who are prevented by their families from being together. Qais is so obsessed with Lailā that he wanders the desert chanting her name, thus inviting the epithet *majnūn*, meaning 'mad' or 'possessed'. Majnūn is also seen in Sufi practices as the possessed devotee questing union with the Divine. Apart from different cinematic renderings of the tale, the figurations of the two lovers has been extremely influential in the conception of lovers in Bombay and Bollywood cinema. See Roy (2015: 56–84).

11. The lyrics of this *qawwālī*.

12. *Alāp* is the opening section of an Indian classical music performance in which the raga structure is introduced in a melodic but unmetred improvisation.

13. This is a well-known line from the <u>Khusrau</u> *qawwālī* composition; *Chāp Tilak sab chīnī moh se nainā milāike*' ('I have lost my sense of myself and my identity after locking gazes with you'). See Sunil Sharma's translation of this verse (2006: 77).

14. The references are to the eternal love story of Krishna and Radha, to the Hindu epic *Rāmāyaṇa* that narrates the exile and subsequent separation of Lord Ram from his wife Sita, to Mira, the devotee of Krishna, who had to face the hostility of her family that was against her love for Lord Krishna, and to the story of love-in-separation of Lailā and Majnūn.

15. Well-known composition by the eighteenth-century Sufi saint Bulleh Shāh from Punjab.

16. Qalandars belonged to the Qalandarīya Sufi order as opposed to the Chishtī order Sufis I have discussed earlier, and Jhoole Lal is one of the popular Sufi saints of the Qalandarīya order.

17. This translation of the song lyrics is from https://www.filmyquotes.com/songs/376. Accessed 19 January 2020. It is interesting that the Sufi devotional song is here addressed to India – the nation whose third colour is green, the colour of Islam. The song is articulating the feelings of the Muslim protagonist who faces humiliation by the community he lives in and by the nation, even though he has lived as an Indian and is an integral part of the country. These lyrics are particularly relevant in the contemporary context of majoritarian Hindu right-wing ascendancy and the constant attack on Muslims – both physically and ideologically – in the years since power has shifted to the ruling Hindu majoritarian party, the BJP.

18. According to Arabic literature, Love has seven different shades. The DVD cover of the film announces *Dil Se* as a journey through the seven stages of love: '*Hub* – attraction; *Uns* – infatuation; *Ishq* – love; *Aquidat* – reverence; *Ibaadat* – worship; *Junoon* – obsession; *Maut* – death' (also *fanā*).

19. Most of the examples I have discussed of lovers dedicated to each other actually embody Sufi concepts of love and worship, for example, in *Mirza Ghalib*, *Shirin Farhad*, *Barsaat ki Raat*, *Veer Zaara* and *Dil Se*. However, there are other films in which the narrative does not realize the essence of the Sufi-inspired concept of love that the lyrics of the song articulate. A recent film, Milan Luthria's *Baadshaho* (2017), uses a Nusrat Fateh Ali *qawwālī*, '*Mere rashke qamar*' ('My enviable moon'), an intensely passionate love song which the narrative about the betrayal of love by the beloved does not actually demonstrate. I would like to thank Swara Bhaskar for first drawing my attention to this song. There are several others, two of which I mention here: '*Māhī ve, mŏḥabbattāṅ sachiyā ne*' ('O my Beloved, my true love') from *Kaante* (2002) and '*Tū hī dīwānagī, tū hī āwārgī, Rabbā merey tu hī merī zindagī / Taubā taubā, 'ishq maiṅ kariyāṅ*' ('You are my madness, you my wandering, O Lord you are my life / O blasphemy, blasphemy, I do and will love') from *Kaal* (2005).

REFERENCES

Bhaskar, Ira (1998), 'Allegory, nationalism and cultural change in Indian cinema: *Sant Tukaram*', *Literature and Theology*, 12:1, March, pp. 50–69.

Bhaskar, Ira (2012), 'Emotion, subjectivity, and the limits of desire: Melodrama and modernity in Bombay cinema, 1940s–'50s', in C. Gledhill (ed.), *Gender Meets Genre in Postwar Cinema*, Urbana, Chicago and Springfield: University of Illinois Press, pp. 161–76.

Bhaskar, Ira (2018), 'Expressionist aurality: The stylized aesthetic of *bhava* in Indian melodrama', in C. Gledhill and L. Williams (eds), *Melodrama Unbound across History, Media, and National Cultures*, New York: Columbia University Press, pp. 253–72.

Bhaskar, Ira and Allen, Richard (2009), *Islamicate Cultures of Bombay Cinema*, New Delhi: Tulika Books.

Duggal, Vebhuti (2010), 'The Hindi film song remix: Memory, history, affect', unpublished M.Phil. dissertation, New Delhi: Jawaharlal Nehru University.

Dwyer, Rachel (2007), *Filming the Gods: Religion and Indian Cinema*, Indian reprint, London and New York: Routledge.

Hamraaz, Harmandir Singh (1980), *Hindi Film Geet Kosh: 1951 to 1960*, vol. III, Kanpur and Delhi: Artico & Delight Press.

Hamraaz, Harmandir Singh (1988), *Hindi Film Geet Kosh: 1931 to 1940*, vol. I, Kanpur and Delhi: Artico & Delight Press.

Kabir, Ananya Jahanara (2003), 'Allegories of alienation and politics of bargaining: Minority subjectivities in Mani Ratnam's *Dil Se*', *South Asian Popular Culture*, 1:2, pp. 141–59.

Kibria, Shahwar (2016), 'The Sufi qawwālī in contemporary South Asian popular culture', unpublished M.Phil. dissertation, New Delhi: Jawaharlal Nehru University.

Manuel, Peter (2008), 'North Indian Sufi popular music in the age of Hindu and Muslim fundamentalism', *Ethnomusicology*, 52:3, pp. 378–400.

Morcom, Anna (2007), *Hindi Film Songs and the Cinema*, Hampshire, England: Ashgate.

Nandy, Ashis (2003), 'An anti-secularist manifesto', in A. Nandy (ed.), *The Romance of the State and the Fate of Dissent in the Tropics*, New Delhi: Oxford University Press, pp. 34–60.

Pandey, Gyanendra (1990), *The Construction of Communalism in Colonial North India*, New Delhi: Oxford University Press.

Panjabi, Kavita (ed.) (2011), *Poetics and Politics of Sufism & Bhakti in South Asia: Love, Loss and Liberation*, New Delhi: Orient BlackSwan.

Qureshi, Regula Burckhardt (1986), *Sufi Music of India and Pakistan: Sound, Context and Meaning in Qawwālī*, Cambridge: Cambridge University Press.

Roy, Anjali Gera (2015), *Cinema of Enchantment: Perso-Arabic Genealogies of the Hindi Masala Film*, Delhi: Orient BlackSwan.

Saeed, Yousuf (2010), 'Muslim piety in Bombay cinema and video/TV media', an unpublished documentation report for the Margaret Beveridge Senior Research Fellowship offered by the James Beveridge Media Resource Centre, Jamia Millia Islamia.

Saeed, Yousuf (2016), 'Introduction to Sufi literature in North India: Focus on Chishtiyah and related orders', Sahapedia, 14 June, https://www.sahapedia.org/introduction-sufi-literature-north-india. Accessed 12 January 2019.

Sarrazin, Natalie (2014), 'Devotion or pleasure?: Music and meaning in the celluloid performances of *qawwālī* in South Asia and the diaspora', in K. Salhi (ed.), *Music, Culture and Identity in the Muslim World: Performance, Politics and Piety*, London and New York: Routledge, pp. 178–99.

Shackle, Christopher (2007), 'The shifting sands of love', in F. Orsini (ed.), *Love in South Asia: A Cultural History*, New Delhi: Cambridge University Press India Pvt Ltd, pp. 87–108.

Sharma, Sunil (2000), *Persian Poetry at the Indian Frontier: Mas'ûd Sa'd Salmân of Lahore*, Delhi: Permanent Black.

Sharma, Sunil (2006), *Amir Khusraw: The Poet of Sultans and Sufis*, Oxford: Oneworld Publications.

Singh, Madan Gopal (2008), 'From the diary of an occasional singer: Sufi music of our times', *Communalism Combat*, 15:134, https://www.sabrangindia.in/breaking-barriers/diary-occasional-singer. Accessed 7 March 2010.

Sundar, Pavitra (2017), 'Romance, piety, and fun: The transformation of qawwālī and Islamicate culture in Hindi cinema', *South Asian Popular Culture*, 15:2, pp. 139–53.

Thomas, Rosie (2014), 'Distant voices, magic knives: Lal-e-Yaman and the transition to sound in Bombay cinema', in R. Thomas (ed.), *Bombay before Bollywood: Film City Fantasies*, New Delhi: Orient BlackSwan, pp. 66–91.

Zuberi, Irfan and Sarrazin, Natalie (2017), 'Evolution of a ritual musical genre: The adaptation of *qawwālī* in contemporary Hindi film', in J. Beaster-Jones and N. Sarrazin (eds), *Music in Contemporary Indian Film: Memory, Voice, Identity*, New York: Routledge, pp. 162–75.

11

Avoiding Urdu and the *Ṭawāʾif*: Regendering Kathak Dance in *Jhanak Jhanak Payal Baaje*

Philip Lutgendorf

With this film, his first foray into technicolour [sic], Shantaram proves that you can turn to your own culture and come up with a superb, engrossing, thought-provoking and well crafted film. Jhanak Jhanak Payal Baaje *is a film which propogates [sic] that India must preserve her artistic purity and not be swayed by 'westernization'. The film is a tribute to the Classical Dances of India.[1]*

(Bali 2019)

Love, hate and the Islamicate

In the growing scholarly literature on Indian popular cinema, two provocative essays have addressed a particularly central but neglected aspect of the Bombay (Mumbai) film: its language. Both Mukul Kesavan's 'Urdu, Awadh and the tawaif: The Islamicate roots of Hindi cinema' and Harish Trivedi's 'All kinds of Hindi: The evolving language of Hindi cinema' make important contributions to an appreciation of the verbal, poetic and rhetorical dimensions of Hindi film, to which I have also referred in posing the question: 'Is there an Indian way of filmmaking?' (Kesavan 1994; Lutgendorf 2006; Trivedi 2006). Kesavan made a pioneering contribution to the study of (what is commonly termed) 'Hindi' cinema by boldly arguing for the centrality of its 'Islamicate' dimension, especially as it is manifested through verbal codes. He may also have overstated his case, and Trivedi, in what is essentially a response to his essay, rightly complicated the picture by highlighting the linguistic complexity of Bombay film dialogue: the number

of speech registers and dialectal variants that it routinely utilizes, the different kinds of narrative and ideological work performed by each and especially the prevalence of what sociolinguists call 'code-switching' between registers.

Of course, any discussion of linguistic conventions in this industry must contend with the basic slipperiness of the Hindi/Urdu distinction and indeed with the problem of whether, when and under what circumstances these are really two languages at all – a complicated, emotional and politically charged topic that has itself generated a good deal of scholarship (e.g. King 1994; Rai 1984; Rai 2001). The presence of dual vocabulary, drawn respectively from the enormous lexicons of Sanskrit and other indigenous South Asian languages on the one hand and from Arabic, Persian and Turkic languages on the other, provides knowledgeable North Indians with a range of word-choice options for both everyday objects and abstract concepts. Highly Sanskritized *śuddh* ('pure, refined') Hindi of the sort promulgated by the government of India since 1947 and used in its official publications and signage as well as in newspapers and school curricula is routinely said to be 'incomprehensible' to many people and is often made the butt of jokes in films – for example, in Hrishikesh Mukherjee's 1975 comedy *Chupke Chupke* ('On the sly'), in which a university professor posing as a wealthy family's chauffeur astonishes his employer with his exaggeratedly formal, *paṇḍit*-like diction. At the same time, this language can have an exalted effect in Hindu religious contexts or when used to invoke the imagined 'classical' culture of pre-Islamic India, just as *khālis* (again, 'pure', 'unadulterated') Urdu, embellished with Persian words and idioms of the kind famously uttered in K. Asif's *Mughal-e-Azam* ('The great Mughal', 1961), may evoke orthodox Muslim practices or the ethos and culture of precolonial Islamicate courts.[2] And whereas Perso-Arabic derived words, as Kesavan correctly observed, predominate in cinema for the all-important topic of romantic love, they may also carry a 'secular' ring that, in certain contexts, evokes decadence and moral opprobrium – in part, the legacy of a long campaign of linguistic 'ethnic cleansing' in which the advocates of Sanskritized Hindi portrayed their favoured language as a chaste Hindu maiden and the rival tongue of Urdu as a lascivious 'kept woman', indeed, as a *ṭawā'if* or Islamicate courtesan (King 1994: 136–37).

It is this bifurcation, within a post-Partition India culturally dominated by a Hindu elite and middle class, between a (supposedly) 'pure' and 'spiritual' Hindi (and by implication, upper-caste Hindu culture) and a 'decadent' and 'worldly' Urdu (and the ostensibly debauched Muslim and Islamicate nobility who once patronized it) that I wish to examine in relation to a single influential film that celebrates North Indian 'classical' dance. By examining the film's narrative, as well as its linguistic registers and the visual codes of its *mise en scène*, I will argue that it powerfully evinces what may be termed the 'love-hate' relationship of the Hindu

intelligentsia of the immediate post-Independence decades towards the legacy of Islamicate courtly culture: a mixture of attraction and repulsion that is addressed, in the film, through an allegorical and gendered narrative of 'purification' (*śuddhi*, a term also used by some modern Hindu leaders to refer to the desired reconversion to Hinduism of low-caste converts to Islam and Christianity). It also parallels an ideologically and (in certain contexts) communally charged discourse about 'Indian' music and dance that evolved during late colonial times but that has remained influential throughout the post-Independence period.

Kesavan's essay title succinctly announces three categories of Islamicate influence on which he focuses: first, the Perso-Arabic vocabulary that pervades much Hindi cinema dialogue and lyrics, especially when they deal (as they so often do) with love; second, the fascination with the decadence of post-Mughal and colonial rentier culture, especially that of Awadh – here a 'love-hate' response is readily apparent in such films as Guru Dutt's 1962 *Sahib Bibi aur Ghulam* ('Master, wife and servant') and Ray's 1958 *Jalsaghar* ('The music room'), both of which Kesavan cites; and third, the similarly ambivalent fascination with the *ṭawā'if*, the courtesan or public woman, manifest in classic films such as Kamal Amrohi's 1971 *Pakeezah* ('The pure one') and Muzaffar Ali's 1981 *Umrao Jaan*. I would add a fourth dimension: a visual one based on the *mise en scène* and reflected in details of set design, costume and body language. This dimension is likewise hinted at by Kesavan in his remark about 'onion domes and scalloped arches', on the one hand, and 'trabeate forms and gopurams', on the other, as cues to, respectively, 'Islamicate' and 'Hindu' visual codes (1994: 245). The film I shall now consider references all four of these dimensions, albeit sometimes obliquely.

Jhanak Jhanak Payal Baaje

Jhanak Jhanak Payal Baaje ('The ankle bells sound', hereafter abbreviated, adopting recent Indian-English journalistic practice, as *JJPB*), directed by Rajaram Vankudre Shantaram (better known as V. Shantaram [1901–1990]), was an influential 1955 film that has been little discussed in the burgeoning scholarship on popular Hindi cinema. A massive hit that achieved both critical and popular acclaim, *JJPB* reportedly ran for two years in one Bombay cinema hall, won four Filmfare awards in 1956 (including Best Picture and Best Director) and, more significantly for my purpose, received special recognition from the government of India in the form of the President's Gold Medal (1955) – a gesture reserved, at the height of the comparatively film-unfriendly Nehru era, for motion pictures that were thought to be especially edifying, conducive to 'national integration' or that projected a favourable portrait of India overseas (Satyajit Ray's *Pather Panchali*,

'Song of the road', would receive it in 1956, and Mehboob Khan's *Mother India* in 1957). The film was sufficiently well known to have a key scene mordantly parodied four years later in one of the climactic sequences of Guru Dutt's *Kaagaz ke Phool* ('Paper flowers', 1959),[3] and many of its songs have remained 'evergreen' favourites. Yet *JJPB*, albeit Shantaram's biggest commercial success and a major boost to his Rajkamal Kalamandir Studio, seems to be regarded, by academic film scholars today, as something of an embarrassment in the oeuvre of a director who is more approvingly remembered for the earlier black and white films he directed for Prabhat Studios of Pune, such as *Amrit Manthan* ('Churning of the ocean', 1934) and *Aadmi* ('Man', 1939, also made in Marathi as *Manoos*). The *Encyclopaedia of Indian Cinema*, which offers brief and admiring reviews of both these films, does not devote an entry to *JJPB*, mentioning it only in Shantaram's biographical note as one of his later works that presented 'degraded versions of the classical arts' (Rajadhyaksha and Willemen 1999: 214).[4] This low assessment may reflect the film's embarrassingly mannered acting, garish sets and ideological heavy-handedness – for all of which (and especially the last) I think it deserves a closer look.

Even if not the first Indian effort in Technicolor, *JJPB* is a film inventively smitten with the visual possibilities of this new format. It won a Filmfare award for art director Kanu Desai and remains justly celebrated among fans today for its hyperbolically colourful sets and costumes. The film unfolds in a fantasy world of vague geographic and temporal location that hovers somewhere between a 'timeless India' of temples and courtly homes lit by candles and oil lamps, and an urban 'modernity' signalled by electric-lit theatre marquees and large foreign automobiles. Even when well-known contemporary landmarks are shown – most notably, during one famous dance sequence, the Brindavan Gardens near Mysore, an 'all-India' tourist destination often represented in twentieth-century postcards and travel posters – the film delights in rendering them in a surreal mode: the gardens' water courses and fountains are injected with dyes so that, as the story's featured pair of lovers dances past them, their waters morph into cascades and jets of fuchsia, yellow and cyan.

Jhanak Jhanak Payal Baaje is above all remembered as a film that glorifies Indian dance and its performers – especially the tradition of Kathak, the North Indian style now regarded as comprising one of the six (or, by some counts, eight) 'classical schools' of dance. Indeed, *JJPB* has been called (in a dissertation on Kathak dance in Hindi cinema) 'the most important film in the category of the Dancer genre' and cited as 'important not only for being the first Technicolor film [*sic*], but also for presenting one of India's classical arts to the masses' (Clark 1997: 115, 116–17). Similar assessments have appeared in a number of internet film reviews (such as the one cited at the beginning of this chapter) and reflect, as

I will argue, the film's success in presenting an allegorized and popularized enactment of a master narrative about cultural history. This narrative developed during the late colonial period and became canonical by the time of Independence; only recently have scholars begun to question it and to reconstruct the history that it has effectively suppressed in a process with both gendered and communalist overtones, and that reflects popular attitudes towards Islamicate cultural forms in South Asia. The ideological thrust of the film can be delineated through an examination of its opening and closing scenes, and I will briefly focus on these.

JJPB opens with an innovative sequence that juxtaposes the film's credits with a pair of dancing feet, their ankles wrapped in bands of the small, clustered bells (known as *pāyal* or *gūṅgharū*) worn by all Indian dancers, to whose jangling sound, used to provide additional percussive effect in performances, the film's onomatopoetic title refers. The credits are rendered in neat squares as art-deco variants of *sāñjhī* or *raṅgolī* – traditional, coloured-powder ritual designs that many Hindu women draw on the ground in front of their thresholds or in temples during festivals – and are given in both Roman and (uncommonly) Devanagari characters but not in Urdu's *nasta'līq* script (Figure 11.1).[5] This ingenious sequence, accompanied by the title song, establishes the film's vibrant colour palette and confirms that its plot will focus on dance even as it projects a Hindu and 'classical' tone.

The final credit frame fades into a close-up of a poster, likewise in Devanagari script, showing a dancing woman in a pair of loose pyjamas and a *colī* ('short blouse') holding an upraised tambourine and announcing a performance by 'the female pupil of *Bhārat Naṭrāj* Mangal Maharaj Banarsi; Rupkala, on stage for the first time!' The poster is torn down by an irate old man (Keshavrao Date) wearing a *caubandī* – a traditional upper garment – whom we soon learn to be Mangal Maharaj himself (Figure 11.2). For when the theatre manager, a middle-aged man

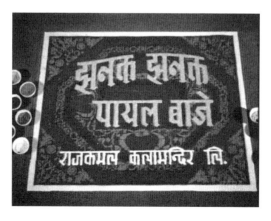

FIGURE 11.1: The film's title credit (*Jhanak Jhanak Payal Baaje*, Rajkamal Kalamandir Ltd., 1955). Film still.

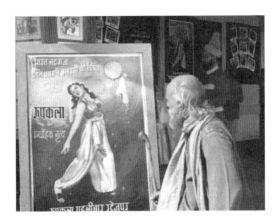

FIGURE 11.2: Mangal Maharaj confronts Rupkala's poster in *Jhanak Jhanak Payal Baaje* (*JJPB*).

in a western-style suit and astrakhan hat, threatens to have him arrested, the old man cries: 'Arrest this shameless woman (*beśaram aurat*), this Rupkala! She performs obscene dance (*aślīl nāc*) and calls herself the student of Mangal Maharaj. *My* student? She is dishonoring my name!'

He continues to make a fuss as Rupkala herself arrives in a massive American sedan, beautifully dressed and adorned, and is quickly whisked away by the manager, who has the old man ejected from the theatre entrance by a uniformed guard. As he leaves, Mangal Maharaj continues to fume at the obviously uncomfortable Rupkala: 'What a whore! (*kañcanī kahīṃ kī*) Giving the *gurukul* ("school", but literally "teacher's family") a bad name, she offers herself for money!' As the teacher and his young pupil – who is soon revealed to be his son, Giridhar ('mountain-bearer', an epithet of Krishna, as is the name of the actor who played him: 17-year-old Gopi Krishna in his screen debut) – stride through the city streets, they see more of the offensive posters, and when they tear down yet another, the camera tracks into the arabesque-carved screen window that it covered, revealing the interior behind it.

This is an opulent, pastel-tinted hall in Islamicate style, with late-Mughal cusped arches and ornate columns, Lakhnavi-style crystal chandeliers, carpeted seating areas with bolster pillows, tall brass flower vases and alcoves covered by transparent draperies (Figure 11.3). Musicians playing ṭabla, *sāraṅgī* and other instruments sit to either side of a central area, and attractive, well-dressed young men and women lounge about as spectators while a dance performance unfolds. The richly adorned danseuse, soon to be introduced as Neela Devi (played by Sandhya, director Shantaram's third wife), sings a brief, non-verbal *ālāp* before launching into a lively performance of the song '*Kaisī yĕh mŏḥabbat kī sazā*'

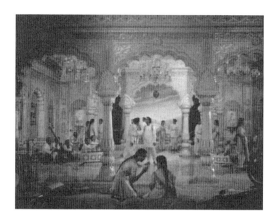

FIGURE 11.3: Neela's mansion in *JJPB*.

('What punishments of love are these?'), a conventional lament about the sufferings of unrequited passion, replete with stock images from Urdu *ghazal* poetry, such as the moth that is irresistibly and fatally attracted to the flame of a candle. One verse declares:

> My heart wastes away, I gasp for air,
> I toss and turn all night.
> Someone has put me in this state today –
> what punishments of love are these?

The performance style is anything but morose, however, and the performer's coquettish glances and gestures (*nakhre*, *adā*) and spirited footwork and turns suggest an ironic take on the lyrics: a passion that is itself a pose, a victim-stance that seductively challenges the supposed tormentor (Figures 11.4 and 11.5). The camera repeatedly cuts between the dancer's heavily made-up face, pouting playfully, and the screen window, which frames the eyes of the two men outside who gaze intently at her. Are they, too, being seduced by the saucy performance?

Although answering this question will, in a sense, occupy the rest of the film's 2 hour and 23 minute running time, the immediate response is a resounding 'no!' For, when the performance ends with loud applause and cries of '*Vāh, vāh!*' ('fantastic, great!') from the spectators inside the mansion, its outer doors burst open and the two voyeurs burst in. This time, it is young Giridhar who delivers an angry, denunciatory speech: 'Say "Woe, alas!" You say " *Vāh, vāh!*" to such cheap, commercial dance (*bāzārī nāc*)? Such affected swaying is called "dance" (*nṛtya*)? It has no dignity or classical basis!'

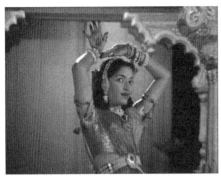

FIGURE 11.4 and 11.5: Neela performs, as Mangal Maharaj and Giridhar watch from outside in *JJPB*.

When the tabla player (who is evidently the young woman's teacher) challenges the irate young man to do better, the latter ties on ankle bells and engages in a rhythmic duel (*jugalbandī*) with the percussionist, leaping about the hall and finally invading the musicians' own seating area to provocatively sound his *gūṅgharū* in their faces; the brief performance – watched intently by Neela – ends in his triumph. And when, to the accompaniment of his father's impromptu *pakhāvaj* (double-headed drum) playing and singing, he performs a 'salute to the guru' (*guru-naman*) involving leaps and slides, all present are amazed, especially the young female dancer. 'This', says the old man proudly, 'is what is called *nṛtya*; *this* is the true art of dance!' He and his perspiring but triumphant son then depart the premises in disgust. After they leave, the old man's identity is revealed by an onlooker, and the assembled musicians bow their heads in reverence – for the great dancer Mangal Maharaj is known by them to bear the title (previously announced in the theatre poster) of *Bhārat Naṭrāj* ('king of Indian dancers') and to be famed 'throughout the country'. Neela, awestruck and lamenting that she has thus far only learned crude *bāzārī nāc*, castigates her own teacher and resolves to become Mangal Maharaj's pupil.

The next scene is set the following morning, in the guesthouse where Mangal Maharaj and Giridhar are staying. As the old man grinds sandalwood paste for his daily worship of an image of Shiva *naṭarāj* (an iconic South Indian representation of the god as 'king of dancers', striking a dance pose within a circle of flames), he discusses with his son the performance seen the day before. He concedes that the dancer Neela has some talent, despite her bad training, and he notes that, of the women they have seen, she is the best. From the conversation, it becomes clear that the two men are looking for a woman, because Giridhar is being prepared by his father to compete, in his turn, for the title of *Bhārat Naṭrāj*: a title bestowed

(they note) only once in ten years at a great competition held at the temple of *naṭeśvar* – the 'lord of dance', another epithet of Shiva. Winning this competition will depend mainly on Giridhar's own talent, but there is a required male-female duet on the theme of Shiva and his wife, Parvati, for which a partner is needed. Although Giridhar appears disgusted at the prospect, his father convinces him to reluctantly accept Neela – who soon arrives to beg for initiation – as a fellow pupil.

After delivering a stern lecture on the rigorous and ascetic training that she will now have to undergo, Mangal Maharaj ultimately blesses her, instructing her to return the next day for an initiation ceremony: 'Your new life will begin at sunrise tomorrow!' (Figure 11.6). And so it does, with the usual ceremonial presentation of sweets and of a red string that the guru ties around the new disciple's wrist, but with Neela strikingly cross-dressed, in a man's brocaded coat and silk turban – as if signalling renunciation of her gender in order to enter the austere company of the master and his son, as the latter's 'guru-brother' (Figure 11.7).

This chaste attitude is not, of course, destined to last. The greater part of the film celebrates, mainly through dance and song, the love that slowly blossoms between Giridhar and Neela as they train together. This eventually attracts the notice and ire of Mangal Maharaj, who accuses Neela of trying to 'ensnare' his son – he has previously announced that Giridhar may consider marriage only after he has made his own reputation and career by securing the *Bhārat Naṭrāj* title. These accusations, combined with the lascivious importuning of the rich Manilal (Madan Puri), who aims to make Neela his mistress, drive her to unsuccessfully attempt suicide by jumping into a river and then (following her rescue by a holy man) into a self-imposed exile as a *jogan* or female ascetic (Figure 11.8).

Meanwhile, Mangal Maharaj recruits another partner for Giridhar, but as the *Bhārat Naṭrāj* competition unfolds before a large audience in the imposing

FIGURE 11.6 and 11.7: Mangal Maharaj accepts Neela as a dance pupil and she assumes a male costume for her initiation in *JJPB*.

FIGURE 11.8: Neela in exile, as a female ascetic in *JJPB*.

Naṭeśvar Temple, the new recruit, bribed by the malicious Manilal, deserts him. Giridhar appears destined to lose, until the despised Neela, pale and feverish from another near-death experience in the forest, unexpectedly takes the stage to accompany him in the Shiva-Parvati duet. After this clinches Giridhar's victory (and heals his own anger at Neela), the placated Mangal Maharaj blesses their union, tying their ankles together with a bright-coloured cord, and they dance in unison to a reprise of the title song.

Dance, gender and nationalism

To a viewer unfamiliar with certain discourses about dance and womanhood that circulated in South Asia during the late-colonial period, some features of *JJPB*'s plot may appear puzzling. If it is all right for women to dance publicly and exuberantly – as the heroine and a large female ensemble regularly do throughout the film – then why does the advertised performance by the dancer Rupkala in the opening sequence so infuriate Guru Mangal Maharaj that he labels it 'obscene' and brands her a 'whore'? Since there appears to be little stylistic difference between Neela's initial performance in her pastel-tinted salon and her later ones as Giridhar's partner, why is the former scorned as 'cheap, commercial dance' whereas the latter leads to a coveted national award (for the male partner) and the paternally sanctified marriage of the duo? And given that the love of the hero and heroine is, from the beginning, obviously reciprocal, and both are equally

forward in advancing it, why does the film never question or apologize for the old father's denunciation of the innocent girl as a 'temptress' out to ruin his son; why does it, rather, seem to relish her self-induced suffering due to having internalized this unjust critique?

The discourses that underpin these plot devices have, in fact, been so well rehearsed in Indian public culture that allusions to them in this mass-market film appear, to most viewers, sufficiently common sense as to require no explanation within its diegesis. They reflected, by the time of the film's production, more than a half-century of earnest cultural propaganda to counter British colonial critiques of Indian dance and its professional practitioners and to reclaim it as a proud symbol of 'national' culture. In the process, a master narrative was constructed, originally from the speculation of late-eighteenth-century Orientalist scholars like Sir William Jones, that the then contemporary Indian music and dance, widely practiced by courtesans who were accompanied by male, usually Muslim, musicians, were but the degraded vestiges of ancient, Brahman-inspired and temple-based performance traditions, now 'almost wholly lost' (Jones 1784 cited in Walker 2014: 11). These theories were embraced by late-nineteenth- and early-twentieth-century Indian nationalists, the majority of whom were from upper-caste Hindu backgrounds, in the service of several agendas. Positing ancient origins for art forms accorded them a certain prestige, since the British conceded that, whatever its present faults might be, 'eternal India' was at least a kind of living museum of fabulous antiquities; moreover, Orientalist scholarship privileged old and textually attested traditions as invariably more authentic and 'pure' cultural forms. Blaming Muslims for the corruption of Indian culture also resonated with a British critique of Islam that was partly a reflection of western Christian prejudices, but was also sharpened by latter-day conflicts with Muslim regimes, both in and beyond the subcontinent. As the East India Company rose to power by acquiring large chunks of the erstwhile Mughal Empire and its successor kingdoms, 'despotic' and 'corrupt' administration was often invoked as justification for their takeover, perhaps most famously in the 1856 seizure of the prosperous kingdom of Oudh, whose Muslim *nawāb* (not incidentally, a key patron of both dance and music, and of the courtesans who performed them) was deposed on the charge of incompetence. When this takeover helped precipitate the bloody Rebellion of 1857, whose champions made a brief attempt to restore both the *nawāb* of Oudh and the Mughal emperor of Delhi to their lost thrones, it sparked long-lasting colonial reprisals that were physical (in the destruction of landmarks and the arrest and execution of thousands of Indians), political (in the increasing marginalization of Islamic elites and the favouring of 'loyal' Hindu ones) and ideological (in the continued positing of a Hindu 'golden age' prior to corrupting Islamic rule, when the subcontinent displayed certain enlightened tendencies that the British were again fostering).

Moreover, in an atmosphere of increasingly repressive censorship (signalled, e.g. by the passage of the 'Vernacular Press Act' of 1878, which sought to monitor the output of the subcontinent's expanding regional publishing industries for 'seditious' sentiments), criticism of 'barbaric' Islamic states of the recent past was not only officially unobjectionable but could, at times, permit veiled critiques of present rulers. Finally, there was the 'woman question': against Victorian charges that Indians were unfit for self-rule because their women were the ill-nourished, unschooled and sexually abused victims of a misogynistic patriarchy, elite Hindus could counter (again invoking the notion of a lost 'golden age') that it had not always been so – this sorry state of affairs, too, reflected the impact of centuries of rule by lascivious 'foreigners' from the (nearer) West.

One particularly vexing dimension of the 'woman question' for the indigenous elite was the status and activities of a class of professional women found virtually throughout the subcontinent, and known in many parts of North and central India as *ṭawā'if*, and in the South and east as *devadāsī*s ('maidservants of god'). These women typically did not marry or were ritually wed to a temple deity, often lived in matriarchal lineages in which they learned music and dance, performed publicly (especially at auspicious functions such as weddings and celebrations of the birth of a son, as well as for the entertainment of wealthy sponsors) and had license to engage in short- or long-term liaisons with their male patrons. The British dubbed these women 'nautch girls' (bowdlerizing the Hindi word *nāc*, from the verb meaning 'to dance') and, in the case of *devadāsī*s, 'temple prostitutes' and made them the subject of a vociferous critique. This combined a lurid male gaze (and, indeed, a policy of forcing *ṭawā'if*s, especially in the aftermath of 1857, into true prostitution in order to 'service the needs' of imperial troops) with self-righteous Christian outrage over a culture so depraved that it could ostensibly sanction such 'abominations' in its religious rituals and houses of worship.

The Hindu elite and intelligentsia – which included some connoisseurs of the 'nautch girls' and their arts – responded to this critique by recourse, once again, to the Orientalist trope of a 'golden age'. Dance forms such as Bharatanatyam (*Bharatanāṭyam*) and Odissi (*Oḍiśī*), they said, had originated thousands of years earlier, descended, along with Indian music, from the primordial and holy *Sāma-veda*, and were taught to women by austere Brahmans as sacred art forms to be practiced in temples and ashrams. During the Muslim period, however, foreign rulers lured or kidnapped the dancers and brought them to their courts and not understanding their sacred calling, induced them to perform 'secular' subjects and also to bestow other, more intimate, favours on them. The narrative of the 'fall' of classical dance – in which the 'vestal virgins' of antiquity became mere 'prostitutes' and their male accompanists no better than pimps – was thus a morality

tale of rapacious Muslim men seducing chaste Hindu women through physical force and cold cash and in the process destroying their artistry.

This narrative elided the primacy of public women in the ancient transmission of music and dance forms, through the pre-Islamic tradition of courtesans (*veśyās*, *gaṇikās*) who were likewise patronized by nobles, though not without a sacerdotal function in certain contexts. It was reinforced both by the British disdain-cum-fascination for 'nautch girls' as entertainers and prostitutes as well as by the Indian nationalist tendency to deflect the critique of 'foreign' rule away from the British Empire and to project it backward in time to regimes that themselves were objects of criticism in British historiography. Understandably, the nationalist discourse that arose during the same period, and that sought to answer colonial critiques of the status of Indian women by positing a sharp divide between the female 'domestic' and male 'public' spheres, had little accommodation for 'public women'. The 'Anti-Nautch' movement, officially launched in 1893 in Madras, was spearheaded by English-educated reformers who argued, according to ethnomusicologist Margaret Walker,

> that they were fighting brothels and the trafficking in women – all dancers were prostitutes and the performing arts of hereditary *ṭawā'ifs* and *devadāsīs* were simply fronts for prostitution [...]. In order for music to ascend to the level of national treasure it first had to be forcibly separated from its past association with courtesans. Music was consequently 'disembodied'. And dance, female dance, was made solely responsible for the immorality associated with the performing arts.
>
> (2014: 95, 96)[6]

The situation was especially problematic for Kathak, the most prevalent 'classical' dance form in Northern India and the style that (in part because of its relatively more expansive repertoire of body movements and its preference for abstract compositions) would come to play the most influential role in the choreography of popular Hindi cinema – Gopi Krishna, the dancer who debuted in *JJPB*, would reputedly, in his half-century career, dance in or choreograph some eight hundred films (Clark 1997: 85). The South Indian Bharatanatyam and the Eastern Odissi forms could each, with some imaginative extension, be provided with pedigrees extending back to the legendary Brahman sage Bharata's circa second-century Sanskrit treatise on performance, the *Nāṭyaśāstra*. More reasonably, they could be linked to attested *devadāsī* traditions based in medieval temple-complexes such as those at Chidambaram in Tamil Nadu (where the original, Chola-period image of Shiva as *naṭarāj* is enshrined in a hall that may once have been used for liturgical performances) or at Puri in Orissa (a Vishnu temple where *devadāsīs* danced the erotic song-cycle *Gītagovinda* as early as the fifteenth

century; Miller 1977: 6). Kathak, however, seemed to have come to maturity in the princely courts of a Northern and central India that was mainly under Islamic rule, and like the architecture, literature, costume and music of the region, to have been markedly influenced by Persian and Central Asian styles and practices. It was, in the most positive assessment, 'the love-child of Moghul-Hindu union' (Gopal and Dadachanji 1951: 73) and the one traditional dance form on which 'the Islamic imprint has been forever stamped' (Clark 1997: 83). It is notable, too, that it was in *nawābī* Awadh and its capital, Lucknow, that the Kathak style particularly flourished (so that the majority of dance teachers who would assume the Brahman surname-cum-title 'Maharaj' in the twentieth century were in fact products of its *gharānā* or artistic lineage), and Lucknow was also the epicentre of nineteenth-century *ṭawā'if* culture. As historian Veena Oldenburg (1992) has shown, Lucknow's professional women, many of whom were trained in music and dance, were among the city's wealthiest citizens, and it was their economic and cultural power, no less than their political support of the Rebellion of 1857, that earned them the special ire of the colonial administration in the latter half of the nineteenth century.

Given these circumstances, providing *ṭawā'if*-style dance with a pre-Islamic, Sanskritic origin and with a genetic link to the other 'classical' forms seemed especially imperative. By linking 'Kathak' – a name apparently first applied only in the early twentieth century to the art form previously known simply as *nāc* ('dance'; Walker 2014: 99) – to a few scattered references to professional 'storytellers' (*kathaka*) in Sanskrit literature, the new nationalist narrative posited, once again, a temple-based tradition practiced and transmitted by male Brahmans, which gradually 'fell' into the possession of female performers and their Islamic clients. In the post-Independence period, this theory was constantly repeated in books, articles, concert programmes and in the oral instruction of (new) middle-class dance students; a recent comprehensive historiography of Kathak cites more than a score of iterations since the 1950s in both scholarly and popular works (2014: 5), of which the following passage is fairly representative:

> The foremost artistes of Kathak were indeed all men, and it is they who served as the principal expositors of the art in the various native States. Women had a place in Kathak, but this was of a different order. They were known as *nach-walis*, or nautch girls, and their dance was called *nach* or nautch. The tradition of this dance of course began with the Moghuls, when there was wholesale importation of dancing-girls from Persia, for the entertainment of the pleasure-seeking rulers and their fawning toadies. Whatever dance these girls brought with them certainly contributed to the shaping of Kathak; but once this was done, the girls began to perform a Kathak of their own – a style which while retaining the basic graces of the art, divested itself

of much of its dignity and directed itself toward sensualism. Eventually, the dance of the nautch girls came to be associated with voluptuousness and lasciviousness, and the dancers came to be characterized as women of easy virtue.

(Khokar [1979] 1984: 134)

Note, in this passage, the easy slippage between Hindi and its Victorian-English bowdlerization (women's dance 'was called nautch', but by *whom?*); the offhand 'of course' that accompanies the actually unproven assertion that it 'began with the Moghuls'; the implication that 'foreign' kings were more 'pleasure-seeking' and prone to flattery than indigenous (read: Hindu) monarchs; the concession that Persian influence on Kathak cannot be denied but that its further development by female performers, despite 'retaining ... basic graces', reflected a debasing take-over of a tradition that properly belonged to its 'foremost artistes' – men; and the convenient use of passive voice to evade the question of whether female dancers were actually prostitutes or merely 'came to be characterized' as such (and again, by *whom?*).

More recent scholarship, especially the work of authors sensitive to feminist readings of history and informed by ethnographic research and the critique of nationalism, has deconstructed this master narrative, though such insights have yet to penetrate public discourse. Work on the *devadāsī* traditions of Bharatanatyam and Odissi dance, for example, has helped to reinstate the primacy of female per-formers and teachers and their agency in transmitting an art form and world-view that was both sacred and unashamedly erotic (Marglin 1985; Soneji 2012). In the case of Kathak, the most comprehensive study of its history to date finds no solid evidence of a link between the modern and contemporary dance form and ancient Hindu narrative traditions or indeed of much presence of male performers prior to the 1920s and 1930s; rather, it proposes the radical counter-reading of an elite, royally patronized pre-modern dance form, of decidedly hybrid Indo-Persian ori-gins, whose accompanying and usually low-caste male musicians and storytellers gradually gained importance through courtly patronage, emboldening some of them to claim Brahman status (Walker 2014: 75–88; cf. Chakravorty 2000, 2008). As a result, as Margaret Walker notes,

[t]he twentieth-century history of *kathak* dance, the dance of the Kathaks, thus contains purposeful gaps: an ancient tradition of storytelling leaps over centuries, moving in giant steps from temple to court and finally to the concert stage. These gaps function not only as a conscious effort to distance *kathak* from the Muslim musicians and dancing girls, but also as a validation of *kathak* in Orientalist terms as ancient and indigenous. Identifying an untainted Hindu, devotional and male past for North Indian dance allowed *kathak* to be adopted, along with *bharatanāṭyam*

and the classical music 'rediscovered' by scholars [...] as a cultural heritage worthy of the newly independent India.

(2014: 15)

The 'happy ending' of the master narrative is the twentieth-century 'regeneration' of debased classical dance forms through the inspiration of a few (mostly) male and almost exclusively Hindu teachers, now collaborating not with courtly patrons but with new middle-class ones and, post 1947, with the government through its cultural institutions. These male professionals teach their dance techniques to (mostly) female amateurs, and such training comes to be regarded as an ideal discipline to instil grace, deportment and national culture into eminently marriageable girls, both in India and throughout its ethnic diaspora.

Screening the master narrative

Returning to the film, I will now consider the ways in which the discourses I have just discussed have shaped its storyline and *mise en scène*. The film's tale of a budding, thwarted and, eventually, patriarchally blessed heterosexual romance is a powerful representation of an idealized national culture articulated through music and dance, which simultaneously valorizes its Sanskritic, high-caste Hindu and male components, while devaluing (albeit through an ambivalent and fascinated gaze) its regional, feminine and Islamicate elements. It systematically tackles each of the four strands of the latter that I noted earlier (following and building on Mukul Kesavan's essay): Urdu language, aristocratic decadence, *ṭawā'if* culture and Islamicate visual codes. Albeit a 'social' film in its genre category, its visual aesthetic suggests a 'mythological' film and its narrative indeed encodes a mythic tale of cultural redemption through ascetic suffering and harsh disciplining of a female body, the unleashing of a virile male one and the replacement of Islamicate forms by Hindu ones.

Notably, there is nothing explicitly 'Islamic' in *JJPB* – no token Muslim character (unless we take the theatre manager in the astrakhan cap to be one), no allusions to Islamic culture or practice in names or situations. Shantaram and other directors of the Nehruvian period, committed to the ideology of 'national integration' and to the commercial imperative of drawing large and diverse audiences, generally avoided an explicit critique of Islamic culture.[7] Yet, as I hope my discussion of the history of Kathak makes clear, the complete elision of Islam and of Muslims, in a film about this particular dance form, itself makes an ideological statement. The film's exclusive focus on what Clark calls 'the Hindu, non-Moghul world of Kathak' (1997: 115) is a powerful endorsement of an invented tradition.

Yet the Islamicate remains vestigially apparent as alluring spectacle and decadent cultural practice, both of which require purification through the extraordinary suffering to which the film subjects its blameless heroine.

In *JJPB*'s opening scene, Mangal Maharaj's ire is aroused by the sight of the poster for a stage performance by a female dancer, who is portrayed in an Islamicate 'harem' costume. This, coupled with her claim to be his pupil, seems to lead to the old man's accusation that she is practicing 'obscene dance' and 'giving herself for money'. This criticism is underscored in the confrontation between Giridhar and Neela that follows, which centres on the phrase *bāzārī nāc*, 'commercial dance' or 'the dance of the marketplace', which Neela is said to have learned in preparation for a performance tour sponsored by her patron and would-be seducer Manilal. The phrase readily evokes the more common one of *bāzārī aurat* – 'public woman' – that is used as a derogatory label for a courtesan, distinguishing her from a respectable married woman, a Hindu *dharmpatnī* or Muslim *begam*. It is notable in the context of the film that Mangal Maharaj and Giridhar actually have no objection to women dancing publicly – indeed, women's services are essential for male-female duets on mythological themes – but only to their dancing for profit. Professional dance, according to the film, should be the domain of men, who are rewarded with such 'national' recognition as the fictitious *Bhārat Naṭrāj* prize, which will cement their fame, and presumably their earning power, as teachers.

The lure of professionalism for female dancers, in the film's ideology, is to be neutralized by marriage: the ultimate salvation, in most films as well as in bourgeois nationalist discourse, for the *ṭawā'if*. Like the heroine Sahibjaan in *Pakeezah* (though without the stigma of having explicitly been a courtesan), Neela becomes marriageable through an almost fatal chain of trials and sufferings that dramatize her willingness to accept her own impurity and to sacrifice herself for the sake of Giridhar's professional success.

As Lori Clark observes: 'The courtesan figure as dancer is a powerful representation of sexuality and how it is perceived [...] how ultimately, female sexuality must be controlled by marriage or death' (1997: 129). Neela's trajectory from *ṭawā'if*-like entertainer to lawful Hindu wife is punctuated by two near-death episodes: her attempted suicide by drowning and her subsequent collapse from starvation and exhaustion in the forest, which ends when she is found (again, by a beneficent Hindu holy man) buried beneath a pile of dead leaves (Figures 11.9 and 11.10).

The master narrative of dance is reinforced in *JJPB* by both linguistic and visual codes. Although all the songs were composed by renowned Muslim lyricist Hasrat Jaipuri, only the first, accompanying Neela's initial and only solo dance,

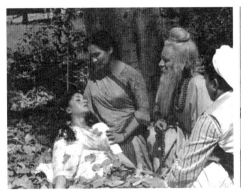

FIGURE 11.9 and 11.10: After nearly dying in the forest, Neela is married by Mangal Maharaj to his son, Giridhar in *JJPB*.

is in what may be termed Urdu, which is heightened by its rehearsal of the stock images of the *ghazal*: the desperate lover and cruel beloved, the moth and candle and so forth.

Both in lyrics and in body language, Neela's performance is an evocation of the *mujrā* (literally, 'presentation of respect'), the Islamicate courtesan's introductory dance before male patrons, which might also be an invitation to a potential liaison (Figure 11.11). Similarly, the accompanying song, its melody carried by the *sarangī* (an instrument especially associated with courtesan performance) is an example of *bandiś ṭhumrī* – a fast-paced, rhythmic form that often accompanied the *mujrā*, sometimes being sung by the dancer herself (as represented here, though in fact the voice is that of a 'playback' singer).[8]

But following Neela's acceptance as Mangal Maharaj's pupil – and a lecture in *śuddh* Hindi, invoking the 'hard work' (*pariśram*) and 'ascetic discipline' (*tapasyā*) that will be expected of her – the rest of the film's songs are in various registers of 'Hindi', as appropriate to the themes of the dances – as in the folksy 'Hame gope gawāl kehte haiṅ' ('I'm called a rustic cowherd'), the lyrics of which suggest the *Brajbhāṣā* dialect of Krishna-oriented poetry, while a blue-painted Giridhar courts Neela as Radha in a pastoral set evocative of religious calendar art. Similarly, during her self-imposed exile, a white-clad Neela sings '*Jo tum todo piyā*' ('If you break our bond, beloved [I will not break it]'), recalling both the imagery and language of the fifteenth-century Rajasthani poet-saint Mirabai.

Visually, the film's two poles are, on the one hand, Neela's palatial, pastel-tinted *havelī*, apparently the gift of her rich patron Manilal (whose title of *bābū* or 'sir' and costume of tailored sports jacket with Jodhpurs and walking stick suggests

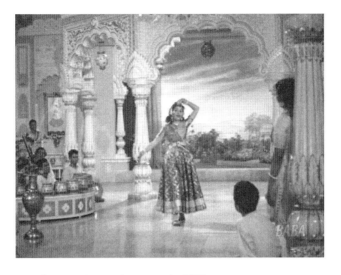

FIGURE 11.11: Neela's opening performance in *JJPB*.

FIGURE 11.12 and 11.13: Mangal Maharaj's quarters in *JJPB*.

the rentier-aristocratic pretensions of the nouveau-riche class), and, on the other, the living quarters and performance spaces of Mangal Maharaj and Giridhar (Figures 11.12 and 11.13).

Whereas the former evokes the Islamicate opulence of the *koṭhā* or courtesan house, the latter presents a more austere geometry of earthen and ochre tones with white lotus accents, reminiscent of the 'Hindu-revivalist' architecture of such complexes as Banaras Hindu University and the large-scale temples endowed by the Birla family.[9] The space centres on a portable shrine for

FIGURE 11.14 and 11.15: The tower and interior of the fictional *Naṭeśvar* Temple in *JJPB*.

the worship of Shiva as 'lord of dance' and so prefigures the film's climactic dance contest set in the *Naṭeśvar* Temple, which both externally and internally is Hindu sacred architecture in block-and-lintel Dravidian style (Figures 11.14 and 11.15).[10]

The sound stage set representing the temple interior features a massive neo-classical *mūrti* of Shiva and a proscenium-arch performance space, both of which would have been improbable in a real temple in the 1950s (nowadays, since life imitates art, such combinations are in fact found, particularly in diasporic temples, which often favour massive icons and stages for cultural performance). The shift from the *koṭhā* to the *mandir* parallels that from Persianized Urdu to *śuddh* Sanskritized Hindi in underscoring the alleged purification of classical dance.

On another level, it may also signal the competition for prestige among members of various Kathak *gharānā*s (literally 'households', but effectively 'schools' or 'lineages'): for most of the influential 'Maharajas' or senior teachers of twentieth-century Kathak belonged to the Lucknow *gharānā*. Its founder, Bindadin Maharaj (1830–1918), was a court dancer for the last *nawāb*, Wājid'Ali Shāh. His three nephews Achhan, Lachhu and Shambhu Maharaj all became famed as leaders of the 'revival' of a purified Kathak in the twentieth century. Achhan's son, Pandit Birju Maharaj (b. 1938), is perhaps its best-known exponent today. Gopi Krishna (1934–1994), on the other hand, reputedly belonged to the little-documented 'Banaras *gharānā*', as do the fictional father-son team in the film, and it is implied that this Hindu city (to which Mangal Maharaj makes a pilgrimage to purchase dance paraphernalia) is home to a purer, more Sanskritic style of Kathak, free of the crude *bāzārī* influences it acquired elsewhere.

Yet this, too, is pure fiction – for *JJPB*'s choreography is more brazenly hybrid than even the most Islamicate Kathak. In the oldest documented styles,

'the dance emphasizes space through gesture and look rather than moving the body around the stage through running or leaping', and in most histories of dance, the supposed Moghul influence is critiqued precisely for emphasizing 'tricks and gymnastic displays (that) [...] overshadowed the dance's original purity of form and style' (Walker 2004: 4, 19). Yet it is Gopi Krishna's 'acrobatic style and incredible speed' that are routinely praised in assessing his performance (Clark 1997: 115); his athletic leaps and slides suggest western ballet and modern dance, though they help to underscore the film's assertion of a 'virile', masculinized Kathak, to which the female dancer in the film – in reversal of the male patron's gaze at the *ṭawā'if* – is visibly and irresistibly attracted (Figures 11.16 and 11.17).

Indeed, the twentieth-century male reclamation of 'classical' dance often emphasized the *tāṇḍava* ('aggressive, virile') mood, briefly mentioned as mythically associated with Shiva in the *Nāṭyaśāstra* (Walker 2004: 190); significantly, Giridhar's climactic performance in the *Bhārat Naṭrāj* competition in *JJPB* portrays Shiva's trident-wielding *tāṇḍava* dance of cosmic destruction – here enhanced by his rage at Neela for her supposed 'faithlessness' in love.

The film's spectacular ensemble numbers offer evidence of other suppressed and forgotten influences on the form of twentieth-century Kathak, especially the Anglo-European and American tradition of 'oriental dance' of the 1920s and 1930s, popularized by Ted Shawn and Ruth St. Denis and later brought to India by the influential teacher Leila Sokhey (a.k.a. Madame Menaka) and the choreographer and impresario Uday Shankar (Walker 2014: 111–15). Other influences include Indian tribal dances (in their typical cinematic sendups of the primitive, complete with feather and bone costumes), Hollywood cabaret, modern dance and western and royal Khmer ballet; several numbers feature large, synchronized

FIGURE 11.16 and 11.17: Giridhar astonishes Neela with his athletic leaps in *JJPB*.

FIGURE 11.18 and 11.19: The final ensemble number in *JJPB*.

orchestral ensembles, utterly unlike the chamber-music groups that normally accompany Kathak.

Ultimately, the dance competition in the *Naṭeśvar* Temple climaxes in a Busby Berkeley–like spectacle of women costumed in tight-fitting gold lamé gowns to resemble brass *pūjā* lamps – a perfect metaphor, indeed, for the film's reduction of the female dancer's body to a literal instrument to assist in the male priest's professional worship (Figures 11.18 and 11.19). The intended audience's enjoyment of such wild semiotic hybridity – a hallucination worthy of a heavily opiated *nawāb* or *raja* and enough to cause any self-respecting *ṭawā'if* to veil herself in embarrassment – was facilitated by the film's pious endorsement of an invented tradition and by its implicit critique of several of the cultural phenomena actually most seminal to the contemporary art of Kathak: Islamicate courtly patronage and the skill and artistry of independent, professional women.

NOTES

1. From the review of *Jhanak Jhanak Payal Baaje* at http://www.upperstall.com/films/1955/jhanak-jhanak-payal-baaje. Accessed 9 October 2010.
2. A striking twenty-first-century example of this is in the dialogue of Ashutosh Gowariker's 'historical' film *Jodhaa Akbar* (2008), in which the emperor Akbar (played by Hrithik Roshan) and his courtiers speak an ornate, Persianized Urdu of a type now rarely encountered in Indian cinema, and his Rajput bride Jodhaa (Aishwarya Rai) and her relatives respond to him in a *śuddh* Sanskritized register that (historically speaking) is unlikely to have been spoken by the nobility of pre-modern Rajasthan. The probability that both Akbar and the historical woman represented by the film's 'Jodhaa' used Persian – the Mughal court

language, which was widely admired and shared by other aristocratic elites – in everyday contexts is, of course, not considered by this mainstream 'Hindi' film.

3. The reference occurs near the end of the Guru Dutt film, when former director Suresh Sinha (played by Guru Dutt in a portrayal generally assumed to be semi-autobiographical), now an ailing and prematurely aged alcoholic, is briefly engaged as an extra at Ajanta Studios, where he once directed hit films. To his horror, he discovers that the leading lady in the scene in which he is to appear, who is dressed as an ascetic woman holding a one-stringed instrument (*ektārā*), is his former discovery and love, Shanti (Waheeda Rehman). The soundstage set with a Hindu temple spire, as well as Shanti's costume, closely parallel the sequence in *JJPB* when the heroine, Neela, becomes an ascetic in order not to distract her lover Giridhar from his dance training but then encounters him anyway. Suresh and Shanti's numbed dialogue about his having 'lost his way' also echoes that between the lovers in *JJPB*, and both scenes end with the men's departure and the women dropping their instruments in shock, after which a sudden gust of wind blows a cloud of dust around them. Given the commercial success of *JJPB* only a few years before, as well as Guru Dutt's cynicism about many mass-market films (cf. his parody of the 1951 hit *Awara*'s famous dream sequence in the 1957 picturization of the *Pyaasa* song '*Hum āpkī āṅkhoṅ meṅ*'), the parody appears to have been intentional.

4. Interestingly, the *Encyclopaedia* repeats the often-stated but incorrect claim that *JJPB* was India's first Technicolor film. In fact, 1952 had seen the release of Mehboob Khan's *Aan* ('Pride', 1952), a Technicolor film shot with an entirely Indian crew. I am grateful to Priya Prasad for this information.

5. Conventionally, high-budget (or in later parlance 'A-list') Hindi films of the post-Independence period, intended for India's major urban markets, present their credits exclusively in Roman script, though the film's actual title is usually briefly displayed in both Devanagari and *Nastaʿlīq* in a seeming gesture of inclusiveness towards the bi-religious and vernacular-literate audience.

6. A similar sanitization and appropriation occurred in the North Indian vocal performance art of *ṭhumrī*, which was likewise rooted in courtesan culture and had been extensively cultivated in the court of Awadh. As it gradually moved to the new space of the public concert hall as a 'light-classical' form, its seductive lyrics were reinterpreted to exclusively express 'spiritual longing' for God, its singers and teachers became male and usually Brahman (albeit rendering lyrics that nearly always assumed the persona of an abject female subject pining for a male lover) and its surviving women performers, in the early twentieth century, 'insisted on being known on concert announcements and record labels as "amateurs", i.e., not "professional women"' (Du Perron 2007: 3). As in the case of the 'classical' dance forms, 'the construction of *thumri*'s invented past has gone hand in hand with the destruction of its actual tradition' (2007: 99). For a similar argument with respect to modern discourse surrounding sixteenth- to eighteenth-century *Brajbhāṣā*-Hindi poetry, see Busch (2011: 217–45).

7. A decade later, Shantaram would direct another successful film, in many respects strikingly similar to *JJPB*, that celebrates the 'revival' of another classical art form: sculpture. *Geet Gaaya Pattharon Ne* ('When the stones sang'), released in 1964, portrays the rise to prominence of a sculptor, Vijay (Jeetendra), who is a descendant of the artisans who chiselled the rock-cut temples at Ellora. Though Vijay's subject-matter – the voluptuousness of various secularized 'goddesses', modelled on his own love and muse, Shanti (played by Rajshree, the daughter from Shantaram's second marriage) – is implicitly Hindu, he is befriended by a possibly Muslim character known only as 'Chacha' ('uncle', played by C. H. Atma), who is smitten with the Persian poetry of Omar Khayyam. Vijay's crowning achievement is a monumental hall built for the industrialist Ramlal in memory of his lost daughter, which explicitly celebrates 'national integration' through four corners representing, respectively, Hinduism, Buddhism, Islam and Christianity – though the goddess-imagery that adorns each is, again, implicitly Hindu. It is also worth noting that the central crisis of this film (Shanti's abduction by a spurned suitor who tries to make her his mistress) reaches its climax when Vijay denounces her after seeing her 'dance' for her captor, who has cruelly (using her crying infant as a pawn) compelled her to tie *gūṅgharū* on her ankles. Echoing the stance of *JJPB*, the dialogue trumpets the claim that a woman who wears ankle bells 'cannot be a wife, but only a whore'.

8. As Lalita du Perron convincingly shows, the twentieth-century sanitization of *ṭhumrī* and its transformation into a concert art associated with male teachers has generally been accompanied by the replacement of the *bandiś* style with the slower, more meditative *bol banāv ṭhumrī* (2007: 3–4).

9. This design scheme also included Islamicate features such as scalloped arches and *jālidār* screens, but these forms had long been favoured by Rajput dynasties and were no longer associated with Islamic regimes.

10. A brief shot of its supposed exterior shows what is apparently the seventeenth-century *gopuraṃ* or gateway tower of the Chamundeshvari Temple, on a hilltop near Mysore, Karnataka.

REFERENCES

Bali, Karan (2019), '*Jhanak Jhanak Payal Baaje*', review, http://www.upperstall.com/films/1955/jhanak-jhanak-payal-baaje. Accessed 9 October 2010.

Busch, Allison (2011), *Poetry of Kings: The Classical Hindi Literature of Mughal India*, New York: Oxford University Press.

Chakravorty, Pallabi (2000), 'Choreographing modernity: Kathak dance, public culture, and women's identity in India', unpublished Ph.D. dissertation, Philadelphia: Temple University.

Chakravorty, Pallabi (2008), *Bells of Change: Kathak Dance, Women and Modernity in India*, Calcutta: Seagull Books.

Clark, Lori (1997), *Kathak in Hindi Films*, unpublished MA thesis, Washington, DC: American University.

Du Perron, Lalita (2007), *Hindi Poetry in a Musical Genre: Thumri Lyrics*, Abingdon: Routledge.

Gopal, Ram and Dadachanji, Serozh (1951), *Indian Dancing*, London: Phoenix House.

Kesavan, Mukul (1994), 'Urdu, Awadh and the tawaif: The Islamicate roots of Hindi cinema', in Z. Hasan (ed.), *Forging Identities: Gender, Community, and the State*, New Delhi: Kali for Women, pp. 244–57.

Khokar, Mohan ([1979] 1984), *Traditions of Indian Classical Dance*, revised ed., New Delhi: Clarion Books.

King, Christopher R. (1994), *One Language, Two Scripts: The Hindi Movement in Nineteenth Century North India*, Bombay: Oxford University Press.

Lutgendorf, Philip (2006), 'Is there an Indian way of filmmaking?', *International Journal of Hindu Studies*, 10.3, pp. 227–56.

Marglin, Frédérique Apffel (1985), *Wives of the God-King: The Rituals of the Devadasis of Puri*, New York: Oxford University Press.

Miller, Barbara Stoler (ed. and trans.) (1977), *Love Song of the Dark Lord: Jayadeva's Gītagovinda*, New York: Columbia University Press.

Oldenburg, Veena Talwar (1992), 'Lifestyle as resistance: The case of the courtesans of Lucknow', in D. Haynes and G. Prakash (eds), *Contesting Power: Resistance and Everyday Social Relations in South Asia*, Berkeley: University of California Press, pp. 23–61.

Rai, Alok (2001), *Hindi Nationalism*, Hyderabad: Orient Longman.

Rai, Amrit (1984), *A House Divided: The Origin and Development of Hindi-Hindavi*, New York: Oxford University Press.

Rajadhyaksha, Ashish and Willemen, Paul (1999), *Encyclopaedia of Indian Cinema*, new revised ed., Chicago: Fitzroy Dearborn.

Soneji, Davesh (2012), *Unfinished Gestures: Devadasis, Memory and Modernity in South India*, Chicago: University of Chicago Press.

Trivedi, Harish (2006), 'All kinds of Hindi: The evolving language of Hindi cinema', in V. Lal and A. Nandy (eds), *Fingerprinting Popular Culture*, New York: Oxford University Press, pp. 51–86.

Walker, Margaret Edith (2004), *Kathak Dance: A Critical History*, unpublished Ph.D. thesis, University of Toronto.

Walker, Margaret Edith (2014), *India's Kathak Dance in Historical Perspective*, Burlington: Ashgate Publishing.

12

The Poetics of *Pardā*

Richard Allen

In this chapter, I investigate a small subset of films within the Muslim Social that dramatize the institution of *pardā* (veiling) through the poetics of misrecognition and mistaken identity.[1] The immediate inspiration for this group of films comes from M. Sadiq's and Guru Dutt's *Chaudhvin ka Chand* ('The full moon', 1960), which introduces a 'comedy of errors' – like mistaken identity situation into the conventions of the Muslim Social. The comedy of errors would subsequently become a common idiom of Bombay Cinema (Allen 2014). However, while in *Chaudhvin ka Chand*, after a momentary unveiling of the female protagonist, one error of identification compounds the next in the kind of chain reaction which characterizes a comedy of errors, the result of mistaken identity in *Chaudhvin* is a tragic one.[2]

By *pardā* I refer to the literal practice of the veiling of women in order to conceal them from the gaze of men who are not of the family, as it is proscribed in the Qur'an (24:31), and also to the broader social conventions where women within domestic space do not appear in front of men who are not related to family. By the 1940s, the Muslim Social had already congealed into a quite recognizable set of conventions (see Bhaskar and Allen 2009). Typically set in the upper-class *nawābī* household of Lucknow, a setting that, as a *Times of India* reviewer noted, is often 'more fancy than real' (1963: 3), the Muslim Social film seeks to preserve the values that inhere in traditional, neo-feudal culture, embodied in the idea of *tahzīb* or manners, against the encroachment of modernity, while acknowledging the need for reform that is manifest in and catalysed by the education both of men and women as in Mehboob Khan's *Najma* (1943) or *Elaan* ('The declaration', 1947). These films tend to counterpose the figure of the good *nawāb*, who learns to acknowledge the claim of virtuous character over allegiances to 'blood lines' and property, with the unacceptable face of traditional aristocratic culture in the person of a greedy, decadent aristocrat, corrupted by a life of indolence. Equally, they contrast the noble figure of the *begam*, the loving, self-sacrificing homemaker and repository of moral value,

with the figure of the *ṭawā'if*, often cast as a woman who has 'fallen' through no fault of her own and who also upholds the values of the culture, even as she is herself denied a proper place within it.[3]

In the Muslim Social, the institution of *parda* and, more specifically, the practice of veiling women have a central role in delimiting traditional cultural values that depend upon preserving the sexual purity of women and protecting them from the intrusive gaze of men. It is *parda* that separates the woman of honour, the *begam*, who is veiled, from the woman of shame, the courtesan, who is publically gazed upon by men. But while the institution of *parda* exists to guarantee patriarchal codes of honour, it also, at the same time, bestows a romantic allure upon a mysterious woman whose face is teasingly concealed behind the veil. The romantic allure of the veiled woman remains consonant with the institution, provided that the moment of unveiling is staged within the circumstances of the arranged marriage. However, once the veiled woman enters the public sphere, then an accidental moment of unveiling, which contravenes *parda* and ignites male desire outside the framework of arrangement, becomes a highly charged event with potentially catastrophic implications.

Chaudhvin ka Chand, Mere Mehboob ('My beloved', 1963) and subsequent examples of the genre take the 'veiled secrecy' of *parda* as their explicit subject matter (*Times of India* 1960: 3). These films give central importance to the stolen glance that occurs at the moment of unveiling, when desire is brought into being as an act of transgression. The significance they attach to the practice of veiling and unveiling is directly related to the cinema itself as a modern medium that makes desire public. For, considered as a medium of visual representation, film demands the presentation of the woman's face (as well as that of a man) in order to represent sexual attraction. The revelatory potential of cinema is explicitly thematized by the role assigned to photography as the social analogue of film. The camera is often bestowed with an investigative, demystifying function that is partly linked to the ubiquitous, evidentiary function given to the photograph in the recognition narratives of Hindi cinema, that is, to narratives that are built around the concealment and revelation of identity. More generally, these films display considerable ingenuity in articulating the expression of mutual desire under conditions where the woman cannot be seen by the man she loves.

The visual and physical concealment that defines *parda* bestows a special power upon the voice which can overcome physical separation. The hero is a master of Urdu poetry, vocalized in song, which unlocks the heart of the heroine and prompts her unveiling (Elison et al. 2016: 95). Drawing on the conceit in the Urdu poetic tradition which links divine and secular love, it is as if the poetic voice is endowed with quasi-miraculous power to break down not only the physical barriers but also the physical distance which may separate the lovers. More prosaically, a

heightened significance is attached to the voice because, under the literal conditions of *pardā*, it is the only means by which the lovers can identify one another.

However, while these films stage the arousal of male desire for an unfamiliar woman, they also suggest the profound ambivalence and risk attached to this possibility, which is dramatized in stories of misrecognition and mistaken identity that are widespread in Hindi cinema as a whole. The risk here is that once female beauty is displayed in the public sphere, outside the framework of the patriarchal family which channels the choice of sexual partner to someone who is already a familiar in the circle of family and friends, it will cause a corrupt contagion of male desire. Provoked by their encounter with female beauty, men come into conflict over the same woman, their desire, though hyperbolically expressed, proves fickle and easily transferable and women lose their dignity and honour. The incipiently tragic threat to female virtue in the public sphere is embodied in the figure of the courtesan, a woman of essential virtue who has 'fallen' into a subjectivity defined by her sexual agency that provokes the fickle gaze of man. The assertion of modern forms of eroticism and desire are thus, to a greater or lesser degree, hedged with shame and ambivalence that issue in punishment or sacrifice. Equally, these films are wedded to a form of melodrama whose *mise en scène* and dramaturgy are aesthetically conservative and freighted towards the preservation of tradition. As with Bombay cinema more generally, much of the fascination and complexity of these films reside in the way they interweave and sometimes radically juxtapose the traditional and the modern in a manner that gives the lie to any reductive conception of the relationship between the cinema and modernity.

Veiling, looking and desire

In this cycle of films, the concealment of the woman's face behind the veil in *pardā* is a conceit around which the act of looking desirously and being looked at is dramatized. They dwell on the moment of love at first sight: the gaze upon the presumptively virginal women's face that is protected unseen, and therefore untouched, beneath the veil. They also eroticize the female space of *pardā* in a manner that bears comparison with the gaze upon the female-only space of the *koṭhā* in a courtesan film like *Pakeezah* ('The pure one', 1971). This gaze has an affinity with, though is not necessarily reducible to, the 'orientalist' gaze upon the harem, so common in eastern-themed western paintings of the late nineteenth century (Said 1979). And the gaze upon the veiled or semi-veiled woman often coexists with the much franker and exhibitionist portrayal of female sexuality in the separate figure of the courtesan. In this respect, these *pardā* narratives are fantasies in which the institution of *pardā* itself is hyperbolically rendered in order to

THE POETICS OF *PARDĀ*

dramatize a *mise en scène* of male desire in a manner that at best has only a tangential relationship to actual historical practices of *pardā*.

The opening sequence of *Chaudhvin ka Chand* evokes the 'oriental' allure of the veiled woman. A lilting melody sings of the youthful and beautiful Lucknow as a land of promise and enchantment. Displayed in long shot are a series of Islamicate archways, leading to further archways and courtyards through which a mysterious woman clad in a *burqa'* walks away from the camera. We are invited to follow the camera's penetrating gaze in the hope of discovering the mystery of the anonymous woman who recedes from our eyes. The story proper opens at a crowded market and fair, located by a *dargāh* or shrine, which juxtaposes the sacred and the profane. The bazaar itself is a symbolically charged space, a place of social contagion, sexual transgression and erotic play that bridges the feudal and the modern. In the midst of the kinetic movement and fireworks of the fairground, we spy in close-up a street seller who moves the arms of a female puppet rhythmically up and down in conjunction with the lifting of her skirt. This bawdy reminder of the promise of unveiling links, by suggestion, the revelation of the female face to unveiling the pudenda and hints at the raw desire that lies beneath the cultured and religious practice of veiling that is echoed in the socially transgressive pursuit of veiled women by the comic character of Shaida (Johnny Walker), who attends the fair with his refined friend Pyare (Rehman).

When Shaida spots one of the veiled women, Jameela (Waheeda Rehman), being robbed, he apprehends the thief. In the heat of the moment, Jameela lifts her veil and exchanges glances with Pyare in manner that links Pyare's stolen glance, which yields love at first sight, to the act of theft (Figures 12.1 and 12.2). Pyare steals a second illicit gaze at Jameela during his sister's party at a moment when they are lighting fireworks (which echo those of the fairground). Here Pyare transgresses the female-only space of *pardā*, where the women, while no longer veiled,

FIGURE 12.1: Jameela lifts her veil – *Chaudhvin ka Chand*.

FIGURE 12.2: Pyare steals a glance at Jameela – *Chaudhvin ka Chand*.

323

FIGURE 12.3: Pyare, concealed, spies on Jameela at the party – *Chaudhvin ka Chand*.

FIGURE 12.4: Jameela framed by fireworks – *Chaudhvin ka Chand*.

remain screened from his sight. As the camera tracks in on Jameela's back, she turns to face him, unaware of his gaze, while Pyare, positioned like the spectator who watches the film, is an unseen witness to the spectacle of female enjoyment (Figures 12.3 and 12.4). Exploding fireworks co-joined with the girls' movements and laughter suggest the uninhibited expression of female pleasure as a *mise en scène* of male desire (like the fantasy of the harem). When Jameela's face finally turns towards Pyare and the spectator in the subsequent scene, it emerges, as if miraculously, out of this effervescent blaze of light. It is an image that anticipates the later association of Jameela's face with the bright orb of the full moon in the signature song of *Chaudhvin ka Chand*, the ultimate paean to the moon-faced beauty of woman.

However, subsequently, the tables are turned upon the voyeur as Jameela and her friend, retiring to the room where Pyare is hiding under the bed sheets, squat on top of him, while making fun of his vain portrait on the wall. Her friend worries what Pyare's sister, Rehana, will say, but Jameela insists that she would say the same thing in front of her and then acts out what she would do to Pyare if he got upset with her by beating the bedclothes, at which point Pyare emerges from underneath them. The women rush out and, fearing the shame caused by their exposure, they vow secrecy, while Jameela covers her head with her *dupaṭṭā* (scarf).

There follows a complex mediation on the erotics of the veil in the form of a *qawwālī*, 'Sharmā ke yeh kyūṅ' ('Why do these women adjust their veils shyly'?) sung by the women and observed by Pyare, with the tacit knowledge of at least Jameela and her friend (Creekmur 2019). This transposition of the *qawwālī* from the all-male, sacred context of the *dargāh* (see Chapter 10 in this

THE POETICS OF *PARDĀ*

 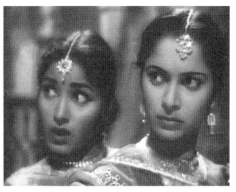

FIGURE 12.5: Pyare spies on the female qawwāls – *Chaudhvin ka Chand*.

FIGURE 12.6: Jameela returns an admonishing glance at Pyare – *Chaudhvin ka Chand*.

volume), to the all-female secular context of women under *pardā* is significant. Here, the erotic dimension of the *qawwālī* is privileged over its spiritual aspects (it has echoes in the all-female *qawwālī* competition in *Mughal-e-Azam* ['The great Mughal', 1960]). At the same time, as in the spiritual version of the song, the nature of the love that is celebrated is one that is provoked and intensified by its prohibition or impossibility that is here registered through the motif of the *pardā* (the veil).

Unlike the *qawwāl*s, Jameela and her friend are aware of Pyare's gaze and turn an admonishing glance towards him as the *qawwāl*s sing: 'There are those who hide and catch a glimpse on the sly. Tell those yearning eyes it isn't nice to mess with beauty' (Figures 12.5 and 12.6). Rehana, Pyare's sister, who is unaware of his presence, joins the *qawwāl*s and defends the importance of preserving woman's honour:

> He who bows to beauty leaves the gathering with honour.
> He who dares lock eyes with them is shamed.

Yet in spite of the rebuke directed towards desirous men from those women of the household who might be shamed by them, the lead *qawwāl*, singing directly to Jameela, vocalizes that, nonetheless, women cannot do without their devotees:

> If there are no eyes what view would one praise?
> How would these creatures survive if their beauty went to waste?
> What would the world be without their soulful, enduring admirers?

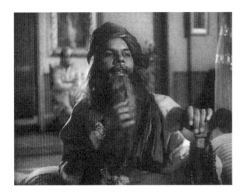 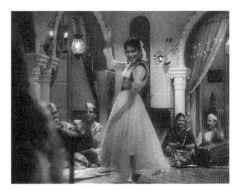

FIGURE 12.7: Shaida in his old mendicant disguise at the *mujrā* – *Chaudhvin ka Chand*.

FIGURE 12.8: Tameezan performs for Shaida – *Chaudhvin ka Chand*.

This scene contrasts with the later performance of the courtesan Tameezan whom Shaida courts throughout the film. During Tameezan's performance she sings of the kind of man who comes to watch her every night: 'the hard-hearted sweetheart [...] who talks serenely but whose heart is vacant'. The man she sings about is a philanderer; however, as she sings, her performance is intercut with shots of Shaida in his old mendicant disguise who pulls faces at her, strokes his long grey beard, shakes his head in an exaggerated fashion, waves his stick about and leaps up and down in dance. This injects levity and even reciprocity into the performance, where now both performer and onlooker are playing a game (Figures 12.7 and 12.8). The performance is followed by banter between the two about his transparent disguise that concludes with him asking her to marry him, while self-mockingly presenting himself as a man who is like the suitors she has sung about. Through her association with Shaida and the comic mode, Tameezan's openly expressive sexuality becomes tolerated, even celebrated. The film stages a playful reciprocity of desire between Tameezan and Shaida in a way that is not possible between Jameela and Pyare. Instead, Pyare is punished for his transgression and Jameela is blamed for lifting her veil. Still, in spite of its conservative conclusion, *Chaudhvin* displays the playful possibilities of the *pardā* narrative that are echoed, though in diminished form, in *Mere Mehboob*.

Mere Mehboob reprises *Chaudhvin*'s erotics of looking and love at first sight, though in a manner that is formally and ideologically both more conservative and more conflicted. Here, the idea of love at first sight is framed in a nostalgic glow as Anwar Hussain Anwar (Rajendra Kumar) remembers his first encounter with Husna (Sadhana) during a song he performs at a college poetry competition in the hope that his beloved will be listening.

> My beloved, in the name of my love
> Let your beautiful eyes assure me of your love
> Return to me the glorious vistas of beauty I have lost...
> My eyes cannot forget that pleasant encounter
> When your beauty collided with my love.

As he sings, we see in flashback an encounter between boy and girl – he in a black *kurta*, she in a black *burqaʿ* – who bump into each other within the romantic microcosm of a walled garden causing her poetry books to fall onto the ground and their eyes to meet (Figure 12.9). Their exchange is silent – a glance of the eye, a touch of the hand – but it is framed by the words of the song that grandly ennobles this momentary exchange and by the words of the poems scattered at their feet that the song recalls. These words will serve to unite them since they are brought together through their love of poetry and they ennoble their love as a romance that emanates from the higher, spiritually informed love of the Urdu poetic tradition. But words are equally a means to keep their physical passion at a distance, for they can communicate with words through the *pardā* screen without the need to see or touch one another, enacting the idea of love through separation that the poetic tradition as a whole celebrates.

Listening from the audience, Husna is no longer veiled, and the omniscient camera gives us a privileged close-up of her tearful response to Anwar's yearning song, even as sight of her is denied to him when, as they encounter each other outside the hall, she is once again veiled. In the performance hall, the gaze of the camera does, as it were, break *pardā*, even as the story maintains allegiance to the institution. Of course, Husna is not literally in *pardā* there, but she is anonymous and the camera intrusively breaks her anonymity. Later on, it voyeuristically enters

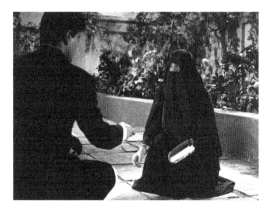

FIGURE 12.9: Love at first sight – *Mere Mehboob*.

the space of a woman's bedroom when Husna meets up with her friend Naseem (Ameeta) in Lucknow. We witness a frank display of eroticism in a private, interior, female space (the *mise en scène* is pink, red and baby blue), as one woman sings to another about the way in which men find a woman's face irresistible, in a manner that recalls but intensifies the erotic charge informing the *qawwālī* scene from *Chaudhvin*. Here, Naseem expresses the man's desire as her own, as she caresses Husna's face: 'Oh Husna, every time I look at you I feel a great rage towards God [...] why didn't he make me a boy'. 'And if you were a boy what would you do?', Husna asks. 'I would sacrifice myself to your beauty like a moth to a flame', Naseem replies. They repair to the bed (Figure 12.10) where Husna sings to Naseem of her love and her desire for the loved one to 'break with your gaze this veil over the eyes', which she acts out with her hands. It is as if, in this scene, the desire to display, rather than merely to talk about the erotic attraction that is denied representation between the heterosexual couple, is attached to the figuration of femininity and manifests itself in the displaced form of lesbian desire that exists behind the veil of *pardā* to which the camera gives prurient access (Ghosh 2002: 214). Fifty years later, in *Dedh Ishqiya* ('One and a half parts passion', 2014), this lesbian desire will come out of the closet.

At the same time, the public display of the woman's body is subject to censure. Anwar's sister Najma (Nimmi) has been reduced to being a singer and dancer on account of inherited debts, and by this means she supports Anwar. In his presence, she performs a public song and dance number to mainly male spectators; however, he is so shamed by her public performance which positions her as little more than a courtesan in his eyes that he says he will kill himself unless she gives up the stage. Her song tells the same story as Tameezan's. It is a tale of fickle men, of 'hypocrite moth lovers' who 'get inside a woman's heart like kohl in our eye, but

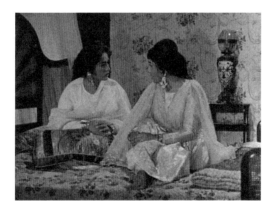

FIGURE 12.10: Husna and Naseem confide – *Mere Mehboob*.

in a split second they are gone like clouds in the skies', and evokes the shameless character of men. Her performance evokes elements of classical Kathak dance and invokes the protection of Allah, but it nonetheless provokes wolf whistles from the men in the audience. In this sense, the shame that Anwar feels, while exaggerated in the person of this earnest, moralistic young man, is deemed to be justified.

In *Mere Mehboob*, as in *Chaudhvin*, there is a dramatic contrast between the serious and comic characters. Here, Johnny Walker plays Binda din Ghayal, a bourgeois Hindu character whose mission is to bring poetry to the world, in reaction to his stereotypically uncouth *baniyā* father who is driven only by money. He comically assumes the name Binda din, which, as Ira Bhaskar pointed out to me, is the name of an accomplished Kathak dancer and close associate of Wājid 'Alī Shāh, to whom the composition of over fifteen hundred *thumrī*s has been attributed, indicating his desire to be as much of a poet as the hero. While *parda* restrictions do not apply to the character, Binda's love at first sight is comically portrayed as a case of not seeing. He literally collides with the woman who becomes the object of his desire while messing about on his bicycle. He pronounces himself wounded (*ghāyal*) by her angelic gaze when they both get up off the ground and following her when he is unwanted, he receives a slap. He absurdly interprets his own situation as parallel to that of his friend, but then in a reversal of fortune that contrasts with Anwar's own, one that puns on the idea of the 'miracle' of love at first sight, Binda's (mis)understanding of their encounter is strikingly confirmed when the girl's father promptly turns up to arrange their marriage.

Deedar-e-Yaar ('Sight of the beloved', 1982), a rather turgid reworking of old formulas, makes little of the erotics of the veil and love at first sight; however, it does give a prominent role to the figure of the courtesan, Husna, played by Rekha, whose representation is informed by a rhetoric of visibility and invisibility that echoes the play of *parda*. Husna is obsessively pursued by a decadent *nawāb* who abuses and neglects his wife, Naseema. When Naseema's brother, the noble Nawab Akhtar Khan (Jeetendra), approaches Husna for help, she falls in love with him and, faced with the demands of the evil *nawāb*, she imagines herself instead dancing in union with Akhtar. The decadent *nawāb* is exorcized by a sanitized fantasy dance sequence in which Husna is transplanted from the Islamicate *koṭhā* into a lavish Technicolor never-never land of temple *devadāsīs* where she encounters her beloved Nawab Akhtar incarnated in the figure of a Hindu god in a manner that recalls the ideological work of *Jhanak Jhanak Payal Baaje* ('The ankle bells sound', 1955; discussed in Chapter 11 of this volume). When Akhtar returns to the *koṭhā* after Husna has taken her life, she appears to him as if in flesh and blood although she is but an illusion. The paradox of the courtesan who, unveiled, visibly embodies desire yet who cannot desire herself is expressed here by a metaphorical screen of invisibility between the would-be lovers who can be present to each

FIGURE 12.11: Imram encounters Asiya covered by a *burqa'* – *Naqab*.

other only in imagination. The purity of a woman's love in *pardā* is guaranteed through her veil, lest the visible expression of her desire corrupt it. The woman tutored in the visible expression of desire can retain the purity of her love only if it is not visibly expressed.

Naqab ('Veil', 1989) revisits the eroticism of the veil in a manner that, at the same time, self-consciously seeks to demystify the institution of *pardā*. Directed by Raj Khosla, *Naqab* weaves a mystery around a woman who is a double of the lead female character. It invokes and explicitly alludes to Khosla's earlier *Woh Kaun Thi* ('Who was she?', 1964) and draws, like this earlier film, on the motifs of Hitchcock's *Vertigo* (1958), as well as Wilkie Collins's melodrama *The Woman in White* (1859) (Kabir 1996: 90). *Naqab* maps the motif of the double onto the opposition between the hidden/veiled and the open/unveiled within the genre of the Muslim Social. In the pre-credit sequence, Imran (Rishi Kapoor), a photographer, encounters a woman in a ghostly turquoise *burqa'* (Figure 12.11), who pursues him in a foggy landscape where the wind briefly raises her veil to reveal her face. Later, he sees a woman in a pale yellow *churidār kameez* who mysteriously appears on the hillside and, later, outside his bedroom window, before he finally begins to track her at a distance, her face half veiled, as her voice echoes through the landscape, 'Oh beloved, come and lift my veil'. The figure of woman is idealized here as a ghostly apparition of beauty with whom the hero falls in love once her face is revealed.

But who is pursuing him through the foggy landscape? It turns out that the woman in the pale yellow *churidār kameez* is Haya (Farha Naaz), and that the woman in the turquoise *burqa'* is her illegitimate half-sister, Asiya (also played by Farha Naaz). Asiya was initially looked after by Haya's mother but then was cast

out of the family when Haya's mother died and was subsequently victimized by an evil *nawāb*, Sajjad Ali Khan. She now remains forever veiled in social occlusion. Although *Naqab* invokes the veil as mystifying the allure of female sexuality, it criticizes the institution of *parda* by presenting it as a product of social oppression that Imran proposes to unmask. Haya is never in *parda*; indeed she is quite happy and free to take photographs with Imran on a fashion shoot soon after they meet. However, once she becomes betrothed to the same abusive *nawāb*, she shares the fate of Asiya and, like her, must be liberated.

Veiling and mistaken identity

While veiling and *parda* dramatize eroticism through concealment, even as they may criticize the transgression of *parda* norms, the veil also becomes an occasion for staging stories and situations of mistaken identity that highlight the perceived danger to personal honour and the stability of patriarchal society that the public appearance of women gives rise to. In *Chaudhvin ka Chand* and *Deedar-e-Yaar*, two men fall in love with the same woman because one of them is confused about her identity. In *Mere Mehboob*, two women are led to believe that the same man loves them, and in *Naqab* two women fall in love with the same man. The stories are only resolved through extreme and often tragic self-sacrifice.

In *Chaudhvin ka Chand*, mistaken identity appears initially as a comic come-uppance delivered to Pyare for his overenthusiastic pursuit of Jameela. As she leaves the room where she had encountered Pyare, she rips a corner of her *ḍupaṭṭā* (scarf) on the door, which Pyare keeps as a love token. However, when Jameela and her friend swap *ḍupaṭṭā*s as part of a game they are playing, he begins to pursue the wrong woman believing that she is Jameela, until he discovers his mistake. However, by this point in the story the ramifications of this mistaken identity have dramatically worsened. Pyare is invited by his mother's imām to marry his daughter so that the imām can undertake *ḥajj* (pilgrimage to Mecca) on behalf of Pyare's ailing mother, but Pyare refuses because he has already fallen in love and he asks his friend, Aslam (Guru Dutt), to marry her instead, sight unseen. Being a loyal and indebted friend, Aslam readily agrees! In a dramatic irony that turns to tragedy, unbeknownst to Pyare, the imām's daughter is Jameela. It is, of course, a central conceit of the film that Jameela is the daughter of an imām, and hence governed by strict *parda*, while at the same time she is played by the beautiful Waheeda Rehman with the alluring persona of the modern movie star. Pyare's mild punishment for breaking *parda* (comically pursuing the wrong woman) has now been intensified by his refusal of an arranged marriage in favour of his own selfish desires, while Aslam, readily accepting the terms of an arranged marriage, is rewarded with a love match that is celebrated in the title song.

A twofold coincidence of misfortune compounds Pyare's error and ultimately seals his fate. In a reprise of the opening scene, Pyare goes with Shaida to the fair at the *dargāh* in search of Jameela, only to follow the wrong woman, Aslam's cousin, Naseema, with whom she has swapped *dupaṭṭā*s. As a result, Pyare again follows the wrong woman and soon preparations are afoot for them to be married. At the same time, because of *pardā* restrictions, whose ramifications multiply as the film wears on, he does not get the opportunity to see Naseema before the wedding and because he thinks she is Jameela, he does not press the issue. At the same time, while he visits his friend Aslam at home, he does not see his wife because she is in *pardā* and therefore remains ignorant of who Aslam is married to.

Aslam and Pyare each recognize in turn the mistake that has been made. In a spontaneous and coincidental violation of *pardā*, Pyare sees Jameela alone and unveiled at Aslam's house when he arrives with bridal jewellery, mistakenly thinking that the woman he believes is his bride-to-be is just visiting Aslam. When Aslam encounters the love-struck Pyare leaving, he assumes he has just seen Naseema at the house until he discovers from Jameela that Naseema never came and realizes with horror the truth which is subsequently confirmed when Pyare responds in ecstasy to Jameela's photograph. Pyare's own revelation occurs when he comes to fetch Aslam to attend his wedding to the person he believes is Jameela, only to discover Aslam in the act of putting a bridal veil upon Jameela. We anticipate Pyare's arrival through a mirror that is positioned between Aslam and Jameela (Figure 12.12), and Sadiq/Dutt frame Pyare's moment of recognition as a mirror shot from Pyare's point of view (Figures 12.13 and 12.14). He watches in horrified fascination as Jameela, like a bride, covers her face with the veil and then uncovers it, in a gesture that at once repeats the moment when he

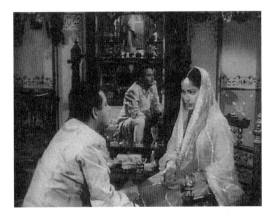

FIGURE 12.12: While Aslam veils Jameela, Pyare is seen arriving in the mirror behind them – *Chaudhvin ka Chand*.

FIGURE 12.13: Pyare sees Aslam with Jameela – *Chaudhvin ka Chand*.

FIGURE 12.14: Pyare reacts to what he sees – *Chaudhvin ka Chand*.

first saw her and the moment when she first unveiled herself for the eyes of Aslam after their marriage.

It is now Pyare's turn to re-evaluate his mistakes, born of the hubris of desire that led him to neglect his mother's wishes. Shamed, he embraces the path of self-destruction. When Jameela arrives at the scene of Pyare's suicide, Aslam pulls her aside to prevent her being witness to the scene. 'What is the matter my lord', she asks, and he responds by pulling the veil down over her eyes. In the immediate context, he is protecting her from the sight of death, but in the context of the film as a whole the gesture hearkens back to the *qawwālī* witnessed by Pyare, in which the women warn that the look of an unveiled woman can have deadly results. While it might seem to have been Pyare's fault, responsibility here is placed squarely on the shoulders of women. If Jameela had fully respected *pardā* and not publicly revealed her face in the bazaar, this tragedy would not have happened. Henceforth, she must be sure to do so.

Pardā, in *Mere Mehboob*, also yields mistaken identity, but there the confusion turns as much upon what is heard and unseen rather than what is simply unseen, in keeping with the overall centrality of word and song to the poetics of *pardā* in the film. Anwar, at the request of his friend Nawab Akhtar (Ashok Kumar), agrees to help his sister with her poetic compositions. He arrives at the house and speaks with her unaware that she is Husna, the woman he has fallen in love with. Their courtship is framed by the *pardā* screen in such a way that they speak to each other of their love without knowing that they are sitting in each other's presence. We see them in a two shot, the *pardā* screen dividing them from the view of each other (Figure 12.15). Their unknown-ness to each other, in contrast to our knowledge, is ironically dramatized when Husna narrates to

FIGURE 12.15: Anwar courts Husna behind a *pardā* screen – Mere Mehboob.

him a song that she recently heard: 'Mere Mehboob'. Anwar asks 'on behalf of a friend' where she heard it, and Husna responds, in like fashion, that the song was composed for her friend. Thus they speak as each other's doubles in a manner that perpetuates the public occlusion of desire, even as their conversation in proximity promotes mutual reverie.

By the third time they meet, Akhtar has revealed to Anwar in Husna's earshot behind the *pardā* screen that his sister studied in Aligarh and that having heard 'Mere Mehboob', she 'hums the song day and night'. Anwar is now in a position to transgress the *pardā* screen and to acknowledge his beloved Husna. Husna briefly looks up from beneath her red veil (which suggests the bridal veil) but then covers her face with her hand, in a final futile gesture of veiling, as if overwhelmed by the force of his glance as he recites the lyrics of their song, 'Mere Mehboob'. She flees, leaving her veil behind in his hand, signalling the force involved in her uncovering, which he then returns to her in the garden, throwing it over her head and then symbolically unveiling her as he sings, 'I have found you, this veil is lifted at last'.

Yet this resolution occurs only after a more radical case of mistaken identity takes place, one that transgresses social mores and threatens the romance. Anwar has an apartment in Lucknow that turns out to be opposite the apartment where Husna's friend Naseemara lives. When Anwar returns from his visit to Husna, whose true appearance still remains concealed to him, he hears the strains of 'Mere Mehboob', which we the audience quickly discover is being sung by Husna herself, issuing from the apartment beyond. He is drawn to the balcony to listen, and when, during a momentary break in the singing, a woman appears at the window, he naturally thinks it is the face of the woman he first heard singing their song, for who else could it be (Figures 12.16 and 12.17)? In fact, the woman in question is the restless Naseemara (invoking the wrong woman of *Chaudhvin ka Chand*),

FIGURE 12.16: Anwar hears Husna singing 'Mere Mehoob' – *Mere Mehboob*.

FIGURE 12.17: Anwar sees Naseemara at the window believing that she is Husna – *Mere Mehboob*.

who returns to the window in the moonlight to exchange prolonged and loving looks with Anwar who, equally restless, has repaired to the balcony to look out at the window.

This balcony assignation on a moonlit night in Lucknow is replete with the romantic iconography of the Islamicate tradition – the balcony, the walled garden and the grand Indo-Islamic background architecture. Yet the scene takes place between the hero and the wrong woman as if, again, the filmmaker seeks to represent a more overt and uninhibited kind of desire which the *pardā* situation itself does not afford but can only do so under conditions where that eroticism is overtly marked as taboo. This shared gaze deeply troubles the boundaries of the conventional morality upheld in the film. Its effects upon both Naseemara and Anwar are profound. Her newly found love is the occasion of a duet where she and Husna both sing the praises of their own lovers; however, she is deeply humiliated when, hiding behind a screen to witness Husna's encounter with her loved one, Naseemara perceives her embracing none other than Anwar.

Subsequently, Anwar is refused Husna's hand on account of his lowly status. Ashamed of the humiliation he has caused Naseemara, and discovering that her brother and his friend, Nawab Akhtar, is destined to lose his estate, he resolves to marry Naseemara in return for a dowry sufficient to pay off Akhtar's debts, which Naseemara's aunt has cannily promised in order to secure his hand for her ward. Though manipulated by Naseemara's aunt, who cunningly witnesses Anwar's tribulations from behind the *pardā* screen, his is a doubly noble gesture that restores honour to both Naseemara and Akhtar, at the expense of his own happiness. Wedding preparations proceed apace, but as he is about to make his vows he discovers, in a final twist of recognition, that it is in fact Husna who is his bride and the

film concludes with his unveiling of her in the marital bed. Naseemara, watching from behind the *pardā* screen, in a reversal of her aunt's act of manipulation, has resolved to demonstrate to him by her own actions that love is a question of worship which cannot be bought and sold. She has sacrificed herself out of her love for both Husna and Anwar.

Deedar-e-Yaar, though made over twenty years later, explicitly reprises the situation of mistaken identity in *Chaudhvin ka Chand*, where one man unwittingly falls in love with a woman who is loved by his friend. How easily dishonour is triggered by desire through mistaken identity is already announced in the film's opening. There Sikander (Deven Verma), a friend of Javed's (Rishi Kapoor), writes a letter to Javed's loved one, Firdaus (Tina Munim), on his behalf. When Firdaus opens the letter, she and her mother are shocked to discover that it is written by her brother, until her father explains. Disguise here also has a playful, redemptive aspect, for it is, after all, the borrowed eloquence that makes possible Javed's expression of love. Javed, manifesting Rishi Kapoor's well-established screen role, is something of a trickster. Subsequently, he evades *pardā* restrictions by orchestrating the firing of a servant and becoming the servant's replacement in order to have intimate access to the woman he loves.

The real drama of mistaken identity emerges from ostensibly benign playfulness, when Javed's friend Akhtar (Jeetendra) meets Firdaus in a jewellery store, in a scene that borrows the play-acting and banter of the store scene in *Jewel Thief* (1967). While Firdaus wears a veil, it is translucent, and while she does not solicit his attention, she plays along with Akhtar who pretends to be the store's salesman (Figure 12.18). Later, echoing *Chaudhvin*, Javed and Akhtar both encounter Firdaus at the fair, and at the moment when Akhtar might discover that he and his friend both love her, Firdaus covers herself with a heavy veil. The action is wholly gratuitous given the fact that in prior scenes she has worn no veil at all, or a transparent veil, and the contrivance is compounded by the fact that because it is windy she has to hold the veil down with her hands! Javed then begs her to reveal herself to his best friend, but she laughs him off. And when they place a bet that one of their lovers is more beautiful than the other (echoing *Chaudhvin*), she jokes that she will only reveal her identity when Akhtar brings his own loved one to compare with her (Figure 12.19).

When her father rejects Javed on account of his 'blood' (indeed, he tries to kill his daughter rather than have Javed 'contaminate' her and the family), Akhtar steps in to offer his hand in Javed's place, using the extraordinary argument to Javed that he will divorce her, bring shame upon the family, and thereby free Javed to marry her. What Akhtar does not know is that the woman he proposes to marry for the sake of Javed is the very same woman that he wants to marry himself, for *pardā* restrictions have prevented them from seeing each other. Approaching the

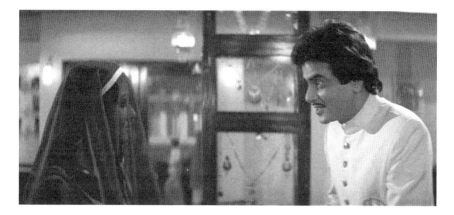

FIGURE 12.18: Firdaus and Ahktar at the jewellery store – *Deedar-e-Yaar*.

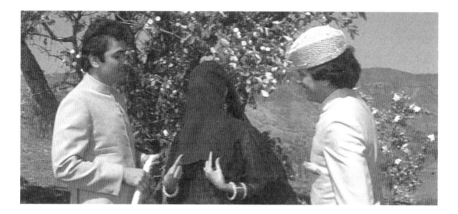

FIGURE 12.19: Akktar and Javed with Firdaus disguised by her veil – *Deedar-e-Yaar*.

marital bed, Akhtar jokes about seeing the face of the woman that his friend Javed has spoken so much about, and he unveils the face of Firdaus (Figure 12.20). His shocked recognition is punctuated by the sound of brass (Figure 12.21), a zoom into her face and out of his and an increasingly rapid sequence of shot/reverse-shot close-ups in the customary fashion of Indian film melodrama of the 1970s and 1980s. Although Akhtar tries to hold onto her, he knows that his love is in vain, and like Pyare in *Chaudhvin* he ends up tragically dying. He is accidently shot after Javed has desperately tried to prevent him from taking his own life.

In *Naqab* it is the fact that the women are doubles of one another, rather than the institution of *pardā* per se, that is the source of mistaken identity. Imran initially confuses Asiya, the apparition in the turquoise *burqa'*, for her half-sister, Haya; however, subsequently, the presence of the veil actually ensures that she is

FIGURE 12.20: Firdaus unveiled by Javed – *Deedar-e-Yaar*.

FIGURE 12.21: Javed reacts in horrified recognition – *Deedar-e-Yaar*.

not mistaken for Haya, and mistaken identity ensues only once she metaphorically and literally drops her veil. Asiya is trapped in a deadly paradox of non-identity. She is either invisible (behind the veil) or is visible only in the guise of someone she is not, her half-sister Haya. The pathos of her situation is dramatized when Imran, who despairs that he has lost Haya to the evil *nawāb*, repairs with Asiya to his mother's house, touched by her helplessness and sense of dread. In a situation in which his mother assumes that Asiya is the woman whom Imran loves and plans to marry, and because of his own drunken, self-pitying delirium, Imran confuses Asiya for the woman he loves and asks her to marry him. Here, as in the Imran's initial confusion of Haya for Asiya, director Khosla exploits the uncertainty of recognition: how can I be sure that one twin is not the other? Asiya's feeling of 'what if?' that follows Imran's mistake yields a beautiful song of self-sacrifice as,

donning the red veil of the bride, she looks at herself in the mirror and her mirror reflection voices her thoughts: 'My sight is changing, it dreams now. Oh Allah, let the veil remain on my face [...] one can't keep away the darkness by stolen light'.

When, at the finale, Asiya finally relinquishes her veiled identity, she does so by assuming the persona of her double in order to rescue Haya, who has now herself been ensnared in the clutches of Sajjad Ali Khan. As Haya's grandfather and his family meet at the grave of Haya's mother, she substitutes herself for Haya whom Imran has meanwhile already rescued. Once back at home with Sajjad Ali Khan, she reveals her identity to him at the moment when she has administered poison to them both. She can publicly announce her true identity only at the point of her death. It is an act that culminates her life of self-negation and self-sacrifice, enabling Haya to marry the man that they both love. And it is only in her death, and through her martyrdom, that her grandfather can finally recognize her as his granddaughter.

Photography, cinema and *parda*

These films demonstrate a high degree of self-consciousness about the place of cinema that depends upon the public display and revelation of the female face. In this context, taking a photograph of the women in *parda* serves to thematize the transgression of *parda* and to link that transgression to the incipiently intrusive and voyeuristic gaze of the cinema itself. Yet, at the same time, given the importance of the institution of *parda* for staging the onset of desire and dramatizing love-in-separation, the rhetoric of cinema is actually used in these films to creatively develop strategies for the representation of the institution of *parda* as much as for its transgression. Thus the unveiling of the woman by the camera aligns the cinema neither with nor against the putative forces of modernity, but enters into a complex and ambivalent relationship to them.

Chaudhvin ka Chand again plays a pivotal role in this cycle of films because of the self-conscious way it explicitly reflects upon the role of the camera. When Shaida, disguised as a mendicant, returns to the fair at the *dargāh* in search of the woman Pyare first spotted there, he carries a concealed camera that he uses to capture a photograph of Jameela as she buys flowers, as if by doing so he can establish her identity once and for all (Figure 12.22). This act of 'taking' her photograph parallels the earlier scenes of the stolen glance, where taking a photograph was linked to the act of theft. Sadiq/Dutt thus make explicit the link between the gaze of the camera and the making public of the face of woman. The apparatus of the camera is associated with the figure of the shaman/trickster, since we have just seen Shaida 'magically' leap backwards up onto a wall, and also in the context of

FIGURE 12.22: Shaida steals a photograph – *Chaudhvin ka Chand*.

the bazaar, a place where cameras were commonly bought and sold as well as one where social classes and genders intermingled (Mahadevan 2015). There is something profoundly disrespectful here about the act of taking this lady's photograph, unknown to her, which is nonetheless justified by the comedic context.

Central to the impact of this scene is the fact that the photograph of the woman's face is substituted by the close-up of her face in the film itself, wherein the *pardā* veil evokes a frame or a picture. In the context of a cinema that, as other films in the cycle attest, is often aesthetically conservative in its dramaturgy, the opening scenes of *Chaudhvin* eloquently dramatize the potency of variable framing and cinematic point of view in broadcasting desire, thereby extending and elaborating upon the powers of photography. At the same time, of course, while the film is complicit in the photographer's act of transgression, inviting the spectator, too, to be thrilled by the revelation of Jameela's face, just as we are complicit later with Pyare's transgression of *pardā* at the party, the revelation does not go unpunished.

The relationship between photography, film and the public availability of the female face is also touched upon in *Deedar-e-Yaar*, when Javed finds himself in possession of a photograph of his beloved that she has thrown out of the window at him in her rage, which occupies pride of place in his bedroom. The photograph is, of course, a standard device for maintaining desire-in-separation in Hindi cinema. However, Firdaus is so alarmed at the prospect of his having the picture that she steals into his room in her *burqa'* to reclaim it. The fact that she seems justified in trespassing into Javed's room to get the photograph back and save her honour suggests the symbolic power attached to the image. Yet, at the same time, this film contrives to have the veil of the heroine translucent to render her face visible, and Firdaus creeps out of her hiding place only after Javed arrives in the room, as if

she desires to be caught. So even here the narrative rationale runs counter to the prohibition against revealing the female face. The filmmaker creates a pretext to dramatize the framing and exchanging of desirous looks in tight close-ups within an intimate space and to allow Javed 'the sin' of unveiling Firdaus in his room.

I have already shown how the trope of unveiling is thematized in *Naqab* in terms of the hero's quest to demystify the secret of the veiled woman, and this quest again is explicitly linked to the act of photography as he follows the mysterious Haya with his camera strapped over his shoulder (Figures 12.23 and 12.24). Imran has in fact been hired as a photographer by Haya's grandfather to illustrate the

FIGURE 12.23 Imram pursues Haya with a camera strapped over his shoulder – *Naqab*.

FIGURE 12.24: The mysterious Haya pursued by Imram – *Naqab*.

poetry written by his son, which is the subject of outright contempt in the film. *Naqab* strains to distance itself from the conventions of the Muslim Social genre that it nonetheless inhabits, by inserting the figure of a modern camera-wielding photographer hero (in a faint echo of David Hemmings in Antonioni's *Blow-Up* [1966]) into a very conventional Muslim joint family. While the cinematic potential of the material is not fully developed – for example, we see him in the act of taking fashion photographs with Haya while never seeing the results – the idea is suggested that it is the eye of the photographer which might capture or fix the identity of the veiled woman. Imran is a detective in search of truth, and the camera is nominally at the service of the demystification of feudal superstitions by the modern rational analytic eye of the camera. There is an echo here of Rishi Kapoor's irreverent Akbar in *Amar Akbar Anthony* (1977) who seeks a snapshot of his beloved Salma (Neetu Singh) only to capture her *nawābī* father's seedy transaction with a courtesan (Elison et al. 2016: 99–100).

In these three instances, photography serves, in different ways, to represent the transgression of *pardā*, with which the films themselves are partially aligned. However, at the same time, these films invariably strive to find innovative ways to represent the institution of *pardā* as much as to break it down. In both *Mere Mehboob* and *Deedar-e-Yaar*, H. S. Rawail creatively uses a frontal tableau with a relatively long take, at once to evoke and to evade the restrictions of *pardā*. The typical Rawail scene is an indoor shot, usually of a lavish interior, taken frontally as a three-quarter two-shot or group shot, with cutting in, if at all, only at moments of greatest climax. This frontal *mise en scène* allows for the dramatic use of the divided two-shot, for example, as when Anwar and Husna converse on either side of the *pardā* screen. Rawail, in part, no doubt, influenced by Sadiq/Dutt in *Chaudhvin ka Chand*, also uses constructions in depth such that the *pardā* screen and the woman behind are held in view simultaneously with the male foreground figure, while the curtain suggests at least a partial or a symbolic invisibility. These strategies of *mise en scène* also render more pointed those moments when an exchange of glances actually take places.

In *Deedar-e-Yaar*, Rawail contrives to incorporate the trope of veiling and unveiling into the orchestration of the *mise en scène* itself by substituting variable focus for cutting into the scene. In several shots, Firdaus's *pardā*'d status is marked by her out-of-focus placement in the *mise en scène*. Moreover, Rawail, exploiting the wide screen, frequently deploys a three-shot, where one of the characters, who is a reference point for the others who are speaking and who will become central to the scene, remains out of focus until such a time as he is required to speak and is 'unveiled' by the shift in focus. For example, when Akhtar goes to visit Husna, the courtesan, to save his sister from the shame of her decadent husband's regular visits there, the husband is out of focus in a three-shot and then emerges into focus as he

THE POETICS OF *PARDĀ*

dramatically reveals the identity of Akhtar as his wife's brother to the courtesan. In a later scene, when Firdaus tries to explain to Javed her silence about knowing Akhtar, the figure of Akhtar appears out of focus between them and then emerges into focus as Javed declares that Akhtar Nawaz is a reality now (Figures 12.25 and 12.26), before being occluded again. The scene is more or less repeated when Javed tells Firdaus that Akhtar's presence in her life is now a reality and Akhtar comes into focus for a moment between them. Rawail's aesthetic strategies here manifest a concerted, if idiosyncratic, attempt to incorporate the trope of veiling and unveiling into the stylistic texture of the work as a way of dramatizing moments of narrative revelation or recognition.

FIGURE 12.25: Akhtar appears out of focus between Javed and Firdaus – *Deedar-e-Yaar*.

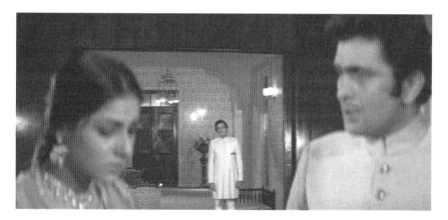

FIGURE 12.26: Akhtar comes into focus as Javed declares that he is now a reality – *Deedar-e-Yaar*.

Deconstructing *pardā*

I have argued that the institution of *pardā* in Hindi cinema is a complex conceit that dramatizes and negotiates the transition from feudal, patriarchal forms of gender relationships to a modernity where women are rendered visible and endowed with public agency and desire. Given that cinema is predicated on the public showing of the woman's face, it would seem that cinema is aligned with modernity and with the breaking of this taboo, an alignment reinforced, as we have seen, by the role assigned to photography in these works. However, this alignment is far from unequivocal, even in more recent works that ostensibly seek to distance themselves from the institution of *pardā*, for the institution of *pardā* in these films and the reassuring moral framework it provides is that which makes possible the thrill of transgression. While it sustains double standards that are deeply oppressive to women, it nonetheless creates a space of narrative, aesthetic and erotic play. The achievement of these films resides in finding creative ways to dramatize and express the emergence of desire in a context where the recognition of desire is strictly unrepresentable.

However, the double standard is not ultimately sustainable and is subverted as early as *Amar Akbar Anthony*, a masala film, where the conventions of the Muslim Social are invoked in order to be parodied, as William Elison, Christian Lee Novetzke and Andy Rotman (2016) have made clear in their incisive analysis. Akbar, whose noble name belies his actual status as a tailor's son, publicly courts his beloved, Salma, a doctor with whom he is already on familiar terms, in a public *qawwālī* performance of '*Parda Hai Parda*' ('A veil is a veil') that parodies *Mere Mehboob*. As Akbar passionately sings, amidst falling coloured veils, in a camp exaggeration of the *qawwāl* (Dwyer 2005: 144) – 'Behind the veil / There is a beloved / and if I don't succeed in unveiling that object of desire / Then my name isn't Akbar' – Salma, whose smiling face is evident beneath her diaphanous veil, seems all-too-ready to meet his request. Indeed, early on, in response to his importuning, Salma and the five *hījabi* women she enters the hall with are eager to lift their veils, in comic unison, only to be prevented by a slap from the cane of Salma's diminutive, cantankerous and patriarchal father. While Salma self-consciously demurs, as per convention, when Akbar accuses her of cruelly toying with his heart (Elison et al. 2016), Akbar ups the ante by taking a diaphanous red veil and ripping it in two, evoking the breaking of the hymen. Salma willingly succumbs, removes her veil and confidently approaches him on stage to place a hand over his lips. Elison et al. write that 'to expose herself thus is the lesser shame' (2016: 95), but actually she feels no shame at all, as is evident when in the next number she trawls her *dūpatta* across her unveiled face as a weapon of seduction.

More recently, the ideological dichotomies that underlie the poetics of *pardā* have been turned inside out by *Dedh Ishqiya*, which challenges the conventions of the Muslim Social with the irreverent and socially subversive milieu of the gangster film. *Dedh Ishqiya* invokes the idea of love at first sight provoked by the enforced separation entailed by *pardā*, under the aura of nostalgia for an impossible fiction. The youthful Khalujan (Naseeruddin Shah) worships through his eyes the dancer Begum Para (Madhuri Dixit), from whom he is separated by a veil. This physical veil is also the metaphoric veil of class that divides servant from mistress. Here, *Dedh Ishqiya* evokes Guru Dutt's *Sahib Bibi Aur Ghulam* ('Master, wife and servant', 1962) which narrates the fascination of an educated but naive lower-class man for his alluring upper-class mistress who is sequestered in *pardā* (according to the practices of upper-class Hindus). This earlier desire is reawakened when Khalujan, now a minor gangster, poses as a *nawāb* and enters a poetry competition to win the hand of Begum Para at a *mushā'ara* (poetry competition), which she is staging to find a new husband. His heartfelt vocalization of poetic words seems to reach out to the Begum across the boundary of time and class, bringing into being an imaginary world of sexual and social fulfilment. Yet, undying love is but an illusion as Begum Para pledges herself to another younger, richer and much less honourable gangster, Jann Mohammed (Vijay Raaz). The reason, it transpires, is that the Begum, aware that Khalujan is penniless, has concocted a scheme to have herself kidnapped and then ransomed by Jaan Mohammed, in order to secure the fortune that her late husband who bankrupted the estate had denied her. The ideal of pure love, and the whole apparatus of the *mushā'ara*, which exists to extol that love, are shown to be an illusion, even if a glorious one.

Dedh Ishqiya echoes *Chaudhvin ka Chand* in the sense that the male hero, driven by hubris, is ensnared by mistaken identity. However, the heroine, far from being an unwitting victim of the social conventions governing female sexuality, actually inhabits and manipulates those conventions for her own ends. Key to her ability to do this is that she does not subjectively identify with the masquerade of femininity she is master of, in which woman is the object of male adoration. Not only is the bid that she orchestrates for her affection a charade but her companion, Munniya (Huma Qureshi), who in turn seduces the sidekick of Khaalujan, Babban Hussein (Arshad Warsi), into helping them, turns out to be her true love. This same-sex romance was inspired by the Urdu short story *Lihāf* ('The quilt', 1942) by Ismat Chughtai (1915–91) (Waheed 2014). At the end of the film, when Khalujan and Babban finally confront the vengeful Jaan Mohammed and his posse in a spray of bullets, the two women, like Thelma and Louise, make their delirious escape, leaving behind them the carnage of cuckolded, impotent, male desire, together with the imaginary *pardā*'d world of the Muslim Social.

NOTES

1. This chapter draws upon arguments first developed in *Islamicate Cultures of Bombay Cinema* which I co-authored with Ira Bhaskar. I wish to thank Ira Bhaskar for sharing her insights into these films and for supplying translations. Thanks also to Spandan Bhattacharya and Anuja Jain.

2. In this context, mention should also be made of Rabindranath Tagore's *Noukadubi* ('The wreck', 1905), where a woman unknowingly marries the wrong man, when veiling and modesty precluded them seeing one another's face during the marriage ceremony, and the groom subsequently confuses her for the bride from another marriage party when they are both victims of shipwreck. *Noukadubi* was adapted in Hindi cinema as *Milan* ('Meeting', 1946), remade in Bengali as *Noukadubi* (1947, and in 2011) and in Hindi again as *Ghunghat* ('Veil', 1960), the same year as *Chaudhvin ka Chand*.

3. By insisting on the importance of the figure of the courtesan to the Muslim Social I do not in any way mean to imply that the courtesan is a uniquely or predominantly 'Islamicate' figure. As Ruth Vanita (2018) has recently made clear, she prevails in a wide variety of contexts in Bombay cinema.

REFERENCES

Allen, Richard (2014), 'Comedies of errors: Shakespeare, Indian cinema, and the poetics of mistaken identity', in C. Dionne and P. Kapadia (eds), *Bollywood Shakespeare*, New York: Palgrave Macmillan, pp. 165–92.

Bhaskar, Ira and Allen, Richard (2009), *Islamicate Cultures of Bombay Cinema*, New Delhi: Tulika Books.

Creekmur, Cory (2019), '*Chaudhvin ka Chand*', https://uiowa.edu/indiancinema/ chaudhvin-ka-chand. Accessed 26 September 2019.

Dwyer, Rachel (2005), *Filming the Gods: Religion and Indian Cinema*, New York: Routledge.

Elison, William, Novetzke, Christian Lee and Rotman, Andy (2016), *Amar Akbar Anthony: Bollywood, Brotherhood, and the Nation*, Cambridge, MA: Harvard University.

Ghosh, Shohini (2002), 'Queer pleasures for queer people: Film, television and queer sexuality in India', in R. Vanita (ed.), *Queering India: Same Sex Love and Eroticism in Indian Culture and Society*, London: Routledge, pp. 209–21.

Kabir, Nasreen Munni (1996), *Guru Dutt: A Life in Cinema*, New Delhi: Oxford University Press.

Mahadevan, Sudhir (2015), *A Very Old Machine: The Many Origins of Cinema in India*, New York: SUNY Press.

Said, Edward (1979), *Orientalism*, New York: Vintage.

Times of India (1960), '*Chaudhvin ka Chand*: Colourful saga of a bygone era', 19 June, p. 3.

Times of India (1963), 'A pleasant, rainbow-hued romance', 3 November, p. 3.

Vanita, Ruth (2018), *Dancing with the Nation: Courtesan in Bombay Cinema*, New York: Bloomsbury.

Waheed, Sarah (2014), 'An archive of Urdu feminist fiction and Bombay's *gaanewalis*', *Economic and Political* Weekly , 49:10, 8 March, pp. 25–27.

13

Transfigurations of the Star Body: Salman Khan and the Spectral Muslim

Shohini Ghosh

On September 10, 2010, my friend and I, as was our practice, went to see the new Salman Khan film on the first day of release. The film was Dabangg and it had been released on a Friday, which was expected to be Eid but turned out to be Jamat-ul-vida (the last Friday before Eid). The theatre was packed. Several rows looked more prominent than others because they had been occupied by boys in white caps and kurtas who had come straight from the Friday prayers. When Salman Khan made his entry, the theatre exploded with thunderous applause. The crowd whistled and clapped and some of the boys with white caps danced in the aisles. The exhilaration of the moment reminded me of a friend's description of watching a Salman Khan film in the old city of Hyderabad during Muḥarram. 'You should have seen the way they cheered when he came on the screen', he had said. 'You would think a Messiah had arrived'.[1]

The fame and notoriety of Salman Khan

On 6 May 2015, a Bombay Sessions Court found Salman Khan guilty of culpable homicide and sentenced him to five years rigorous imprisonment for a drunken driving incident in 2002 in which his Land Cruiser ran over sleeping pavement dwellers, killing one and injuring others.[2] On the same day, the High Court granted him interim bail pending appeal.[3] The verdict provoked an impassioned and polarized debate. Industry professionals expressed their sympathy for Salman, while the mainstream media, barring exceptions, criticized the star for using his privileged

status to get speedy bail. However, regardless of their editorial stance, almost all TV channels devoted the day to the unfolding events. The media event was no less notable for the fan frenzy on display. Thousands gathered at his house and on the premises of the court and lined the stretch of road that lay between the two. Hundreds had travelled from various parts of India to be with 'Bhaijaan' ('brother', the affectionate name given to him by his fans) when the courts delivered their judgement. As the news of the interim bail spread, the crowds went into a frenzy of celebration. They danced on the streets singing a rejigged version of Salman's hit song from *Kick* (dir. Sajid Nadiadwala, 2014): '*Jumme ki raat hai / Chumme ki baat hai / Allāh bachāye mujhe yeh court case se*' ('It is the night of Jumma [Friday] / The night of the chumma [kiss] / May Allah save you from this court case').[4]

Salman Khan is one of the most-discussed but least-studied stars of Bombay cinema. When Martin Shingler recommends expanding the scope of studying Bollywood stars, he provides a wish list of top stars, including Aamir Khan and Shah Rukh Khan, but Salman is conspicuous by his absence (2012: 182). Despite his staggering box-office success and formidable fan base, Salman Khan's films have been subject to academic indifference, if not disdain.[5] Salman Khan is arguably Bollywood's most controversial star. To admit to being a fan of Salman is to elicit astonishment and disbelief. While the star, along with Aamir Khan and Shah Rukh Khan, has been part of Bollywood's ruling triumvirate exerting tremendous command over the box office and their expansive fan bases, it is commonly assumed that Salman-starrers cater primarily to the 'substratum of the urban lumpen and working-class male audiences', pejoratively described as the 'lowest common denominator' (Sen and Basu 2013: 12). The ripped, muscular body of Salman – an object of much veneration by his fans – is confirmation for many that his star appeal has more to do with brawn than brain (Figure 13.1). 'The ridicule directed at body building', observes Yvonne Tasker, 'stems in part from the ambiguous status of the musculature in question'; for some critics, muscles are merely 'non-functional decoration' (2002: 78). The locus of deep ambiguities, the star text of Salman Khan is created as much by his on-screen performances as his off-screen reputation.

The annals of cyberspace are replete with stories about his fits of violence, unpredictable mood swings and criminal cases for drunken driving and poaching endangered animals. Notwithstanding the dark side of Salman Khan, the star's box-office saleability and devoted fan base remains unshakeable. Exercising a 'bad object choice' to study Bombay cinema's enfant terrible, this chapter explores the star's early success in the B and C centres of film distribution and his tremendous popularity among particular constituencies of the subaltern viewer.[6] It pays special attention to the working-class Muslim with whom the star has enjoyed a special affiliation.

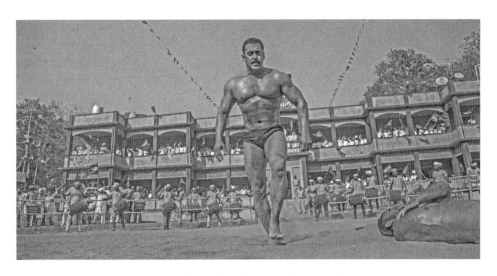

FIGURE 13.1: The ripped, muscular body of Salman Khan – *Sultan*. *Courtesy*: Ali Abbas Zafar.

The rise of Salman Khan

Starting his career as a romantic hero in *Maine Pyar Kiya* ('I have fallen in love', dir. Sooraj Barjatya, 1989), Salman Khan's rise to superstardom was accompanied by as many hits as flops. While his romantic comedies, including *Andaz Apna Apna* ('A style of one's own', 1994), *Pyar Kiya to Darna Kya* ('Don't be afraid to love', 1998), *Judwaa* ('The twin', 1997), *Biwi No. 1* ('Wife no. 1', 1999), *No Entry* (2005), *Mujhse Shaadi Karogi* ('Will you marry me?', 2004), *Maine Pyar Kyun Kiya* ('Why did I ever fall in love?', 2005) and *Partner* (2007), added substantially to his success at the box office, his stature was consolidated by action films that explore the shadowy underside of the urban experience where ethical boundaries have collapsed and the protagonist occupies the liminal space between legality and criminality.

In 2009, Salman Khan's career took a sharp upward swing with the blockbuster *Wanted* (dir. Prabhu Deva), followed by the stupendous success of *Dabangg* ('The fearless', dir. Abhinav Kashyap, 2010), a film that converted a large section of the more elite multiplex audience into Salman fans. *Outlook* reported:

> Despite his unquestionable star appeal, box-office clout and exclusive membership of the Khan trinity, Salman has been largely side-lined as the B and C centre hero, the one loved by the masses and inconsequential for the classes. But the resounding success of *Dabanng* changed everything. An action-comedy set in the rural badlands,

Dabanng was not only a sensation in Salman Khan's traditional fan base but also captured the imagination of the urban middle classes who were prone to deride Salman-starrers as lacking 'class' and 'taste'.

(Joshi 2010: n.pag.)

In an interview to *Tehelka Magazine*, Salman described *Dabangg* as a 'sten-gun assault on the polite multiplex crowd' who he hoped would 'whistle and dance on the chairs' which is precisely what they did (Chaudhary 2010). Reeling under the shock of *Dabangg*'s success, national weeklies like *Outlook*, *India Today*, *Tehelka* and *Brunch* carried, for the first time, cover stories on the star. The success of these two films were followed by *Bodyguard* (dir. Siddique, 2011), *Dabangg 2* ('The return of the fearless', dir. Arbaaz Khan, 2012) and *Ek Tha Tiger* ('Once, there was a tiger', dir. Kabir Khan, 2013), each of which crossed the 100-crore mark. Made with a budget of 80 crores and shot over several international locations, *Ek Tha Tiger* swept both Salman-strongholds and multiplex audiences making net domestic collections of nearly Rs 200 crores and over 300 crores worldwide. At the time of its release, it was Salman's most expensive and profitable film. The following year, *Kick* earned 165 crores in the first week and over 300 crores by the end of the fourth week. With an estimated annual income of 244 crores, Salman Khan became Bollywood's most saleable star and the undisputed hero of both the 'masses' and the 'classes' (Lall 2015).

How is Salman Khan's stardom distinct from that of Shah Rukh Khan and Aamir Khan? Unlike the two, Salman Khan, till much later in his career, seldom worked with top directors or big banners. Through his films and countless endorsements for high-end products, Shah Rukh has been a lifestyle icon for upward mobility and self-made success. His biographer Anupama Chopra writes:

A leading monitoring firm called the Agency Source (TAS) tabulated that between 1994 and 2006, Shahrukh appeared in 281 print ads and 172 television commercials. In 2005 alone, he endorsed approximately 34 different products. Shahrukh was the ubiquitous symbol and conduit for the new consumerist society.

(2007: 160)

Like Shah Rukh, Aamir Khan was also a highly paid endorser of brand names who, with the success of the TV show *Satyamev Jayate* ('The truth will prevail') consolidated his position as an inspirational brand ambassador for corporate social responsibility. While Shah Rukh and Aamir have been the icons for a globally mobile generation in post-liberalization India, Salman's stardom is located along the underbelly of the very landscape over which they reign.[7] Designated 'king of the single-screen', Salman Khan's traditional fan base was located in provincial towns, suburban areas, urban slums and *mohalla*s. As his success in the B and C

centres demonstrates, a very large slice of his traditional fan base comprises subalterns for whom the changes unleashed by the forces of globalization did not accrue many benefits and who were inessential to the multiplex economy.

The diegetic universe of the early Salman Khan action films invokes a sense of dystopic exile and entrapment that stands in direct contrast to the utopic worlds inaugurated by the urban romance and family films.[8] With a few notable exceptions, a majority of Salman's action films are set in the heart of the 'informal city'. For Ranjani Mazumdar, the 'informal city' articulates 'an alternative topography, an alternative community, and an alternative urban consciousness' (2007: 151). Standing in opposition to the 'commodity spectacle' staged in the high-budget urban romance films and family melodramas, the 'urban delirium of gangster films' navigates alleys, claustrophobic hutments, docks, abandoned factory sites and half-constructed buildings to offer us a prism through which the experience of disenchantment can be grasped (2007: 161). To these spaces, the Salman Khan action film adds the train and the space of the railway station. In these films, the protagonist played by Salman belongs mostly to the urban underclass who inhabits this 'informal city' and whose 'basic resource of survival' and most potent arsenal is his personal body (Biswas 2013: 237).

The master trope of Salman Khan's stardom is his ripped and six-pack muscular body. Both action and romantic melodramas starring Salman are designed to display the body of the star, in particular his famous torso. The much-awaited moment in a Salman Khan film is when his shirt comes off for a fight or song sequence. Fashioned over many films, this moment has acquired a frenzied popularity with audiences.[9] The preoccupation with the muscular look is not merely derivative of western body-fashion but affiliated to an 'Indian working class male dream of the muscular body, linked to Indian ideas of fitness and health and other traditional role models such as wrestlers' (Dwyer 2014: 243).[10] A long-time and dedicated bodybuilder, Salman Khan constantly underscores self-fashioning and attainability of the ripped body. In films like *Baaghi: A Rebel in Love* (1990), *Jaagruti* ('The awakening', 1992), *Veergati* ('The martyrdom', 1995), *Tumko Na Bhool Payenge* ('Never will I forget you', 2002), *Garv: Pride and Honour* (2004) and *Sultan* (2016), the body becomes, for the man who has lost everything, the last surviving weapon in the battle against injustice.

Salman Khan and the Muslim

The cusp of the new millennium witnessed heightened religious polarization as Hindu right-wing forces consolidated political power following the demolition of the Babri Masjid in Ayodhya.[11] Muslims were cast as unreliable citizens whose loyalties were perpetually in doubt. The anxiety suffered by the ordinary

Muslim – randomly targeted for interrogation, torture and incarceration merely on the basis of suspicion – found reflection, as it were, in the unpredictable vicissitudes that beset Salman Khan. Like Sanjay Dutt before him, Salman was sent to jail, brought to trial and struggled to establish his innocence. Notwithstanding circulating stories about his generosity and philanthropic work, Salman, even at the best of times, walks a risky tightrope. Criminal allegations and the possibility of punishment persist like shadows. There is no telling when he will slip and fall from the Olympian heights of superstardom into the dark crevasses of notoriety. In an interview, he confessed to admiring heroes who are able to come back from the edge, after being vanquished, to reclaim their respect and dignity (Chopra 2015: 80). This could well be an analogy for the star himself, who after every crisis manages to rise from the ashes. Salman's ability to survive in adversity may explain why, among his billion fans, the underprivileged Muslim forms a devoted constituency.[12]

The star earned the wrath of this fan following when he was seen to be making peace with Narendra Modi (now, prime minister of India), believed by many to have been responsible for the pogrom against Muslims in Gujarat in 2002. In February 2014, journalist Syed Firdaus Ashraf wrote that Salman's new film *Jai Ho* ('Long live!', dir. Sohail Khan, 2014) failed at the box office because disappointed Muslim fans had boycotted the film in protest against his softened stance in favour of Modi. Salman Khan had met Modi, then chief minister of Gujarat, to discuss tax emption for his new release. About the meeting, Ashraf writes:

> Not only did Salman Khan call on Modi in Gandhinagar on the eve of the release of his *Jai Ho*, but also dined with him, apart from flying kites, during Makar Sankranti. He also described Modi as a 'good man', and followed it up with an interview where he said that since the judiciary had given Modi a clean chit why should he apologise for the Gujarat riots?
>
> (2014: n.pag.)

Ashraf writes that the Urdu press, which rarely reports on Bollywood news, commented extensively on this. According to Ashraf, the community's disillusionment impacted on the film's box office performance, which is why '*Jai Ho*'s opening weekend collections did not reflect the usual fan frenzy of a Salman Khan film'.

Eid celebrations are incomplete without a Salman Khan release during which, there is a heightened circulation of Salman Khan's photographs. A prominently displayed Photoshopped poster in Old Delhi shows Salman Khan wearing a white prayer cap and keffiyeh holding a *tasbīḥ* (prayer beads) in his hands. The star's special affiliation to multiple constituencies of Muslim viewers has evolved through chance, accident and intuition as well as through off-screen circumstances which

influenced how Salman Khan's on-screen persona began to be understood. Since no fan base is ever homogeneous, Salman Khan's films address a diversity of spectatorial positions within this constituency. *Dabangg*, which was released on Jamat-ul-vida (the last Friday before Eid), is particularly interesting because it invites the viewer to occupy multiple subject positions and enjoy a diversity of spectatorial pleasures. By splitting and merging the off-screen star and actor with the on-screen character, the pious festivities of Eid are inoffensively reconciled in the scene in which Salman Khan/Chulbul Pandey rouses the small-town police force with the twin intoxication of what is prohibited in orthodox Islam – music and alcohol. 'The lyrics do not specify what is being drunk' say music directors Sajid and Wajid, 'but those who like their drink, will greatly enjoy the song'. In other scenes, 'Muslimness' is mapped onto the *mise en scène* through locations, property, architecture and the aesthetics of clothing, for example, in the song-sequence that was shot in Dubai and Abu Dhabi. Such cultural signifiers are recognized easily by Salman Khan's huge following in South Asia and the Middle East.

The expensively mounted geopolitical thriller *Ek Tha Tiger* radically altered the imagination of Salman Khan films and extended the cinematic range of his star persona.[13] A romantic spy thriller, the film is about a RAW agent code-named Tiger (Salman Khan) and an ISI agent Zoya (Katrina Kaif) who fall in love during a mission in Dublin and abandon their respective outfits in search of a life together. The informal city is left far behind as the action unfolds across transnational locations. The spectacular opening sequence is set against the distinctive vistas of Mardin, an old Mesopotamian city in the southeast Anatolian region of Turkey where Tiger, wearing a keffiyeh around his neck, is introduced against the distinctive stone buildings of Mardin, including the dome of the famous Zinciriye Medressi (Sultan Jesus Madrasa). The rest of the film moves through Delhi, Dublin, Istanbul and Havana where the action unfolds against the backdrop of famous landmarks and architectural sites. The urbanity, style and high production values of *Ek Tha Tiger* extend the cinematic range of Salman's star persona even though, or precisely because, it took a risk in not accommodating the star's trademark moments and mannerisms. *Ek Tha Tiger* made the star more acceptable among the higher echelons of the middle classes.[14] The denouement of the film witnesses a significant narrative shift that liberates the narrative of the Indo-Pak romance from privileging one country over another – a choice that Indians and Pakistanis are always asked to make. In the Pakistani blockbuster *Tere Pyar Mein* ('In your love', dir. Hassan Askari, 2000) the lovers choose Pakistan, after a violent disavowal of the 'enemy country'. *Gadar: Ek Prem Katha* ('Revolt: A love story', dir. Anil Sharma, 2001) reciprocates the idea with as much hostility. Even the protagonists of the non-belligerent *Veer-Zaara* (dir. Yash Chopra, 2004) predictably choose India. The country of the male protagonist (and the filmmaker) has conventionally

been the desired destination. In a refreshing twist, the lovers in *Ek Tha Tiger* turn their backs on both countries and make the world their home.

To suggest that Salman Khan has a special appeal to Muslims is not to argue that his success is confined only to Muslims or to the working classes for that matter. Superstardom demands an expansive fandom across multiple constituencies. For example, the documentary *Being Bhaijaan* (Shabani Hassanwala and Samreen Farooqui, 2014) is about three Hindu boys and their followers in Nagpur who have dedicated their lives to the worship of Salman Khan. Despite his strong personal identification with Islam, Salman's star persona seamlessly reconciles a number of religious and cultural identities. The multireligious character of his family is an integral part of the star discourse: 'I feel blessed to be born and brought up in a house that respects every religion', says Salman Khan. 'In *Galaxy* God is one, though our paths to reach the almighty are different'.[15] As he once said on a TV show: 'My mother is Hindu, my father is Muslim, my second mother is Catholic – so *hum Hindustan hai* ["We are India"]' (Khan 2010).[16] In Bollywood, a cosmopolitan appeal is common to all superstars, but for Muslims, the lure of Salman Khan could well be entangled with the many conundrums of living in a culturally diverse society where real or imagined erotic desires frequently exceed the limits of social prescriptions.[17]

The early action films: Speaking to the exiled

In *Garv: Pride and Honour*, Arjun Ranawat (Salman Khan) is an honest cop who believes that 'traitors have no religion' and who strongly endorses 'encounter killings' because the law of the land has failed to deliver justice. For Arjun, criminality and corruption are not endemic to outliers but are embedded within the state and the legal system. The ostensible enemy is Pakistan but as Ranawat repeatedly claims, the enemies of the country are everywhere and occupy the highest echelons of power. When his conscientious colleague Haider Ali (played by Salman's brother Arbaaz Khan) is transferred on grounds that Muslims cannot be trusted to fight their brethren, in a scene that dramatically mobilizes the melodramatic conventions of Bombay cinema, Arjun takes his protest to the highest authorities.

ARJUN: This is very wrong, Sir. Traitors have no caste or religion. They are neither Hindu nor Muslim. The mere fact that I am a Rajput or that you are a Brahmin is no proof of us being patriots. This very reprehensible and communal mindset is today responsible for alienating, like Hyder Ali, hundreds of young Muslims forcing them to walk down the wrong path.[18]

As Arjun delivers his lines, the camera moves increasingly closer to his face where the noiresque half-light in the room adds greater intensity to his words. In the next sequence, Arjun walks into the office of the director general of police (Puneet Issar) to stage another forceful rhetorical performance.

DGP: Silence! That insolent junior of yours who took his shirt and belt off and threw them at the Commissioner? You are saying he is correct? And that we are all non-secular and communal? Isn't that what you are trying to say?

ARJUN: If any of your superiors called you and told you that you are a Sikh and therefore you will aid the Khalistani terrorists and because of that, you were being transferred from Punjab, then you may not have liked that either.

Taken aback at this blunt riposte, the DGP falls silent. The camera moves closer till Arjun is held in full frontal close-up. Dramatically mobilizing the rhetorical conventions of Bombay cinema's melodramatic mode, Salman Khan delivers the final dialogue.

ARJUN: Sir, if you were not stopped from fighting Sikh terrorists then why is Haider Ali Khan being stopped from fighting Muslim criminals and ISI agents? Without any proof or evidence, just to cast aspersions on the basis of one's caste or religion is unconstitutional. [*After a beat*] Sir, our Constitution gives pre-eminence to duty. The best man for the job. It does not give pre-eminence to religion [...]. Hyder Ali Khan is a soldier who would allow his uniform to be adorned a million times by distinction but would never allow it to be tainted – even once.

The dialogue-delivery in this sequence is particularly forceful because words like 'communal' and 'unconstitutional' are uttered in English with the latter word immediately reinforced and followed up with its Hindi translation, as has been conventional till recently.[19]

A more allegorical dissension plays out in *Tumko Na Bhool Payenge*, a film with an intricate emplotment (of which certain elements are clearly inspired by *The Long Kiss Goodnight* [dir. Renny Harlin, United States, 1996]). Veer Pratap Singh (Salman Khan) is the only son of Thakur Pratap Singh, a feudal landowner, engaged to marry his fiancée, Muskaan (Diya Mirza). Veer's happy and idyllic life starts getting disrupted when unexplained hallucinatory visions keep appearing from another life. In one of his visions, he is attacked by a huge wolf-like dog, while in another, he sees himself or a phantom double being chased. As these visions

keep intruding into his life, he begins to suspect that there is more to his past than he can remember. He asks those around him to help him fill the gaps. His parents, lover and friends provide explanations, but each version is different. His body, so lovingly nurtured by his parents, carries scars of injuries whose history of infliction seems lost. One day, a crisis precipitates a series of incidents during which Veer is seen to possess lethal fighting skills for which he has no memory of ever being trained. Finally, Pratap Singh is compelled to tell Veer the truth about his arrival into their family. Veer, he says, is not their biological son but had come to them, three years back, wounded and unconscious. When he revived, he could not remember his past. Having just lost their own son, the couple eagerly embraced him as their own. An unsettled Veer takes permission from his parents and sets out in search of his lost history.

When Veer gets off the train in Bombay, he is gripped by a sense of déjà vu and uncanny familiarity. He runs into people who recognize him, but he cannot remember them. The police seem to be hunting for him, but he has no idea why. As he unsurely navigates the unknown landscape of the city, he hears the *azān* (call to prayer). What follows is perhaps one of the most striking sequences in the film. As Veer follows the *azān* into the masjid, he finds his body enacting a sequence of rehearsed and familiar gestures: washing his hands and feet as part of the ritual ablutions and, as the camera moves around him in a circular track, covering his head with a handkerchief in preparation for prayer. The body seems to remember what the mind has forgotten. The dynamism of the camera movements come to a halt as he kneels down to pray. The camera, now still and contemplative, observes him in close-up as he rediscovers each bodily ritual gesture. In a sequence comprising mid-shots and close-ups that separate Veer from the other supplicants, a routine collective ritual becomes an introspective personal journey into the lost labyrinth of the past. The practiced enactments of the body become the first step to accessing the hidden recesses of a forgotten history. Veer sends up a prayer: 'You have told me what I am, now tell me who I am'.

The puzzle is yet unsolved. As he steps out of the mosque a young boy calls him 'Ali Bhaijaan' and embraces him affectionately when suddenly he is shot dead by an unidentified assassin. As his past starts unravelling in fragments, we learn that Veer is Ali, a hired hitman whose closest friends and comrades were his girlfriend Mehak (Sushmita Sen) and friend Inder (Inder Kumar). The young teenager who dies in front of him is his beloved younger brother Azaan. They had been orphaned in childhood, and Ali had brought him up like a son. Now he was dead, and Ali had not even recognized him. But the police are still after him. As they give him chase, Ali runs along a rail track and jumps onto a moving train. As he enters the compartment, the visitations return, first as flashes, then more coherently and finally they unspool in front of him like a seamless film leading up to the

final moment of remembrance: the betrayal by Inder, his trusted friend and business partner. Selling out to a political coterie for a large sum of money, Inder had framed Ali on a false assassination charge. When Ali had tried to flee in order to escape the police, Inder had trapped him on a train, shot five bullets into him and let him fall into the river. As the train hurtles across a high bridge over a river, we watch Ali's body in free fall. Inder goes back and marries an unsuspecting Mehak. The affective charge of the 'betrayal' sequence is intensified through rendering the images dreamlike and painterly. Ali, who watches the images unfold in the dark compartment, is framed by noiresque lighting while the treachery suffered by his phantom double unfolds through a grainy, sepia tone rendered unreal through canted close-ups.

Inder's treachery is not only the pivot around which the narrative unfolds but also the locus of the film's affective charge. For this unexpected and terrible betrayal, Ali avenges himself. Deploying his muscular body as resistive shield and retaliatory weapon, he destroys all those who were complicit with Inder's treachery. Having avenged himself, he returns, to live with his adoptive family. Embracing Pratap Singh he says, 'My name is Ali and I am a Muslim'. Pratap Singh pushes him away angrily: 'How dare you bring religion between a father and son? Is this what I have taught you?' Overcome with emotion, Ali embraces his father who says, 'You are my son. That's all'. The father-son embrace at the end of the film is a moment of utopian reconciliation in dystopian times. By allowing the cinematic reconciliation to be made on the terms laid down by the Muslim protagonist, the film allows an exilic community to wrest back its desires and aspirations from the debris of majoritarian prejudice. A parable of intimate betrayal and retaliation, *Tumko Na Bhool Payenge* is an allegorical assertion that there can be no peace without justice.

The accessibility of films on the internet has altered the chronology of watching films. Notwithstanding their dates of release, all films are now available for streaming at all times. *Tumko Na Bhool Payenge* did average business when it was released, but, over the years, it has been gaining currency among Salman cinephiles who keep revisiting the actor's older films. Yet, the significance of the film is intimately tied to the moment of its release. Elaborating on how Deleuze understood history, Richard Rushton argues that 'films can express certain things during certain historical periods that they cannot during other historical periods' (2012: 7). *Tumko Na Bhool Payenge* was released on 22 February 2002, just five days before the Godhra train incident that became the trigger for the statewide carnage that killed several hundred Muslims. The pogrom rode on the back of an aggressive campaign by Hindutva groups to build a Ram temple in Ayodhya, in the very place where the Babri Masjid once stood (see Varadarajan 2002). It was during this dark and foreboding lead-up to the Gujarat Genocide that posters of the

film started appearing across the city. Pegged heavily as an Eid release and featuring a celebratory Eid Mubarak song, the pre-publicity, anticipating the release of the film, itself became, in that moment, a mark of resistive cultural assertion.

Transfigured body, transfigured landscape

The Salman Khan film that most purposefully intervenes in the public debates on contemporary Hindu-Muslim relations is *Bajrangi Bhaijaan* ('Brother Bajrangi', dir. Kabir Khan, 2015), a story of unlikely friendships and a journey of discoveries. Six-year-old Shahida (Harshali Malhotra) comes to India with her mother to visit the shrine of Niẓāmuddīn Auliyā. On their way back, she wanders out of the Samjhauta Express and gets left behind. The family is frantic. The difficulty of searching for a lost child across the border is made harder by Shahida's speech impairment. She cannot speak even though she can hear perfectly well. Shahida's grandfather hopes that somewhere in India is a good man (*khuda ka nek banda*) who will look after her. The man is 'Bajrangi' Pawan Kumar Chaturvedi (Salman Khan), an acolyte of the monkey-god Hanuman. The rest of the film is about Bajrangi's growing attachment to the child who he calls 'Munni' and his efforts to reunite her with her parents in Pakistan. During the journey, Bajrangi learns to confront his own unthinking prejudices about Muslims and Islam.[20]

Neither Pawan nor Rasika (Kareena Kapoor), the woman he loves, share the bigotry of their Hindutva-enthused fathers. In fact, Pawan is a huge disappointment to his father who heads the RSS *shakha* ('branch') of Pratapgarh.[21] He is disastrous in his studies, taking twenty years to reach class ten and finally graduating on his eleventh attempt. He is inept at wrestling because he is ticklish. Worse, when his father stands on the RSS stage singing to the glory of a strong Hindu nation, Pawan is the only fidgety boy in the long line of disciplined cadres. Pawan modestly declares, 'In all the subjects that were dear to my father, I had absolutely no interest'. Bajrangi certainly does not embody the manhood valorized by the Hindu right. No wonder that his father, even after his death, glowers at him from the framed picture on the wall.

Rasika's father Dayanand (Sharad Saxena) is a Hindu bigot. He does not allow 'Mohameddans' to rent rooms in his building as he does not like the smell of non-vegetarian food contaminating his pure vegetarian air. When he gets to know that Munni (Shahida) is a Muslim from Pakistan, he asks her to be removed forthwith. But Dayanand's bluster does not command obedience. Rasika disapproves of her father's bigotry and reprimands Bajrangi for sharing his views. The rest of the family is happy to have Munni around. When the Pakistan Embassy shuts down after an unruly attack by the saffron-brigade, the youngest member of the family is delighted that Munni's stay in their house has been extended. Ravi

Vasudevan argues that Bombay popular cinema with its 'strong pedagogic insistence' is able to capture 'transitions in the cognitive map' more powerfully than art or parallel cinema (2003: 99). The latter, notes Vasudevan, speaks 'a language of conscientization' in order to 'strengthen a civil social discourse of reasoned representation, communication and debate' whereas the power of popular cinema lies precisely in 'outflanking such a discursive terrain' (2003: 99–100).[22] Mediated through a melodramatic mode of emotional excess, humour and playfulness become the driving vectors of affect in *Bajrangi Bhaijaan*.

The journey to Pakistan (cinematically recreated through shooting in parts of Rajasthan and Kashmir) transforms Bajrangi.[23] When he enters Pakistan having extracted 'permission' from a most exasperated officer of the Border Security Force, he finds himself being pursued by the police. The word spreads that an Indian spy has infiltrated the country. Bajrangi and Munni find a friend and accomplice in TV stringer Chand Nawab (Nawazuddin Siddiqui) who helps them dodge the cops while documenting with his camcorder the entire expedition.[24] The two make common cause, even though Bajrangi has no idea what '*watan parast*' means and Chand Nawab struggles to pronounce '*desh bhakt*', the Urdu and Hindi variations for 'patriot'. The search for Munni's parents takes Bajrangi into spaces that are anathema to him. In one sequence, he darts out of a mosque and refuses to re-enter but quickly changes his mind when he spots a police van approaching him. Later he tells Chand Nawab that, for Munni, he was willing to enter any place of worship, so the trio reach the *dargāh* of Hazrat Amin Shah, which is known for its power to reunite the separated. Bajrangi feels diffident about crossing the threshold into the *dargāh*, but when he does, he is overwhelmed by the shrine (shot in Kashmir's famous Aishmuqam Dargah), and the impassioned singing of the *qawwālī*, '*Bhar do jholī*':

Fulfil my wishes, O Mohammad
I will not go back empty-handed
My eyes are brimming with tears
My heart is full of sorrow
Fulfil our wishes, Beloved Master
I will not go back empty-handed.

Sitting among the devotees, Bajrangi's eyes brim with tears. Munni has fallen asleep so she does not see her mother, who has also come to the same *dargāh*. Later, she will spot her mother in the footage that Chand Nawab had shot providing the final clue to locating her home. At the end of the film, Munni is reunited with her parents and also finds her voice. When, during the last sequence, she sees Bajrangi crossing the border from Pakistan into India, she strains to shout 'Mama' ('uncle'), which

is what Bajrangi wanted her to call him. The '*mannat*' asked from both *dargāh*s, one in India and the other in Pakistan, comes true. The film ends with Bajrangi and Munni in reconciliatory embrace on the border of India and Pakistan. This is a parting that carries within it a promise of another meeting. The affective universe of the film is driven by some of Bombay cinema's best-loved conventions – a lost-and-found narrative, accidental partings, coincidental meetings and happy reunions. Yet, it is through the staging of these conventions that the film recalibrates the cinematic imagination of Pakistan and Kashmir.

The stunning vistas of Kashmir's mountains become a recurrent visual motif in *Bajrangi Bhaijaan*. The film opens with aerial shots of undulating snow-capped mountains. The alpine peaks of these soaring ranges surround the pastoral setting of Munni's home. It is this arcadian landscape in a photo on a desk-calendar at the police station that Munni identifies as her home. Bajrangi puts it away safely as a vital clue. Later, a little boy, who looks at the picture carefully, discovers that the photo is of Switzerland – as was printed on the corner of the torn page. The maulana of the mosque comments that such mesmerizing mountains could be found only in Kashmir. 'Does that mean I have to go back to India?' asks Bajrangi anxiously. 'No', laughs the maulana, 'A small piece [of Kashmir] belongs to us too'. The stunning vista returns when the trio take a bus towards the mountains. Munni is delighted by its familiarity while Bajrangi is enchanted by its beauty. Notwithstanding the beauty of the landscape, Bajrangi is unwavering in his mission of taking Munni home. For him geographical terrains, whether or not divided by borders, are less important than the happiness of the human beings who occupy that land. Ironically, Bajrangi will never get to see the idyllic environs of Munni's home. He will offer himself as distraction to the police so that Chand Nawab can take the child safely home to be reunited with her mother. Bajrangi's determined and ethical action of returning to the land its people reverses the historical preoccupation with privileging the landscape over the people who inhabit it. According to Ananya Jahanara Kabir, film and literature have the ability to create 'phantom maps' that invoke cartographic time and space that no longer exist in geography (2013: 45). We could similarly argue that films have the ability to invoke phantom maps of the future. As Bajrangi and Munni pass through the cinematic landscape of the film, India 'passes' as Pakistan and India-administered Kashmir 'passes' as Kashmir in Pakistan, while on one occasion even Switzerland 'passes' as Kashmir. The phantom map thus invoked brings dissenting geographies together, signalling, were we to follow this logic to its end, an altered imagination around Kashmir's home and belonging. This spectral map gathers greater affective force because it unfolds around the star body of Salman Khan.

Conjurations of the star body

In the darkness, the camera moves across the dull golden glow of a barred window. Inside, harnessed to sandbags and a slab of stone, a bare-bodied muscular man strains to pull an enormous weight. As his foot hits the ground, clouds of dust rise and fill the frame. As he strains against the weight, his chest muscles ripple and shine. With slanted shafts of light falling across the darkened wrestling pit, the contours of his athletic body become discernible, as he stands at the far end, in half-shadows, swinging a pair of exercise clubs. His shoulders, arms and neck become an undulating landscape of muscles, rippling, rising and falling. One giant drop of sweat falls and scatters into tiny droplets as it hits the soft soil of the wrestling pit. More dust clouds fly as his two sturdy hands grip a thick braided rope. As he hoists himself up to climb, granules of dust scatter in the hazy half light of the pit.

This impressionistic montage, invoking an elemental, almost mythic force, is the prelude to the star's first appearance in *Sultan*, a film that reclaims and reworks some of the key conventions of a Salman Khan action film. When the film opens, Sultan is an out-of-shape former champion wrestler employed in a desultory government office in Rewari district, Haryana, whose only passion is to fundraise for a blood bank in memory of his deceased son. The past is revealed through flashback. An Olympic gold-medallist from a small village in Haryana (Figure 13.2),

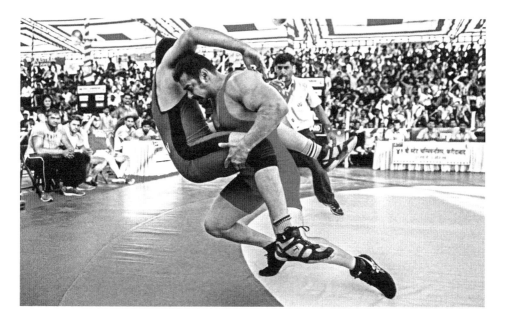

FIGURE 13.2: Salman Khan as an Olympic wrestler – *Sultan*.
Courtesy: Ali Abbas Zafar.

Sultan gave up the sport at the peak of his career when his newborn son died and his wife, Aarfa (Anushka Sharma), left him. The baby had inherited his father's rare blood group, so when he needed a transfusion his father was away wining another world title. Had Sultan been with his child, he might have lived. A world-class wrestler herself, Aarfa had set aside her own ambitions to have their baby. When the newborn dies, she holds Sultan responsible. She had urged him to stay for the delivery but riding high on his success, he was confident that nothing in his life could go wrong. 'It's good to have dreams', Aarfa had cautioned, 'but in chasing them, don't go so far as to leave your loved ones behind.' When Aarfa leaves him, life stagnates for Sultan until a young sports entrepreneur persuades him to become a prize fighter for a new sporting enterprise called Pro-Takedown, an international mixed martial arts championship. But Sultan's mental and physical debilitation makes the task hard, if not impossible. The rest of the film is about Sultan picking himself up from the debris of his broken life and mastering a new and perilous sport to emerge a champion again.

As is evident from the summary, the narrative arc of the film is structured around the rise and fall of Sultan's life. He hits his first low when Aarfa tells him she cannot love a man who has no aim or ambition in life. Sultan is shattered. His father says: 'In order to earn respect, it is sometimes important to experience humiliation'. Struck by his father's words Sultan picks himself up and starts training to be a wrestler, eventually emerging a winner and marrying Aarfa. But when personal tragedy strikes again, he hits another devastating low. The day he returns to find that his child has died, Sultan takes an exercise club and beheads the statue that the village had erected in his likeness. Sultan's defeats and failures are not due to external circumstances alone but to his own complicity in them. Yet, he refuses the closure that defeat offers, choosing instead to struggle to his feet and renew the ascent to success (Figure 13.3). Sultan Ali Khan sounds remarkably like Salman Khan. The autobiographical citations would be recognized easily by fans of Bombay cinema whether or not they are fans of the star.[25]

The diegetic world of *Sultan* is steeped in the ordinary. The opening credit title unfolds over Sultan's desultory routine of waking up, brushing his teeth, making tea, reading the newspaper and leaving for work. Yet, the same star body is able to transfigure the ordinary through the exhilaration of kinesis that is affectively spatialized in the kite-catching sequences in *Sultan*. Prior to becoming a wrestler, Sultan was the champion kite-catcher of the area. Every time a kite was cut, he would be the first to retrieve it. In an energetic parkour-style sequence, Sultan takes up a rival's challenge and races through the village towards the descending kite. Leaping over cycles, buffalos, gates and walls and cutting through a crowd watching a local wrestling match, Sultan and his rivals reach the rooftops. As the camera rises higher and higher we see the kite-catchers jumping from rooftop

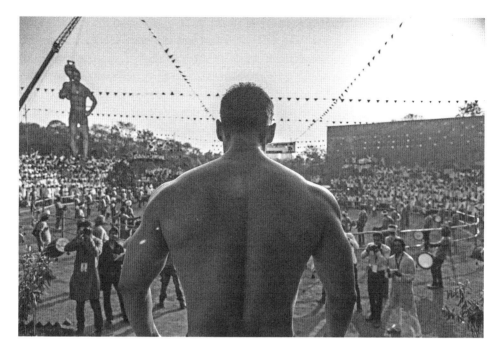

FIGURE 13.3: The return of Salman Khan – *Sultan*.
Courtesy: Ali Abbas Zafar.

to rooftop, terrace to terrace, moving through people's doors, balconies, courtyards and clotheslines. The sequence culminates when, sighting the kite, Sultan makes a dash through the crowded street but crashes into a scooter. He slaps the offending driver for not looking out. The driver, who returns the blow with equal force, turns out to be Aarfa. In the process, Sultan loses the challenge but the star body has already electrified the *mise en scène* through the sheer thrill of movement.

If Salman Khan's star body invests unremarkable spaces with remarkable energy, then it also allows new worlds to be imagined around the body of the Muslim. In the unexceptional landscape of Rewari, the body of the Muslim is also rendered unexceptional. When Sultan falls in love with Aarfa he has no idea who she is, and when she keeps him at bay, it is because she does not want 'emotions' to come in the way of her sporting ambitions. She also tells him that when she does marry, it would be to a *pehelwan* (a wrestler). Towards the end of the film, before an injured Sultan goes for the climax fight, Aarfa makes him promise that he will return alive. 'Make me a promise', she says, 'wrestler to wrestler, husband to wife.' In this entire negotiation of life and love between Sultan and Aarfa, religion is never a priority.

In the film, Sultan's primary identity is as the '*jaan*' ('life') and '*shaan*' ('pride') of Haryana. Yet, his religious identity is not effaced. When Aarfa proposes to Sultan, she asks: 'Will you read the *nikāḥ* with me?' In the cinematic universe of *Sultan*, religion is spectacularly ordinary and seamlessly braided into social life. This is established early in a fleeting shot when Sultan drives past a *burqa*'-clad woman holding the hand of a little boy dressed up as the blue-bodied Hindu god Krishna. Sultan imagines Aarfa as the famous Hindu warrior queen of Jhansi who is forever ready to go into battle. When asked what he feels about winning the gold medal, Sultan in his broken English says: 'proud, happy, *Bhārat Mātā ki Jai*' ('victory for Mother India'). The father of a boy tells Aarfa that his son wants to change his name from 'Rakesh' to 'Sultan' so that he could grow up to be like him. The inextricability of cultures is invoked in the refrain of the title song.

> *Khūṅ meṅ tere miṭṭī,*
> *Miṭṭī meṅ tera Khūṅ*
> *Upar Allāh, neeche dhartī,*
> *Beech meṅ tera junūṅ*
> *Aye Sultan.*
>
> ('There is the soil in your blood
> And your blood is in the soil
> With Allah above,
> And the soil down below
> Your Madness lies between.
> Aye Sultan.')

Like *Bajrangi Bhaijaan*, *Sultan* too conjures a phantom map of an aspirational future. The inextricability of composite cultures and the ordinariness of religious identity in *Sultan* allow for a generic shift. *Sultan* pulls the 'Muslim' and the 'Social' together but by evacuating the signifiers commonly attached to its representational conventions, it signals the possibility of reimagining the 'Muslim Social'.

Conclusion

While this chapter is driven by my own cinephilic fascination for the star, it is also an attempt to understand Salman Khan's stardom in relation to a period that was (and continues to be) marked by religious polarization and haunted by the spectre of the 'dangerous' Muslim. Salman Khan's stardom has run parallel to the rise of Hindutva, the polarization along communal lines and the surveillance

of the bodies of Muslim men. It is my argument that the heightened visibility of Salman Khan's star persona, enmeshed as it is in a complex web of accumulating affects and significations, inaugurates new possibilities around the visibility and spectrality of the Muslim. *Bajrangi Bhaijaan* and *Sultan* were both released after the BJP led by Narendra Modi formed the government in 2014 after winning a massive electoral mandate bringing in its wake further polarization, alienation and the targeting of Muslims. The desire, fascination, frenzy and affection with which the body of Salman Khan is gazed upon, mirrored in *Sultan* by the crowds that throng to watch and cheer the champion wrestler, is a quiet inversion, however inadvertent and accidental, of the hostile, surveillant gaze. This is the unintended excess of Salman Khan's stardom.

ACKNOWLEDGMENT

This chapter is a substantially revised and expanded version of a paper that recently appeared as 'The irresistible badness of Salman Khan', in M. Lawrence (ed.), *Indian Film Stars: New Critical Perspectives*, London: Bloomsbury, 2020, pp. 193–203.

NOTES

1. Author's unpublished notes at the screening of *Dabangg* on its opening day.
2. On 28 September 2002, a car allegedly driven by the actor rammed into the American Express Bakery in Bandra, Mumbai, killing one person and injuring four others. Salman reportedly fled the scene. His lawyers have argued that he neither drove the car nor fled the scene. In 2002, he was charged under Section 304 (I) of the IPC for 'causing death through rash and negligent driving'. In 2013, a Mumbai court ordered a retrial under the non-bailable Section 304 of the IPC for 'culpable homicide not amounting to murder'. He also faces criminal charges for allegedly poaching a blackbuck, an endangered animal, during the shooting of *Hum Saath Saath Hain* in 1998. To provide accurate and factual information about his cases, Khan's lawyers maintain a website: http://www.salmankhanfiles.com/files/. Accessed 24 March 2015.
3. Khan was sentenced to five years of rigorous imprisonment under IPC 304 (II) for culpable homicide not amounting to murder, one year of simple imprisonment (SI) for causing grievous hurt, three months of SI for minor injuries, two months of SI for failing to give data about driving license, six months of SI for drunk driving and two months of SI for not carrying his license. The sentences are to run concurrently. Salman Khan appealed to the Bombay High Court, which on 10 December 2015 acquitted him of all charges. An emotional Salman Khan broke down as the verdict was announced. In response to a petition filed by the Maharashtra government, the Supreme Court directed the actor to respond to the appeal and issued a notice that the final decision on the matter would be delivered by the Supreme Court.

4. The lyrics of the original song are '*Jumme ki raat hai / Chumme ki baat hai / Allāh bachāye mujhe tere waar se* ('It is the night of Jumma / It's the night of the kiss / May God save me from your love'). For Muslims Friday (Jumma) is a day for special prayers and the word '*waar*', which literally means attack or assault, is often used metaphorically for falling in love.

5. One of the few scholars to have taken muscular bodies seriously, Nandana Bose has this to say about Salman Khan: 'His physique hinders his dancing abilities; an Indian Hulk Hogan, Khan's stiff and taut body is suitable for display and action but not much else' (2013: 1600). An exception to this attitude is Krupa Shandilya's (2014) essay on *Dabangg*.

6. The industry categorizes exhibition centres as A, B and C class centres on the basis of market size, often measured in terms of the population of the place and its purchasing power. Geographically, B and C refer to non-metropolitan centres that are characterized by poor infrastructure, lower pricing of tickets and low levels of investment.

7. When the first song of *Ek Tha Tiger* was released, Salman, the 'king of the single screen', decided to first screen it for the theatre ushers of single-screen theatres: http://www.indiatvnews.com/entertainment/bollywood/salman-khan-gift-to-all-single-screen-theatre-staff-4609.html. Accessed 10 November 2019.

8. Bollywood action films are melodramas where action and emotions are inextricable. Action films are frequently propelled by narratives of attachment – to friends, lovers, parents, siblings or a cause. Fans often ask Salman why he has stopped acting in 'romantic films', to which his reply is that all his action films are also romance films. The inextricability of action and romance are often signalled by titles like *Baaghi: A Rebel in Love* and *Lucky: No Time for Love*.

9. On *Dus ka Dum* in 2010, actors Govinda and Ritesh Deshmukh and director David Dhawan, supported by an ecstatic studio audience, persuade Salman Khan to take his shirt off to deafening applause from both men and women: https://www.youtube.com/watch?v=U_2gmBMIBiU. Accessed 31 March 2015. See also Khan's performance at Rockstars Concert, in Atlantic City, in 2006 and the *Chote Ustaad* TV show where again the audience persuades him to take his shirt off: https://www.youtube.com/watch?v=GO13xSk0fao and https://www.youtube.com/watch?v=duP92CxWXgA, respectively. (Both) Accessed 31 March 2015.

10. Rachel Dwyer contends that bodybuilding is as much part of the consumerist culture as it has allowed the middle classes to 'buy' a good body through not just exercise but expensive dietary plans and steroids. She writes that earlier, other than sportsmen or wrestlers, 'it was only the working class who were muscled as they often performed physical labour and had to walk long distances but were often malnourished' (Dwyer 2014: 243).

11. The Hindu right groups led by the political party BJP revived a movement to declare the ground under a medieval mosque (Babri Masjid) the birthplace of Lord Ram, a mytho-religious personality revered in North India. On 6 December 1992, thousands of Hindu right activists, in complete violation of the law and the Constitution of India, demolished the Babri Masjid paving the way for the building of a Ram temple.

12. The scholarship on Bruce Lee shows that he enjoyed tremendous popularity in the United States in the ghettos. Gina Marchetti (2001: 41) writes: 'Everyone involved in *Enter the Dragon* recognized the importance of [Bruce] Lee's connection to the American Martial Arts subculture and the crucial import of the popularity of Martial Arts and Hong Kong film in the black community'.

13. Director of *Kabul Express* (2006) and *New York* (2009), Kabir Khan has consistently sought to bend the tropes of popular cinema to subvert the predictable representations of Muslims in Bombay cinema. *New York*, about three friends one of whom turns out to run a sleeper cell, marks a significant shift by extricating 'terrorism' from the commonly depicted signifiers of being Muslim.

14. The images and songs from *Ek Tha Tiger* found circulation in more elite spaces. Expensive men's magazines featured Salman Khan on the cover dressed in formal wear, and Archies, usually invested in lifestyle icons like Shah Rukh and Hrithik, produced a greetings card that, when opened, played the 'Masha Allah' song from the movie. In an interview Salman says: 'For high society I am Tiger, with the masses I am Chulbul [of *Dabangg*]' (Risbood 2012).

15. Galaxy is the name of the building where Salman has lived with his family since childhood (Ahmed 2012).

16. 'Hum Hindustan hai' translates as 'we are India'.

17. Unlike Aamir, Shah Rukh or any actor of his generation, Salman is still single. The fact that he has romanced many beautiful women but settled with none must add to the lure of his star persona.

18. All translations are by the author unless otherwise stated.

19. Arjun was adopted and brought up by a Hindu woman (played by Farida Jalal) after he was orphaned in the pogrom against Sikhs in 1984. It is therefore suggested that Arjun was born a Sikh. The bar-dancer who Arjun loves is Jannat (Shilpa Shetty) whose name suggests she might be Muslim.

20. As he grew up watching Rāmlīlā and sometimes playing the role of Hanuman, Kabir Khan believed that Hanuman did not belong to just one religion but was part of the cultural heritage and ethos of everybody living in India. The rise of Hindutva began to change that. Kabir Khan says:

> As [the Bajrang Dal] and other Hindu fundamentalists engaged in polarising society along communal lines, they appropriated Bajrangi, the one god whom we associated with joy and who we thought belonged to all of us […]. This intensified with Babu Bajrangi, the leader of the Gujarat wing of the Bajrang Dal who played a central role in the 2002 riots and who was caught on tape talking about how he wished to kill 25,000–50,000 Muslims […]. I felt it was time to reclaim Bajrangi. I decided to name the endearing protagonist of my film Bajrangi.
>
> (2015: 5)

21. The RSS (The Rashtriya Swayamsevak Sangh) is a Hindu supremacist organization that is the ideological parent of the Hindu right political party, the BJP. The RSS works through grassroots-level mobilization of men through clusters called 'shakhas' (branches).

22. But Vasudevan cautions that the politics of such an 'outflanking' can go in different directions: 'Providing the possibilities of both reassembling the national on a more chauvinistic ground and side-stepping its discursive frames in order to look at the social as social without clear ideological and political trappings' (2003: 100).

23. A large part of the shooting was done in Madawa, Rajasthan, while Munni's home scenes were shot in Arru near Pahalgam. When he made the film, Kabir Khan had never visited Pakistan.

24. In a clever instance of intertextuality, Chand Nawab's introduction is a hilarious reconstruction of the real namesake' s unedited piece-to-camera (P2C) that had gone viral on the internet in 2008.

25. The eponymous hero says: 'There is only one man who can defeat Sultan, it is Sultan himself'. Salman Khan has often made a similar statement that hangs on the cusp of swagger and self-reflection – that if anyone defeats Salman Khan, it would be Salman Khan himself. Reportedly, this is what his father, Salim Khan, told him during one of his bad phases: 'There is only one person who can destroy your career, and it is you'. A similar observation about Sultan is made by Nandini Ramnath's review of *Sultan* on 6 July 2016. See http://scroll.in/bulletins/11/can-success-lead-to-a-more-fulfilled-life-its-complicated-for-indians-according-to-a-new-survey. Accessed 12 November 2019.

REFERENCES

Ahmed, Afsana (2012), 'In Sallu's home God is one', *Hindustan Times*, 20 September, https://www.hindustantimes.com/chandigarh/in-sallu-s-home-god-is-one/story-mShGBvkexDP0tnSVdDNyQK.html. Accessed 16 June 2021.

Ashraf, Syed Firdaus (2014), 'Why Salman Khan's Muslim fans are angrý', Rediff, 3 February, https://www.rediff.com/movies/column/why-salman-khans-muslim-fans-are-angry/20140203.htm. Accessed 16 June 2021.

Biswas, Moinak (2013), 'Bodies in syncopation', in M. Sen and A. Basu (eds), *Figurations in Indian Film*, Basingstoke and New York: Palgrave Macmillan, pp. 236–52.

Bose, Nandana (2013), 'From Superman to *Shahenshah*: Stardom and the transnational corporeality of Hrithik Roshan', in M. Sen and A. Basu (eds), *Figurations in Indian Film*, Basingstoke and New York: Palgrave Macmillan, pp. 158–78.

Chaudhary, Shoma (2010), 'Is the measure of this man just a moustache?', *Tehelka Magazine*, 7:37, 18 September, pp. 38–45.

Chopra, Anupama (2007), *King of Bollywood: Shah Rukh Khan and the Seductive World of Indian Cinema*, New York: Warner Books.

Chopra, Anupama (2015), *The Front Row: Conversations on Cinema*, New Delhi: Harper Collins Publishers.

Dwyer, Rachel (2014), *Picture Abhi Baaki Hai: Bollywood as a Guide to Modern India*, New Delhi: Hachette.

Garv: Pride and Honour (2004), Puneet Issar (dir.), India: Cinevista.

Global Movie (2013), interview with Salman Khan, January, www.globalmovie.in. Accessed 10 November 2019.

Joshi, Namrata (2010), 'Sallu boti, anyone?', *Outlook*, 20 September, http://www.outlookindia.com/article/sallu-boti-anyone-/267041. Accessed 10 November 2019.

Kabir, Ananya Jahanara (2013), *Partition's Post-Amnesia: 1947, 1971 and Modern South Asia*, New Delhi: Women Unlimited.

Khan, Kabir (2015), 'Eye', *The Sunday Express Magazine*, 8 November.

Khan, Salman (2010), interview, *Aap ki Adalat*, India TV, 6 September, https://www.youtube.com/watch?v=9MShezEywWI. Accessed 30 August 2021.

Lall, Pavan (2015), 'The cash machine demigod', *Fortune*, May, pp. 95–104.

Marchetti, Gina (2001), 'Jackie Chan and the black connection', in M. Tinkcom and A. Villarejo (eds), *Keyframes: Popular Cinema and Cultural Studies*, London: Routledge, pp. 137–58.

Mazumdar, Ranjani (2007), *Bombay Cinema: An Archive of the City*, Minneapolis: University of Minnesota Press.

Risbood Vaibhavi V. (2012), 'Prem is the real me at home: Salman', *Times of India*, 27 December, https://timesofindia.indiatimes.com/entertainment/hindi/bollywood/news/prem-is-the-real-me-at-home-salman-khan/articleshow/17778546.cms?from=mdr. Accessed 20 June 2021.

Rushton, Richard (2012), *Cinema after Deluze*, London: Continuum.

Sen, Meheli and Basu, Anustup (eds) (2013), *Figurations in Indian Film*, Basingstoke and New York: Palgrave Macmillian.

Shandilya, Krupa (2014), 'Of enraged shirts, gyrating gangsters, and farting bullets: Salman Khan and the new Bollywood action film', *South Asian Popular Culture*, 12:2, July, pp. 111–21.

Shingler, Martin (2012), *Star Studies: A Critical Guide*, London: Palgrave Macmillan.

Tasker, Yvonne (2002), *Spectacular Bodies: Gender, Genre and Action Cinema*, London: Routledge.

Varadarajan, Siddharth (ed.) (2002), *Gujarat: The Making of a Tragedy*, New Delhi: Penguin Books.

Vasudevan, Ravi (2003), 'Selves made strange: Violent and performative bodies in the cities of Indian cinema, 1974–2003', in I. Chandrashekhar and P. C. Seal (eds), *Body City: Citing Contemporary Cultures in India*, Delhi and Berlin: Tulika Books and House of World Cultures, pp. 74–109.

14

Terrorism, Conspiracy and Surveillance in Bombay's Urban Cinema

Ranjani Mazumdar

Fear, as many suggest, is a response to perceptions of danger that penetrates social memory, thrives on ambiguities and generates states of paranoia. The fear associated with terrorist actions, bomb blasts and other such cataclysmic events is partly linked to our inability to comprehend, systematize and judge these sites of conflict. The number of times we hear about these events and their magnitude shapes our relationship to paranoia. Television news spectaculars have transformed traumatic events of the recent past into narratives of suspense and surprise (Lutticken 2006). This is now fundamental to the way the media functions and it is here that 'conspiracy' emerges as a form of narrative with dramatic explanatory power, opening out historical wounds to a parade of detail, documents, plans, security discourses and technology (Jarett 1999; Christensen 2002; Keeley 1995; Nadel 2002). This media theatre of crisis management depends to a large extent on emotional geographies of fear, located in the archives of our memory. As I will show, conspiracy as a formal technique has entered the terrain of some films from Bombay to specifically present the city as a space controlled by Islamic terrorists.

This chapter looks at three films from Bombay where conspiracy as a narrative device is deployed to confront a city besieged by terrorism. The films are Anurag Kashyap's *Black Friday* (2004), Rajkumar Gupta's *Aamir* (2008) and Neeraj Pandey's *A Wednesday* (2009). The filmmakers belong to a community of cinephiles and are therefore extremely conscious of and dedicated to their craft (Mazumdar 2010).[1] Yet these twenty-first century films instil a disturbing fear of the Muslim by referring to various terrorist attacks of the last two decades. They work with an investigative cartography, staging the city through narratives cluttered with evidentiary details, an aggressive marking and arranging of information and a constant presence of the visual media as the ultimate arbiter of knowledge. Unlike popular melodramas, the films discussed here open out cataclysmic

events through re-enactments and precision style unravelling,[2] and in this process a 'mobile script' is carved out to mediate the relationship between paranoia and citizenship (Sturken 1997a, 1997b).[3] If the social practice of paranoia is rooted in the belief that the truth is not fully available, then in these films, conspiracy is the form through which the spectator is provided the illusion of comfort and control over contemporary events, the city of Bombay and history. Conspiracy selectively opens out an archive of memory to frame the city's present as a landscape threatened by Islamic terrorism, ironing out rival visions of truth for a unified and singular projection.

In his work on the presence of conspiracy narratives in American culture, Gordon B. Arnold suggests that, for the ordinary person, conspiracy does not signify a literal or criminal act, but more a generalized perception that people are targets of deception and manipulation (2008: 4). As a cultural narrative and as a mass phenomenon, conspiracy acquires widespread circulation when everyday life is disrupted by a traumatic event. In such a situation, conspiracy emerges as a seductive force since it helps explain complex situations in a simple cause and effect narrative. The conspiracy narrative is not a frozen structure in time but a constantly shifting horizon of meaning that has changed since the early days of the cold war to the present global context of uncertainty and fear (Arnold 2008: 4). The history of investigative journalism in India, which started in the 1980s, may have provided a template for the consolidation of the conspiracy form. The sensational structure of investigative journalism lends itself to narrative unravelling and disclosure techniques. In the films discussed here, the language of conspiracy is deployed to link urban paranoia, civil disturbance and political intrigue to the presence of Islam and terrorism. Central to the unravelling of conspiracy is the appropriation of obsessive surveillance techniques in the cinematic language of looking, mapping and processing information. The surveillance form caters to a desire for transparency and provides illusory control over traumatic events (Levin et al. 2002). But where and how did the city of Bombay get mired in the discourse of conspiracy and surveillance? How does this template showcase the city? Where did all this start? For this we need to look back at the recent past.

The archive of memory

The destruction of the Babri Masjid in December of 1992 marked a major moment in the subcontinent's history, representing a break with a particular self-image of modern India. The demolition itself, as a widely photographed event, emerged as a major sign in the construction of a memory archive of conflict. The sixteenth-century mosque located at Ayodhya was the site and subject of a long drawn out

dispute with Hindu right wing groups who claimed that the mosque had been built over the birthplace of Ram. Fuelled by the Hindu nationalists, the dispute took a politically ugly turn and on 6 December 1992 a mob of almost 150,000 Hindu militants destroyed the mosque (Jaffrelot 2007; Menon and Nigam 2007: 36–60). The demolition was followed by riots in different parts of the country but the grizzliest effects were felt in Bombay where almost 2,000 Muslims were killed. In January of 1993, a series of bomb blasts at several marked locations in Bombay followed the riots. For many residents, the riots and the blasts have become the temporal mark to divide the city's history into the before and after of 1992/93.

Anthropologists, historians, journalists and filmmakers have tried to make sense of the cityscape following the blasts. Thomas Blom Hansen's engagement with the 'Muslim Mohalla' in his account of Bombay and the Shiv Sena provides a history of violence within the informal networks of the city. Blom Hansen sees both the 1993 blasts and the decline of Bombay's famous textile mills as critical to the consolidation of a Muslim identity in the city. His vivid description of life in Central Bombay remains one of the most powerful accounts of the city's internal disenchantment and despair (Blom Hansen 2001). In a somewhat similar vein, Radhika Subramaniam undertakes a phenomenology of Bombay's crowd to build a vast archive of terror and suspicion located in the daily rhythms of the city. The context for Subramaniam's exploration of this 'culture of suspicion' is Bombay after 1993 (Subramaniam 1999). Arjun Appadurai suggests a process of 'ethnicization' that started with the consolidation of the Shiv Sena in the 1970s and reached its apogee in the post 1992/93 moment when Hindu militants pushed for a rewriting of 'urban space as sacred, national and Hindu space' (2000: 630). The desire for a space without Muslim bodies emerged as a specific response to the problem of scarce housing and the language of cleansing was conveniently adopted to deal with Muslim presence (2000: 644). More recently, Gyan Prakash (2010), in his account of Bombay's 'mythic imagination', acknowledges that the riots and the bomb blasts caused considerable damage to the city's cosmopolitan ethos. Bombay cannot but address the transformation of the city post the events of 1992/93. It is as if the city has been marked forever.

The demolition of the Mosque itself as an event of medieval intensity resulted in an almost unmanageable archive of photographs, documentary footage and television news – all of which continues to circulate via print to video, television to the internet and persists as a spectacular memory of the recent past. The presence of saffron flags atop a solid mass of architecture, the unruly crowd gathered all around, images of destruction after explosions and riots in various parts of the country, men holding swords, pictures of political leaders – these images are now firmly ensconced in the popular imagination, stoking speculation, anger, hatred, bewilderment and even complete apathy (Figures 14.1 and 14.2). This

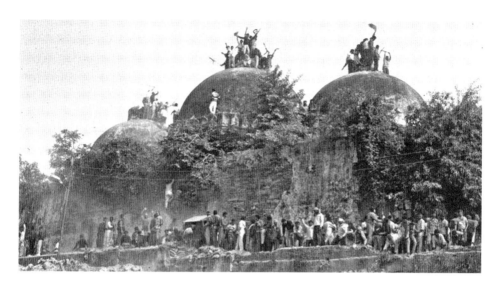

FIGURE 14.1: Hindu militants atop the Babri Mosque just before its destruction.
Source: The Leaflet: Constitution First, 2018, https://www.theleaflet.in/is-the-refusal-to-refer-ismail-faruqui-judgment-to-a-larger-bench-a-victory-or-defeat-for-muslims/. Accessed 20 June 2021.

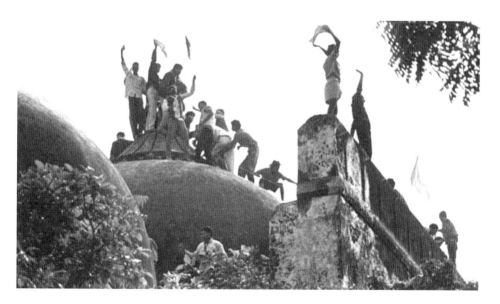

FIGURE 14.2: A closer view of the Babri Mosque showing militants waving saffron flags.
Source: Deutche Welle, https://www.dw.com/en/demolition-of-indias-babri-mosque-the-hindutva-project-25-years-on/a-41672139. Accessed 20 June 2021.

complicated weave of images has congealed into a 'technology of memory', playing an important role in the power dynamics of memory production (Sturken 1997b: 10). In her fascinating work on the production and constant transformation of memory linked to the war in Vietnam, Marita Sturken writes that recognizing the 'changeable script' of memory today is crucial to understanding its cultural function (1997b: 17). For Sturken, camera images have a special power to hold and contain memory and in this the still photograph is particularly potent. However, it is not just the camera image's ability to contain memory that makes it significant but also its role as a producer of memory. As I have already stated, the vast archive of photographic and video images on the demolition of the Babri Masjid, and the violence that followed, circulates across diverse media formats. It was produced immediately after the events in almost every magazine and newspaper cover. Islamic and Hindu fundamentalist groups have also used the demolition in propaganda videos and pamphlets to voice opinions against each other. Dislodged from its original moment of production, the visual force of the demolition now circulates via television and the internet and is reproduced whenever the subject is discussed. Given that the site has been embroiled in a court battle for a long time, with the final declaration of the judgment on 9 November 2019, news items featuring photographs of the Mosque that once stood in Ayodhya have been recurrent but sporadic.[4] The first controversial court verdict by the Allahabad High court (30 September 2010) brought the images back fully into circulation, including those of destruction. The three-member bench ruled that the land should be divided three ways between the three groups involved in the dispute (Roy 2010).[5] Today, the photographic account of the demolition and its aftermath remains a powerful sign of destruction that can stoke a range of passionate responses.

Memory archives write the present in complicated ways. Feelings of loss and bewilderment, anger and humiliation can get channelled into sites that evoke a density of narratives which become attached to the memory archive. No archive is unified and singular in its affective force field. Riots, terrorist attacks and bomb blasts get attached to the memory archive when they are described or discussed in newspapers, magazines, television and on the internet. Bombay has witnessed a series of terrorist attacks since the demolition. The first reaction came in the form of ten blasts in March 1993 which killed 300 and injured more than 700. In July of 2006, seven bombs rocked a suburban train in the city killing 174 people and injuring more than 300. In November of 2008, the city witnessed more than ten coordinated shooting and bomb attacks, including the three-day terrorist takeover of the Taj Hotel located in South Bombay. This event was televised globally and a documentary based on the surveillance footage accessed later now circulates on the internet. When a city's contemporary history becomes marked by

such cataclysmic events the details of which still remain obscure, the events get replayed constantly through an extended memory archive within which all the events appear connected. The paranoid narrative is therefore constituted through a series of such attachments and is one of the ways in which the idea of the 'mobile script' can be thought of (Sturken 1997a, 1997b).

The first direct reference to the demolition and its effects on Bombay was seen in Mani Ratnam's *Bombay* (1995). Soon other films such as Mahesh Bhatt's *Zakhm* (1998) and Khalid Mohammed's *Fiza* (2000) followed. These films have relied on the emotional contour of redemption within Hindi cinema's moral universe to narrate what they saw as a crisis of humanity. Subsequently, the events in Bombay were deployed to create another kind of paranoid urban cinema. Drawing on both the memory archive for its conspiracy narrative, as well as the technological world that has emerged in the thickets of urban life after globalization, this form of urban cinema deploys the aesthetics of surveillance to evoke an affective world of anxiety. As we will see, various forms of communication technologies are drawn into a new loop of sensations that generate a fear of the Muslim, and consequent feelings of helplessness and paranoia. In these films the city is not presented as knowable but as an abyss of decrepitude.

Bombay's takeover in *Black Friday*

Anurag Kashyap's film *Black Friday* based on the Bombay bomb blasts of 1993 was perhaps the first to deploy the structure of a conspiracy film. Largely committed to reproducing the structure of the book authored by S. Hussain Zaidi, *Black Friday* uses real names and places. This became the primary reason for the long-drawn out delay in its release, due to legal worries that the film could influence the thirteen-year-old trial on the synchronized bomb attacks. That trial ended in September of 2006 and the film was released soon after to critical acclaim, receiving favourable reviews both in India and abroad. Matt Zoler Seitz (2007) of *The New York Times* described the film as 'raw and epic', a mix of

> shocking, agitprop-inflected imagery (disfigured bombing victims, police torture of suspects); cool-headed police procedural details; and documentary devices (including numbered, white-on-black chapter titles) and a nonlinear structure that spends the entire second half explaining the origins of the bombers' alienation.

Arnab Bannerjee's review in the *Hindustan Times* referred to the film as 'passionate throughout, not once making judgmental claims or being irresponsible' (Bannerjee 2007).

Black Friday provides us with extensive shooting of Bombay and tries to recreate the events before and after the 1993 serial blasts (Figure 14.3). At one level, the film is a revenge narrative which shows Tiger Memon and Dawood Ibrahim as the kingpins behind the planned attacks. At another level, we have Badshah Khan (Aditya Srivastav), one of the prime accused in the conspiracy, who is manipulated emotionally to join Tiger Memon's gang to participate in the blasts after his working life got destroyed by the riots. There are several other characters in the film, but it is Badshah Khan, as the foot soldier, who offers the crucial testimony in the film, which opens out a terrifying world of terrorism. The investigation of the conspiracy is led by Rakesh Maria (Kay Kay Menon), the principal investigator on behalf of the police. The film is divided into five chapters, each pushing a particular dimension of the conspiracy.

Black Friday also uses terrorism as the template to penetrate the layers of the city and its gangster world. A reviewer of the film took special note of how the

> camera penetrates through the dark and grimy interiors of a city which is quite literally a tinderbox, waiting to implode anytime. The plot of the 1993 bomb blasts is painstakingly recreated and the long list of characters in the transnational drama, are given body and form.
>
> (Mohamed 2007)

This X-ray-like penetrative quality became the high point of the film, enabled by the presence of characters who take us through various sites with their testimonies. Right from the beginning *Black Friday*'s perceptual economy depends on a form that draws in testimony and witness accounts to galvanize a truth discourse in accordance with the point of view of the police. This discourse relies to a large extent on Khan's account, which in the film becomes increasingly problematic.

Black Friday unfolds like an investigative narrative. The confessions extracted by the police out of suspected terrorists form a visual and aural track through which the conspiracy is accessed. The film begins with such a confession leading up to the blast at the Stock Exchange, and then inhabits the point of view of the police to push the investigation. The police interrogation sequences are shot using a red filter, while the rest of the narrative appears in standard colour. This movement and juxtaposition between the interrogation scenes and the larger universe of action that unfolds through the extracted confessions, privileges the police point of view. It is in the course of the investigation that we stumble upon Badshah Khan through whom the entire conspiracy is laid out for the spectator. At one level, this is a conventional police procedural form where witness accounts are generated to tightly structure information and details. At another level, the movement from scenes of interrogation at the police headquarters to dramatic detailing across the

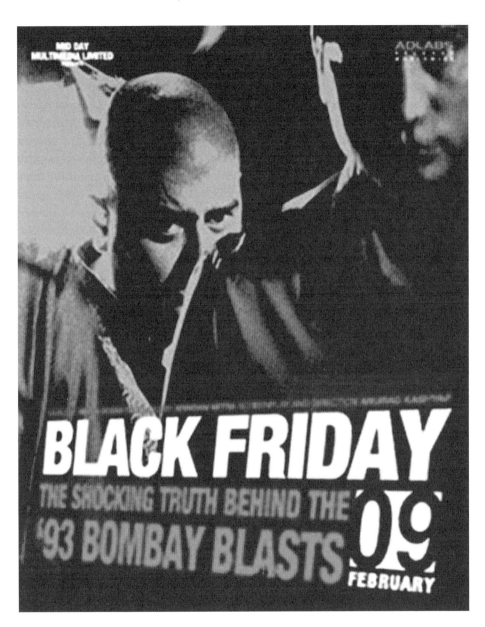

FIGURE 14.3: Poster of *Black Friday*.
Courtesy: courtesy of Anurag Kashyap.

city deploys the aesthetics of surveillance. As the narrative unfolds, we are given access to a powerful terrorist network, moving with a camera that literally operates like an X-ray machine, scripting a desire for social and spatial control. In the course of this journey, Islamic signage is liberally deployed – we encounter people reading the *namāz*, there is conversation about *ramazān*, the sound of a *qawwālī* occasionally plays on the soundtrack and mosques dot the city. The concept of X-ray vision, as I use it here, is a way of identifying the camera as penetrating through multiple layers of the city. The clutter of the object world does not prevent the X-ray vision from moving aggressively through the thickets of the city.

Badshah Khan willingly becomes a witness for the state after he recognizes and admits to Rakesh Maria that he became a terrorist because of *Allāh*, but soon realized that *Allāh* was not with them. Khan's confessional voice is played over other images and mesmerizes the spectator to embark on a journey with him, to see the chronology of involvement from his point of view. We travel to Islamabad and Dubai; we access discussions on meat and vegetarianism. Khan's voice operates as his memory that takes the spectator to where Khan has already been. Within the structure of the film, Badshah Khan is witness, interviewee and narrator, all rolled into one. Without this play of testimony, *Black Friday*'s desire to reveal the truth about the conspiracy could not have been achieved. Khan's speech as an act of bearing witness appears in the narrative to lend credence through the power of confession. To confess is to admit to a crime creating an order of truth telling that has been deployed so inventively in non-fiction cinema. Khan sits in front of Rakesh Maria as his crystal clear voice takes us on a flashback journey to different sites and spaces. Kashyap encourages us to engage with the narrative, to look at the scale of the plan that moves beyond borders. Khan's narration of the plan works through a back and forth structure where the voice comes and goes. While at one level the voice merges with the world that is being recounted, it is also reinstated as the testimony of a state witness. There is a doubling of truth value as the voice and the visual narration of the past provide two tracks of visual and aural evidence (Figure 14.4).

Khan's testimony has a travel structure as he recounts his visits to places such as Dubai and Islamabad, narrating times, events and memories. The narration is dotted with details of training camps, the airlines they travelled by, the hotel where everyone met, issues related to visas and so on. The narrative is mesmerizing as it collates a soundtrack of Muslim names, Islamic fervour and Pakistani involvement. We hear what the police wants us to hear and we move through the film inhabiting the point of view of the police. Despite Khan's mesmerizing voice, the method of recall gives the police the authoritative evidence that they are searching for. Factual documentation serves as evidence, but evidence of *what* becomes a fundamental question. Badshah Khan's voice narrates the world of individual responsibility,

TERRORISM, CONSPIRACY AND SURVEILLANCE

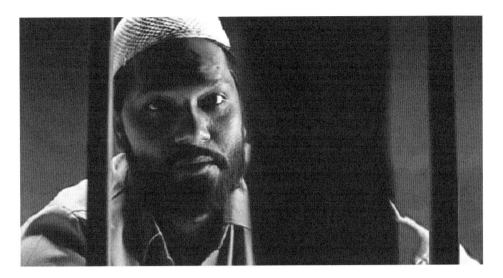

FIGURE 14.4: An anguished Badshah Khan in custody – *Black Friday*.

social context, everyday hardships and common sense, confronting a charged historical moment along with the mundane. The testimony acquires an emotionally powerful expression, presenting Khan as a figure who stands in for the country's misled and troubled Muslim youth. With this testimony, Anurag Kashyap was clearly hoping to complicate the world of the conspiracy, but the use of the testimony in the service of the police ultimately creates serious tension in the film.

If Badshah Khan's testimony generates a cross-border sweep, the testimony of Asgar Muqadam (Tiger Memon's manager) offers a different account. Muqadam has clearly been tortured by the police. He sits there only in his underpants narrating the actual planting of the bombs. We hear Muqadam's voice as he walks us through the major sites of the city where the bombs have been placed. We see Badshah Khan along with a man named Farukh Pawle, in a car with a bomb, desperately looking for a convenient place to leave the car. We see the stock exchange, the Air India building. We hear the conversation between Farukh and Badshah Khan as they express their anger about the Shiv Sena and their desire to destroy the passport office. The dense crowd of Zaveri Bazaar is laid out as a man named Mushtaq walks through the busy market to park a two-wheeler with the bomb. Muqadam's confession showcases the city through the terrorist plan and the process unfolds quite literally as we move through different sites. Neighbourhoods are named, strategies described and the planners are placed at the heart of the city. Bombay's take over by terrorists remains overwhelming in these sequences and the ability to paralyze the city with the blasts appears frightening.

In a very balanced review, Smita Mitra (2007) recognized the implications of the films structure. For Mitra,

> the torture sequences taken from Maria's point of view implicate the spectator as we enter the problematic terrain of strategies and mechanisms of evidence and confessions that most police investigations routinely deploy. If the police investigation is the 'protagonist' of the film then clearly Maria is the figure through whom that negotiation is enacted for us.

The urban map of *Black Friday* is no doubt spectacular. Kashyap used hidden cameras to mount the cityscape which could not have been done without a careful plan. In an interview on the making of the film, Kashyap recounts,

> We did research to recreate things. I saw the real locations, I saw the actual footage of the films from [the government's] Films Division, I read all the newspapers. I read a book called *Voices* written by Sebastian, a human rights lawyer, looked at lots of press photographs [...] It was a difficult film. The most difficult thing was to create 1993 when there were no cell phones, no satellite television and the latest car was Maruti 1000. We had to shoot on the streets of Mumbai and avoid all the modern cars [...] We had to avoid people with mobile phones. While shooting in that atmosphere, we had 25 cars of our own. It is worse than making a period film because there you know you can't shoot here so you go to a place that suits your script. But I needed the city, so I had to shoot here, at the same time I had to trim the city. I somehow managed it. I shot mostly from a top angle and focused on my characters. There was a lot of guerrilla type shooting where nobody in the city came to know – we shot with hidden cameras.
>
> (Patcy 2007)

Kashyap's narrative confirms the X-ray vision that I see as central to the strategy of the film. The use of non-stars and hidden camerawork was also influenced by the strategies adopted in sting operations.[6] Kashyap was determined to map the city as a character and in several conversations emphasized how Bombay had never been captured on film like it had been in *Black Friday*. The ability to move through a dense landscape of architectural and human mass, television and radio technology, lavatories and garbage, to unearth the men behind the conspiracy, marked *Black Friday*'s X-ray vision. Perhaps the best example of this remains the six-minute chase staged in the film when Imtiaz Gawate is arrested. A cop team arrives in Central Bombay after a prisoner names Gawate during the interrogation. They start questioning various people to pick up clues on the whereabouts of Gawate. This search soon results in an extended chase through squalor, wires,

alleyways, water pipes, underground tunnels, train tracks and more. The soundscape and the kinetic carving out of diverse perspectives to map the chaos and density of Central Bombay is indeed quite spectacular. A tired Gawate is finally picked up, slapped and taken away for what is perhaps the most brutal form of police torture. The chase exists in the film as a marker of this desire for a penetrative vision, a scanning of spatial density to pick up the body that will be brutalized for more testimony and confession. No matter how dense the space is, the cops manage to penetrate the layers and the camera strives to capture this process of unravelling.

The sensorium of *Black Friday* is accentuated by its powerful soundtrack. While the musical score is deployed to enhance the seductive universe of the conspiracy, the soundtrack also contains audio produced by television and radio, to mark the time of the events. Each testimony offers an account of the conspiracy and as we move through the film, the voice is dislodged from the body of the speaker, independently producing information on global financial transactions, RDX (colloquially referred to as *Kala Sabun* which means black soap) smuggling, the underworld, Islam, Pakistani camps and more. The combined effect of strong visuals and a mesmerizing soundtrack adds to the roaming surveillance style of the film. Kashyap believed that the film's power lay in its assemblage of all the men responsible for heinous crimes against the state and the web they got caught up in. He also felt that no one was singled out by the film, everyone was interrogated – the conspirators, the victims and the powerful network of the police (Bannerjee 2007). This supreme confidence in being able to put the whole story together 'objectively' remains the fundamental problem with *Black Friday*. Despite Kashyap's belief that the film indicted everyone, Rakesh Maria remains the figure who processes all the information produced by the investigation. The fascination for the details of the conspiracy and the step-by-step account of the plan, accessed via testimonies produced after torture, reaffirms faith in this conduct of the police. All uncertainties and difficult questions are ironed out, and detection is accorded a special place. The X-ray vision with its powerful intensity makes the prisoners turn their life into a form of public spectacle and by default become accomplices in the surveillance tactics of the police, the filmmaker and the spectators.

The archaeology of the stereotype: *Aamir*

If *Black Friday* directly engages with the conspiracy behind the 1993 blast, *Aamir* is located in the present, in a world that we can now refer to as post-1993. Directed by Rajkumar Gupta, *Aamir* is the story of a non-resident Indian (NRI) doctor from London named Aamir Ali (Rajeev Khandelwal) who arrives in Bombay to meet

his family. At the airport, he experiences discrimination at the hands of a customs officer who has his bags checked three times. If his name was Amar not Aamir, would the officer do the same, asks Aamir. This opening stages the rising conflict in the city and the 'culture of suspicion' that operates in everyday life. The airport sequence plays out the Hindu-Muslim divide and we assume the film is now going to engage with these issues. However as soon as Aamir exits from the airport, he is drawn into a nightmarish experience in which he is the sole 'good' Muslim up against a hidden and powerful Islamic network in the city. Aamir's family has been kidnapped and for their release, he must perform a role for the terrorists and plant a bomb in a crowded bus. As in *Black Friday* we enter the interior world of the conspiracy, which is masterminded for the spectators by the Muslims of the city. However, unlike *Black Friday*, *Aamir*'s world is an entirely Islamic world with no representatives of the State mediating the conspiracy.

The moment Aamir steps out of the airport, a cell phone is handed over to him by two unknown men on a bike. Thereafter he is constantly tracked by an ominous voice on the phone. While Aamir can only hear the voice, we as spectators can see the anonymous caller on screen, framed in expressionist style shadows, the face revealed only partially. This is the kingpin of the terrorist network whose powerful control of the city is made explicitly clear throughout the film. In a dramatic moment staged at a restaurant where Aamir has been asked to wait, we hear the cell phone ring. The sound of the ring electrifies the atmosphere and there is palpable tension on Aamir's face as he picks up the phone. The kingpin on the other side issues some instructions and a reluctant Aamir comes out with the phone to buy dry fruits at a local store. When Aamir tries to stuff the dry fruits in his pocket, the kingpin asks why he is not eating what he has bought. A bewildered Aamir wildly looks around to see several people talking on cell phones. The protagonist is trapped by the cell phone, his every movement watched and communicated via all the Muslims who have the phone in their possession (Figure 14.5). We follow a bewildered Aamir through a decrepit urban landscape as he tries to make sense of all the instructions given to him by the voice on the phone. The network expands when Aamir is asked to call Karachi. Next he encounters a prostitute who speaks with a Bengali accent, clearly marking Bangladesh Muslims and their presence in Bombay within the network. Video images of Aamir's kidnapped family are revealed to him on the screen of the cell phone. The film plays with the ring of the phone throughout creating a soundscape of cellular technology, the ominous threatening voice of the principal kingpin and the ambience of traffic. The city is overwhelmingly under surveillance not by the state but by the Muslim terrorists. They possess the All-Seeing Eye, the omniscient gaze and a network of committed members who are working towards a revenge on the system. The figure of the terrorist is given a voice that is even more threatening as it pervades the film via phone conversations.

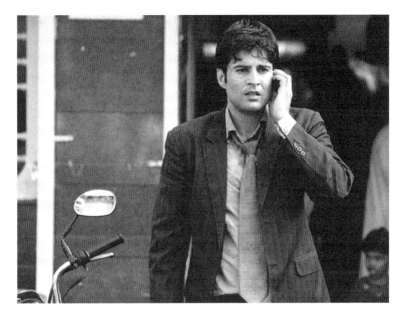

FIGURE 14.5: The protagonist in *Aamir* trapped by the cell phone.

In establishing this network, the filmmaker accesses spaces of Bombay through two stereotypes of Muslims in South Asia – that of food and filth – both deployed to convey the emotive charge of 'disgust'. In his philosophical treatise on disgust, Winfred Menninghaus writes:

> [T]he fundamental schema of disgust is the experience of a nearness that is not wanted. An intrusive presence, a smell or taste is spontaneously assessed as contamination and forcibly distanced.
>
> (2003: 1)

Gupta plays out this logic of 'disgusting nearness' by forcing Aamir and by the same logic, the spectator, to confront the city's squalor identified in the film with the Muslim community. The form of observation is decidedly tactile with Aamir forced to walk through sites where he can smell, hear and touch that which is perceived as 'disgusting'. As we watch in horror and fascination, a parade of stereotypes unfolds on screen. Almost every serious response has expressed discomfort at the use of the social and cultural landscape in the film. Shohini Ghosh (2009) saw a double purpose in the depiction of urban squalor – to educate Aamir on the plight and living conditions of Muslims and to show how this congested space operated as a 'hostile panopticon' monitored by 'seen and unseen eyes'. Aarti Wani and Kuhu Tanvir

have also referred to the hostile presence of the Muslim crowd and the grotesque usage of eating habits to articulate cultural difference (Wani 2008; Tanvir 2010). There are some moments that remain more troubling than others.

In one sequence the protagonist is led to a toilet across a *chawl* (working class housing originally designed by the British) area and we see him enter the filthiest possible makeshift bathroom where the stench makes him sick. Aamir finds a little note tucked in the wall of the toilet. When he takes it out, we can see his face contorted as nausea overwhelms him. Aamir finally runs out and in a long shot we see him vomiting in the middle of waste and garbage. Rajkumar Gupta's desire to touch the senses was part of his shooting strategy. Rajeev Khandelwal recalls how during the shooting of the toilet sequence, 'the entire crew was wearing medical masks because the stench was so strong' (Rajendran 2009). Not only does this showcase a typical NRI nightmare, the sequence also makes filth a visible sign for the representation of Muslim spaces. The same strategy is adopted in the hotel where Aamir is made to wait in a room. The hotel, which is architecturally Islamicate, has decaying walls, windowless rooms and sinister looking men. Aamir is taken to a room where the television seems incongruous. A tray full of food is brought into the room and the sight of meat combined with the claustrophobia of the room adds to his sense of despair.

Like filth, the play with food is equally revolting. The unnamed kingpin is constantly presented with piles of food. The camera deliberately plays with close-ups of meat while the sound of chewing is highlighted on the audio track. The film appears to revel in this grotesque ensemble, completely oblivious to the stereotypes it is mobilizing. These sequences are repeated often and the discourse of food itself is strategically located to establish the iconography of a community (Tanvir 2010). The most troubling sequence, however, showcases Aamir's walk across a butcher's alley holding a red suitcase with the bomb (Figure 14.6). A song plays on the soundtrack which is intercut with close-ups of raw meat being chopped. The cold faces of men with their cloth caps are placed behind the carcasses. The walk is stylized and the association of butchers and butchery with a community is made quite directly. This sequence in particular draws on the aesthetic power of disgust which relies on the simultaneous ability to repel, captivate and enthral the spectator. The affective charge of disgust has played a critical role in the workings of the social world we inhabit. Disgust usually has a physical and fleshy quality and is generated through experiences of touch, sight, smell, taste and sound. As some have argued, both disgust and contempt play a role in reinforcing social hierarchy. Modern democratic structures rely far less on tolerance and respect, and much more on the widespread circulation of contempt. Disgust operates through the schisms of daily life, and functions with a supreme confidence in the belief that the lower order smells and pollutes. When this takes an extreme form,

TERRORISM, CONSPIRACY AND SURVEILLANCE

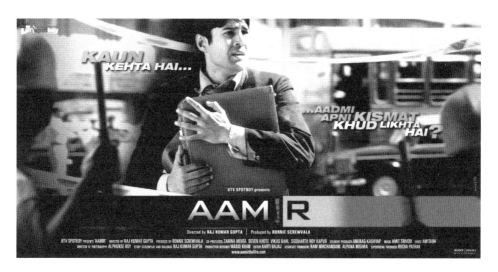

FIGURE 14.6: Poster of *Aamir* highlighting the sequence with the red suitcase.
Source: IMP Awards, http://www.impawards.com/intl/india/2008/aamir ver5.html. Accessed 20 June 2021.

the threat to democracy becomes a potent force (Miller 1997). *Aamir*'s director, Rajkumar Gupta, expressed no qualms in playing with such feelings of disgust. Gupta (2009) wanted to show Aamir's isolation from the larger community and the use of primitivist iconography to distinguish between the educated Muslim and the others seemed important to him. This marking of locations inhabited by the Muslims in *Aamir* produces space as diseased and terrifying through a carefully crafted geography of filth, decay and garbage. Space is structured to cry out for action and cleansing, and Aamir's predicament in the midst of this horrifying landscape of enveloping space only adds to such an appeal.

Aamir's filmic strategy is to create a dense accumulation of crisis images that feed a spectator who is implicated in a paranoid visual economy. The methods adopted for such a strategy are quite inventive. Alphonse Roy, a wildlife photographer was hired to shoot for the film. Roy drew on his own skills and used telephoto lenses from a distance where the crowd could not see the camera. Given that Khandelwal was not so well known, he was asked to mingle with the crowd. This would not have been possible with a big star so having an unknown face helped to set the design for the urban landscape. Roy used two cameras – one for the close-ups and one for the long shots. This allowed him to carve out Bombay's urban blight as well as showcase the despair writ large on Aamir's face, creating the desired field of affect (Roy 2009). It was this combination of the unself-conscious crowd (not knowing that a camera was looking at them) with a demoralized Aamir

caught in a network of surveillance that generated a terrifying experience of fear. As Zygmut Bauman says:

> [F]ear and evil are Siamese twins; you can't meet one, without meeting the other. Or perhaps they are but two names of one experience – one of the names referring to what you see or what you hear, the other to what you feel; one pointing 'out there' to the world, the other to the 'in here' to yourself. What we fear is evil; what is evil is fear.
>
> (2006: 54)

Perhaps the biggest fear in the world today is the fear of insecurity which results in the endless pursuit of protection and the search for security. The inability to provide that full security and freedom from all fears feeds the language of insecurity and the demand for more surveillance technologies. The mapping of space in *Aamir* is paradoxical – the surveillance mechanism appears to be in place, but it is in the hands of Muslim terrorists. They can see and track, navigate and plan, terrorize and be ubiquitously present. This is where the technology of vision meets the evil of terrorism, defining and marking space as we move through Bombay's by bylanes. In *Aamir*, the terrorist conspiracy invades Bombay, producing the ubiquitous paranoia for greater control of spaces marked as other.

The corridors of power in *A Wednesday*

Like *Aamir*, *A Wednesday* (dir. Neeraj Pandey) deals with one day in the life of Bombay and the sequence of events gathers intensity in a narrative that showcases the point of view of both a police officer and a 'Common Man' who takes to vigilante action. *A Wednesday* also boasts of performances by two veteran character actors, Naseeruddin Shah and Anupam Kher, both products of the National School of Drama and both known for their skills with acting. Drawing these two stalwarts into the film, the director situates them as opponents who at heart believe in the same thing. One of the film's posters framed the police officer and the Common Man in a bid to take charge of the city (Figure 14.7). An ordinary man, sick of his life of fear, decides to take the law into his own hands. Imagining himself as a vigilante, this unnamed Common Man (Naseeruddin Shah) challenges the cops to a game in which the ultimate targets are the jailed terrorists who according to him continue to operate from their prison. The cops do not seem to have an adequate plan to fight terrorism and so the Common Man decides to act. He settles down with his cell phones, sim cards and a laptop on the roof of a half-constructed building to proceed with a plan.

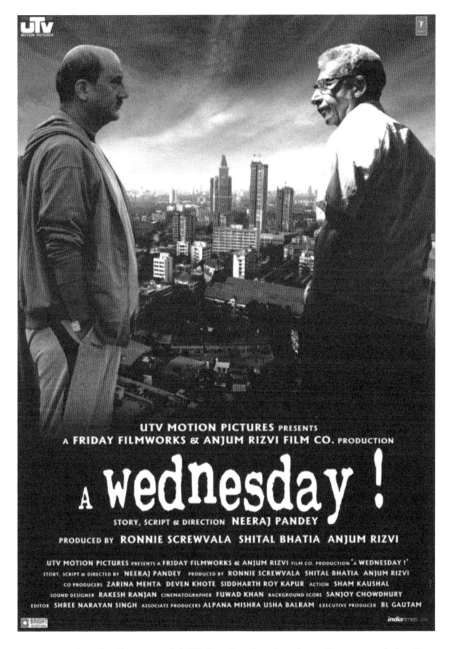

FIGURE 14.7: A stylized poster of *A Wednesday* showing the policeman and the Common Man as opponents in the city of Mumbai.
Source: IMDB.

Prakash Rathod (Anupam Kher) is the Commissioner of Police, who gets a call from the Common Man demanding the release of four militants in exchange for information on bombs that have been planted in various parts of Mumbai. At first, Rathod thinks the caller is a prankster, but soon changes his mind when the bomb planted right opposite his Police Headquarters is found. Soon a cop team swings into action along with a computer hacker to help track the location of the anonymous caller. The suspense builds up and finally Rathod agrees to hand over the militants. It soon transpires that the Common Man himself wants the militants dead and masterminds blasts to have them killed. In an extra constitutional move, the cops bypass the law to handover the militants, and the Common Man at the end of the film talks about the plight of the ordinary citizen. Unlike *Aamir* and *Black Friday*, *A Wednesday* does not take us through the alleys of the city. Instead the view of the city is deliberately refracted through surveillance technologies, the television and the police headquarters. *Black Friday* is an investigative return to an event, *Aamir* is the step-by-step chronicling of a hapless victim's journey across Bombay's dense neighbourhoods. The street level view so central to these films is largely absent in *A Wednesday* which draws significantly on the stylistic features of the Hollywood conspiracy film to chart out the simultaneous unfolding of spaces linked to power.

A Wednesday was received quite well by critics and almost all noted the film's technical finesse and good acting. But there were several who felt a sense of disquiet about the film's moral vision. Khalid Mohamed (2008) in his otherwise favourable review for the *Hindustan Times* said: '[L]ike it or not, there is in-between-the-lines Muslim thrashing here besides the ongoing obsession of associating terrorism with Islam'. Namrata Joshi's review in *Outlook* said, 'It is gripping, terse and well crafted, has a twist that throws you off kilter. But this twist which makes it so distinctive a thriller leaves you deeply disturbed' (2008). Even Nikhat Kazmi (2008) who gave the film four and a half out of five stars wrote, 'One might quibble with the fascist end of the film where the rule of law is given a go by'. Disturbed by the vigilantism of the film, Shubra Gupta (2008) ended her review for the *Indian Express* with the question: 'Do we blow up people who blow us up? Does an eye for an eye take us anywhere?' So, what is the main problem with the film? Why does it evoke disturbance? The answer lies in the way a dense interplay of information is processed through a panoptical surveillance citadel crafted by a lone figure who is made to stand in for a man of the crowd.

A panoramic view of the city can be seen from the rooftop where the Common Man sits with all his gadgets (Figure 14.8). This view of the city is dramatically shot to make him appear like a messiah figure out to rescue the city. The events unfold in compressed time, filled with action, suspense and excitement. This Common Man communicates through his internet and cell phone and is in touch with a television

TERRORISM, CONSPIRACY AND SURVEILLANCE

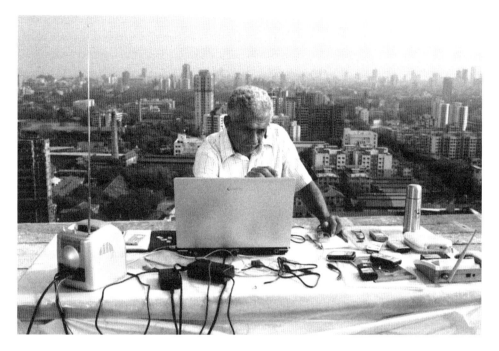

FIGURE 14.8: Rooftop view of the Common Man (Naseeruddin Shah) sitting with all his gadgets – *A Wednesday*.

reporter, the chief of police and the police officer escorting the militants. Several spaces and people are drawn into the loop of action – the chief minister, the truck carrying the terrorists, the TV station, the police station, the highly technologized 'war room' at the police station and so on. There is a communication network established between these spaces through the relay of phone conversations as we move across different sites. The 'corridors of power' are depicted quite literally, generating a vision of the city that is refracted through the world of the police, the media, informants and state functionaries. The constant movement in the film from the Common Man on the terrace adds to its dramatic pace. The unknown vigilante controls the view of the whole city and successfully masterminds an operation drawing in the government and media. New technologies of information such as sim cards, the internet and the computer provide the vigilante figure access to the corridors of power.

Surveillance, writes McKenzie Wark,

> [is] only one element of an integrated form of power, vectoral power. Its other elements are the capacity to receive and transmit information, the capacity to archive

and analyze information, and the capacity to move resources to and from given destinations in a timely and accurate fashion.

(2002: 396)

There are two kinds of vector technologies – one that moves physical objects and one that moves information. Wark describes how the movement from one point to another under specific conditions is crucial to vector technology which ultimately translates into the ability to order the things one perceives. Vector power depends on the quantitative and qualitative transformation of perceived spaces of the world into a resource that is then deployed to order the movement of resources in that world. What emerges in the process is a new world and a plan that can be drawn on a map (2002: 398–99). In *A Wednesday* we see the attempt to create a new vision of Bombay through a careful relay of bodies and information. As the Common Man maps a circuit across different spaces through the movement of people in positions of power, the police, the TV crew and the terrorists, vectoral power combines with the panoptical vision of the city from the rooftop. This attempt at a transcendental position occupied by the Common Man structures the morality of the film. He is neither Hindu nor Muslim; the Common Man's world-view is supposedly the vision behind the film.

A Wednesday manages to highlight the communication network of a high-speed society. The *Hindustan Times* review said the film contained 'speed, energy and technical dazzle' (Mohamed 2008). The technologies responsible for the flow of information operate like a roving surveillance machine and the pathologies linked to the experiences of a high-speed society are foregrounded in the imagination of the film. The Common Man's iconic presence operates at several levels. He moves from being an ordinary man of the crowd to a figure in control of the city. The credit sequence at the beginning is superimposed on a montage of typical Bombay shots – a combination of heritage buildings, traffic, overpasses, bridges, the train platform and the walking crowd. The Common Man is set up as a figure of the crowd. He walks, takes the train and has the demeanour of an ordinary middle-class man. This force field changes once he inhabits the roof top. Now the Common Man is able to inhabit two orders of experience – both required in any surveillance mechanism. First, he can feel the pulse of the people, knows their anxieties and their daily experiences. Secondly, he can play the messiah who is supremely confident about his ability to clean up the city. The nature of this reaction to government impotence and the explanation for extra constitutional means is situated via a dramatic speech in reply to Rathod's questions during a significant conversation between the two. The speech contains the following lines:

What do you do if a cockroach enters your house? You do not treat them as pets, you kill them [...]. I am someone who is afraid to get into a bus or a train these days [...] I am someone whose wife thinks he is going to war [...] I am someone who suspects the person carrying a rosary. I am also the one who is afraid to grow his beard and wear a cap [...]. I am just a stupid man of the crowd wanting to clean his house [...] this has nothing to do with my religion [...]. I just want to remind you that people are very angry. We are resilient by force, not by choice [...] the fault is ours, we get used to things quite easily [...]. Instead of fighting, we begin to get used to it [...]. But we have our compulsions, we have to maintain a family. That is why we appoint a government to run the nation. All of you, the government, the police force, intelligence. But you are doing nothing [...]. Why are you not nipping them in the bud? It takes you ten years to prove a person guilty? [...] All this has to stop. This whole system is flawed. If you don't clean up this mess then we will have to do something about it. I know this will create an imbalance in our civilized society. The blast was not just a terrorist attack but a question posed by them – We will go on killing you, what can you do? They asked us this question on Friday, repeated it on Tuesday, I am just replying on Wednesday.

It is in this speech that we are provided some clues to the Common Man's religious identity, even as nothing is literally specified. The speech mediates the emotional terrain of the ordinary citizen's anxieties and becomes critical to the strategy of the film. A reviewer referred to this as a 'meticulously worded Common Man's discourse' which sought to address 'every single question that might arise in the audience's mind out of ambiguity, if any' (Malani 2008). This abstract positioning of the 'audience' and the 'people' both in the film and in some of the reviews elides the structuring of power and paranoia to position the spectator.

A Wednesday presents surveillance as an empowering force to make visible the red tape and delays involved in making the city free of terror. Through the Common Man's strategic location, action and dramatic speech we are provided access to a distant world of material resources and bodies as well as information, in constant movement. The movement of the imprisoned terrorists, the television crew, the police force, combines with the flow of information that circulates between the common man, the police, the TV reporter and the terrorists.

The film appears to be in constant motion, the messiah figure placed at a high-altitude position as he monitors and tracks the result of his actions with the help of TV news feeds provided by the reporter. Through this figuration of vectoral power, urban paranoia is given a voice, acted upon and played out as an extra-constitutional force and surveillance emerges as a populist 'weapon of the weak'.

The technological uncanny

The role of technology and new media in the channeling of fear is palpable in all three films. The rhetorical strategy of *Black Friday* is aided by the conscious use of the television as an information machine. Television news is placed within the narrative world as both image and sound, operating as a knowledge-structuring device. Spectators are shown watching TV for news on the riots and the blasts. Its recurring presence in the film operates as a heuristic device drawing our attention to a highly charged soundscape where evidence, causality and motivation are understood through certain techniques. The constant sound of the news also functions as a unifying device, acting as an imaginary bond. If the internet and cell phone form the main thread for the staging of action in *A Wednesday*, then in *Aamir* the network that generates the narrative loop is the cell phone. These objects of audiovisual knowledge production generate tension in the narratives, operating as sites of possibility and negative energy. They operate as uncanny mediums without which the films cannot tell their story. At one level they are necessary objects that mark the time, the structure and the unfolding of events. At another level they produce fear, paranoia and the uncertainties of life.

A Wednesday uses a power point presentation to encapsulate within three minutes the scale of the terrorist network. An officer conducts a presentation for Prakash Rathod with projected photographs of the four terrorists at the heart of the negotiations with the Common Man. The profiling of the four is rattled off at rapid pace quite authoritatively by the officer. The four men are convicts who have not yet been through a trial. The officer's presentation however expresses no hesitancy. Rather, all speculation and ambiguities are resolved by a narrative that marks each one of the four within a truth regime generated by the police. The production of details adds to the truth telling form, the rapid movement of slides displays hyper-real choreography of guns, freeze frames, crowd scenes, faces, ships, the sea – a random collation of eclectic images. Speculation based on information gathered through surveillance strategies is transformed into a narrative of the factually known. No trial is required here as information is laid out for the police chief and the spectator. It is this moment that makes Rathod take the decision to hand over the four terrorists to the Common Man. The officer's speech, with words like *jihād*, guns, the names of the terrorists, Pakistan, Lashkar and Al Qaida, combines with the swishing sound of the power point to form a sonic effect and an affective tonality of sensations. Fear is given a form, a body and a force through audiovisual technology and contributes to the creation of an immersive atmosphere of dread (see Goodman 2010).[7] This modulation of affect in compressed time via a complex circuit of emotions that moves across technology, the body, still photographs and sound design, creates a vibrational force that ends up

TERRORISM, CONSPIRACY AND SURVEILLANCE

FIGURE 14.9: Prakash Rathod (Anupam Kher) at the police station's high-tech informational space – *A Wednesday*.

influencing all subsequent decisions. The rapid pace of the film is in fact largely created through a careful management of sonic frequency. Neither the audience, nor the police, nor the media are given much time to reflect. The ability to take quick decisions is made possible with the help of new technologies. The surveillance power of the film ultimately makes the case for an expanded and yet flexible notion of the law in the hands of the police (Mukherjee 2009) (Figure 14.9).

All three films produce visual and sensory knowledge as they map the city of Bombay. In this urban cartography, the signs of globalization emerge not from the display of lifestyle images and consumption but through the overwhelming presence of communication technologies. While all three films pose a counter globalizing cartography, they mediate terror through realist strategies of representation, drawing on a repertoire of the stylistic devices deployed by news programmes, reality TV, surveillance cameras and police procedurals. The resultant archive is one in which the urban landscape emerges as a site taken over by Muslims, desperately in need of social control. Terror in all the films becomes a communication strategy, a social fact that alters our sense of place. Terror transforms regions into landscapes of fear. Viewers are drawn into a cartographic mapping of sites coded by violence, sites that perform their backwardness, their decay and their crumbling ruin. We are then positioned to speculate about the history of the city. Bombay is presented as a space that demands action on itself, a strategy of cleansing that

must first understand the truth about its decay. This is a city deeply affected by the archive of memory associated with the demolition of the Babri Masjid. The spiral of events that followed the demolition opened the city's subterranean geography for discussion, speculation and intervention. Bombay's recent past of cataclysmic events now haunts these spaces.

The 9/11 attack on the twin towers in New York forms a memory archive that has made us into what Marita Sturken refers to as the tourists of history (2007: 7). Through kitsch and consumerist products, the twin towers circulate, feeding contemporary paranoia and fear. The archive of memory linked to the demolition of the Babri Masjid and the bomb blasts that followed find two different articulations in Bombay cinema. The first is the melodramatic form dealing with the emotional texture of conflict, division and loss. The second is the kind of cinema I have discussed here where cinematic technology colludes to produce the desire for surveillance and spatial control, drawing spectators into a new way of navigating Bombay. The obsessive translation of a complex situation into a cartography of space, conspiracy and fear, becomes highly problematic as the overwhelming desire to control the city and its Muslims comes to the fore in all three films.

ACKNOWLEGDEMENTS

I would like to thank Ravi Sundaram, Shikha Jhingan, Shaswati Mazumdar, Shohini Ghosh, Sabeena Gadihoke, Ira Bhaskar, Kalpana Ram, Ravi Vasudevan, Kuhu Tanvir, Arjun Appadurai, Richard Allen and Arien Mack for their comments and suggestions.

This chapter was previously published in a Special Issue of *Social Research* 78:1, Spring 2011.

NOTES

1. While the multiplex has had a history in other parts of the world since the 1970s, in India, the first multiplex opened in Delhi in 1997. The transformation of single screen theatres to multi-screen ones has created a situation where different kinds of films are often screened in the same complex. The rise of a new group of filmmakers attempting to break out of a typical 'Bollywood' mould is located in this period since they can now find a venue at the multiplex. This new form emerged in mid-2000 and co-exists with the typical Bollywood film at the multiplex. The architectural form of the multiplex has transformed the circuits of production and circulation of cinema.

2. Hindi cinema has historically dealt with Hindu-Muslim conflict through narratives of community and redemption. There was always a line that would not be crossed by filmmakers. It is this boundary that is bypassed in this new genre of films dealing with paranoia.

3. In her analysis of the Hollywood films dealing with Vietnam, Sturken suggests that the experience of the war and its aftermath produced a constantly shifting and mobile script. This mobile form can be accessed across several textual forms that include photographs, objects, films and art.

4. On 30 September 2010, the Allahabad High Court ruled on the Ram Janmabhoomi-Babri Masjid land title case. The judgement of the three-member bench (2:1 majority) ordered a three-way division of the disputed land between the Sunni Waqf Board, the Hindu Mahasabha and the Nirmohi Akhara. The bench in their final judgement stated that in the absence of documentary evidence, no party could stake a claim. The three-way split was therefore the only option. Since none of the three parties were satisfied with the verdict, they approached the Supreme Court. See note 5.

5. On 9 November 2019, the Supreme Court of India declared its final judgement on the Ayodhya dispute and ordered that a trust be granted responsibility for the building of a Hindu temple and an alternate land site be provided to the Sunni Waqf Board for the construction of a mosque.

6. In March 2001, under what it called Operation West End, *Tehelka*, an independent weekly news magazine, conducted a sting operation to expose officials of the Indian government. *Tehelka* reporters used spy cams and masqueraded as arms dealers offering bribes to several government officials. They shot their transactions with army officers and friends of the ruling party, finally forcing several people to resign after the expose. For an account of the *Tehelka* sting operation, see Mazarella (2006). See also Tejpal (2007).

7. Sound contributes immensely in the creation of atmospheric ecologies. While we tend to foreground the optical form of cinema, the aural dimension remains equally important, particularly in creating affective regimes of dread, fear and terror. The films discussed here significantly deploy the sound track to generate the sensorium of dread.

REFERENCES

Appadurai, Arjun (2000), 'Spectral housing and urban cleansing: Notes on millennial Mumbai', *Public Culture*, 12:1, pp. 627–51.

Arnold, Gordon B. (2008), *Conspiracy Theory in Film, Television and Politics*, Greenwood, CT: Praeger Publishers.

Bannerjee, Aranab (2007), 'Kashyap's persistence pays off!', *The Hindustan Times*, 12 February, https://www.hindustantimes.com/india/kashyap-s-persistence-pays-off/story-o1s9EwaxwJ2EtANAJk9ToL.html. Accessed 5 January 2020.

Bauman, Zygmut (2006), *Liquid Fear*, Cambridge: Polity Press.

Blom Hansen, Thomas (2001), *The Wages of Violence: Naming and Identity in Postcolonial India*, Princeton, NJ: Princeton University Press.

Christensen, Jerome (2002), 'The Time Warner conspiracy: JFK, Batman, and the Manager Theory of Hollywood film', *Critical Inquiry*, 28, pp. 591–617.

Ghosh, Shohini (2009), 'Style and prejudice: A reading of *Aamir*', *Communalism Combat*, 15, https://www.sabrang.com/cc/archive/2008/sep08/cover.html. Accessed 5 January 2020.

Goodman, Steve (2010), *Sonic Warfare: Sound, Affect and the Ecology of Fear*, Cambridge: MIT Press.

Gupta, Rajkumar (2009), interview with the author, Delhi, 28 October.

Gupta, Shubra (2008), 'A Wednesday', *Indian Express*, 6 September, http://archive.indianexpress.com/news/a-wednesday/357951/. Accessed 5 January 2020.

Jaffrelot, Christophe (2007), *Hindu Nationalism and Indian Politics*, New York: Columbia University Press.

Jarett, Greg (1999), 'Conspiracy theories of consciousness', *Philosophical Studies: An International Journal for Philosophy in the Analytic Tradition*, 96, October, pp. 45–58.

Joshi, Namrata (2008), 'A review of *A Wednesday*', *Outlook*, 22 September, p. 86.

Kashyap, Anurag (2005), interview with the author, Delhi, 24 August.

Kazmi, Nikhat (2008), 'A review of *A Wednesday*', *The Times of India*, 5 September, https://timesofindia.indiatimes.com/entertainment/hindi/movie-reviews/a-wednesday/movie-review/3449896.cms. Accessed 5 January 2020.

Keeley, Brian L. (1995), 'Of conspiracy theories', *The Journal of Philosophy*, 96:1, pp. 109–26.

Levin, Thomas Y., Frohne, Ursula and Weibel, Peter (eds) (2002), *CTRL Space: Rhetorics of Surveillance from Bentham to Big Brother*, Cambridge: MIT Press.

Lutticken, Sven (2006), 'Suspense and surprise', *New Left Review*, 40:1, July/August, pp. 95–109.

Malani, Gaurav (2008), '*A Wednesday*: Movie review', *Economic Times*, 5 September, https://economictimes.indiatimes.com/industry/media/entertainment/a-wednesday-movie-review/articleshow/3447419.cms?from=mdr. Accessed 5 January 2020.

Mazarella, William (2006), 'Internet X-ray: E governance, transparency and the politics of intermediation in India', *Public Culture*, 8:1, pp. 473–505.

Mazumdar, Ranjani (2010), 'Friction, collision and the grotesque: The dystopic fragments of Bombay cinema', in G. Prakash (ed.), *Noir Urbanisms: Dystopic Images of the Modern City*, Princeton, NJ: Princeton University Press, pp. 150–84.

Menninghaus, Winfried (2003), *Disgust: The Theory and Sensation of a Strong Emotion*, Albany: State University of New York Press.

Menon, Nivedita and Nigam, Aditya (2007), *Power and Contestation: India since 1989*, New York: Zed Books.

Miller, William Ian (1997), *The Anatomy of Disgust*, Cambridge: Harvard University Press.

Mitra, Smita (2007), '*Black Friday*: A review', *Economic and Political Weekly*, 42:16, 21 April, pp. 1408–09.

Mohamed, Khalid (2007), 'Review of *Black Friday*', *Times of India*, 9 February, https://timesofindia.indiatimes.com/entertainment/hindi/movie-reviews/black-friday/movie-review/1587135.cms. Accessed 5 January 2020.

Mohamed, Khalid (2008), '*A Wednesday*', *Hindustan Times*, 5 September, https://www.hindustantimes.com/movie-reviews/review-a-wednesday/story-U1zOMCB0uqsRmtV8wHeFCP.html. Accessed 5 January 2020.

Mukherjee, Rahul (2009), 'A reply to terrorism on A *Wednesday*: A citizen vigilante's prescriptions for governing terrorism', *Fear: Sarai Reader*, 8:1, pp. 242–49.

Nadel, Alan (2002), 'Paranoia terrorism and the fictional condition of knowledge', *Contemporary Literature*, 43:1, Summer, pp. 406–21.

Patcy, N. (2007) 'We shot *Black Friday* with hidden cameras: An interview with Anurag Kashyap', *Rediff India Abroad*, 7 February, https://www.rediff.com/movies/2007/feb/07anurag.htm. Accessed 5 January 2020.

Prakash, Gyan (2010), *Mumbai Fables*, New York: Harper Collins.

Rajendran, Priya (2009), 'I want to create a brand for myself: Rajeev Khandelwal', *Hindustan Times*, 31 October, https://www.hindustantimes.com/entertainment/i-want-to-create-a-brand-for-myself-rajeev-khandelwal/story-6CICyf4WoMS4Gwc461JzjP.html. Accessed 20 June 2021.

Roy, Alphonse (2009), interview with the author, Delhi, 28 October.

Roy, Kumkum (2010), 'Issues of faith', *Economic and Political Weekly*, 45:50, 11 December.

Seitz, Matt Zoller (2007), 'Madness in Mumbai', *New York Times*, 8 February, https://www.nytimes.com/2007/02/08/movies/09blac.html. Accessed 5 January 2020.

Sturken, Marita (1997a), 'Reenactment, fantasy and the paranoia of history: Oliver Stone's docudramas', *History and Theory*, 36, December, pp. 64–79.

Sturken, Marita (1997b), *Tangled Memories: The Vietnam War, the Aids Epidemic, and the Politics of Remembering*, Berkeley: University of California Press.

Sturken, Marita (2007), *Tourists of History: Memory, Kitsch, and Consumerism from Oklahoma City to Ground Zero*, Durham, NC: Duke University Press.

Subramaniam, Radhika (1999), 'Culture of suspicion: Riots and rumor in Bombay: 1992–93', *Transforming Anthroplogy*, 8 January, pp. 97–110.

Tanvir, Kuhu (2010), 'Myth, legend, conspiracy: Urban terror in *Aamir* and *Delhi-6*', *Fear: Sarai Reader*, 8, pp. 248–53.

Tejpal, Tarun (2007), 'The Tehelka expose: Reclaiming investigative journalism in India', http://www.taruntejpal.com/TheTehelkaExpose.HTM. Accessed 1 January 2011.

Wani, Aarti (2008), 'Aamir at the multiplex', *Film International*, 6:6, 25 November, pp. 91–95.

Wark, McKenzie (2002), 'To the vector the spoils', in T. Y. Levin, U. Frohne and P. Weibel (eds), *CTRL Space: Rhetorics of Surveillance from Bentham to Big Brother*, Cambridge: MIT Press, pp. 396–401.

Contributors

HILAL AHMED is associate professor at the Centre for the Study of Developing Societies (CSDS), New Delhi, India, and was until recently a fellow at the Nantes Institute for Advanced Studies Foundation, Nantes, France. He works on political Islam, Muslim politics of representation and the politics of symbols in South Asia from an interdisciplinary perspective. He is author of *Muslim Political Discourse in Postcolonial India: Monuments, Memory Contestation* (2014); *Siyasi Muslims: A Story of Political Islam in India* (2019) and, with Peter R. deSouza and Sanjeer Alam, *Democratic Accommodations: Minorities in Contemporary India* (2019).

* * * * *

RICHARD ALLEN is chair professor of film and media art and dean of the School of Creative Media, City University, Hong Kong. His research interests lie in film theory and the philosophy of film, film aesthetics and poetics, and melodrama and affective piety. His books include *Projecting Illusion* (1995), *Hitchcock's Romantic Irony* (2007) and, with Ira Bhaskar, *Islamicate Cultures of Bombay Cinema* (2009). He is completing a project called *Bollywood Poetics*.

* * * * *

IRA BHASKAR is professor of cinema studies at the School of Arts & Aesthetics, Jawaharlal Nehru University, New Delhi. She has co-authored *Islamicate Cultures of Bombay Cinema* (2009) with Richard Allen, and her publications have appeared recently in *Melodrama Unbound: Across History, Media, and National Cultures* (2018); *Routledge Handbook of Indian Cinemas* (2013); *Film Melodrama Revisited* (2013) and *Gender Meets Genre in Postwar Cinemas* (2012). Her current research interests include melodramatic forms and histories, the cinema of Ritwik Ghatak, film music and early sound cinema, trauma and memory studies, and partition and communalism and Indian cinemas.

* * * * *

SHOHINI GHOSH is Sajjad Zaheer Professor at the AJK Mass Communication Research Centre at Jamia Millia Islamia, New Delhi. She is the director of *Tales*

of the Night Fairies (2002), a documentary on the sex worker's rights movement in Calcutta, and the author of *Fire: A Queer Classic* (2010). Ghosh writes on contemporary media, popular cinema, documentary films and queer sexualities. She is working on a book tentatively titled *Violence and the Spectral Muslim: Action, Affect and Bombay Cinema at the Turn of the 21st Century*.

* * * * *

NAJAF HAIDER is professor of medieval and early modern history at the Centre for Historical Studies, Jawaharlal Nehru University, New Delhi. He graduated from the Aligarh Muslim University and obtained a doctoral degree in Mughal history from the University of Oxford. Haider was Samir Shamma Fellow at St Cross College, University of Oxford, visiting professor twice at the University of Vienna and visiting professor, Sonderforschungsbereich, University of Bonn. He is on the editorial board of *International Journal of Asian Studies*. Haider has published on monetary economy, cultural communication, Mughal accountancy and the intellectual history of Islam.

* * * * *

KATHRYN HANSEN is a cultural historian and scholar of Indian languages with a special interest in theatre and performance. Her book *Stages of Life: Indian Theatre Autobiographies* presents the life stories of four artists in the Parsi theatre. Her first monograph, *Grounds for Play: The Nautanki Theatre of North India*, won the A. K. Coomaraswamy Book Prize. She is professor emeritus of Asian Studies at the University of Texas at Austin, where she served as director of the Center for Asian Studies and interim director of the South Asia Institute.

* * * * *

SHWETA SACHDEVA JHA teaches English at Miranda House, University of Delhi. Publications from her research on the history of the *ṭawā'if* include: 'Eurasian women as *tawa'if* singers and recording artists: Entertainment and identity-making in colonial India', *African and Asian Studies* 8:3 (2009); 'Frames of cinematic history: The *tawa'if* in *Umrao Jan* and *Pakeezah*', in Manju Jain (ed.), *Narratives of Indian Cinema*; and '*Tawa'if* as poet and patron: Rethinking women's self representation', in A. Malhotra and S. Lambert-Hurley (eds), *Speaking of the Self: Gender, Performance and Autobiography in South Asia*. She is currently working on Gothic fiction in Urdu.

* * * * *

SHIKHA JHINGAN is an associate professor at the Department of Cinema Studies, School of Arts and Aesthetics, Jawaharlal Nehru University, New Delhi. Her research work focuses on music and the technologies of sound dispersal across

diverse media platforms. Her work has been published in journals such as *Feminist Media Histories*, *Seminar* and *Bioscope: South Asian Screen Studies*. Jhingan is a founding member of Media-storm, an independent women's filmmaking collective formed in Delhi in 1986.

* * * * *

PETER KNAPCZYK is assistant professor of Hindi-Urdu in the Middle East and South Asia Studies Program at Wake Forest University. He is writing a book on Shiʻi devotional literature in North India and its role in the development of Urdu literary culture.

* * * * *

PHILIP LUTGENDORF, professor emeritus of Hindi and modern Indian studies at the University of Iowa, is the author of two books on the *Rāmāyaṇa* tradition, *The Life of a Text* (1991) and *Hanuman's Tale* (2007), as well as articles and essays on South Asian popular culture and Hindi cinema. His translation of the *Rāmćaritmānas* of Tulsidas, the Epic of Ram, is being published in seven volumes by the Murty Classical Library of India.

* * * * *

RANJANI MAZUMDAR is professor of cinema studies at the School of Arts & Aesthetics, Jawaharlal Nehru University, New Delhi. Her publications focus on urban cultures, popular cinema, gender and the cinematic city. She is the author of *Bombay Cinema: An Archive of the City* (2007) and co-editor with Neepa Majumdar of the forthcoming *Blackwell Companion to Indian Cinema*. She has also worked as a documentary filmmaker and her productions include *Delhi Diary 2001* and *The Power of the Image* (co-directed). Her current research focuses on globalization and film culture and the intersection of technology, travel, design and colour in 1960s Bombay cinema.

* * * * *

SUNIL SHARMA is professor of Persianate and comparative literature at Boston University. His interests are in the areas of Persianate literary and visual cultures, translation and travel writing. He is the author of *Mughal Arcadia: Persian Poetry at an Indian Court* (2017). He is also a founding board member of the Murty Classical Library of India (MCLI).

* * * * *

KAVITA SINGH is professor of visual studies at the School of Arts and Aesthetics, Jawaharlal Nehru University, New Delhi, where she teaches the history of Indian painting and the history and politics of museums. Her edited volumes include *Scent*

upon a Southern Breeze: The Synaesthetic Arts of the Deccan (2018); *Museum Storage and Meaning: Tales from the Crypt*, with Mirjam Brusius (2017); and *No Touching, No Spitting, No Praying: The Museum in South Asia*, with Saloni Mathur (2014). She was awarded the Infosys Prize for the Humanities in 2018.

* * * * *

Rosie Thomas is professor of film at the Centre for Research and Education in Arts and Media (CREAM), University of Westminster, where she directs the India Media Centre. Her early research as a social anthropologist was on the Bombay film industry and, since 1985, she has published widely on Indian cinema, with a special focus on pre- and early post-independence films. Throughout the 1990s she developed programmes for UK television, many on South Asia–related topics. She is a founding editor of the Sage journal *BioScope: South Asian Screen Studies* and author of *Bombay before Bollywood: Film City Fantasies* (2015).

Index

9/11 attack 394

A

Aadmi (1939) 298

Aamir (2008) 29, 370, 381–86, 388, 392, *fig. 383, fig. 385*
 communication network in 382
 disgust and contempt, theme of 383–84
 distinction between educated Muslim and others in 385
 experience of discrimination in 382
 surveillance technologies in 386

'Abdullāh, Ḥāfiẓ Muḥammad 42, 44

'Abid 135–41, 151n4

Abraham, John 224

Ádā, Umrāo Jān 116

ādāb 11

Adl-e-Jahangir (1955) 71

Adventures of Alibaba and the Forty Thieves (1980) 223

Afghani, Saba 267

Agra Fort 4

Ahmad, Nazīr 99

Aḥsan, Mehdī Ḥasan 44
 Dil Farosh 44

Aja Nachle 69, 71

Akbar, Emperor 3, 4, 14, 15, 76, 132, 141, 142, 144–50, 152n12, 155, 156, 158, 162, 164, 165, 171, 177, 184, 316n2

Akbarabadi, Seemab 234

Akbarnāma 132, 141, 145–50, 152n11, 158

Akhtar, Begum (Akhtari Bai) 231, 236–40, 248, 253, 256n8, 256n10

Akhtar, Jan Nisar 240

Al-Hilaal (1935) 212

Alam-ara (1931) 66, 70

Alfred Theatrical Company of Bombay 43–44, 55

Alhambra 11

Ali, Muzaffar 106, 297

Ali, Naushad 230, 237, 241, 250, 256n11

Ali, Sajid 70

Ali Baba and the Forty Thieves Killed by a Slave Girl, The Story of 205 *see also* Galland

Alibaba, Boses' (1937) 204, 207, *fig. 211, 222*
 as anti-colonial allegory 209
 characters of Marjana and Abdullah in 208–9
 and cosmopolitan modernity 210–12
 dance modes in 209–12
 orientalism and racism in 209–10

Alibaba, Mehboob's (1940) 204, 212, 222
 and Hollywood orientalism 213
 as melodrama 214–15
 'Oriental' dance in 215
 influence of *Chiu Chin Chow* on 216–17

Alibaba, Wadia's (1954) 204, 217, 222
 international orientalism in 220
 Marjana's syncretic persona in 221

and the nationalist movement 219

strong female characters in 218, 219

stunt action in 218

Urdu-Islamicate idioms in 220–22

whipping and violence in 218–19

Alibaba 40 Dongalu (1970) 217

Alibaba and 40 Thieves (1980) 223

Alibaba aur 40 Chor (2004) 224

Alibaba Chalis Chor (1927) 203, 206, 213

Alibaba or the Forty Robbers 206

Alibabavum 40 Thirudargalum (1956) 217

Alif Laila (1993–96) 76

All India Muslim League 7

All India Radio (AIR) 26, 239–40

Ganguly's account of Lucknow radio station 239

mahfil-like recording on 240

Amānat, Āghā Ḥasan 40, 110

Amar Akbar Anthony (1977) 18, 291n9, 342, 344

Ambalewali, Zohrabai 263

Ambedkar, B. R. 7

Amin, Shimit 282

Amrit Manthan (1934) 298

Amrohi, Kamal 106, 176, 177, 297

Anārkalī 14, 155

Anarkali (1935) 236

Anarkali (1953) 71

Andaz Apna Apna (1994) 349

Anderson, Benedict 109

Angūrbālā 232

Anīs, Mīr 95–96, 103n11

Anti-Contagious Diseases Act 107

anti-nautch movement 107, 127n7, 307

Appaduri, Arjun 372

Arabesque design/motifs 9, 11, 13, 17, 18, 19

Arabian Nights, Tales of the 12, 17, 204–06, 209, 213, 215, 222

Arabian Nights fantasy films/genre 81n4, 203–04, 212 *see also Alibaba* (1937); *Alibaba* (1940); *Alibaba* (1954)

Arabic 3, 11, 42, 77, 92, 106, 111, 115, 170, 212, 261, 284, 292n18, 296

Arabic calligraphy 11

'Ārām', Nasarvānjī Mehrvānjī 41, 42

Arnold, Gordon B. 371

Artorthy, Premankur 233, 234

Arya Subdoh Natya Mandali 68

Aṣgar, Husain Aḥmad 120

Ashan, Medhī Ḥasan 44

Ashraf, Syed Firdaus 352

Asif, K 296, 81n7

Aspi 267

'Ātish', Khwāja Haidar Alī 118

Auliyā, Niẓāmuddīn 262, 264, 291n5, 358

Aurangzeb, Emperor 3, 4, 5, 8

Awadh 5, 6, 12, 13, 84, 86, 88, 92, 99, 116, 117, 125, 220, 237, 272, 297, 308, 317n6

Awadhi 12, 40, 52, 84, 86, 90, 103n1, 103n2

Awadhi epics 3

'Āzād', Moḥammad Ḥusain 107–08, 125

Ab-i-Hayat 108

Azmi, Kaifi 240

B

Baaghi: A Rebel in Love (1990)

Babar (1960), 248–49

Babayan, Kathryn 9, 10

Babri Masjid/Mosque demolition 29, 187, 196–97n7, 351, 357, 366n11, 371–72, *fig.* 373, 374, 394

Bābur, Emperor 2, 3, 132, 196n7

Bāburnāma 145, 147

Badayuni, Shakeel 102, 230, 237, 239, 240, 256n11, 264

INDEX

Bahāristān-i-Nāz 112–13

Bahu Begum (1967) 14

Bai, Jaddan 233

Bāi, Jānki 232

Bai, Rattan 57, *fig. 58*

Bai, Waheedan/Wahidan 213, 226n22, 236

Bajirao Mastani (2015) 19, 76, 86, 188

Bajrangi Bhaijaan (2015) 358–60

Bālā, Fāno 206

Balam, Akbar 277

Baliwala, K. M. 44, 46, 58

Banārsīdās 92

Bandmann, Maurice 216

Banerjee, Arnab 375

Banerjee, W. C. 6

Bano, Iqbal 54

Bano, Naseem 72

Bāno, Hamīdā 248–49

Barabankvi, Khumar 230, 241

bārah-māsā 91

Barsaat ki Raat (1960) 248–49, 256n13, 271–75, 278, 292n19

Basant Panchami 10, 30n4

Basant Pictures 217

Bauman, Zygmut 386

Bayzai, Bahram 77

Bedekar, Vishram 73

Begam, Zebunissa 112

Behl, Aditya 91–92

Being Bhaijaan (2014) 354

Benazīr and Badr-e-Munīr 15

Benegal, Shyam 277

Bengali film 26, 204, 207, 346n2

Bengali language/literature 87, 110, 212

Bengali music/song 208, 209, 212, 233

Bengali theatre 206–07, 212

Berkeley, Busby 209, 215, 316

Betab, Pt Narayan Prasad 262

Bhagwat, Mohan 196n2, 197n10

bhajan 232–33, 255n3

Bhakti/bhakti 3, 4, 10, 13, 23, 30n2, 89, 90, 91, 96, 97, 252, 260, 262, 274, 275, 288, 290n2, 291n9

Bhansali, Sanjay Leela 19, 25, 83, 182–83, 185–86, 188, 194

Bhārat Mātā ('Mother India') 191, *fig. 191*, 197n10, 364

Bharatanatyam 306, 307, 309

Bhartiya Janata Party (BJP) 185, 186, 196n3, 196n4, 196n7, 292n17, 365, 366n11, 368n21

Bhaskar, Ira 252, 329

Bhatt, Mahesh 375

Bhau, Sultan 274

Bhaumik, Kaushik 65

Bhavaiyās 42

Bhosle, Asha 241

Bhukhari, Z. A. 230

Bihzād 146

Bīrbal 155

Biswas, Anil 237, 241, 250

Biwi No. 1 (1999) 349

Black Friday (2004) 370, 375–81, *fig. 377*, *fig. 379*, 382, 388, 392

 as investigative narrative 376–78

 Khan's testimony in 378–79

 reviews of 375–76

 soundtrack of 381

 X-ray vision, concept of 29, 376, 378, 380–81

Blackburn, Stuart 109

Blow Up (1966) 342

Bodyguard (2011) 350

Bollywood cinema 1, 8, 15, 16, 18–20, 24, 25, 26, 27, 28, 30n1, 30n4, 86, 260, 262, 278, 280–89, 291n10, 347–65, 394n1

 Bollywood film songs/music 84, 280–89

Bombay (1995) 375

Bombay Amateur Theatre 45
Bombay bomb blasts of 1993 374, 375
Booth, Gregory 220, 226n21
Boral, R. C. 233
Bose, Modhu 26, 204, 207–12, 225n18
Bose, Sadhona 207–12, 214–15, 225n11
'Brahmo-Bengali' trend of music 233
Brahmo Sabhā/Samāj 6
Braj (Bhasha) 40, 41, 52, 84, 86, 89–90, 103n9
British Empire 6, 307
Broecke, Pieter van den 162
Brown, Katherine Butler 4
Buddhism 13, 190, 318n7
Buxar, battle of (1764) 5

C
Calcutta Amateur Players theatre group
207, 225n11
Ćāndāyan 3, 12, 84
Capitol Cinema 38
Census of India 30n5
Chak De! India (2007) 16, 282
Chakravorty, Dipesh 108
Chakravorty, Pallabi 107
Chaman Andāz 112, 113, 115
'Chandā', Māh Laqā Bāi 22–23, 108,
111–12, 114, 116, 124
Chandavarkar, Bhaskar 233
Chashmha-ye Siyah (1935) 75
Chatopadhay, Saratchandra 70
Chaudhvin ka Chand (1960) 18, 263, 320,
329, 334, 336, 342, 345, 346n2
mistaken identity in 331–33, *figs. 332, 333*
mujrā in 326, *fig. 326*
photography in 339–40
transgression of pardā in 323–25,
figs. 323, 324, 325
Chetan, Raghav 189–90
Chishtī brotherhood/order 88, 274, 290n5,
292n16 *see also* Sufism

Chishtī, Salīm, shrine/tomb of 264, 276
Chitradoot 236
Chitrāvalī 157
Chittor, siege of (1303) 87, 189
Chopra, Aditya 69, 286
Chopra, Anupuma 350
Chopra, B. R. 76
Chopra, Priyanka 18, 224
Chopra, Yash 264, 278, 353
Christendom/Christian culture 9
Chu Chin Chow (1934) 216–17
Chughtai, Ismat 345
Chupke Chupke (1975) 296
Citizenship Amendment Bill 185
Clark, Lori 310–11
Cleopatra (1934) 214
Coke Studio 288
Collins, Wilkie 330
Colman, George 205
comedy of errors 320
conspiracy narratives 371 *see also* Aamir;
Black Friday; A Wednesday
communication networks in 375, 389–90,
393
surveillance techniques in 371, 374–75,
386, 388, 389–93
role of television news in 370, 372, 391,
392–93
urban landscape in 379–81, 382–85, 388,
393
crime melodramas 48
Curzon, Lord 6

D
D-Day (2013) 19
Dabangg (2010) *see* Khan, Salman
Dabangg 2 (2012) 350
Dabīr, Mirzā 95–96
dādrā 116, 232, 232, 237, 239, 255n2
Dāgh 5, 237

INDEX

Dāghistānī, Alī Qulī Khān Wālih, 174–75

Dakhani 5

Dakhanī, Walī 5

Dalmia, Vasudha 109

dargāh 259–60, 262–65, 267, 272, 275–76, 278, 282, 290n5, 291n5, 291n6, 291n8, 291n9, 323, 324, 332, 339, 359, 360

 Ajmer Sharīf 197n9, 272, 274, 275

 Haji Ali 276–78, *fig. 276*, *fig. 277*

 Hazrat Amin Shah 359

 Niẓāmuddīn 264, 290–91n5, 358

Daroowala, Dali 268, 271

Das, Asok 142–43

Das Gupta, Kamal 233

Dastān-e-Amīr Hamzā 15

Dastan-e Laila Majnu (1974) 68–69

Dā'ūd, Maulānā 12, 84

Dayar-e-Madina (1975) 14

Death of Khān Jahān Lodhī, The 135–41

Deccan Queen (1936) 212

Dedh Ishqiya (2014) 18, 328, 344–45 *see also pardā*

Deedar-e-Yaar (1982) *see also pardā*

 the courtesan in 329–30

 mistaken identity in 336–37, *fig. 377*

 photograph in 340–41

 mise-en-scène in 342–43, *figs. 343*

Dehalvī, Kishan Lal 118

Delhi 6 (2009) 285

Delhi Sultanate(s) 2, 3, 4, 12, 88, 188, 189, 192

Desai, Jayant 262

Desai, Kanu 298

Desai, Meghnad 242

Desai, R. L. 68

Dev (2004) 286

devadāsīs 306–09, 329

Devanagari script/charaters 5, 299, 317n5

Devdās 70

Dey, K. C. 233

Dey, Manna 241

dharma nirapekśatā 266

Dharmendra 223

dharmyudh 190

Diab, Hanna 204

Dil Gudāz 125

Dil Se (1998) 282, 283–85, *fig. 285*, 289, 292n18, 292n19

*dīwān*s 112, 114, 116, 119, *fig. 121*, 122–4, 126, 128n12

 Dīwān-i-Malkā Jān 120–22, *fig. 121*

Dixit, Madhuri 69, 345

dohā 249–50

Dukhtar-e-Lor (1932) 75

Dulari, Miss 232

Dutt, Geeta 241

Dutt, Guru 28, 297, 298, 317n3, 320, 331, 339, 342, 345

Dutt, Sanjay 352

Dutt, Sunil 246, *fig. 247*

Dutta, J. P. 106

Dwīvedī, Mahāvīr Prasād 100–01

Dwyer, Rachel 14, 366n10

E

East India Company 5, 6, 109, 305

Ek Hi Rasta (1939) 212

Ek Tha Tiger (2013) 350, 353, 367n14

Elaan (1947) 14, 320

Elison, William 344

Elphinstone Company 41, 110

Encyclopaedia of Indian Cinema 298

Euro-American orientalism 213–17

European melodrama 21, 48

F

Fairabi, Zaheer 231

Faizabad 6, 236

Famous Sibaris Trio 221

fanā 16, 264, 284, *fig. 285*, 292n18 *see also* Sufism

Fanaa (2006) 286

Farīd, Baba 288

Farīd, Ghulām 274

Fatehpur Sikri 4, 264, 276

Fatehpuri, Farman 111

Faẓl, Abū'l 146, 147, 149–50, 155, 158

Fazli, Nida 286

Fearless Nadia 219

Firdausī 40, 64, 70, 72–74, 77, 81n3, 152n8

Firdausi (1935) 75

Fiza (2000) 17, 276, 282, 375, *fig. 276–77*

Forde, Walter 216

Forty Thieves: A Grand Romantic Drama, The 205

G

Gadar: Ek Prem Katha (2001) 353

Gaiety Theatre 38, 45, 225n9

Gaisberg, Frederick William 231

Galland 204–05, 208, 209, 214, 216, 218, 219, 222, 225n5, 225n6, 225n7, 225n13, 226n29 *see also Adventures of Ali Baba and the 40 Thieves; Arabian Night, Tales of the*

Gandhi, M. K. 7

 campaign of *satyagraha* 7

Ganguly, Rita 239–40

Garv: Pride and Honour (2004) 351, 354–58

genre painting 48

German expressionism 252

gharānās 120, 314

ghazal 11, 13, 15, 16, 19, 23, 25, 26–27, 38, 40, 47, 51, 53, 57, 61, 64, 65, 68, 70, 76, 95, 110, 112, 116–17, 119, 122–23, 229–56, 262, 263, 264, 301, 312

 see also Akhtar, Begum; 'Chandā', Māh

Laqā Bāi; Mahmood, Talat; Malkā Jān; Saigal, K. L.; *taẓkira*s

in Adalat (1958) 254

in *Babar* (1960) 248

in *Babul* (1950) 244

in *Barsaat ki Raat* (1960) 248

of Bahādur Shāh Ẓafar 53–54, 249

in cinema 25–27, 231, 240–44

in *Daag* (1952) 250

in *Garm Hava* (1973) 276

in *Gazal* (1964) 245, 246

by Ghālib 234–36, 247–48

and the gramophone era 231–36, 255

in *Lal Quila* (1960) 54, 249

love as theme in 229

in *Madhumati* (1958) 251

maḥfil-style 244–49, 253, 255

melancholic 249–55

in *Mirza Ghalib* (1954) 247–48

as a musical genre 229–56

in Parsi theatre, 40, 47, 51, 53, 57, 61, 110

and playback singers 241

prominent exponents of 230–33, 236–40, 238

in *Roti* (1942) 237

by Santoshi 236

spatial venues for 230

structure of rhyme in 229

in *Taj Mahal* (1963) 244

and *ta'rīf* songs 245–46

by ṭawā'if poets, 116–26

by Waheedan Bai 236

Ghaznavi, Rafiq 231

Ghosh, Anindita 110

Ghosh, Nabendu 57

Ghosh, Shohini 383

Ghulami Zanjeer (1931) 3

Ghurid Dynasty 10

Gilmartin, David 9

INDEX

giraha lagānā 262
Gitagovinda 307
Gopi Krishna 300, 307, 314, 315
Gorakhpuri, Firaq 237
Gowariker, Ashutosh 24, 76, 132, 280,
 282, 316n2
Great Rebellion of 1857 5–6
Gujarati 39–41, 48, 65, 66, 68
Groot, Rokus de 69
Gujarati theatre 21, 43
Gul-e-Bakavali (1927) 223
Gulabo Sitabo (2020) 18
Gulistān 65
Gulshan-i-Arab (1929) 3
Gulshan-i-Nāz 112
Gulzar 232, 255n5, 282, 283
Gulzār-i Nasīm 40
Gupt, Somnath 66
Gupta, Amlan Das 107
Gupta, B. L. 186
Gupta, Rajkumar 370, 381, 384, 385
Gupta, Shubra 388

H

'Habāb', Amānullāh K̲h̲āṅ 42–43
 Sharar 'Ishq 43
Habermas, Jürgen 109
Hafiz, 231, 237
'Ḥālī', Alt̤āf Ḥusain 99–101, 107–8
 Muqaddama-i-She'r-o-Shā'irī 108
Hamzā, Amīr 15
Hamzānāma 15
Hamzānāma paintings 133
Hansen, Kathryn 67, 74, 109
Hansen, Thomas Blom 372
Ḥasan, Abū'l 151n4, 158, *fig.* 159, 160
Ḥasan, Mir 15, 40
Hashmi, Emraan 288
Hashmi, Fayyaz 241
Hassan, Mehdi 243–44, 249, 252

Hātifī 64
Hemmings, Adeline Victoria 119, 124 *see*
 Jān, Malkā
'Hilal', Hakīm Banno Ṣāḥib 120
Hindavi 3, 4, 5, 12, 16, 22, 84, 86, 92–98,
 103n3, 262
Hindi 3, 5, 6, 22, 52, 57, 66, 68, 75, 84,
 86–87, 88, 98, 99, 100, 109, 123, 204,
 226n20, 226n30, 296, 306, 309, 312,
 314, 355, 359
Hindi film(s)/cinema 1, 13, 73, 76, 182, 188,
 194, 220, 230, 240, 295, 297, 298, 307,
 317n2, 317n5, 321, 322, 340, 344,
 346n2, 375, 394n2
Hindi film music 241, 243
Hindi/Hindi-Urdu literature 88, 98, 100,
 101, 102, 224n2
Hindu-Muslim relations *see also* Hindutva;
 Babri Masjid/Mosque demolition
 Hindu polarization 185, 196n4
 Hindu values of peaceful coexistence 187
 Hindu-Muslim conflict 83, 103n4, 394n2
 Hindu-Muslim unity, 7–8, 222, 358,
 382, 394n2
 in *Bajrangi Bhaijaan* (2015) 358–60
 in *Garv: Pride and Honour* (2004)
 354–58
 in *Padmaavat* (2018) 8, 19, 83–84, 87–88,
 188–95.
 the Padmaavati controversy 185–88
 in *Tumko Na Bhool Payenge* (2002)
 356–58
Hinduism 1, 13, 187, 190, 192, 195, 196n4,
 198n16, 297, 318n7
Hindustani 5, 40, 41, 42, 51, 65, 66, 74, 241
 Hindustani music 38, 47, 107, 229,
 255n2, 255n3
Hindutva/Hindu right 8, 10, 18, 57,
 183–88, 194–95, 196n2, 197n8,

197n16, 292n17, 351, 357, 358, 364, 366n11, 367n20, 368n21, 372

Hīr-Rāṇjhā 67, 77

Hiranand, Shanti 237, 239, 240

Hitchcock, Alfred 207

Hodgson, Marshall 1, 8–13, 80n2

Holi 10, 30n4

Hollywood cinema
 cabaret in 315
 conspiracy film 388
 epics 76
 Vietnam films 395n3
 western in 208
 orientalism/orientalist tropes in 209, 213, 217, 220, 222

Hum Tum Aur Woh (1938) 212

Humāyūn, Emperor 132, 146, 147, 172, 248
 tomb of 4, 11

Humayun (1945) 14, 28

Hume, A. O. 6

Husain, Imām 86, 92–93, 94–95, 96, 99

Husain, Qadar 120

Hussain, Shah 288

I

Imam, Chaudhary Zia 230

Imperial Film Company of Bombay/Studios 75, 213

Imperial Studios 213

Indar Sabhā ('Indra's court') 21, 38, 40–41, 52, 110

India Act (1935) 7

Indian Imperial Theatrical Company 43

Indian National Congress 6–7

Indian secularism 7, 266

Indo-Islamicate culture/forms/milieu/motifs 11, 12, 21, 26

Indo-Muslim cultural heritage/culture 42, 74, 108, 125

Indubālā 232

Iqbal, Muhammad 7

Irani, Ardeshir 213

Irani, Faredoon 213

Iranian cinema 71, 75
 Dukhtar-e-Lor 75

Islam 1, 2–8, 12, 276, 280, 292n7, 297, 305, 310, 318n7, 353, 354, 358, 371, 381

Islamdom 9

Islamicate courtesan films 14

Islamicate culture 1–2, 5, 8–20, 106
 aesthetic forms of 29
 influence of Arab-Persian culture in 10–11
 in Hindi cinema 295–97
 motifs and idioms in cinema of 13–20, 297
 origin of 8–10
 in post-independence India 8

Islamicate Cultures of Bombay Cinema 13, 15

Islamicate/oriental fantasy films, 203–224
 Mishra's Arabian Nights fantasy films 203

Islamophobia 18, 19, 83
 Islamophobic historical films 8 *see also Padmaavat* (2019)

I'timādu'd Daula 162, 166–67, 169–70, 171, 173
 tomb of 4

Iyengar, Niranjan 283, 287

J

Jaagruti (1992) 351

Jab Tak Hai Jaan (2012) 19

Jahan Ara (1964) 245

Jahāngīr, Emperor 3, 14, 23, 133, 141–45, 147, 151n5, 151n6, 152n7, 155–78
 justice of 156–62, *fig. 159*, 174–5
 Mu'tamad Kḥān's account of 163–64
 nightly sessions (*majālis-i shabāna*)
 of scholars, poets and nobles with 160, 162

INDEX

and love of Nūr Jahān 162–66, 169–74

Jahāngīrī painting 141–45, 158–60

Jahāngīrnāma 141–44, 150, 151n6, 152n7, 156–58

Jai Ho (2014) 352

Jaikishan, Shanker 57, 250

Jainism 13

Jalsaghar (1958) 297

Jallandhari, Hafiz 237

Jama Masjid (Delhi) 264, 290n5

Jān, Asgharī 232

Jān, Azīz 232

Jān, Bībī Chhattā 124

Jān, Bībī Gunnāh 124

Jān, Bībī Khurshīd 124

Jān, Bībī Naṣīran 124

Jān, Gauhar 232

Jān, Kālī 232

Jān, Malkā 119, 120–4, *fig. 121*

Jān, Qāmrān (Manjhu) 117, 118 *see* Mushtarī

Jān, Umrāo (Bi Chuttan) 117, 118, 124 *see* Zohrā

Jaravchi, Nakshab 230

'Jauhar' (Javahar Singh) 119

jauhar 87, 187, 190, 195

Jāyasī, Malik Muḥammad 12, 83, 84–84, 87, 88, 91–92, 183, 186, 188

Jewel Thief (1967) 336

Jewess, The 58

Jha, Shweta Sachdeva 231

Jhanak Jhanak Payal Baaje (1955) 297–304, 310–16, 329

 awards and recognition of 297–98

 Bhārat Naṭrāj competition in 302–04, 315

 commercial success of 297–99

 and the control of female sexuality 306–07, 311–12

 credits in 299, *fig. 299*

 and the elision of Muslims in 310–11

 and the historical construction of Kathak dance 307–10

 Islamicate style in 300

 Kathak dance in 300–02, 311–12, 314–16, *figs. 302, 313, 316*

 and the Orientalist trope of a Hindu golden age 305–07

 and the male reclamation of classical dance 315

 as master narrative of cultural history/ nationalism 304–16

 technicolor in 298

Jhariā, Kamlā 232

Jhingan, Shikha 262

Jinnah, Muhammad Ali 7

Jodh Bai 155

Jodhaa Akbar (2008) 18–19, 24, 76, 86, 132, 185, 280, 282, 316n2

Johar, Karan 282, 287

Jones, Sir William 305

Joshi, G. N. 237, 240

Joshi, Namrata 388

Joshi, Prasoon 282, 286–87

Joshi, Sanjay 109

Judwaa (1997) 349

Junoon rock band 281, 288

K

Kaagaz ke Phool (1959) 298

Kabīr 274

Kabir, Ananya Jahanara 360

Kadivar, Darius 76

Kaikāus ane Sudāba 66

Kala Pani jail 216

Kalam, A. P. J. Abdul 184

Kalvi, Lokendra Singh 185

Kalyani 263

Kapoor, Kedar 72

411

Kapoor, Prithviraj 72, 73

Kapoor, Rishi 69, 336, 342

Kapoor, Shammi 68, 69

Karbala, battle of 86, 92–95, 100

Karni Senas 185–88, 194–95

Kāshmīrī, Āghā Hashr 21, 38, 51–53,
 55–61, *fig. 56*, 81n12 *see also Yahūdī
 kī Laṛkī*

 adaptations from Shakespeare 55

 Ankh ka Nasha ('Eye's delight') 57

 Bhakt Sūrdās ('Surdas') 57

 Bhārat kī Pukār ('India's cry') 56

 Bhīshma Pratigyā 57

 Bilva Mangal 57

 Dhruva Charitra ('The tale of Dhruva') 57

 genres composed by 55–57

 Gharīb kī Duniyā ('The world of the
 poor') 56

 Hindustān Qadīm o Jadīd ('Hindustan old
 and new') 56

 Khūbsūrat Balā 55

 Rustam o Sohrāb ('Rustom and
 Sohrab') 57

 screenplays of 57

 Shirin Farhad ('Shirin and Farhad') 57

 Silver King 53–54

 Sītā Banvās ('Sita's Exile') 57

Kashyap, Anurag 370, 375, 378, 379,
 380, 381

Kathak dance 4, 10, 17, 25, 207, 209, 210,
 221, 298, 307–10, 314–16, 329

Kathāvāchak, Rādheshyām 43–44

Kavirāi, Sundar 90

Kazmi, Nikhat 388

Kesari (2019) 194

Kesavan, Mukul 13, 220, 295, 296,
 297, 310

Keshavdās 90–91

Keskar, B. V. 239

Khakee (2004) 16, 282

Khaljī, Alāuddīn 8, 83, 87, 184, 186,
 187, 188–94

Khaljī, Jalāluddīn 188–91, 193

Khan, Aamir 18, 348, 350

Khān, Abdullāh 137, 140, 151n4

Khan, Arbaaz 354

Khān, Dargāh Qulī 97–98

Khān, Diyānat 169–70

Khān, Khāfī 171–73

Khan, Mehboob 14, 26, 203, 204, 207,
 212

Khān, Muhammad Sādiq 168

Khān, Mu'tamad 151n5, 163–64

Khan, Nusrat Fateh Ali 281–82,
 285, 292n19

Khan, Salman 34–68, *figs. 349, 361, 363
 see also Bajrangi Bhaijaan; Ek Tha
 Tiger; Garv: Pride and Honour; Sultan;
 Tumko Na Bhool Payenge*

 and the ability to survive in adversity 352

 appeal across religions/cultures 354

 body image of 351, 361–64

 criminal allegations about 347–48, 352,
 365n2, 365n3

 fame and notoriety of 347–48

 and Muslim working class fans 348, 351–53

 rise of 349–51

 romantic comedies of 349

 stardom of 350–51

 and success of *Dabangg* (2010) 349–50

Khan, Sayyid Ahmad 6

Khan, Shah Rukh 18, 348, 350,
 367n14, 367n17

Khandelwal, Rajeev 384

Khangarot, R. S. 186

Khari Boli 4–5

Khatau, Kavas P. 44

khayāl 232, 255n3

Khayālīs 42

Khayyam 240

Kher, Anupam 386

Khmer ballet 315

Khori, Edaljī 41

Khosla, Raj 330, 338

Khūn-e nāhaq 66

Khusrau (son of Jahāngīr) 141–44, 157

Khusrau, Amir 3, 30n4, 64, 68, 70, 77, 81n3, 88, 193–94, 262, 274, 285, 291n5, 291n10

Khusrau-Pervez 267, 268

Khusrau-Shīrīn 66

Khwaja ki Diwani (1981) 277

Kick (2014) 348

Kidivar, Darius 76

Kidwai, Saleem 107

Kimyagarov's Tajik films 76

kirtan 233, 255n3

Kohli, Kunal 286

koṭhā 47, 230, 231–32, 253–54, 313, 314, 322, 329

Krishna 3, 4, 30n2, 30n4, 89, 101, 102, 103n8, 274, 292n14, 300, 364

Kumar, Dilip 21, 26, 57, 242–44, *fig. 242*, 249–52, 256n11, 256n12

Kumar, Pradeep 71, 267

Kumar, Raj 72

Kumari, Meena 21, 57, 60, 246, *fig. 246*, *fig. 247*

Kurbaan (2009) 19

L

La Juive (Halévy) 58

Lady of Lyons, The 48

Lahori, Abdul Hamid 135

Laila Majnu (1953) 68

Laila Majnu (1976) 69

Laila Majnu (2018) 70

Lailā-Majnūn 21, 64, 66, 67, 69, 70, 76, 274, 291n10

Lailā-Majnūn films 68–70, 77

blending Persianate and Arabic elements 69

Iranian version of 75

Malaysian version of 81n7

Pakistani versions of 81n7

Laili and Majnun (1936) 75

Lakhnavi, Behzad 230, 237, 239

Lakhnawī culture/courtesan culture 6, 14, 125

Lal Quila (1960) 54

Lal-e-Yaman (1934) 212, 217, 221–22, 259, 290n1

Lalita, K. 108

Lang, Fritz 207

Lawrence, Bruce B. 1, 9

Lelyveld, David 239

Light of India Theatrical Company 43

Lodis 2

Long Kiss Goodnight (1996) 355

Love Story 2050 (2008) 18

love-jehad 187, 197n8

Loy, Shankar Ehsan 282–83

Lucknow 5, 6, 13, 40, 44, 93, 109, 110, 116–19, 120, 124, 125, 126, 230, 237, 239–41, 272, 308, 314, 320, 323, 328, 334, 335

Ludhianvi, Sahir 240, 245

Luthria, Milan 281

M

Macziewski, Amelia 107

Madan J. J. 207

Madan Theatres 57

Madhok, D. N. 240

Madhubala 71, 249, 267

Madhumālatī 12, 16

Madhumati (1958) 16

Madine ki Galian (1981) 14

Mahabharata (1988–90), 76

Mahābhārata 57, 67, 192

Mahal, Khās 116

413

Maharaj, Birju 314

maḥfil(s) 14, 17, 26, 116, 118, 229, 230, 231, 232, 233, 234, 237

maḥfil-style *ghazal* 244–49, *figs. 246, 247*, 253, 255

Mahmood, Talat 231, 233, 240, 241–43, *fig. 243*, 249–251

Maḥmūd of Ghaznı 10, /1

Maine Pyar Kyun Kiya (2005) 349

majlis 93–94, 95, 100

Maqbool (2003) 16

Mamluks 2

Mangeshkar, Lata 241, 252–54

Manto, Sa'ādat Ḥasan 177, 231

Manuel, Peter 229, 232

Maqbool (2003) 16

Markel, Stephen 133

Maratha Confederacy 5

marṣiya 84, 86, 92–98, 100, 102, 103n3, 103n11

 and Battle of Karbala 92–95, 100

 classical iteration of 95

 development in North India of 92

 Ḥālī's critical evaluation of 99–100

 in Hindavi 92, 95–97

 language of 97–98

 and mourning 95, 100

 virahiṇī trope of longing and lament in 96–98

 women's voices in 96–97

Marzbān, Behrām Fardun 41, 42

Marzolph, Ulrich 204

maṣnavī 3, 13, 16, 19, 21, 40, 64–77, 97 *see also Lailā Majnūn, Shīrhīn Farhād*

 in Bombay cinema 68–75

 films inspired by Firdausī's *Shāhnāma* 72–73

 in Iranian Cinema 75–77

 in Parsi theater 66–67

 of Vāmiq and Azrā 71

Master, Homi 68

Mazumdar, Ranjani 351

Mehboob Productions 213

Mehra, Rakeysh Omprakash 282

Mehta, Anil 69

melancholic *ghazal* 242, 249–55, 276

melodrama/melodramatic mode or form 55, 57, 60–61, 214, 215, 217, 222, 252, 259, 322, 330, 337, 351, 355, 359, 366n8, 370, 394

memorialization of Muslim invasion 21, 25

memory archive of conflict 371–75

 and demolition of the Babri Masjid 371–74

 and Bombay terrorist attacks 374–75

 and stories of redemption 375

 and conspiracy narratives 375–94

Menninghaus, Wilfred 383

Menon, Raghava 234

Mere Gharib Nawaz (1973) 14

Mere Mehboob (1963) 14, 321, *fig. 328*, 344

 see also pardā

 love at first sight in 326–27, *fig. 327*

 intrusive camera in 327–28

 comic contrast in 329

 mistaken identity in 331, 333–36, *figs. 334, 335*

 mise-en-scène in 342

Milan (1967) 16

Mille, Cecil B. de 214

Minerva Movietone 66, 68, 72

Mishra, Ambrish 241

Mīr, Mīr Taqī 5, 108

Mira/Mirabai 90, 103n8, 312

Mir'āt-Khayāl 112

Mirigāvatī 3, 12

Mirza Ghalib (1954) 73, 234, 247–48, 264, 292n19

Mirza, Saeed 277

Mishra, B. P. 203, 206, 213

Mitra, Smita 380

Modi, Narendra 196n4, 352, 365

INDEX

Modi, Rustam 68

Modi, Sohrab 21, 22, 25, 38, 57, 58, 60, 68, 71–72, 176, 234, 248, 264

Mohan, Madan 239, 240, 252–54, 256n10

Momin 5, 237

Monseratte, Father 164

Moradabadi, Jigar 237

Morcom, Anna 107

Moti, Hari 231

Mountbatten, Lord 7

Mughal Empire 2, 3, 5, 12, 17, 155, 156, 160, 162, 163, 171, 175, 177, 178, 305

Mughal justice 155–62, 174–78
 as God's will 155
 Islamic law of retribution (*lex talionis*) in 174–75
 and Jahāngīr's chain of justice 156–62, *figs. 159, 161*
 of Muḥammad Shāh 162
 and notion of ideal kingship 156–57
 in *Pukar* (1939) 176–77
 and romantic love 174–78

Mughal painting 158
 'Ābid's *The Death of Khān Jahān Lodhī* 135–41, 140, *fig. 136*
 Akbar fights with Raja Mān Singh in *fig. 148*
 of the *Akbarnāma* 132, 141, 145–50 *fig. 148*, 152n11, 152n13
 depiction of Jahāngīr's justice in 158–60, *fig. 159*
 depiction of Khusrau's rebellion in 142–44, *fig. 143*
 depiction of music in 133
 as historical resource 133
 as interpretation of historical events 134, 141
 and Jahāngīrī painting 141–42, *fig. 143*
 of the *Pādshāhnāma* 135, 138–41, 150, 151n4, *figs. 136, 139*

relationship between text and image in 132–51
 reference in *Jodhaa Akbar* to 132
 Shāh Jahān's accession ceremony in *fig. 139*
 Shāh Jahān's first *darbār* in *fig. 161*

Mughal-e-Azam (1960) 14–15, 71, 73, 102, 184, 296, 325

Mughals 4, 8, 145, 146

Muḥammed, Prophet 92–93, 165, 261, 267

Muharram 93

Mujhse Shaadi Karogi 20

mujrā(s) 4, 13, 14, 26, 27, 230, 312

Mukesh 241, 251

Mukherjee, Prabhat 206, 208

Mukhī, Soshī 206

Mulk (2018) 20

Mullick, Pankaj 233

Mumtaz 73, 74

*munshī*s 38, 39–44, 115–16, 119, 124

'Murād', Karīmuddīn 42–43

Murād, Murād 'Alī, 44
 Alāūddīn 44
 Harishchandra 44
 Chandrāvalī 44

*mushā'ara*s 110, 113, 123, 126, 230, 244, 246–47

Mushtarī 117–19, 124, 127n10, 127n11

Muslim Devotional 14, 17, 81n4, 277, 291n8

Muslim marriage (*nikāḥ*) 164–66, 164

Muslim presence, interpretation of 183–85, 194
 and Muslim religiosity 184, 194
 and Muslim homogeneity 184, 194
 and Muslim historicity 184, 194

Muslims and Indian citizenship 184–85, 196n3

Muslim Social 14, 15, 16, 17, 18, 19, 25, 81n4, 223, 263, 271, 275, 276, 320–21,

415

330, 342, 344, 345, 346n3, 364 *see also*
New Wave Muslim Social; *parda*
drama of mistaken identity in 17, 18,
320
themes of 14
Muslim stereotype(s) 17, 183–85, 216,
224n3, 381, 384
Muslim/Muslim themed historical films 14,
18, 72–75
Muzaffar, Sayyid 148–50
My Name Is Khan (2010) 16, 19, 282, 287

N
'Nādir', Durgaprasad 112
Naim, C. M. 111
Najma (1943) 14, 226n27, 320
Najmabadi, Afsaneh 9, 10
Nakkash (2019) 20
namāz 192, 193, *fig. 193*, 378
Nandy, Ashis 266
Narang, S. D. 57
Nargis 254
'Nāsikh', Imām Baksh 118
Nasīm, Dayā Shankar 40
Nastaʿlīq script 5, 41, 43, 317n5
Nath, Prem 73
Nath, Surendra 213
National Register of Citizens 185
National Studios 213
Nāṭyaśāstra 307, 315
Naushad *see* Ali, Naushad
Nausherwan-e-Adil (1957) 72
Naushīrwān (Khusrau Anushīrwān) 157–58
Naqab (1989) *see also parda*
hidden/veiled vs. open/unveiled in 330–31
doubles and mistaken identity in 337–39
photography and demystification in
341–42, *figs. 341*
Naqvi, Janveer 267
Nath, Prem 73

Nath, Surendra 213
nautch girls/performances 106, 116, 127n7,
206, 225n11, 306–09
nawābī culture 13, 17, 106, 125, 308, 320
Nawal Kishore Press 109
Nazir (Nazir Ahmed Khan) 71
Nazir, C. S. 45
Nazīr, Nazīr Beg 44
Shakuntalā 44
Gulrū Zarīnā 44
Nehruvian period 8
Nevile, Pran 234
New Alfred Theatrical Company 43–44, 55
New Theatres 57, 212, 233, 234, 241
New Wave Muslim Social 15, 16, 276
Nihalini, Govind 286
Nirmal 254
Nizāmī 64, 65, 68, 69, 70, 77, 81n3, 291n10
see also Lailā-Majnūn
No Entry (2005) 349
No'manī, Shiblī 175
Noor Jehan 263
Noor Jehan (1967) 14
Noor-e-Yaman (1935) 221
Noukadubi (1947) 346n2
Noukadubi (2011) 346n2
Novelty Theatre 46
Novetzke, Christian Lee 344
Nūr Jahān (Mihru'n Nisā') 112, 162–78 *see
also Pukar*
coins issued under name of 168, *figs. 169,
172*
crime of 174–75
hunting expedition of 176
Khāfī Khān's biography of 171–73
and *nikāḥ* ceremony with Jahāngīr
165–66
rank of 166
rise to power of 166–68
Tavernier's short biography of 170

INDEX

wealth of 168

Nūshīrvān the Just 72

O

Odissi 306, 307, 309

Ogra, Sohrabji 44

Oesterheld, Christina 97, 109

Oldenburg, Veena 107, 308

Operation West End 395n6

Oriental genre 12, 15, 17, 18, 65, 68, 81n4, 203–27 *see also* Ali Baba; *Alibaba*; *Chiu Chin Chow*; Lailā Majnūn, Shīrīn Farhād

and Alibaba films 206–24

dance in 2010–12, *fig. 211*, 215

international orientalism in 212, 220, 223

pastiche of 18

sources of 15, 203–04

Urdu Islamicate aspects of 210, 214, 217, 219, 220–22

Orsini, Francesca 109, 229

P

Padmaavat (2018) 8, 19, 76, 83–84, 86, 87–88, 102, 182–98

budget of 86

controversy over 83–84, 86–87

Indian history as a clash of civilizations in 191–94

opposition of Karni Sena (SRKS) to 182–83, 185–88

Muslim portrayal in 83, 183–85, 188–94

similarity of criticisms to 83, 195–96

Padmāvat, Jāyasī's 12, 22, 83–87, 188

and *premākhyān* genre 87

story of 84–85, 87

virahiṇī trope in 84–85

Pādshāhnāma paintings 135–41, 151n3, 151n4, *figs. 136, 139*, 160, *fig. 161*

Pakeezah (1972) 14, 23, 106, 297, 322

Pakistan 7–8, 30n4, 243, 262, 278, 281, 288, 353, 354, 358–60, 368n23, 381, 392

Pandey, Neeraj 288, 370, 386

Panipat (2019) 194

Para, Begam 68

pardā (veiling) in Hindi cinema 9, 113, 114, 320–46 *see also Chaudvin ka Chand*; *Deedar-e-Yaar*; *Mere Mehboob*; *Dedh Ishqiya*; *Naqab*

the allure of the veiled woman in 322–29

and mistaken identity 331–39

and the motif of double 330–31

photography and 339–43

and the power of the voice 321–22

in *Sahib Bibi aur Ghulam* (1962) 345

Parī, Bībī Majho Ṣāḥibā Yahūdan 124

Parsi community in India 39–40, 57, 67

and Gujarati language 39–40

Parsi theatre 6, 37–62, 64, 65–66, 67, 68, 72, 74, 81n12, 109–10, 230 *see also Indar Sabhā*; Kāshmīrī, Āg̲h̲ā Ḥashr *Behrāmgor ane Bānū Hoshang* 66

and Bombay cinema 38, 55, 57, 60–61, 206, 217, 220, 222

and *Dād denā* 51

and design of urban playhouses 44–51, *figs. 46, 50*

Gujarati language in 39–40, 41, 42, 43, 48

Kaikāus ane Sudāba 66

Lailā-Majnūn in 66

mythologicals in 57

nasr-i muqaffā in 52

Rustam ane Barjor 66

Rustam ane Sohrāb 66

Shakespeare plays in 40

Shahzāda Shyābakhsh 66

Shirin Farhad 57, 70

Shīrīn-Farhād in 66

Shīrīn-K̲h̲usrau in 66–67

Urdu language and culture in 38, 40–44, 51–55, 57, 60, 61

Partition Plan 7

Partner (2007) 349

Parvez II, Khusrau 70

Patel, Cowasjee *fig. 49*

Patel, Dadabhai Sohrabji 41

Paṭhān, 'Ināyat Khān 232

Pavlova, Anna 207, 210

Pelsaert, Farncisco 162

Persian language 2, 3, 4, 11, 40, 42, 64–65, 70, 71, 73, 76, 96, 111, 112–13, 117, 118, 120, 122, 170, 173, 176, 224n2, 262, 296, 316n2

Persian epics 64, 66, 72–75, 76–77 *see also Shāhnāma*

Persianate films 67–79 *see also* Lailā-Majnūn films; *Rustam Sohrab*; Shīrīn-Farhād films; Sikandar
cultural origins of 65–66, 73
produced in Iran 75–76, 77
epics about kings of Iran 72–74
romances 66–71
stories about folk hero Rustam 73–75

Persian literary tradition(s) 65–66, 97

Persian romances 64, 66–71 *see also* Khusrau-Shīrīn; Shīrīn-Farhād; Vāmiq-Azrā

Perso-Arabic language/tradition 13, 103n1, 229, 296, 297

Petievich, Carla 111, 112

Phantom (2015) 19

photography 340–42

Phukan, Shantanu 97

Plassey, battle of (1757) 5

Pollock, Sheldon 11

Post, Jennifer 107

post-Partition India 7–8

Prabhat Studios 298

Prakesh, Gyan 372

premākhyān 84–7, 88–92, 102, 103n1 *see also* Sufi romances
Aditya Behl on 91–92
virahiṇī trope in 88–92

Premchand, Munshī (Dhanpat Rai Srivastava) 110

Pritchett, Francis 111, 244

Progressive Writer's Movement 240

Pseudo-Jahāngīrnāma 162, 165–66, *fig. 167*

Pukar (1939) 14, 25, 72, 176–77

Punjabi 81n7, 204, 225n20, 262, 274, 281, 283

Punjabi *qiṣṣa* 4

Pyar Kiya to Darna Kya (1998) 349

Q

qāfiya 50–51

qalāms 248

qawwālī 13, 15, 16, 17, 19, 69, 232, 248, 259–92, 325, 328, 333, 344, 359, 378 *see also* Sufism; techno-*qawwālīs*
all-female 263–64 *see also* Sufism; techno-*qawwālīs*
and Bhakti tradition 262, 274–75
in *Bajrangi Bhaijaan* (2015) 280
in *Barsaat ki Raat* (1960) 271–75, *figs. 273, 274, 275*
in *Chaudhvin ka Chand* (1960) 328
dargāh 259–60, 262–64, 267, 272, 276, 281, 282, 290n5
devotional 261, 262, 263, 264, 266–67, 271, 278, 280, 281, 283
in *Dharmputra* (1961) 264–67, *figs. 265, 266*
in *Fiza* (2000) 27678, *figs. 276, 277*
in *Garm Hava* (1973) 27
at Haji Ali *dargāh* 276–78
improvisation in 262, 274
in *Jodhaa Akbar* (2008) 280
in *Khwaja ki Diwani* (1981) 277

INDEX

in *Marine Drive* (1955) 267

in *Mirza Ghalib* (1954) 264

in *Mughal-e-Azam* (1960) 325

in *Salim Langde Pe Mat Ro* (1989) 277

Sahir Ludhianvi's 265

in *Shareef Daku* (1938) 262

in *Shirin Farhad* (1956) 267–71, figs. 268, 269, 270

in *Sitamgar* (1934) 262

Sufi conception of love (*'ishq*) in 262, 263, 271, 272–75, 280, 281–82, 284, 288

and Sufi philosophy 260–62

in *Veer Zaara* (2004) 278–80, figs. 279, 280

in *Zeenat* (1945) 263

qissa-dāstān storytelling tradition 4, 204, 224n2

Qureshi, Regula Burckhardt 107, 242

R

Raanjhana (2013) 282

Rab Ne Bana Di Jodi (2008) 19, 206

Rabindra Sangeet 233

radīf 50–51

Radio Celyon 235

Rafi, Mohammed 54, 241, 248, 249, 251

Rahman, A. R. 282

Rai, Himansu 207

Rājgīrī, Shaikh Mīr Sayyid Mañjhan Shaṭṭārī 12

Rajhans, B. S. 81n7

Rajkamal Kalamandir Studio 298

Rajput identity/patriotism/pride 185, 187, 192, 194

Rām Līlā 44

Ram, Malik 118

Rama Rao, N. T. 217

Ramachandran, M. G. 217

Rāmāyaṇa 57, 67, 76, 192, 292n14

Rānīnā, Nānābhāī Rustamjī 43

'Ranj', Moḥammad Faṣīḥ-al-Dīn 112–14, 117, 119, 124

Ranjeeta 69

Rao, Vidya 107

'Rasa', Moḥammad Ibrāhīm Shāh Ṣāḥib Bahādur 123

rasa 13, 61

Rashtriya Swayamsevak Sangh (RSS) 196n2, 197n10, 358, 368n21

Rāst Goftār 45–46

Ratnam, Mani 282, 375

'Raunaq', Mahmūd Miyāṅ 42

Khūn-i 'Āshiq 48

Ravikant 230, 248

Rawail, H. S. 342–43

Ray, Satyajit 297

Rebellion of 1857 5, 6, 106, 107, 114, 116, 118, 126, 305, 308

Red Fort in Delhi 4, 54

Rehman, Waheeda 323, 331, 317n3

reincarnation romance 16

Reinhart, Kevin 9

Rekhta/rēkhtā 3, 4, 95–96, 103n3, 103n12, 112

rēkhtī poetry 108, 111–12

Riazu'sh Shu'arā 174

Rīti poets 90

Rizvi, Hussain 263

Rizvi, Syed Shaukat Hussain 263

Rockstar (2011) 19, 282

Romeo and Juliet 48, fig. 50

Roshan 240

Rotman, Andy 344

Roy, Alphonse 385

Roy, Anjali Gera 13

Roy, Raja Ram Mohan 6

Rubinstein, Ida 210

Rūmī 97–98

Russell, Ralph 230

419

Rustam Kaun? (1966) 75
Rustam Sohrab (1963) 73–4, 81n12
Rustom and Sohrāb 39–40
Rustom the Champion (1982) 75
Rustom-e-Baghdad (1963) 75
Rustom-e-Rome (1964) 75

S

Saawariya (2007) 19
Sadiq M. 320, 332, 339, 242
Sadiq, Muhammad 100
Saeed, Yousuf 14
Sagar, Ramanand 76
Sagar Movietone 212–13
Sāheb, Maulvī 42
Sahib Bibi aur Ghulam (1962) 297
Ṣāḥibā, Bībī Manjhū 124
Sahni, Jaideep 286
Saigal, K. L. 26, 57, 213, 231, 233–35, 241
St. Denis, Ruth 315
Saksena, Ram Babu 123
Salazkina, Masha 223
Salīm-Anārkalī love story 14, 155–56
Sampath, Ram 282
Sampath, Vikram 119
Sandhya 300
Sangari, Kumkum 252, 255
Sanskrit 4, 5, 61, 76, 88, 103n9, 184,
 290n2, 296, 307, 308
Santoshi, P. L. 236, 271
Santoshi, Rajkumar 282
Sanyal, Pahari 233
Saraiki 262
Sarrazine, Natalie 288
Sasanian culture 10
Sathyu, M. S. 276
Sayyids 2
Scheherazade, Diaghlev's 210
Schofield, Katherine Butler 106
Seitz, Matt Zoler 375

Sen, Hiralal 203, 206, 207
Sepanta, Abdol-Hossein 75
Sethi, G. R. 262
Shah Behram (1935) 72
Shāh, Bulleh 274, 283, 288
Shāh Jahān, Emperor 3, 14, 90, 135–41, *fig.*
 139, 145, 157, 160, *fig. 161*, 163, 168,
 169, 172
Shāh, Muḥammad 162, 171, 174
Shāh, Nāder 5
Shah, Naseeruddin 345, 386, *fig. 389*
Shah, Shoham 289
Shāh, Wājid 'Alī 40, 108, 116, 118, 125,
 272, 329
Shāh, Waris 274
Shah-e-Iran (1934) 78
Shahid (2013) 20
Shahjahan (1946) 14
Shāhnāma 21, 40, 64, 65, 66, 70, 71–72, 74,
 75, 76, 77, 82n13, 82n15, 145, 152n8
Shahzāda Shyābakhsh (Siyāvash) 66
shā'irī 54
Shakespeare Nāṭak 40
Shakuntalā 43, 44, 67, 76
'Shams' (Mirza Aga Alī) 117–18
Shankar, Uday 210, 315
Shantaram, Rajaram Vankudre 297–98,
 300, 310 *see also Jhanak Jhanak*
 Payal Baaje
 and *Geet Gaaya Pattharon Ne*
 (1964) 318n7
'Sharār', Abdul Halīm 125, 126, 131
Sharia 2
sharīf women 113–14, 117
Sharma, Kidar 240
Shawn, Ted 315
Sher Afgan 162, 162, 166, 169, 170–71, 173
Sheridan, R. B. 205
Shergill, Rabbi 281, 288
Shi'i elegy *see marṣiya*

420

INDEX

Shingler, Martin 348

Shirin Farhad (1956) 70

Shirin va Farhad (1935) 71

Shirin Farhad ki to Nikal Padi (2012) 81n10

Shīrīn-Farhād 11, 21, 64, 66, 75–77, 267

Shīrīn-Farhād films 70–1, 81n10

 in Iranian cinema 75

Shiv Sena 372, 379

Shiva-Parvati dance duet 27

Shokhī, Ḥazrat 123

Shree Rajput Karni Sena (SRKS) 22, 25, 84, 86–8, 182–3, 185–6

Siḥr ul-Bayān 40

Sikandar (1941) 72, 73

Sikandar-e-Azam (1965) 79

Sindhi 262

Singh, Dara 75

Singh, Lata 107

Singh, Mādho 137, 140

Singh, Mān (of Amber) 147–50

Singh, Randhawa 72, 75

Singh, Ratan 189–90, 192–93

Sitapuri, Nadim 118

social lives of ordinary Muslims 20

Sohnī-Mahīwāl 67, 77

Sokhey, Leila 315

Sone ke Mol kī Khurshed 41

Sturken, Marita 374, 394, 395n3

Subramaniam, Radhika 372

Sudarshan, Pandit 73

śuddh/Sanskritized Hindi 6, 296, 312, 314, 316n2

Sufi devotional music 259, 261, 292n17

 see also qawwālī

 in *Aur Pyaar Ho Gaya* (1997) 281

 in *Awaaraapan* (2007) 288

 in *Chak de! India* (2007) 282

 in *Dil Se* (1998) 282, 283–85, fig. 285, 289

 in *Delhi 6* (2009) 282

 in *Dev* (2004) 286

 in *Fanaa* (2006) 286

 in *Fiza* (2000) 282

 in *Jodhaa Akbar* (2008) 282

 in *Kaal* (2005) 289

 in *Kachche Dhaagey* (1999) 281

 in *Khakee* (2004) 282

 in *Kurbaan* (2009) 287

 in *Mohra* (1994) 281

 in *My Name is Khan* (2010) 287

 in *Rab ne Bana di Jodi* (2008) 286

 'remix aesthetic' in 289

 in *Rockstar* (2011) 282

 in *Shaheed-e-Mŏhabbat Boota Singh* (1999) 281

 in *A Wednesday* (2009) 288

Sufi romances 12–13, 83–92 *see also premākhyān*

Sufism 2–3, 155, 260–62 *see also qawwālī*

 and Bhakti 3, 260, 262, 274, 275, 288, 290n2, 291n9

 in Bollywood songs 280–89, 292n19

 'ishq (love) in 155, 260–61, 262

 'ishq-ĕ ḥaqīqī (Divine love) in 13, 155, 260–61, 271, 282, 287, 288

 'ishq-ĕ majāzī (phenomenal, human, or worldy love) in 155, 261, 271, 281

 and love-in-separation 16

 and performance of miracles 267, 291n9

 informing *qawwālī*s 262–80

 philosophy of 260–62

Suhravardī 12

Sukhvinder 283

Sulochana 206

Sultan, Razia 112

Sultan (2016) 361–64, figs. 361, 363

Sultana, Munawar 244

Sultanpuri, Majrooh 240, 241–42

Sundar, Pavitra 262

Suraiya 73, 74, 248

Suri, Mohit 288
Susheela, Miss 231
Swarnalata 71, 79
Syrian folktales 205

T

tableau 48, 55 *see also* melodrama
Tagore, Debendranath 6
Tagore, Rabindranath 207, 346n2
Ṭahmāsp, Shāh 146, 152n8
tahzīb (cultural etiquette) 106, 107, 125, 241, 320
Taj Mahal 4, 14, 17, 140, 166
Taj Mahal (1941) 73
Taj Mahal (1963) 14, 73, 244–45
Tales of the Arabian Nights 12, 15, 17 *see also* Galland
Ṭālib 'Alī ibn Abī 93
tāṇḍava 315
Tanvir, Kuhu 383–84
ṭappā 232, 255n2
tarāna 232, 255n3
ta'rīf songs 245
Tasker, Yvonne 348
Tassy, Garcin de 114
Taubatu'n Nasūh 99
Tavernier, Jean Baptiste 170, *fig. 172*
ṭawā'if(s) 13, 296, 106–28, 311, 315 *see also* 'Chandā', Māh Laqā Bāi; Malkā Jān; *tazkirās*
 British discrimination against 107, 116
 in court of Awadh 125
 distinction between *sharīf* women and 113–14
 life history of Zohrā and Mushtarī 117–19, 127n11
 marginalization by reformers of 107–08
 in Mutiyaburj region 116
 origin of word 106–07
 patrons of 116

role in Rebellion of 1857 107
and Sharār's chronicle of *lakhnawi* culture 125
use of *takhallus* (pen name) 117
as writers of poetry and songbooks 112–13, 118–19, 120–24, 126
*tazkirā*s (songbooks) 111 *see also* 'Chandā', Māh Laqā Bāi; ghazal; Malkā Jān
and vernacular literary cultures 109–10
on women poets 111–16
by Durgaprasad ('Nādir') 112–15, 117
Khana-i-Khayāl 119
by Mohammad Faṣīḥ-al-din ('Ranj') 112–14
Tarāna-i-Khayāl 119
Tazkirat-al-Khawātīn 126n3
Tazkirat al-nisa-i-Nādirī 112
techno-*qawwālī*s 288–89
Tere Pyar Mein (2000) 353
Teri Meri Kahani (2012) 19
Tharu, Suzie 108
Thief of Baghdad (1926) 223
Thokar (1939)
Thomas, Rosie 15, 65, 290n1
ṭhumrī 40, 110, 116, 122, 123, 231, 232, 233, 237, 239, 252, 255n2, 312, 317n6, 318n8, 329
Thunthi, Dadabhai Ratan 42
Timūr 145–46, 152
Timūrid Empire 3, 146–47, 164
triple *ṭalāq* 184–85
Trivedi, Harish 295
Tughlaks 2
Tumko Na Bhool Payenge (2002) 351, 355–58

U

ul-'Ābidīn, Zain 95

Umar Khayyam (1946) 73

Umrao Jaan (1899) 22

Umrao Jaan (1981) 14, 23, 106, 297

Umrao Jaan (2006) 14, 23, 106

Unsurī 71

urban playhouses *see also* Parsi Theater
architectural design of 45–50, 46
audience participation in 48–50, 51
distinctions of class and status of play-
goers in 44–45
melodramatic tableau in 48
performance style in 48, 50
stage design in 47–48

Urdu dramatists/playwrights 38, 42–44,
110

Urdu language 3, 4–5, 6, 11, 13, 15, 38,
41–42, 47, 50–55, 57, 60, 61, 64–66,
70, 72, 74–75, 87, 92, 99, 103n3, 212,
220–22, 223, 242, 262, 295–97, 310,
312, 314, 316n2

Urdu literary/print culture 10, 84, 86,
103n3, 106–28

Urdu poetry/poetic tradition 5, 6, 38, 41, 54,
61, 106–8, 111–26, 230–31, 236, 239,
241, 321

V

Vaishnav/Vaishnavism/Vaishnavite 3, 4,
30n2, 290n2

Vakil, Nanubhai 57

Vāmiq-Azrā 64, 71, 76

Vanmala 72

Vasudevan, Ravi 250, 359, 368n22

Vasunia, Phiroze 72

Veer (2010) 185

Veer-Zaara (2004) 278–80, *figs. 279, 280,*
292n19, 353

Veergati (1995) 351

Vernacular Press Act 306

Victoria Theater 45, 46, *fig. 46*

Victoria Theatrical Company 41, 43, 47,
206

Vidyavinode, Kshirode Prasad 206, 207,
209

Vijayanagarā 10

viraha 84, 85, 91, 252, 255

virahiṇī trope 69, 74, 84–86
in *Baiju Bawra* (1952) 102
and *bārāh-māsā* genre 91
in Bombay cinema 101–02
in Khusrau 88–89
in *marṣiya* 94–98
in Mughal-era *rīti* poems 90–91
in Padmāvat 83–85, 92
in *premākhyān* 88–92
in *Pyaasa* (1957) 101–02
reformers criticism of 98–101
in Sūrdās's poems 89

W

Wade, Bonnie 133

Wadia, Homi 204, 217

Wadia, J. B. H. 212, 217, 219, 220,
290n1

Wagoner, Philip 10

Walī Dakhanī 5

Walker, Johnny 323, 329

Walker, Margaret 107, 307, 309

Wani, Aarti 283–84

Wanted (2009) 349

Wark, McKenzie 389

Warsi, Aziz Ahmed Khan 276

Wednesday, A (2009) 370, 386–91, 392,
figs. 387, 389, 393
and communication networks 388–90
critical reception of 388
identity of the Common Man in 390–91
plot of 388
surveillance technologies in 391, 392–93

Williams, Richard 116

Woman in White, The 330
Wong, Anna May 216

X
Xavier, Jerome 157

Y
Yahudi (1958)
 Sohrab Modi's performance in 60
 significance of Meena Kumari's role in
 60
Yahūdī kī Laṛkī (The Jew's Daughter, 1913)
 38, 51–53, 55–60, *fig. 58*
 comic contrast in 52
 as critique of colonial state 55–56,
 57, 59, 60
Yazdegird 77

Yazid 93, 95, 96
Yazdī, Sharafuddīn Alī 146, 152n9

Z
Ẓafar, Bahādur Shāh, 5, 53–54, 249
Zafarnāma 145, 146, 147, 152n9, 152n13
Zaidi, S. Hussain 375
Zainab 96–97
Zakhm (1998) 375
Zarachvi, Nakshab 263
Zauq 5
Zinciriye (Sultan Jesus) Madrassa 353
Zindagi Na Milegi Dobara (2011) 81n10
Zohrā 117–19, 124, 232